F r a
ANGELICO

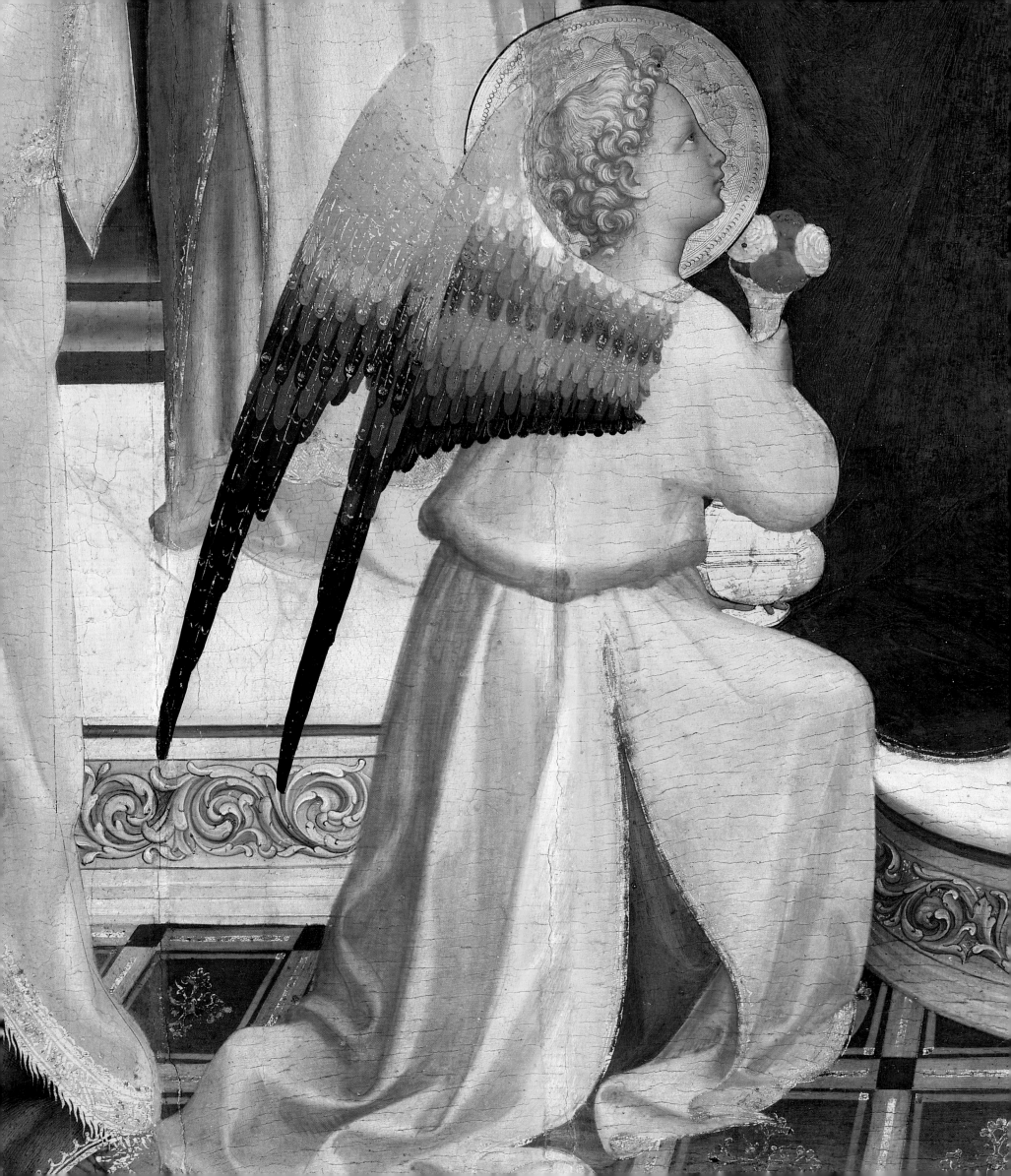

Fra
ANGELICO

John T. Spike

ABBEVILLE PRESS
PUBLISHERS
NEW YORK LONDON PARIS

JACKET FRONT:

Detail of the predella of the Altarpiece with Saints James,
John the Baptist, Francis, and Dominic
(catalog 114B)

JACKET BACK:

ANNUNCIATION
(catalog 24)

FRONTISPIECE:

Detail of the central panel of the San Domenico Altarpiece
(catalog 15A)

FOR THE ENGLISH-LANGUAGE EDITION:
Editor: Abigail Asher
Jacket and Interior Typographic Design: Barbara Sturman

FOR THE ORIGINAL EDITION:
Editor: Paula Billingsley
Series Design: Marco Zung
Layout: Elena Pozzi

First edition
2 4 6 8 10 9 7 5 3 1

Library of Congress Cataloging-in-Publication Data
Angelico, fra, ca. 1400-1455.
Fra Angelico / John T. Spike.
p. cm.
Includes bibliographical references and index.
ISBN 0-7892-0322-7
1. Angelico, fra, ca. 1400-1455—Catalogs.
I. Spike, John T. II. Title.
ND623.F5A4 1997 96-51128
759.5—dc21

CONTENTS

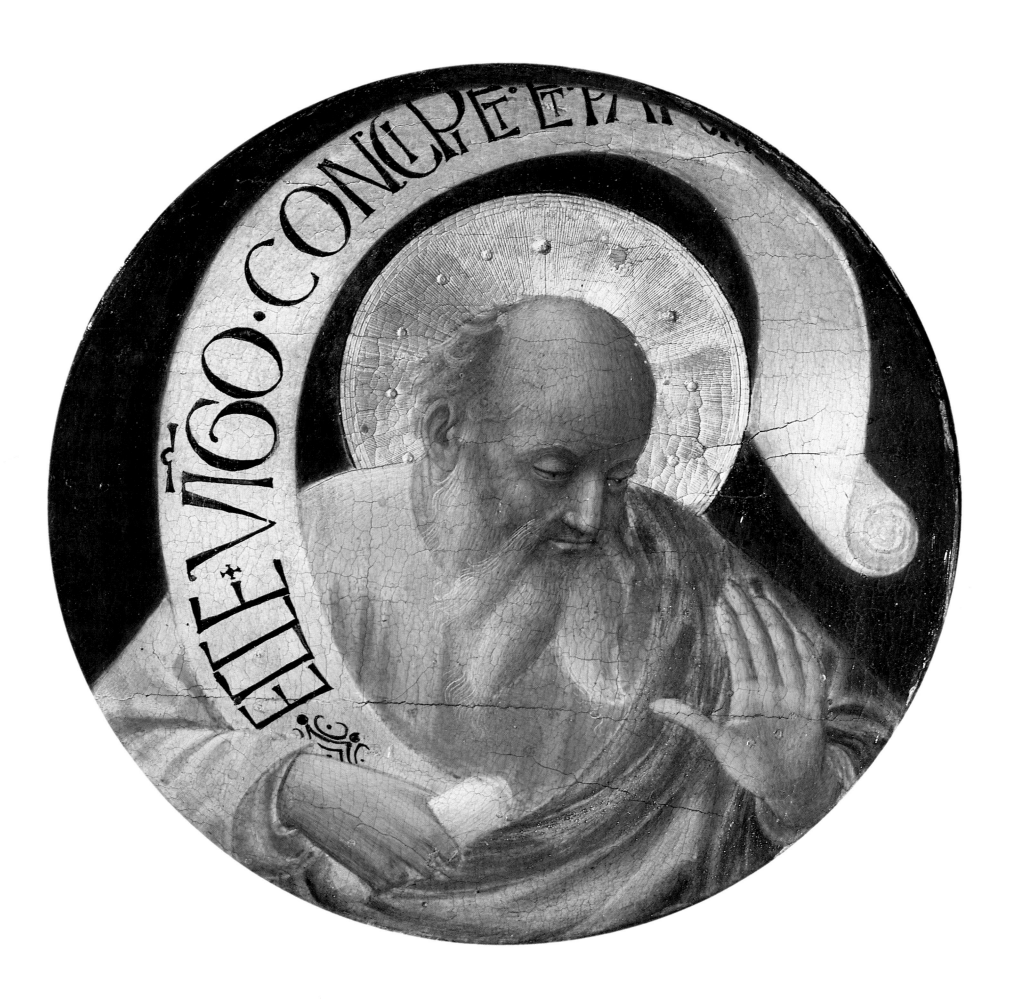

*This book
is dedicated to Michele,
my wife*

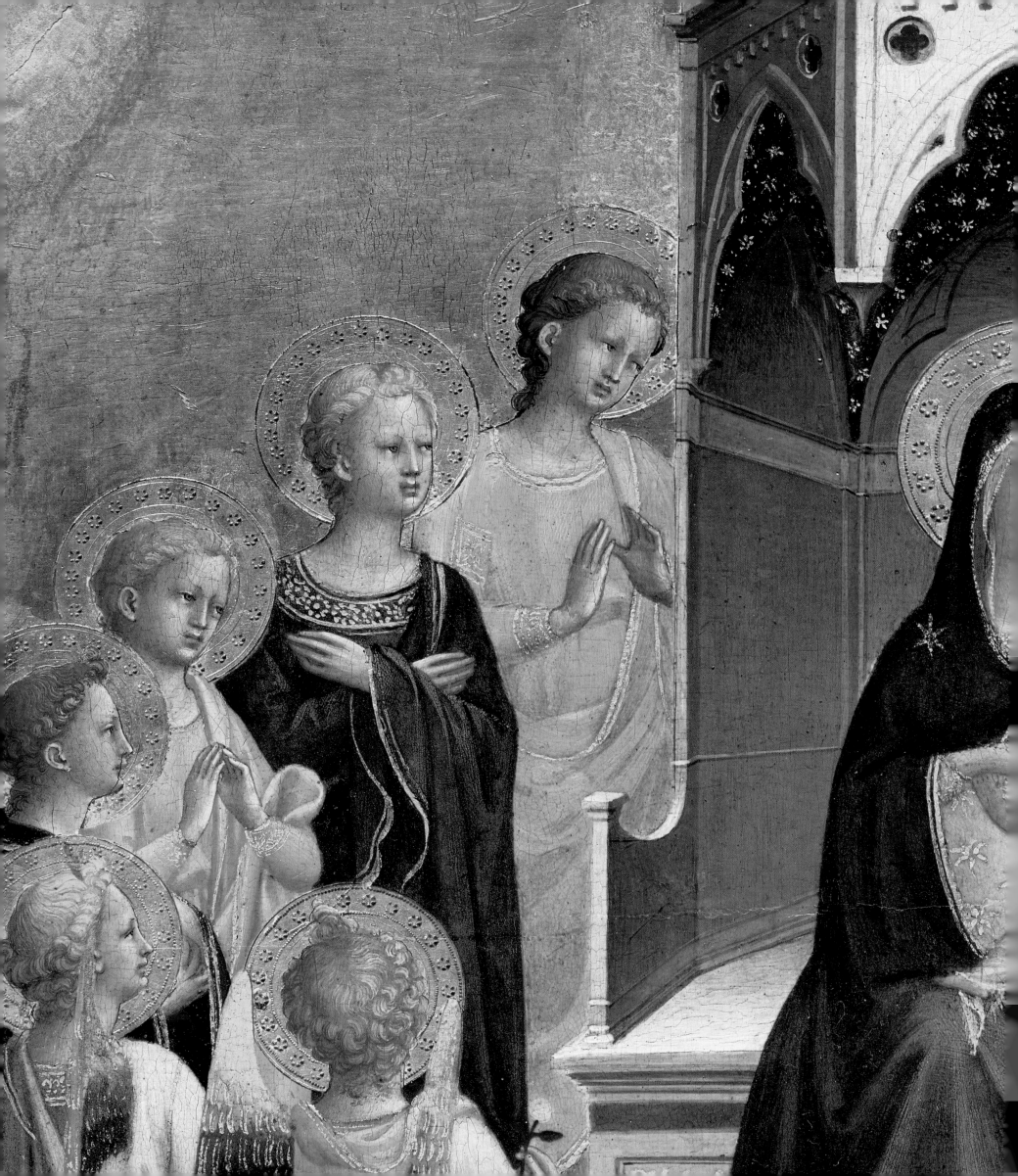

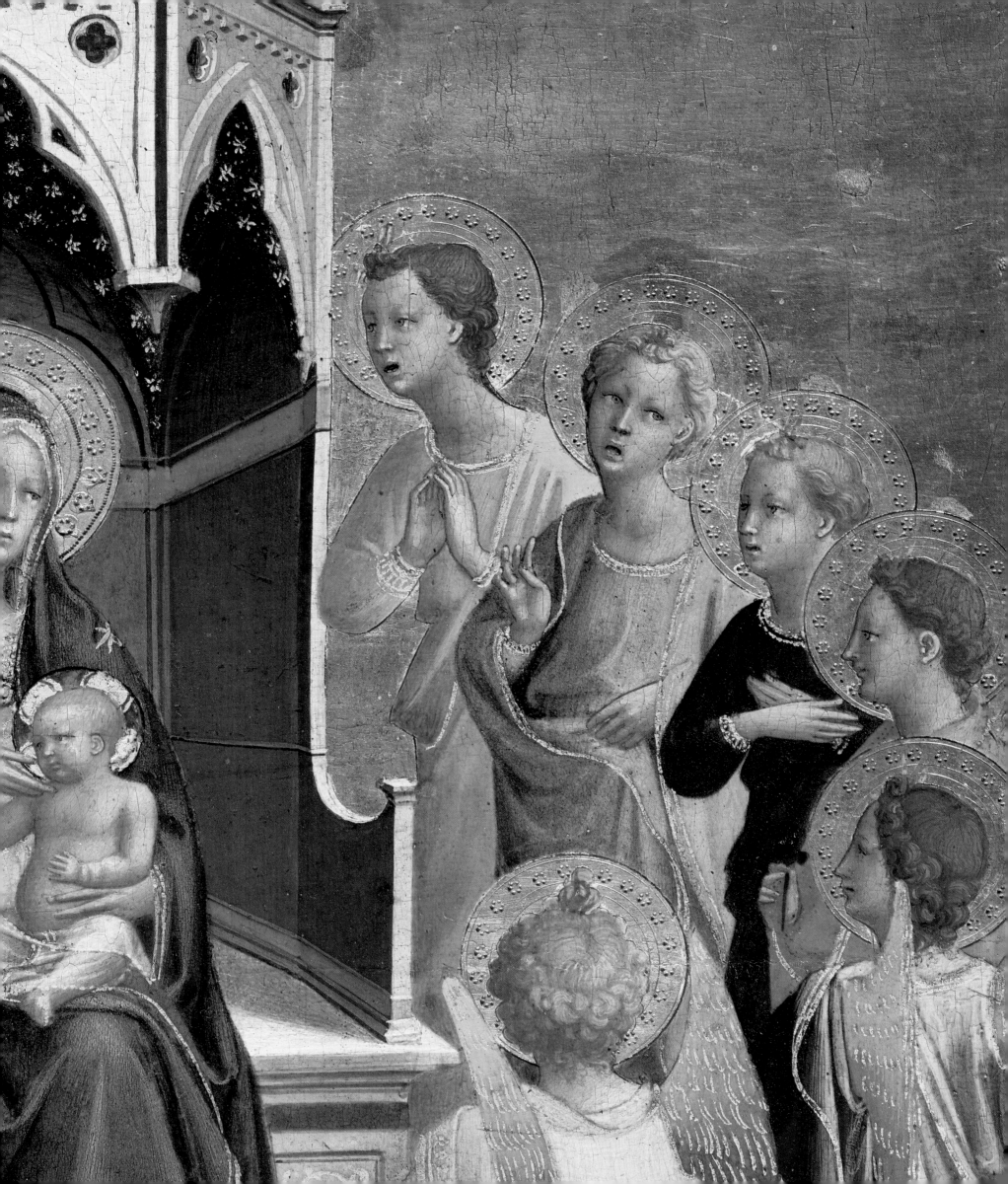

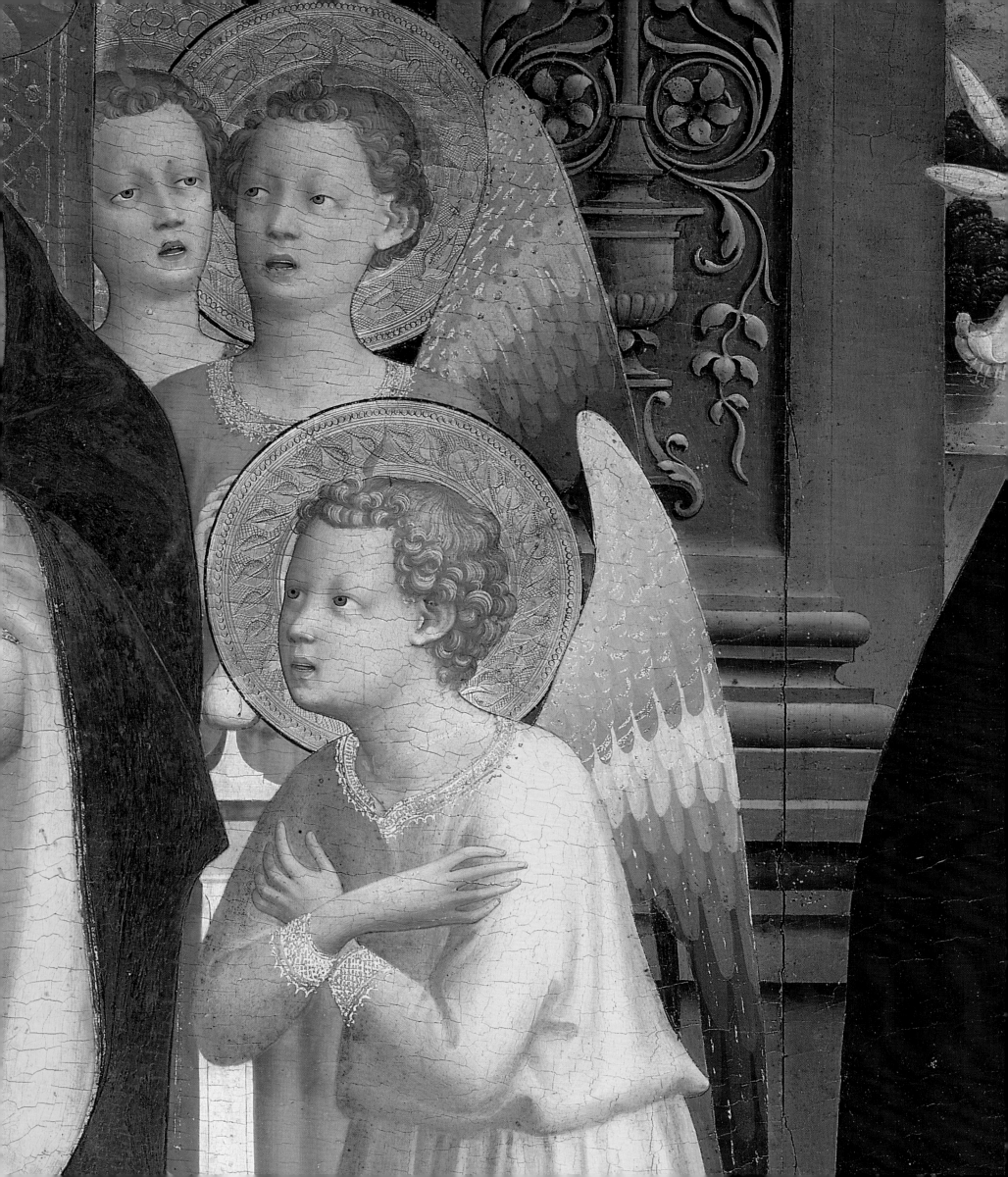

PREFACE AND ACKNOWLEDGMENTS

"It was his custom never to retouch or repaint any of his works, but to leave them just as they were when finished the first time; for he believed that such was the will of God. It is said, indeed, that Fra Giovanni never took a brush in his hand until he had first offered a prayer; nor did he ever paint a *Crucifixion* without tears streaming down his cheeks." Thus Vasari, in 1550, following his conversations with an old friar at San Domenico, Fiesole, described Fra Angelico's method of working. Nothing that I have learned about Fra Angelico has given me any reason to doubt the veracity of this account.

Vasari meant to honor Fra Angelico by removing him from the general company of painters and placing him in the direct employment of God. The distinction that Vasari bestowed upon Fra Angelico had unforeseen consequences, however. Within very few years of Vasari's writing, Fra Angelico's contributions to the art of his own time were forgotten or misunderstood: he came to be seen as a precious gothic relic who had lived on into the age of Masaccio.

This misconception has flourished in the scholarship of our century in the persistent tendency to date the artist's paintings five, ten, and sometimes twenty years too late—or to attribute his paintings to his young assistants. When the Annalena Altarpiece is assigned its more probable date of c. 1430, we realize that the emergence of the rectangular *sacra conversazione* altarpiece owes far more to Fra Angelico than to any other painter, including Masaccio. One of the purposes of this book is to demonstrate that Fra Angelico possessed one of the most innovative and responsive pictorial minds of the early quattrocento—and that his contemporaries admired him for precisely these qualities.

My other theme in this book has been an attempt to show that Christian piety and Renaissance humanism were by no means exclusive quantities in the generation of Fra Angelico and the Council of Florence of 1439. The extraordinarily creative program of his frescoes in San Marco, for which I have been able to offer the first comprehensive (but far from exhaustive) interpretation, is proof in itself of Fra Angelico's contacts with humanistic theologians and of his ability to reconcile their fascination with the immortality of the soul with the Incarnation doctrines of Saint Thomas Aquinas, the Dominican doctor of the church. It will surprise some to read that Fra Angelico was a theologian in the new humanist cast. Yet this artist's lifelong fascination with the written word and with accurate transcriptions of texts in Latin, Greek, and Hebrew place him squarely in the forefront of Renaissance philology. No other artist of his time took such care with language. Indeed, Fra Angelico's paintings contain more inscriptions—and more unique inscriptions—than those of any other artist of the fifteenth century.

It must have been his formation as a Dominican that enabled him to participate in the theological debates that animated spiritual life of Florence and Rome during the first half of the quattrocento. Certainly the Order of Preachers equipped him with an unequaled command of rhetorical techniques that no one had ever previously translated into the medium of painting— the *Last Judgment* he painted for Ambrogio Traversari and the *Deposition* for Palla Strozzi were both enormously influential breakthroughs in this regard.

Since Fra Angelico was praised by contemporary humanists such as Cristoforo Landino, and mainly employed by them—including, in addition to Ambrogio Traversari and Palla Strozzi, Cosimo de' Medici, and Popes Eugenius iv and Nicholas v—we must assume that his art responded in significant respects to their way of thinking.

In the research and writing of this book I have received assistance from many people, whom I shall endeavor to name here.

As always, I am deeply grateful for the encouragement of my friend and admired colleague,

OPPOSITE:
Detail of the central panel of
the San Domenico Altarpiece
Church of San Domenico, Fiesole
(see page 85 and catalog 15a)

Vittorio Sgarbi, who has never overlooked an opportunity to assist my studies. I have also profited from the kindness of his delightful parents, Rina and Giuseppe Sgarbi.

My researches for this book were undertaken in Florence at the Kunsthistorisches Institut in Florenz, the Istituto Universitario Olandese di Storia dell'Arte, and at the Berenson Library of Villa I Tatti of Harvard University. In the United States, I used the excellent facilities of the New York Public Library, the Frick Art Reference Library, and the Englewood (New Jersey) Public Library. Feliciano Paoli traced for me the Italian translation of Pseudo-Dionysius the Areopagite and other rare works in the Biblioteca e Civico Museo di Urbania and the Biblioteca Universitaria di Urbino. Andrew Blume at Harvard University kindly discussed these problems with me and provided photocopies of materials in the Fine Arts Library. For many courtesies, I am indebted to the professional staffs of all these institutions.

In addition, several individuals were extraordinarily generous with loans from their private libraries: Father Christopher Zielinski, prior of San Miniato al Monte, with whom I enjoyed several fascinating discussions of Florentine Neoplatonism; John Varriano sent me an English edition of the works of Pseudo-Dionysius the Areopagite in which I found the key to unlock the program of San Marco; Creighton Gilbert shared with me his exceptional knowledge of this field; Miklós Boskovits gave his important new book, *Immagini da Meditare*; Nancy and Thomas Galdy kindly lent me Krautheimer, Kristeller, and I forget how many other books.

Magnolia Scuderi, director, and Giovanna Rasario, vice-director, of the Museo di San Marco were exceptionally helpful for which I am extremely grateful. As I am to P. Tito S. Centi, O.P., who shared with me his unique knowledge of San Domenico, Fiesole, and gave me his important biography, *Il Beato Giovanni, pittore angelico*.

To Sergio Negrini, my editor at R.C.S. Libri & Grandi Opere, and to Liana Levi in Paris, I offer my heartfelt thanks for the opportunity to write this book, and for their unfailing patience, notwithstanding the strains caused by my lateness with the manuscript. I am grateful to Abigail Asher and Barbara Sturman at Abbeville Press for their fine work on the English edition of this book.

Hellmut Wohl kindly read the typescript at a critical stage; his favorable response gave me a much-needed lift.

During the preparation of this book I have enjoyed an active correspondence with many colleagues and friends. With sincere apologies to anyone omitted in the haste of these late moments, I would like gratefully to acknowledge the good advice and encouragement of Canon John Azzopardi; Giorgio Bonsanti; John Bugeja Caruana; Jean Cadogan; Giovanni Carnevali; Laura Casalis; Rev. Peter Casparian; Walter B. Denny; Marco Fossi; Mino Gabriele; Jane and George L. Hersey; Paul Joannides; Anthony and Nancy Kronman; Cristina Acidini; Bert W. Meijer; Arnold Nesselrath; Alan Perreiah; Franco Maria Ricci; Roberto Saporito; John Speed; Patrizia Spinelli; Tiziana Stella; Dominique Thiébaut; Giuseppe Valentino; Donatella Volpi, to whom I owe a lasting debt of gratitude for her colleagueship and confidence in my abilities; Wendy Watson; Alice Sedgwick Wohl.

Finally, I would like to thank my beloved wife, Michele, and son, Nicholas, for their customary good humor and affectionate tolerance during these many months of total dedication to the friar of Fiesole. Nicholas has reached the age (thirteen) when he can lend a hand as our much-needed in-house computer technician. Michele, my partner-in-life, has worked alongside me at every stage of this project, responding with encouragement or with corrections, as the case required, but always with insight and inspiration. It is only fitting that I dedicate this book to her.

JOHN T. SPIKE
Via Giramontino, Florence, July 1996

OPPOSITE:
Detail of the predella of the
San Domenico Altarpiece
National Gallery, London
(catalog 15b)

OVERLEAF:
Detail of San Romualdo
from *CRUCIFIXION WITH
ATTENDANT SAINTS*
Chapter Room, Convent of San Marco
(see pages 134-35 and catalog 22)

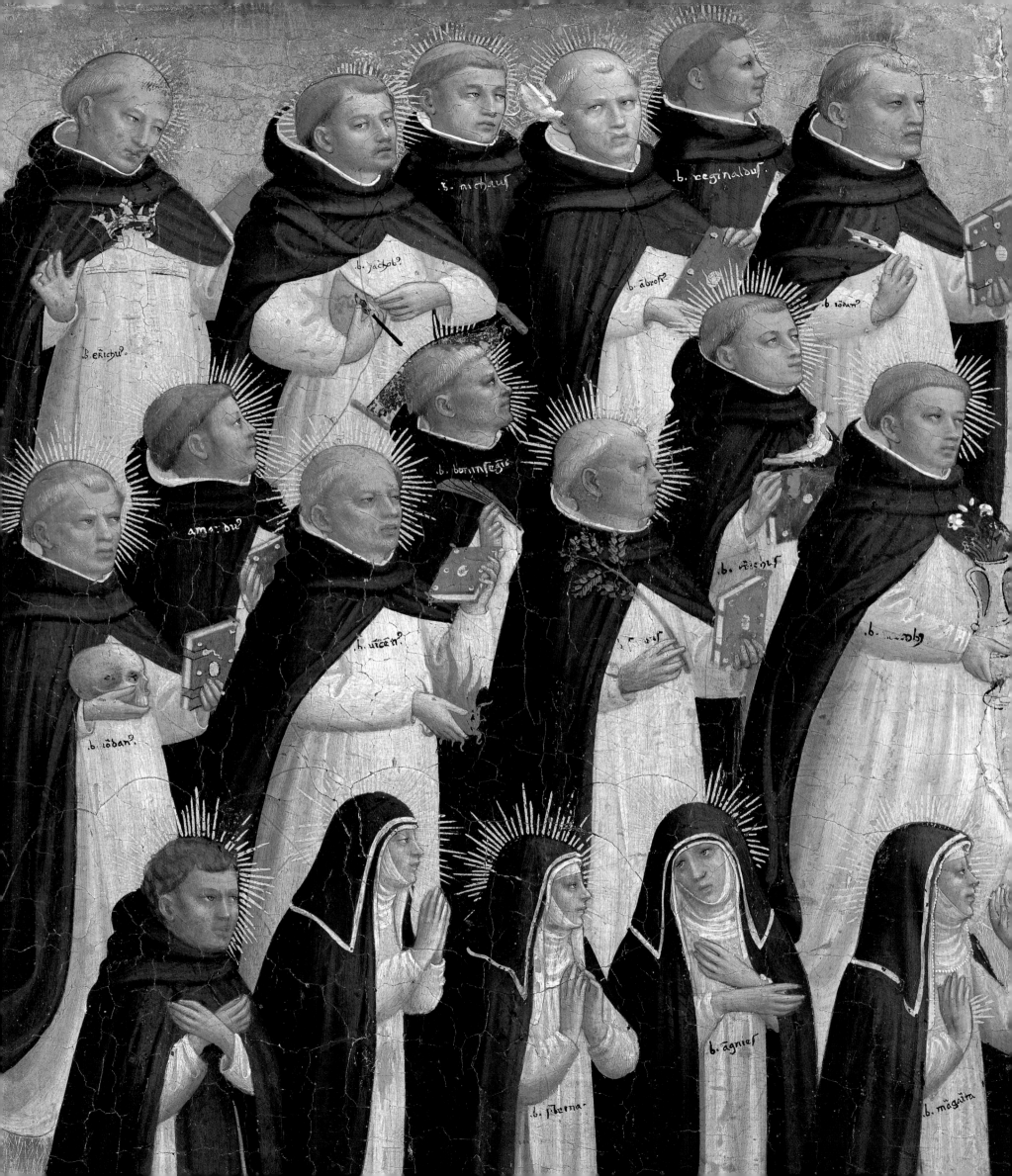

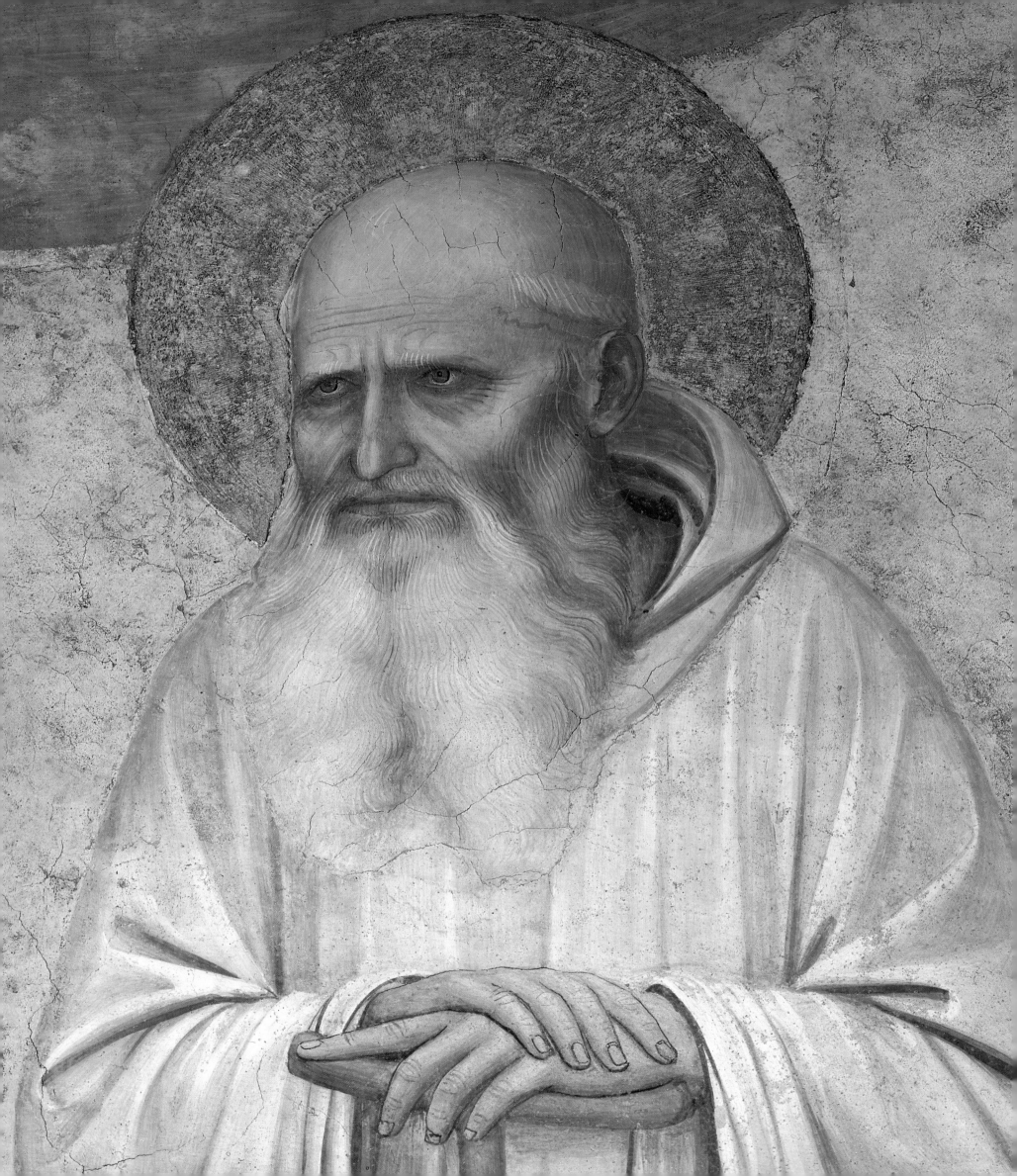

LIFE AND WORKS

THE PAINTER WE HONOR TODAY WITH

the words *angelico* and *beato*[1] was known in his own time as

Fra Giovanni, the name he adopted when, around 1420,

he took the vows of a Dominican friar.[2] Before he left the

world to enter the church, the young man's name was

Guido di Piero; very little else is known about his family

or the first two decades of his life. Guido di Piero was born in the last years of the trecento in the Mugello region to the

north of Florence.[3] By 1417, when he first emerges into the documentary light of day, he was already living and working

as a painter in Florence. ℂ On October 31, 1417, Guido di Piero was accepted as a member of the Compagnia di San

Niccolò, a religious confraternity that held its meetings in the church of Santa Maria del Carmine in Florence.[4] His

admission into the group was an implicit recognition of his Christian piety, and, no less, of his secure professional status.

The young painter had been introduced by Battista di Biagio Sanguigni, a miniaturist, twenty-five years old, who like

Guido di Piero was a resident in the *popolo* of San Michele

Visdomini in the center of town near to the Duomo.[5]

Sanguigni had entered the Compagnia di San Niccolò two

years earlier[6] and now he extended the opportunity to his

neighbor, and, possibly, his workshop companion. Some of

Sanguigni's miniatures are known today, as is the fact that

he purchased his colors and rented his house from the

monks of Santa Maria degli Angeli.[7] ℂ A few months later,

in January and February of 1418, Guido di Piero was paid

twelve florins, a good sum, for a lost painting [*tabule altaris*]

in the Gherardini Chapel in Santo Stefano a Ponte.[8] The

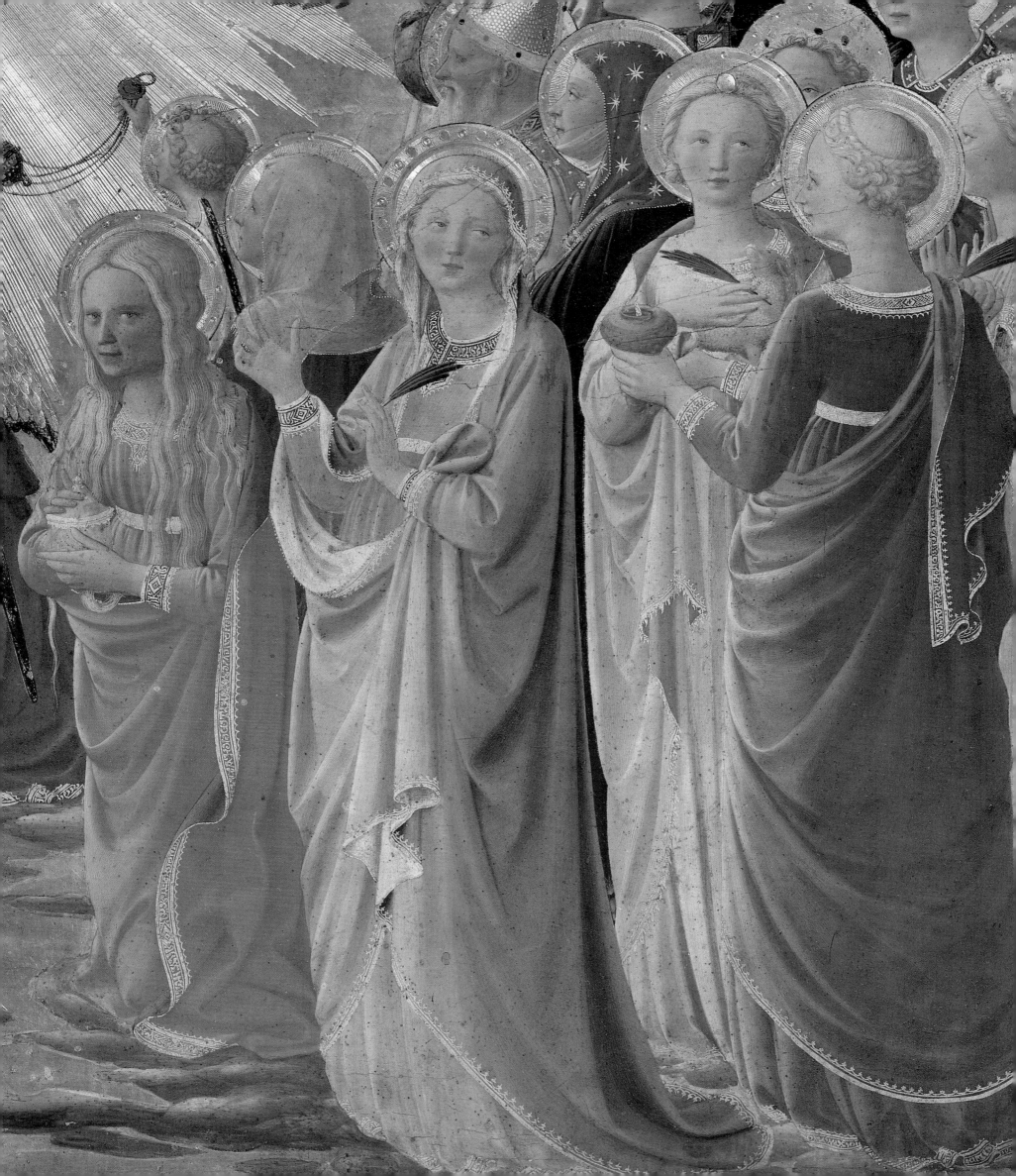

assignment had come to him from the *capitani* of Orsanmichele, a committee of citizens who were the executors of a testament that provided for the decoration of the chapel. Guido di Piero had thus the satisfaction of exhibiting one of his works, apparently an altarpiece, in a prominent church near the main artery of the city, the Ponte Vecchio.

Neither this first recorded work nor any other painting made by Guido di Piero, before he became Fra Giovanni, has yet been identified. The formative years of any painter are notoriously difficult to reconstruct; in the case of Fra Angelico's juvenilia, the problem is exacerbated by the failure of the early sources to throw any light on the character or duration of his artistic training.

Because Guido di Piero lived in the vicinity of Santa Maria degli Angeli, and later, as a friar, painted manuscript illuminations, many authors have suggested that he was a pupil of Lorenzo Monaco (c. 1370-1424), under whose direction the Camaldolese convent sponsored a flourishing workshop of painters and miniaturists.[9] It is possible to trace some significant connections between Fra Angelico and Lorenzo Monaco, their combined vocations of painter-priest being but one of them. Furthermore, certain paintings by Fra Angelico can be shown to have been inspired by well-known examples by Lorenzo Monaco, who died in 1424. But the major stumbling block to this hypothesis is the fact that the earliest datable works by Angelico—the San Domenico Altarpiece and the San Pietro Martire Altarpiece from the early 1420s—do not display the calligraphic ornament, angularities, and metallic colors that are constant elements of Lorenzo's International Gothic style. It would be difficult to explain how, or why, Guido di Piero, if he had apprenticed with Lorenzo Monaco, would have been able to cast off his master's stylistic teachings in such a short span of time.

The identity of Fra Angelico's master remains unknown today mainly because the question was completely ignored by the early sources, including Vasari, who dedicated a long biography to "Frate Giovanni Angelico da Fiesole," as he was already known by 1550.[10] The hagiographic tradition that had arisen about the pious friar seems to have discouraged Vasari from his usual investigations into the family background and artistic formation of his subject. Vasari comments only that Guido's talent was already evident when he was *giovanetto*, and that, after his profession, Fra Giovanni perfected himself through the study of Masaccio's frescoes in the Brancacci Chapel in the Carmine church (1425-26). "Vasari is as poor in facts as he is rich in praise of the painter" was the inarguable judgment rendered by Gaetano Milanesi in 1878.[11]

In the absence, therefore, of either documentation or testimony related to Angelico's master, Filippo Baldinucci sought in the latter half of the seventeenth century to resolve this question on the basis of stylistic analysis. As Baldinucci was the most informed historian and connoisseur of Florentine art since Vasari, and had access to innumerable paintings of the trecento and quattrocento that have not survived, his views deserve more serious consideration than they currently receive:[12]

Vasari says that he made himself a worthy painter through his study of Masaccio's works, which, indeed, is very likely. It is no less true, however, that Fra Angelico's frescoes clearly demonstrate that he was a pupil of Gherardo dello Starnina, who flourished in the years before Masaccio began to paint, or was even alive. In the time of Starnina, our venerable painter was still young, but he dedicated himself to painting with great profit. He always retained the style of Starnina, which he improved as to its delicacy and tactility after he had seen the paintings made soon thereafter by Masolino da Panicale.[13]

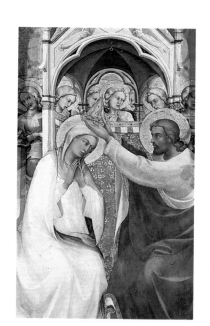

Although Baldinucci had been misled by both Vasari and an unreliable sixteenth-century chronicle[14] into the erroneous belief that Fra Angelico was older than Masaccio by a full generation (they were contemporaries), he did not allow this misconception to prejudice his own conclusions, namely, that Angelico was principally formed under the influence of Gherardo Starnina (c. 1354-before 1413), whose style he then made more natural and substantial through emulation of Masolino. Angelico subsequently responded as well to some of Masaccio's pictorial innovations, as we shall see.

That Gherardo di Jacopo Starnina was the critical personality in Florentine painting during the transition between the fourteenth and fifteenth centuries had already been underscored by Vasari. Despite his importance, however, Starnina's accomplishment was eclipsed in the centuries following his death due to the destruction of his principal works, the stories of Saint Jerome in Santa Maria del Carmine (1404) and his frescoes in Santo Stefano in Empoli (1409), major cycles of which only random fragments have been recovered. In 1904 Osvald Sirén identified a fascinating group of paintings by an anonymous painter whom he memorably dubbed the "Maestro del Bambino Vispo."[15] The engaging liveliness and humanity of the paintings by the Maestro del Bambino Vispo were recognized by subsequent scholars, but their contribution to Florentine painting could not be evaluated so long as none of them could be dated. There was a tendency to view the Maestro del Bambino Vispo as a charming conservative who practiced on into the 1420s. In the last three decades, through the scholarship of Luciano Berti, Luciano Bellosi, and Jeanne van Waadenoijen, the panel paintings of that master have been restored to Starnina, who died prematurely before 1413.[16]

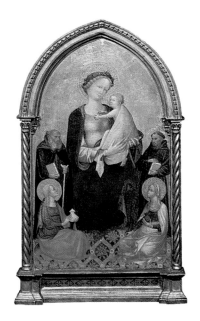

If we examine a characteristic work by Starnina, the *Madonna and Child Enthroned with Saints Anthony Abbot, Francis of Assisi, Mary Magdalen, and Lucy* (right), dated by Miklós Boskovits between 1404 and 1409, we seem to find ourselves in the presence of an embryonic composition by Fra Angelico.[17] Although we cannot state with certainty that Guido di Piero was an apprentice in the large workshop that Starnina is known to have directed in his last years, we can agree with Baldinucci's observation that Starnina's works of circa 1410 undoubtedly laid the foundation for our young artist's future development. In the few years left to him following his return from Spain after 1401, Starnina began to purge his style of late gothic sinuosity, eliminating many of the fripperies of drapery folds and edges and endowing his figures with greater weight. Starnina was a pioneer of the gothic taste for naturalistic details, and thus prepared the way for the life studies of the Renaissance. The beards worn by Starnina's prophets and hermits are unruly and neglected in contrast to the perfectly combed and oiled beards of Lorenzo Monaco's apostles and patriarchs. But of greater value, perhaps, to Fra Angelico were the steps taken by Starnina to suppress much of the extraneous ornamentation that choked and flattened Florentine paintings of the late trecento. As a result, Starnina's figures are the first in some time to step forward from the background and bring some individuality to their roles.

The scholarly debate that currently rages around the famous *Thebaid* in the Uffizi has bearing upon this question.[18] In 1940 Roberto Longhi was the first to reassign this panel, traditionally attributed to Starnina, to Fra Angelico.[19] Longhi pointed out, moreover, that this animated painting of hermit saints and diminutive chapels scattered high and low in a gothic landscape could probably be identified with the painting of this subject ascribed to Fra Giovanni in the 1492 postmortem inventory of Lorenzo de' Medici's possessions.[20] For many years, Longhi's attribution fell on deaf ears; in the most recent scholarship, however, the *Thebaid* has re-emerged as a major early work by Fra Angelico, although the

Gherardo di Jacopo Starnina
*MADONNA AND CHILD
ENTHRONED WITH SAINTS
ANTHONY ABBOT, FRANCIS OF
ASSISI, MARY MAGDALEN,
AND LUCY*
Private collection

dates proposed for its execution vary from 1415 to 1425. In my opinion, the *Thebaid* is a masterpiece of gothic anecdotal naturalism that deserves to be regarded as the capstone of Starnina's career. In any event, the fact that this important work is debated between the young Guido di Piero and the late Starnina is a good indication of the close relationship between these artists.

It should also be noted that the most progressive painter to emerge in Florence around 1420, Tommaso di Cristofano Fini, called Masolino da Panicale (c. 1383-1435), was a pupil of Starnina. At least a decade older than Angelico, Masolino presumably was among the first Florentines to study with Starnina after the master's return from Spain around 1402. During the 1420s or 1430s no artist comes as close to Angelico as does Masolino (and vice versa). Baldinucci saw that Masolino had been the catalyst in Angelico's achievement of a fully modern style. By the same token, the great critics of a hundred

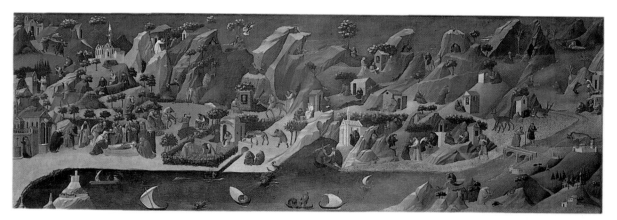

years ago, Joseph Crowe and G. B. Cavalcaselle, were accustomed to speaking of Masolino and Fra Angelico in the same breath. In their view, "both artists laboured, technically speaking, on the same principles; and they may be supposed to have been educated in the same school."[21]

There is still general agreement among scholars that the works executed by Guido di Piero around 1420, when they are identified, will most likely owe much to Masolino's delicacy and refinements. The small Cedri Madonna in Pisa (catalog 95) was mostly overlooked by scholars until 1973, when Carlo Volpe convincingly restored its attribution to the early Fra Angelico. The cause of the Cedri Madonna was eloquently taken up by Boskovits in 1976, who underscored its strongly Masolinesque quality. Recently Carl Brandon Strehlke has suggested that the Cedri Madonna can probably be taken as similar in style to the lost altarpiece executed in 1418 by Guido di Piero in the Gherardini chapel of Santo Stefano al Ponte.

"FECIESI FRATE DI SANTO DOMENICHO"

Within a few years, Guido di Piero resigned from the Compagnia di San Niccolò. A laconic notation under his name in the roster of the confraternity notes that he had become a Dominican friar.[22] This turning point in the artist's life took place before June of 1423, when he is first cited with the name he adopted upon his profession, "frate Giovanni de' frati di san Domenicho da fiesole" (fra Giovanni of the friars of San Domenico in Fiesole).[23] The document in question has importance beyond its record of a

Gherardo di Jacopo Starnina
THEBAID
Galleria degli Uffizi, Florence

small payment received for painting a crucifix, now lost, for Santa Maria Nuova, because it reveals that after taking his vows Fra Angelico did not withdraw from his art for numerous years of religious instruction, as was once supposed. Furthermore, it is significant that the earliest record of the friar-painter finds him employed on a work for a convent other than his own. The same document refers to payments to two artisans from Fra Giovanni's former neighborhood, San Michele Visdomini, which indicates that he was permitted to make use of his previous professional contacts.

When Guido di Piero became Fra Giovanni, he was already a master painter, perhaps twenty-two to twenty-five years old. On the basis of his statistical examination of the Dominican communities at San Domenico in Fiesole, and Santa Maria Novella in Florence, Creighton Gilbert has confirmed that it was out of the ordinary for a person of Angelico's maturity to enter the order.[24] Indeed, Guido di Piero and his brother, Benedetto, seem to be the only laymen to have joined San Domenico in Fiesole at any time during this decade. As a convent of the Dominican Observance, San Domenico mostly recruited from other Dominican houses.[25]

Apart from the Christian spirituality that is manifest in his art, no other motive (if one were needed) to take this decisive step is known to us. As we noted above, by the time of Vasari's biography, Fra Giovanni *Angelico* was already enveloped in a saintly aura that seems to have discouraged the historian's usual curiosity as to his subjects' origins. As a result, not a single word on the artist's family background or early education has come down to us. These are notable omissions from a time when a person's life was to a great extent predetermined by his birth. Moreover, no documentation regarding either of Fra Angelico's parents has ever been discovered. His signatures inform us that Guido di Piero was the son of a certain Piero, and, once in a document, he added that Piero was the son of a certain Gino,[26] but no record of the occupation or familial residence of any of Fra Angelico's ancestors is available. This lacuna is especially curious in view of Angelico's documented intimacy with his brother, Benedetto, and his sister, Checca.[27] Since their entrance into a religious order required the renunciation of any personal wealth, the question arises as to how it was possible for the family of Guido and Benedetto di Piero to forego the lifetime earnings of two sons. If Fra Angelico came from an affluent family, his father and other relatives would have inevitably left some trace in the archives of the *catasto* (the civic office of taxation) or in some other branch of the ubiquitous Florentine bureaucracy. The conclusion is inescapable that Guido, Benedetto, and Checca di Piero were either born into abject poverty or, as seems more likely in view of the boys' specialized training, orphaned when they were still children. The social stability and emotional sustainment of a religious convent might have been attractive to the artist and his younger brother, a trained scribe, if they were indeed bereft of family support.[28]

It has sometimes been suggested that Fra Angelico's vocation might have been inspired by the preaching of an itinerant Dominican, Fra Manfredi da Vercelli, who attracted large crowds in Florence during these same years.[29] More recent analysis, however, has determined that Fra Angelico, both before and after he took vows, was frequently employed by Santa Maria Novella, the mother church of the Dominicans in Florence. Most of these works have unfortunately been lost, although a paschal candle painted by him before 1419 still existed in Vasari's day.[30] The Dominicans of Santa Maria Novella were the honored hosts in 1419 and 1420 to Pope Martin v, who disapproved of Fra Manfredi's activities. Eugenio Marino[31] and Andrea De Marchi have therefore suggested that Angelico's

call to the Dominicans was more likely encouraged by the patronage he received from Santa Maria Novella under the aegis of Leonardo Dati, the *maestro generale* of the Dominicans since 1414.[32] Dati was a friend of Coluccio Salutati and other Florentine humanists; he played a key role at the Council of Costanza, where the Great Schism had been ended by the election of Pope Martin v. At Metz in 1421 Dati had championed the cause of the Observantists' reforms with a paper entitled *Laments Regarding the Friars of Lapsed Observance*. Between 1418 and 1420 Dati founded San Pietro Martire, the first Observantist Dominican nunnery in Florence, for which Fra Giovanni executed the altarpiece a few years later. Moreover, as De Marchi has pointed out, it was Dati who executed on January 25, 1419, the testament of Barnaba degli Agli, which provided six thousand florins to the Observantist Dominicans for the reconstruction and enlargement of the church and convent of San Domenico, Fiesole. The Observantist friars had been obliged to abandon Fiesole in 1409 because their founder, Fra Giovanni Dominici, had fallen afoul of Florentine papal politics in that schismatic era.

A few words on the Observantist reform movements are perhaps in order here. In the aftermath of the Black Death of 1348, the belief was widespread among the leading thinkers of the time, both laymen and ecclesiastics, that they were living in a morally debased age. The crisis of conscience that induced Boccaccio, in his old age, to denounce the *Decameron* was but one manifestation of this dark mood. Rumors of dissolution and vice among the clergy were a primary topic of public discourse, and the cynical political motives behind the removal of the papacy to Avignon did nothing to allay such accusations. The second half of the trecento yearned to recover the superior moral values of the duecento, when Saint Dominic and Saint Francis founded their mendicant orders, and of the early trecento, when Dante weighed heaven and earth in his *Divine Comedy*.[33] As a result, movements for reform arose from within the various mendicant and monastic orders; they called for the establishment of Observantist convents, where the clergy would commit themselves to live according to the stringent rules and constitutions of their saintly founders, including the ban on the possession of property.[34] The principal obstacle to overcome was the possible antagonism of the friars and monks in the older, and often wealthy, convents where considerably less ascetic conditions prevailed. With the effective end of the Great Schism in 1417, the Roman popes of the first half of the quattrocento—Martin v, Eugenius iv, and Nicholas v—consistently supported the Observance, which had taken on humanist connotations because of its concern with historical authenticity.[35] In Florence, lay support of Observantists reached its highest point under Cosimo de' Medici, who during the 1420s began construction on a convent and church for the Franciscan Observantists at Bosco ai Frati, and, in 1436, acquired the convent and church of San Marco, Florence, for the friars of San Domenico, Fiesole—to name two projects to which Fra Angelico would contribute.[36]

DOMINICAN PAINTINGS OF THE 1420S

After his transfer to Fiesole in the early 1420s, Fra Angelico created in the convent a fully functioning workshop for the production of paintings on every scale, from miniatures to ornate polyptych altarpieces. Unfortunately no chronicle or contemporary witness can throw light on either this fundamental moment in his career, or the names or numbers of his assistants. Apart from Fra Benedetto, who was a manuscript

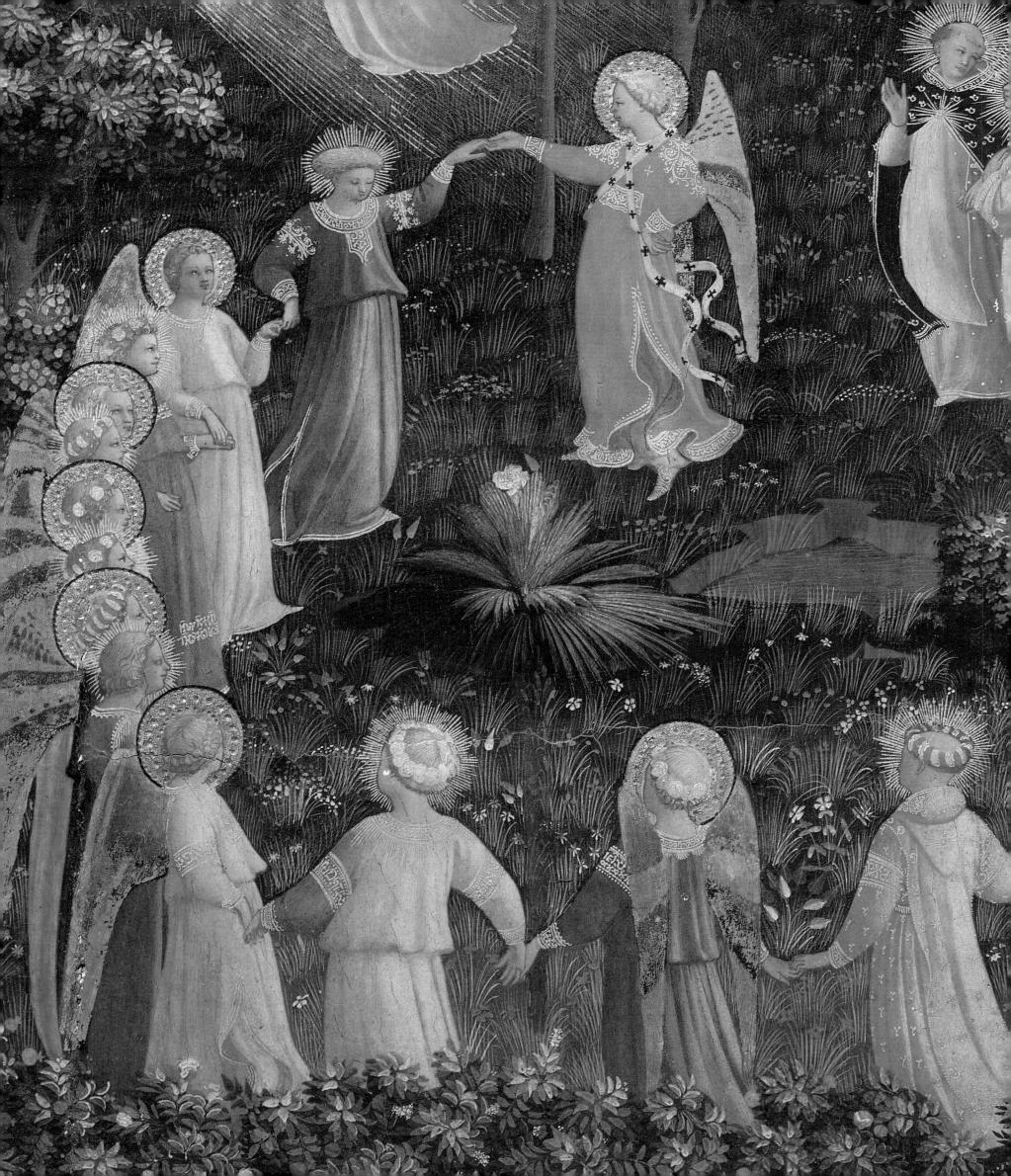

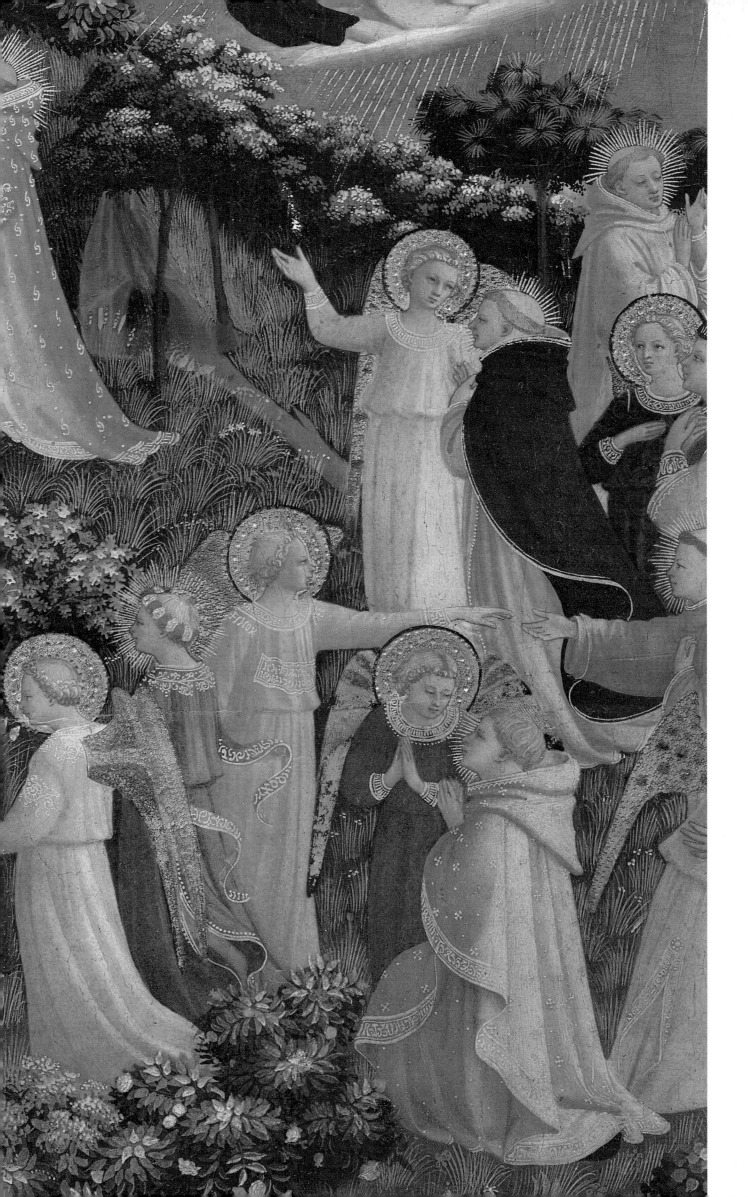

Detail of
LAST JUDGMENT
Museo di San Marco, Florence
(see pages 104-5 and catalog 67)

scribe, not a painter, it does not appear that any of the other friars trained under him or participated in his works. One suspects that the transfer from Florence to Fiesole by his friend, Battista di Biagio Sanguigni, was inspired by the possibility of collaborations on manuscripts. Sanguigni was the master of Zanobi Strozzi (b. 1412), who grew to become Angelico's most adept imitator, after Benozzo Gozzoli.[37]

The earliest document for an extant painting dates from the end of the decade, 1429, when we learn that San Domenico was still owed for an altarpiece executed for the Florentine convent of San Pietro Martire.[38] Until recently, many scholars tended to designate 1429 as roughly the point of departure for their analysis of Angelico's career. In a number of important studies, however, Miklós Boskovits has convincingly argued that the San Pietro Martire Altarpiece (catalog 73) could have been executed as many as three years earlier than 1429.[39] His analysis was confirmed by the discovery by John Henderson and Paul Joannides of the 1429 date of the Santa Croce Altarpiece (catalog 70), a notably more mature work.[40] As a result, the date of Angelico's polyptych for the high altar of San Domenico, Fiesole, which all critics agree is an earlier creation, can be advanced to the early 1420s. Although the construction of the Fiesole convent required the entire decade and part of the next, the friars were able to hold services in the church as early as 1420 and an altarpiece in celebration of their foundation would have been an appropriate assignment for their new friar-painter.

These early altarpieces will be discussed in detail in the Plates section of this volume, but suffice it to note that the San Domenico Altarpiece, although drastically modernized in 1501 by Lorenzo di Credi, fully justifies Baldinucci's claim that the young Angelico was formed under Starnina and matured with observations of Masolino. Both the Virgin and her company of adolescent angels are portrayed with the slender proportions that are the hallmarks of Masolino's figure style. The stern-faced saints who flank her throne take their expressions and stiff stances from Starnina's more antiquated approach. Angelico's individuality is evident in the extraordinary luminosity of his colors; the black-and-white habits of the Dominican saints are illuminated with a light that emanates from within, yet does not seem unnatural.

In 1420 Florentine painters stood, no doubt unaware of the fact, on the threshold of a new epoch. After two decades of unrecorded activity, Masolino was prepared to emerge as the city's most progressive artist, sensitively pursuing Starnina's impulse toward simplicity while breaking new ground in naturalistic description of draperies and human characteri-zation. At the same time, a dazzling foreigner—Gentile da Fabriano (c. 1370-1427)—made an impressive entrance on the scene. Gentile brought from Venice a luxurious and gilt palette that represented the culmination of International Gothic style. His works, especially his *Adoration of the Magi* for Palla Strozzi in Santa Trinita (see page 266), signed and dated 1423, were favorably received, but the extent of his influence on Florentine painters has been overstated, doubtless because the importance of Starnina has been overlooked during most of our century. Gentile da Fabriano offered a paradigm of oriental luxury and a reper-tory of interesting poses and facial types, but he did not alter the subsequent course of Florentine painting. That task fell to a young genius from Castel San Giovanni, Maso di ser Giovanni, called Masaccio (1401-1428), whose meteoric career streaked across the 1420s like a portent of things to come.[41]

Angelico's two early altarpieces for San Domenico and San Pietro Martire are closely comparable except for one significant distinction: in the later altarpiece, the figure of the

Virgin Mary is clearly dependent upon Masaccio. As many scholars have observed, the weighty pyramidal conception of the seated Virgin represents Angelico's response to Masaccio's Virgin in the Sant'Anna Metterza Altarpiece (see page 266), which was executed in collaboration with Masolino in 1424 or early 1425. Masaccio's own source for this sculpturesque, if somewhat ponderous, conception of the female figure was Giotto.

By 1420 a number of Florentine painters—for example, Giovanni del Biondo (1385-1437)—had turned to observations of Giotto to lead them away from the flat and ornamented style of the late International Gothic.[42] The young Masaccio so immersed himself in the monumental compositions of the early trecento that Bernard Berenson dubbed him "Giotto re-born."[43] The idea of a return to the great epoch of the previous century would be of fundamental importance for Angelico at San Marco, as we shall see. He should have felt an instinctive sympathy for the concept, because Giotto was his illustrious predecessor from his native Mugello; and because the Observantist reform was devoted to the concept of a spiritual revival of an earlier period.

Vasari named Fra Angelico first among the Florentine artists who made capital of the Brancacci Chapel frescoes by Masaccio, which I believe were mainly finished by the beginning of 1426. Although later centuries tended to see Fra Angelico as an inspired *retardataire*, we now realize the truth of Vasari's observation—none of Masaccio's contemporaries responded more rapidly, or with more intelligence, to his stylistic innovations than Fra Angelico. They were very different artists, of course, and it would be beside the point to consider Angelico backward because he declined to become a follower of Masaccio. Angelico was never tempted, as was Andrea del Castagno, to imitate Masaccio's frequently coarse realism, nor to explore the labyrinthine workings of perspective illusionism, as did Paolo Uccello. In view of his formation, and of his purposes, it is more than likely that Fra Angelico was just as impressed by Masolino's frescoes in the Brancacci Chapel. Unfortunately it is difficult for us to trace his specific responses to these because the major part of Masolino's contribution, the vault and lunettes of the Brancacci Chapel, was destroyed in the eighteenth century.

We can adduce a date in the later 1420s for Fra Angelico's illuminations in the San Marco Missal (no. 558; catalog 69) on the basis of its notable connections with his San Pietro Martire Altarpiece, on the one hand, and with Masaccio and the Brancacci Chapel, on the other. The San Marco Missal is believed to have been executed for San Domenico, Fiesole; it is the only complete surviving illuminated manuscript by the artist, to whom Vasari attributed several other manuscripts, apparently in error.[44] A *terminus post quem* (point after which it must date) of early 1426 is indicated by the correspondence between the figure of Christ in the miniature of *The Calling of Saints Peter and Andrew* (page 9) and that of Saint Peter in Masaccio's *Raising of the Son of Theophilus* in the Brancacci Chapel.[45] One wonders, in fact, whether the slight differences in Angelico's figure are reflections of Masaccio's original design before its subsequent modifications by Filippino Lippi. It must have been from Masaccio that Angelico took the idea to look to some Roman sarcophagus or frieze to copy the poses of the fleeing soldiers in *The Conversion of Saint Paul* (page 21). This almost unique instance of Fra Angelico meditating upon ancient sculpture is indicative of the extraordinary inroads that classical studies were beginning to make into Florentine culture.

No traces of antique art, and very few of Masaccio, for that matter, can be detected in another major Dominican commission from this decade. For the sacristy of Santa Maria Novella, Fra Angelico executed four reliquary panels whose individual stylistic differences

seem to indicate that the series was executed over the course of several years. De Marchi has suggested that the commission for the earliest of these must date from 1424, the only year in which Fra Giovanni Masi, the patron of these works, was sacristan of Santa Maria Novella.[46] On the other hand, Padre Centi has noted that Masi occupied important roles at the convent since at least 1418.[47]

These reliquary panels are conceived with a preciosity and ornamentation that are appropriate for objects intended for the display of holy relics on the altar on specific feast days. Their delicate figures and exquisite gilding invite comparison to Gentile da Fabriano, but the slender figures reveal at least as much influence from Lorenzo Ghiberti, the gold-smith and sculptor whose career intersected with Fra Angelico's on numerous occasions.[48]

PAINTINGS FOR PRIVATE PATRONS

From the beginning of his new activity in Fiesole, Fra Angelico was permitted to execute commissions for patrons outside of the Dominican order. By the mid-1420s he had gained a reputation as one of the most important painters of Florence.

On December 15, 1425, a leading citizen of the city, Alessandro di Simone di Filippo Rondinelli, stipulated in his last will and testament that twenty gold florins were to be spent after his death for an altarpiece to be placed in his family's chapel in the church of San Lorenzo. Alessandro di Simone instructed also that the painting should represent the Annunciation, flanked by his family's patron saints, and that the work was to be confided to the "fra [. . .] of the order of San Domenico." As Andrew Ladis, who published this document in 1981, has rightly observed, the only painter who could possibly have been referred to in this way was Fra Angelico.[49] The Rondinelli Altarpiece was ultimately not executed because Alessandro di Simone made different provisions in a subsequent testament. The fact remains that Fra Angelico, although working in a convent on the outskirts of the city, was considered an appropriate choice to paint an altarpiece for San Lorenzo, one of the most ancient and prestigious churches in Florence.

The artist's favorable reputation among the Florentine laity is further demonstrated by the notable number of paintings for private devotion that can be assigned to the 1420s and early 1430s. In particular, the friar was called upon for intimate paintings of the Madonna and Child in the company of angels and saints. Few of these panels were created for portable altars or folding diptychs, as had hitherto been the rule in Florentine painting. Fra Angelico seems to have been the first artist in Florence to respond significantly to the desire of private citizens to have devotional paintings for which no liturgical purpose was intended. A notable exception are the two wings showing the Blessed and the Damned, which must have formed part of a portable triptych of some importance. Its luminous colors—even on the precipitating damned—indicate a date for this work in the early 1430s.

In this generation, therefore, the Florentines took the first steps toward the revival of a long-abandoned custom: the collection and enjoyment of paintings by distinguished masters. In the classical texts they could read numerous references to private collections of the famous paintings of antiquity, whose styles and qualities were knowledgeably discussed. Petrarch and a few others during the trecento had enthusiastically collected ancient Roman coins. Under the influence of the Florentine humanists, the cultural elite of the city began in the quattrocento to compete to form important collections of classical sculptures and

Detail of the Blessed from the
door of a triptych
Private collection, Great Britain
(catalog 84)

artifacts.[50] From the 1492 postmortem inventory of Lorenzo de' Medici (called "the Magnificent"), we can see that by the end of the century the *stanze* and corridors of the Palazzo Medici were adorned not only with antiquities, but also with an extensive collection of paintings and sculptures by contemporary Florentines, including several panels attributed to Fra Angelico.[51]

Small panels representing the Madonna and Child by Fra Angelico are conserved today in public museums from Saint Petersburg to Detroit. Because the paintings in this group vary considerably as to quality and style, their attributions and dates have been frequently been disputed—as a glance at the bibliographies in the catalog at the back of this book will confirm. *The Virgin and Child Enthroned with Twelve Angels* (catalog 81), in Frankfurt, is one of Angelico's most ambitious compositions of the early 1420s, inspired by Starnina and Masolino, inviting comparison with the San Domenico Altarpiece.

The popularity of Angelico's graceful conceptions of the Madonna and Child spawned a host of imitations, which must be separated from the autograph corpus. This scholarly task was complicated during the first half of the twentieth century, when altogether too much responsibility was ascribed to Angelico's workshop. This tendency culminated in 1952 with the publication of the first edition of John Pope-Hennessy's *catalogue raisonné*. Subsequent publications of Umberto Baldini and Miklós Boskovits, among others, have effectively countered this overly restrictive approach to Angelico attributions. For most authorities, it no longer seems likely that Fra Angelico, especially at the outset of his career, employed a coterie of assistants who touched their brushes to nearly every panel he painted, even tiny ones that would hardly have called for collaboration.

THE *LAST JUDGMENT*,

SANTA MARIA DEGLI ANGELI, FLORENCE

Detail of the Damned from
the door of a triptych
Private collection, Great Britain
(catalog 84)

Although the dating of 1431 proposed by Stefano Orlandi can no longer be sustained,[52] it must have been toward the end of the 1420s that Fra Angelico painted the *Last Judgment*, the culminating work of his early phase of development. The two hundred and seventy diminutive participants in this spectacular vision of Christ in glory between the gates of heaven and the portals of hell are drawn with the same somewhat short and cephalized proportions of the Franciscans depicted in the predella panels of the Santa Croce Altarpiece of 1429. Many of the blessed souls and angels who embrace in the Edenic meadow are rendered with a miniaturist precision that nearly rivals the delicacy of the reliquary panel of the *Adoration of the Magi* in the Museo di San Marco.

Fra Angelico reserved a radically different technique for the grimacing and tortured souls of the damned, however. His deliberately crude touch in these passages was long believed by scholars a defect for which his assistants were to be blamed. Yet few other works in the artist's career were praised so unreservedly by all the early sources as was this *Last Judgment* executed for the Camaldolese church of Santa Maria degli Angeli.

Ten years earlier, Guido di Piero had lived and worked with artists associated with Lorenzo Monaco and his workshop at Santa Maria degli Angeli. The commission for the *Last Judgment* now brought him together with the principal theologian at the same convent. Although Anna Santagostino Barbone was not able to find any passages in Ambrogio

Traversari's writings that could be said to have inspired the imagery of Fra Angelico's *Last Judgment*, she was justifiably convinced that its untraditional and hitherto unexplained iconography presupposed the intervention of Traversari, the Camaldolese monk who oversaw the study of Greek and Latin at Santa Maria degli Angeli.[53]

Albeit none of Fra Angelico's biographers, least of all Vasari, describe him as in contact with Traversari (1386-1439) and the innermost circle of Florentine humanists, the connection comes as no surprise in the light of Angelico's subsequent patronage by such humanists as Palla Strozzi, Cosimo de' Medici, and Pope Nicholas V. Traversari, moreover, is known to have been keenly interested in religious art.[54] Richard Krautheimer[55] has persuasively argued that Traversari effectively replaced Leonardo Bruni as advisor for the program of the Gates of Paradise executed for the baptistry by Lorenzo Ghiberti after 1425.[56]

Traversari's cell at Santa Maria degli Angeli, where he was made prior in 1430 and general of the Camaldolese order in 1431, was a favorite retreat for humanist scholars, including his close friend, Niccolò Niccoli (c. 1364-1437). The latter visited him daily to converse on theological subjects and to take down from dictation Traversari's translations of the Greek fathers of the church, including Saints John Chrysostom, Gregory Nazianzus, and Basil. In the mid-1420s, Traversari was persuaded by Cosimo de' Medici to translate a purely pagan work of classical learning, the *Lives of the Philosophers* by Diogenes Laertius. Twenty years before the 1439 Council of the Union in Florence, Ambrogio Traversari had been one of the first voices in the West to call for the unification of the Roman and Eastern churches.

Two new observations can be adduced as evidence of Traversari's direct participation in the conception of the *Last Judgment*. To begin with, the prominence of Adam, Abraham, Moses, David, Aaron, Job, and other Old Testament personages in the tribunal of saints on either side of Christ the Judge is most extraordinary.[57] This role was reserved for the apostles, although the rule was gradually relaxed to include such saints as Francis and Dominic. For a textual justification for this iconography, which Fra Angelico would hardly have improvised on his own, we must look to patristic literature. In his *Commentary on Luke* (XI, 28) Eusebius of Caesarea writes, in the context of his discussion of the Transfiguration:

> *in the fulfillment of the age, when the Lord comes with the Father's glory then it will not only be Moses and Elijah who shall attend him, and it will not only be three disciples who are there, but all the prophets and patriarchs and just men. And it will not be up a high mountain but to heaven itself that he will lead the worthy by his godhead.*[58]

The prophets and patriarchs were similarly honored in the writings of Gregory of Nazianzus, John Chrysostom, and Theodoret of Cyrus.[59] Although precedents can be found for the representation of Old Testament personages with golden halos, the sanctity conferred upon them in this *Last Judgment* calls to mind the fact that Moses, Job, and others in this company were considered saints by the Eastern church. The distinctive iconography of this tribunal thus constitutes a forthright declaration of the ecumenical beliefs for which the most eloquent spokesman at this time was Ambrogio Traversari.

A second observation that argues in favor of Traversari's involvement in planning this painting is the knowledge of classical philosophy, such as Traversari is known to have possessed, that is reflected in the overall composition of the *Last Judgment*. As Santagostino Barbone has

Detail of the
Santa Trinita Altarpiece
Museo di San Marco, Florence
(see pages 106-7 and catalog 74)

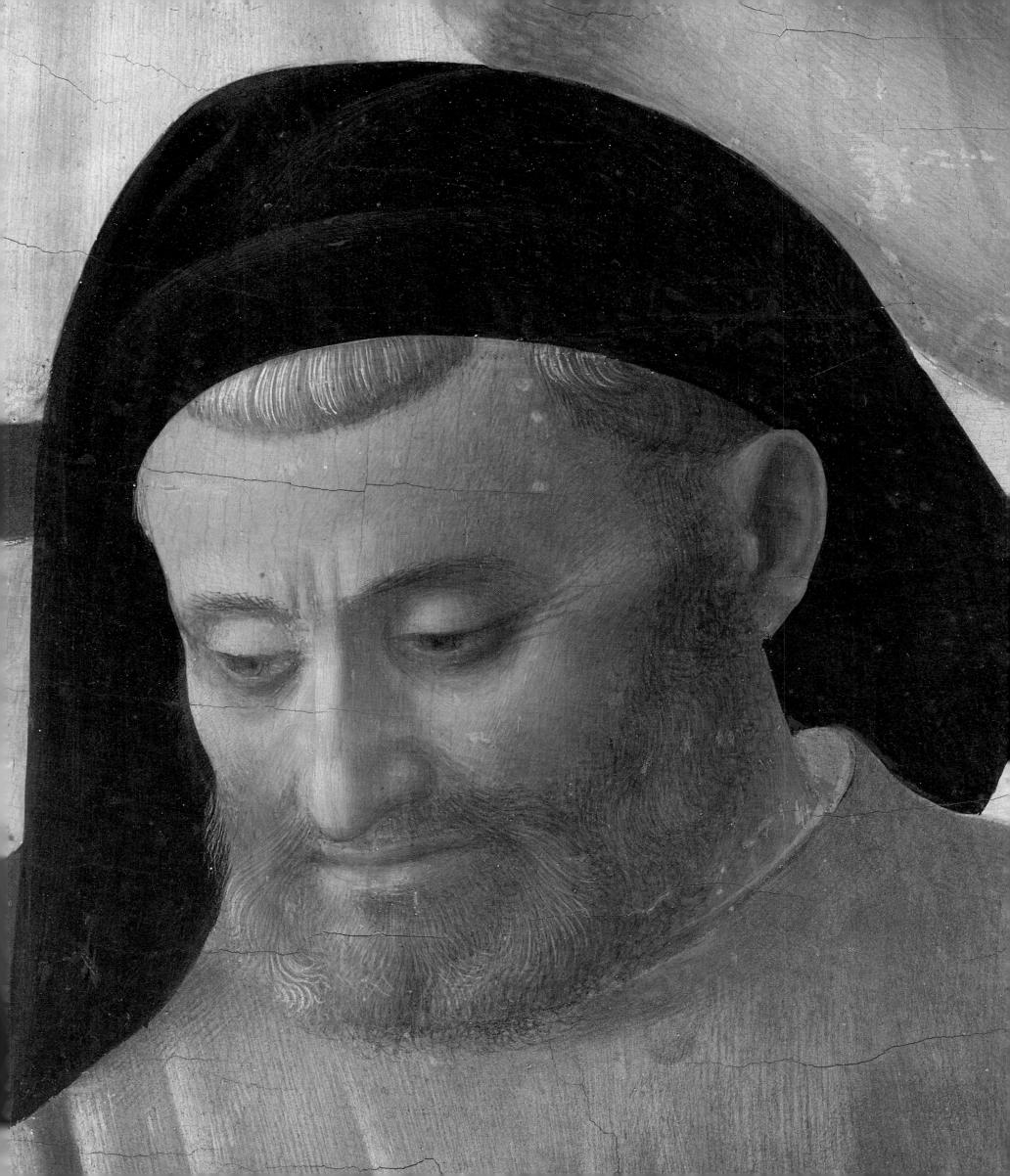

observed, the extensive depiction of the reception of the blessed outside the gates of heaven does not occur in other treatments of the Last Judgment.[60] Indeed, the Bible does not provide a textual source for these details of paradise. As the reader will find discussed in the commentary to this painting in the Plates section, the essential elements of Angelico's conception, including its symmetry between paradise and hell, are derived from the afterworld described in the myth of Er in Plato's *Republic*. Furthermore, the texts that inspired Fra Angelico's sublime depiction of the angels and the beatified dancing to the accompaniment of the music of the spheres are all either classical or patristic.

THE SANTA CROCE ALTARPIECE, 1429

In 1429, the Compagnia di San Francesco received from Fra Angelico a panel painting for the confraternity's chapel in the basilica of Santa Croce, Florence. The document published by John Henderson and Paul Joannides refers to the artist as "Fra Guido," another sign perhaps of the reputation garnered before his Dominican vows.[61] The same scholars have convincingly identified the work in question with a disassembled polyptych whose panels are now divided among museums in Florence, Altenberg, Berlin, and the Vatican.

The importance of the Santa Croce polyptych as the earliest securely dated work in the artist's *oeuvre* will not be fully realized until the two lateral panels with saints, formerly in the Certosa of Galluzzo, receive an urgently needed restoration. Despite their present darkened state, it is obvious that these panels representing Saints John the Evangelist(?) and John the Baptist, left, and Saints Francis and Onophrius, right, display a capacity to design full-scale, three-dimensional figures that Angelico had not yet commanded at the time of the San Pietro Martire Altarpiece a few years earlier. For example, Saint Onophrius is placed in an athletic *contrapposto* stance, a rare use by Angelico of a common ancient motif, which thus serves to remind us that the late 1420s witnessed our painter's initial response to Masaccio's frescoes in the Brancacci Chapel. The lateral saints as a group, and in facial types, seem comparable to the actors in Fra Angelico's *Deposition* for Santa Trinita, an observation that tends to confirm the date of circa 1432 that has been proposed for that work.

The variety of stylistic currents encompassed in the Santa Croce Altarpiece as a whole reveals that 1429 was a moment of transition for Angelico. As various authors have noted, the predella stories of Saint Francis pay open homage to Giotto's frescoes on this theme in the Bardi Chapel of the same church. On the other hand, the overall design of the polyptych, and in particular the central panel of the *Madonna and Child*, derives from one of the principal works of Lorenzo Monaco, the Monte Oliveto Altarpiece, dated 1410. The artist may have been specifically instructed to emulate this famous prototype. If not, then this explicit borrowing of a motif signed by Lorenzo Monaco could perhaps be taken as evidence of training received in Monaco's circle following the abrupt truncation of his (presumed) association with Gherardo Starnina.

A final observation can be made. For the first time in a major public commission by Angelico, we can detect the intervention of studio assistants, specifically, in some of the predella panels. The collaboration of pupils is proof of an expanded workshop and, concomitantly, of the remarkable volume of work that was being produced in the Fiesole studio during these years. The quantity of surviving works, often in the form of dispersed panels, makes it clear that Fra Angelico's workshop was continuously occupied with the production

Detail of the
Santa Trinita Altarpiece
Museo di San Marco, Florence
(see pages 106-7 and catalog 74)

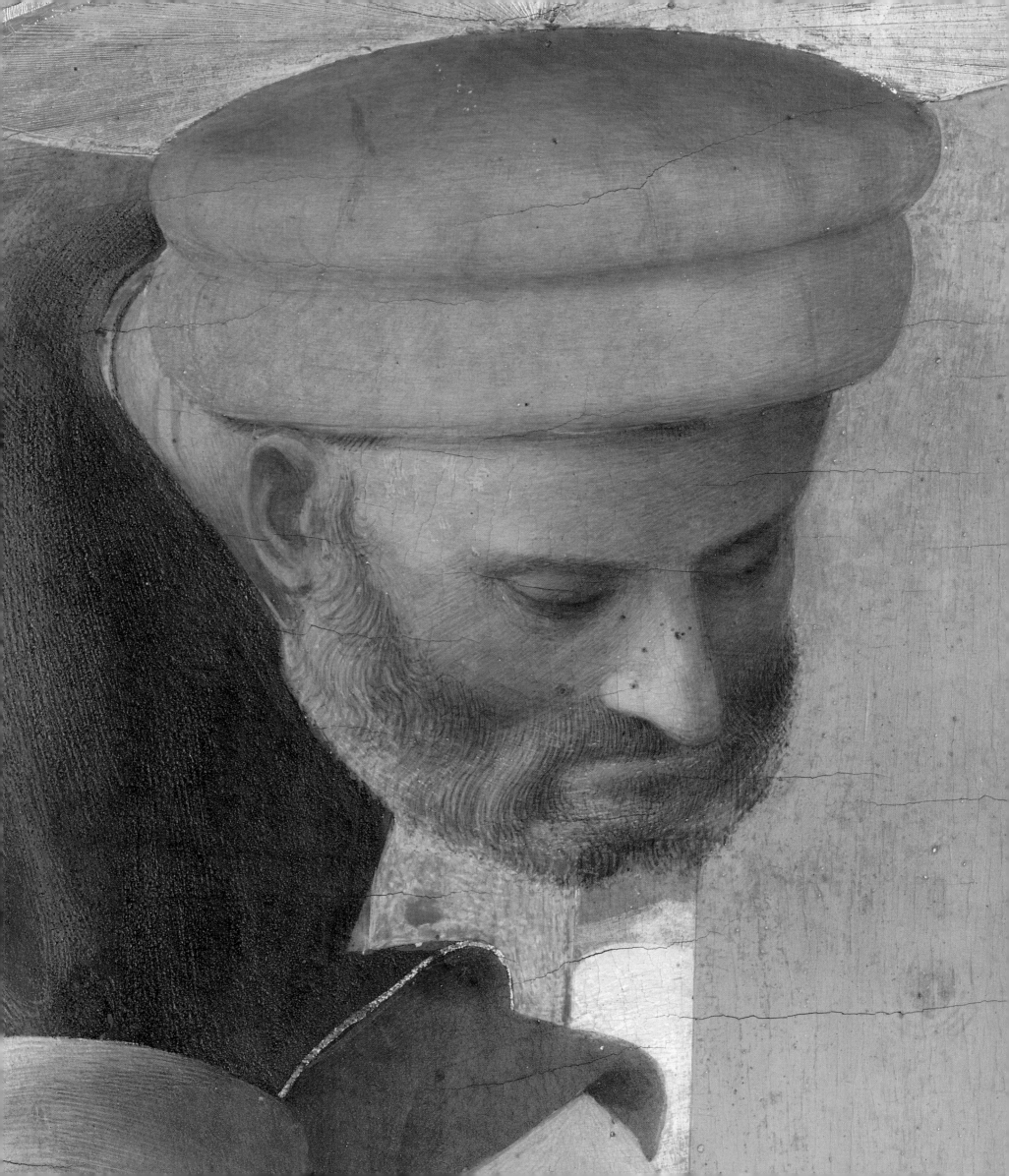

of altarpieces during the decade leading up to 1438, when he devoted all of his energy to the decorations for the church and convent of San Marco in Florence. Toward the beginning of this span must date the dismantled altarpiece (catalog 114), of which the predella has been identified with certainty: it included *The Naming of the Baptist* in Florence and other panels in Fort Worth, Philadelphia, and San Francisco. The catalog in the back of this book lists many more works than can be addressed in this introductory essay, which can only comment selectively upon those paintings that serve to illustrate the development and enrichment of Angelico's art.

THE SANTA TRINITA ALTARPIECE:

DEPOSITION OF CHRIST, c. 1430–32

From the relatively conservative design of the Santa Croce Altarpiece Fra Angelico proceeded to paint his *Deposition of Christ*, formerly in Santa Trinita, Florence (catalog 74; see pages 106-111), a work that marks one of the most significant breakthroughs of his career. Unfortunately, the precise date and circumstances of its commission have yet to be determined.

Throughout the 1420s the prominent Strozzi family was engaged with the construction of a new sacristy for Santa Trinita that was also intended to serve as their funerary chapel.[62] Construction began under the auspices of Nofri Strozzi and was continued uninterruptedly after his death in 1418 by Palla Strozzi, family scion and noted humanist. Two altarpieces were required for the two chapels in the new sacristy. In 1423 Gentile da Fabriano completed his scintillating *Adoration of the Magi*, which immediately became one of the most celebrated paintings in the city. The other commission, although undocumented, must have gone to the dean of Florentine painters, Lorenzo Monaco, whose small paintings still occupy the three gables of Fra Angelico's *Deposition of Christ* in its present form.[63]

As Monaco was dead by 1424, scholars have generally assumed that his unfinished polyptych was subsequently consigned to Fra Angelico for completion. The date of Angelico's extraordinary *Deposition* (a painting that seemed to Henry James in the nineteenth century "as clear and keen as if the good old monk stood there wiping his brushes"[64]) has proved particularly elusive to establish, although fragmentary documents of 1429 and 1432 may refer to its payment and its installation. According to Darrell Davisson's controversial reconstruction of events, Lorenzo Monaco completed his altarpiece, but its central panel and predella panels were later replaced by Fra Angelico following the exile of Palla Strozzi in 1434 as part of a *damnatio memoriae* ordered by the Medici.[65]

I believe it is more likely that Palla Strozzi, who made an unspecified payment to San Domenico, Fiesole, in 1429, ordered these changes himself. It is important to bear in mind that the new Strozzi sacristy in Santa Trinita was a private commission of unprecedented ambition. Its purpose was to create a semi-public space, which would reflect honor on the Strozzi as a model of Florentine cultural and architectural distinction. There was a plan to install a library for scholars that would house the ancient and modern manuscripts in the collection of Palla Strozzi, the second largest in Florence after Niccolò Niccoli's. It is reasonable to assume that Lorenzo Monaco's altarpiece, which may have been executed as early as circa 1420, already appeared outmoded by the end of the same decade. Not only

Detail of the
Santa Trinita Altarpiece
Museo di San Marco, Florence
(see pages 106-7 and catalog 74)

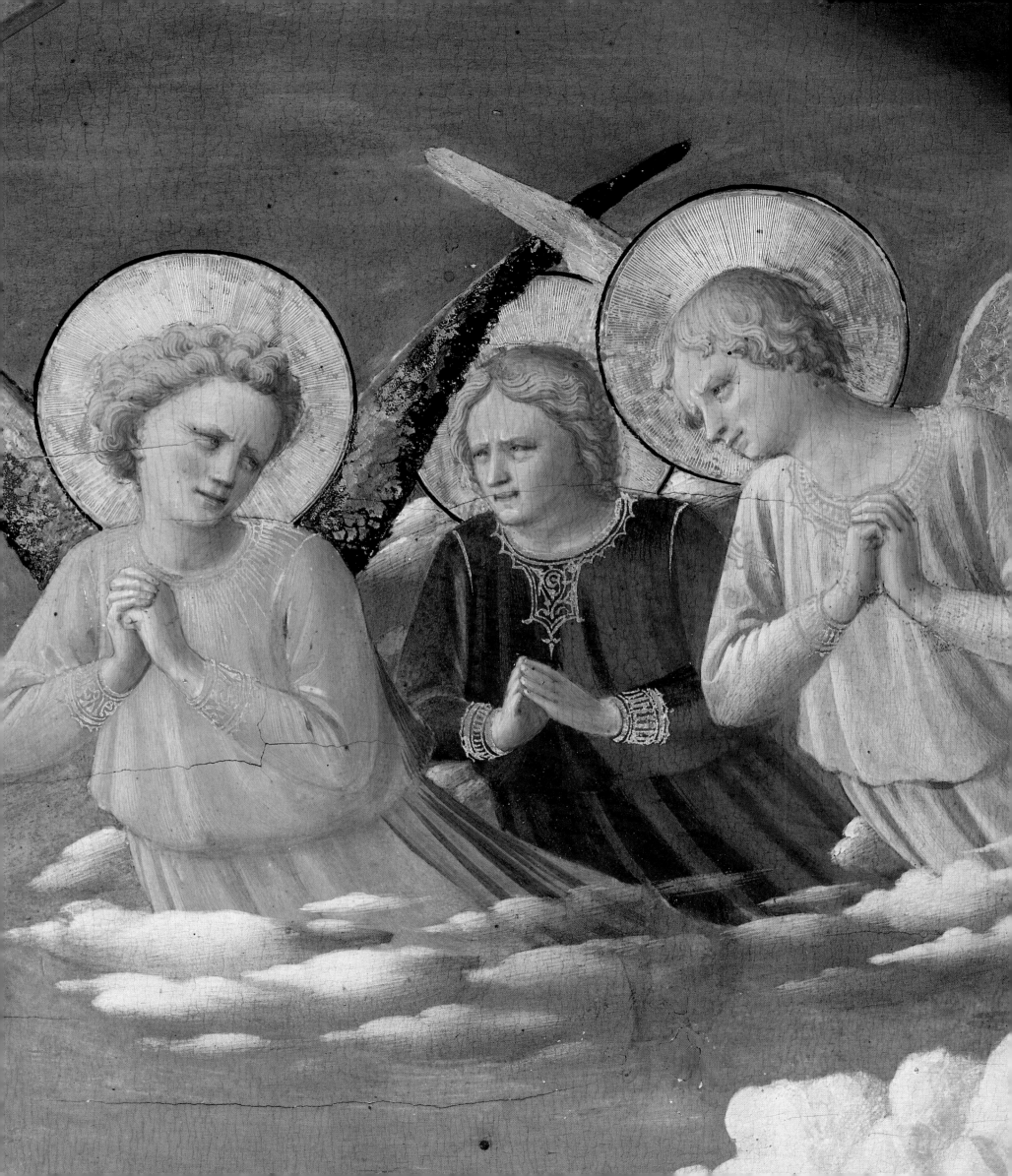

did it suffer the comparison with Gentile's splendid *Adoration of the Magi*, but in the mid-1420s, a family of far less importance, the Brancacci, had unveiled a chapel in the Carmine church with extraordinary frescoes that put all the others to shame.

It seems clear that Fra Angelico's assignment from Palla Strozzi was to paint a worthy pendant to Gentile's altarpiece and, if possible, to respond as well to the Brancacci Chapel. Despite the restraints of the suspended gothic arches, the landscape background in Fra Angelico's *Deposition* is the most naturalistic that had yet appeared in an altarpiece. The sole precedent for *plein-air* effects of daylight and atmosphere was Masaccio's *Tribute Money* (see page 266).[66] Moreover, Fra Angelico succeeded in evoking a comparable expanse of distance and space without the benefit of Masaccio's knowledge of perspective.

The humanistic bias of Palla Strozzi is reflected in the carefully rendered Hebrew and Greek inscriptions on the cross; Fra Angelico is virtually the only painter in Italy during the first half of the century to include these difficult inscriptions, for which he would probably have had to have recourse to Giannozzo Manetti, as Avraham Ronen has pointed out.[67] No less innovative for a sacred composition of this time is the inclusion, at right, of contemporary personages (possibly portraits) who learnedly discuss the Deposition and the symbols of the Passion. No doubt Masaccio's extensive use of portraiture in the Brancacci Chapel makes its influence felt here. For more details on the *Deposition*, the reader is referred to the commentary in the Plates section; suffice it for now to observe that Vasari was right to name Fra Angelico as the first Florentine to respond in kind to the Brancacci Chapel; indeed, Palla Strozzi must have known that Fra Angelico was the only painter in Florence around 1430 who could.[68]

FRA ANGELICO AND MASACCIO

For the Strozzi Chapel in the sacristy of Santa Trinita, Fra Angelico was called upon to compose a sacred story with a literary or allegorical subtext in the monumental new style of the Brancacci Chapel. His assignment, in essence, was to transfer the narrative tradition of mural painting onto the panel of an altarpiece. He fulfilled this commission with remarkable independence, without imitating either the landscapes, gestures, or perspectival schemes of the two pioneers, Masaccio and Masolino.

Nevertheless, his reaction to the Brancacci Chapel is clearly displayed in the Santa Trinita *Deposition*, if mainly in terms of the paths not taken. "In it he seems bent on showing how far a scene from sacred history—for him, that is, an event purely allegorical in value—differs from events of secular history."[69] Masaccio, the insatiable realist, had dedicated himself to proving precisely the opposite. He must have seemed to Fra Angelico, above all, as an ingenious inventor of compositions, whose figures suffered from an excessive realism that verged on the unseemly. Given his choice between the serenity of Masolino's portrayal of Adam and Eve before the Fall, and the sheer agony of Masaccio's depiction of their Expulsion, Fra Angelico unhesitatingly opted for the former. Today it is difficult for us to share a preference for honey-smooth faces over craggy, realistic ones, but a sense of the unbridgeable gap between heaven and earth was fundamental for Fra Angelico, an artist whose life, as John Ruskin rightly said, "was almost entirely spent in the endeavor to imagine the beings belonging to another world."[70]

Fra Angelico did learn from Masaccio the value of leavening his idealized facial

types with observation from life; faces that have the personalized appearance of portraits are a recurrent feature of Angelico's mature style after this date. But he declined to adopt realism as a goal in itself; this decision enabled him, on the one hand, to realize his religious visions, but on the other, garnered him in the nineteenth century an undeserved reputation as a *retardataire* painter.

MASOLINO AND

THE THREE *ANNUNCIATIONS*

At the time that he was called upon by Palla Strozzi, Fra Angelico's long-standing admiration for Masolino had recently been reinforced. For Masolino, the eventful 1420s had opened and closed with a curious and unexpected symmetry. After capturing the lion's share of important commissions during the first half of the decade, Masolino had gone off in September 1425 to work in Hungary, while the Brancacci Chapel was still in progress, almost as if he were fleeing from the overpowering presence of his junior partner, Masaccio. When Masolino returned to Florence at the end of 1427 (or by May 1428, at the latest), he discovered that Masaccio had been called to Rome, where he suddenly died, at twenty-seven. At the decade's end, therefore, Masolino was indisputably the most progressive painter in Florence, and not obliged to share the credit for the Brancacci Chapel with any living competitor.

At some time prior to March 1429, when he too transferred to Rome for important works, Masolino executed two paintings of the Annunciation, both of which were to exert decisive influences upon Fra Angelico.[71] Both paintings are preserved today in the National Gallery of Art, Washington. One of these *Annunciations*, perhaps the earlier rendition, consists of two half-length panels of the Angel Gabriel and the Virgin. Formerly in the Kress Collection, these panels were probably cut out of a larger work of unknown provenance. The other Washington *Annunciation* (left) is one of the major works of Masolino's career. Executed for San Niccolò Oltr'Arno, and thus on view in the same church as the Quaratesi Altarpiece by Gentile da Fabriano, this *Annunciation* by Masolino was profusely praised by Vasari's second edition (1568) as a masterpiece by Masaccio.[72] In this painting Masolino used all the perspectival tricks at his command to draw the spectator into and under the ceiling of the Virgin's chamber.[73]

Although the Annunciation to the Virgin was traditionally one of the most beloved themes in Florentine painting, it had not figured notably in Fra Angelico's oeuvre prior to this time.[74] Three *Annunciations* by Fra Angelico—in Cortona, Montecarlo in Tuscany (now on view in the Museo di San Giovanni Val D'Arno), and Madrid—have generally been dated to the 1430s, however, without consensus regarding the sequence of their execution. The noted similarities between these three *Annunciations* are testimony to the powerful suggestion of Masolino's two *Annunciations* now in Washington, D.C.

In my opinion, Fra Angelico painted the earliest of these three *Annunciations* (catalog 7) around 1430 for San Domenico, Cortona. Its pallid tints and somewhat bland facial types are frequently encountered in Fra Angelico's paintings of the years between 1429 and 1433, the respective dates of the Santa Croce Altarpiece and the Linaiuoli Tabernacle. For example, the Virgin could be the sister of the young man who wears a floppy red

Masolino da Panicale
ANNUNCIATION
National Gallery of Art, Washington

mazzocchio on his head at the extreme right of the Strozzi *Deposition*. Both are direct descendants of Masolino's Eve. These are the years of Fra Angelico's most faithful adherence to Masolino's aesthetic, as exemplified in the latter's *Raising of Tabitha* (see page 266) in the Brancacci Chapel and the San Niccolò *Annunciation*.

Fra Angelico's inexperience with the new developments in perspective can be detected in the Cortona *Annunciation*, wherein both the architecture and the treatment of space are far simpler than in the Montecarlo and Madrid versions. To create depth, he is obliged to make heavy use of one of Masolino's mainstays in the Brancacci Chapel, namely, the receding arches of a loggia viewed from the exterior. In the Montecarlo (catalog 100) and Madrid *Annunciations* (catalog 88) and in subsequent treatments of this theme, Angelico successfully adapted the more complicated spatial organization of the San Niccolò *Annunciation*.

Although the predella panels were executed by an assistant, the main panels of the Montecarlo *Annunciation* are substantially autograph. Paul Joannides has convincingly linked this picture to the commission received in 1432 from the Servites of Sant'Alessio in Brescia, although the reasons for its non-delivery (or rejection) remain mysterious.[75] The lack of details in the architecture seems to indicate a desire to work expeditiously, but the interior of the Virgin's chamber is cohesive and precise; the foreshortened marble panels on the wall allow our eyes to take the measure of the room in a way that is not possible in the Cortona version. Joannides noted that the fictive stone panels on the walls were painted to cover over a series of arches, and he suggested that Fra Angelico may have made these modifications after an interval of several years. The basic composition and the predella leave no doubt, however, of their invention in the early 1430s. The third in this sequence of *Annunciations* must be the painting that was removed from San Domenico, Fiesole, in the seventeenth century and is today in the Prado, Madrid. The consecration of the Fiesolan Convent in 1435 provides a *terminus ante quem* for this work, which displays a confidence of execution and an expansiveness of proportions that place it near the Linaiuoli Tabernacle of 1434.

THE ANNALENA ALTARPIECE

The Annalena Altarpiece (catalog 61) has generally been dated by scholars to the 1430s on the grounds of the close resemblance between the pale, oval faces of the Virgin and Child and of Saint Lawrence with certain secondary figures in the Strozzi *Deposition of Christ* of about 1432.

In 1953 W. and E. Paatz discovered that the convent from which the altarpiece derives its name, San Vincenzo d'Annalena, near Porta Romana in Florence, was not built until after 1453. The painting must therefore have been transferred to that church from an unknown location. Recently, William Hood has underscored the specifically Medicean iconography of the altarpiece.[76] The six saints—Peter Martyr, Cosmas and Damian, John the Evangelist, Lawrence, and Francis of Assisi—who attend the Virgin and Child in the Annalena Altarpiece are all Medici name saints.[77] Hood proposed to date the altarpiece to 1434-35, reasonably suggesting that it had been commissioned by the Medici for their chapel in the transept of San Lorenzo, Florence, adjacent to the old sacristy designed by Filippo Brunelleschi.

If we accept the hypothetical provenance, there are good reasons to date the work to around 1430, prior to Cosimo's exile, therefore, rather than after his return. In 1429 the

funeral of Giovanni di Bicci, the founder of the family fortune, took place in this chapel.[78] A recently published document has revealed that at the same time Cosimo de' Medici and his brother, Lorenzo, gave eight hundred florins to the Chapter of San Lorenzo in order to endow the annual observance of the feasts of their family saints, Cosmas and Damian, and John the Evangelist.[79] The commissioning of an altarpiece depicting these saints would have been an appropriate provision for these annual celebrations.

An earlier dating for the Annalena Altarpiece would establish its absolute priority as the first example of a *sacra conversazione* altarpiece.[80] In this new conception, which quickly became standard, the Madonna and Child are enthroned in the midst of the saints with whom they share a "holy community" in heaven.[81] The replacement of all gothic segments and arches by a simple rectangular frame seems a foregone conclusion to our eyes, but it was revolutionary then. Only Brunelleschi, the founder of early Renaissance style and the on-site architect, could have ideated such an innovation. The early date also means that the Annalena Altarpiece was the work that inspired the clause in the 1434 chapel program of San Lorenzo by which any new altarpiece was required to be a "square panel without canopies, honorably painted."[82] Thus Brunelleschi and Fra Angelico, although not specifically named in the document (which was issued during the exile of Cosimo de' Medici), must be credited with the invention of the *sacra conversazione*.

There is moreover a definite trace of Brunelleschi's beloved antiquity in the characterization of Saint Cosmas, who strongly resembles a Roman orator.[83] It is worth noting that Donatello's stucco relief of Saint Cosmas in the adjacent sacristy is similarly portrayed in a classical bareheaded pose.

THE LINAIUOLI TABERNACLE

In 1433 the powerful guild of the Linaiuoli, or wool cloth merchants, contracted Fra Angelico to paint the shutters, interior panel, and predella for a tabernacle of the Madonna and Child for their general offices near the Mercato Vecchio in the heart of Florence. As designed and erected by Lorenzo Ghiberti, the immense scale of the tabernacle (17 ft. 4 in. × 8 ft. 10 in.; 5.28 × 2.69 m) is more evocative of a monumental doorway than a winged triptych (catalog 68; see pages 112-15).[84] The commission for the Linaiuoli Tabernacle was the most extensive, and the most generously paid, project that Fra Angelico ever executed for a secular organization or patron. Father Stefano Orlandi has pointed out that the son of the guild's procurator had recently professed at the convent of San Domenico of Fiesole.[85] The designation of Fra Angelico, however, may have been in all events a foregone conclusion.

As we have seen, after Masolino's departure in 1429 the major painting commissions in Florence seem to have been awarded perforce to the Dominican friar of Fiesole. During the 1430s Fra Filippo Lippi (c. 1406-1469) and Domenico Veneziano (c. 1400-c. 1461) gradually came of age, but were not serious alternatives to Fra Angelico for the greater part of the decade. The only other painter in contention was Paolo Uccello (c. 1397-1475), who returned in 1431 after several years' work on mosaics in Venice. But Uccello seems not to have made a major success in Florence until his 1436 equestrian portrait of Giovanni Acuto in the Duomo. Who else, then, could Ghiberti have chosen for this momentous collaboration—Bicci di Lorenzo?[86]

Detail of the
Santa Trinita Altarpiece

In addition to his advanced position in contemporary painting, Fra Angelico possessed another quality that would have recommended his services to Ghiberti. The purely Ghibertesque style of the four standing saints on the tabernacle shutters are incontrovertible evidence, as Ulrich Middledorf rightly noted, that Angelico was willing to adapt his style to the requirements of the commission.[87] Except for the greater naturalism of their faces, any one of these elegantly attired figures could readily substitute for Ghiberti's statues in niches on Orsanmichele. Mary Alexander has demonstrated that some of Angelico's saints were adapted from statues on the facade of the Duomo.[88] He was no doubt encouraged by Ghiberti to endow his figures with the solidity of sculpture.

For many years the critics regarded the Linaiuoli Tabernacle—perhaps inevitably, as it was the artist's sole securely documented commission—as a turning point in his development. The Linaiuoli Tabernacle seems, rather, to have constituted for Angelico a Ghibertesque *intermezzo* in the mid-1430s, a period that embraced only one other significant work, a polyptych of the Madonna and Child with four flanking saints executed for San Domenico, Cortona (catalog 8), where the painter had previously sent his *Annunciation*. The painter's work on the large panels for the Linaiuoli commission must have occupied him into 1434; in all events, the tabernacle was not completed until the end of 1435. Its execution thus coincided with the political upheavals that carried the Medici into power, an ascent that was soon to have personal consequences for Fra Angelico.

THE CONSECRATION OF
SAN DOMENICO, FIESOLE, 1435

By the early 1430s the reconstruction and enlargement of the church and convent of San Domenico, Fiesole, as provided for by the legacy of Barnaba degli Agli, was completed. The official consecration did not take place until 1435, but a Dominican chronicler of the event wrote in 1516 that the three paintings in the church by Fra Angelico had been executed many years before. Indeed, Fra Angelico probably set to work on the high altarpiece soon after he entered the order in the early 1420s. The San Domenico Altarpiece (catalog 15; see pages 84-85), which now stands over the first altar on the left side, is the artist's only work still in the church (and it was much modified by Lorenzo di Credi around 1501).

The *Annunciation*, or Prado Altarpiece (catalog 88), now in the Prado, Madrid, originally hung on the rood screen in the church; it was sold by the friars for a great sum in the seicento. *The Coronation of the Virgin*, now in the Louvre, Paris (catalog 92; see pages 116-23), was executed for another altar on the rood screen. Although there is no documentation of any kind for the construction and decoration of the church or convent, these two Marian subjects were certainly executed after 1430. A span of several years must divide the *Annunciation*, c. 1430, and the *Coronation of the Virgin*, which constitutes the most advanced display of linear perspective and anatomical foreshortenings in Fra Angelico's entire career. If the chronicle is correct, then the ingenious rendering of the pavement from an oblique angle is a bold anticipation of Leon Battista Alberti's perspective theories published in 1436.

Fra Angelico also painted a number of wall frescoes, two of which suffered the

same fate of subsequent removal. Indeed their precise number and locations cannot be determined due to subsequent modifications of the buildings. Only a fine *Crucifixion* (catalog II) remains in situ in the chapter room or *sala capitolare*. Remarkable for the foreshortening of the head, which inclines toward the spectator, this *Crucifixion* was rejected by Pope-Hennessy but is probably an autograph work of the mid-1420s. A damaged fresco *Madonna and Child* (catalog 14), with its superb sinopia, was painted over the entrance to the church, but transferred inside the convent a century later. More mature in manner is the fresco of the *Madonna and Child with Saints Dominic and Thomas Aquinas* (catalog 13), which was taken to Russia in the nineteenth century, and which seems to date from circa 1430. This somewhat stolid composition possibly graced the upstairs dormitory of the friars.[89] Very difficult to judge in its present condition is the *Crucifixion with the Virgin and Saints Dominic and John* (catalog 12). Now permanently affixed to a wall in the Louvre, this darkened and damaged fresco was probably made for the refectory of San Domenico. A delicate restoration might reveal affinities between these elongated figures and their counterparts at San Marco of circa 1440. It is not unreasonable to imagine that the friar tooks steps to embellish his own convent upon his return from several years of intense activity at San Marco in Florence.

After 1429 the ordinary chapter business of the Fiesole Dominicans is better documented and the name of Fra Giovanni (Angelico) is regularly cited.[90] In 1429, his brother, Fra Benedetto, was ordained a priest.[91] The qualities of administration and efficiency that enabled Angelico to direct a productive workshop were employed as well in the service of his brethren. During an interval when the prior of the convent was absent, from December 1432 to January 1433, Angelico functioned as *vicario*, or substitute, and signed a notarial act. In May 1435 Angelico was mentioned in the will of the sister of Fra Antonino Pierozzi, the prior who later became a beloved bishop of Florence and was eventually canonized as Saint Antoninus.[92]

THE RISE OF
COSIMO DE' MEDICI, 1433–34

During the same winter of 1435-36, when the Dominican Observantists consecrated their ample new convent in Fiesole, they unexpectedly achieved their long-anticipated goal of obtaining a convent in Florence itself. In 1418, after the Observantists' return from their exile in Foligno and Cortona, they had attempted to displace the Silvestrine mendicant friars from the convent of San Marco on the northern perimeter of the city. Their accusations of excessive laxity against the Silvestrines were upheld by a prelate appointed by Pope Martin V, but no further action was taken during the 1420s.[93]

Suddenly, in 1436, the Dominicans' claims upon San Marco were resolved to their satisfaction. The Observantist friars were the beneficiaries of a chain reaction of political events that had culminated in 1434 with the political ascendancy of Cosimo de' Medici. The main episodes of these turbulent years can be summarized as follows. For fifty years Florence, one of the world's great mercantile cities, had been ruled by a government established by conservative patricians in the aftermath of the revolt of the Ciompi, or cloth

workers, in 1378. The legislative and administrative system of the Florentine commune was characterized by a cumbersome bureaucracy and tortuous methods of selecting officials.[94] An oligarchy of the most prosperous families controlled the system, yet the character of a representative republic survived until 1434, when Cosimo de' Medici's return from exile opened a new and decisive chapter in Florentine affairs.

In 1433 the government, which was in the hands of Rinaldo degli Albizzi, was at the height of its unpopularity, the result of a "disadvantageous peace that closed a dishonorable war" against Lucca.[95] The clever Florentines had undone themselves when Filippo Brunelleschi's ingenious plan to divert the Serchio River into the center of Lucca had flooded their own camp instead. The recurrent conflicts with Milan also depleted the public treasury and brought on higher taxes.

Following the death in 1429 of his father, Giovanni di Bicci, Cosimo de' Medici's importance rapidly increased. "In a city of merchants and financiers, the richest banker, who has the control of foreign markets and who can influence the financial transactions of the whole known world, must necessarily be a person of great importance, and it was exactly this position which Cosimo held."[96] Cosimo's increased stature aroused the suspicions of Rinaldo degli Albizzi, who had good reason to be concerned. The moderate stand taken by the Medici during the Ciompi revolt had made them popular with the lower middle classes, who merely needed a leader to unite them into a powerful party. The Medici were also supported by many leading families with whom they had family connections or whose loyalty had been openly bought by Giovanni di Bicci; this was a political technique that Cosimo would perfect.

By the spring of 1433 Cosimo's popularity had so increased that Rinaldo degli Albizzi had privately resolved to destroy the Medici faction at any cost in order to protect the republican government from a takeover. On September 1 Cosimo de' Medici was precipitously imprisoned by order of the *signoria*. During the days that ensued his life hung in the balance. On October 8 he was exiled for five years to Padua; he subsequently obtained permission to proceed to Venice.

In June 1434 a new protagonist appeared on the stage of Florentine politics. The recently elected Pope Eugenius IV, in flight from a Roman rebellion, was received with honors by the Dominicans of Santa Maria Novella. In September Eugenius IV restrained Rinaldo's call to arms against a pro-Medici *signoria* that had been elected. He thus played a key role in Cosimo's recall from exile by popular acclaim on October 1. In short order the leaders of the Albizzi faction were decapitated or exiled. These events embarrassed the pope, however, who had sought to restore peace without recriminations.

Although Cosimo successfully avoided public responsibility for the drastic measures against his rivals, the *signoria* was clearly responsive to his desires. Perhaps the most Machiavellian of the reprisals was the banishment for ten years of Palla Strozzi, scion of one of the city's most admired families, who appears to have been blameless in the matter of Cosimo's exile. Notwithstanding his ancient friendship with the Medici, Palla Strozzi was never permitted to return to Florence, despite numerous appeals on the old man's behalf. His ten-year exile was twice renewed, and Strozzi died a broken man in Padua at the age of ninety-two. Cosimo evidently regarded him with a mixture of fascination, fear, and envy. In any event, the removal of this distinguished humanist made Cosimo the unrivaled Maecenas of Florentine art and letters.

Detail of the
Santa Trinita Altarpiece
Museo di San Marco, Florence
(see pages 106-7 and catalog 74)

EUGENIUS IV AND

COSIMO DE' MEDICI INTERCEDE ON

BEHALF OF THE OBSERVANTISTS

Now Cosimo, having applied himself to the temporal affairs of the state, the conduct of which was bound to leave him with certain matters on his conscience—as is the case with all those who are fain to govern states and take the leading place—awoke to a sense of his condition. . . . To remove this weight from his shoulders he held conference with Pope Eugenius, who was then in Florence, as to the load which lay on his conscience. . . . Pope Eugenius had settled the Observantist Order in San Marco; but, as their lodging there was inadequate, he remarked to Cosimo that, if he was bent on unburdening his soul, he might build a monastery.[97]

Thus Vespasiano da Bisticci, Cosimo's biographer and eyewitness to these events, explained Cosimo's adoption of the Observantists' cause. Other motivations that may have guided his actions will be discussed below. In June 1435 Pope Eugenius IV had granted to Dominican Observantists authority to establish a friary in the convent of San Giorgio alla Costa in Florence. This solution did not content them for long, however. A few months later, on January 21, 1436, Eugenius IV summarily ordered the Silvestrines to cede San Marco to the Dominicans and to transfer forthwith to the smaller convent of San Giorgio alla Costa.[98] According to Fra Giuliano Lapaccini, author of the *Chronicle of San Marco* (written at mid-century), this papal bull was issued at the request of the *signoria* but "out of respect for" Cosimo and his brother, Lorenzo de' Medici.[99]

In February a first contingent of friars duly transferred to San Marco, which they found in deplorable condition. A fire the previous year had ruined one of the dormitories, and part of the roof of the church had fallen in.[100] Fra Angelico was not among these friars, undoubtedly because it would have been impractical for him to dismantle his studio in Fiesole. Besides, there was nothing for him to do at San Marco until major structural renovations were completed. This undertaking of several years' duration was assigned to Michelozzo, Cosimo's preferred architect.

THE *DEPOSITION* FOR

SANTA MARIA DELLA CROCE

AL TEMPIO, FLORENCE

On April 13, 1436, a commission came to Fra Angelico from Fra Sebastiano di Jacopo di Rosso Benintendi for an altarpiece representing the Deposition from the Cross. The patron was the grandson of a most holy woman, Beata Villana delle Botti, whose cult was associated with Santa Maria Novella.[101] This *Deposition* (catalog 66) was installed above the altar in the oratory of the Compagnia di Santa Maria del al Tempio in Florence, a confraternity that assisted condemned prisoners with their

final prayers and spiritual preparations before they were conducted to the place of execution on the outskirts of the city.[102] Beata Villana is included among the mourners grouped with archaic simplicity around the prostrate body of Christ. Inscribed about her head in good humanist script, as if spoken by her, are the words, XP[IST]O YH[ES]V LAMOR MIO CRVCIFISSO.[103] "The Cross rises up like an everlasting symbol of pain, whilst the impregnable walls of a town stretch into the distance, as if to remind us that earthly life is a barrier to piety and true faith."[104]

A payment of eighteen *lire*, eight *soldi* in early December has generally been taken by scholars as a basis to date the Croce al Tempio *Deposition* to 1436.[105] Ulrich Middledorf, however, rightly noted that this sum was too small to constitute a final payment; he also noted that the ornamentation on the edge of the Virgin's mantle includes the letters MIIIIXXXX, which he read as an encoded date of 1440.[106] For unknown reasons, Fra Angelico seems to have completed this *Deposition* therefore only after his return from Cortona. Indeed, the somewhat soft features of the figures are more comparable to the San Marco frescoes than to the Cortona Altarpiece (catalog 8), whose Ghibertesque refinement suggests a date of 1435-36.

CORTONA, 1437–39

Fra Angelico's whereabouts are not recorded in 1437, the year in which the reconstruction of the now Dominican convent of San Marco began in earnest. A journey to Umbria or, at the least, communication with the Dominicans of Perugia in 1437, has been assumed since Padre Marchese (1845) published this date for the Perugia Altarpiece on the basis of church annals compiled circa 1570. A recent article by Andrea De Marchi has upset this applecart, however, arguing persuasively for a date in the 1440s for Angelico's altarpiece in San Domenico, Perugia.

In March 1438 the painter's presence is documented in nearby Cortona, where he may well have arrived at any time during the previous year.[107] Angelico was among the witnesses to the testament of the local merchant for whom he had recently executed the Cortona Altarpiece. Angelico's fresco, *Saint Peter Martyr Enjoining Silence* (catalog 18), in a lunette over the entrance to San Domenico, Cortona, is now usually assigned to this documented sojourn. The fresco cannot easily be dated in its present, much damaged, condition, but the supposition finds probable confirmation in an April 1438 decision by Pope Eugenius IV permitting the prior of San Domenico, Cortona, to use gift monies in order to make paintings for the church.

It is not known whether Fra Angelico painted other frescoes in San Domenico, Cortona, during this visit, but his activity there was surely linked to the decision taken by Cosimo de' Medici in 1438 to donate to the Dominicans the old high altarpiece of San Marco. An inscription attached to the frame of this magnificent painting records its transfer to Cortona in 1440. Presumably, its replacement by Fra Angelico was ready, or nearly ready, by this time. Work on the new high altarpiece for San Marco had not begun by April 1438, when Domenico Veneziano wrote his famous letter to Piero de' Medici, Cosimo's son, recommending himself for the job, noting that "Fra Filippo [Lippi] and Fra Giovanni [Angelico] had already so much to do." Writing from Perugia, Veneziano apparently knew that Angelico was currently working in Cortona and seems to believe that the friar's services had not yet been engaged at San Marco, but there are limits as to how much can be read into this brief letter.[108]

The only certainty is that, if the work was indeed completed by 1440, the commission for the new altarpiece must have been offered to Fra Angelico at this same moment. Although 1438 is the year traditionally assigned for Fra Angelico's transfer to San Marco, there is no reason to think that he would have abandoned his studio of many years at just the moment when he was called upon to paint the largest panel of his career and eight unusually elaborate predellas. His consultation on the program of frescoes to be executed in the convent would have required frequent visits to Florence, where he would have been witness to the historic events of 1439.

THE COUNCIL OF FLORENCE

In 1436, when Eugenius IV had come to Florence for the solemn consecration of the cupola of the Duomo, the entire city had celebrated the exceptional achievement of its architect, Filippo Brunelleschi. For the orators and humanists of Florence, including Leon Battista Alberti, the magnificent crowning of their cathedral was a confirmation of their efforts to make Florence the heir to classical Rome. In his treatise *On the Civic Life* (1437-38), Matteo Palmieri wrote, "the city is not made of stones, but of men; and these men must cultivate and dedicate themselves to fruitful production."[109]

It was also in 1436 that Leonardo Bruni (1369-1444), the revered chancellor of the commune, wrote to the church leaders assembled in Basel to make the case for Florence as the ideal place for a council to effect a union between the Eastern and Western churches. This humanist dream, which Ambrogio Traversari had nurtured since at least 1419, came to pass in January 1439, when the ecumenical council of Eugenius IV was transferred from Ferrara to Florence. The threat of plague was the stated motivation for this move, but the offer by Cosimo de' Medici to provide for all the expenses of the council and its distinguished participants was a godsend to the impoverished papacy.

For almost eight months a daily pageant enlivened the streets of Florence. While the pope again resided with the Dominicans at Santa Maria Novella, suitable accomodations in private houses were found for John VIII Palaeologus, emperor of Byzantium; for the patriarch of Constantinople and the metropolitan of Kiev; and for the five hundred other bishops, archbishops, and prelates of the Eastern and Western churches.[110] "Pope Eugenius had assembled in his court all the learned men he could find, friars and priests and seculars, and caused benches to be erected in Santa Maria Novella for the council, which, by the advice of learned men was called the 'Council of the Greeks.'"[111] At the solemn opening of the council, Chancellor Bruni addressed the assembly in Greek.

The goal of the council was to end the schism of East and West. The Byzantines hoped that Christian union might save their empire from the Turkish invasion. At issue were subtle points involving the language of the Creed and the jurisdiction of the Roman pope. Daily sessions to debate these issues were conducted at Santa Maria Novella to the rapt attention of all present. The leading discussant on behalf of the East was Bessarion (1403-1472), the humanist archbishop of Nicaea, who was made a cardinal by Eugenius IV. Tommaso Parentucelli, the future Pope Nicholas V, distinguished himself on behalf of the West in his debates with the Ethiopians, Armenians, and eastern Jacobites. In July 1439 Eugenius IV issued the papal bull announcing the union of the Christian church. Although the Concord was not ratified in Byzantium, which fell soon afterward to the Turks, the prestige garnered by the pope and by Cosimo de' Medici was immense.

Detail of the
LAST JUDGMENT
Museo di San Marco, Florence
(see page 104 and catalog 67)

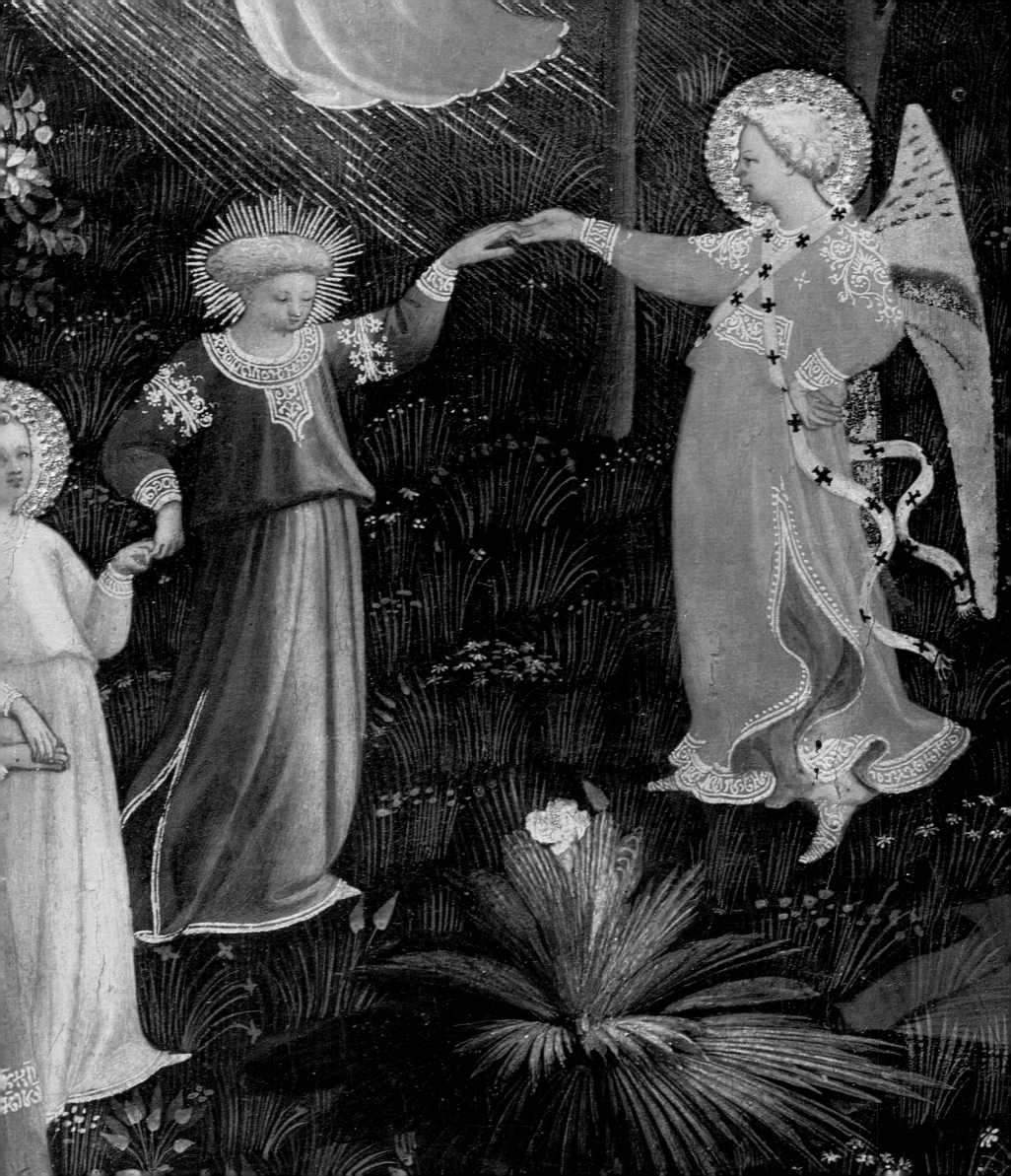

A LIBRARY FOR SAN MARCO

The erudite debate between the Greeks and the Latins was waged upon the common ground of Holy Writ, the body of Christian doctrine that encompassed not only the Old and New Testaments, but also the authoritative biblical commentaries written by the early church fathers, very often in Greek. Before the council sessions began, the Latins were naturally apprehensive that the historical continuity between Byzantium and antiquity might give a decisive advantage to the Eastern debaters. It must have seemed to Leonardo Bruni and to the other humanists as though all their efforts since 1396, when Manuel Chrysoloras was brought to Florence to teach Greek language and literature, had been in preparation for this event. The monasteries of Europe had been systematically searched for the classical texts that had been lost from view in the West. Then followed the laborious work of copying, correcting, and, when necessary, translating the manuscripts into Latin. Bruni recalled afterward, "The study of the Greek language had been extinct in Italy for 700 years when Chrysoloras came here. . . . Inspired by this fact and for other reasons, I made myself such a willing and fervent pupil of Chrysoloras that at night I dreamt about what I had learned during the day."[112]

In 1438, Ambrogio Traversari wrote from Ferrara requesting a colleague to obtain a certain volume from the library of Niccolò Niccoli because its contents would be invaluable for the forthcoming debates.[113] The library formed by Niccoli before his death in 1437 was the achievement of a lifetime devoted to learning. Using first his own fortune, and then resorting to Cosimo de' Medici's, Niccoli had collected nearly eight hundred manuscripts by Greek and Latin authors, both sacred and profane. It was Niccoli's library that provided the manuscripts necessary for Traversari's translations.[114] Despite his notoriously acerbic personality, Niccoli had generously allowed other humanists to borrow and to copy his precious codices.

In a testament drafted in 1430, Niccoli made an extraordinary provision: he wished his books to be conserved together after his death as a library open to all at Santa Maria degli Angeli, the convent of his friend, Traversari. Apart from the volumes left by Boccaccio to the convent of Santo Spirito, no public collection of books yet existed in Italy. At the beginning of the quattrocento, Coluccio Salutati (1331-1406), the humanist chancellor, promulgated in Florence the importance of libraries as "centers of scholarship, laboratories that could produce 'critical' [comparative and definitive] texts, sanctuaries of the *studia humanitatis.*"[115] Salutati's collection was sold by his sons after his death; it thus fell to Niccolò Niccoli, who acquired many of the chancellor's manuscripts, to realize the dream of a public library.

In January 1437, two weeks before his death, Niccoli revised his testament to permit his executors to decide the most suitable repository for his books. It is generally assumed that this shift away from Santa Maria degli Angeli was suggested by Cosimo de' Medici, who was both an executor and the principal creditor of Niccoli, for the considerable sum of nearly 250 florins.[116] Having accepted the responsibility in the previous year of rebuilding the convent of San Marco for the Observantist friars, Cosimo would have realized that the addition of the Niccoli library would lend an incomparable distinction to the project.[117] The Dominican friars do not appear to have been consulted in this decision.[118]

THE RENOVATIONS AT SAN MARCO

Late in life, Cosimo de' Medici confided to Vespasiano da Bisticci that his greatest error had been his failure to invest his wealth in buildings ten years earlier than he did; he feared that nothing would remain of his accomplishments apart from what he had built.[119] This conviction has been aptly called "Cosimo's faith in architecture as autobiography in stone."[120] Whatever his psychological, political, or religious motivations may have been, Cosimo invested a prodigious sum of money in San Marco.[121] His contemporaries recognized Cosimo's personal identification with the San Marco project: "San Marco è opera sua" (San Marco is his work) was the succinct conclusion of Flavio Biondo, no more than a decade after its completion.[122] Even Sant'Antonino, prior at San Marco until 1440, recalled events in these terms, writing, "once he had taken possession of the convent, Cosimo in his munificence undertook to build the monastery."[123] Indeed, the early sources tend to neglect Michelozzo, the gifted architect whose delicate geometry is everywhere in evidence in the convent and library. As the construction records are not preserved, the unequivocal attribution to Michelozzo dates back only to Vasari, who refers emphatically to the "disegno e modello di Michelozzo."[124]

Although the Silvestrines had failed to keep San Marco in good repair, Michelozzo found that most of the weight-bearing walls around the cloister were structurally sound. He first restored the refectory to usable condition with new tables and chairs provided by Cosimo and Lorenzo de' Medici. During 1437, a dormitory containing twenty cells was built in the corridor on top of the refectory on the eastern side of the cloister. The ten cells with windows that now look onto via La Pira would later be decorated with Fra Angelico's most important frescoes. According to Raoul Morçay, based on the brief indications in the Lapaccini *Cronaca*, no building took place in the convent in 1438 while the Medici acquired permissions from the families and confraternities that held rights to chapels and rooms in the church and convent.[125] Instead, most of Michelozzo's work in the church is believed to have been carried out during 1439. In addition to repairs, he constructed a new choir for the friars behind the high altar and a rood screen (*tramezzo*) in the nave. The colonnaded cloister, the chapter room, and the north dormitory on the first story, where the library would be attached, were constructed during 1440-41. The south dormitory, on the Piazza San Marco, is generally believed to have been completed in 1442. If this date could be definitely confirmed, it would help to date the frescoes by Angelico in the seven novice's cells (cells 15-21).[126]

In 1441, Cosimo de' Medici received the formal authorization of his co-executors to install the Niccoli library at San Marco. Tommaso Parentucelli, later Pope Nicholas v, was commissioned to draw up a plan for the arrangement of the manuscripts. The humanistic profile of the library emerges clearly from its inventory. When the library was completed in 1444, the codices of the Bible and of the Greek and Latin church fathers, and the leading scholastics (with the notable exclusion of the Parisian and Oxonian masters still influential elsewhere in Europe), were attached to benches in the right nave (*ex parte orientis*) of the library. The works of great classical philosophers, Plato, Aristotle, and their commentators (Plotinus); the scientific works of Euclid and Ptolemy; as well as grammaticians; historians; and poets were chained to the benches in the left aisle (*ex parte occidentis*).[127]

Assuming that he had already completed the San Marco Altarpiece, Fra Angelico

probably began to paint frescoes in cells in the east dormitory during 1440. His *Crucifixion*, painted in the refectory underneath this level, unfortunately has not survived. The monumental fresco *Crucifixion with Attendant Saints* on the north wall of the chapter room (catalog 22; see pages 132-35) was probably executed after August 22, 1441, when Angelico is documented at a meeting held in the church sacristy because the chapter room was not yet complete.[128] As far as can be determined, Angelico and his assistants—but chiefly the master—managed to complete all of the paintings in the convent, including the chapter room, refectory, cloister, dormitory corridors, and forty-four individual cells, within the space of three years from 1440 to 1442. It should be borne in mind that the friars' regular religious observances would have precluded work on many days. Artists of the time, moreover, seem generally to have

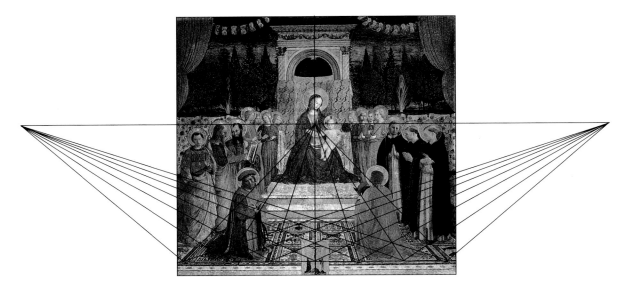

avoided painting frescoes during the hottest months of the summer and the coldest months of the winter.[129]

Everything had to be ready before January 6, 1443, when, in the presence of Eugenius IV and the papal curia, the high altar of San Marco was solemnly rededicated to Saints Mark, Cosmas, and Damian. The chosen date, the feast of the Epiphany, was annually the occasion of a festive procession from the Duomo to San Marco by the Compagnia dei Magi, a confraternity associated with San Marco. Although Cosimo became active in the Compagnia only after 1434, he lost no time in making its imagery his own. Cosimo's private cell in the north dormitory was frescoed with *The Adoration of the Magi* (catalog 56; see pages 160-61). Twenty years later Angelico's greatest pupil, Benozzo Gozzoli, unfurled his masterpiece, *The Procession of the Magi*, across three walls of the family's chapel in the Palazzo Medici. The theme of wise men bringing precious gifts struck a chord in Cosimo.

THE SAN MARCO ALTARPIECE

The rededication of the high altar to Saints Cosmas and Damian together with the titular saint, San Marco, required the execution of a new altarpiece. This was the most important painting that Cosimo de' Medici had commissioned heretofore.[130] The San Marco Altarpiece (catalog 71; see pages 124-29) is a virtual compendium of Medicean iconography on every level, ranging from the red balls of the family crest in the Turkish

Perspective scheme
(from H. Wohl, 1980) of the
San Marco Altarpiece
Museo di San Marco, Florence
(see page 124 and catalog 71a)

carpet to the dominant roles afforded to Saints Cosmas and Damian.[131] Cosimo's name saint kneels in the foreground to address the spectator directly. The kneeling Medici saints comprise the lower corners of a triangle whose apex is the Virgin.[132] Saint Mark holds his gospel open to chapter six, where Angelico has transcribed in humanist script verses 2-8. The selected text was rich in allusions: the transcription of Jesus's command to the Apostles to go forth two by two and to heal was apparently intended to convey an apostolic importance to the activities of the two physicians, Saints Cosmas and Damian, whose lives and martyrdom were depicted in the predella panels beneath the main composition.[133] Finally, Christ's commandment of poverty was specifically pertinent to the Observantist Dominican friars.

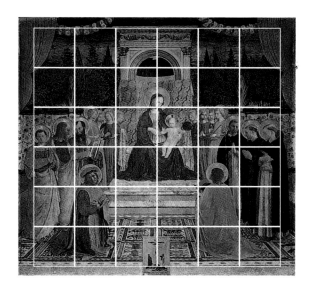

Alberti grid superimposed on the San Marco Altarpiece
Museo di San Marco, Florence
(see page 124 and catalog 71a)

"Not since the *Tribute Money* of Masaccio had there been seen such an ordered and measured arrangement of personages around a central fulcrum, in this case the enthroned Virgin and Child."[134] The comparison to Masaccio is just; indeed, Masaccio's *Tribute Money* and his *Trinity* in Santa Maria Novella (see page 266), where he had employed a Brunelleschian perspective, are the sole precedents in Florentine painting for the rigorous geometry of the San Marco altarpiece by Fra Angelico. The underpinnings of this geometry are provided by the subtle, yet insistent, pattern of the Anatolian carpet in the foreground of the composition. Hellmut Wohl has traced the orthogonals in this carpet to a single vanishing point (opposite) in the chest of the Virgin.[135] This use of perspective for both symbolic and spatial purposes had been anticipated by Masaccio.

In addition, the equal divisions of the front edge of the carpet recall the module system Masaccio had employed to lend structure to the complicated narrative of the *Tribute Money*.[136] A close examination of Angelico's composition reveals that the six sections of the carpet provide the module for a grid of thirty-six squares, which is the reticulated veil proposed by Leon Battista Alberti in his 1436 *On Painting (Della pittura)* as a technical aid for obtaining correct perspective.[137] Angelico's use of the Albertian grid has not previously been noticed, no doubt because it is ingeniously concealed. The four sides of the grid do not precisely coincide with the edges of the square panel, but rather have been inset. A glance at the diagram (above) reveals that the margin outside the grid corresponds to the empty space above the throne's architrave, on either side of Saint Lawrence, left, and Saint Peter Martyr, right, and the black border of the Anatolian carpet. The vertical median of

the grid descends through the Virgin and aligns with the figure of the crucified Christ, superimposed at the bottom of the altarpiece. Furthermore the diagram informs us how Angelico used the grid to establish a subtle symmetry between the two halves of the composition. When we examine the arrangement of the eight saints and eight angels within the sections of this grid, we discover that the two halves of the composition are virtually mirror images of each other.

Two other observations make inescapable the conclusion that the San Marco Altarpiece was constructed on an Albertian foundation. A direct relationship between the height of the figures and the module of the grid was fundamental to Alberti's thought, as Hellmut Wohl has brilliantly analyzed in connection with the Saint Lucy Altarpiece by Domenico Veneziano, painted about the same time.[138] In Angelico's altarpiece we can see that despite subtle differences (Saint Lawrence is a little shorter, while Saint Peter Martyr is slightly taller, etc.) the canon of proportions is equivalent to three modules, or one-half of the grid. In addition, the use of the vanishing point to create a centric guideline for the position of the heads is a technique advised by Alberti. The nine predella panels are similarly constructed with an Albertian clarity that distinguishes them from the artist's usual tendency to organize his predella panels along oblique diagonals.

Although Fra Angelico was fully capable of devising an Albertian system based upon his own reading of *On Painting*, it is more likely that Alberti himself designed this geometric grid. Angelico seems not to have employed this grid in other works; moreover Cosimo de' Medici clearly desired to obtain the best and the most modern solutions for the decoration of San Marco. Alberti was readily available for consultation during these years. Following the publication of his treatise, which established his credentials as a humanist, Alberti entered the service, in Florence, of Pope Eugenius IV from 1439 to 1443.

THE SAN MARCO

FRESCOES

Immediately upon completion of the San Marco Altarpiece, Fra Angelico was engaged to decorate the adjacent convent with the most extensive cycle of frescoes executed by any single artist in the quattrocento. More than fifty in number, the San Marco frescoes fulfill a wide variety of purposes, depending upon their locations. The principal entrance from the piazza leads the visitor into the western loggia of the delightful cloister designed by Michelozzo, now called the Cloister of Sant'Antonino. At the far end of the loggia the monumental figure of Saint Dominic embracing the cross informs the viewer in unequivocal terms that he has entered a sacred precinct of the Dominican order. This theme is confirmed and elaborated by the frescoes of half-length figures that were painted in lunettes over each door leading off the cloister. For example, the lunette above the entrance into the church sacristy depicts Saint Peter Martyr pressing his finger to his lips to enjoin silence. The cloister, it will be recalled, was the only public space where conversation was permitted. Over the entrance to the hospice for travelers, Fra Angelico painted a Pilgrim Christ received by two Dominican friars.

THE *CRUCIFIXION*

IN THE CHAPTER ROOM

The portrait of the order's founder, Saint Dominic, stands over the door leading into the chapter room, or Sala Capitolare. In convents of every order, the chapter room is the chamber where the friars or monks would meet as a body to conduct their daily affairs, including confession of faults, and where important visitors to the convent were entertained. No doubt by virtue of their public functions, chapter rooms held the most significant decorations in the convent. A prominent Crucifixion scene was traditional. In the trecento decorations of the so-called Spanish Chapel in Santa Maria Novella, the important *Crucifixion* by Andrea Bonaiuti is surrounded on all sides by an encyclopedic explication of Dominican theology, with hagiographic representations of Saints Dominic, Peter Martyr, and Thomas Aquinas.

The chapter room at San Marco is like that of no other Dominican convent.[139] Its decorations are confined to a single great fresco, the *Crucifixion with Attendant Saints*, which fills the wall opposite to the entrance (catalog 22; also pages 132-35). In marked contrast to the Albertian perspective of the San Marco Altarpiece, the *Crucifixion* is composed with the utmost simplicity. The three crosses and the skull identify the site as Golgotha, yet all other vestiges of historical time and place have been suppressed. The fresco could aptly be entitled a *Meditation on the Crucifixion* (as Tancred Borenius has suggested), for it is clearly not a narration of the biblical event. Furthermore, the extraordinary gathering of saints on the right is portrayed in their wonder and contemplation of Christ's sacrifice, rather than their grief over his death.[140] The entire decoration has been conceived as a compilation of several discrete series of portraits, mostly imaginary, of sacred personages. The key to reading this work must necessarily be provided by the identities of these personages and the significance of their presence together, because the artist has given us only these.

The work has three distinct components: the multifigured Crucifixion; the semi-circular border with ten medallions of prophets; and, at bottom, the Dominican tree of life with seventeen circular portraits of distinguished members of the order.[141] M. J. Marek underscored the Medicean iconography of the main field, where the family saints are all represented.[142] Furthermore, the scholar noted that the representation of the saintly founders of conventual orders would have pleased the reform-minded Pope Eugenius IV. The prominence afforded to Saint Dominic kneeling at the foot of the cross is appropriate for a Dominican chapter room. The existence of various interconnected themes must be assumed for this fresco by Angelico, who was called upon to address many audiences simultaneously.

In my opinion, the ten medallions provide important evidence for a new reading of this work. This border, as the inscriptions make clear, is devoted to prophecies of Christ's sacrificial death. The Crucifixion is the predominant object of meditation in the friars' cells upstairs. The medallion at the head of the cross contains a pelican, a well-known symbol of Christ's self-sacrifice drawn from the *Physiologus*, a natural history manual compiled in the early Christian era.[143] Eight of these prophets are Old Testament figures clearly identified by name: Daniel, Zachariah, Jacob, David, Isaiah, Jeremiah, Ezekiel, and Job. The medallion at the base of the border on the right side depicts the Erythraean Sibyl. Her prophecy, which was transcribed by Saint Augustine in his *City of God*,[144] is the appropriate conclusion to the series, as it is the only one that prophesies the Resurrection of Christ and the souls of the chosen.

Detail of the
*NAMING OF SAINT JOHN
THE BAPTIST*
Museo di San Marco, Florence
(catalog 114B)

The medallion on the opposite, lower left, side of the border portrays the only prophet whose name is not inscribed; indeed, this classically draped doctor is the only unidentified figure in the entire fresco. He cannot be Pseudo-Dionysius the Areopagite, as has recently been suggested,[145] because the second-century(?) patristic author known by that unwieldly name was not, of course, a pre-Christian prophet.[146] Furthermore, the prophecy on his scroll, DEVS NATVRE PATITVR (God suffers in [or: by his] nature), cannot be found in the writings of Pseudo-Dionysius—which is hardly surprising because these words would be wholly out of character for this early Christian visionary. This prophecy is a fundamental concept of Platonism, asserting that the divine soul suffers from its association with the body.[147] Pseudo-Dionysius was profoundly influenced by Platonism, to be sure, but he was at pains to demonstrate precisely the opposite point of view in this case—namely, that Christ's divinity was uncorrupted by his incarnation. Only a classical sage or philosopher could be responsible for this non-doctrinal thought. The halo worn by the unidentified sage is possibly evidence that he is one of the Greek philosophers whom the Eastern church recognized as saints. The inclusion of this classical sage and the Erythraean Sibyl in the company of Old Testament prophets implicitly assigns them a scriptural authority that they had not held in the Roman church since late antiquity. Their representation in Fra Angelico's fresco can only be ascribed to the influence of the Florentine humanists' study of Saint Augustine and other church fathers, who had notable sympathy for the writers of Plato and the third-century Neoplatonist Plotinus.[148]

The learned prophecies in the medallions must have been provided to Angelico by a contemporary humanist, as William Hood has already pointed out; he suggested Fra Giuliano Lapaccini as possibly the source. Not enough is known about Lapaccini's theology to confirm or deny this hypothesis. The advisor in question may well have been Giannozzo Manetti, whose presence has already been detected elsewhere in this work by Avraham Ronen as the source for the correct Latin, Greek, and Hebrew inscriptions on the *titulus crucis* of the cross.[149] The first humanist to master Hebrew, Manetti was one of the Greek enthusiasts who visited Traversari's cell at Santa Maria degli Angeli during the 1420s along with Cosimo and Lorenzo de' Medici, Niccolò Niccoli, and Leonardo Dati.[150] In the name of scholarly precision and theological truth, Manetti replaced the freer, more rhetorical style of early translations with a stricter, more literal method.[151] He drew upon a wide range of classical and patristic sources for his combination of the patristic vision of man as the divine image with its antecedents in Stoicism and Platonism.[152] Ronen has pointed out that Fra Angelico was the only painter of this period to use correct Hebrew letters on his paintings, and virtually the only Florentine to do so for fully fifty years. It is probably significant that the usage ceases with Manetti's departure from Florence in the mid-1440s.[153]

The same background of Florentine humanism that informs the inscriptions in this fresco is clearly felt in the *Crucifixion* itself. Indeed, there is no other explanation for the representation in a Dominican chapter room of the whole host of saints who founded other religious orders. At least a third of the composition is devoted to these eight saints framed between Saint Dominic and, at extreme right, Saints Thomas Aquinas and Peter Martyr. Standing are Saints Ambrose; Augustine; Benedict; and Romuald, founder of the Camaldolese order. Kneeling are Saints Jerome; Francis; Bernard of Clairvaux, reformer of the Cistercians; and Giovanni Gualberto, founder of Vallombrosa. Their presence can only be explained as a personification of the humanistic themes of *pax fidei* and *concordantia catholica*[154] that had seemed to find their first realization in the union of the Greek and

Detail of
*SAINT JAMES THE GREAT
FREEING HERMOGENES*
Kimbell Art Museum, Fort Worth
(catalog 114c)

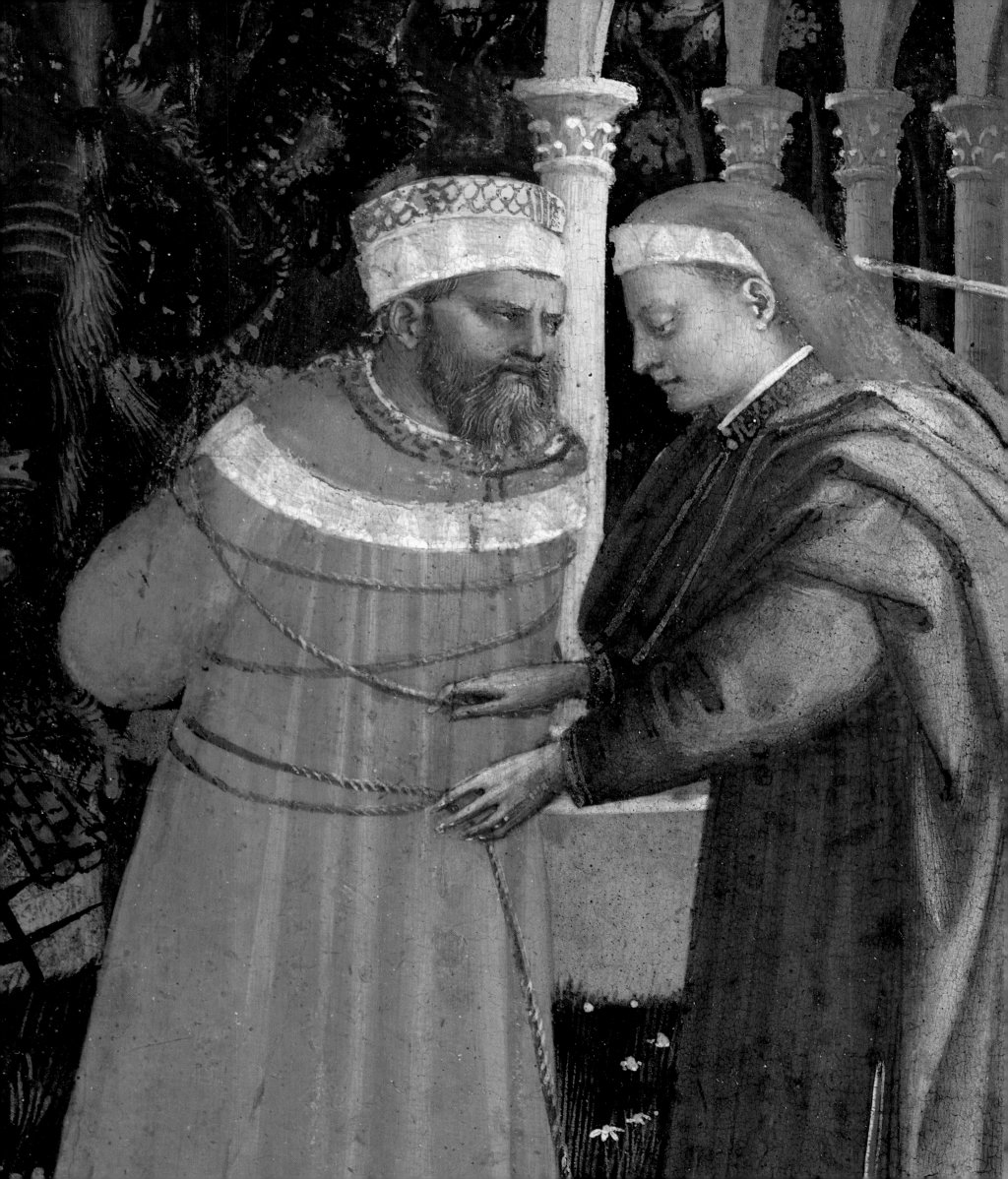

Latin churches in July 1439. One could say that the ecumenical text for Angelico's fresco was sounded by Ambrogio Traversari in his address to the Council of Florence: "Now we see and admire with extreme joy the members of the holy and mystical Body, who have come together from different lands to join their hands in their prayer to be united in a single faith and in divine grace under the cornerstone of Christ."[155]

In retrospect, it would be unusual if the San Marco decorations contained no reference to the historic council, which could not have taken place without Cosimo's personal patronage.[156] The council, moreover, was still meeting at Santa Maria Novella;[157] its last session in Florence was held on February 24, 1443, a month after the pope's visit to San Marco.[158] Furthermore, as Castelfranchi-Vegas has rightly pointed out, there is no reason to assume Fra Angelico was exempt from the pervasive influence that the "humanist climate must have had in a place as small and as strongly unified as Florence was at that time, where projects, protagonists, and ambitions constantly intersected."[159] Indeed, Fra Angelico's knowledge of the new *teologia filologica* is clear: we detect it in the impeccable Hebrew and Greek inscriptions in his paintings for Palla Strozzi and Cosimo de' Medici and in his references to patristic texts—first in the *Last Judgment* for Ambrogio Traversari, but even more fully at San Marco, as we shall find when we come to the frescoes in the cells.

FRA ANGELICO AND HUMANISM

Although Fra Angelico has sometimes been called a humanist, his paintings have never been discussed within the context of contemporary Florentine humanism. The question has doubtless seemed irrelevant ever since Vasari structured his biography on the premise that Fra Angelico's saintliness made him fundamentally different from other painters. Vasari's approach can still be detected today, slightly modified for our secular age, in the frequently encountered belief that Fra Angelico's religious profession kept him apart from the time and place in which he lived. The popular conception of a friar-painter who was in, but not of, this world has a powerful appeal but is profoundly unhistorical.

Vasari meant to honor Fra Angelico by removing him from the general company of painters and placing him in the direct employment of God. In short order, as a result, Angelico's relationship to his contemporaries was forgotten and misunderstood: he was seen as a precious gothic relic from an earlier time. It has only been during the last quarter of this century that studies into the dates of his works have revealed that Fra Angelico possessed one of the most flexible and creative pictorial minds of the quattrocento—which no doubt explains why he was held in such high regard by Lorenzo Ghiberti, Domenico Veneziano, Cosimo de' Medici, Pope Nicholas v, and Cristoforo Landino, to name but a few of his contemporaries. Since Fra Angelico was praised by humanists such as Landino, and mainly employed by them, it can reasonably be assumed that his paintings responded in some way to their mode of thinking.

The modern word "humanist" has taken on a broad spectrum of meanings; its original sense as used here derives from the *studia humanitatis* (humanistic studies), a well-defined cycle of disciplines, including grammar, rhetoric, poetry, history, and moral philosophy, all of them based on classical Greek and Latin authors.[160] The literature on the history and development of Florentine humanism is a favorite tilting ground for academic historians, but there is general consensus that Petrarch (1304-1374) was the chief reviver of the ideal

of classical literary eloquence.[161] Humanism as a professional application of literary and rhetorical skills on behalf of both society and the state received enormous impetus from the appointment of Coluccio Salutati as chancellor, or Latin secretary, of the Florentine republic in 1375.[162] All the other Italian powers, including the papacy, quickly followed this precedent of appointing humanists as chancellors, secretaries, and writers. Through the urging of Salutati, and the financial sponsorship of Palla Strozzi, Manuel Chrysoloras was brought to Florence in 1396 to begin public lessons of Greek grammar and literature. Thus, early in the quattrocento, "the linguistic barrier to full knowledge of the extant works of classical antiquity was breached."[163] Until his death in 1406, Salutati was the highly respected champion of classical studies in Florence. His disciples included two of the leading humanists of the next generation, Leonardo Bruni and Poggio Bracciolini (1380-1459), and he was mentor to a group of young Florentine patricians, including Niccolò Niccoli and Roberto de' Rossi. It was with de' Rossi that the young Cosimo de' Medici studied Latin and philosophy.[164]

Of course, the humanists' vastly expanded reading of pagan literature and philosophy aroused suspicion both at the outset of the quattrocento and at its denouement. It is important to distinguish these two very different moments, however. Criticisms leveled against Salutati by Fra Giovanni Dominici for seeking Christian allegories in classical poetry were but the dying gasps of scholasticism; even the title of Dominici's treatise, *Lucula noctis*, for firefly (the classical word is *lampyris*) was emblematic of the medieval Latin that the humanists were in the process of rubbing out.[165] Salutati's reply to Dominici was a humanist manifesto of the value of the *studia humanitatis* for the training of the clergy and for the advancement of Christian learning and faith.[166] In all events, the debate was no longer an issue by 1426, at least, by which time Masaccio had included a posthumous portrait of Salutati in the Brancacci Chapel; Bruni and Traversari were competing to provide the learned program for Ghiberti's *Doors of Paradise* for the Baptistry; and Leonardo Dati, a humanist, was the *maestro generale* of the Dominicans. Indeed, the theological engagement of humanism was nowhere more explicit than in the nave of Santa Maria Novella, where Masaccio painted his mystical *Trinity*.[167]

By 1440, when Fra Angelico was painting his frescoes in San Marco, the reconciliation of Christianity to Greek and Latin culture seemed at hand. In their desire to adapt classical ideas to their Christian faith and practices, the humanists discovered that they had authoritative precedents in the church fathers. In a famous passage of his *Confessions* (VIII, 9, 13-14), Augustine describes Neoplatonism as containing the distinctive Christian doctrines about God and his word, the creation of the world, and the presence of the divine light. In his *De doctrina Christiana*, Augustine invited Christians to take from pagan writers—Plato, for example—whatever they found useful for understanding and preaching the gospel. Bruni's translation of a letter in which another church father, Saint Basil, defended the reading of pagan poets by a Christian youth was widely circulated, and there are many more such examples.[168]

The Council of the Union, and the presence in Florence of distinguished Greek philosophers, prepared the way for the Neoplatonism that would flourish in the second half of the quattrocento. It was not against this groundbreaking generation of humanists that the Dominican reformer Girolamo Savonarola (1452-1498) leveled the charge of paganism, but rather against his contemporary, the philosopher-humanist Marsilio Ficino (1433-1499). In our attempt to interpret Fra Angelico's frescoes at San Marco, it is important to recognize that Florence during the council was neither the hellenistic capital that Ficino and Lorenzo the

Magnificent tried to make it, nor the new Jerusalem, as was willed by Savonarola. The Florentines of 1440 were pleased to compare their city to classical Athens, but they were engaged in a debate that recalled the Athens where Saint Paul had preached, "the Jews demand miracles and the Greeks seek after wisdom; But we are preaching a crucified Christ."[169]

When the Florentine humanists sought to reconcile the apparent dichotomy between the Greek love of wisdom and the incarnation of Christ, they turned first to Augustine. In the last book of *De Trinitate* Augustine reviews twelve attributes or names given to the Triune God: eternal, immortal, incorruptible, immutable, living, wise, powerful, beautiful, just, good, happy (*beatus*), and spiritual.[170] Then Augustine argues that these many ways of looking at God can be reduced to one unifying attribute, which is wisdom.[171] That Augustine opened a window for Christian humanists onto Greek philosophy is confirmed by the innumerable citations of his works in their treatises. As early as 1403 Cino Rinuccini, who was opposed to the humanists in many respects, granted them at least their preference for Plato over Aristotle, quoting the authority of Augustine, "They say that Plato is a greater philosopher than Aristotle, adding that Saint Augustine called Aristotle the prince of philosophers, excepting only Plato. They do not say why Augustine gives priority to Plato: because his opinion of the soul is more compatible with the Catholic faith."[172]

THE FRESCOES IN THE
DORMITORY OF SAN MARCO

The major part of Fra Angelico's decorations in San Marco are on the upper floor of the convent, where he and his workshop executed forty-three frescoes in forty-five cells of the north, east, and south dormitories and three large frescoes in the north and east corridors. The west flank of the cloister is occupied by the nave of the church. The library, designed by Michelozzo to resemble a graceful basilica in miniature, has its entrance in the middle of the north dormitory. The double cell at the west end of the north dormitory, which contains a large fresco of the *Adoration of the Magi*, is identified, by old tradition, as Cosimo de' Medici's private cell. As the site of the library, the north corridor was accessible to visitors; its cells are therefore assumed to have been assigned to the lay brothers and guests of the convent. On the evidence of the frescoes themselves, the east and south dormitories are believed to have held the cells of, respectively, the clerics and the novices. These two wings would therefore have been *in clausura*, not normally open to lay visitors.

No decoration in a convent on this scale had ever been undertaken by the Dominicans, nor by anyone else. The more relaxed Camaldolese at Santa Maria degli Angeli did not employ Lorenzo Monaco for any comparable purposes, for example.[173] Fresco paintings were almost always reserved for the areas of common use: the ground floor of the cloister, the chapter room, and the refectory. The unprecedented and never-to-be-repeated scope of Angelico's decorations was entirely financed by Cosimo de' Medici, whose expenses on San Marco had totaled the immense sum of thirty-six thousand *ducati* by 1453.

Neither the sequence nor the selection of the subjects of the frescoes can be associated with any single biblical text or iconographical tradition. There are distinct patterns of organization, however, and the occasional suggestion that the decorations of the cells were decided at random by the inhabitants themselves must be dismissed as absurd. It is clear

Detail of the
CORONATION OF THE VIRGIN
Cell 9, Convent of San Marco, Florence
(see page 157 and catalog 35)

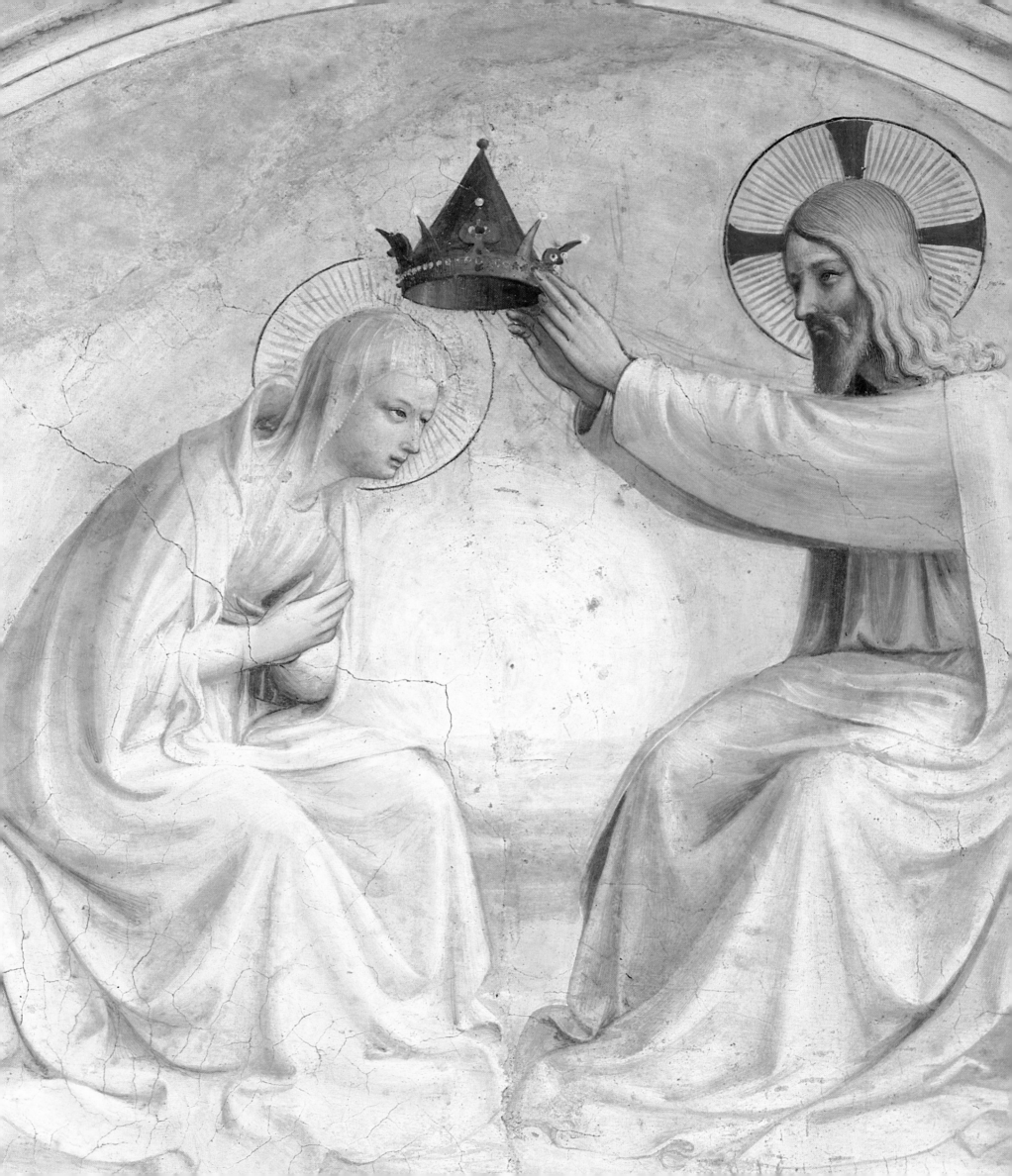

that the cycle of paintings at San Marco was not arranged in accordance with the Aristotelian categories and compartments of knowledge that were employed in the Spanish Chapel at Santa Maria Novella. Although Saints Dominic, Peter Martyr, or Thomas Aquinas are usually present as witnesses or contemplatives, the sole constant in these forty-six frescoes is the presence of Christ, generally as the crucified Christ, but also as resurrected spirit or as the logos that is incarnated in the Virgin Annunciate.

The striking distinctions, from every point of view, from spiritual to artistic, between the frescoes in the three dormitories—and even between the frescoes on opposite sides of the same corridors—have frustrated every attempt to define the underlying principles of this arrangement. The explanation for this program must be sought outside of the usual art historical frameworks.

That Fra Angelico declined to relate the life of Christ according to the traditional narrative is not merely a difference, but extraordinarily revealing. Any Renaissance reader confronted with a text—in our case, with a cycle of frescoes—that was not organized in a systematic, Aristotelian way, and that presented dreamlike images instead of historical narratives, would immediately recognize the non-discursive method of Plato, who cast his ideas in the form of dialogues and myths with esoteric as well as exoteric meanings.[174] Saint Thomas Aquinas himself pointed out that God does not think discursively.[175]

It is not unexpected, therefore, to find that the frescoes in the two dormitories *in clausura* are organized according to principles laid down by the most Platonic of the early church fathers, Pseudo-Dionysius the Areopagite, in his treatise *The Ecclesiastical Hierarchy*. The identity and even the dates of Pseudo-Dionysius, who adopted the name of one of Saint Paul's pupils in Athens, are today a matter of debate, but for a thousand years his authority was unquestioned. Saint Thomas Aquinas wrote commentaries upon the works of Pseudo-Dionysius, although the Angelic Doctor sometimes hesitated before this early church father's espousal of Platonic concepts of the soul.[176] It was the Platonic terminology of Pseudo-Dionysius, however, that so aroused the enthusiasm of the Florentine humanists. Ambrogio Traversari dedicated himself to the translation of the collected Dionysian writings from Greek into Latin, completing this task in 1437.[177] Thus such famous texts as the *Ecclesiastical Hierarchy*, the *Divine Names*, and the *Celestial Hierarchy* were all available in the library of San Marco on the eighth bench, *ex parte orientis*, immediately following the first seven benches that contained the codices of the Bible.

In his writings, Pseudo-Dionysius organized the clergy into three ascending levels just as he had done for the angels in his fundamental *Celestial Hierarchy*. He then proceeded to discern subdivisions of triads within each category. The single row of cells in the south dormitory of the novitiates and the two rows of cells in the east dormitory of the clerics contain frescoes of progressively greater elaboration, from both a spiritual and an artistic point of view. The three divisions in Fra Angelico's frescoes correspond to the Dionysian principle that the worshipers should be initiated into the Christian mysteries according to their capacity to understand.[178]

The catechumens, as the convent's novices could also be called, were enjoined to follow the instructions of their superior, to listen to the singing of the Psalms and to the reading of the holy texts. They were not to participate in the sacred acts of their superiors, nor "in the contemplation reserved for the perfected sight of the perfect."[179] These cells, numbers 15 through 21 in the south dormitory (catalog 38), have always been recognized as a distinct group on the basis of their frescoes, each of which represents a Crucified Christ

Adored by Saint Dominic. The appropriateness of these relatively simple scenes of the founder saint in prayer before the crucified Christ for the education of the young novices is manifest.[180] The *Crucifixions* in each of the novices' cells are the only aspect of the San Marco decorations that conform to the letter of the Dominican constitutions, which foresaw iconic images in the cells of only the Crucifixion, the Virgin Mary, or Saint Dominic.

The three principles that Pseudo-Dionysius used to distinguish his hierarchies, including that of the clergy, are purification, illumination and perfection.[181] The double cell (numbers 10 and 11; catalog 36-37; see pages 158-59) located at the intersection of the south and east dormitories has been convincingly identified as that of the prior, since the subjects of its two frescoes are appropriate to the duties of that office.[182] The theme of the Purification of the Virgin, also represented in the *Presentation in the Temple* fresco in the prior's cell, was specifically associated with the novices at San Marco.[183] Indeed, the remarkable prominence of the flames on the altar in the fresco seems inspired by the Dionysian emphasis on fire as an agent of purification.[184] In the other chamber of the prior's cell, the Madonna and Child are represented in *sacra conversazione* with Saint Augustine, the church father whose monastic rule was observed by the Dominicans, and with "the Dominican" Saint Thomas Aquinas, the Angelic Doctor. Their presence was therefore emblematic of the theological training of the friars.

Although the two rows of cells in the east, or clerics', dormitory have customarily been treated as a unit, there are significant divergences in artistic quality and thematic complexity between the frescoes in outer cells 1 through 9, which have always been appreciated for their visionary character, and the less elaborated conceptions in the inner cells 22 through 29. These cells on the cloister side are believed to have been occupied by the younger friars, including those not yet ordained as priests.[185] Four of the eight cells on this side contain meditations on the Crucifixion, each one slightly varied from its neighbor. The other frescoes, with one exception, also depict subjects of Christ's suffering. The Christ in the Tomb in cell 26 (catalog 43) is especially appropriate for the Passion imagery of the younger clerics' row of cells. The half-length figure of Christ in his tomb is a traditional representation of *Corpus Domini*, an essentially Dominican theme, since the liturgy for this feast was believed to have been written by Saint Thomas Aquinas, who is shown kneeling with pen and text in hand.

The *Baptism* in cell 24 (catalog 41) is the only exemption from the Passion imagery in this sequence. Its fundamental importance as a rite of illumination made its representation obligatory at this point in a Dionysian program.[186] In sum, the frescoes in the friars' cells 22 through 29 are related to the novices', but the friars' meditations are pursued into greater depth and expanded in scope. The dogma of Saint Thomas Aquinas is specifically evoked; however there is a significant absence of the more complex themes of the Resurrection. The frescoes in cells 22 through 29 are therefore consistent with the description offered by Pseudo-Dionysius of the second, or middle, rank of initiates into the mysteries: "their second quality is, after purification, the illumination which makes it possible to contemplate certain sacred things."[187]

Pseudo-Dionysius writes of the highest rank of priests, "they have the power, more divine than the others, of being enlightened in the perfect understanding of the sacred illuminations which they have been permitted to contemplate."[188] There is no reason to doubt, therefore, that the purpose of Fra Angelico's celebrated frescoes in cells 1 through 9 was to evoke the third and highest rank of this Dionysian hierarchy. The sublime quality of these frescoes is implicitly recognized, even by the numbers traditionally assigned to them, which do not in fact reflect their position on the upper floor of the convent.[189]

Having guided us through the preparatory levels of purification and illumination, the Areopagite now brings us to the threshold of perfection. The writings of Pseudo-Dionysius do not include a hierarchy of miracles or episodes, of course; we must look elsewhere for the explanation of the selection and arrangement of the mysteries depicted in cells 1 through 9. But at least two critical aspects of Dionysian thought can be shown to have been employed in the conception of the program for these cells. In the first place, the number nine is quintessentially Dionysian, since it is divisible into three triads. The paramount importance of the triad emerges clearly when we examine the subjects of the frescoes. Finally, Pseudo-Dionysius did not neglect to inform us as to the purpose of this spiritual journey: "I have said in solemn fashion that our greatest likeness to and union with God is the goal of our hierarchy."[190]

The vast literature dedicated heretofore to the sublime frescoes in cells 1 through 9 has restricted itself to the simple enumeration of their stories. To the best of my knowledge only two authors, both recent, have attempted to discern the theological meanings that the viewers of these frescoes were intended to understand "according to their capacity," to use the words of Pseudo-Dionysius. Confining himself mainly to the examination of the three large frescoes located in or contiguous to the clerics' dormitory—the *Annunciation*, the *Crucifixion with Saint Dominic*, and the *Madonna delle ombre (Madonna of the Shadows)*— Georges Didi-Huberman has uncovered a treasure trove of references to Pseudo-Dionysius and to the two great Dominican doctors, Saints Albertus Magnus and Thomas Aquinas. In a new book, Paolo Morachiello has hypothesized that the frescoes in this row illustrate "the fundamental mysteries which contain in themselves the entire story of Salvation."[191] Although Morachiello's hypothesis is neither specific nor complete enough to resolve the program of these frescoes, his observation that the first three cells comprise a conceptual triad is shared here.

Morachiello proposes that Fra Angelico's program begins near the center because the frescoes in cells 1 through 3, respectively, *Noli me tangere*, *The Lamentation*, and *The Annunciation* (catalog 27-29; see pages 146-49), comprise a reverse-order sequence dedicated to the Resurrection, the Passion and death, and the Nativity. That scholar's attempt to apply this triad to cells 4 through 9 was unsuccessful, however, because of his assumption that these three mysteries were only to be contemplated in the chronological sequence in which they are encountered in the Bible.

Yet, if its structure were basically narrative, the program of these frescoes would already have been deciphered long ago. For the theologian who designed this program, however, the wisdom contained in the Bible, like God himself, existed before the beginning of time, exists outside any humanly comprehensible system of time, and is eternal. In the beautiful words of Georges Didi-Huberman, "Fra Angelico's images in calling out to one another, seem to warn the beholder: you cannot understand one image—one Biblical story—without having trod the path of all the others."[192]

The frescoes in cells 1 through 9 are organized into three successive triads: the meditation on Christ's Passion and death, which was the sole theme of the novices' and younger friars' cells, is now joined with meditations on the profound mysteries of the Incarnation and the Resurrection. The Incarnation of Jesus Christ in the Virgin's womb, his sacrifice on the cross, and the Resurrection after three days in the tomb are the fundamental elements of the Redemption of humankind: the resurrected and eternally triumphant Christ will welcome in heaven the souls of the redeemed.

In cells 1 through 3, the triad of Redemption is examined in the following order: the

Resurrection, the Passion, and the Incarnation of Christ. In the table that follows, we can see that the same triad is repeated, using different meditations, in the successive cells without ever replicating the precise sequence. The journey begins with the *Noli me tangere* and culminates in the *Coronation of the Virgin,* a subject that corresponds perfectly to the Dionysian thesis that the purpose of a hierarchy is nothing less than union with God.

THE TRIAD OF REDEMPTION AND UNION WITH GOD

CELL	STORY	MYSTERY
I	*Noli me tangere*	Resurrection
2	The Lamentation	Passion
3	The Annunciation	Incarnation
4	The Crucifixion	Passion
5	The Nativity	Incarnation
6	The Transfiguration	Resurrection
7	The Mocking of Christ	Passion
8	The Maries at the Tomb	Resurrection
9	The Coronation of the Virgin	Union with God

Detail of
NOLI ME TANGERE
Cell 1, Convent of San Marco, Florence
(see page 147 and catalog 27)

The sequence R-P-I-P-I-R-P-R-U, which reads like a form of versification,[193] achieves its inevitable resolution in cell 9 with the *Coronation of the Virgin* (catalog 35; see pages 154-57), a theme that represents not only the union of Mary's soul with God, but, on other levels, the unification of Christ with his church. The unity of this triad had been asserted in the thirteenth century by Saint Albertus Magnus in his dictum "Conceptio est propter nativitatem, nativitas propter passionem; passio propter redemptionem"[194] (He was conceived in order to be born; he was born in order to suffer the Passion; he suffered the Passion for the sake of our Redemption). Thus the Dominican doctor summarized thousands of pages of learned exegesis.

That this sequence of cells should begin with *Noli me tangere* has always seemed inexplicable to anyone seeking a straightforward narrative. No other episode of the New Testament could serve better, however, to exemplify a pressing concern of the time of Fra Angelico: the necessity of the soul to ascend to God. This Resurrection story was told only by Saint John the Evangelist, whose gospel begins, philosophically, "In the Beginning was the Word" (20:11-18). His story recounts that during her vigil outside the empty tomb, Mary Magdalene encountered the resurrected Jesus, whom she mistook for a gardener. When he called her name, she recognized him and reached to embrace him, but Jesus told her, "Touch me not for I am not yet ascended to my Father." An insistence on the separateness of body and spirit—and on the incapacity of the body's senses of sight and touch to comprehend the spirit—is a prime tenet of Platonism, as Saint Augustine and the other patristic writers were happy to acknowledge. For his part, Pseudo-Dionysius wrote in the *Ecclesiastical Hierarchy,* "To us death is not, as others imagine, a complete dissolution of being. It is, rather, the separation of two parts which had been linked together."[195]

The Platonic exaltation of the immortal soul exhilarated the Florentine humanists, but it ran the risk, in Christian terms, of despising the world created by God and demeaning the Incarnation. Fra Angelico found the solution for this dilemma in Saint Thomas Aquinas's teaching, "There is no salvation outside the mystical body of Christ."[196]

In the culminating fresco of the *Coronation of the Virgin*, six saints are represented in a state of spiritual union; the meditations in cells 2 through 8 leave no doubt that the path to the apex leads through the Incarnation, the Passion, and the Resurrection.

The resplendent garden in the *Noli me tangere* is Fra Angelico's way of contrasting the paradisiacal realm of the soul with the cold and barren tomb that looms behind the Magdalene. The fence in the background identifies this garden as the *hortus conclusis* (enclosed garden), or Garden of Eden. Saint Paul called the Redeemer "a new Adam."[197] In his recent book, Georges Didi-Huberman has made important strides toward demonstrating the complexity and richness of the theological references that can be traced in this fresco. Using semiotic theory and his reading of Pseudo-Dionysius the Areopagite, Didi-Huberman goes so far as to identify the red splotches in the grass as mystical signs of Christ's wounds, the stigmata. In the light of our reading of these frescoes as a cycle on Redemption, it is possible to identify Saint Paul's Letter to the Hebrews (9:21, 11:28, 12:24) as Fra Angelico's source for the "sprinklings of blood" that that scholar observed. As the principal biblical commentary on the Redemption through the sacrificial body of Christ, the Letter to the Hebrews was one of the essential sources for the formulation of the San Marco frescoes.

The reader is referred to the plate section for descriptions of the frescoes in cells 1 through 9. It is worthwhile to note the formal devices, which have not previously been noticed, by which Fra Angelico subtly unified the compositions within each of the three triads. The frescoes in the first three cells are distinguished by the motif of a chamber with a rounded opening, which appears twice as the mouth of the sepulchral cave and in the *Annunciation* as the vaulted chamber of the Virgin. Numerous texts for this association of tomb and womb can be cited,[198] and were not uncommon in Renaissance art: witness Piero della Francesca's *Madonna del Parto* in the cemetery chapel of Monterchi.[199] "There is a similarity between Christ hidden for three days in the tomb and hidden for nine months in the Virgin's womb, and it suggests the seed that must fall to the ground and die to bring forth fruit" (John 12:24).[200]

The frescoes of the central triad in cells 4 through 6, representing the *Crucifixion*, the *Nativity*, and the *Transfiguration* (catalog 30-32; see pages 150-53), are all composed around the shape of the cross. Thus we find the cruciform "tau," a Greek symbol, superimposed upon the stable of Bethlehem, again prefiguring the Passion of the newborn Christ. This imagery offers one possible explanation for the extraordinary pose of the Transfigured Christ in cell 6.

The final triad of frescoes (catalog 33-35; see pages 154-57) departs slightly from this pattern, because of the necessity of distinguishing the culminating fresco, the *Coronation of the Virgin*. The pronounced circles in this composition are ancient symbols of perfection, unity, and the universe. The subtle horizontal forms of the clouds seem to be the vestiges of the altar-like forms of the steps in the *Mocking of Christ* in cell 7 and the tomb in *Maries at the Tomb* in cell 8. A possible interpretation of the imagery that we have discerned in these triads would be that the mysteries of the Incarnation, the Passion, and the Resurrection are embedded in these symbols of tomb/womb, the cross, and the altar.[201]

When we turn now to the three large frescoes in the corridor, the *Annunciation* (catalog 24; see page 131), the *Crucifixion with Saint Dominic* (catalog 16), and the *Madonna delle ombre* (catalog 26), we realize that the triad of Incarnation, Passion, and Resurrection has been before our eyes all this time. The *Madonna delle ombre* represents both Resurrec-

tion and spiritual union, because the Madonna and Child are engaged in *sacra conversazione* with the saints and martyrs in paradise.

THE FRESCOES IN
THE NORTH DORMITORY

Detail of
CRUCIFIED CHRIST WITH SAINT JOHN THE EVANGELIST, THE VIRGIN, AND SAINTS DOMINIC AND JEROME
Cell 4, Convent of San Marco
(see page 151 and catalog 30)

As the site of the library and the double cell of Cosimo de' Medici, the north dormitory would not have have been *in clausura*; it must also have held the cells of the lay brothers (*conversi*), who shared many of the devotions of the friars, but remained secular.

Apart from the festive *Adoration of the Magi* in Cosimo's cell, these frescoes have generally received less attention because of the noticeable participation of assistants in their execution. The biblical narratives in cells 31 through 36 on the inner, or cloister, side of the corridor (catalog 48-53) were probably painted by the young Benozzo Gozzoli on the basis of designs by Fra Angelico (which was their working method in Orvieto in 1447 and in the Chapel of Nicholas v in the Vatican). These frescoes are easily distinguished from the Crucifixions in cells 40 through 43 (catalog 57-60), which were painted by Fra Angelico with the assistance of a mediocre pupil.

The extensive employment of assistants in this corridor was probably the inevitable response to the need to finish the decorations before January 1443. Despite the unevenness of their execution, however, the frescoes in the north dormitory display a thematic cohesiveness and a guiding pictorial intelligence that strongly suggest that they were executed in conjunction with the original program of decorations undertaken in the cells *in clausura* by Fra Angelico.

The frescoes in this lay wing of the convent do not pertain to the ecclesiastical hierarchy of the Areopagite, but they similarly are divided into groups that presuppose different audiences. The biblical stories in the inner cells 31 through 36 are narrative scenes in which, for the sake of historical accuracy, no Dominicans are represented. For this reason, and for the abundance of references to Roman and classical antiquity, these cells were probably not destined for the unlearned lay brothers, but possibly for visiting users of the library. For example, the subject of Christ's Descent into Limbo was of particular interest to the humanists, who were concerned that their beloved philosophers of antiquity should escape from perdition. (It follows, moreover, in the historical sequence between the adjacent *Crucifixion* in cell 30 and the *Noli me tangere* across the corridor, in cell 1.) As to the *Sermon on the Mount* in adjacent cell 32, the motif of Christ holding a scroll sitting in a circle of his disciples is borrowed from a classical composition of Socrates teaching his acolytes. Presumably the justification for the inclusion of Martha and Mary in the foreground of the *Agony in the Garden*, cell 34, is to be found in a patristic source, perhaps Origen. Finally, the philological bias of these accounts is revealed in a detail such as the prominence of the Sanhedrin representative in the *Arrest of Christ*. There could be many more examples; these are offered to invite deeper examination of the individual frescoes.

The Crucifixion scenes in cells 40 through 43 on the outer, or garden, side of the north dormitory were most likely decorated for the lay brothers of the convent, as Giorgio Bonsanti was the first to observe. The inclusion of Dominican saints endows these paintings with the character of meditations. Unlike the novices, who were instructed to emulate the

founder in his prayers before a vivid Crucifix, the lay brothers were sufficiently experienced to contemplate decisive moments of the Crucifixion story. The triple Crucifixion in the large cell 37 (catalog 54), plausibly identified by William Hood as the meeting room of the lay brothers, emphasizes the salvation promised by Christ to the good thief, a common sinner.

The frescoes in Cosimo's cells 38-39 seem to combine aspects of the two distinct series we have identified. Thus the *Adoration of the Magi* is a humanistic reading (the Magi have brought an astrolabe) of its story, in which all writers have detected references to the eastern panoply of the Council of Florence. The Holy Family and the Magi in this fresco were painted by Fra Angelico himself. Benozzo Gozzoli was largely responsible for the *Crucifixion* in the outer cell; the omission of Saint Lawrence from the Medici saints in this painting is a certain indication that it was executed after 1440, the year of Lorenzo's death.

THE ADVISOR TO

THE SAN MARCO FRESCOES

The exceptional erudition of the fresco program in San Marco requires us to assume the intervention of a theological advisor, if not more than one. The theological training of Fra Angelico made him uniquely equipped to execute a pictorial program capable of bearing an immense rhetorical weight without collapsing.

While it has always been recognized that personal ambition and family prestige must have been motivating factors for Cosimo's patronage, no one has ever suggested that Cosimo had any say whatsoever in the selection of subjects painted by Fra Angelico. It has seemed odd perhaps to think that a layman would dictate theology to Fra Antonino Pierozzi, prior of the convent, later canonized, or to Beato Angelico. Yet the interest and involvement in theological issues on the part of the Florentine humanists cannot be overstated. Recent studies have identified numerous instances in which Florentine laity, and the Medici in particular, had extraordinary impact upon the liturgy of the churches that they supported.[202] In 1453, as an example of how the library of San Marco was intended to be used, Niccolò Luna was given a cell in San Marco while he wrote a treatise on the nature of the soul.[203]

It has sometimes been suggested that Cosimo de' Medici would not have concerned himself with paintings that no one, apart from the solitary friar in his cell, would have seen.[204] Leaving aside the unresolvable question as to whether visitors to the public library, situated in the middle of the north corridor, would ever have been permitted a glimpse of the cell frescoes, the fact remains that Angelico's frescoes were completed in time to be admired by Eugenius IV and the assembled papal curia one month before the conclusion of the Council of Florence. The San Marco decorations would doubtless have been understood by the erudite and distinguished guests on that day as Cosimo's response to the historic debates that he had underwritten. We now can see that the famous decision by Eugenius IV to stay the night at San Marco was occasioned not only because there was so much for him to look at, but also because there was so much to talk about.

The provision of instruction to the friars was the fulfillment of a humanistic concern originally voiced by Coluccio Salutati and Petrarch; in this respect, the gift of the frescoes in the friars' cells was analogous to the donation of the Niccoli library. To the

suggestion that Cosimo would not have been in a position to intrude upon the sacrosanct privacy of the friars' cells, any number of examples of his influence over the most intimate affairs of the San Marco community can be invoked. The privilege of maintaining a personal cell in their dormitory (in violation of the constitutions[205]) was perhaps the most extraordinary of these, but the insertion of his name saints into the liturgical calendar of the friars was hardly less significant.[206] In 1455 Cosimo even played a key role in the friars' decision to abandon their institutional rule of poverty.[207]

For many authorities, Miklós Boskovits among them, the selection of subjects to be depicted in the cells and corridors was most probably made by Fra Antonino Pierozzi, the future Sant'Antonino.[208] Both Giorgio Bonsanti and William Hood have responded, however, that no compelling connections can be drawn between Antonino's writings and the frescoes.[209] Moreover, Fra Antonino made no mention of the paintings in his own account of the rebuilding of San Marco.

The theory that Fra Angelico on his own initiative, or at the request of the other friars, decided to furnish their dormitory with a splendid cycle of paintings cannot be sustained in view of the obvious conflict between this plan and the restrictions imposed by the Dominican constitutions.[210] Furthermore, Nicolai Rubinstein has quoted from the *Chronicae*, composed in the 1450s by Sant'Antonino, wherein the friar sharply attacked the comfort and sumptuous display of Dominican convents, asking, "what would the holy founder Saint Dominic say if he could see their houses and cells enlarged, vaulted, raised to the sky, and most frivolously adorned with superfluous sculptures and paintings?"[211] Fra Antonino would hardly have made this comment (and others like it) if he had formulated—or had authorized one of his friars to formulate—the most ambitious decorations ever executed in a dormitory of friars.

Finally, the contents of the frescoes themselves, with the emphasis on patristic themes that we have noted, strongly suggests to my mind that the division of cells according to a Dionysian hierarchy and the mystical interpretation of such themes as the Coronation of the Virgin and the Transfiguration reflect the presence of a humanist advisor in the employ of Cosimo de' Medici. Three persons come immediately to mind. Ambrogio Traversari is known to have pursued patristic studies in depth and to have been interested in acting as an advisor to works of art. Giannozzo Manetti is presumed to have provided Fra Angelico with the correct Hebrew inscription on the *titulis crucis* in the chapter room and was strongly attracted to Christian Platonism. Tommaso Parentucelli possessed the requisite culture to have informed this program and was in fact called upon by Cosimo de' Medici to provide the organizational plan for the library. As the humanist Pope Nicholas v, Parentucelli would later summon Fra Angelico to Rome to decorate his personal study and private chapel with frescoes.

RHETORIC AND STYLE
IN THE SAN MARCO FRESCOES

Between 1439 and 1443, working under extreme pressures of time, Fra Angelico completed the high altarpiece with its ancillary panels for the church of San Marco and nearly fifty frescoes in the cloister and dormitories of the adjacent convent. Even allowing for the participation of assistants in many of the frescoes of the north and south

dormitories, another painter under normal circumstances might have executed only the altarpiece in such a limited span of time. The stylistic variations within the group have led many scholars to propose that Fra Angelico returned to San Marco at subsequent intervals to add the frescoes in the north dormitory as well as the *Annunciation* and *Madonna delle ombre* in the corridors. Following the 1983 restoration of the frescoes, however, Giorgio Bonsanti concluded that the convent's decorations were mainly completed by January 1443, which view is justified, as we have seen, by the programmatic integrity of the five rows of cells.[212]

Angelico's works at San Marco evince a surprising variety of stylistic solutions. The Albertian geometry that he applied so easily and effectively to the composition of the San Marco Altarpiece is not so readily discernible in the frescoes in the convent.[213] Examination of the different sections of frescoes in the three dormitories reveals that Fra Angelico deliberately adjusted his stylistic modes according to his rhetorical purposes. The striking contrast between the visions in the friars' cells *in clausura* and the biblical stories in cells 31 through 36 demonstrates this point unequivocally. Fra Angelico did not want the friars' contemplations of the sacred mysteries to be bogged down by descriptive details.

No previous painter apart from his immediate forerunner, Masaccio, had ever endeavored to vary and control the pictorial elements at his command to suit the theological shadings of his argument. At the Brancacci Chapel Masaccio had endowed his *Tribute Money* with a redolent aura of classical antiquity. Michael Baxandall has already demonstrated that the classical literary theories of the Florentine humanists fundamentally affected the ways in which Alberti and other humanists viewed painting after the publication of *On Painting* in 1435.[214] Although Alberti fixedly concentrated on the proper composition of an *historia*, his implicit comparison of painting to literary rhetoric is present throughout San Marco.

While Angelico mainly abstained from Albertian spatial perspective in the convent frescoes, some influence of *On Painting* may be detected in the pronouncedly Giottesque character of the friars' cells. During the 1420s Fra Angelico had briefly responded to Masaccio's rediscovery of Giotto's monumentality and noble simplicity, but nothing in Angelico's previous works prepares us for the extraordinary spatial and compositional compression of these frescoes, above all those in cells 1 through 9.

Joseph Crowe and G. B. Cavalcaselle had good reason to place Fra Angelico among the Giottesque painters.[215] Recent writers on San Marco have overlooked the observation by Roberto Longhi that the *Maries at the Tomb* in cell 8 is directly based on the trecentesque fresco of the same subject by Giusto di Padova in the Battistero in Padua.[216] Whether Fra Angelico knew this fresco personally, as seems unlikely, or through an analogous work, does not affect the significance of his adoption of a Giottesque prototype, upon which he then superimposed a vision of Christ's soul in a mandorla. The compositional outline of the *Transfiguration* in cell 6 was adopted from the panel of this subject by Taddeo Gaddi (1300–?1366) in the sacristy of Santa Croce.[217] Fra Angelico was sufficiently independent to borrow what suited him from the earlier master without lapsing into archaisms.

The interesting distinctions that Crowe and Cavalcaselle drew between Giotto and Angelico also suggest the different intentions of Angelico and Masaccio: "Giotto had more nature, Angelico more ideal. . . . Giotto created his type in the full consciousness of feelings excited to an extraordinary degree by the revival of religion in art, Angelico took the type of Giotto and gave it an intense religious feeling and a more perfect material shape."[218]

As it is not currently possible to reconstruct the sequence in which Fra Angelico

completed the frescoes in the convent, it is difficult to address his stylistic developments over the years of San Marco. Furthermore, the artist's exercise of a *theologia rhetorica* would in any event complicate this question.[219] A few general observations on style can be made, however. For example, the frescoes in cells 1 to 9 and 22 to 29 in the clerics' dormitory are believed to have been among the first executed, perhaps around 1440-41. The proportions of these figures seem more contained—more Giottesque, in fact—than in the presumably later *Crucifixion* in the chapter room, probably datable to 1442. The relatively reduced color scheme in the clerics' dormitory might be attributed to the preponderance of Passion subjects, but there is nonetheless greater use of pale greens and reds in the chapter room *Crucifixion*, which is theologically consonant. And this generally lighter palette, with a tendency toward pastel tonalities, is found in the *Adoration of the Magi* and in the other frescoes on the garden side of the north dormitory, usually considered among the last frescoes to be completed. The figures in those frescoes have comparatively slender proportions and point the way to Angelico's post–San Marco style.

The accomplished execution of the frescoes in cells 31 through 36 by an assistant—probably Benozzo Gozzoli (1421-1497)[220]—further suggests that the north dormitory was among the last to be decorated. Gozzoli's hand does not seem to appear in either the south or east wings of the cloister, although he may have contributed to the novices' *Crucifixions*.

Detail of
CHRIST RESURRECTED AND THE MARIES AT THE TOMB
Cell 8, Convent of San Marco
(see page 156 and catalog 34)

PROJECTS FOR EUGENIUS IV

IN ROME, 1445–47

Fra Angelico is documented as a witness to various financial transactions at San Marco in 1441 and 1442, leading us to assume that he resided in Florence during the final phase of the reconstruction of the convent. His activities in the immediate aftermath of the rededication of San Marco in January 1443 are not recorded. Some two years later, in July 1445, the Observantist Dominican communities of San Marco and San Domenico in Fiesole formally separated. "Fra Joannes de Florencia," as he signed the document drafted by Fra Antonino Pierozzi, was among the friars who remained in Fiesole.[221] While the San Marco convent could count upon the financial support of Cosimo de' Medici, the friars in Fiesole were presumably dependent upon the income earned by Fra Angelico and by his brother, Fra Benedetto.[222] Within a few months, in fact, Fra Benedetto received a commission from Cosimo de' Medici to produce an antiphony and other choral manuscripts for San Marco.[223]

After July 1445 Fra Angelico's whereabouts are not documented until May of the next year, by which time he was in Rome in the employment of Pope Eugenius IV. He very probably had been called to Rome in the autumn of 1445, because an old tradition credits his intervention with the pope as instrumental in the nomination of Fra Antonino to the Archbishopric of Florence in January 1446.[224] His presence in Rome was most likely the reason for his absence from a chapter meeting in Fiesole on January 25, 1446.[225]

When Eugenius IV departed Florence in March 1443, the continuing Council of the Union was transferred to the Lateran. The departure of the papal court noticeably depleted the humanist ranks in Florence. Georgius Gemistus Plethon, for example, had been appointed papal secretary on the recommendation of Cardinal Bessarion.[226] Thus two

of the leading debaters on the Greek side, indeed the two most fervent apologists for Christian Platonism, became influential figures at Rome.

In August 1445 the bronze doors cast by Filarete for Saint Peter's were installed (they were retained when the basilica was rebuilt and are still *in situ*). Although Vasari reports that the doors were twelve years in the making, their design must have been radically modified in the last phase of production in order to include illustrations of the arrival of the Emperor John VIII Palaeologus in Ferrara and his reception by Pope Eugenius IV, the Council of the Union in Florence, and the decree of the union of the Greek and Latin churches. The foliated decorations on either side of the doors are notable for their heady dose of classical mythology and history; the humanist program for these representations of Argus, Europa, Persephone, Jason and the Argonauts, Perseus, and Narcissus, among others, has never been completely deciphered.

The vexed question of Fra Angelico's works for Eugenius IV in Rome has been effectively addressed by Creighton Gilbert.[227] On the basis of his meticulous analysis of the contradictory sources and fragmentary documents, Gilbert concluded that Fra Angelico was employed by Eugenius IV for frescoes in the tribune of Saint Peter's and in a *cappella del Sacramento* in the Vatican Palace. The frescoes in the apse of Saint Peter's were demolished in the reconstruction of the basilica that soon followed. Vasari referred to paintings of the Life of Christ in the Chapel of the Sacrament in the palace, which were replaced by a staircase built by Pope Paul III after 1534.[228] A fresco fragment representing the head of Christ (Palazzo Venezia, Rome, as by Benozzo Gozzoli), correctly assigned by Boskovits to Fra Angelico in these same years, was probably saved from one of these lost cycles.[229] When Eugenius IV died on February 23, 1447, his body was carried to this "small chapel recently painted."[230] The early documents called this chapel "small" to distinguish it from the Sistine Chapel on the same level of the palace. The humanistic character of these lost frescoes can be deduced from the series of portraits of famous men that were noted by Vasari.[231]

A *Crucifixion* with a donor figure of Cardinal Juan de Torquemada (catalog 6) is one of the few panel paintings that can confidently be assigned to Fra Angelico following his transfer to Rome in the mid-1440s. An upright *Pontifical Saint*, first published by Pope-Hennessy as originally one of the lateral wings of this portable triptych, was identified by Boskovits as a portrait of Eugenius IV in the guise of San Sisto (catalog 6A). The actors in these panels have the attenuated proportions and the blond, translucent colors that we noted in the late frescoes in the north dormitory at San Marco. They are noticeably more substantial, however, than Angelico's style prior to the San Marco years, when the artist used contrasts of bright colors to model his figures. His source for this development toward firm and tangible surfaces is not known, but may have been the impressively physical style of Fra Filippo Lippi (c. 1406-1469), who had matured into a formidable competitor.

"FAMOUS BEYOND ALL OTHER ITALIAN PAINTERS," ORVIETO, 1447

In May 1446 Angelico was sounded out by Francesco di Barone Brunacci, a Benedictine of Perugia and a glass painter in the service of the pope, as to whether he would be available to undertake an important project in Orvieto.[232] After nearly forty years of

construction, the grandiose Chapel of San Brizio in the right transept of the Duomo of Orvieto had been completed. Paintings were now required, beginning with the vault, which was divided by ribbing into two quadripartite spaces. While Fra Angelico did not travel to Orvieto that year, he was apparently free in principle to accept assignments away from Rome during the unhealthy summer months.

Fra Angelico and three assistants, including Benozzo Gozzoli, were painting unspecified subjects in the apse of Saint Peter's when Pope Eugenius IV died on February 23, 1447. The election of Tommaso Parentucelli as Pope Nicholas V on March 6, 1447, allowed Fra Angelico to continue painting uninterruptedly until June 1, when he ceased work for the summer. On May 11 he accepted the commitment to paint the vault and adjacent lunettes of the Cappella di San Brizio in Orvieto. The *operai* of the Duomo noted in their records that this Observantist Dominican was "famosus ultra omnes alios pictores ytalicos" (famous beyond all other Italian painters).[233]

On June 8 Fra Angelico participated in Orvieto in the observance of the feast of Corpus Domini. Benozzo Gozzoli and his two other assistants, Giovanni di Antonio della Checca, his nephew, and Iacopo di Antonio da Poli, had accompanied him from Rome.[234] The artist set immediately to work designing a commanding *Christ Seated in Judgment* and a tribune of *Sixteen Prophets* (catalog 90; see pages 170-75) for two sections of the vault. On July 11 a local painter named Pietro da Nicola was added to the team. Work proceeded throughout the summer. At the end of August, Giovanni di Antonia della Checca was sent to Florence to buy pigments and other painting materials not available in Orvieto. By September 28 two of the four vanes in the vault had been painted, and Angelico had apparently completed the designs for the other two.

Recent restoration has underscored the importance of Gozzoli as the painter of most of these frescoes. In the interest of proceeding as rapidly as possible, Angelico devoted his energies to projecting the paintings, which were then executed by his capable junior partner. The tremendous height of this ceiling was no doubt a factor in this decision. In 1447 Fra Angelico had probably arrived at fifty years of age, and a daily ascent of the scaffolding may have been more of a strain than he cared to endure. He also knew that most observers would be unable to detect the differences between his and Gozzoli's brushes at such a distance.

For unclear reasons, Fra Angelico never returned to complete the work in the Duomo of Orvieto. The *operai* may have had difficulty in raising the necessary funds;[235] however, Gozzoli's brief return to the city in the summer of 1449 seems to indicate their willingness to proceed. Fifty years later, Luca Signorelli followed Angelico's designs in completing the other two sections of the vault and then proceeded to paint his masterpiece in the lunette on the adjacent wall of the chapel.[236]

THE ELECTION OF
POPE NICHOLAS V, 1447

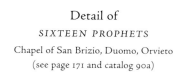

Detail of
SIXTEEN PROPHETS
Chapel of San Brizio, Duomo, Orvieto
(see page 171 and catalog 90a)

The jubilation that humanists felt over the accession of one of their own, Tommaso Parentucelli (1397-1455), to the papal throne was heightened by the unexpectedness of the event; the new pope Nicholas V had been named cardinal only a few months

before. The Florentine delegation to the Vatican outshone all the others for its pomp. An elegant oration, lasting an hour and a quarter, was delivered by Giannozzo Manetti, to whom the new pontiff responded in perfect Ciceronian style.[237] Vespasiano recorded that "all the learned men of the world flocked to Rome on their own initiative. Some Pope Nicholas sent for because he desired that they should reside at the court of Rome."[238] Rome became the center of literary activity as the pope set about to collect the whole of ancient literature in good copies and to make Greek authors available in translation.[239] A compulsive bibliophile all his life, Nicholas v spent unstintingly on behalf of the Vatican library; according to his biographer, "not since the time of Ptolemy, had there been collected such a store of books."[240]

THE PERUGIA ALTARPIECE

In 1985, Andrea De Marchi proposed to postpone by a full decade the date of Angelico's Perugia Altarpiece (catalog 94), which had always been dated to 1437 on the basis of a chronicle compiled in 1578.[241] Although De Marchi's bold hypothesis has not been accepted by subsequent scholars, it is fully convincing. The figures and draperies in this painting are described with a precision and refinement that is closely comparable to Angelico's frescoes of 1448 in the Chapel of Nicholas v, and not with the *Deposition* for Santa Maria della Croce al Tempio, 1436-40. Furthermore, as other scholars had already observed, the beardless Saint Nicholas who quietly reads a sacred text is certainly a portrait. Indeed, there is no doubt that this is a sympathetic and intimate glimpse of Angelico's friend, the newly elected Nicholas v. For a fuller description of this altarpiece, the reader is referred to the Plates section.

THE CHAPEL OF NICHOLAS V, 1448

Upon his return to Rome from Orvieto in the autumn of 1447, Angelico was immediately employed in projects of the greatest personal interest for the pope. Payments for blue ultramarine on February 15, 1448, and for gold leaf on March 30, are believed to be associated with the fresco decoration of the Cappella Niccolina (catalog 104-7; see pages 176-85), the private chapel of Nicholas v in the Vatican Palace.[242]

The three sides and ceiling of this "small and private" chapel were filled with paintings rich with classical and patristic allusions. Four magnificent figures of the Evangelists dominate the low ceiling; their authority is symbolically transmitted to the eight full-length fathers of the church standing like pillars in the four corners of the chapel. Two of these, Saint Anastasius and Saint John Chrysostom, are also doctors of the Eastern church. No trace remains of the fresco of the Deposition that originally decorated the altar wall. Despite having suffered various misadventures over the course of time, Angelico's paintings representing the lives of Saint Stephen and Saint Lawrence on the three other walls are reasonably well preserved.

As might be expected from this pope at this point in history, the frescoes abound with references to Roman architecture and costumes. The humanistic program remains to be reconstructed in detail, but interesting observations have been made by Castelfranchi-Vegas, who notes the paleo-Christian effect that results from covering all the walls entirely

with paintings.[243] The selected episodes indicate the parallels in the lives of the two proto-martyrs: Stephen, a Greek-speaking Jew ordained by Saint Peter, who upbraided the elders of Jerusalem for their ignorance of the scriptures; and Lawrence, one of the most venerated martyrs of Rome, who died shortly after his pope, Saint Sixtus, in 258. The stories of each saint include their consecrations as priests, their distribution of goods to the poor, and their courageous confessions of the faith, followed by martyrdom. The exemplary lives of these saints thus serve to demonstrate the historical continuity between the early churches of Jerusalem and Rome.

THE *STUDIOLO* OF NICHOLAS V, 1448–49

The private study of Nicholas V enjoyed only a brief existence quite out of proportion to the funds and planning that were lavished upon it. It was located in close proximity to the chapel, but all traces of it were lost when it was destroyed a half-century later for the renovations carried out under Julius II. Vasari knew nothing of this *studiolo*, and many modern scholars have mistakenly identified it with the Chapel of Nicholas V itself.

Fra Angelico's contributions are documented only in the papal accounts for 1449, which record that "Fra Giovanni da Firenze" was paid 182 ducati for his paintings in it. Several other payments regarding the construction of the studio have come to light.[244] In 1450 purchases were made of 2,100 leaves of beaten gold to gild cornices in the room, 2,000 leaves for capitals, and another 2,000 for unspecified uses. In March 1451 two windows with painted glass were installed.

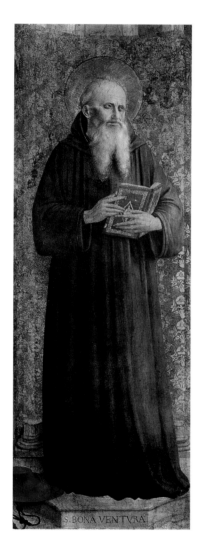

One has a tantalizing fragmentary image of this studio, with its low windows and its square yards of gold leaf capitals and cornices. It evokes a series of studioli of notable owners, Federigo da Montefeltro, Isabella d'Este, Francesco de' Medici, which all seem to have been tiny spaces of great richness deep inside vast palaces. This little known lost room of Nicholas V might have been the first. After the last reference to it in 1454, it seems to have been lost to view; its privacy evidently kept it from being alluded to, and presumably no more expenditures were made.[245]

These evocative thoughts of Creighton Gilbert take us as far as the meager evidence will allow. We cannot speculate as to the philosophical program that the grecophile Nicholas V might have chosen to adorn his intellectual sanctuary, but this hidden chamber with its carved and gilt furnishings and gallery of luminous faces by Fra Angelico seems to have been a secret that no subsequent pope wished to divulge.

The architectural exigencies of the cinquecento are always cited as having required the destruction of this *studiolo*, as well as Angelico's other frescoes in the Cappella del Sacramento and in Saint Peter's. That subsequent popes preserved only one—the Chapel of Nicholas V—of the four fresco cycles executed by Fra Angelico for Eugenius IV and Nicholas V leads one to suspect that the decorations commissioned at this singular moment in church history were not deemed relevant by all of their successors on the throne of Saint Peter. Certainly our understanding of Fra Angelico's career would be significantly different

Saint Bonaventure from the
Chapel of Nicholas V
Vatican Palace, Vatican City
(catalog 106)

today had these frescoes survived. The last years of his activity have often been unjustly considered a decline in his achievement, whereas the sad fact is that most of his Roman works from the intensive years of 1445 to 1449 are lost.

PRIOR OF SAN DOMENICO,
FIESOLE, 1450–52

Following the return of the papacy to Rome in 1443, both Eugenius IV and Nicholas V set to work repairing roads, bridges, and public edifices. Fra Angelico was but one of the illustrious painters called to Rome in this decade in anticipation of the jubilee year 1450. His name does not appear, however, among the surviving records of the many special decorations and ephemera that were erected during the year for the benefit of the thousands of pilgrims who flocked to Rome.

By June 10, 1450, in fact, Fra Angelico was far away from the tumult of the Jubilee. On that date he presided over a meeting of the seven other friars at San Domenico, Fiesole, of which he was the newly elected prior.[246] His return to Fiesole may have been occasioned by the last illness of his brother, Fra Benedetto, who died in the first months of that year.[247] Benozzo Gozzoli did not accompany his master to Fiesole, but traveled on his own to Montefalco to undertake major fresco commissions in the churches of San Fortunato and San Francesco.

As prior, Fra Angelico met in February 1451 with Fra Giuliano Lapaccini, prior of San Marco, to settle the accounts owed for manuscripts made by the friars in Fiesole.[248] One of Angelico's first tasks upon his return from Rome had been to estimate the value of miniatures painted by Zanobi Strozzi in several choir books destined for San Marco.[249]

THE BOSCO AI FRATI ALTARPIECE, 1450

The two-year priorate at Fiesole was not spent in retirement. In this brief interval before his definitive return to Rome in 1453, Fra Angelico was continuously employed on more paintings for the Medici than he had time to complete. The prestigious commission for the Silver Treasury of the Church of Santissima Annunziata was reportedly confided to him in 1448 by Piero de' Medici, Cosimo's son. It is possible therefore that the desire of the Medici to enjoy the services of their favorite painter also lay behind Angelico's temporary return from Rome.[250]

As construction on the oratory in Santissima Annunziata continued into 1451, Fra Angelico probably addressed himself in the meantime to the altarpiece for the Franciscans at Bosco ai Frati in the Mugello, near the Medici family seat at Cafaggiolo. This convent designed by Michelozzo was another of Cosimo de' Medici's Observantist charities.[251] The inclusion of a portrait of Saint Bernardino of Siena in the predella provides a *terminus post quem* of 1450, the year of the saint's canonization by Nicholas V. The altarpiece may have been commissioned, however, in connection with the Observantist Franciscan General Chapter, which was held at this convent in 1449.[252]

In the Bosco ai Frati Altarpiece (catalog 63), Fra Angelico shared with his Florentine

patrons some of the lessons he had brought back from the school of Rome. The six saints and two angels who flank the Madonna and Child are arranged with a bilateral symmetry that recalls the San Marco Altarpiece. But the results obtained in this late work are far more static and are largely indifferent to Alberti's concern for variety and animation. There is an archaic flavor to the immobile faces and the passive gestures of the sacred personages, whose stiffness recalls early Christian mosaics in Rome. The affinities in the proportions and typologies of the figures with the Cappella Niccolina are indisputable, but paleo-Christian sources are here even more pronounced in their impression upon the composition as a whole.

The reversion to early Christian prototypes and the iconography of the Madonna of Humility, who sits upon a cushion and not a throne, are a conscious evocation of Franciscan simplicity. On the other hand, the emphasis afforded to archaeological details adapted from Roman monuments might have seemed incongruous in the friars' hermitage in the Mugello woods.[253]

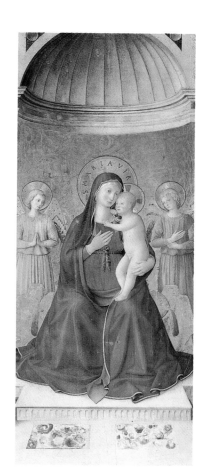

Bosco ai Frati Altarpiece
Museo di San Marco, Florence
(catalog 63)

THE *LEX AMORIS*
FOR THE SILVER TREASURY OF
SANTISSIMA ANNUNZIATA

On October 23, 1451, Fra Angelico paid two florins for paper to Vespasiano da Bisticci, the bookseller and biographer whom we have often cited in these pages.[254] As prior of the convent, Angelico would have had any number of reasons to acquire a considerable quantity of paper; as an artist, he would have needed paper at just this time in order to make the preparatory drawings for the most important work of his last years, the *Lex Amoris* panels that decorated the doors of the Silver Treasury in the oratory of Santissima Annunziata, Florence.

The commission from Piero de' Medici was one of extreme prestige: the miraculous image of the Annunciation in Santissima Annunziata had become one of the city's most favored shrines. No important visitor left Florence without praying before it; many worshipers donated precious objects of silver in grateful recognition of the Virgin's intercession. Fra Angelico was engaged to execute as many as forty small scenes of the Life of Christ (thirty-two by the master or his workshop are today preserved in the Museo San Marco) to decorate the outside of the *armadio*, or cabinet, where the most valuable ex-votos were kept safe. The original appearance of this silver treasury is not recorded, but it is known that this impressive structure was commissioned for a new oratory that Piero de' Medici had built adjacent to the chapel of Santissima Annunziata and near the room in the convent where he had provided a spiritual sanctuary for himself in emulation of his father's arrangements at San Marco.

The immediate inspiration for adorning an ecclesiastical furnishing with an extensive cycle of paintings would have come from the sacristy of Santa Croce. Around 1335, Taddeo Gaddi had executed twenty-eight panels representing the lives of Christ and of Saint Francis, which were inset into the upper part of a large credenza.[255] The paintings, now mainly preserved in the Accademia, constituted one of the principal repertories of Giottesque stories in Florence, and must have been a point of constant reference for Fra Angelico when he was designing the frescoes for the cells at San Marco.

The paired inscriptions of the *Lex Amoris,* or Law of Love (catalog 62; see pages 186-90) reconcile the Eastern prophetic roots of Christianity with the New Testament according to the teachings of Saint Thomas Aquinas. The Annunciate Virgin was implicitly evoked by this use of inscriptions because Aquinas had demonstrated that Mary constituted the theological "boundary" between the Old and New Testaments.[256] These paintings were complementary to the frescoes commissioned by Cosimo de' Medici for San Marco less than a decade before, in the sense that the *Lex Amoris* can be compared to an illustrated Bible for which the San Marco cycle provided the commentary. Both series culminate with the *Coronation of the Virgin* as a symbol of ecclesiastical and spiritual union.

The connection between the Silver Treasury and San Marco has never previously been observed, however, because these works are structured upon rhetorical criteria that are diametric opposites. The strictly linear narration of the life of Christ that unfolds in the *Lex Amoris* can best be understood as what Fra Angelico would have painted at San Marco had he taken the Spanish Chapel for his prototype. There can be no doubt but that the ultra-literal approach taken in the *Lex Amoris*—which comes complete with self-explanatory charts and graphs—was dictated by its destination in a public place. Fra Angelico deliberately conceived his paintings for the *Lex Amoris* as illustrations to the texts that are the true protagonists of this pedagogical program. The striking contrast between the Silver Treasury stories and the mystical and ineffable visions in the cells *in clausura* at San Marco is explainable, therefore, not as an Aristotelian criticism of a Platonizing program, but as a consistent application of the principle that the Christian mysteries are to be revealed to the faithful according to their capacity to understand.

THE LAST YEARS, 1453–55

Fra Angelico remained in Fiesole until at least April of 1453, when he declined a commission from the leading citizens of Prato to paint frescoes in the apse of their Duomo.[257] At the urging of Sant'Antonino, then archbishop of Florence, the aging friar had allowed the *provveditore* of the Duomo to escort him personally to Prato to view the site on March 30, 1453.[258] Presumably he feared that he had neither the time nor the energy to complete such an ambitious undertaking.

An inability to bring his assignments to completion is the unfortunate *leitmotiv* of the last years in Fiesole. Of the thirty-five extant scenes of the *Lex Amoris* for Santissima Annunziata, only the panel containing the first nine subjects is generally regarded as autograph. Apart from three scenes by Alessio Baldovinetti that were inserted in the series at a very early date, most of the project was executed by an anonymous, but gifted, pupil working from Angelico's designs. The large round panel representing the *Adoration of the Magi* (catalog 109) known today as the Cook Tondo for its distinguished nineteenth-century provenance, was also left unfinished. His patrons, the Medici, later entrusted this *Adoration of the Magi* to Filippo Lippi to complete. The distinction between the two artists' hands has recently been elucidated by Boskovits in an admirable study.[259]

Perhaps the industrious friar left these works in abeyance because he had received an urgent call from Rome. In point of fact, however, the circumstances of his return to Rome, where he died of natural causes in 1455, are unknown. Fra Angelico is last mentioned in life in a contract of December 1454, in which he was named as one of three

prominent painters who might be called upon to judge a decoration being executed in Perugia.[260] It has often been suggested that he was engaged on works for Cardinal Torquemada and the Dominicans of Santa Maria Sopra Minerva, because it was in that convent that he died on February 18, 1455, and was buried with great dignity in the chapel of Saint Thomas Aquinas in the church.[261]

His recumbent form was sculpted on the marble tomb slab accompanied by appropriate inscriptions. According to a chronicle compiled some years later by the Dominican Girolamo Borselli (d. 1497), the two epitaphs on this tomb were personally composed by Pope Nicholas V.[262] This attribution may not be reliable, because Nicholas V was already ill at the time and died a month later, on March 24. Stefano Orlandi has plausibly identified Fra Domenico di Giovanni da Corella as the probable author of the four commemorative Latin couplets inscribed on the wall above the tomb.[263]

> *Glory of painters, and mirror of virtue, Giovanni, Florentine, is laid in this place. He was a religious, a friar of the holy order of Saint Dominic and a humble servant of God. His pupils lament their loss of such a learned man: who could ever find another brush like this? The country and the order weep to have lost their master to whom there was no equal in the art of painting.*

"FRA GIOVANNI ANGELIC & GRACEFUL & DEVOUT"

The fame of Fra Angelico's accomplishments did not decline after his death. Quite the contrary. In his poem "Theotocon" of 1469, Fra Domenico da Corella, the possible author of the artist's epitaph, endowed the painter and his panels at Santissima Annunziata with extraordinary praise:[264]

> *where there are the silver reliquaries with various figures hidden behind the doors painted by the angelic painter named Giovanni, who was not inferior to Giotto and Cimabue whose fame was sung in the Tyrrhenian cities by Dante with sweet language. He flourished with his many virtues, temperate nature and sincere in his faith. To him it was rightly conceded to surpass other painters in representing the grace of the Annunciate Virgin, so often depicted by the hand of Giovanni.*

While Fra Domenico da Corella clearly identified the artist's name as Giovanni, it was the poetic trope "angelicus pictor" (angelic painter) that rightly struck his readers' imaginations. Coming from the pen of another Dominican, the description of a friar as an *angelicus pictor* must have been intended to invoke an association with the "doctor angelicus" of the same order, Saint Thomas Aquinas.[265] That great theologian was honored with the supreme laud of "angelicus" in recognition of his wisdom and insight into the divine mysteries. It is most significant, moreover, that Angelico's epitaph in Santa Maria Sopra Minerva eulogizes him as "tanto doctore" (such a learned man).

In Florence, Marsilio Ficino formulated the term *mens angelica* (angelic mind) as a Christian counterpart to the philosophical concept of *nous*, or divine wisdom.[266] It is in this

context that we must view the ascription of the quality *angelico* to our painter by Cristoforo Landino, one of the Neoplatonists, in his very influential comments on art published in 1481: "[Fu] Fra giovanni angelico & vezoso & divoto & ornato molto con grandissima facilità" (Fra Giovanni [was] angelic & graceful & devout & painted much with great skill).[267]

The telegraphic syntax of Landino's sentence seems to have persuaded Vasari, among other later readers, that Fra Giovanni Angelico was the usual appellation for this artist. A careful reading of Landino's text demonstrates that it was the author's intention to use "angelico" as an adjective and not as a name, but Vasari's *Lives* established a precedent that has become universally accepted.[268]

The epithet "angelico" is unquestionably appropriate. Fra Angelico served his religious order with exemplary obedience and humility; his life has justly been celebrated by his church as a model of Christian vocation. The touching piety of this artist's creations has endeared them to countless people who have no other knowledge of Italian art. And the sincerity of his devotion to a vision of a celestial paradise has recommended his paintings even to those who know nothing of his faith.

PLATES

THE SAN DOMENICO ALTARPIECE

The Virgin sits enthroned with the Christ child upon her lap; they are encircled by a host of adoring angels. She delicately offers the child two roses, red and white. The Virgin is sometimes called the "rose without thorns," and the white rose symbolizes her purity.[1] The dark tint of the red rose is associated with the blood spilled in the Passion of Christ, for which reason it also has eucharistic connotations appropriate for an altarpiece.

A pair of saints, their faces drawn and solemn, attends the Virgin and Child on either side. Their downward-pointing toes are a vestige of gothic style that betrays the early date of this work, circa 1420. The black and white habits worn by Saint Thomas Aquinas, at far left, and by Saints Dominic and Peter Martyr, at right, underscore the Dominican patronage of this altarpiece, executed for the high altar of Fra Angelico's own convent in Fiesole. At far left, Saint Thomas Aquinas, the "Angelic Doctor" of the Dominican order, holds attributes of a quill and a book inscribed with the Latin words of Psalm 104, verse 13: *He waterest the hills from his upper chambers: / the earth shall be filled with the fruit of thy works.* This text, an Old Testament foreshadowing of the Incarnation, was the subject of Saint Thomas's inaugural lecture when he became Master of Theology at Paris in April 1256.[2]

The golden-robed apostle at Aquinas's side holds only a book but must be Saint Barnabas, the name saint of Barnaba degli Agli, whose testament of 1418 provided six thousand florins for the completion of the church and the construction of the convent with cells for twenty friars.[3] Barnabas was a Cypriot Jew who accompanied Paul in missionary voyages to Antioch and Cyprus. Fra Angelico's portrayal of this rarely represented saint is curiously reminiscent of the traditional appearance of the apostle Peter. Perhaps the artist's repertory of faces and types was limited at this early date: the small panel of Saint Mark now in Chantilly, but originally in one of the pilasters of this altarpiece, is basically this same Saint Barnabas in miniature.

Fra Angelico would have difficulty recognizing the San Domenico Altarpiece in its present condition. Around 1501 the work was radically "modernized" by Lorenzo di Credi, who suppressed the gothic pinnacles that were so unsightly to Renaissance eyes and removed the pointed arches that separated the saints from the Virgin. Credi filled in the spaces between the saints and angels and above their heads with classical architecture and some glimpses of arcadian landscape. Fra Angelico's figures of seventy years earlier seem fragile and weightless in comparison, but it is a testimony to their forward-looking qualities that these transformations could be accomplished at all.

By 1420 Fra Angelico was already an impressive proponent of a Florentine late gothic style of painting that was noticeably more sober and less ornate than its International Gothic counterpart. Although Lorenzo Monaco is often cited as an influence on this early phase in Angelico's development, his sources are instead to be traced to Gherardo Starnina, the Florentine *caposcuola* until his untimely death around 1412, and to Masolino, his near-contemporary. Despite its alterations, the San Domenico Altarpiece tells us about the most advanced painting in Florence during these largely uncharted years.[4]

Vasari reserved particular praise for the predella of this altarpiece (now in London), wherein Fra Angelico exhibited his ability to portray the serene expressions of the beatified: "But the predella and the ciborium are better preserved. An infinitude of little figures are seen in heavenly glory; they are so beautiful that they truly appear to be in paradise. And no one who goes up close can ever have his fill of looking at them."

Central panel of the
San Domenico Altarpiece
Tempera and gold on panel,
83½ × 93¼ in. (212 × 237 cm)
Church of San Domenico, Fiesole
(see catalog 15A)

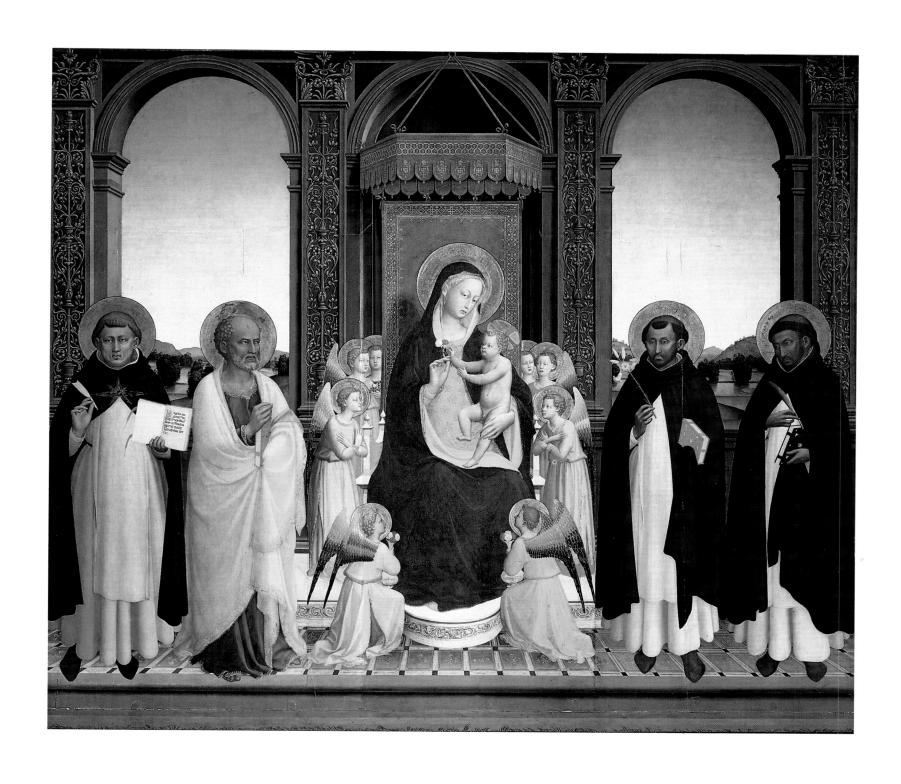

THE SAN PIETRO MARTIRE ALTARPIECE

The youthful Virgin sits upon a throne that is entirely covered with a patterned cloth of honor. The child stands upright on her leg and makes a sign of benediction. The golden orb in his left hand symbolizes his dominion over the world. In her right hand, the Virgin holds a round jar or box of ointment, an attribute of the Magdalen, who on the day of the Resurrection brought "sweet spices" to the tomb of Christ in order to anoint his body (Mark 16:1). Its presence is thus a poignant reminder of Christ's Passion and death. The Dominican Observantist nuns for whom this altarpiece was made around 1425 must have had a particular devotion to Mary Magdalene, who was represented directly below in the original predella (now in the Courtauld Institute, London) in a position usually reserved for the Virgin.[5]

The Virgin and Child are flanked by two pairs of saints, including the three principal Dominicans: Saint Dominic, left, and, on the right side, Saints Peter Martyr and Thomas Aquinas, who holds the Bible open to Psalm 104:13. John the Baptist occupies a prominent position as the patron saint of Florence. These saints are markedly smaller than the seated Virgin, as Vasari (1568) was the first to note: "con figure piccole assai."[6] As the titular saint of this Florentine convent, Saint Peter Martyr enjoys a privileged proximity to the Christ child.

In the spaces between the pinnacles of the triptych Fra Angelico painted two scenes from the life of Saint Peter Martyr. A fiery preacher, Peter of Verona made several visits to Florence, contributing greatly to the importance of the Dominican convent of Santa Maria Novella. He was also a relentless inquisitor, for which he paid the supreme price of assassination by heretics in the mountains between Como and Milan. The fatally wounded saint used the blood from his gashed head to write on the ground his last words, "*io credo. . . .*" He was canonized in the following year, 1253. The appalling drama of the saint's martyrdom is depicted with remarkable spontaneity and effect. The artist repeated this invention in his most important surviving manuscript illuminations, the San Marco Missal (no. 558), still in the museum at San Marco.

The convent of Saint Peter Martyr was founded in 1418 by Leonardo Dati, who was the master general of the Dominicans, as the first Observantist nunnery in Florence. This altarpiece was in place above the high altar by 1429, but its execution is generally dated to around 1425-26 in recognition of its direct dependence upon the *Sant'Anna Metterza Altarpiece* (Uffizi, Florence), an early collaboration of Masaccio and Masolino of 1424-25.[7] Under the influence of Masaccio, Fra Angelico has looked backward a full century for inspiration in the monumental art of Giotto. The composition is dominated by the massive and pyramidal figure of the Virgin. Unlike Masaccio, however, Fra Angelico has not relied upon classical statuary for the pose of his conservatively dressed child.

The four saints in the side wings of the triptych are posed stiffly in a row, as in the San Domenico Altarpiece, but they demonstrate notable progress in other respects. The features of Saint Dominic, for example, are sufficiently personalized to be considered a portrait. The polychrome stone on which they stand is skillfully shaded in order to suggest a floor that recedes into space.

Detail of the Martyrdom of Saint Peter from the San Pietro Martire Altarpiece
Tempera and gold on panel,
54 × 66⅛ in. (137 × 168 cm)
Museo di San Marco, Florence
(see catalog 73)

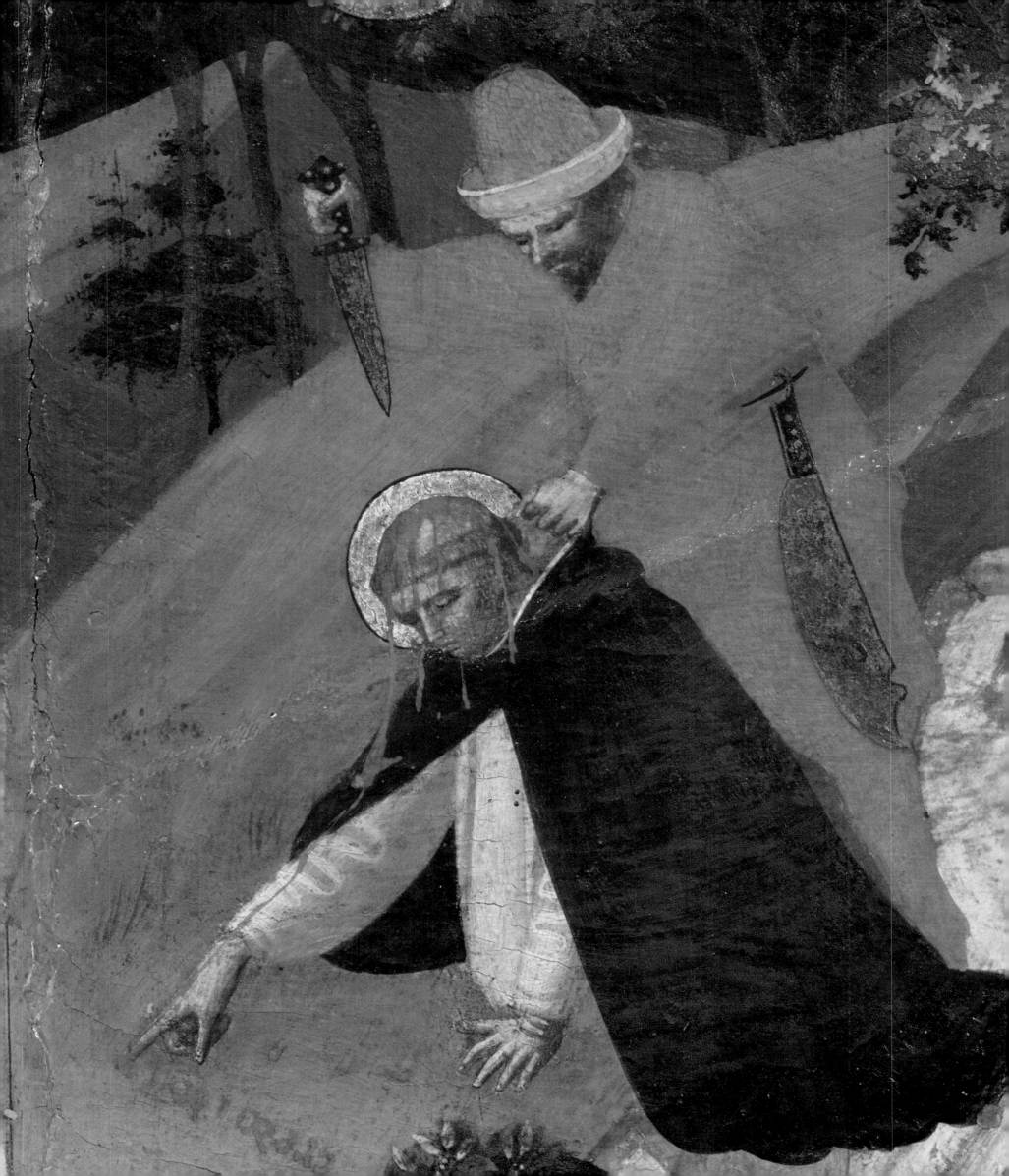

San Pietro Martire Altarpiece
Museo di San Marco, Florence
(see catalog 73)

E·SANCTVS·PETRVS·MA·TIR· S·ANCTVS·THOMAS·SDCCIO

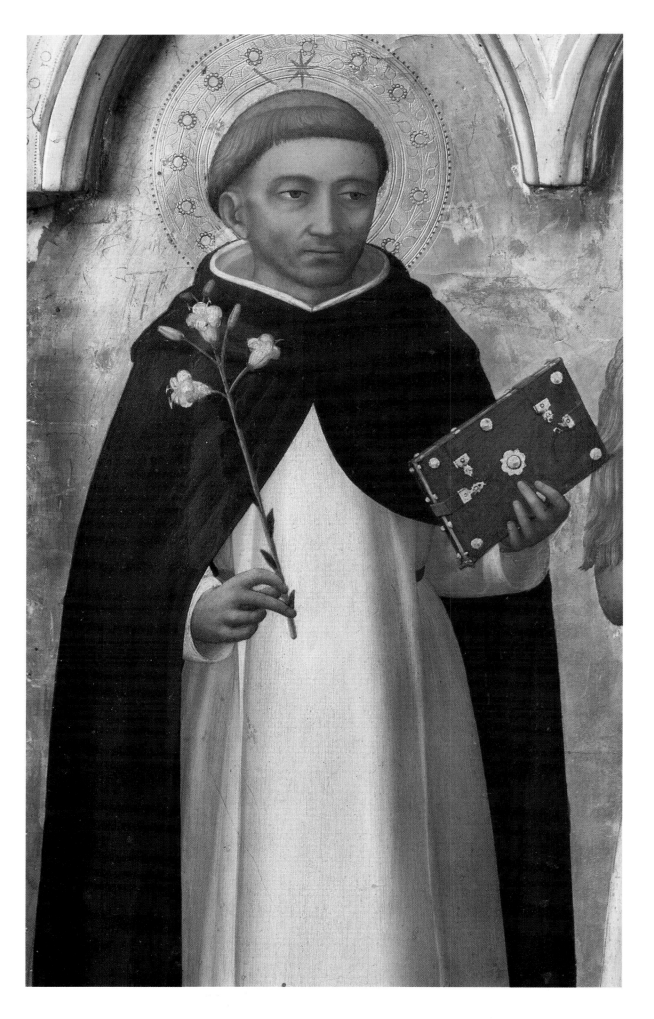

Detail of Saint Dominic
from the San Pietro Martire
Altarpiece
Museo di San Marco, Florence
(see catalog 73)

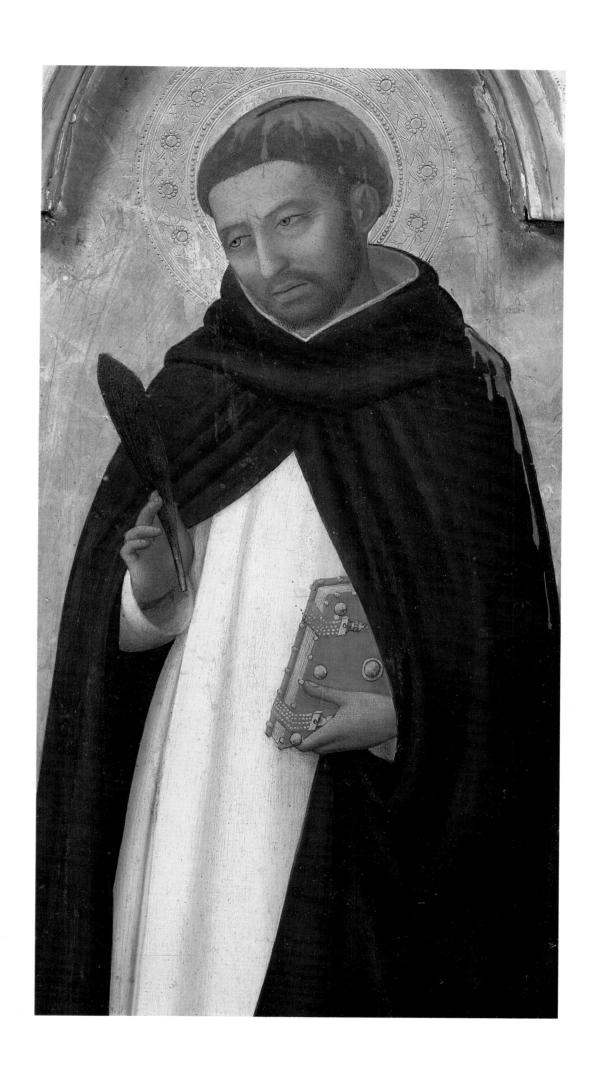

Detail of Saint Peter Martyr
from the San Pietro Martire
Altarpiece
Museo di San Marco, Florence
(see catalog 73)

THE *ANNUNCIATION*
AND THE *ADORATION OF THE MAGI*

The central panel of this carved and gilt tabernacle is divided into separate representations of the Annunciation to the Virgin and the Adoration of the Magi. In the upper register, in accordance with the Gospel of Saint Luke (1:26-38), the angel Gabriel is shown kneeling before Mary, to whom he has announced, "Behold, you will conceive in your womb, and bring forth a son, and you shall call his name Jesus." Mary, whose womb is already visibly full, replied, "*Ecce ancilla Domini, fiat mihi secundum verbum tuum.*" ("Behold the handmaid of the Lord; let it be with me according to your word.")

In the nineteenth century, this diminutive panel exemplified the art of Fra Angelico. John Ruskin published his own pencil sketch of it, entitled *Ancilla Domini*, as the frontispiece to the fifth volume of his *Modern Painters*: "No subject has been more frequently or exquisitely treated by the religious painters than that of the Annunciation, though as usual, the most perfect type of its pure ideal has been given by Angelico, and by him with the most radiant consummation (so far as I know) in a small reliquary in the sacristy of Sta. Maria Novella."[8]

A century later, Georges Didi-Huberman has extolled the radiance of this *Annunciation* in the very different vocabulary of semiotics: "we are tempted to recognize in the image only a luminous saturation pushed to the limit, as if the whole story had been told to us—and in the most laconic way possible—only to manifest visually the brilliance of divine grace. The background of gold, everywhere damascened by wisps of red, evokes the divine mantle of light celebrated in the Psalms.[9] The place itself seems to be made entirely of a multitude of haloes, to the point that the haloed dove is hardly discernible in the image."[10]

The lower register of the tabernacle is devoted to the Adoration of the Magi as described by Saint Matthew (2:1-12). After following the star in the East (depicted by Angelico directly above the heads of Joseph and the Christ child), the three wise men found the child with his mother in Bethlehem and fell down and worshiped him. The Virgin is shown seated, holding the child on her lap. On her head is the star that also appears in the *Madonna della stella*. One of the Magi has removed his crown as he kneels before them. The two other wise men (sometimes called "kings") approach. At right, their retainers are occupied with their horses and converse together confusedly—they do not yet understand the Epiphany.

The two distinct events represented in this tabernacle, separated by nine months, are unified by the theme of the Incarnation. For this reason, Fra Angelico minimized the horizontal division between the upper and lower registers and created a pervasive visual harmony between them. Although two scenes are represented, Fra Angelico has made but a single painting. The celestial hierarchy is carefully illustrated: Christ is shown in heaven in the pinnacle of the arch; his spirit descends and enters Mary, the Queen of the Angels. In Bethlehem, the Virgin holds the incarnate Christ, who is worshiped by the princes of this earth.

This tabernacle is one of the four reliquaries painted for Santa Maria Novella on commission from the Dominican friar Giovanni Masi, who died in 1434. The reliquaries are each decorated with different stories of the Virgin, to whom the Dominicans were particularly devoted. The *Annunciation* and *Adoration of the Magi* would come first in a chronological sequence of these stories, and several scholars, beginning with Langton Douglas,[11] have suspected that the present panel was the first of the series to be executed, probably during the 1420s.[12]

Detail of the
ADORATION OF THE MAGI
from the *ANNUNCIATION* and
the *ADORATION OF THE MAGI*
Tempera and gold on panel,
33⅛ × 19¾ in. (84 × 50 cm)
Museo di San Marco, Florence
(see catalog 75B)

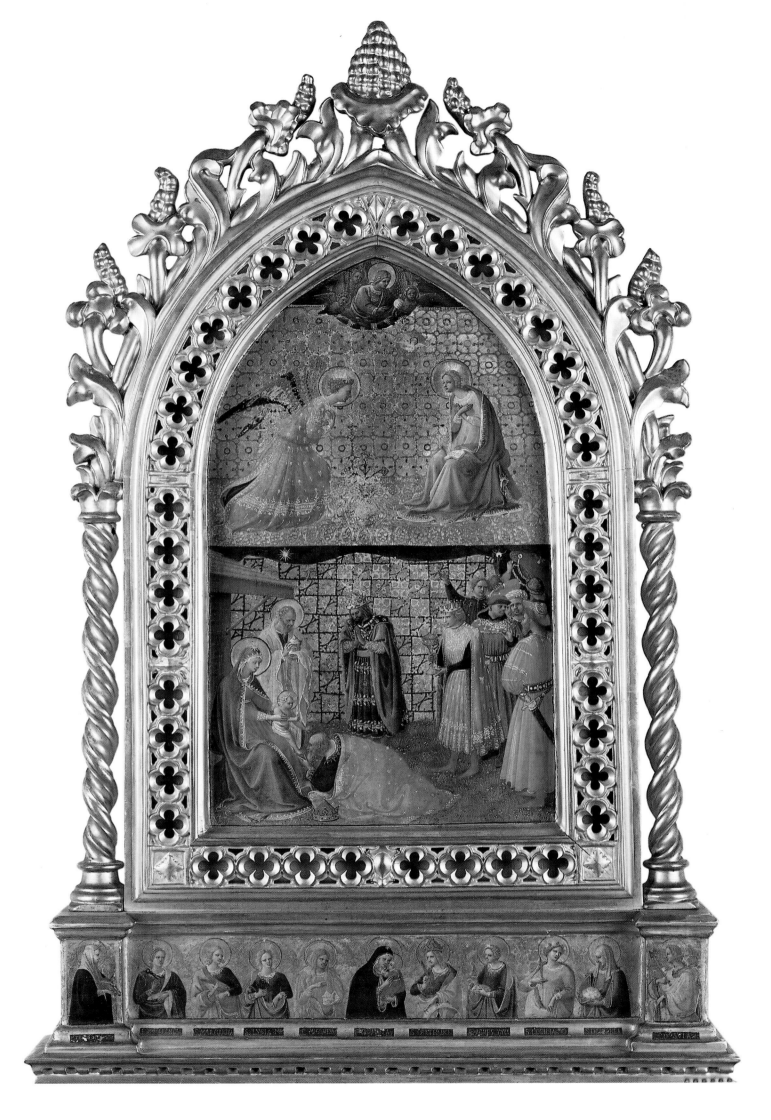

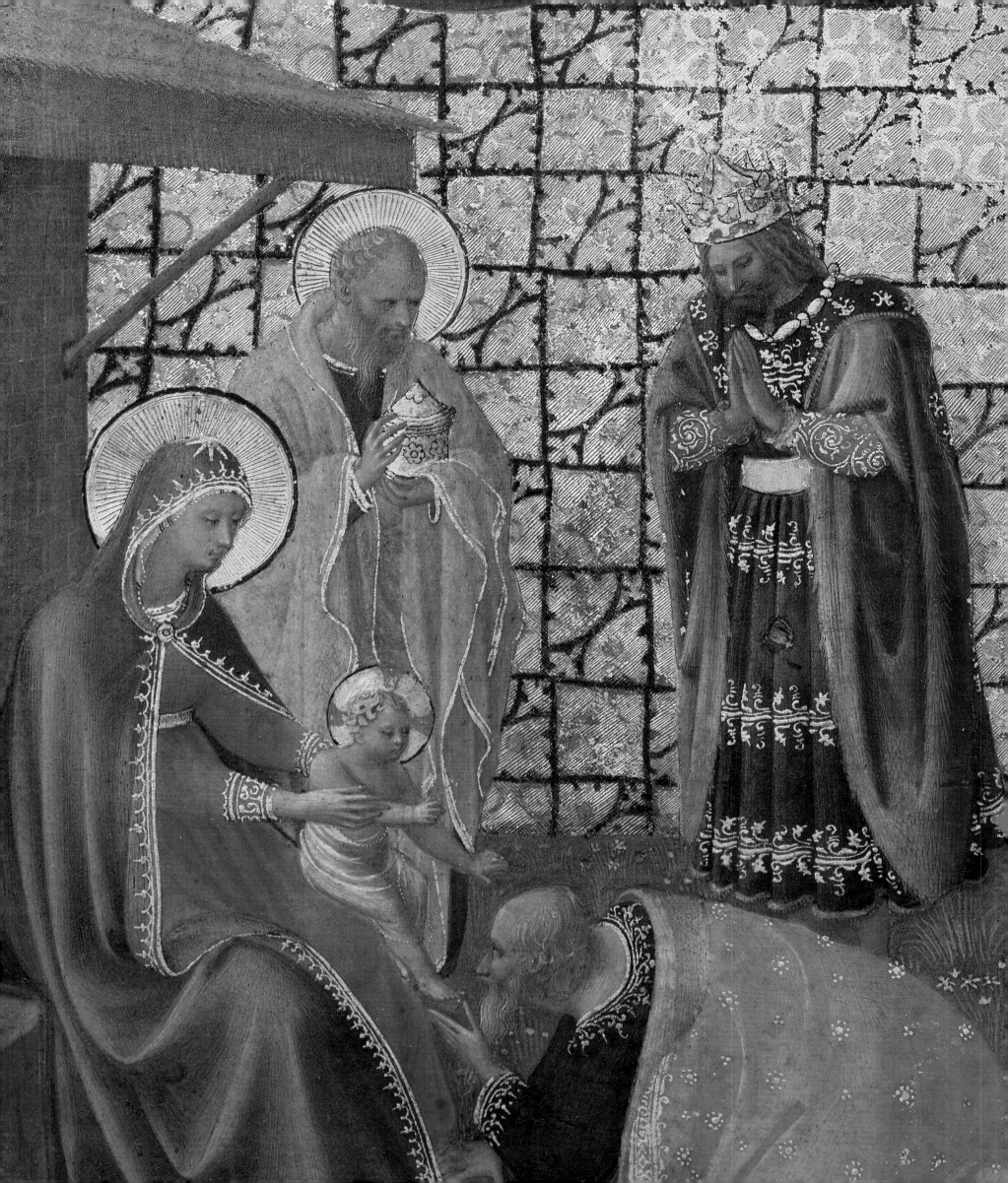

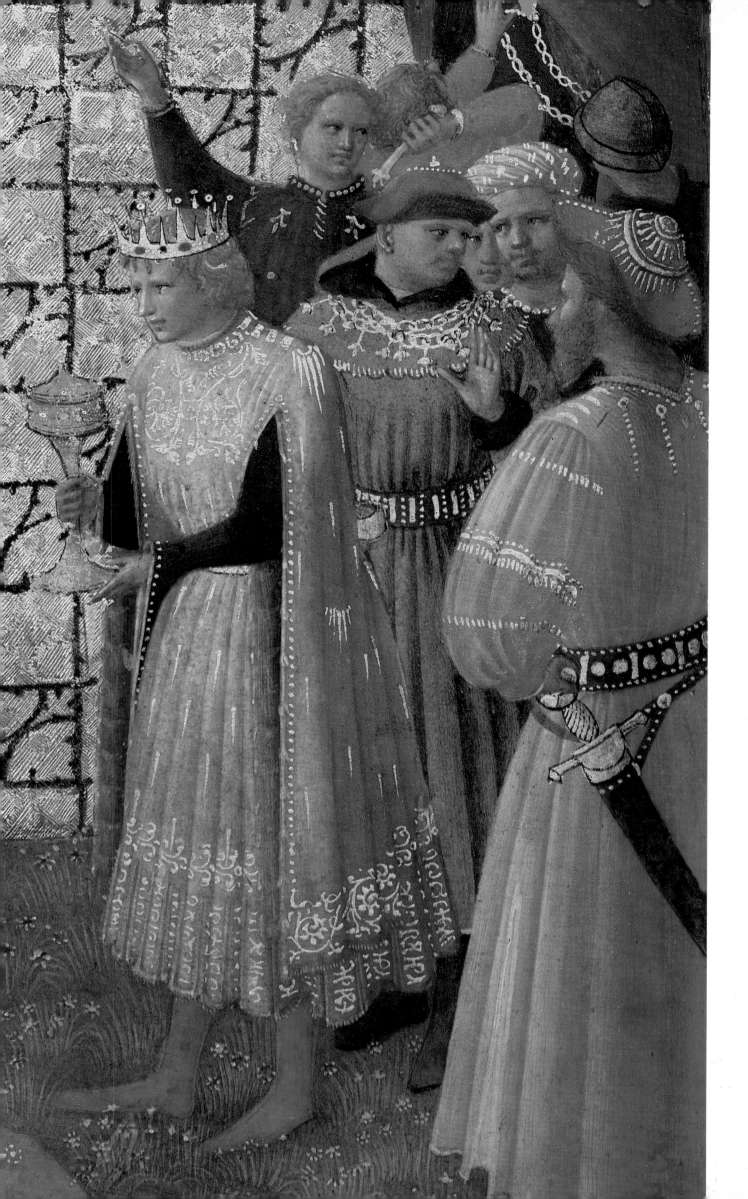

Detail of the *ADORATION OF
THE MAGI* from the
ANNUNCIATION and the
ADORATION OF THE MAGI
Museo di San Marco, Florence
(see catalog 75B)

MADONNA DELLA STELLA

The Virgin and Child are enclosed within a splendidly gilt tabernacle like a statuette in a niche.[13] The standing Virgin wears a dark blue cloak lined with gold over a dark red dress. With her left arm she holds the child, who is dressed in a long red tunic. He presses his face to hers; this tender gesture of intimacy is based upon a Byzantine prototype known as *Glykaphilousa* or *Elousa*, meaning "affectionate, loving."[14]

At the top of the panel, Christ is shown half-length inside a mandorla comprised of blue cherubim. The crown that descends from his hands identifies the Virgin as *Regina Coeli*, the Queen of Heaven.[15] She is adored on all sides by pairs of angels, whose robes are colored in accordance with their ranks in the celestial hierarchy. The two angels nearest Christ are seraphim, whose red robes are symbolic of Divine Wisdom.[16] The representation of Christ in heaven and, embraced by the Mother of God, on earth invites us to contemplate simultaneously, and in an order corresponding to the structure of the cosmos, God apart from the Incarnation (above) and God made man for our universal salvation (below).[17]

The *Madonna della stella* takes its traditional title from the golden star adorning her head, a motif that can be traced back to early Christian art. André Grabar has discussed its representation on a sixth-century ampulla bearing an image of the Virgin: "The star is a symbol that Grace has descended on Mary; in pagan and Imperial iconography, it symbolized the astral existence of the persons above whom it was placed."[18]

In Christian art, a single star evokes the star of Bethlehem that guided the wise men to the Nativity.[19] The twelve stars that enclose the Virgin in this tabernacle are a reference to the twelve stars in the crown of the "woman clothed in the sun" cited in Revelations 12:1.[20]

The three principal Dominican saints are represented in lozenges in the base of the reliquary: Peter Martyr, Dominic, Thomas Aquinas. One of the attributes of Saint Dominic (center) is the star, said to have appeared on his forehead on the day he was baptized.[21] Saint Thomas Aquinas, the "most saintly of the learned and the most learned of the saints," is identified by his attribute of a sun on his breast.[22]

The *Madonna della stella* is the most celebrated of the four reliquary tabernacles that Fra Angelico painted for Santa Maria Novella on commission from Fra Giovanni Masi (d. 1434). These carved and gilt panels served to display sacred relics on the altar on feast days. The *Madonna della stella* is one of the three such reliquaries that remained in the sacristy of Santa Maria Novella until 1868, when it was transferred to the Museo di San Marco. The fourth reliquary is generally assumed to be the *Dormition of the Virgin* in the Gardner Museum, Boston.

A precise dating for the *Madonna della stella* remains to be established. The patron, Fra Giovanni Masi, was sacristan of Santa Maria Novella in 1424, but he was influential in the convent from at least 1418.[23] The four panels evince stylistic divergences that would seem to indicate that they were executed over a span of years. The *Madonna della stella* seems to fall into the second half of the 1420s, but the conservative characteristics of these reliquaries make them particularly difficult to date.

MADONNA DELLA STELLA
Tempera and gold on panel,
33⅛ × 20⅛ in. (84 × 51 cm)
Museo di San Marco, Florence
(see catalog 75A)

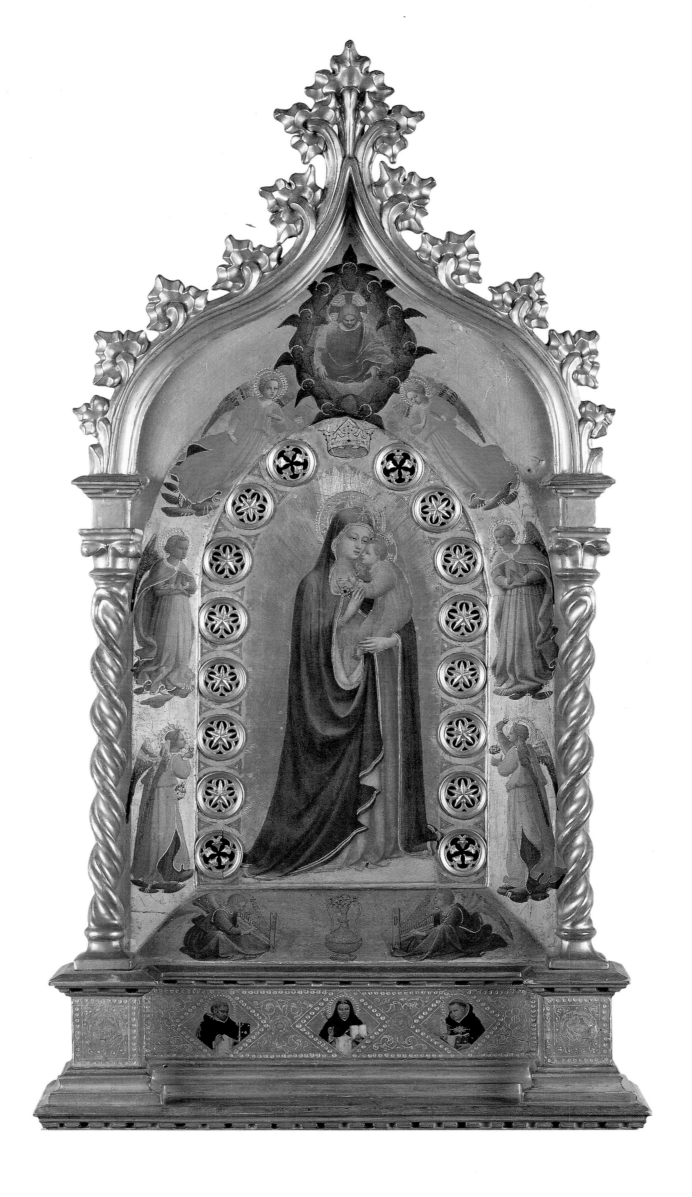

LAST JUDGMENT

The Gospel of Saint Matthew (25:31-46) contains the fullest description of the Last Judgment:

When the Son of man comes in his glory, and all the angels with him, then he shall sit upon the throne of his glory: And before him shall be gathered all the nations, and he shall separate them one from another, as a shepherd divideth his sheep from the goats. . . . Then shall he say unto them on the left hand, Depart from me, ye cursed, into everlasting fire, prepared for the devil and his angels. . . . And these shall go away into everlasting punishment: but the righteous into life eternal.

Saint John writes in his Gospel (5:28-29), "the hour is coming in which all that are in the graves shall hear his voice, and shall come forth; they that have done good, unto the resurrection of life; and they that have done evil, unto the resurrection of damnation."

In Fra Angelico's interpretation of this mighty theme, Christ the Judge appears in glory surrounded by angels in a celestial circle that dominates the painting from its apex. With his upraised right hand, Christ beckons the resurrected faithful toward the gates of the heavenly Jerusalem. His left hand points downward, consigning the sinners to the stony mouth of hell. The Virgin and Saint John the Baptist are represented as intercessors who occupy places of exceptional proximity to the Son. The heavenly host is completed by twenty-four prophets and saints who are seated in a tribunal, twelve on each side.[24]

On the earth below, two rows of openings mark the tombs whence the dead were awakened by the trumpeting of angels. The empty sarcophagus in the foreground must be the grave from which Christ himself arose. This strange cold road of death divides the damned from the saved. At right, a swarm of hideous devils push the sinners into a Dantesque inferno.[25] On the other side, lissome angels greet the awakened good with embraces and join hands in a stately dance. At far left, their souls ascend to the radiant city of God.[26]

The *Last Judgment* was painted by Fra Angelico for the Camaldolese convent of Santa Maria degli Angeli from 1425 to 1430.[27] The painting was considered a masterpiece by his contemporaries: no fewer than five sources before Vasari singled it out for praise. Since the nineteenth century, however, many writers have doubted that the crude and brutal scenes of the *Inferno* could have issued from the good friar's brush. We now recognize that Fra Angelico adapted his technique to heighten the disparity between the sacred and the profane. This observation was already made by Ruskin:

In order to effect clearer distinction between heavenly beings and those of this world, Angelico represents the former as clothed in draperies of the purest color, crowned with glories of burnished gold, and entirely shadowless. With exquisite choice of gesture, and disposition of folds of drapery, this mode of treatment gives perhaps the best idea of spiritual beings which the human mind is capable of forming.[28]

Indeed, Fra Angelico's painting of the *Last Judgment* is most extraordinary, and memorable, for its elaborate, vivid, and affecting portrayal of paradise. While numerous precedents can be cited for his inferno, no artist before him had described the process by which the souls of the good ascended to God. Nor can any biblical texts be cited as the source for his

Detail of the Damned from
the *LAST JUDGMENT*
Tempera and gold on panel,
41⅜ × 82⅝ in. (105 × 210 cm)
Museo di San Marco, Florence
(see catalog 67)

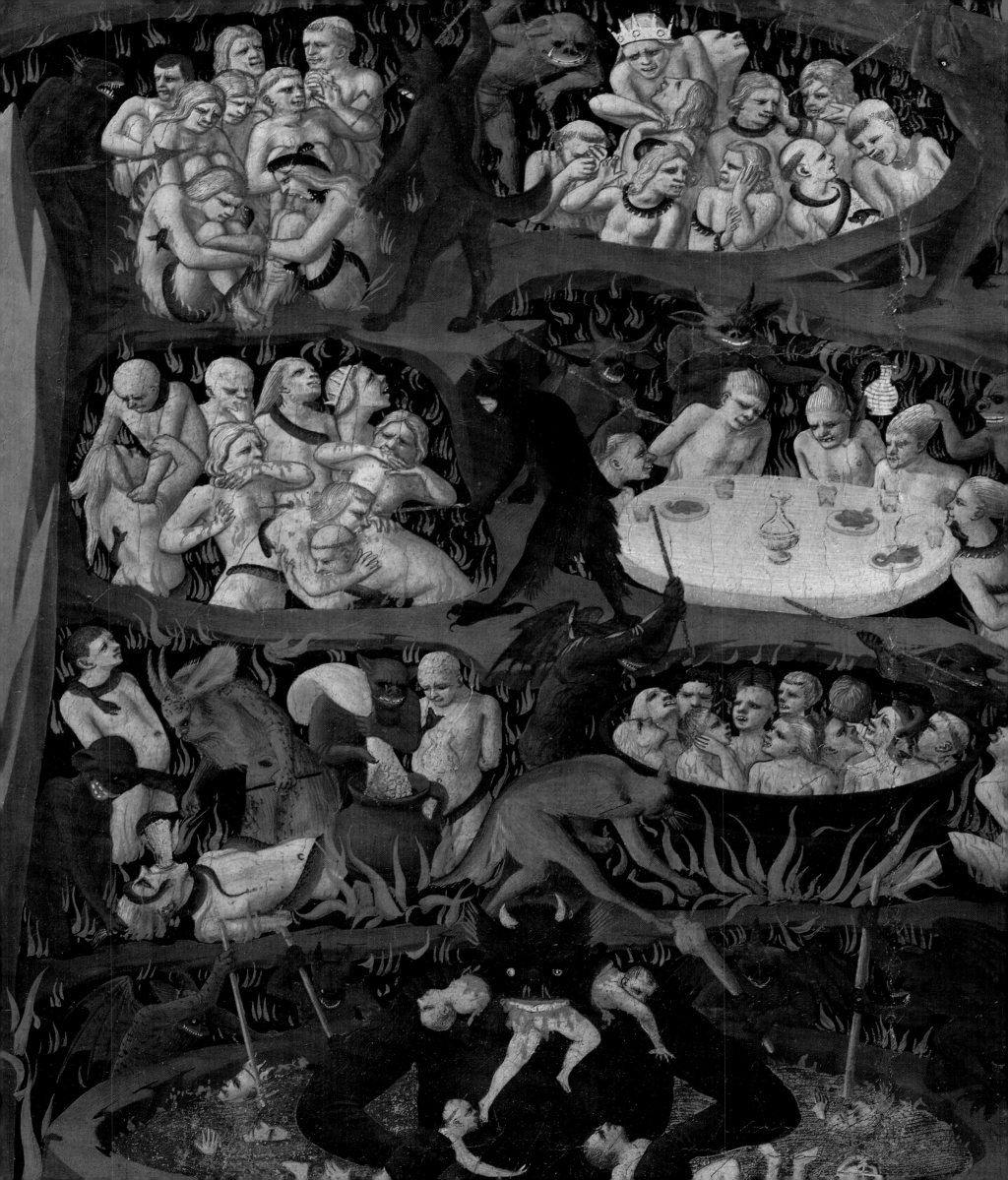

interpretation of this theme. In all likelihood, the innovative iconography of this painting was suggested to the artist by Ambrogio Traversari, the priest whose cell at Santa Maria degli Angeli was a meeting place for Florentine humanists.

Traversari's devoted study of the early fathers of the church is doubtless reflected in the representation of Adam, Abraham, Moses, Abel, Aaron, and so many other Old Testament personages in the tribunal alongside Christ. Christian tradition venerated the patriarchs of course but generally illustrated them (as at Santa Maria Novella) as awaiting the Second Coming from the depths of limbo.

Furthermore, Traversari was perhaps the only Florentine ecclesiastic of the 1420s who would have felt comfortable with a painting that described paradise in terms borrowed directly from the *Republic* of Plato. In Part XI, which is dedicated to the immortality of the soul and the rewards of goodness, Plato recounts the myth of Er. A brave man named Er was killed in battle, but on the twelfth day, he came to life again and told what he had seen in the other world. He said that his soul had traveled to a wonderfully strange place, where there were, close to each other, two gaping chasms in the earth, and opposite and above them two other chasms in the sky. Between the chasms sat judges, who having delivered judgment, ordered the just to take the right-hand road that led up through the sky, while they ordered the unjust to take the left-hand road that led downward. Er then saw the souls, when judgment had been passed on them, departing, some by one of the heavenly and some by one of the earthly chasms. And the throng of souls arriving from heaven seemed to have come from a long journey. They turned aside into the meadow and encamped there as for a festival, gladly exchanging greetings. After seven days spent in the meadow the souls set out again on the eighth and came in four days to a place from which they could see a shaft of light stretching from above straight across earth and heaven, like a pillar. Er goes on to describe a cosmos composed of eight revolving spheres; on each of the circular edges, he saw a siren singing a single note of constant pitch. Their eight notes comprised the musical scale.[29]

In Fra Angelico's paradise, as in the afterworld glimpsed by Er, the souls of the beatified joyfully embrace. Together with angels, they dance serenely in a ring to the accompaniment of the music of the spheres.[30] The artist could not have depicted in a more vivid or pleasing way an ancient concept that originated with the Greeks: music and the human soul are both aspects of the eternal.[31]

The Pythagorean theory that the sound of the circular movement of the celestial spheres creates a sublime harmony was commented on and propagated by countless thinkers after Plato, especially Marcus Tullius Cicero, Saint Augustine (*De musica*), and Boethius, the fifth-century author of the most widely read treatise on music in the Middle Ages. The discovery by Pythagoras that musical intervals are determined by arithmetic ratio had special significance for early Christians, since *logos*, the Greek word for ratio, is identified with God in the first verse of the Gospel of Saint John ("In the beginning was the Word . . .").

The use of Pythagorean metaphors by the early church fathers justified their study by Traversari and the other humanists. For example, Clement of Alexandria (c. A.D. 150-126), made ample use of musical and mathematical knowledge in his *Exhortation to the Greeks*, a treatise in which Christ is called the New Song:

> *See how mighty is the New Song! They who were otherwise dead, who had no share*
> *in the real and true life, revived when they but heard the song. This pure song, the*

binding of the universe and the harmony of all things, stretching from the center to the
circumference and from the extremities to the center, reduced this whole to harmony
. . . in accordance with the fatherly purpose of God, which David earnestly sought.[32]

Renaissance thinkers like Filippo Brunelleschi, architect of the cupola of the cathedral, were challenged and excited by the Pythagorean belief that mathematics and numerology contained the keys to the hidden structure of the universe. We can be sure that the geometrical precision of the two rows of opened tombs in this *Last Judgment* reflects a numerical symbolism that remains to be interpreted, especially because Fra Angelico never repeated this motif in any of his later treatments of this theme. The two rows of tombs are similar, but not identical: ten openings are represented on the side of the good souls as opposed to nine on the part of the damned. The receding edges of the stone necropolis, when connected, create a pyramidal form that recalls the lambda diagram used to explain the Pythagorean theorem of the opposition between even and odd numbers. The left side of the lambda, toward the beatified, is composed of the even numbers, which symbolize the unlimited. And ten is a perfect Pythagorean number. On the right side are the odd numbers, representing the limited. The total of nine tombs on the side of the damned is probably related to Cicero's famous reading of the *Republic*, wherein the earth is identified as the ninth sphere of the cosmos, where all is transitory, nothing lasts.[33]

As the most difficult and unusual commission that Angelico had received thereto, the successful realization of the *Last Judgment* can be counted among the milestones of his career. Its composition, not to mention its wealth of philosophical and patristic sources, doubtlessly influenced Raphael's Neoplatonic conception of the *Disputa del Sacramento*, 1509, in the Stanza della Segnatura in the Vatican.

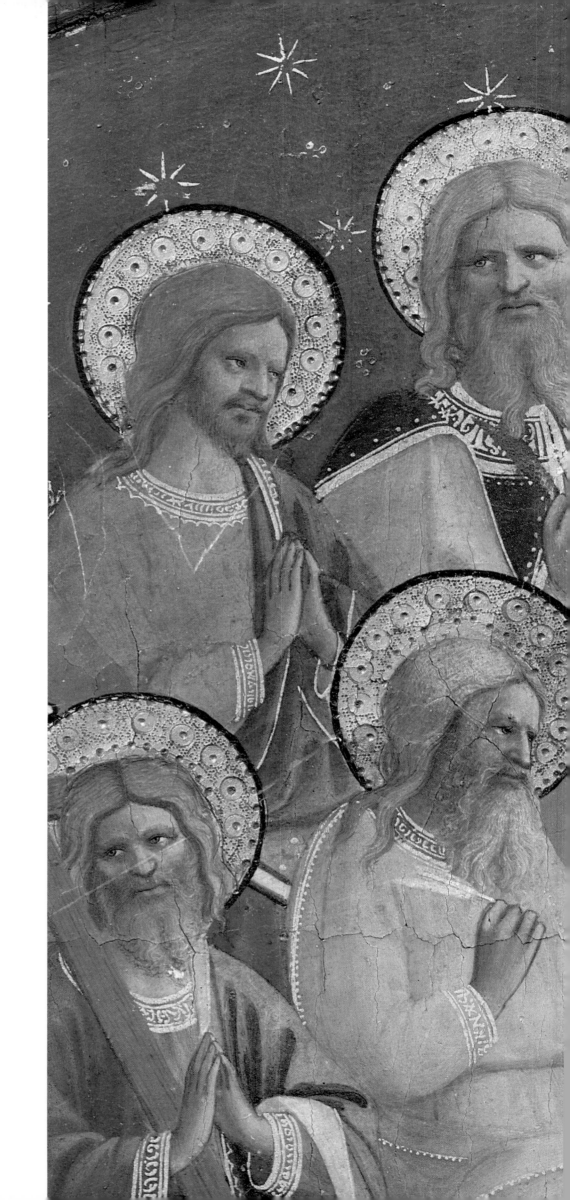

Detail of Prophets from
the *LAST JUDGMENT*
Museo di San Marco, Florence
(see catalog 67)

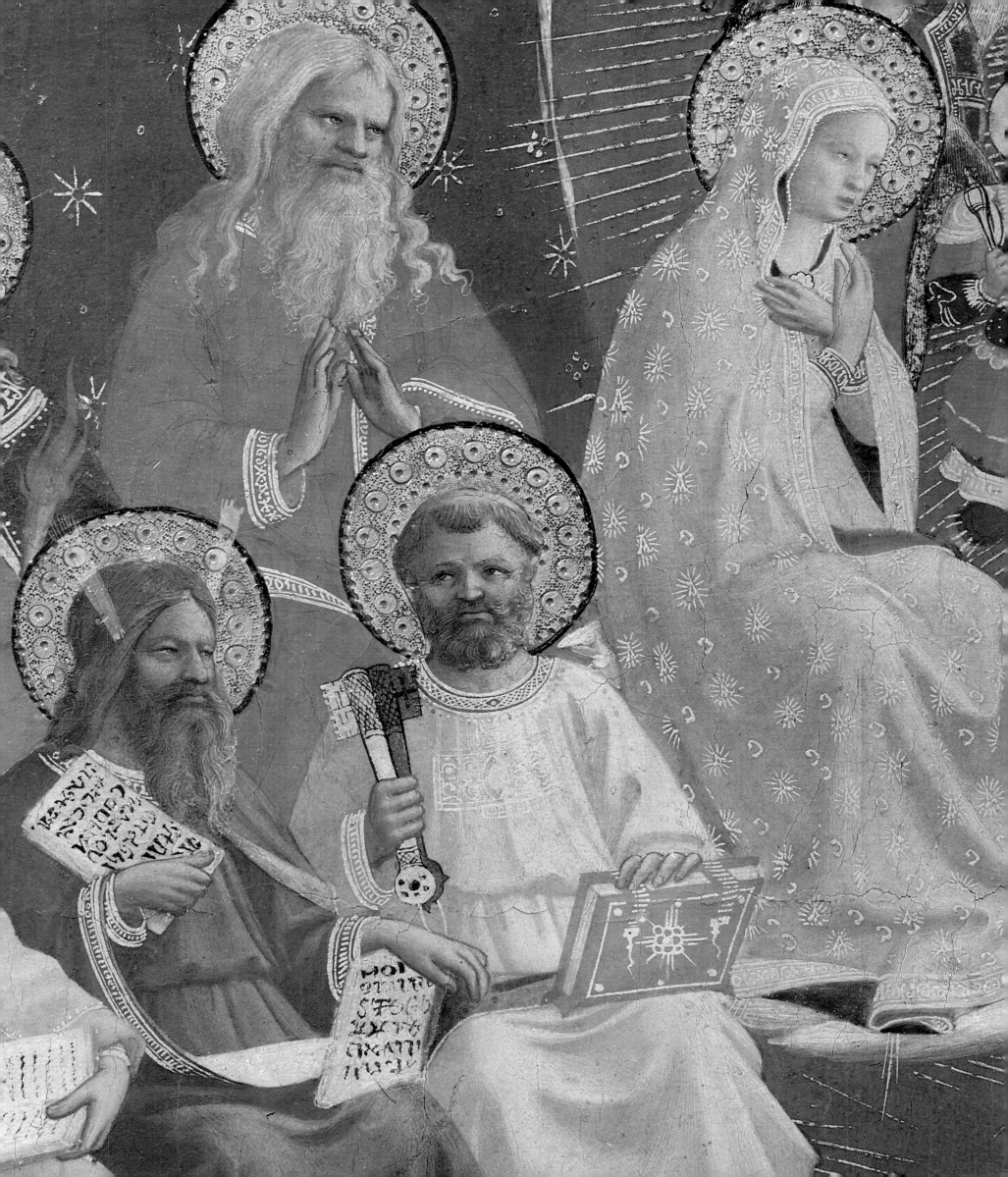

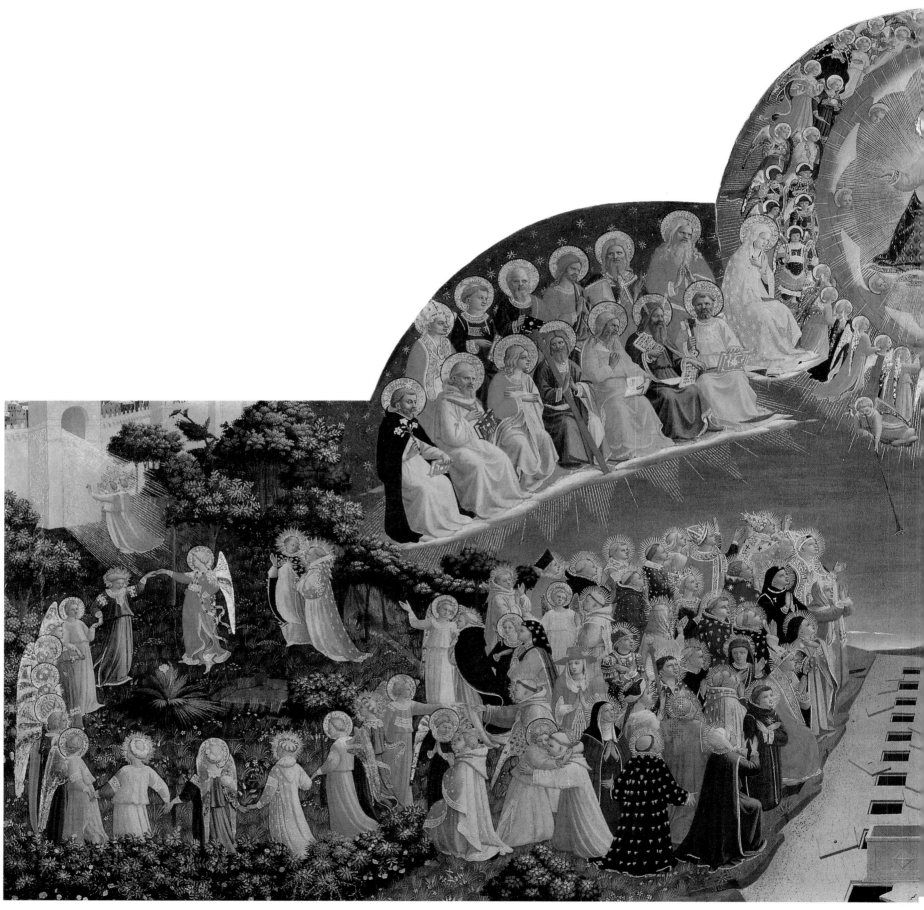

LAST JUDGMENT
Museo di San Marco, Florence
(see catalog 67)

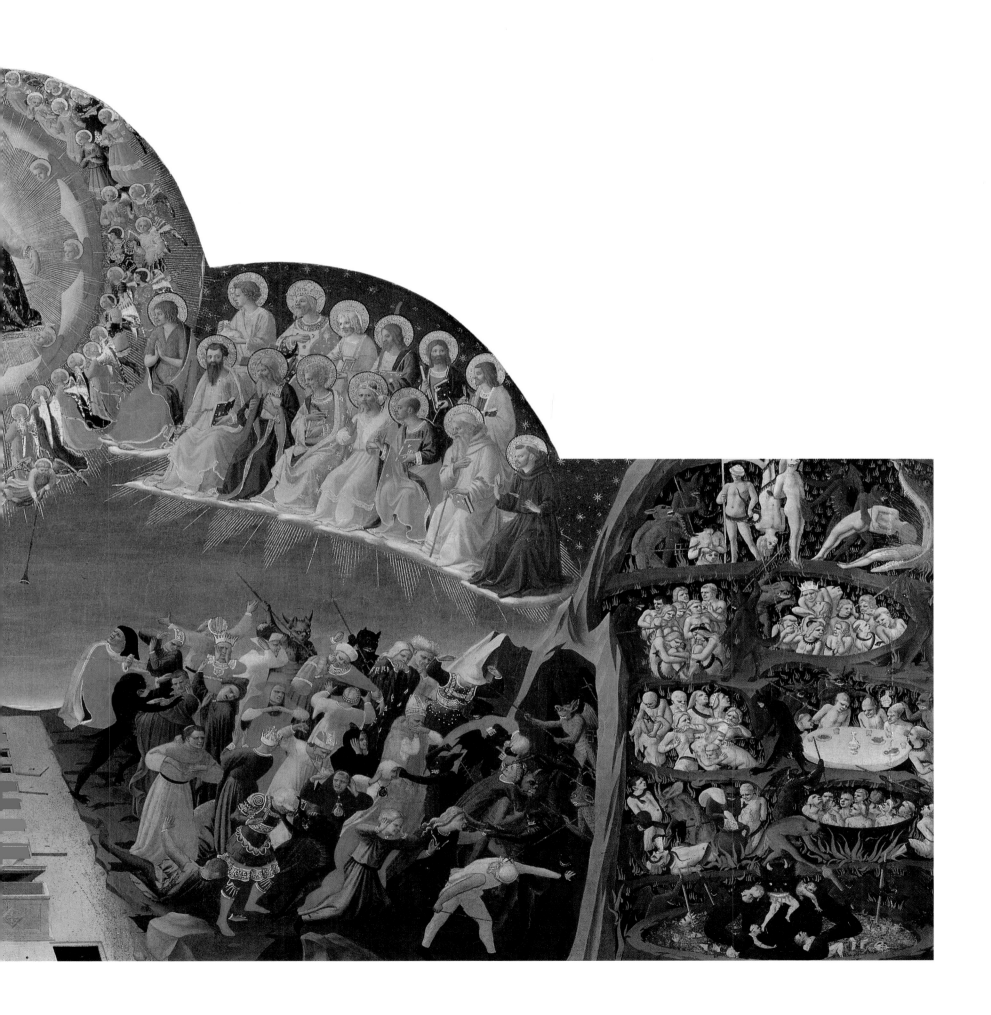

SANTA TRINITA ALTARPIECE

The Deposition, or the taking down of the body of Christ from the cross, is described in all four gospels. When it was evening and there was darkness over the whole land, Jesus uttered a loud cry and breathed his last. A rich man from Arimathaea, named Joseph, received permission to take the body of Christ and to lay it in a rough-hewn tomb. According to Saint John, Nicodemus, the learned member of the Sanhedrin, also assisted at the Deposition.

Fra Angelico's great *Deposition* is by no means a straightforward recitation of the biblical narrative. At the center, Joseph of Arimathaea, Nicodemus, and the young Saint John the Evangelist, all haloed, lower the lifeless body of Christ. Two unidentified gentlemen, sometimes considered portraits, also participate.[34] At left Fra Angelico has depicted the many women who had followed the *Via Crucis* procession from Jerusalem, including the three Maries. Two other holy women in this group who have halos have never been identified. There are no textual or pictorial precedents for the group of worshipers, at right, who contemplate the event and sagely discuss the crown of thorns and the three nails. The young man kneeling in the foreground is believed to represent the Blessed Alessio degli Strozzi, a holy ancestor of Palla Strozzi, the humanist who commissioned this altarpiece for the sacristy of Santa Trinita.

The insertion of contemporary personages would in any event transform the composition from a narration to a meditation that the spectator would implicitly share with the other onlookers. To leave no doubt about his intentions, Fra Angelico has also rewritten the time and place of his theme in order to direct our meditations onto a predetermined path. In place of despairing night, Fra Angelico has depicted the most glorious of days. Most extraordinarily for a Deposition from the cross, "the colours seem to *sing*," noted Henry James, "like new-fledged birds in June."[35] To be precise, our Lord was crucified in spring, the season of renewal. In place of Golgotha strewn with the skulls of executions past, the participants in this meditation tread upon the flowery carpet of a paradisiacal garden. The theology behind these motifs is fundamental: Christ died for the salvation of humanity. This concept is embodied in the English name for this day, Good Friday.

Giulio Carlo Argan has observed that the contemporary figures at right stand for *docta pietas*, "the religion of the mind, the faith of the humanists," while the devout group of women in fervent prayer at left represent *caritas*, "the piety of the poor in spirit, the religion of the heart."[36] One of the painting's purposes, therefore, would be to show that Christ was the common ground between the Christian ideal of the church and the intellectual ideal of the humanists.[37]

The painting is divided into three distinct sections by the pointed arches at its upper margin. Three inscriptions in the base of the frame convey to us, with unusual specificity, the sentiments of the personages directly above. These three Old Testament prophecies were carefully chosen from the readings for Holy Saturday, the day following the Crucifixion.[38] Thus, from Zacharias 10:12, the three Maries "grieve over him, as one grieves at the death of the first-born." The Psalms, which Jesus cited so often in life, are the source of the text beneath the deposed Christ, "I am counted among them that go down into the pit: I am as a man who hath no strength."[39] Finally, the discussants at right are appropriately assigned a response from this office that can be understood as their very words: "Behold in what manner the just one dies, yet no one comprehends Him in his heart."

Santa Trinita Altarpiece
Tempera and gold on panel,
69¼ × 72⅞ in. (176 × 185 cm)
Museo di San Marco, Florence
(see catalog 74)

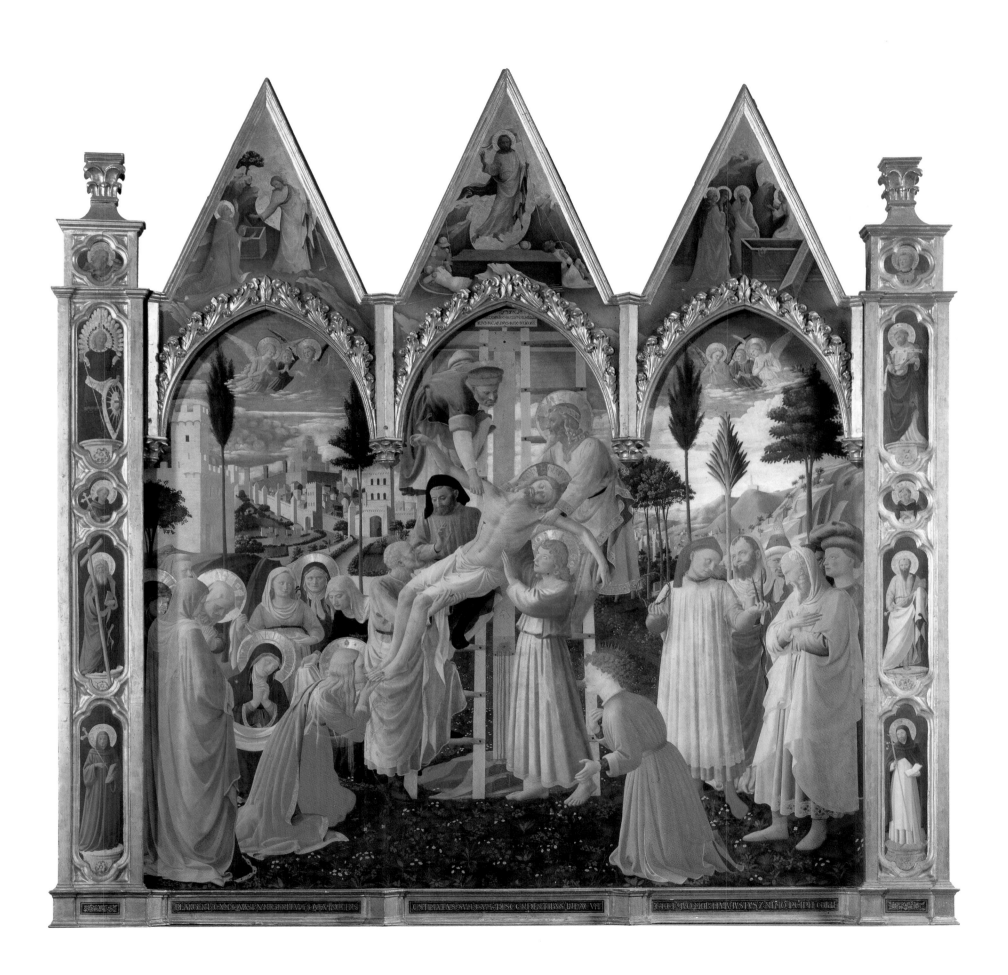

Fra Angelico's *Deposition* was destined for an altar in the sacristy of Santa Trinita that the Strozzi family had built to serve as their funerary chapel. The circumstances of this commission are unknown, but the three pinnacles with resurrection scenes by Lorenzo Monaco are an indication that Angelico was called upon to replace an altarpiece executed by that older artist. Fra Angelico modified the sides and base of the polyptych, painting standing figures of saints for the lateral pilasters. These modifications were probably ordered by Palla Strozzi before July 1432 as part of his campaign to expand and embellish his chapel. The original altarpiece by Lorenzo Monaco, which may have been ordered at the time of his father's death in 1418, would have appeared noticeably old-fashioned next to the *Adoration of the Magi* painted by Gentile da Fabriano, painted in 1423 for a new altar that Palla Strozzi had erected in this same sacristy.

The philosophical character of Angelico's *Deposition* was probably dictated by Palla Strozzi's intentions to install his scholarly library in the sacristy. The same may be true of Gentile's earlier work, since the Magi were emblematic of wisdom. From a theological point of view the Deposition marks the end of the cycle of Incarnation that was first revealed to the wise men in the Epiphany. Many other connections between the two paintings could be cited.

In this *Deposition* Fra Angelico introduced a number of rhetorical devices that he would pursue in depth in the frescoes commissioned by Cosimo de' Medici at San Marco. Chief among them was the transmutation of a biblical event into a theological meditation. The artist was no longer painting an illustration to a sacred text, but composing a learned commentary. In Renaissance terms, Fra Angelico's painting demonstrated that poetry would no longer be the exclusive preserve of writers.

Detail of the
Santa Trinita Altarpiece
Tempera and gold on panel,
69¼ × 72⅞ in. (176 × 185 cm)
Museo di San Marco, Florence
(see catalog 74)

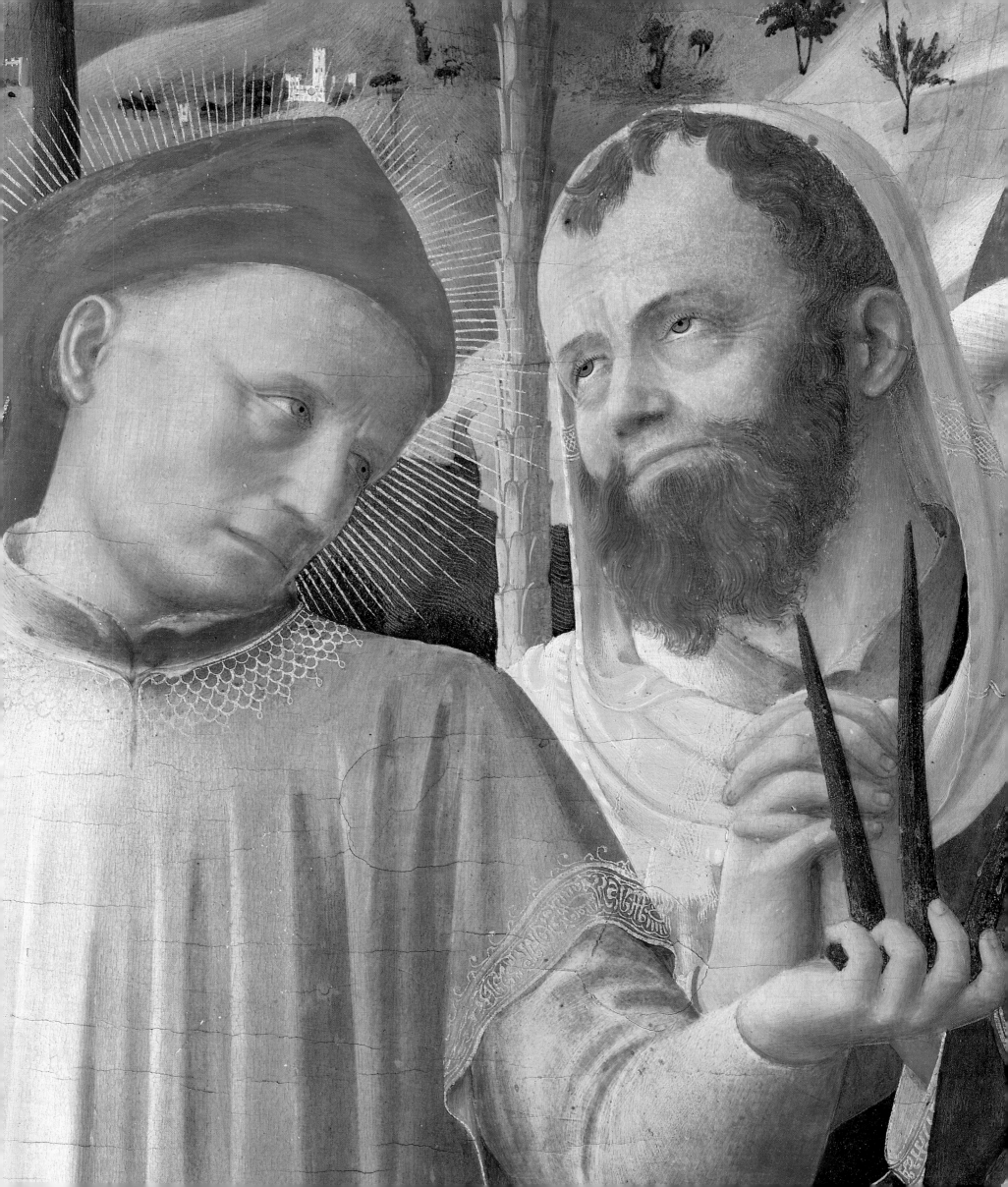

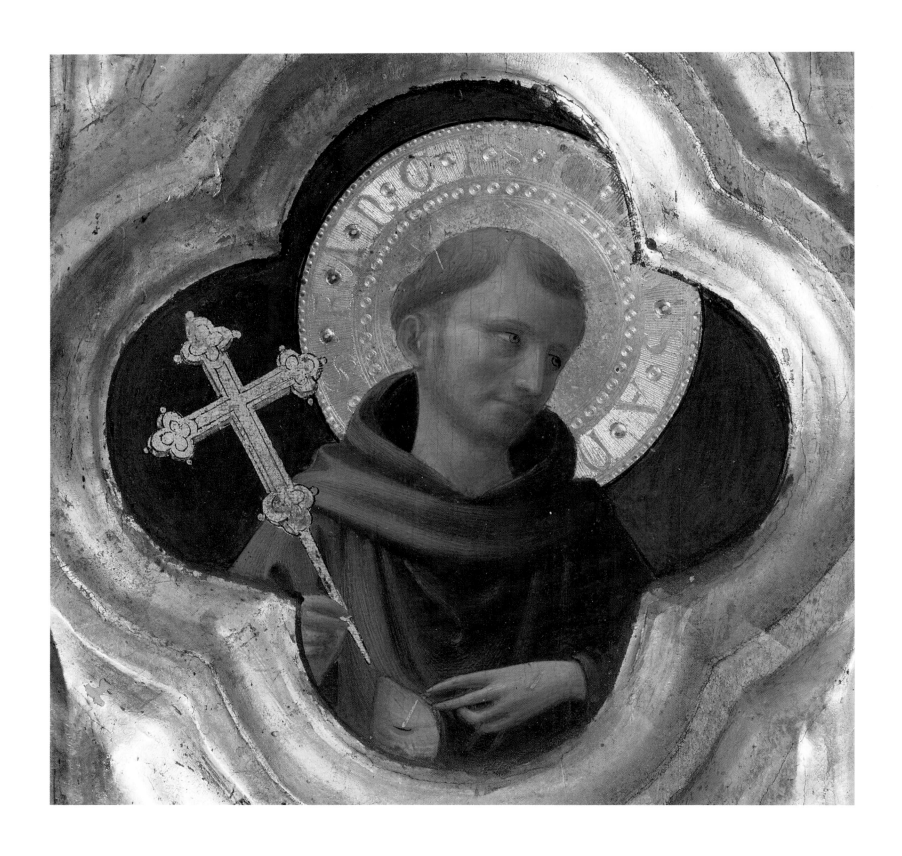

Details of medallions in
the pilasters of the
Santa Trinita Altarpiece
Museo di San Marco, Florence
(see catalog 74)

LINAIUOLI TABERNACLE

In 1433 the Arte de Linaiuoli, or guild of the wool merchants, commissioned Fra Angelico to execute the paintings for a monumental tabernacle. The architectural frame was designed by Lorenzo Ghiberti, who may also have influenced the design of Angelico's paintings. The tabernacle was the most important commission that Angelico executed for a civic, as opposed to ecclesiastic, foundation. Unfortunately, its original effect is difficult to judge because the structure was removed in 1777 from the guild's palace, which was subsequently torn down.

Ghiberti's design for the tabernacle is a curious, and not wholly successful, amalgam of the simplified lines of Roman architecture and an irresistible urge toward ornamentation. Fra Angelico was called upon to paint full-length figures of saints on the inside and outside surfaces of the two shutters. When these doors were closed, the spectator saw Saint Mark and Saint Peter depicted against dark backgrounds, as if to evoke statues standing in niches. It has been shown that Fra Angelico adopted some of these poses from sculptures on the facade of the Duomo.[40] Saint Mark, as the patron of the guild, appears again when the shutters are opened, together with Saint John the Baptist, protector of Florence. The gilt backgrounds on the inside of the shutters are suggestive of the celestial luster emanating from the Madonna and Child of the central panel. Sadly darkened by time, and perhaps mistreatment in the past, the four saints on the shutters are most admirable for the sinuous, silky elegance of their draperies, which are clearly indebted to Ghiberti's sculptural style.

The imposing proportions of the Madonna and Child may perhaps be explained by the requirement to emulate or replace a large mural painting of this theme formerly in the palace by a painter of the duecento. In all events this treatment of Fra Angelico's favorite subject is relatively static and lacking in human warmth. As Padre Centi has recently noted, it is almost as if Angelico were inhibited by the terms of his contract, or chilled by the stone frame.[41]

The luxuriant curtains that part to reveal the Virgin and Child are an interesting iconographic innovation that was presumably inspired by the numerous references in both the Old and New Testaments of the curtains (or veils) that shielded the holiest parts of tabernacles and temples. On another level these fine draperies can be considered a disguised attribute of the wool merchants' guild itself. Indeed there appear to be direct references to the activities of the Linaiuoli in the central predella below, the *Adoration of the Magi*. A kneeling youth at left brings a bolt of red dyed cloth as his gift. In the background, some young men appear to measure the sleeve of one of the wise men. Meanwhile, the curious attention paid to Saint Joseph's hands remains to be explained.

The other two predella panels represent the Martyrdom of Saint Mark and Saint Peter Preaching in the Presence of Saint Mark. This last subject illustrates the tradition that the Gospel of Mark contains the direct teachings of Peter. The panel has most often been commented on for its vivid evocation of the contemporary streets of Florence. The background is a virtual compendium of architecture observed from Masaccio's frescoes in the Brancacci Chapel. As Castelfranchi-Vegas has rightly observed, the audience for Peter's sermon combines elements of popular devotion, represented by the seated women, and the learned culture of the time, as personified by Saint Mark and the scholar beside him with a scroll in each hand.[42]

Detail of Saint Peter Preaching in the Presence of Saint Mark from the predella of the Linaiuoli Tabernacle
Tempera and gold on panel, in marble tabernacle sculpted on design by Ghiberti,
17 ft. 2 in. × 8 ft. 9 in. (5.28 × 2.69 m)
Museo di San Marco, Florence
(see catalog 68)

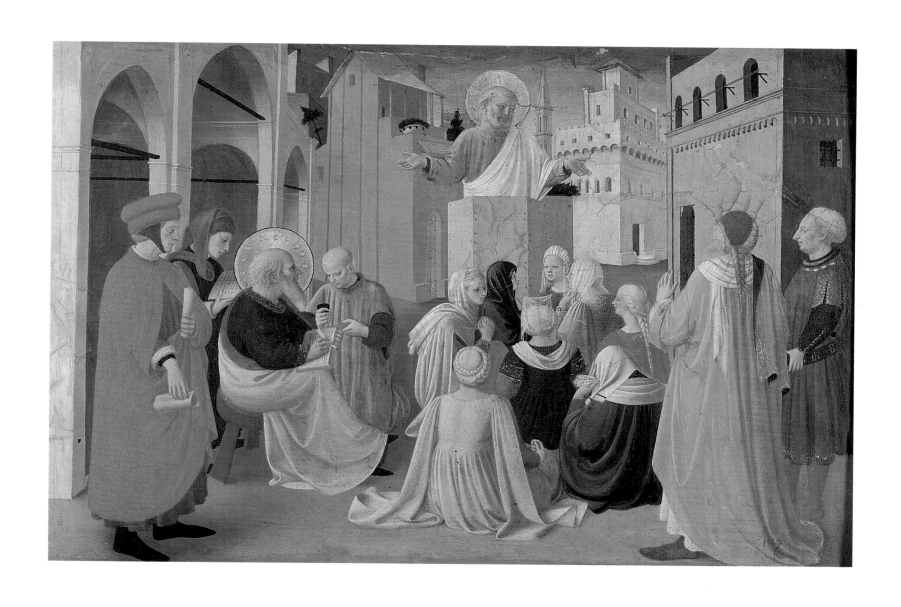

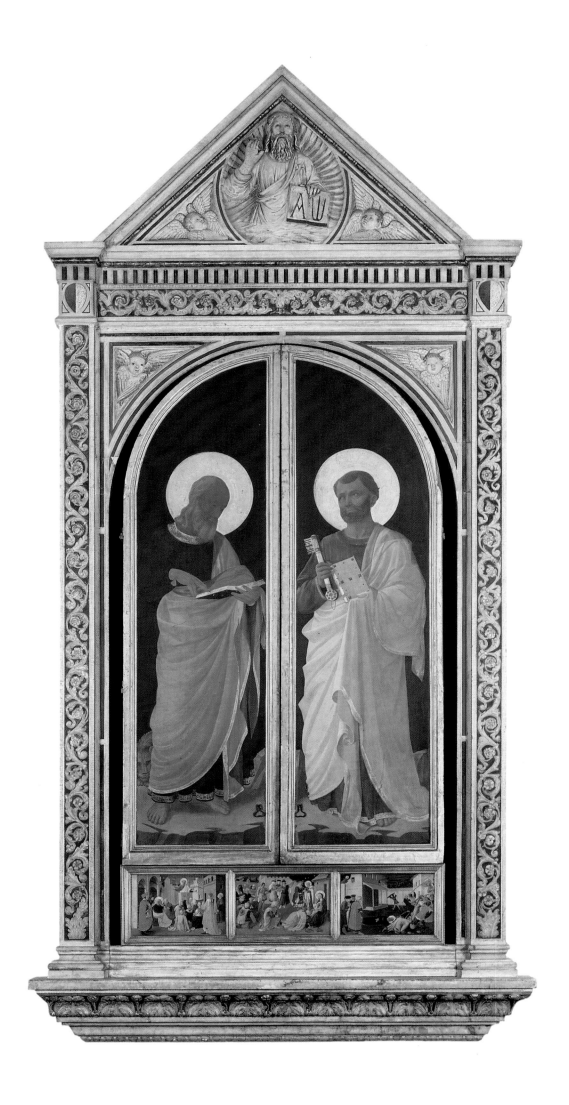

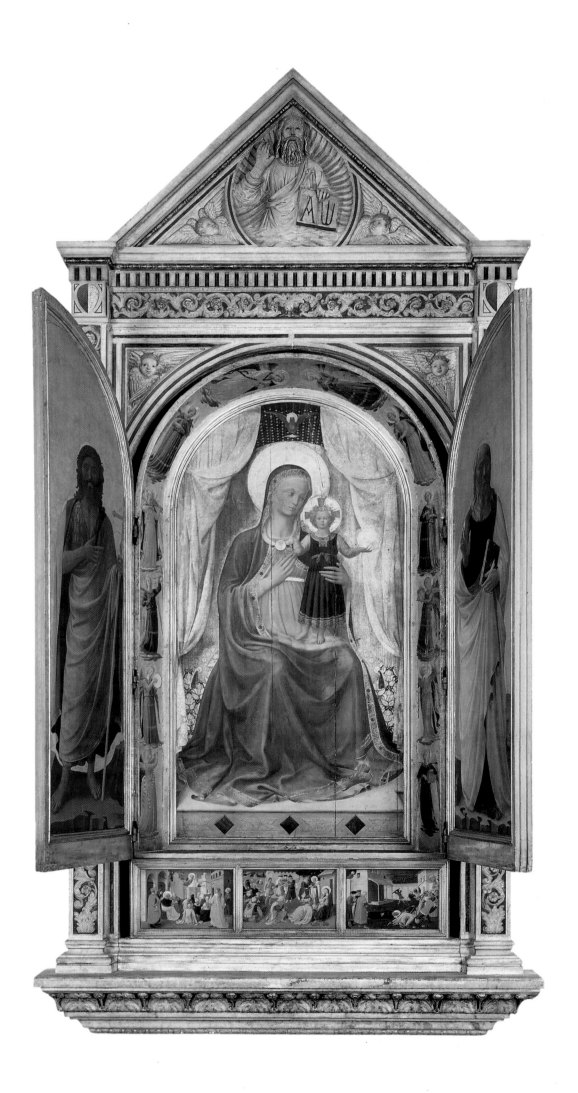

Linaiuoli Tabernacle
(closed, left, and open)
Museo di San Marco, Florence
(see catalog 68)

CORONATION OF THE VIRGIN ALTARPIECE

FROM SAN DOMENICO, FIESOLE

With solemn and filial devotion, Christ the King crowns the Virgin Mary, Queen of Heaven. The ceremony unfolds beneath a sculpted canopy at the summit of nine resplendent steps of polychrome stone.[43] The throne is encircled on all sides and below by a throng of music-making angels and by a multitude of saints and patriarchs.

The halos of many of these sacred personages are elaborated with inscriptions. The Virgin's halo has a verse from the Little Office, "Ego Mater Pulchrae . . . ," that the Dominican friars recited every evening.[44] On the left side of the throne Fra Angelico portrays three saints whose books, all with legible texts, ascend in a graduated hierarchy of increasing proximity to the Godhead. Nearest to the spectator, and facing outward, Saint Thomas Aquinas holds a book with three biblical verses appropriate to his commentaries. Directly above the Angelic Doctor is represented Saint Dominic, whose testament exhorts his friars to charity, humility, and poverty. Finally, Saint John the Evangelist is represented as the capital of this pillar of figures: he displays the first seven verses of his gospel, "In the beginning was the Word. . . ."

The devotion to the Coronation of the Virgin can be traced to the early Christian epoch when Gregory of Nazianzus and Saint Ephraem identified certain passages in the Bible as foreshadowings of this post-Resurrection event. Chief among these is the episode from 1 Kings 2:19 in which, after Solomon was crowned king of the Israelites, his mother, Bathsheba, came to ask a favor. "And the king rose up to meet her, and bowed himself unto her, and sat down on his throne, and caused a seat to be set for the king's mother; and she sat at his right hand."[45] The Christian exegetes also traced a relationship between the Coronation of the Virgin and the mystical union celebrated in the Song of Songs of Solomon.

The Coronation of the Virgin was frequently represented on Florentine altarpieces in the trecento and quattrocento. On its most basic level of meaning, the theme exalts the importance of the Virgin as intercessor for the faithful; the subject was also widely recognized as emblematic of the union between Christ and his Church, as personified by the Virgin.

This altarpiece by Fra Angelico was executed for the church of the artist's own convent, San Domenico in Fiesole, prior to its dedication in 1435. In its original position over an altar on the right side of the *tramezzo* (rood screen), the *Coronation* would have directly faced the lay congregation in the nave. The predella panel below the main panel represents the *Corpus Domini* in its center (where the celebrating priest would show the Eucharistic wafer) and six episodes from the life of Saint Dominic.

In contrast to the great number of individual representations of Saint Dominic, extensive cycles of his life are relatively rare. Fra Angelico's predella for the *Coronation of the Virgin* is one of the most significant to be preserved from the quattrocento.[46] The six scenes are taken from the definitive *De Vita et miraculis S. Dominici . . .* compiled by Theodoric of Appoldia, c. 1290.[47] The most delightful of these, *Saints Peter and Paul Appearing to Saint Dominic*, is imbued with a visionary quality appropriate to its theme. While at prayer in Saint Peter's, Rome, Dominic suddenly sees the two apostles coming toward him. As Peter gives him a staff and Paul, the Bible, they tell him, "Go thou and preach." The scene is dominated, however, by the ghostly arches of the basilica, painstakingly rendered according

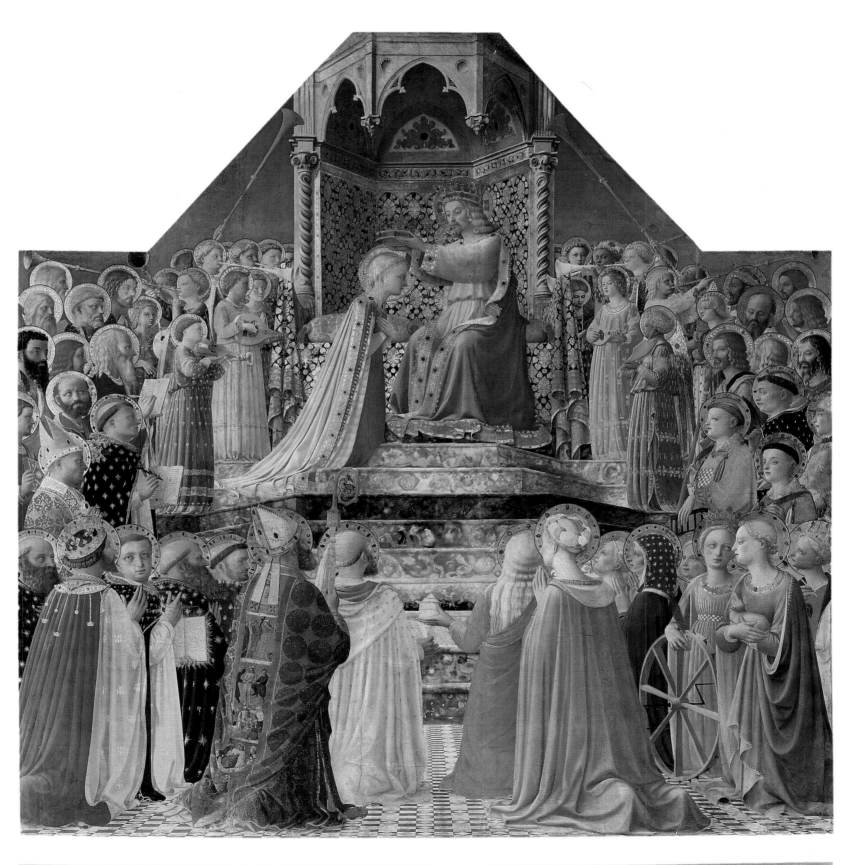

to the new science of perspective. In the *Dispute of Saint Dominic and the Miracle of the Book*, also illustrated here, Fra Angelico narrates an important story of Dominic's relentless war against heresy. On the left side of the painting, Dominic and a companion present a volume of his writings, which, after a long disputation held at Fanjeaux, was subjected to a test of fire. When Dominic's book and one by a certain heretic were thrown into the fire, the heretical tract was immediately consumed by the flames. Dominic's book sprang forth from the fire, undamaged, as a sign of its holiness and truth.

This painting by Fra Angelico has always aroused comment for its ingenious rendering of the multicolored pavement in the foreground. There are virtually no precedents for the realism and seeming modernity of this oblique point of view, which anticipated by at least a year the publication of Alberti's discussion of perspective in 1435. Although Vasari praised the *Coronation* in the highest terms, its execution by Fra Angelico was doubted by several twentieth-century critics who did not believe him capable of such an innovation.[48] It is true that Fra Angelico's interest in complicated perspectival systems was limited to the brief period encompassed by this painting, c. 1434, and the San Marco Altarpiece, 1440.

Detail of *CORONATION OF THE VIRGIN* Altarpiece from San Domenico
Musée du Louvre, Paris
(see catalog 92)

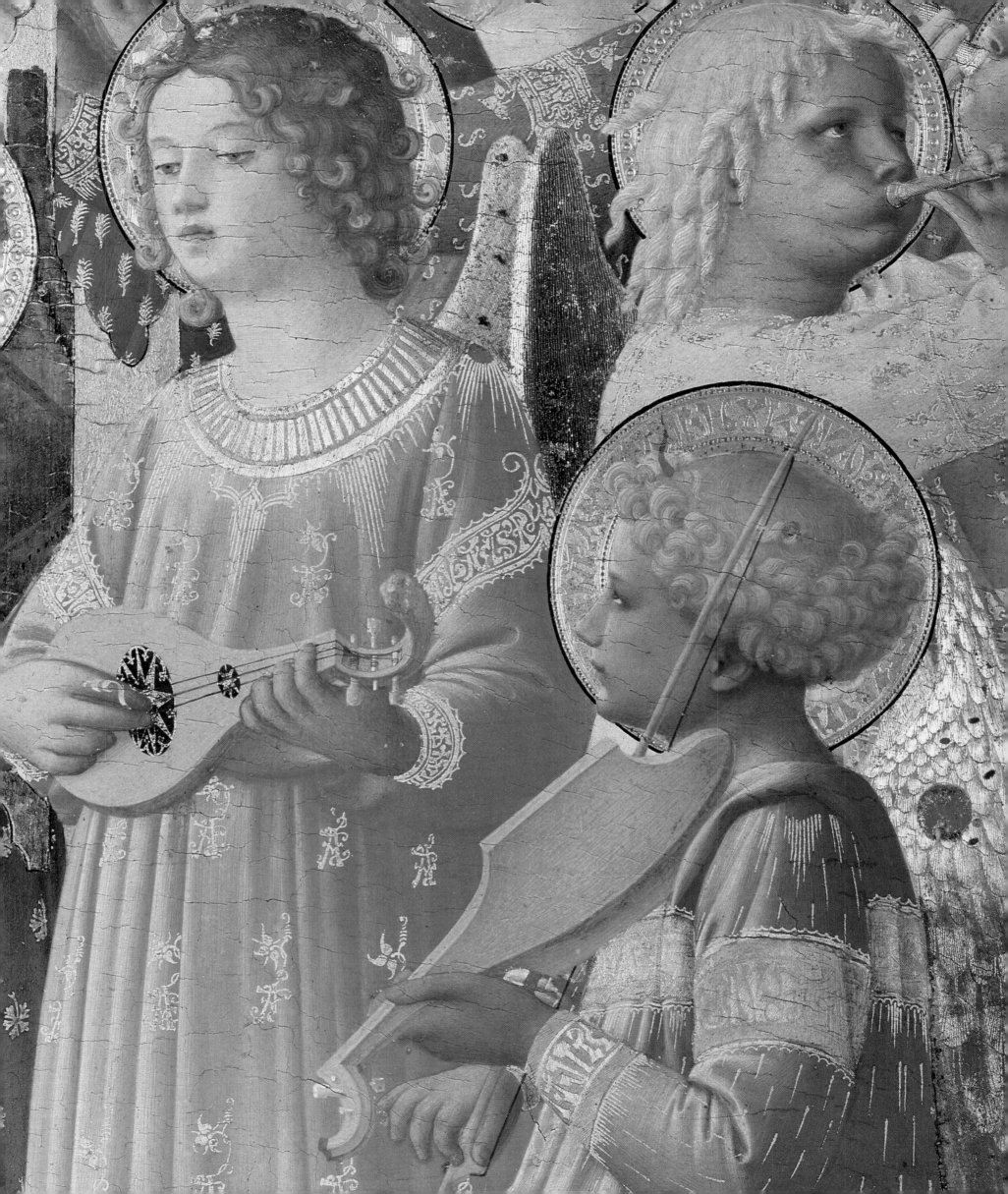

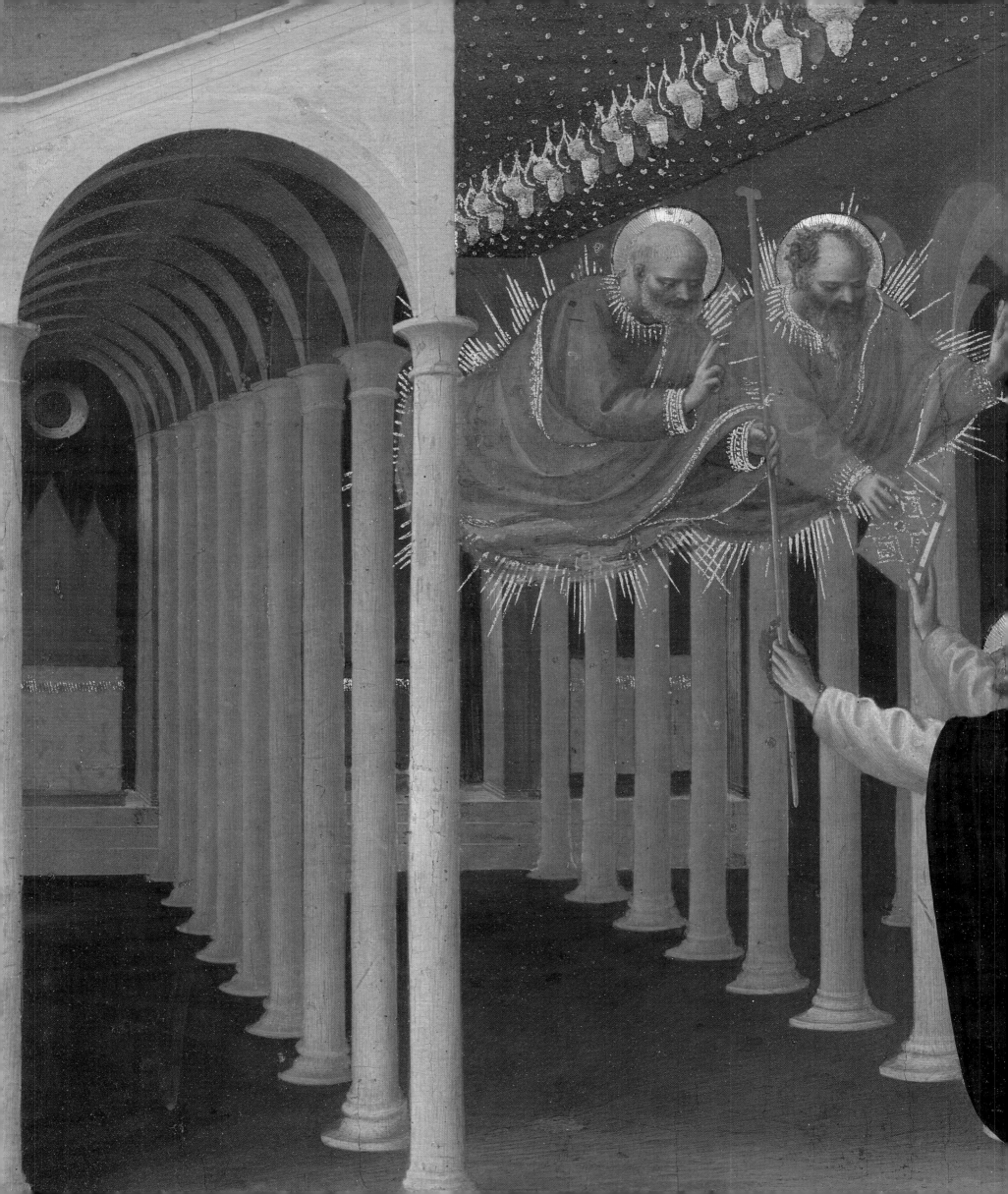

Detail of Saints Peter and Paul
Appearing to Saint Dominic
from the predella of the
CORONATION OF THE VIRGIN
Altarpiece from San Domenico
Musée du Louvre, Paris
(see catalog 92)

Detail of the Dispute of Saint
Dominic and the Miracle of the
Book from the predella of the
CORONATION OF THE VIRGIN
Altarpiece from San Domenico
Musée du Louvre, Paris
(see catalog 92)

THE SAN MARCO

ALTARPIECE

The San Marco Altarpiece, which formerly stood over the high altar of the Church of San Marco, has come down to us as a noble ruin. In the nineteenth century, a corrosive attempt to clean the altarpiece dissolved its surface instead, stripping the painting down to its underlying architecture. Prior to that assault, this cardinal masterpiece of the early Renaissance had already been seriously mistreated and diminished. Its original frame, no doubt designed by the architect Michelozzo, was removed at an early date and the nine panels in its predella dispersed to collections around the world. Only a handful of the small paintings of saints that adorned its flanking pilasters have as yet been identified.

In the main field of the altarpiece, the Madonna and Child are shown enthroned beneath a classical niche of recognizably Michelozzian design. Eight angels and eight saints are distributed with calculated simplicity on either side of the throne. The foreground is covered by a magnificent carpet inlaid with zodiacal symbols. The two kneeling saints can be identified by their costumes as Cosmas and Damian. Their prominence underscores the importance of Cosimo de' Medici, the patron of the altarpiece and of the renovations at San Marco. On January 6, 1443, this altar was rededicated to these two saints together with Saint Mark.

The Medicean components of the altarpiece are readily discerned. At far left, Saint Lawrence and Saint John, shown in profile, are the name saints of Cosimo's brother and father, Lorenzo and Giovanni. Adjacent to them, Saint Mark, titular saint of this church, holds his gospel open to chapter 6, verses 2-8. The relevant passage describes how Jesus sent the Apostles out in pairs to heal the sick and to cast out devils; the text seems intended to bestow apostolic status upon the physician saints Cosmas and Damian, whose lives and martyrdoms are illustrated in eight panels in the predella. These three saints of the early church—Lawrence, John, and Mark—are balanced on the right side of the composition by three mendicant friars of the thirteenth century. Saint Dominic faces outward, his hands folded in prayer; the church and convent had been transferred to the care of his Observantist friars thanks to Cosimo's intervention. Saint Francis of Assisi and Saint Peter Martyr, another Dominican, are shown in profile; they were the patron saints of Pierfrancesco and Piero de' Medici.

The Madonna and Child enthroned are understood to signify the Church itself. The two groups of figures on either side lead to them in the way that columns in the nave of a church lead inevitably to the apse. The pair of drawn-back draperies allude to the curtains of a temple or sanctuary (II Samuel 7:2; Letter to the Hebrews 9:13). The extraordinary carpet in front of them is not merely a device for the spatial organization of the picture. The insertion of this specifically Eastern motif is an unmistakable allusion to the Council of the Union, gathered at one time in Florence, which had recently brought together the Greek and Latin churches. Unfolded across the lower part of the painting, the oriental carpet reminds the spectator that it was in the East where the Church began, where Christ walked. Behind the throne a splendidly printed cloth encloses this sacred precinct. The *hortus conclusis*, or enclosed garden, is a primary image of the Virgin, derived

San Marco Altarpiece
Tempera and gold on panel,
principal panel: 86⅝ × 89⅜ in.
(220 × 227 cm)
Museo di San Marco, Florence
(see catalog 71A)

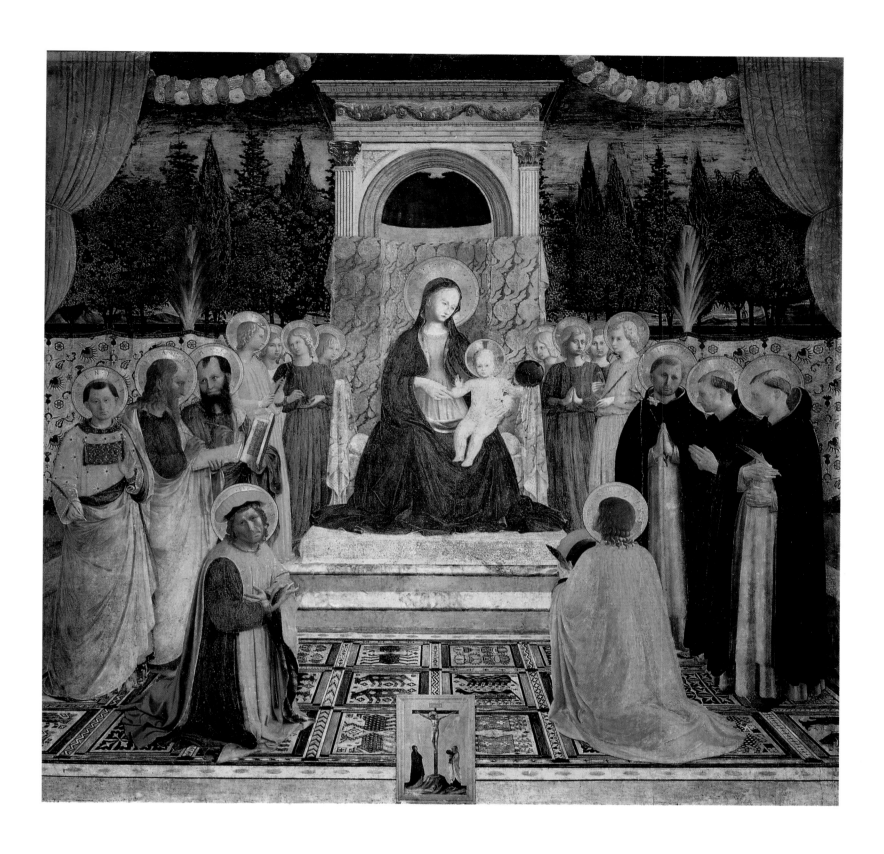

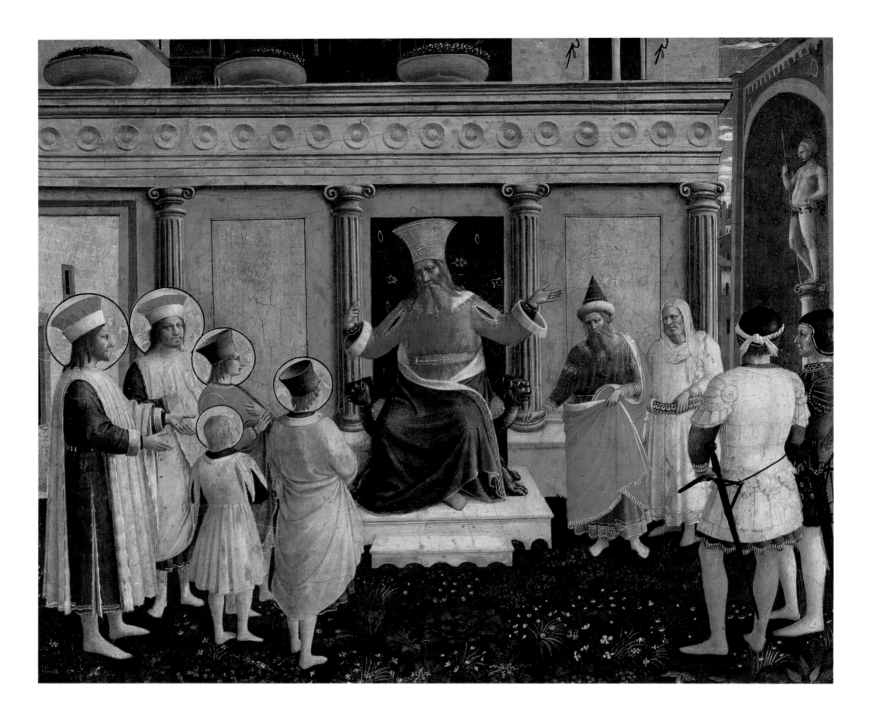

from the Song of Songs of Solomon. From the Hours of the Virgin, for Matins, comes
the text that is the source for the luxurious trees and garlands of roses in the distance.

> I was exalted like a cedar in Lebanon,
> and as a cypress tree on Mount Zion;
> I was exalted like a palm tree in Cades,
> and like a rose in Jericho, and as a fair olive
> tree in a pleasant field, and grew up as a plane
> tree by the water.[49]

The design of the San Marco Altarpiece was innovative in every respect. Until this
date, the figurative arrangements of these paintings could be said to have been dictated by
the architecture of the frame. The painter's task had essentially been to insert the Virgin

Detail of Saints Cosmas
and Damian Present Their
Brothers to the Proconsul Lysias
from the predella of the
San Marco Altarpiece
Alte Pinakothek, Munich
(see catalog 71A)

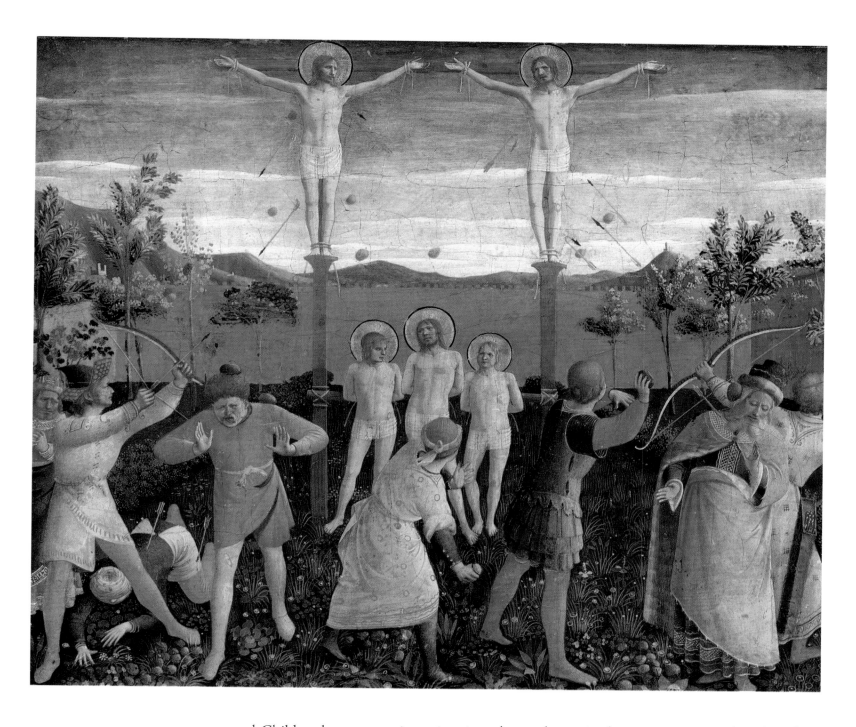

and Child and accompanying saints into the predetermined compartments and angles of a traditional gothic polyptych. Although Fra Angelico has generally been regarded as a conservative artist, no painter contributed more than he to the development of the Renaissance altarpiece, beginning with the Annalena Altarpiece of c. 1430. The rectangular format of that work dictated a friezelike arrangement for the *sacra conversazione* that was unified spatially, but otherwise not so different from precedent. To an extent that has not hitherto been recognized, Fra Angelico composed the San Marco Altarpiece according to the principles of perspective and proportion that Leon Battista Alberti had recently published in his *Della pittura* of 1435. Indeed, in our discussion of this painting in the introductory essay to this volume, we concluded that Alberti, who was in Florence at this time, very probably assisted Fra Angelico with the design for this altarpiece.

As the reader can quickly observe from the figure on page 53 in the introductory essay, the geometric pattern of the oriental carpet provides the coordinates for a grid of

thirty-six squares. This square grid has not hitherto been recognized, perhaps because its sides do not precisely coincide with the edges of the painting; instead its sides are determined by the architrave of the niche and by the front edge of the rug. By use of this "reticulated veil," as Alberti termed his grid, the artist could distribute his figures with flawless symmetry. The painter has subtly adjusted their poses to disguise the fact that the right and left halves of the painting are essentially mirror images of each other.

As the diagram on page 52 demonstrates, the pattern in the carpet further serves to lead the spectator's eye into depth. The dark receding lines are the orthogonals in a one-point perspective that converges squarely on the Virgin. It is surely not by chance that the Virgin has been made the fulcrum of the spatial system of this altarpiece, nor that the *Crucifixion* in the foreground (where it takes the place of the customary crucifix on the altar) is aligned to serve as the central orthogonal in this simultaneously geometric and sacred perspective. This vertical axis originally extended into the predella below in the poignant scene of the Lamentation now in Munich.

The predella panels now in various museums are generally well preserved and thus afford us an impression of the delicacy and chromatic richness of the original altarpiece. Each of these episodes is represented with a wealth of scenographic and anecdotal detail; they were undoubtedly influential on the subsequent development of history painting in Florence. The scene of Saints Cosmas and Damian presenting their brothers to the Proconsul Lysias has notable affinities with the fresco of the *Resurrection of the Son of Theophilus* by Masaccio in the Brancacci Chapel. Presumably there is some allegorical justification for the prominence afforded to Lysias, who unsuccessfully exhorts the saintly brothers to idol worship. The fictive stone behind him is inset with disconcerting eye motifs. In the *Attempted Martyrdoms of Saints Cosmas and Damian by Fire* Fra Angelico has represented an expansive landscape with remarkable ease. In this episode in the fabulous legend of the saints, the wicked attempt to kill them and their brothers resulted only in their tormentors being assailed by their own arrows and stones.

Detail of Attempted
Martyrdoms of Saints Cosmas
and Damian by Fire from
the predella of the
San Marco Altarpiece
Alte Pinakothek, Munich
(see catalog 71E)

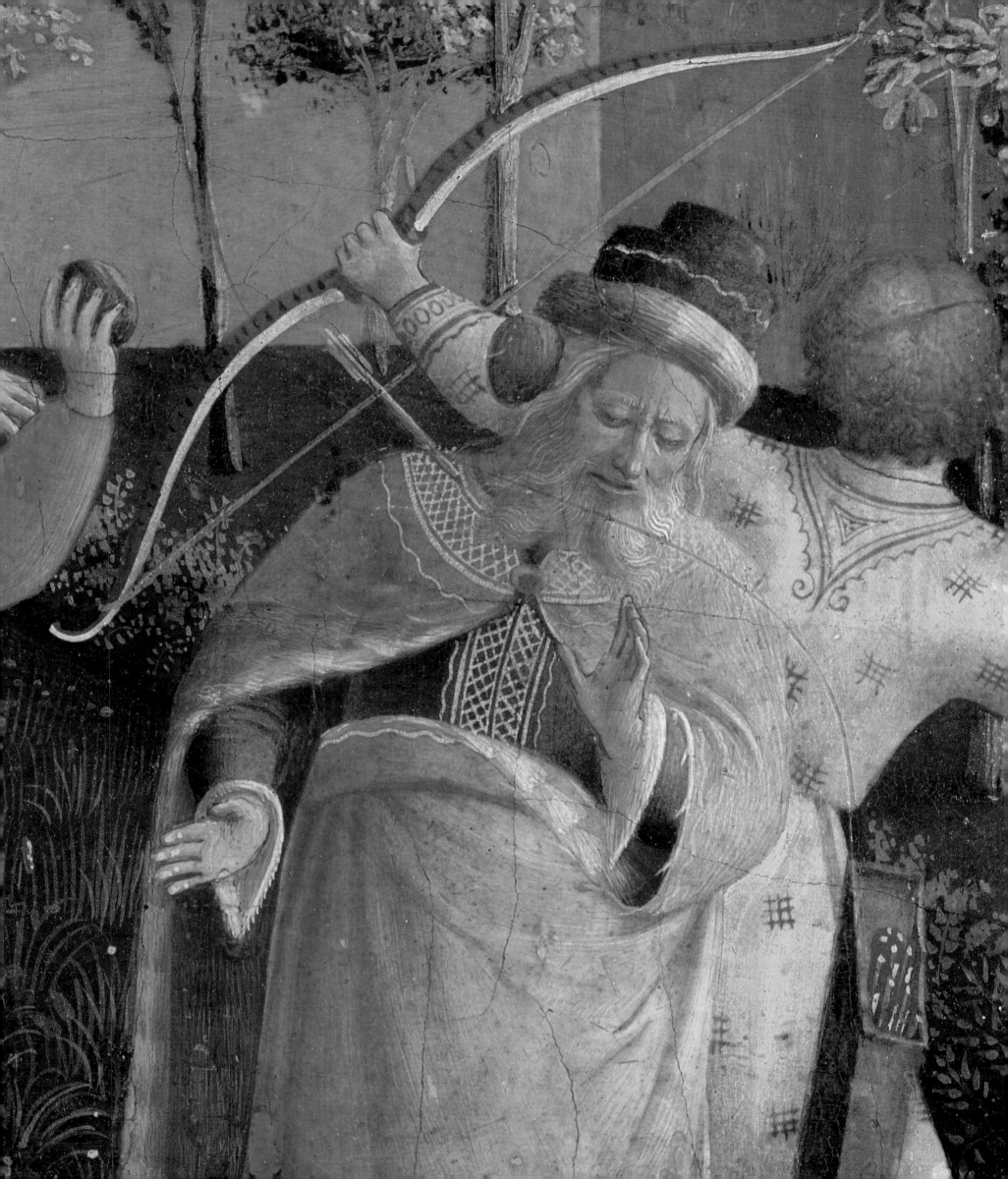

FRESCOES FOR THE
CONVENT OF SAN MARCO, FLORENCE

In 1436 the convent of San Marco in Florence was ceded by a papal bull of Eugenius IV to the friars of Fra Angelico's convent of San Domenico, Fiesole. The Observantist Dominicans had long wanted a suitable home in Florence, and their wishes were realized through the combined intervention of the pope and Cosimo de' Medici. Extensive repairs to the convent and church of San Marco were required at once, although an intrepid first group of friars lived uncomfortably in temporary shelters in San Marco for almost two years. During the first phase of the reconstruction Fra Angelico was employed at the friary of San Domenico in Cortona, where his presence is documented in March 1438.

The sequence of Michelozzo's works in the convent and choir of the church is not documented, but all the construction appears to have been completed in time for the rededication of the high altar of the church on January 6, 1443. This solemn ceremony was attended by Eugenius IV; afterward the pope paid the friars and their patron the extraordinary honor of staying the night in Cosimo's private cell in the north dormitory. In 1444, the library in the center of the north wing was completed; it was furnished with four hundred sacred and philosophical manuscripts.

During three extraordinarily intense years of activity—from 1440 to January 1443—Fra Angelico designed and executed with a handful of assistants nearly fifty frescoes on the two levels of the convent of San Marco (see diagram on page 216). The spaces for the frescoes varied from the overdoor lunettes in the cloister to the privacy of the friars' cells in the dormitories. There were no precedents for monastery decorations on this scale; indeed the lavishness of this display was clearly inconsistent with the asceticism of the Dominicans. The only explanation for this departure from the rule must be that Cosimo de' Medici, who spent an unheard-of thirty-six thousand *ducati* on San Marco, wished to impress the leaders of Christendom, who were then assembled for the Council of the Union, with the extent of his ecclesiastical commitment.

After the visit of the pope in 1443, it is not clear how many people were granted the privilege of viewing the frescoes in the friars' cells, in particular those in the east and south dormitories, which were *in clausura*, and not generally accessible to visitors. Visitors to the library would have passed through the north wing, but Vasari (1568) does not describe even these frescoes. The frescoes on the upper floor of the convent, including the major series of frescoes in cells 1 through 11, did not receive detailed discussion until the nineteenth century.

Twentieth-century scholars have concerned themselves almost exclusively with hypotheses regarding the sequence and the extent of Fra Angelico's personal execution of the San Marco frescoes. As a result of the 1984 restoration of the frescoes, it is now possible to conclude that the responsibility for the design of these works must be assigned to Fra Angelico alone, who was also the principal executant of the major compositions in the chapter room, dormitory corridors, and cells 1 through 9. The noticeable collaboration of assistants, especially in the north and south dormitories, does not alter this fact.

The most compelling argument in support of Fra Angelico's primacy in the conception of these frescoes is, in fact, the organic cohesion of the series as a whole. As we have discussed on pages 62-68 the frescoes at San Marco progress in theological thought from the simplest symbolism to the deepest mysteries. Only the cloister lunettes that were visible to the public had meanings as simple as their titles.

View of the north corridor of the Convent of San Marco with the ANNUNCIATION
(see catalog 24)

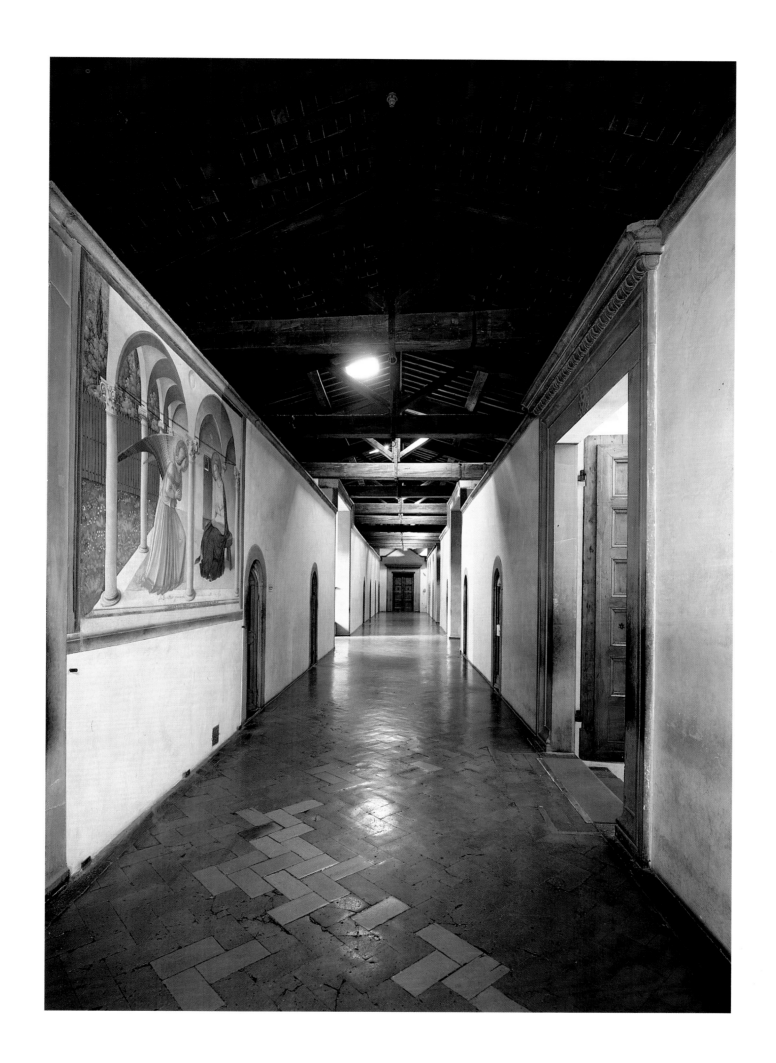

CRUCIFIXION WITH ATTENDANT SAINTS

I looked long; one can hardly do otherwise. The fresco deals with the pathetic on the grand scale, and after taking in its beauty you feel as little at liberty to go away abruptly as you would to leave church during the Sermon. . . . The three crosses rise high against a strange completely crimson sky, which deepens mysteriously the tragic expression of the scene, though I remain perforce vague as to whether this lurid background be a fine intended piece of symbolism or an effective accident of time. . . . Between the crosses, under no great rigour of composition, are scattered the most exemplary saints—kneeling, praying, weeping, pitying, worshipping. . . . Everything is so real that you feel a vague impatience and almost ask yourself how it was that amid the army of his consecrated servants Our Lord was permitted to suffer. . . .[50]

Thus Henry James responded to this *Crucifixion* in 1874. He felt, rightly, as though he had been to church. The *Crucifixion* is not an illustration of any one of the four Gospel accounts of this historical event. In Fra Angelico's conception, neither soldiers nor mockers are privileged to share the vision of the saintly witnesses at the foot of the cross. The strange red sky is an effect of time and abrasion, not artistic intention, but its unreality does not disturb us any more than it did James.

The reconstruction, decoration, and rededication of San Marco in 1443 were carried out before the eyes of all Christendom, still in Florence for the Council of the Union. Although Henry James praised its seeming informality of composition, the content of this great fresco was carefully deliberated to reflect this unprecedented convergence of religious and historical events. The identity of San Marco as a Dominican convent is conveyed by the central position afforded to Saint Dominic, who kneels at center, and to the portraits of Dominican saints and elders that constitute the lower border of the lunette. Saints Thomas Aquinas and Peter Martyr are shown in the main field at the far right.

The Calvary group of the three Maries and Saint John is confined to the narrow space between the crosses of the good thief, left, and Christ. Almost a third of the fresco, at far left, is dedicated to what might be termed a "civic" contingent of saints. Cosmas and Damian and Saint Lawrence are the protectors of Cosimo and Lorenzo de' Medici. The evangelist Saint Mark, titular saint of the convent, shows his gospel; John the Baptist, the protector of Florence, directs the viewer's attention to the Crucifixion.

On the other side of the painting, Saint Dominic has been represented as one of an extraordinary group of founders of other Christian orders, whom we would not expect to find illustrated in a Dominican chapter room, except for Saint Augustine, whose monastic rule they followed. Standing behind Dominic are, from left, Saints Ambrose, Augustine, Benedict, and Romuald. Kneeling, from left, are Saints Jerome, doctor of the church, Francis of Assisi, Bernard of Clairvaux, and Giovanni Gualberto.

The decisively ecumenical character of this assembly can only be understood as a reference to the *pax fidei*, or peace among Christians, that was the triumphant theme of the recently declared union of the Eastern and Western churches. In his address to the council sessions in Florence in 1439, Ambrogio Traversari had welcomed the reunion of the separated members of the mystical body of Christ. His imagery was drawn from the Letter to the Ephesians (2:13-18), a biblical source that must also have inspired the iconography of this *Crucifixion*[51] and the *Adoration of the Magi* fresco in Cosimo de' Medici's cell at San Marco (see page 160).

Detail of
CRUCIFIXION WITH ATTENDANT SAINTS
Fresco, 17 ft. 10½ in. ×
30 ft. 10½ in. (5.50 × 9.50 m)
Chapter Room,
Convent of San Marco, Florence
(see catalog 22)

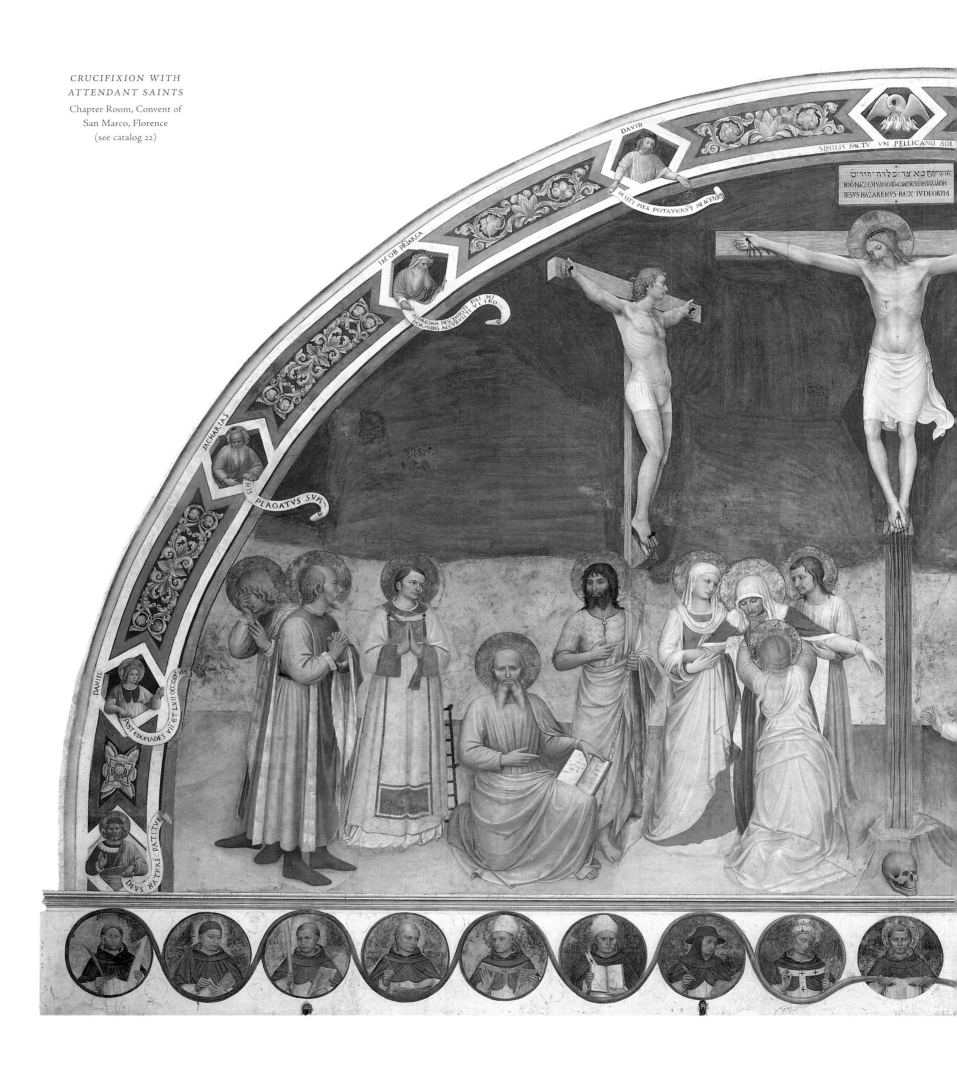

CRUCIFIXION WITH
ATTENDANT SAINTS
Chapter Room, Convent of
San Marco, Florence
(see catalog 22)

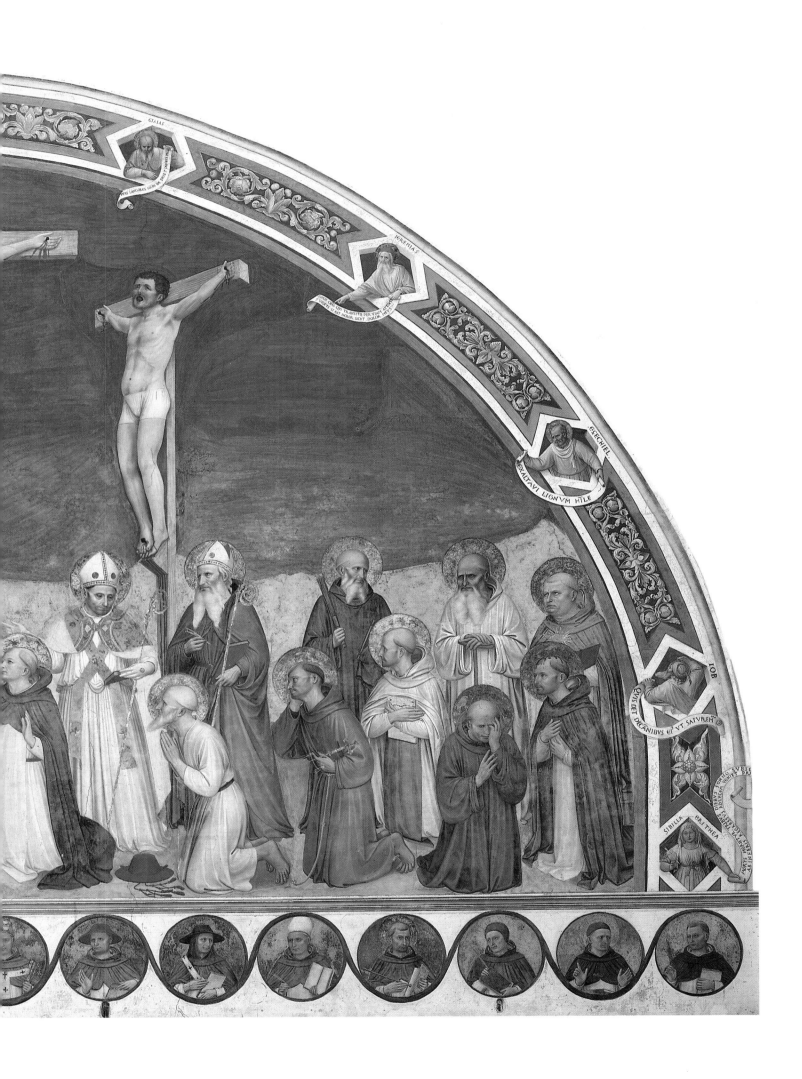

ANNUNCIATION

Saint Luke is the only evangelist to provide an account of one of the central mysteries of Christianity, the Incarnation of Christ in the Virgin Mary (1:26-38). The angel Gabriel was sent from God to Nazareth to the house of Mary, a virgin betrothed to a man named Joseph. The words exchanged between Gabriel and Mary are the source for most of the Marian liturgy of the Catholic church and have inspired countless pages of profound and pious analysis by theologians. "Hail, O favored one, the Lord is with you!" Mary was troubled at this saying and Gabriel responded, "Do not be afraid, Mary, for you have found favor with God. And behold, you will conceive in your womb and bear a son, and you shall call his name Jesus. He shall be great and the Lord God shall give unto him the throne of his father, David." When Mary asked how this could be, since she had no husband, the angel said to her, "The Holy Spirit shall come upon you and the power of the highest shall overshadow you. With God, nothing shall be impossible." Mary then said, "Behold I am the handmaid of the Lord."

The *Annunciation* on the inner wall of the north dormitory is Fra Angelico's most famous work. Millions of people love this painting, no doubt because they are touched by the tender faith of the Virgin, whose large eyes mirror her intelligence, and by the ineffable goodness of the angel Gabriel. Their two solitary figures are perfectly framed in the arches of a delicate loggia yet their relationship to the architecture seems natural and unmeditated. Nothing could be further from the truth, of course, but it is the genius of Fra Angelico that this image can be enjoyed on every level from the human to the divine.

The painting is replete with symbolism that ranges in complexity from the glorified "M" of Mary's loggia to the *fenestrum crystallinam*, the barely glimpsed window in the distant chamber that is a medieval attribute of Mary and specifically her intact virginity.[52] The garden at her doorstep is no simple meadow, but paradise itself, since Mary was conceived without original sin. The Dominican doctor Albertus Magnus developed an entire theory that the *locus*, or place, of an event is not understood as neutral space but as a "virtue" capable of engendering the forms within it.[53] This interpretation was supremely appropriate for the Virgin who held in her womb the Incarnation. Mary herself is a *locus* in this view, and any place where she is represented becomes another of her attributes.

Few observers of the time would have overlooked the extraordinary representation of the Virgin's chamber as a classical loggia designed by Michelozzo. This *Annunciation* is a veritable emblem of San Marco after its renovations, and it is still serving that purpose today. The evocation of the adjacent library is extremely significant because, as Albertus Magnus explained, Mary, among her infinite qualities, is herself a library. When Saint Luke affirmed that Mary "kept all these words to herself," he meant that she held the Word and all the holy scriptures within herself.[54] Nor did any visitor or friar need to be reminded that Mary is also a temple, a theological concept that explains one of the longest-standing enigmae in architectural history, namely, Michelozzo's decision to give the first public library the form of a Roman basilica.

The *Annunciation* on the inner wall of the north dormitory was placed at the intersection of the secular and clausura zones on the upper level of the convent. A large inscription at the base of the fresco enjoined the friars to say the Ave Maria, based on the greeting spoken by Gabriel, every time they passed this fresco. Secular visitors to the library were invited to express their own devotion to the Virgin; the Annunciation was

Detail of
ANNUNCIATION
Fresco, 90½ × 117 in.
(230 × 297 cm)
Convent of San Marco, Florence
(see catalog 24)

ANNUNCIATION
Convent of San Marco, Florence
(see catalog 24)

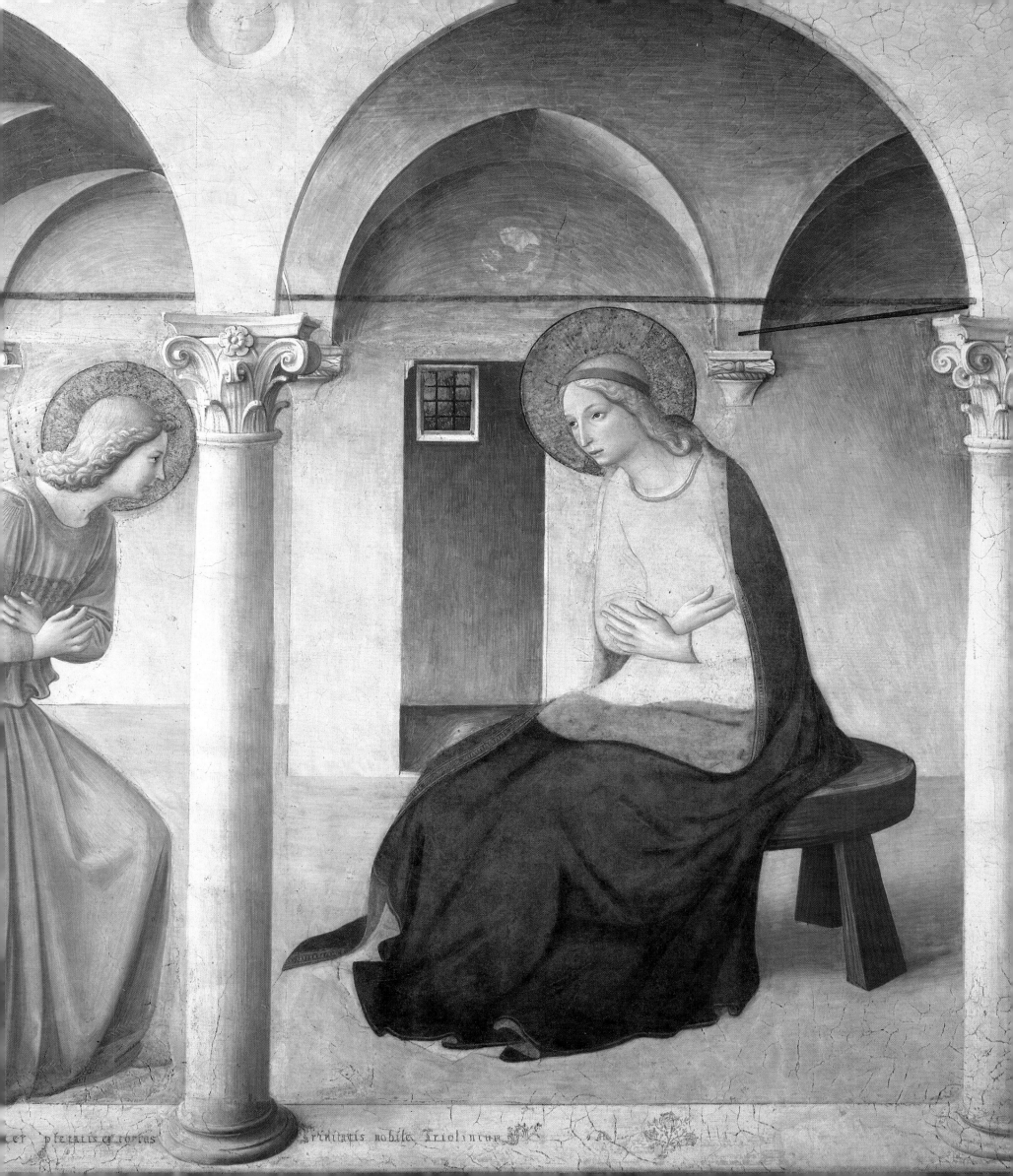

virtually a Florentine emblem, in part because of the dedication of the cathedral to Santa Maria del Fiore and in part because of the miraculous image of this subject nearby at Santissima Annunziata.

Only the friars who were privileged to enter the dormitories *in clausura* could know that this fresco marked the initiation of an extraordinary cycle of paintings dedicated to meditations on the three central tenets of the redemption brought by Christ: Incarnation, Passion, and Resurrection. The Little Office of the Madonna encapsulates these three concepts in words that emphasize their theological unity: "Instill your grace in our spirit, O Lord; you, who revealed by the annunciation of the angel the incarnation of your Son, lead us through his passion and death to the glory of the Resurrection."[55]

The *Annunciation* is placed so that it is nearly opposite Angelico's *Crucified Christ Adored by Saint Dominic*, the towering Passion representation that dominates the east, or clerics', dormitory of San Marco. On the inner wall, opposite cells 5 and 6, the *Madonna delle ombre*, a celestial vision of a *sacra conversazione*, completes this sequence of faith. It has never previously been observed that these three frescoes constitute the paradigmatic declaration of the theme that Fra Angelico proceeded to explore in subtle variations in the triple triads of cells 1 to 9.

Detail of
ANNUNCIATION
Convent of San Marco, Florence
(see catalog 24)

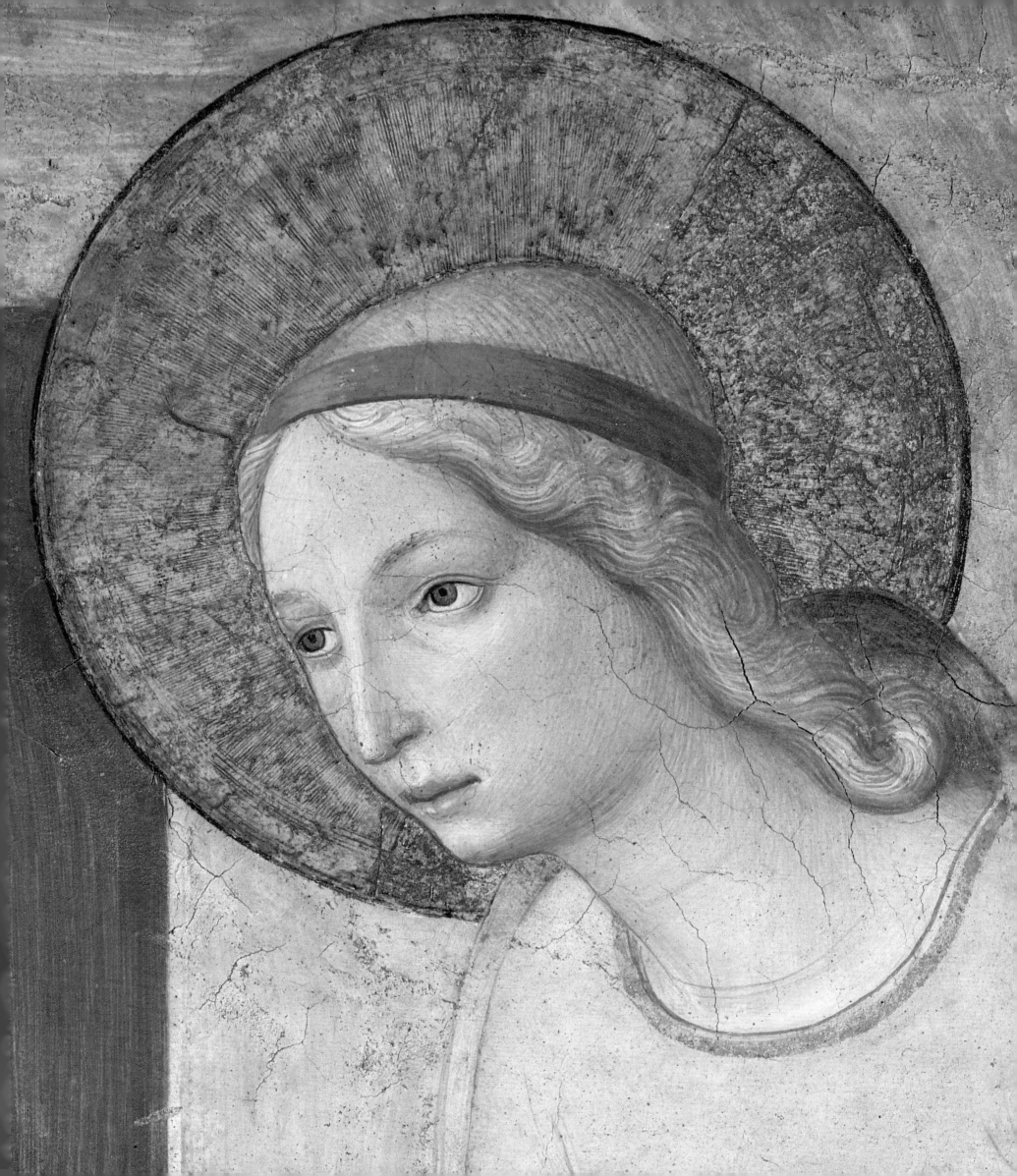

MADONNA AND CHILD ENTHRONED WITH

EIGHT SAINTS (MADONNA DELLE OMBRE)

The Madonna and Child are represented enthroned on a dais in front of an apsidal recess. The canopy is surmounted by an attic, which is supported by fluted Corinthian pilasters. On either side of the throne we see a wall divided by Corinthian pilasters of larger dimension. The Madonna gazes tenderly at the child, who directly addresses the spectator with a sign of benediction. The global orb in his other hand is the attribute of Christ the King. Eight saints attend the Madonna and child in *sacra conversazione*. To the left stand Saints Dominic, Cosmas, Damian, and Mark. On Saint Dominic's book are written the words he spoke on his deathbed admonishing his friars to be charitable, humble, and poor. Saint Mark shows his Gospel, of which the first two verses are clearly legible. On the right side of the throne stand Saints John the Evangelist, Thomas Aquinas, Lawrence, and Peter Martyr.

The company of saints is essentially the same that appears in the San Marco Altarpiece in the adjacent church. Paul Muratoff praised the ample space separating the throne from the lateral saints. "No one but Fra Angelico himself could so gracefully have combined those groups of figures according to the rhythmic formula of three plus one."[56] Langton Douglas was similarly moved: "How beautiful is each separate note in this ten-toned chord!"[57]

The *Madonna delle ombre* is the only painting in the convent that was not carried out in pure fresco technique. This work alone was painted by Fra Angelico with pigments in tempera applied *a secco* to an underpainting of fresco on the wall.[58] The reasons that inspired this exception are not known, but the colors of this painting are noticeably richer and more brilliant as a result.

The popular title of this painting located midway in the east dormitory of the clerics refers to the delicate and inexplicably touching shadows that are cast upon the wall by the Corinthian capitals. The light entering from the end of the corridor, through a window in the facade of the convent, is the ostensible cause of these shadows, but there is no reason to think that this observation is a piece of gratuitous naturalism on the part of Fra Angelico. The explanation for this motif must lie somewhere in the vast possibilities of meanings associated with the shadow image in western culture.

Like the beloved in the Song of Songs of Solomon (2:3) with whom she is traditionally identified, the Virgin is seated "under His shadow with great delight."[59] The shadow of God covered Mary at the moment of the Incarnation; their presence harks back to the *Annunciation* that inaugurates the triad of frescoes in the upper corridors of San Marco.

Shadows also possess connotations of unreality that may constitute another level of meaning in this work. It is in this sense that the image of shadows is invoked in the Letter to the Hebrews (8:1-5). Speaking of Jesus, Saint Paul writes: "Now this is my main point: just such a high priest we have . . . in the heavens. . . . Now if he had been on earth, he would not even have been a priest, since there are already priests who offer the gifts which the [old] Law prescribes, though they minister in a sanctuary which is only a copy and a shadow [*umbrae*] of the heavenly."

The lesson that this text would have imparted to the friars as they contemplated the *Madonna delle ombre* was the reminder that the painter's vision of the heavenly personages was as fictive as those shadows on the wall.

In this instance, the apostle found himself in accord with Plato's warnings on the illusory quality of art.[60] The Florentine humanists of this generation would have known the philosopher's words by heart: "The art of representation is therefore a long way removed from truth, and it is able to reproduce everything because it has little grasp of anything, and that little is of a mere phenomenal appearance."[61] These concepts received their fullest expression in the shadow imagery in the parable of the cave, in the same book.

We need not conjecture that the friars were reading Plato, although his works were readily available in their library. The program for Fra Angelico's frescoes in the friars' dormitories was primarily drawn from the mystical texts of Pseudo-Dionysius the Areopagite, the most Platonic of early church fathers.[62] In a recent analysis Georges Didi-Huberman has demonstrated that Dionysian concepts of "dissimilarity" justify and explain the four large panels of trompe l'oeil marble that provide the base for this fresco. These luxurious patterns of precious stones at first glance seem incongruous in the austere whiteness of the convent, but there is ample pictorial precedent to support their interpretation as mystical evocations of marble altars and tombs, either of which could be appropriately represented underneath this painting. "Dissimilar" images were preferable to resemblant ones, because, Pseudo-Dionysius explained, nothing can resemble God: "He is formless." The polychrome panels painted by Fra Angelico do not consist of precious stone any more than his brush can claim to have portrayed the face of God.[63]

As I have discussed in the introductory essay, Angelico's frescoes in the south and east dormitories *in clausura*, where the *Madonna delle ombre* is situated, comprise a cycle dedicated to meditations on the Incarnation, the Passion (suffering and death), and the Resurrection of Christ. The purpose of these Christian mysteries is the redemption of humankind and the ultimate union of our souls with God. Fra Angelico first declared this mighty theme in his three frescoes in the corridors on the upper floor of San Marco. The *Madonna delle ombre* is the third of this series; in addition to the Resurrection, its subject also represents union with God, because the *sacra conversazione* of the saints with the Madonna and Child takes place in heaven after the resurrection of their spirits.[64] The *Madonna delle ombre* is therefore the logical culmination of the other two corridor frescoes, the *Annunciation*, representing the Incarnation, and the monumental Passion scene, *Crucified Christ Adored by Saint Dominic*.

The splendor of this cycle of frescoes has struck many viewers as out of character for a convent of Observant Dominicans. A justification for this departure from the Dominican constitutions, which restricted the decoration of the cells, can be found in the *Ecclesiastical Hierarchy* of Pseudo-Dionysius the Areopagite, the basis of the San Marco program, where the patristic author states, "The heavenly beings, because of their intelligence, have their own permitted conceptions of God. For us, on the other hand, it is by way of the perceptible images that we are uplifted as far as we can be to the contemplation of what is divine."[65] Although the dates and identity are now in dispute for this church father, who was supposed to be the direct pupil of Saint Paul, the authority of Pseudo-Dionysius was unquestioned throughout the Middle Ages. The Dominican Angelic Doctor, Saint Thomas Aquinas, quoted Dionysius about seventeen hundred times.[66]

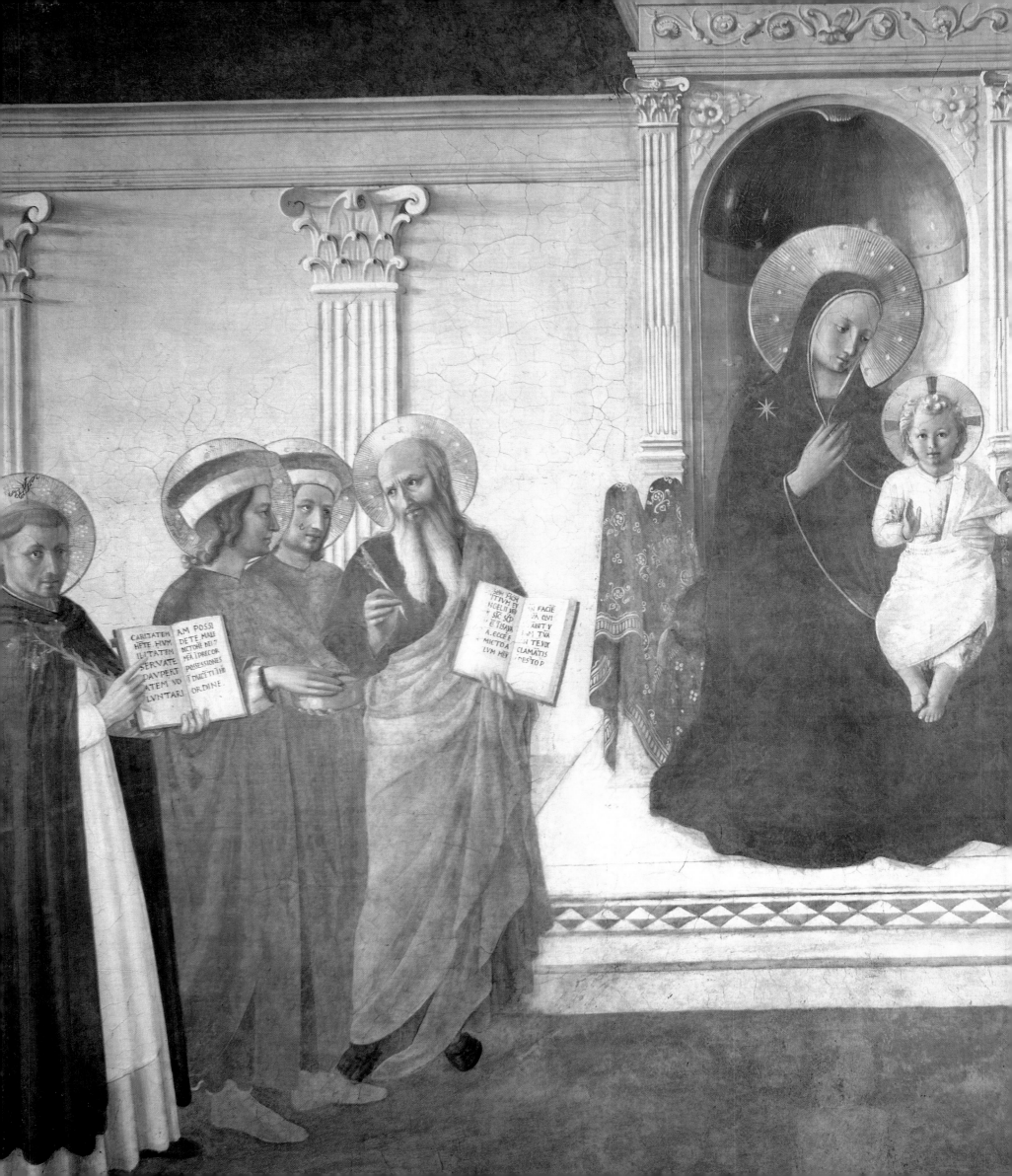

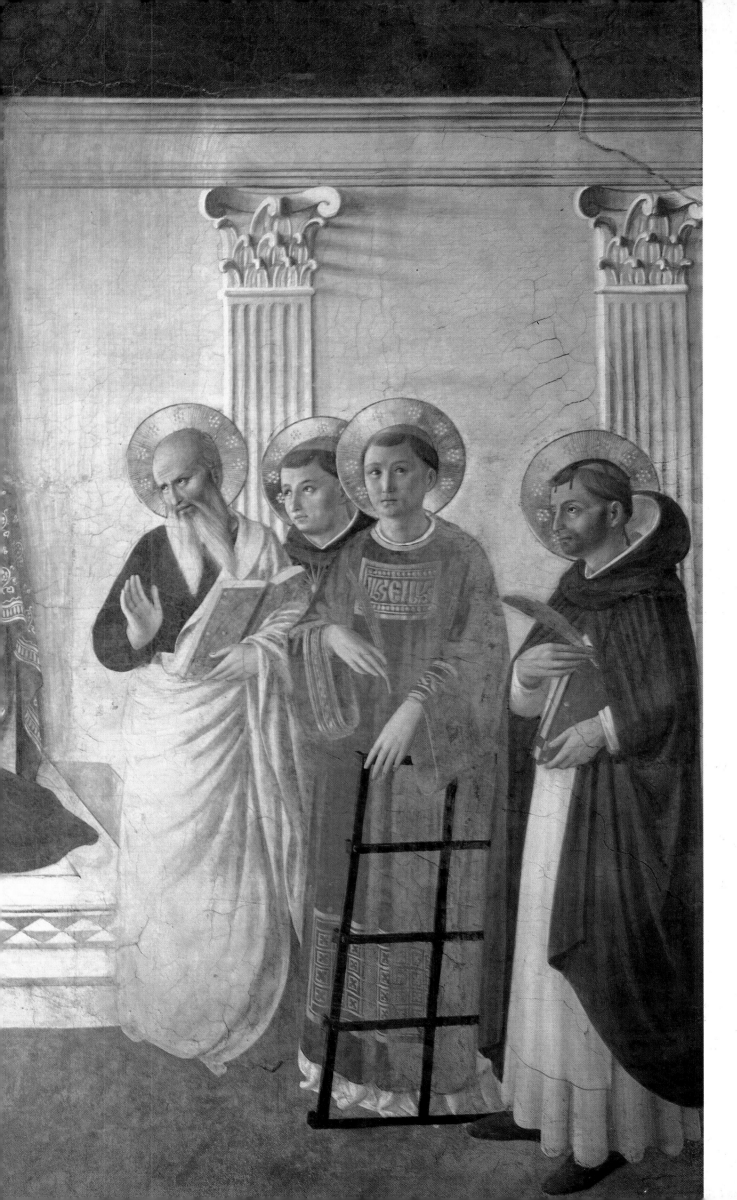

VIRGIN AND CHILD
ENTHRONED WITH
EIGHT SAINTS
(*MADONNA DELLE OMBRE*)
Fresco and tempera, 6 ft. 4 in. ×
8 ft. 10½ in. (1.95 × 2.73 m); with
marble base, 10 ft. 5 in. ×
8 ft. 10½ in. (3.20 × 2.73 m)
Convent of San Marco, Florence
(see catalog 26)

THE PRIESTS' CELLS: The First Triad

▸ CELL 1: *Noli me tangere* ▸ CELL 2: *Lamentation* ▸ CELL 3: *Annunciation*

The frescoes in cells 1 through 9 have always been admired as the most fully realized and the most mystical of Fra Angelico's paintings at San Marco. These nine frescoes were conceived by Fra Angelico as spiritual exercises corresponding to the third and highest level, which represents perfection, of the *Ecclesiastical Hierarchy*, a major tract by Pseudo-Dionysius the Areopagite. For an explanation of the Dionysian program of the San Marco frescoes the reader is referred to pages 64–69.

Although the frescoes in cells 1 through 9 do not adhere to the customary biblical sequence, their arrangement is far from random. The number nine immediately recalls the classic Dionysian scheme of the triple triad. Indeed, the frescoes are readily divided into three triads containing meditations on the mysteries of the Incarnation, the Passion, and the Resurrection of Christ—the same triad of Christian redemption that is expressed in the three frescoes in the corridors. But these connections could not be discerned by the uninitiated and were not intended for their eyes. Only the ordained priests, who had profoundly contemplated the Christian mysteries, would understand that the frescoes in these nine cells were grouped and ordered in accordance with their theological meanings and not according to the names of their images. Thus, *Noli me tangere*, the *Lamentation*, and the *Annunciation* comprise a complete triad encompassing the Resurrection, the Passion, and the Incarnation, in that order. In cells 1 through 9, the three mysteries are revealed in triads, but never in precisely the same sequence—an effective, if mystical, demonstration of the indivisible wholeness of Christian dogma.[67]

The choice of *Noli me tangere* as the first subject in this row of cells has always perplexed those accustomed to paintings as illustrations of biblical narratives. Yet this episode, in which the resurrected Jesus said to the Magdalene, "Touch me not, for I am not yet ascended to my Father," is a perfect emblem of a number of Dionysian concepts that are crucial to the meaning of this final and highest hierarchy. The goal of every hierarchy, said Pseudo-Dionysius, is union with God.[68] In the *Noli me tangere* of cell 1, the immortal soul is liberated from the body; in the *Coronation of the Virgin* in cell 9 the sequence of frescoes culminates in an image of the union of the Virgin's soul with God.

The three frescoes in this first triad are visually unified by the artist's depiction in each of a tomb or enclosed vaulted space. According to Thomas Aquinas the sepulcher of Christ could be understood as a symbol of Mary's virginal womb, which was similarly glorified by the passing through it of the body of Christ.[69] In the *Annunciation* in cell 3 the enclosed loggia is a visual metaphor of Mary as the sacred receptacle of the Incarnation. The shadow that passed over Mary at the Incarnation (Luke 1:35) is prominently depicted on the wall behind her. The association of womb and tomb is a powerfully compressed statement on mortality; it alludes, moreover, to Mary's foreknowledge of the Passion of Christ, even at the instant of his Incarnation.

The Annunciate Virgin in cell 3 is shown as distinctly lower in position than the Angel Gabriel, a striking departure from the traditional iconography (because at the Annunciation Mary was instantly exalted above all the angels). This emphasis upon her humility underscores the aspect of the Annunciation as an epiphany—a revelation of God to a mortal person. The frescoes in cells 6 and 9, which are each the final component in their respective triads, also have this quality of epiphany.

NOLI ME TANGERE
Fresco, 65⅜ × 49¼ in.
(166 × 125 cm)
Cell 1, Convent of San Marco, Florence
(see catalog 27)

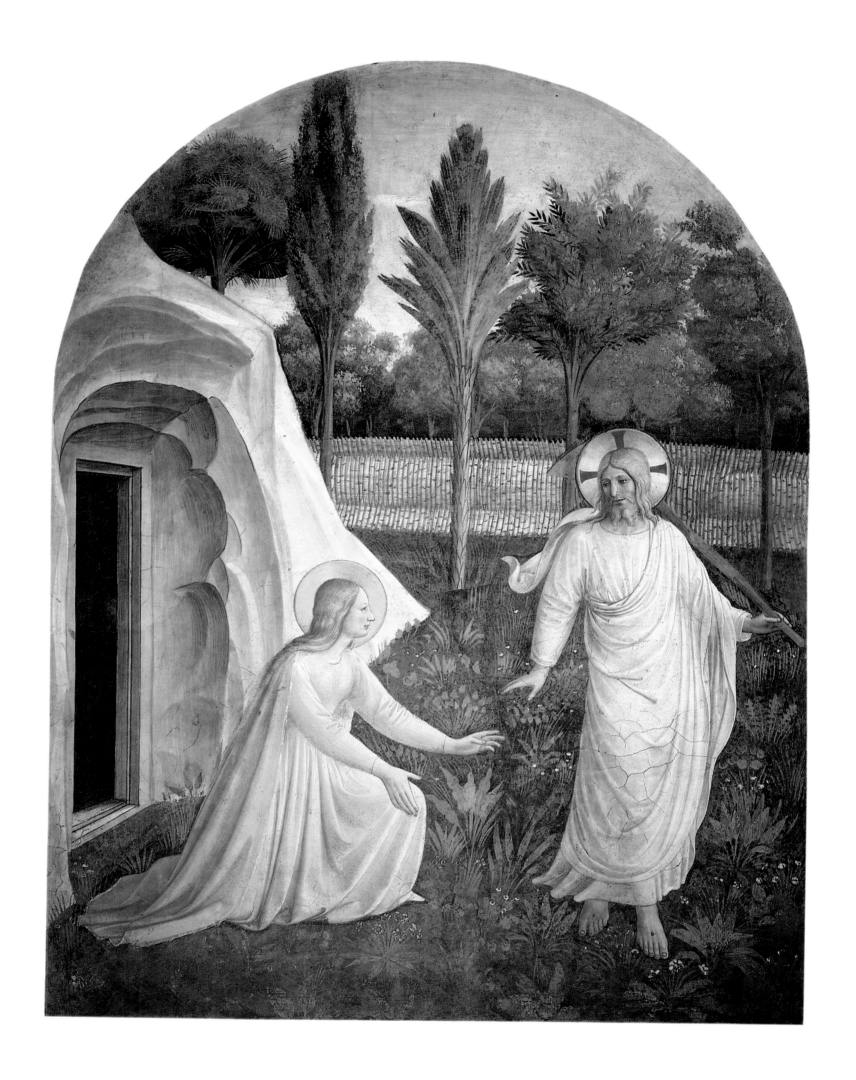

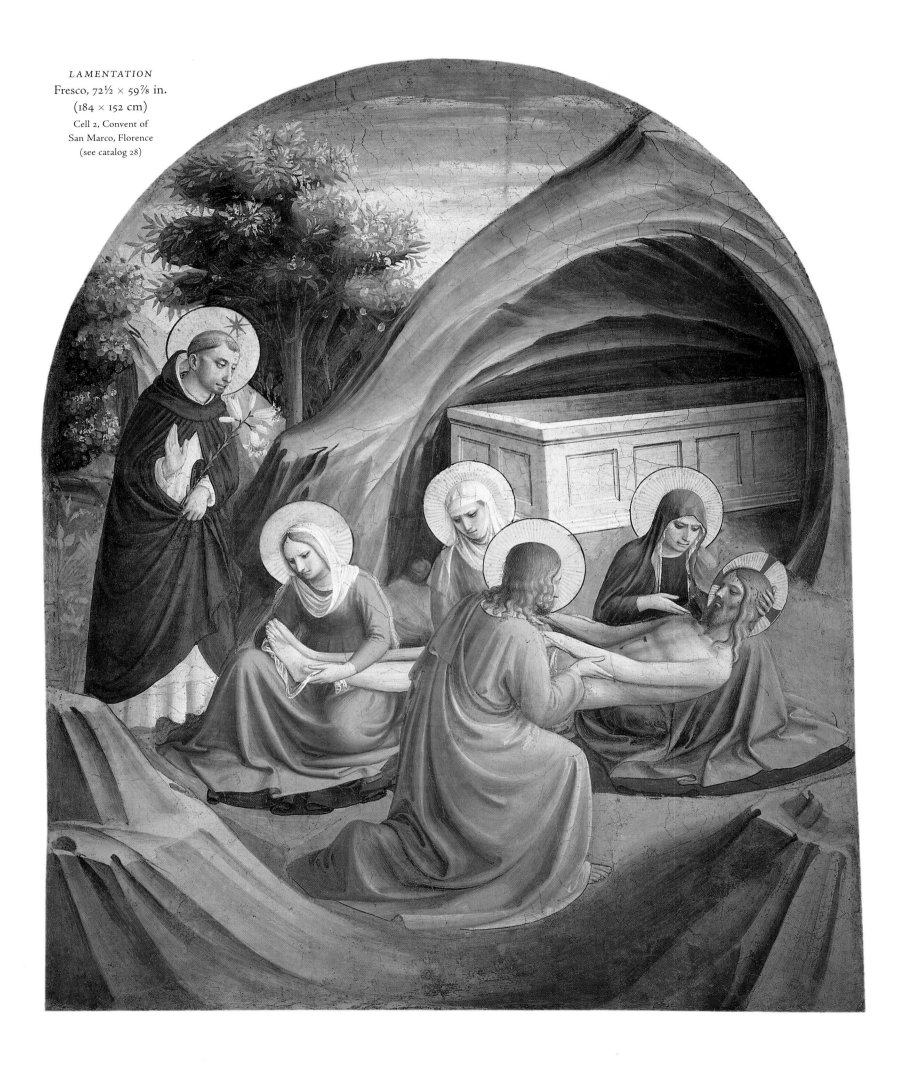

LAMENTATION
Fresco, 72½ × 59⅞ in.
(184 × 152 cm)
Cell 2, Convent of
San Marco, Florence
(see catalog 28)

ANNUNCIATION
Fresco, 69¼ × 58¼ in.
(176 × 148 cm)
Cell 3, Convent of
San Marco, Florence
(see catalog 29)

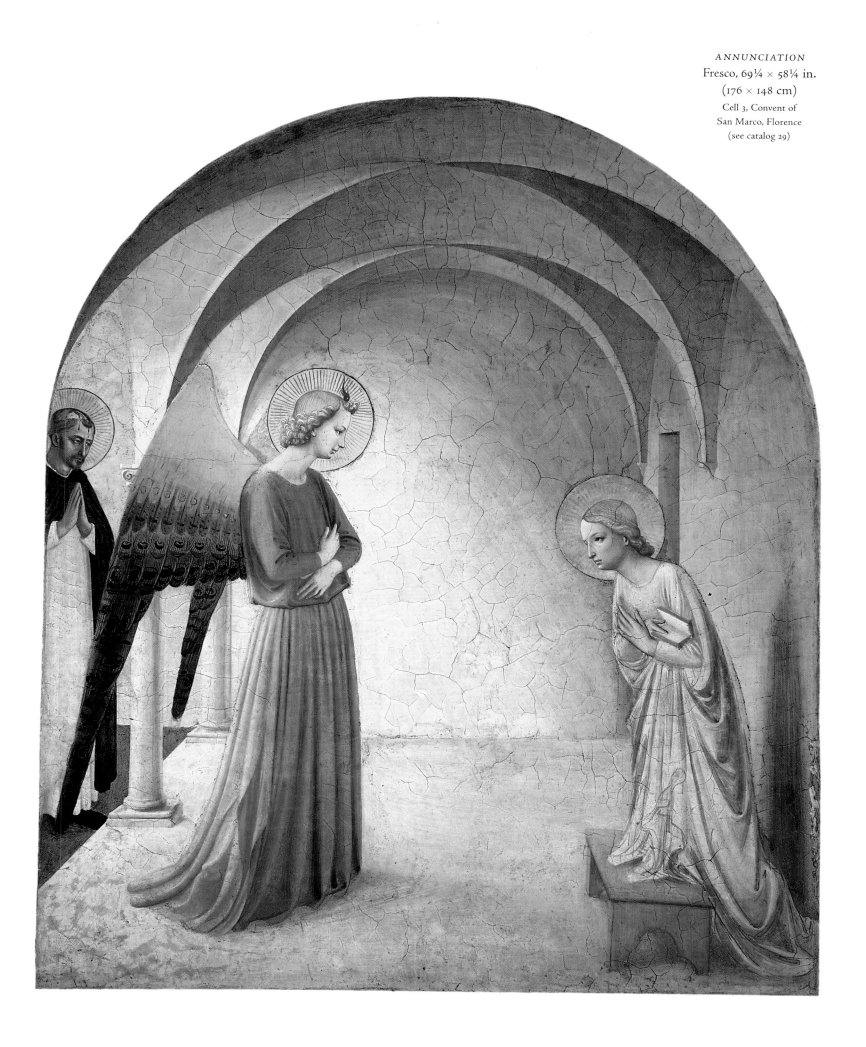

THE PRIESTS' CELLS: The Second Triad

▸ CELL 4: *Crucified Christ with Saint John the Evangelist, the Virgin, and Saints Dominic and Jerome* ▸ CELL 5: *Nativity* ▸ CELL 6: *Transfiguration*

The second triad begins with the Cross and concludes with the outstretched arms of Christ transfigured on Mount Tabor. Even in the central image, the *Nativity*, Fra Angelico has superimposed a cross, shaped like a Greek tau, on the front of the manger at Bethlehem. In the second triad the biblical stories are meditated in the sequence Passion, Incarnation, Resurrection.

In each of these three paintings, the symmetry and simplicity of the figurative arrangements are strongly reminiscent of Giotto and the trecento. The rocky setting of the *Crucifixion* in cell 4 does not refer even remotely to the actual environs of Golgotha; its v-shaped framing of the cross is a Giottesque motif that Fra Angelico employed throughout San Marco.

The *Nativity* in cell 5 has always aroused comment as the sole painting in the first nine cells where the intervention of assistants can readily be detected. Fra Angelico apparently painted the figures in the foreground, but the angels on the roof of the stable and other passages of the background are too weak to be ascribed to the master. Assistants may also have worked on the landscape setting of the *Crucifixion*; the splendid *Transfiguration* is a masterpiece entirely executed by Fra Angelico.

The participation of Saints Dominic and Jerome in the *Crucifixion*, of Saint Catherine of Alexandria[70] in the *Nativity*, and of Saint Dominic and the Virgin in the *Transfiguration* in cell 6 ensures that none of these images can be read as illustrations of the historical events described in the Bible. Saint Dominic, as founder of the order, is portrayed as the exemplary worshiper in most of the frescoes at San Marco. These are the only two frescoes in which Saints Jerome and Catherine of Alexandria are cast in this role. The meanings that could be inferred from the inclusion of the classical doctor of the church are too numerous to cite; in the present context, it is significant that Saint Jerome underscored the distinction between the *historia*, or text, of the Bible, and *tropologia*, the science of penetrating the Bible's depths of allegorical meaning.[71]

The second triad concludes with the *Transfiguration*, which is described by the three synoptic gospels in nearly identical terms. Jesus took the apostles Peter, James, and John with him and went up a high mountain. As he prayed, "He was transfigured before them, and his face shone like the sun, and his garments became white as light" (Matthew 17:1-8). It was the opinion of early Christian writers that the transfigured Christ provided the Apostles with a first glimpse of a Resurrection so glorious that their eyes were blinded.[72] Pseudo-Dionysius the Areopagite also related this event to the Resurrection that awaits all the faithful. "But in time to come . . . we shall be ever filled with the sight of God shining gloriously around us as once it shone for the disciples at the divine Transfiguration."[73]

The compositional structure in the *Transfiguration* is based upon Taddeo Gaddi's panel, c. 1340, of this subject (now in the Galleria dell'Accademia, Florence), but the cruciform pose of Christ is a brilliant theological invention by Fra Angelico. His outstretched arms are a declaration that the cross is the measure of all things. The Transfigured Christ placed among Elijah, Moses, and the Apostles represents "the Lord of both the Old and New Covenants."[74] The glowing nimbus resembles an ardent flame and can be read as the sun, or even, for its ovoid shape, as a symbol of the whole world.[75]

CRUCIFIED CHRIST WITH SAINT JOHN THE EVANGELIST, THE VIRGIN, AND SAINTS DOMINIC AND JEROME
Fresco, 70⅛ × 59 in.
(178 × 150 cm)
Cell 4, Convent of San Marco, Florence
(see catalog 30)

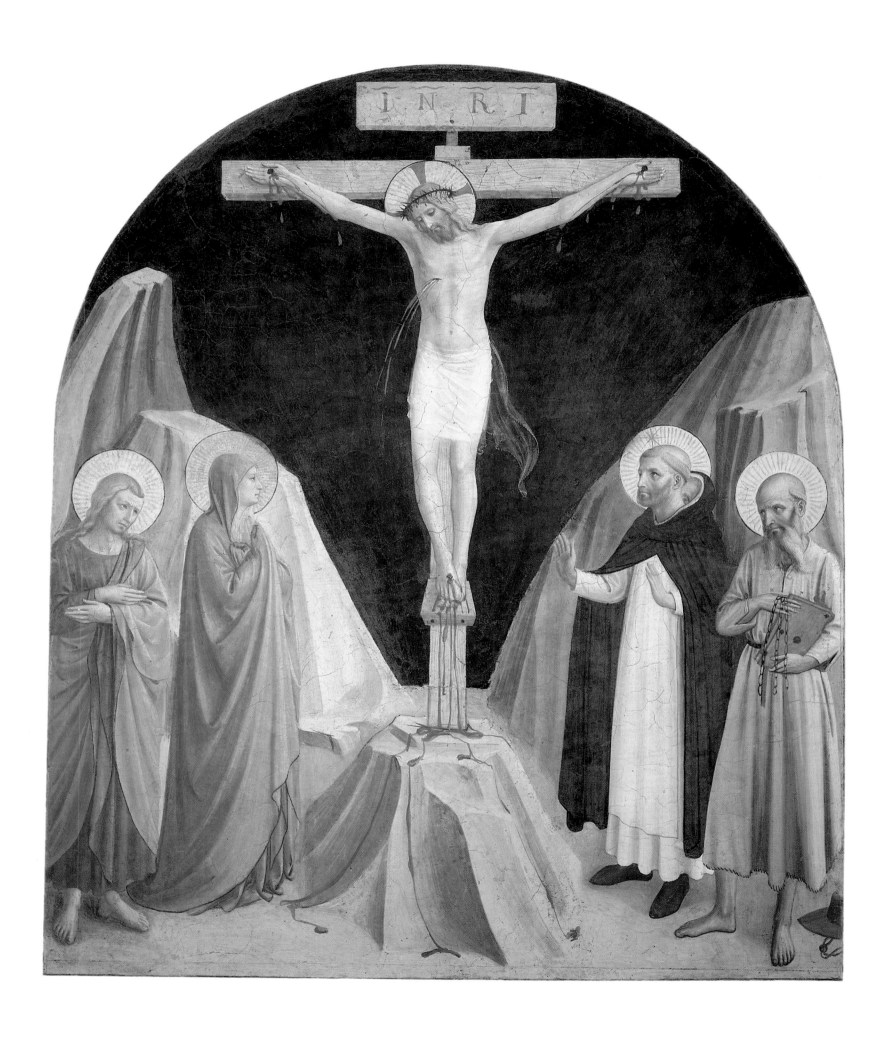

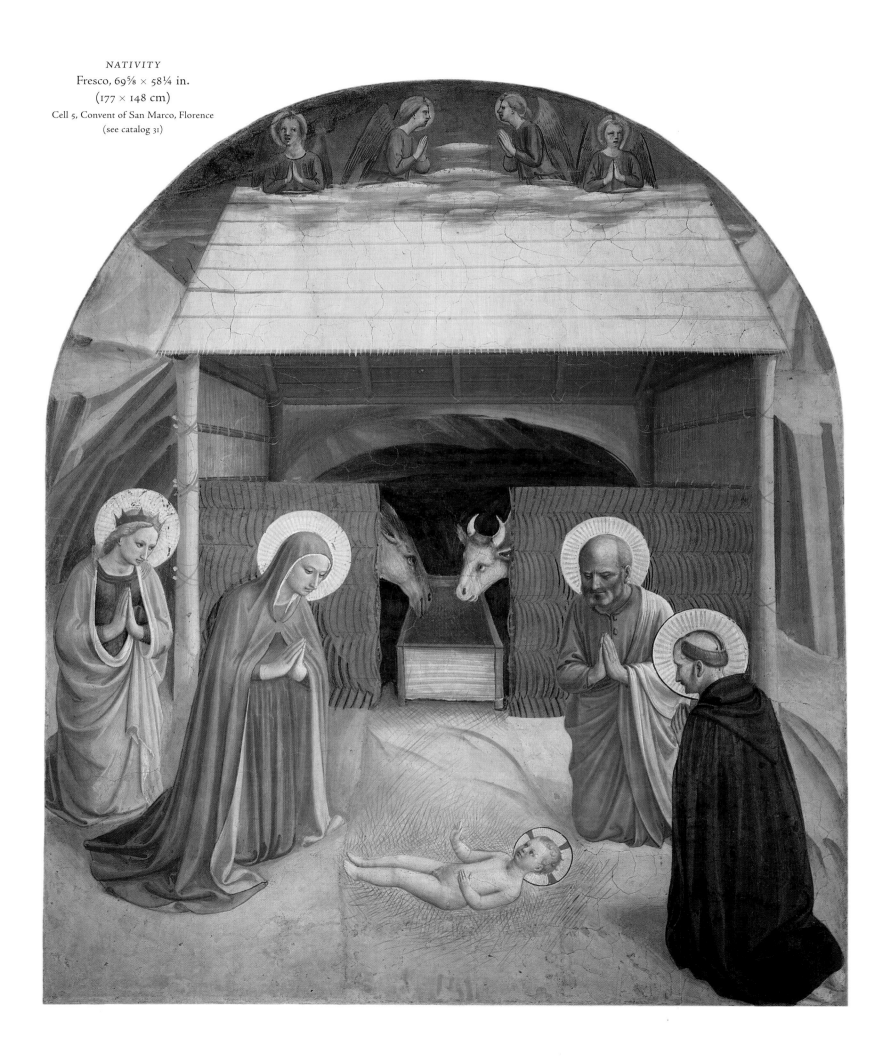

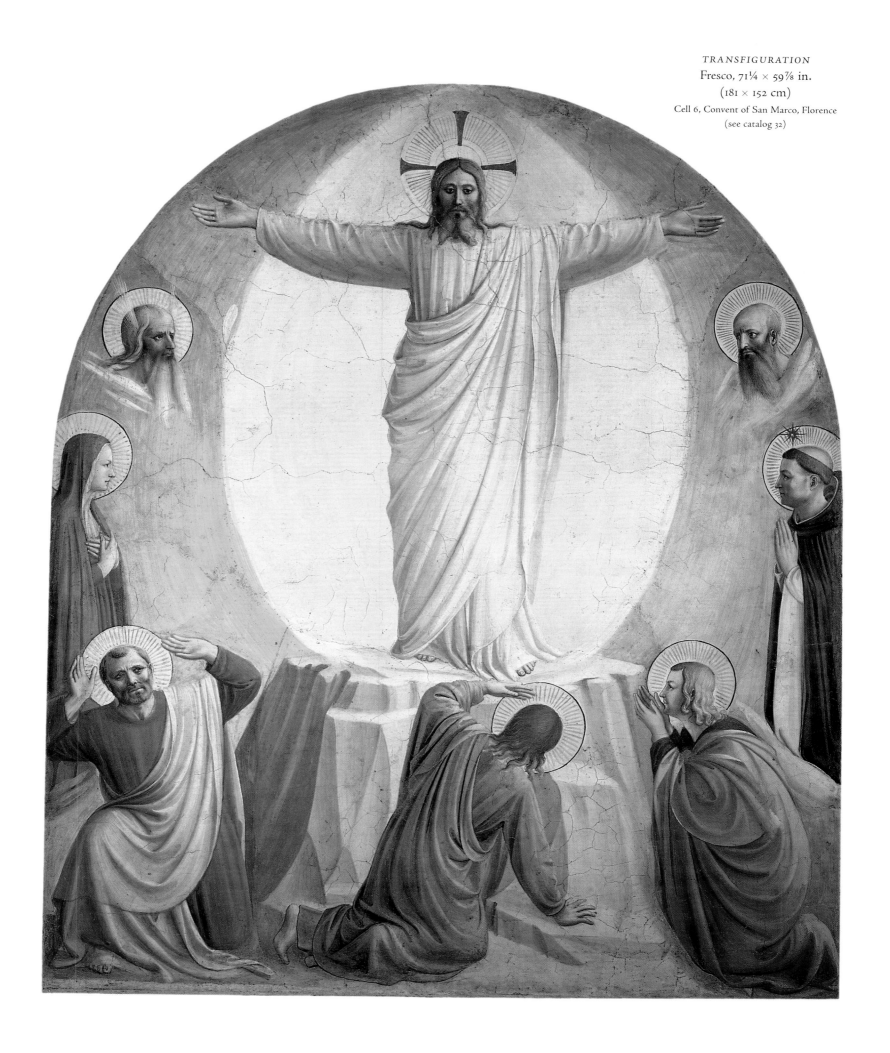

THE PRIESTS' CELLS: The Third Triad

▸ CELL 7: *The Mocking of Christ with the Virgin and Saint Dominic* ▸ CELL 8: *Christ Resurrected and the Maries at the Tomb* ▸ CELL 9: *Coronation of the Virgin*

The third and final triad of cells departs from the established pattern in order to bring the hierarchy to its majestic conclusion. The Passion and the Resurrection of Christ are represented in this final sequence by *The Mocking of Christ* in cell 7 and *Christ Resurrected and the Maries at the Tomb* in cell 8. The *Coronation of the Virgin* in cell 9 symbolizes union with God, the goal of every hierarchy, according to Pseudo-Dionysius the Areopagite.[76]

The violence and humiliation that Christ suffered from his jailors before he was crucified is evoked in cell 7 in an atmosphere of unearthly stillness. Angelico's depiction of only fragmentary details of the spitting, slapping tormentors was probably inspired by a famous *Man of Sorrows*, 1404, by Lorenzo Monaco (Galleria dell'Accademia, Florence).[77] The earlier picture could also have suggested to Fra Angelico the triangular arrangement of the two meditative witnesses: the Virgin, left, and Saint Dominic, right.[78] In all other respects the comparison with Lorenzo Monaco underscores the striking originality of Fra Angelico's conception. The space in this undefined place is rendered with a Renaissance clarity and coherence that accentuates the strangeness of the mocking symbols suspended in air.[79] Christ's eyes are closed by a blindfold—his expression is untroubled. He sits upright with a regal bearing; the orb in his hand symbolizes his dominion over all the world.[80] The insults of his captors do not distress him: they are the necessary fulfillment of the prophesies of redemption (Isaiah 50:6). The finely portrayed expressions of the Virgin and of Saint Dominic convey the same understanding. The Virgin averts her face, but she is not tearful as in a *Mater Dolorosa*. Saint Dominic attentively studies the scriptures. In Isaiah 53:5 Saint Dominic could read, "But he was wounded for our transgressions, he was bruised for our iniquities . . . and with his stripes we are healed."

Pictured in cell 8 are Mary Magdalene, Mary the mother of James, and the Virgin Mary, who brought spices to the tomb to anoint the body of Christ. Upon entering, they saw an angel, who said to them, "He has risen, he is not here; see the place where they laid him." (Mark 16:1-6). The composition of this fresco conforms closely to a fresco by the Giottesque artist, Giusto de' Menabuoi,[81] except in two important respects: the depiction of the risen Savior in a glorious mandorla, center, and of Saint Dominic in contemplation at left. The unconventional insertion of an image of Christ's risen soul provides a critical transition into the final painting of the cycle, in the adjacent cell 9, which does not represent the Incarnation in accordance with the triad pattern established in cells 1 through 6, but achieves instead the fruits of Christ's Redemption: union with God.

Enthroned upon clouds, the Son of God crowns his mother Queen of Heaven. This ritual is a mystical marriage between Christ and his church, which Mary symbolizes. The invisible and indescribable architecture of heaven is depicted as radiant clouds and rings of circles symbolic of unity, perfection, eternity. Below them on celestial clouds the spirits of Saints Thomas Aquinas, Benedict, Dominic, Francis of Assisi, Peter Martyr, and Mark are united in their contemplation with the infinite and eternal God. They are not blinded by the celestial brilliance, as the Apostles were at the Transfiguration, because they raise "the immaterial and steady eyes of their minds to that outpouring of Light."[82]

MOCKING OF CHRIST WITH THE VIRGIN AND SAINT DOMINIC
Fresco, 73⅝ × 59½ in.
(187 × 151 cm)
Cell 7, Convent of San Marco, Florence
(see catalog 33)

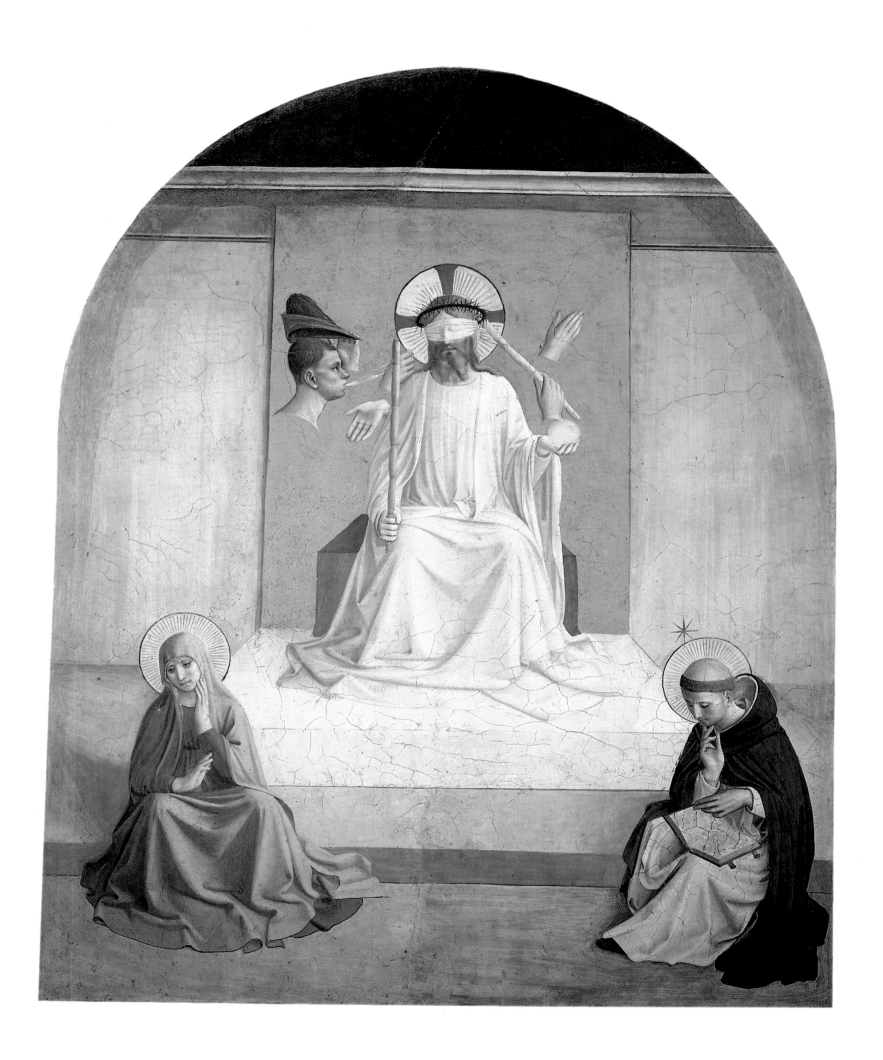

CHRIST RESURRECTED AND
THE MARIES AT THE TOMB
Fresco, 71¼ × 59½ in.
(181 × 151 cm)
Cell 8, Convent of San Marco, Florence
(see catalog 34)

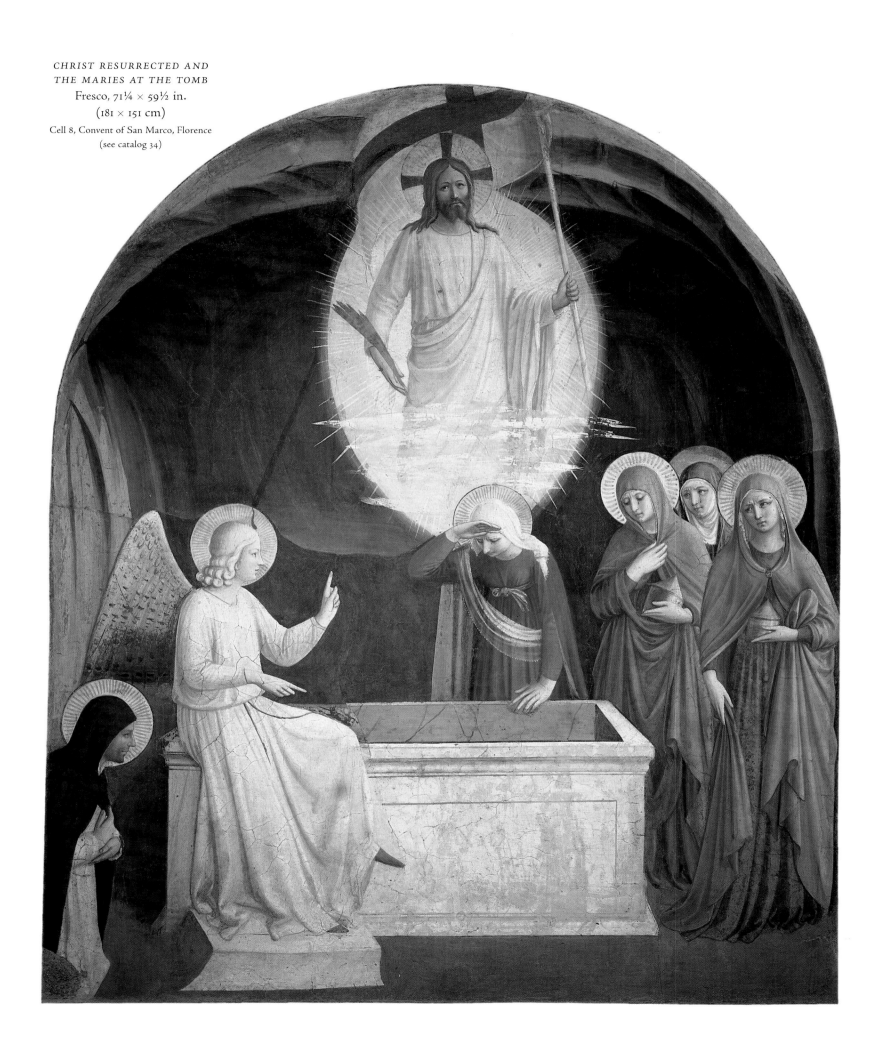

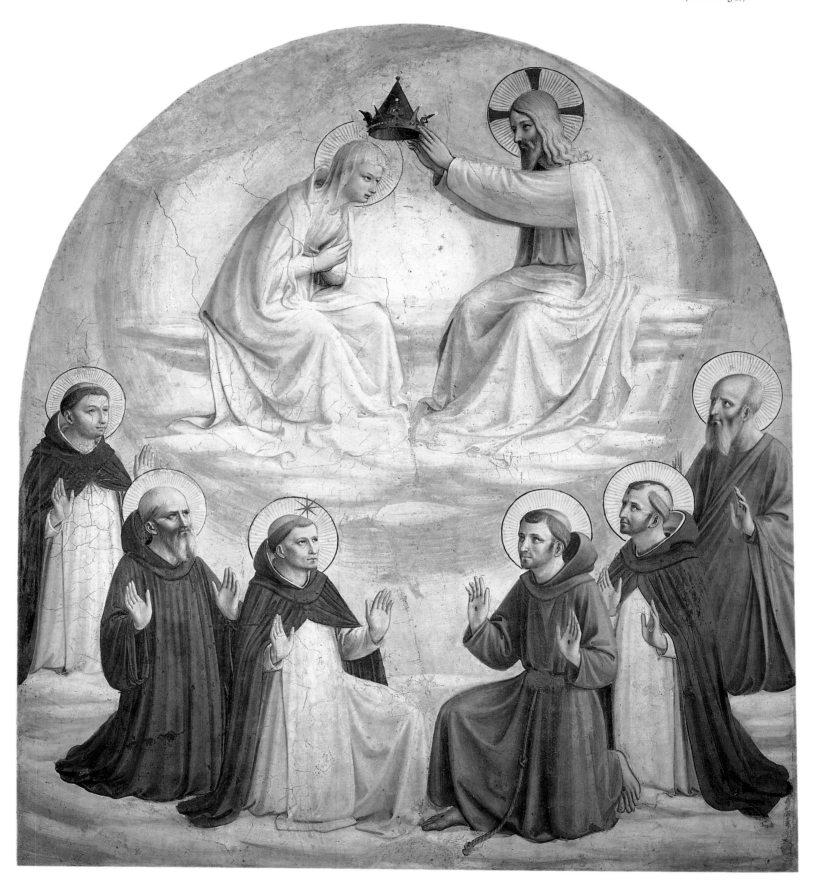

THE PRIOR'S DOUBLE CELL

▸ CELL 10: *Presentation in the Temple* ▸ CELL 11: *Madonna and Child Enthroned with Saints Augustine and Thomas Aquinas*

The double cell in the southeast corner of the convent has plausibly been identified as the habitation and office of the prior.[83] Its location at the intersection of the clerics' and the novices' dormitories was appropriate to the prior's double role as the senior priest of the convent and as the spiritual guide for the novices. The first occupant of this double cell was Fra Antonino Pierozzi, who was later canonized as Sant'Antonino in 1523. Fra Antonino was the prior at San Marco during the crucial period of its rebuilding and transformation into a convent of Observantist Dominicans. He was on good terms with Cosimo de' Medici and moved with ease in every stratum of Florentine society. In 1446, Fra Antonino was made Archbishop of Florence by Pope Eugenius IV, who acted—according to an old tradition—on the advice of Fra Angelico, who was then painting for the pope in Rome. Sant'Antonino was much loved by his episcopal flock for his unfailing generosity and inflexible integrity. His theological treatises are more distinguished for their practical good sense than for their originality. None of his writings includes any reference to Fra Angelico's paintings at San Marco, and it is not believed that he was the formulator of its erudite iconographic program.[84]

The frescoes by Fra Angelico in cells 10 and 11 representing, respectively, the Presentation in the Temple and the Madonna with Child Enthroned with Saints Augustine and Thomas Aquinas are appropriate to the functions of the prior. The reader will find photographs of these two frescoes in the catalog (36, 37); a color detail of the *Presentation in the Temple* is illustrated on the opposite page.

The education of the Dominican novices at San Marco was associated with the Feast of the Purification of the Virgin, a theme that coincides in the Bible with the presentation of the infant Jesus in the temple. According to the Gospel of Luke (2:25-35), the Lord had revealed to Simeon, traditionally a temple priest, that he would not die until he had seen the Messiah. He was very old on the day that the infant Jesus was presented in the temple of Jerusalem. In Fra Angelico's touching portrayal of Simeon, the aged priest regards the Christ child in his arms with great severity, but the child is not afraid.

The companion fresco in cell 11 represents the two saints appropriate to the spiritual leadership of the prior. The Dominicans followed the monastic rule attributed to Saint Augustine, one of the most revered doctors of the church. A comparable association of the enthroned Madonna and Child with Saint Augustine and a Dominican saint (Peter Martyr) is found on a panel by the Biadaiolo Illuminator, a Florentine painter of the mid-fourteenth century. The iconography of this gabled panel, now in the Lehman Collection of the Metropolitan Museum of Art, New York, assures its origin in a prominent Dominican foundation in Florence.[85] Saint Thomas Aquinas, the Angelic Doctor, was the greatest theologian of the Dominicans. His commentaries on the Bible and on the early church fathers were fundamentally influential on Roman Catholic doctrine.

Detail of
*PRESENTATION IN
THE TEMPLE*
Fresco, 67⅜ × 45⅝ in.
(171 × 116 cm)
Cell 10, Convent of San Marco, Florence
(see catalog 36)

COSIMO DE' MEDICI'S DOUBLE CELL

▸ CELL 39: *Adoration of the Magi*

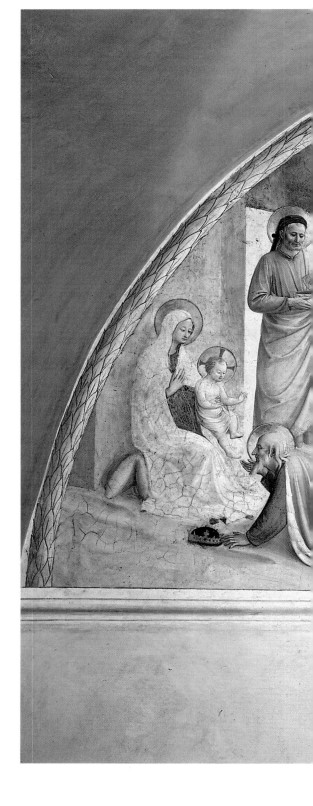

In recognition of his assistance to the convent Cosimo de' Medici received the extraordinary privilege of a double cell in the north dormitory, between the church and the library, to use as a private retreat. It was most unusual for a layman to maintain a cell in a friary, where only the prior enjoyed the convenience of two connected rooms, in any case. It was here that Eugenius IV spent the night of January 6, 1443, following the rededication of the Church of San Marco to Saint Mark, and to Cosimo's name saints, Cosmas and Damian.

The inner room, cell 39, is raised on steps as though it were the diminutive choir of a church. The small space is brightly decorated by an *Adoration of the Magi* frescoed in a lunette by Fra Angelico and assistants. A tabernacle with an image of the Corpus Domini is recessed into the wall in the middle of the lower edge of the *Adoration*. This niche must have been used to hold the Eucharist, which strongly suggests that this cell originally served as a private chapel with an altar installed beneath the tabernacle and fresco.[86] This rare privilege for a layman was possible only with pontifical authorization.

For the altarpiece of his chapel Cosimo chose to have illustrated the Adoration of the Magi, the same theme that Palla Strozzi had commissioned from Gentile da Fabriano in a famous polyptych for the sacristy of Santa Trinita. The story of the wise men from the East had powerful connotations for Florentine humanists, and had become a kind of emblem for Cosimo following his takeover of San Marco in 1436. The convent was the site of the Compagnia dei Magi, a religious confraternity that staged a magnificent procession with cavalcades and costumes every year on the feast of the Epiphany, January 6.[87] The rededication of the church on Epiphany 1443 was timed to coincide with this event. The thematic connection with the Council of the Union, which had declared the union of the Greek and Latin churches in 1439, and was still in session, could not have been more perfect.

According to the Gospel of Saint Matthew, when Jesus was born in Bethlehem, wise men from the East came to Jerusalem following a star. In Fra Angelico's fresco the Holy Family and the sainted Magi are neatly grouped on the left side of the lunette. A crowd of their retainers fills the other half of the painting. The child Jesus sits beneath a great monolith that has been convincingly identified by Padre Tito S. Centi as the cornerstone mentioned repeatedly in the scriptures.[88]

The specific source for Cosimo's *Adoration of the Magi*, however, is the Letter to the Ephesians, wherein Saint Paul speaks of Christ as the cornerstone of a new temple to hold the distant "strangers and foreigners" who were now reconciled by the sacrifice of Christ on the cross (2:16-21). The altarpiece in Cosimo's private chapel thus contains all the themes of his ecclesiastical patronage, including the reconstruction of San Marco, Fra Angelico's frescoes on the redemption of Christ and the union with God, and the Council of the Union.

In the *Adoration of the Magi*, Fra Angelico pictorially describes the process by which the disordered seekers on the right side of the lunette become progressively enlightened as they approach Christ.[89] At the center of the composition, on the vertical axis that descends to the Sacrament tabernacle, one of the Eastern visitors holds an armillary sphere, no doubt as an attribute of Christ's wisdom: an armillary sphere is comprised of several concentric spheres cut away into sections or rings so that the viewer can see their interrelationships. For Renaissance scholars, this mechanism would have been considered

ADORATION OF THE MAGI
Fresco, 68⅞ × 140½ in.
(175 × 357 cm)
Cell 39, Convent of San Marco, Florence
(see catalog 56)

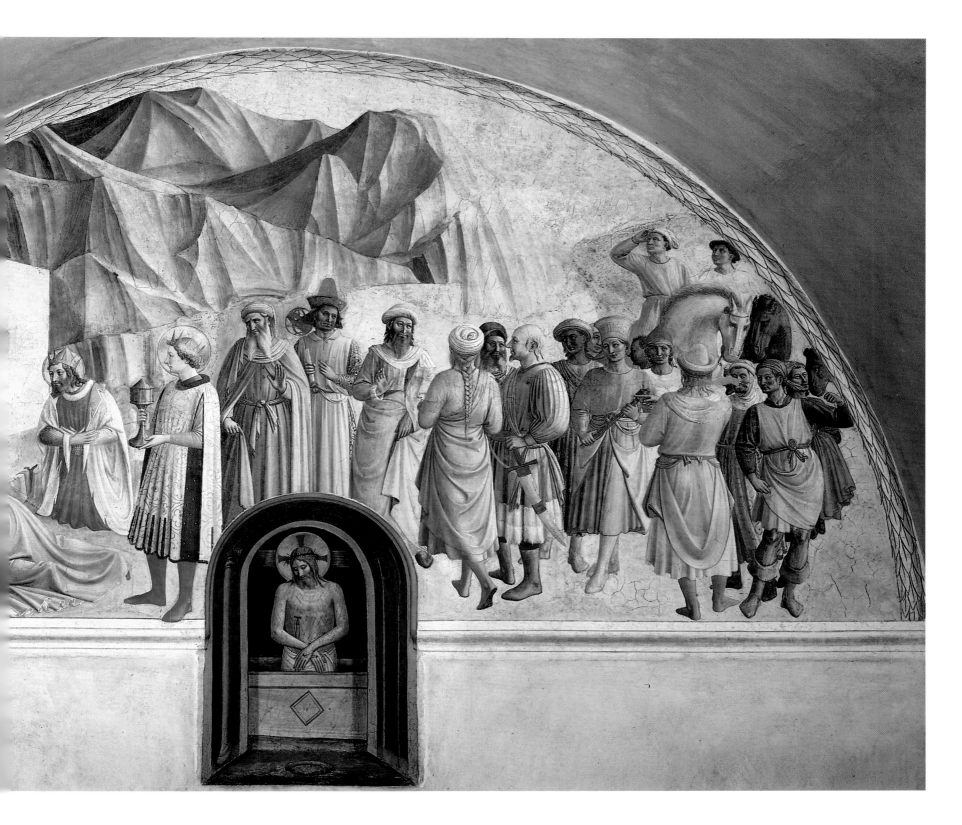

a priceless gift for the wise men to bring because it incorporated the astronomical knowledge of Pythagoras, the Greek philosopher who formulated the theory of the cosmos as a series of concentric spheres obedient to divine laws of mathematics and geometry. Porphyry, the third-century student of the Neoplatonic philosopher Plotinus, wrote that Pythagoras received his instruction in astronomy from the Chaldeans, the Mesopotamian people who were acknowledged by all antiquity to be the masters of that science.[90] Porphyry concludes, "Other secrets concerning the course of life Pythagoras received and learned from the Magi."[91]

LAY BROTHERS' CELLS

▶ CELL 42: *Christ on the Cross with the Virgin and Saints Joseph
of Arimathaea (?), Longinus, Dominic, and Martha*

The frescoes in cells 40 through 43 in the north dormitory are believed to have been occupied by the lay brothers of the convent. These *conversi*, as they were called, remained secular and did not live isolated *in clausura* with the professed friars, although they observed most of their devotions. The lay brothers did not share the learning of the friars, but dedicated themselves instead to the practical tasks of the community. Each of these cells holds a fresco depicting Saint Dominic in meditation on a particular moment of the Crucifixion.

The story of the Roman soldier, traditionally named Saint Longinus, who pierces the side of Christ with a lance is told only in the Gospel of John: "But one of the soldiers with a spear pierced his side and forthwith there came out blood and water" (19:34). The Eucharistic connotations of this event have been much discussed by theologians. The *Crucifixion* in cell 42 is by far the most complex interpretation of this theme in this row of cells. It is surely not coincidental that it is the only fresco of these four that was executed by Fra Angelico without significant participation by assistants.

Many aspects of its enigmatic imagery await explanation. The bearded man at left who beholds the cross has generally been identified as Saint Mark, but he does not hold a book, nor does Mark describe the piercing of Christ's side. Joseph of Arimathaea took down the body of Christ from the cross (John 19:38), but this figure cannot be certainly identified with him. The presence of Martha at the Crucifixion is so unusual that her name is perforce inscribed in her halo. The patristic author Origen wrote an influential commentary on Martha and Mary as emblems of the active and passive lives.[92]

The only note of interpretation that we can add for the moment concerns the rivulets of blood that trace their various paths down the mound of the cross. This unforgettable motif, which is at once so painful and so delicate, appears on every one of the *Crucifixions* at San Marco. These wandering threads of blood are not characteristic of Fra Angelico's other paintings of this subject in his career. The explanation must lie in the theme of redemption that unifies the frescoes of San Marco. In the Letter to the Hebrews, which devotes particular attention to the theme of Christ's sacrifice for the redemption of humankind, Saint Paul (or his disciple) wrote that the blood of Jesus guarantees the faithful a way to the sanctuary of heaven (10:19-20).[93]

*CHRIST ON THE CROSS
WITH THE VIRGIN AND
SAINTS JOSEPH OF
ARIMATHAEA(?), LONGINUS,
DOMINIC, AND MARTHA*
Fresco, 77⅛ × 78⅜ in.
(196 × 199 cm)
Cell 42, Convent of San Marco, Florence
(see catalog 59)

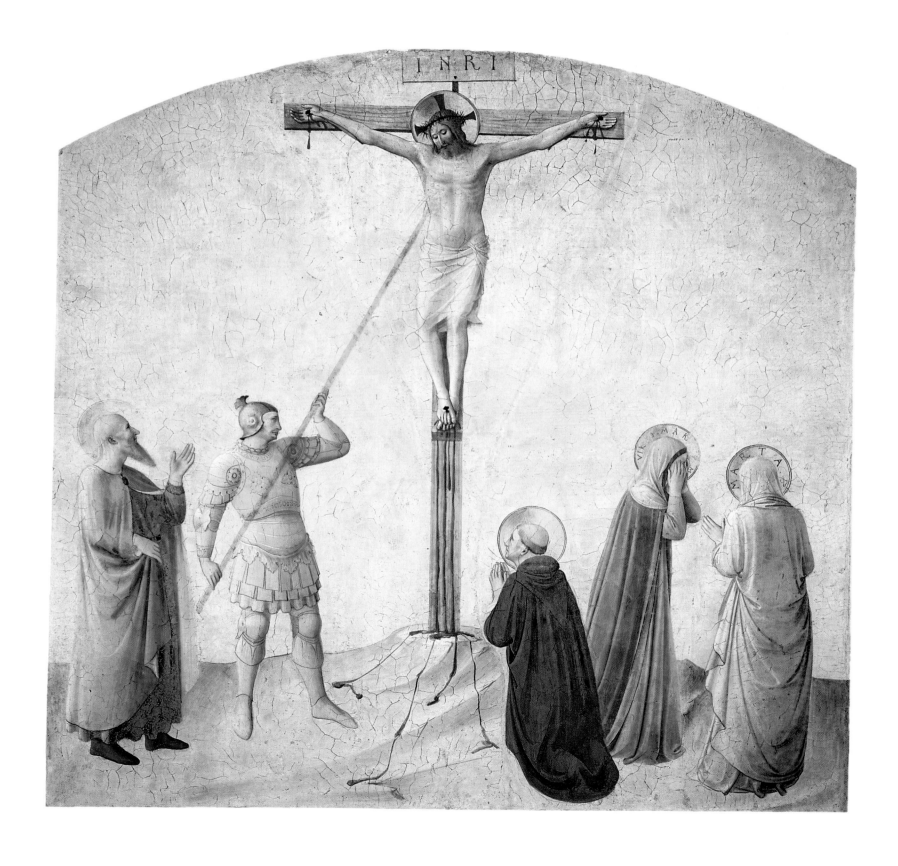

THE PERUGIA ALTARPIECE

The Madonna and child are shown seated on a throne with an apsidal back that is gilt and incised for most of its height. A stone arch with a red (but possibly originally blue) interior vault springs from the gilt capitals. The two green wedges in the corners of this arch are Romanesque derivations in the style of the architect Leon Battista Alberti. The Virgin assists the child as he blesses the spectator with one hand and in the other holds a pomegranate, a symbol of the Church because of the unity of the countless seeds contained within a single fruit.[94] On either side of the Madonna and child, angels in bright raiment offer baskets filled with red, pink, and white roses. Similar roses are displayed in golden vases in front of the dais. These roses, gathered in rings, probably symbolize the rosary, which was established as a Marian devotion by Saint Dominic.

The Perugia Altarpiece by Fra Angelico was painted for the chapel of San Niccolò in the church of San Domenico in Perugia. These two saints are represented in the left wing of the altarpiece. Saint Dominic preaches from a Bible open to thirteen verses from the Second Epistle of Saint Paul to Timothy (4:1-13). A bareheaded Saint Nicholas, wearing his bishop's regalia, quietly studies a book. On the ground beside him is his attribute, the bags of gold that the saint gave as dowries to three poor, honest girls.[95] Saints John the Baptist and Catherine of Alexandria, with her wheel, are shown as a pair in the right wing of the altarpiece. Their particular significance to this chapel is not known because the circumstances of the commission are not documented. The polyptych was completed with an upper register with roundels of the Angel Gabriel and the Virgin Annunciate, a predella with three wide panels depicting stories of the life and martyrdom of Saint Nicholas of Bari, and two pilasters at either side, each containing six small standing figures of saints.

The two predellas with *The Birth of Saint Nicholas, His Vocation, His Charity to Three Poor Girls* and *Saint Nicholas Addressing an Imperial Messenger and Saving a Ship at Sea* were removed to the Musée Napoléon in Paris in 1813, and are today in the Pinacoteca Vaticana. These are replaced by copies in the reconstructed frame in Perugia. The third predella with *Saint Nicholas Freeing Three Men Condemned to Execution and The Death of Saint Nicholas* is still in Perugia. The altarpiece lost its original frame during the nineteenth century; the neo-gothic frame constructed for the polyptych in 1915 probably presents the work in a misleadingly conservative manner.

The Perugia Altarpiece is the most important altarpiece executed by Fra Angelico in the 1440s following the completion in 1443 of his work at San Marco. The unassuming and studious figure of Saint Nicholas—who so little resembles the miracle-working bishop in the predella—is surely an undisguised portrait of Pope Nicholas V, as Andrea De Marchi was the first to observe.[96] The election of the humanist Tommaso Parentucelli to the papacy in March 1447 is therefore a *terminus post quem* for this painting. A legendary bibliophile, Parentucelli was employed by Cosimo de' Medici to organize the library of San Marco in the very years that Fra Angelico was painting frescoes in the convent. As pope, Nicholas V committed the wealth of the church to the formation of the greatest library in Italy. He was the great patron of Fra Angelico's last years; that the painter and the pope were friends is demonstrated by the affectionate intimacy of this portrait in what must have been a characteristic pose.

Elements of Dominican and papal iconography are joined in a way that lend support to De Marchi's identification of this portrait of Nicholas V. The pomegranate held by the

Detail from the predella of
the Perugia Altarpiece
Tempera and gold on panel,
50⅜ × 34⅝ in. (128 × 88 cm)
Galleria Nazionale dell'Umbria, Perugia
(see catalog 94D)

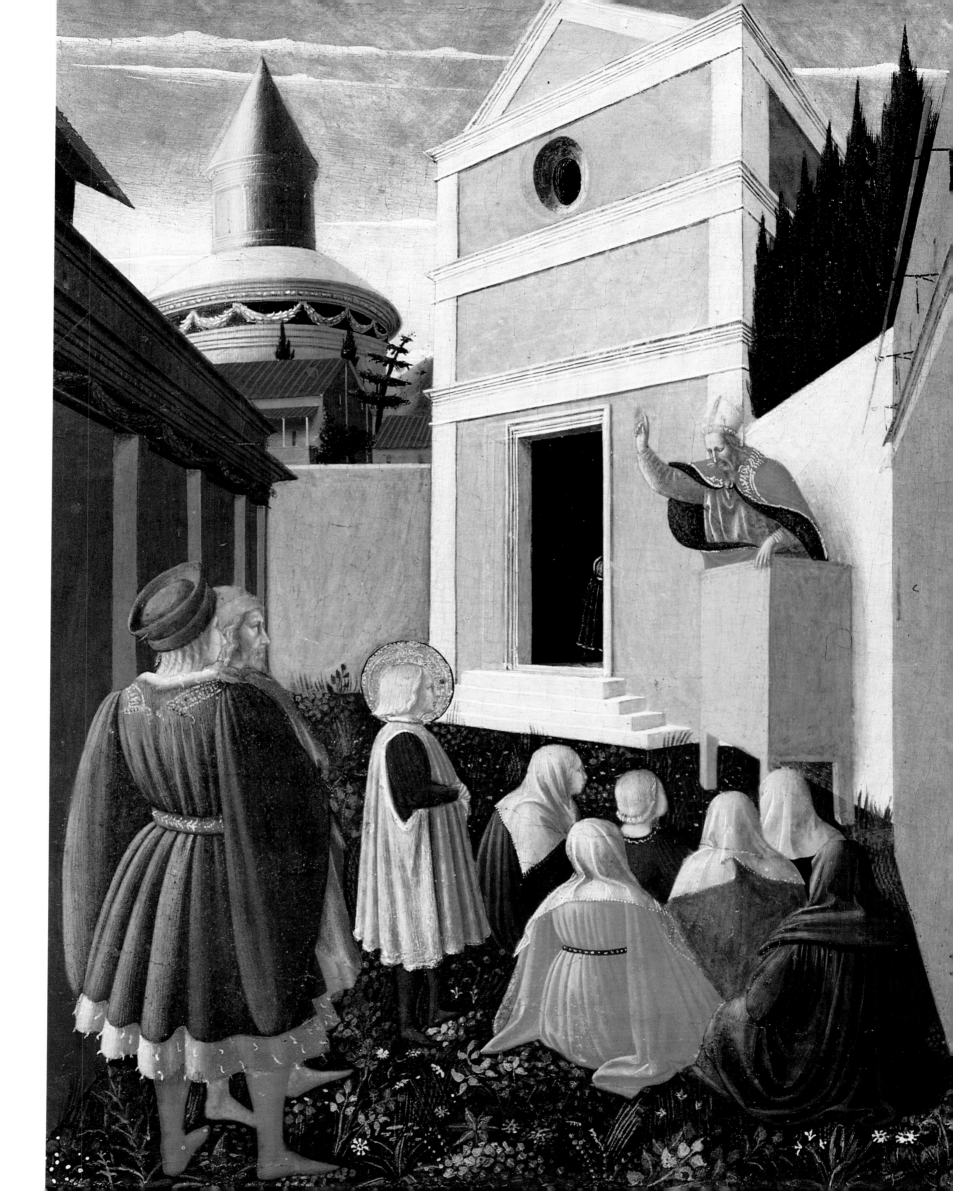

Christ child, for example, alludes to this pope's strenuous efforts on behalf of Church unity.[97] But the most convincing proof is to be found on the pages of the book that Saint Dominic holds, almost brushing the shoulder of Saint Nicholas. Fra Angelico never quoted this passage from Saint Paul on any other of his paintings of Saint Dominic, but Paul's opening words of advice, "I charge thee . . . Preach the word," were certainly pertinent to him. By the same token, Paul's concluding words at the end of this long excerpt must have touched the heart of Nicholas v Parentucelli: "When thou comest, bring with thee the books, especially the parchments."

Detail of *SAINT NICHOLAS ADDRESSING AN IMPERIAL MESSENGER* from the predella of the Perugia Altarpiece
Perugia, Galleria Nazionale dell'Umbria
(see catalog 94E)

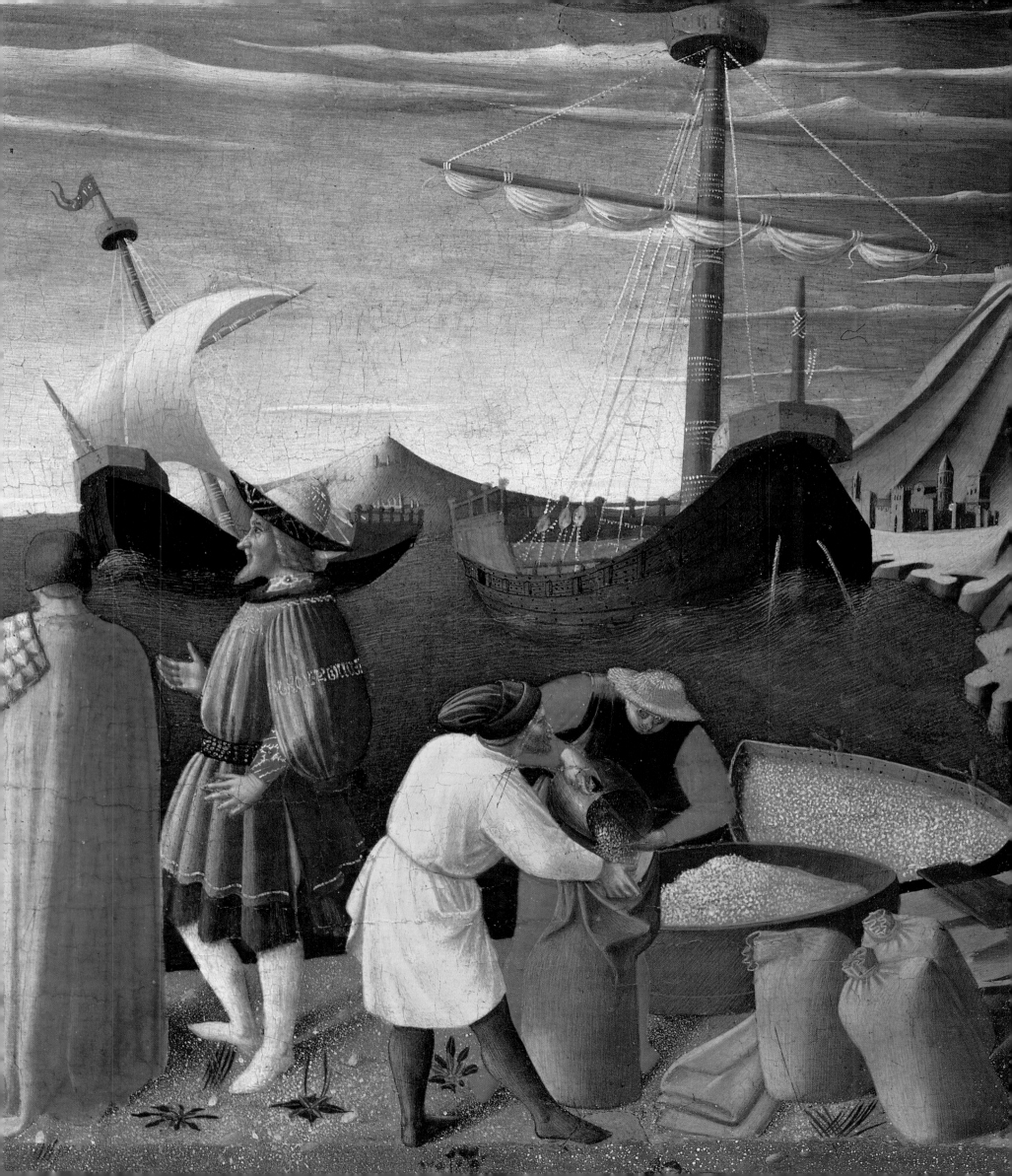

Perugia Altarpiece
Perugia, Galleria Nazionale dell'Umbria
(see catalog 94A)

FRESCOES IN THE CHAPEL OF
SAN BRIZIO, ORVIETO

▶ *Sixteen Prophets* ▶ *Christ Seated in Judgment*

In the summer of 1447 Fra Angelico and his assistant, Benozzo Gozzoli, painted frescoes representing Christ Seated in Judgment and Sixteen Prophets in adjacent vanes in the gothic vault of the right transept of the Duomo of Orvieto. The frescoes are situated so that Christ the Judge appears to dominate both the end and side walls of the chapel. Seated upon radiant clouds, Christ holds the world in his left hand and raises his right hand in a commanding gesture that must have influenced Michelangelo's Christ in his *Last Judgment* in the Sistine Chapel. But Angelico's reading of the divine judge is far more graceful than apocalyptic; he would have agreed with John Ruskin, "No herculean form is spiritual, for it is degrading the spiritual creature to suppose it operative through impulse of bone and sinew; its power is immaterial and constant, neither dependent on, nor developed by, exertion."[98]

The sixteen prophets are shown seated, tier upon tier, in a tribune of judgment on Christ's proper left side. The gothic ribbing of the vault was an almost insurmountable obstacle to the artist's efforts to make a unified conception, and the necessity of arranging his figures inside triangular divisions is uncomfortably apparent. The rigidity of the prophets is slightly relieved by a certain amount of interaction within the group, especially among the nine that comprise the apex of the pyramid. The fresco mainly appeals for its luminous enamel-like colors, which have been liberated from much overpainting by the recent cleaning and restoration. In the corresponding vane on the other side of Christ, the Virgin is shown in the midst of the Apostles. This triangular section of fresco was designed by Fra Angelico in the summer of 1447, but only painted by Luca Signorelli fifty years later.

The Orvieto frescoes are among the best documented of Fra Angelico's career, although paradoxically Gozzoli's brush is as much in evidence on the ceiling as his master's. The project was star-crossed from the beginning. Fra Angelico had accepted the assignment because he was content to escape the Roman heat during the summer months when the pope did not require his services. It seems that the accommodations provided by the *operai* of the Duomo were not excessively comfortable, since a payment was required to purchase more straw for the friar's mattress. The difficulty of working at Orvieto was another possible bone of contention between the artist and the *operai*. It was necessary more than once to send to Rome and Florence for artist's materials that were lacking. And a pall was cast over the whole undertaking in the very first month when, on June 25, one of the masons on the project fell from the scaffolding and died a few days later after much suffering.

These contrary circumstances may have been a factor in the aging friar's decision not to ascend the scaffolding every day, but rather to devote much of his energies to designing the cartoons for these frescoes. The much younger Gozzoli was allowed to do most of the actual painting. Fra Angelico's own hand can be discerned in the principal figures: Christ the Judge, the first row of prophets, including Moses, and selected other heads. The program of this *Last Judgment* is interesting for the equivalent importance assigned to the separate groups of the Old Testament prophets, on one side, and the Virgin and the Apostles on the other.

SIXTEEN PROPHETS
Chapel of Saint Brizio, Duomo, Orvieto
(see catalog 90A)

PAGE 172:
Detail of *CHRIST SEATED
IN JUDGMENT*
Chapel of Saint Brizio, Duomo, Orvieto
(see catalog 90)

PAGE 173:
Detail of *SIXTEEN PROPHETS*
Chapel of Saint Brizio, Duomo, Orvieto
(see catalog 90)

PROPHETARVMLAVDABILISNVMERVS

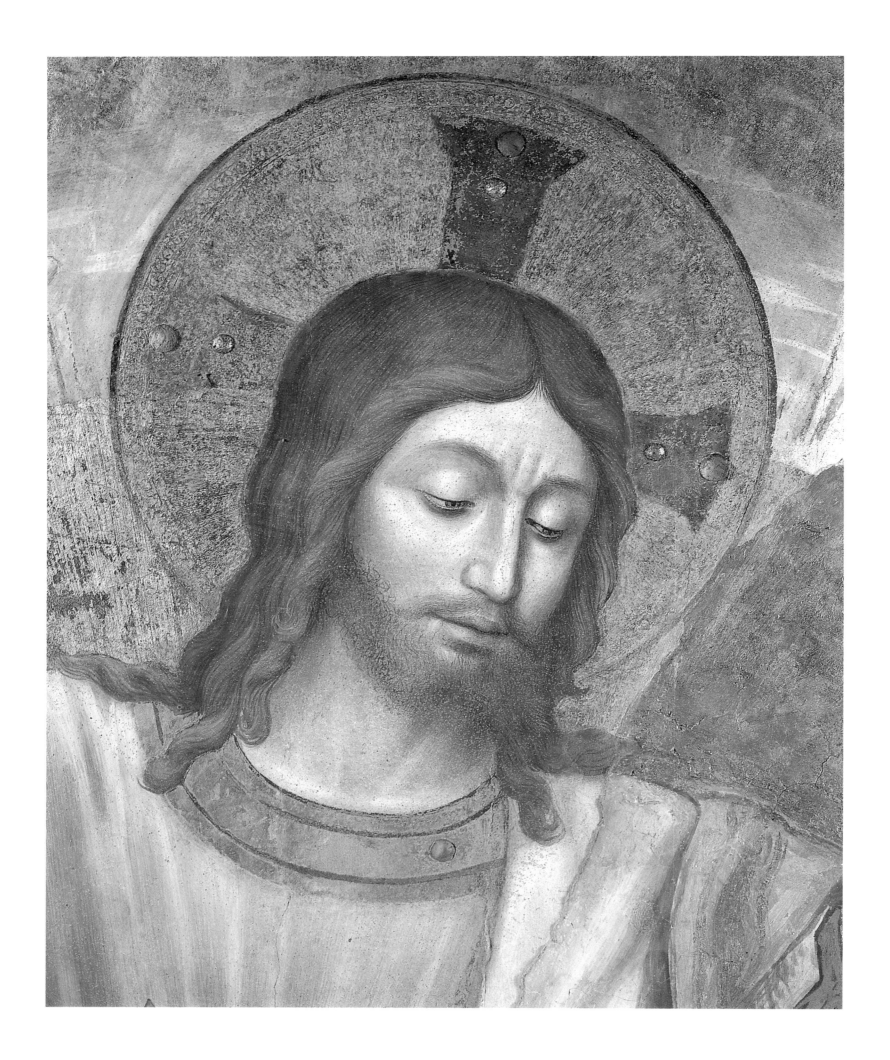

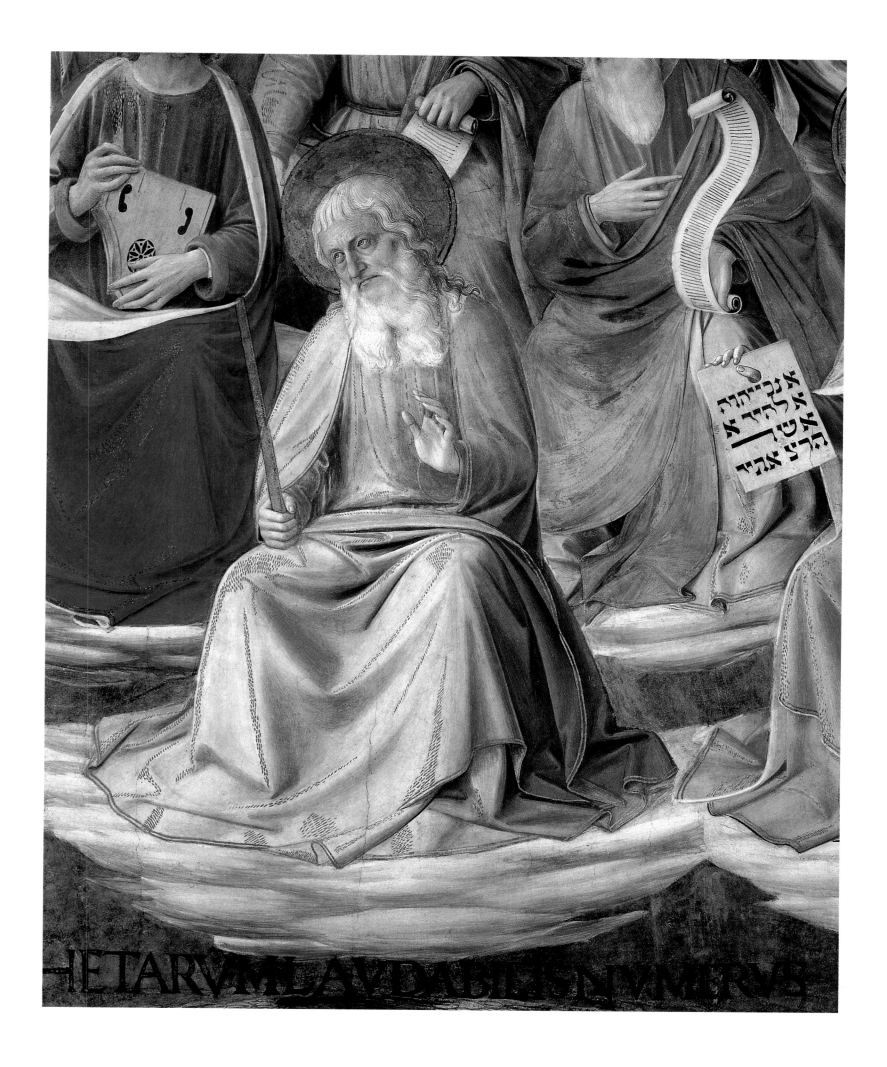

CHRIST SEATED IN JUDGMENT
Chapel of Saint Brizio, Duomo, Orvieto
(see catalog 90B)

CHAPEL OF NICHOLAS V

The Chapel of Nicholas V (Cappella Niccolina) is the only surviving fresco cycle of the four executed by Fra Angelico during his half-decade of intense activity of papal service in Rome, from 1445 to 1449. By February 18, 1448, Fra Angelico had already begun work on these paintings, which completely fill the small secret chapel used by Nicholas V to celebrate Mass in private. For Langton Douglas, these Vatican frescoes represented Fra Angelico's highest achievement, "an anthology of his artistic virtues."[99]

The vault of the rectangular chapel is divided by ribbing into four vanes, one for each of the four Evangelists. The restoration in progress during the writing of this book has revealed the superb quality of these four figures, especially the Saint Luke, shown with his attribute of an ox, who is rendered with refined tints and miniaturist delicacy more to be expected in a painting on panel than in a wall fresco. The Evangelists are shown against an azure dome of heaven made precious by golden stars. It was traditional to represent Saints Matthew, Mark, Luke, and John on the vault of a chapel as a sign of the divine origin of their Gospels. In the four corners of the chapel Fra Angelico painted standing figures of eight saints and doctors of the Church, whose authority thus descends directly from God.

The three walls of the chapel are divided into two registers with stories of Saint Stephen in the lunettes above, and Saint Lawrence below. Stephen was one of the first deacons ordained by Saint Peter in Jerusalem. Fluent in Greek, he ministered to the needs of the Greek widows in the early Christian community. Stephen was thoroughly versed in the scriptures and he fearlessly debated the unconverted Jews in the synagogues of Jerusalem. His vigorous debate with the elders of the Sanhedrin occupies the right half of a lunette in which Fra Angelico depicted in the other half, by contrast, the saint's words being gratefully received by a congregation of women seated under an open sky. Stephen was the first Christian martyr. His preaching infuriated his enemies, who cast him out of the city gates and stoned him to death; a consenting witness on the scene was Saul of Tarsus.

In the lower register of each wall are scenes from the life of Saint Lawrence, the Roman martyr of the third century. They represent: his ordination by Saint Sixtus; the pope giving him the treasures of the Church while the imperial soldiers forcibly enter through the door at left; Saint Lawrence's distribution of these treasures to needy widows, orphans, and crippled; the saint's interrogation by the Emperor Decius; a small inset scene of Saint Lawrence converting his jailor; and, finally, his martyrdom on the fiery gridiron.

The parallels between the ordinations, ministry, and martyrdoms of the two courageous deacons, Stephen and Lawrence, have been carefully drawn in order to demonstrate the continuity between the early Church of Jerusalem led by Saint Peter and the early Church of Rome guided by the popes. The august basilicas and finely detailed friezes and capitals of the architectural settings evoke one of the principle themes of Nicholas V's papacy: the restoration of the Eternal City to its ancient glory as *caput mundi*.[100] The imposing gates of Jerusalem in the lunette of Saint Stephen doubtless refer to Nicholas V's construction of new walls in Rome and the aqueduct of the Acqua Vergine.

Fra Angelico painted portraits of Nicholas V in the guise of his classical antecedent, Sixtus II, in the episodes of Lawrence's ordination and receipt of the Church's money. Nicholas V identified closely with Saint Lawrence, the protector of booksellers, librarians, and bibliophiles. As Sixtus II hands the paten and the chalice to the young deacon, a young religious directly behind them holds one of the precious volumes that were also given to

Detail of Saint Stephen
Preaching and Saint Stephen
Addressing the Council from
the Chapel of Nicholas V
Frescoes, 21 ft. 7⅞ in. ×
13 ft. 1½ in. (6.6 × 4 m)
Vatican Palace, Vatican City
(see catalog 104B)

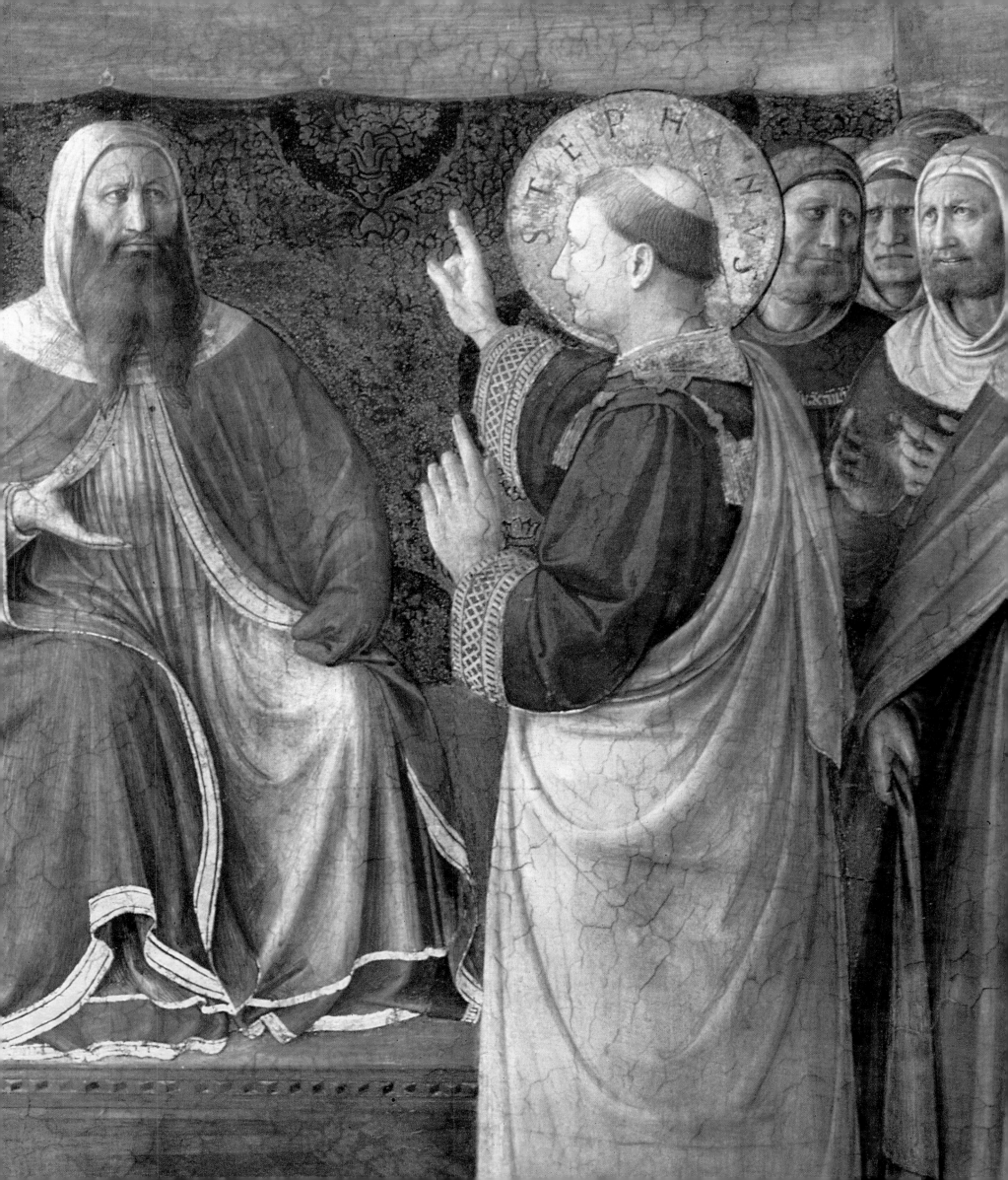

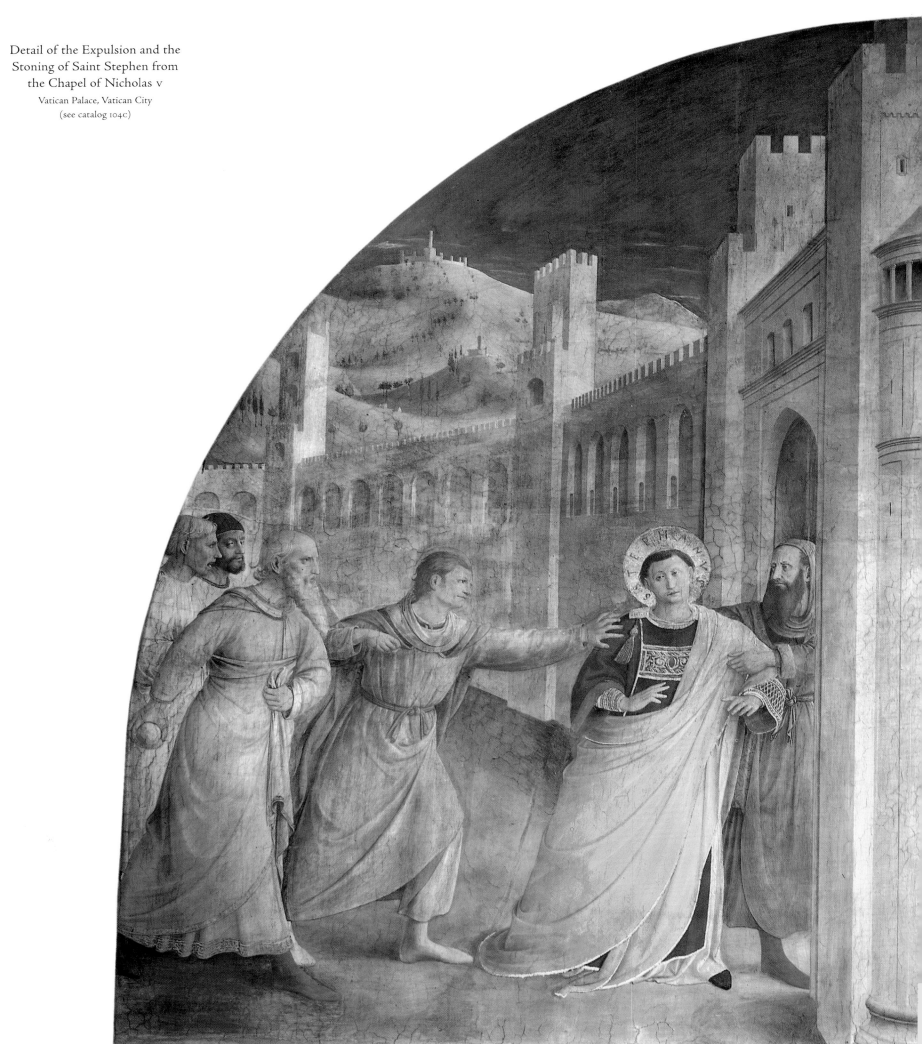

Detail of the Expulsion and the
Stoning of Saint Stephen from
the Chapel of Nicholas V
Vatican Palace, Vatican City
(see catalog 104c)

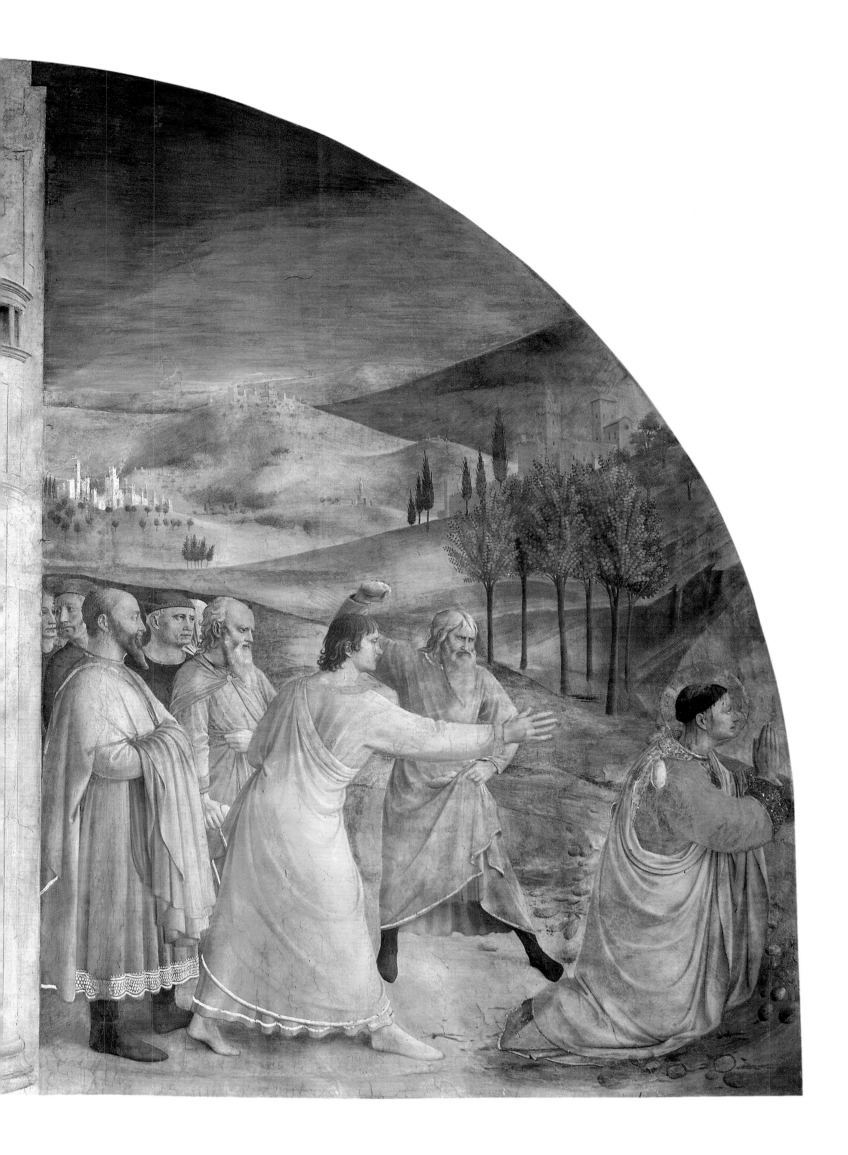

Lawrence for safekeeping. References to the life of Nicholas v may well be concealed in these frescoes. For example, the casting out of Saint Stephen represented a schism in the Jewish church; Tommaso Parentucelli, the future Nicholas v, was personally witness to many schismatic crises in the Catholic church. The fine portrayal of Stephen debating the Sanhedrin might recall Parentucelli's brilliant orations at the Council of the Union. This idea is reinforced by the striking similarities between Fra Angelico's portrayals of Stephen and Lawrence. The painter has expended little effort to distinguish his two protagonists— quite the contrary.

In the fresco *Saint Lawrence Giving Alms*, the artist consciously compares the saint to Christ, as Father Alce has pointed out.[101] Clearly written on the pectoral of his red dalmatic, which is emblazoned with mystical flames, are the letters: JHESVS CHRISTVS. He is shown enclosed within the apse of a superb basilica, the Catholic church, and his heart is superimposed over the place of the altar. Douglas considered this fresco the greatest of all Fra Angelico's works, the fitting climax of his whole career. "It is the complete and final expression in art of both the artistic and religious creeds of some of the best men of the early quattrocento."[102]

The touching portrayals of the poor, blind, and maimed in this fresco directly recall Masaccio's great painting, *Saint Peter Healing with His Shadow*, in the Brancacci Chapel. Indeed, numerous passages in the Chapel of Nicholas v reveal Fra Angelico turning for inspiration to this Florentine antecedent, which was dedicated to the same theme, the Roman papacy. Although critics are wont to praise the correct perspective of the various church naves depicted in these paintings, the relationship of Angelico's figures to this architecture is much the same as in the frescoes of Masaccio and Masolino, a generation earlier. Many of these fine views function mainly as symbolic backdrop. The contrast with the expansive and consistent treatment of space in the San Marco Altarpiece, for example, could hardly be more pronounced, considering the late date. In view of Nicholas v's fascination with paleo-Christian culture, it is likely that Fra Angelico took the opportunity to study the same late classical mosaics that Masaccio had drawn upon for the *Tribute Money* in the Brancacci Chapel.

The contributions made by Benozzo Gozzoli and by Fra Angelico's other assistants in the Chapel of Nicholas v have generally been assigned too much importance. Many of the heads ascribed to Gozzoli in the past can now be seen, thanks to the restoration still in progress, to have been painted by the master. Moreover, it seems clear that Gozzoli was employed to execute Fra Angelico's designs and not to impress his own personality on any part of the program.

Detail of the Ordination of
Saint Lawrence from the Chapel
of Nicholas v
Vatican Palace, Vatican City
(see catalog 105A)

O V E R L E A F :
Details of Saint Lawrence
Receiving the Treasures of the
Church from Pope Sixtus II and
Saint Lawrence Giving Alms
from the Chapel of Nicholas v
Vatican Palace, Vatican City
(see catalog 105B)

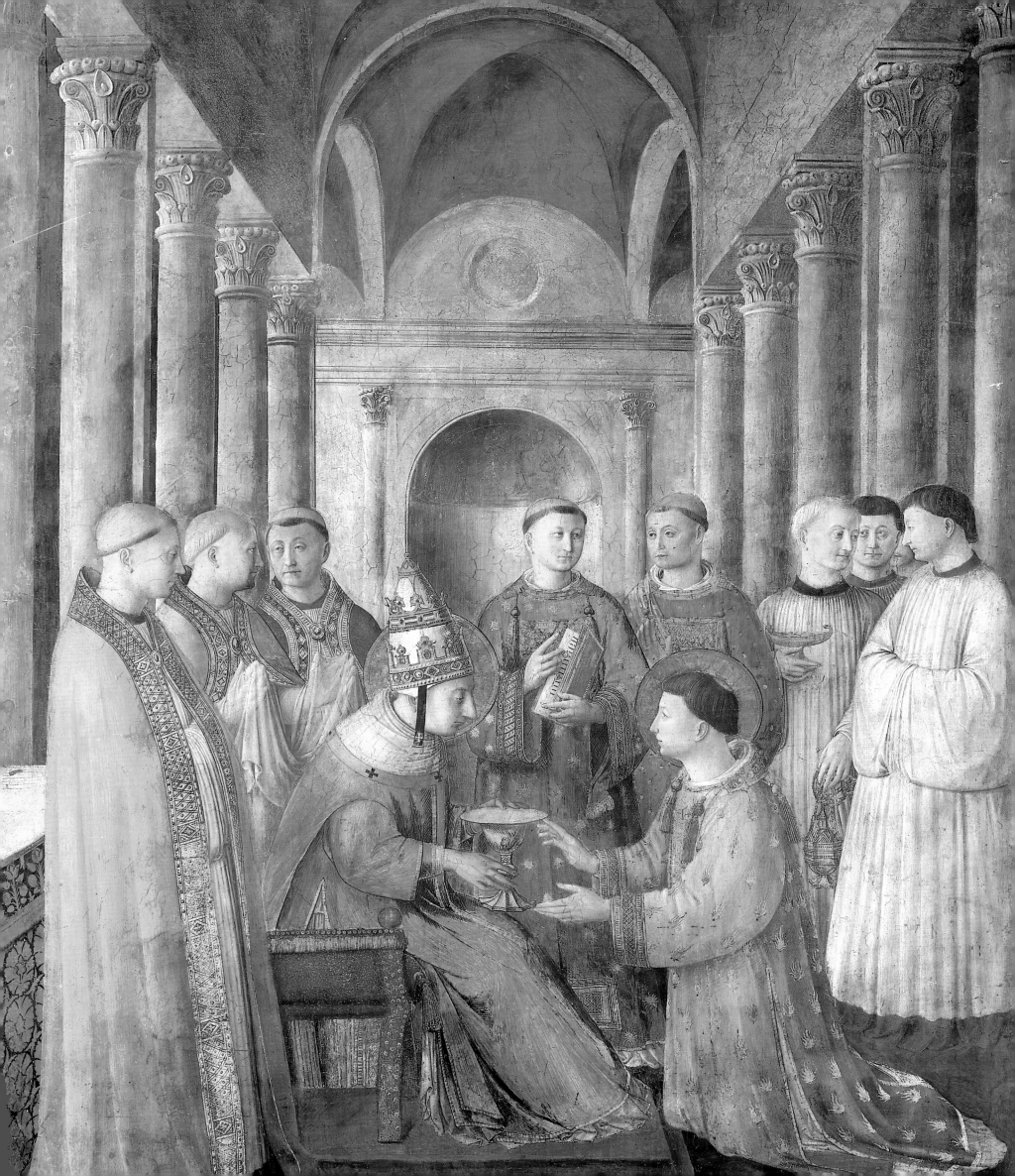

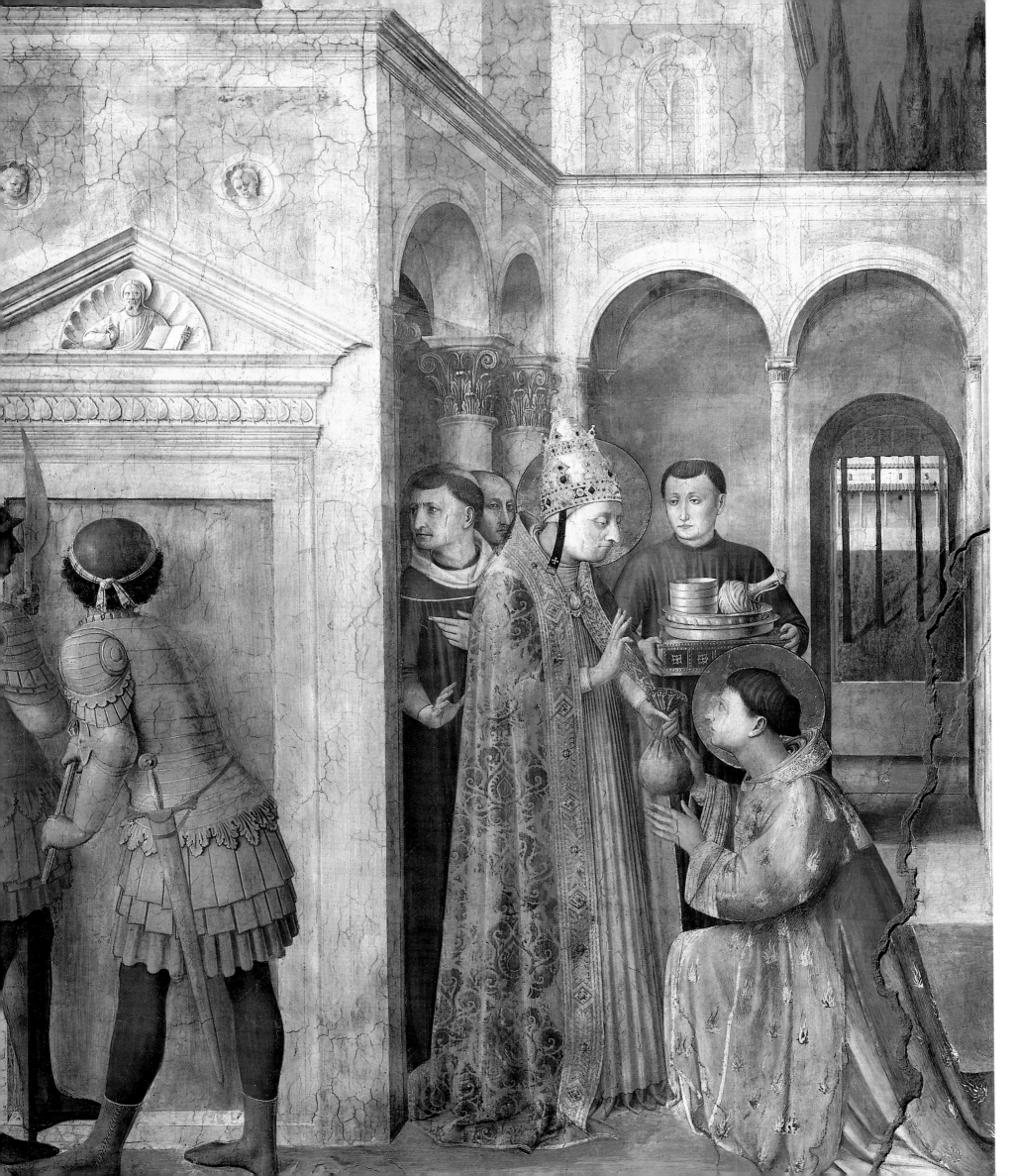

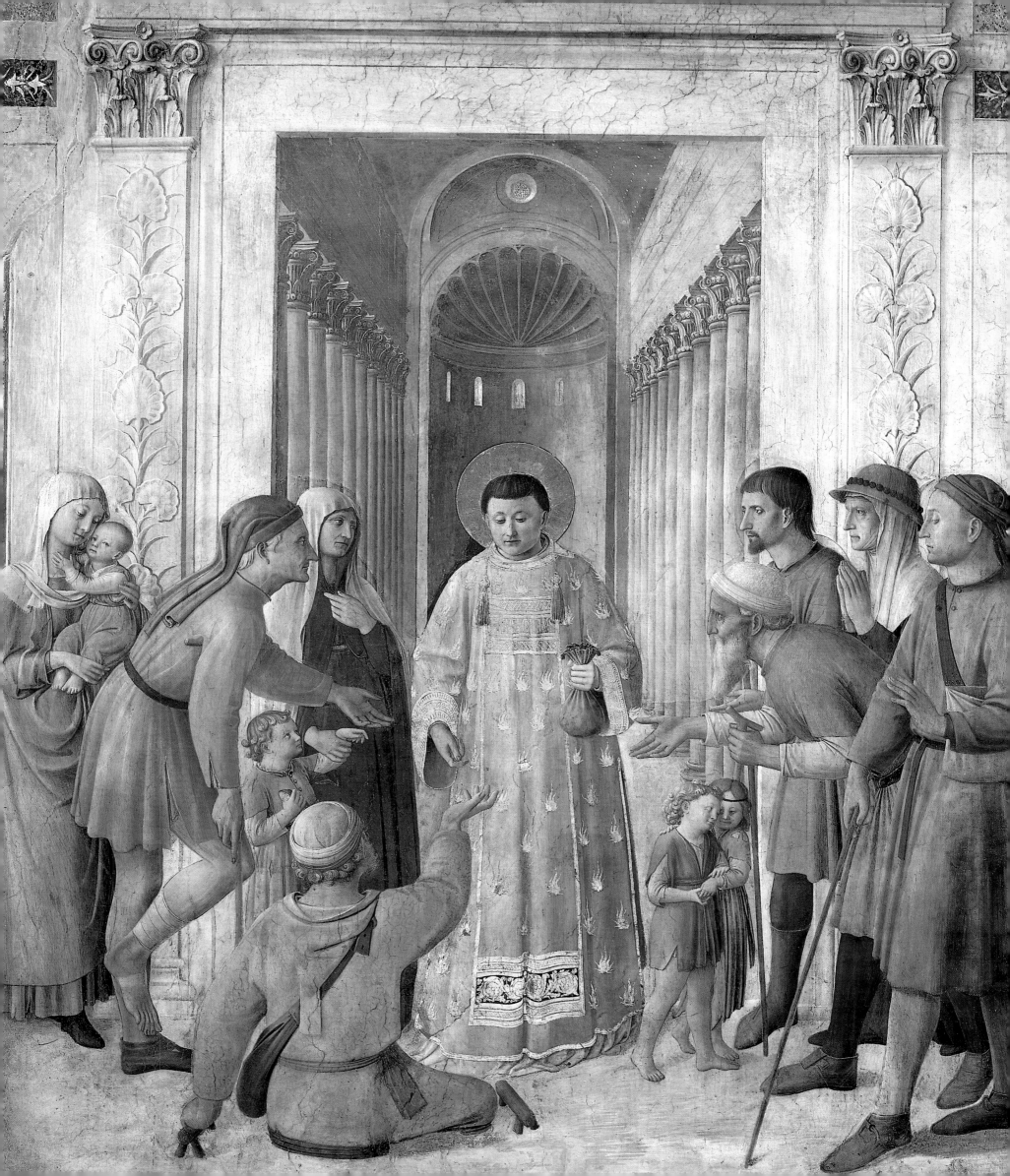

Detail of the Four Evangelists
from the Chapel of Nicholas V
Vatican Palace, Vatican City
(see catalog 107)

SILVER TREASURY OF

SANTISSIMA ANNUNZIATA

In 1448, according to an early chronicle,[103] Fra Angelico received from Piero de' Medici, Cosimo's son, the prestigious assignment to decorate the doors of a silver treasury for the new oratory to be constructed near the chapel of the Santissima Annunziata in the church of the same name. Fra Angelico did not begin work on this extensive series of small paintings until after his return from Rome in 1449/50. The silver treasury panels were the last major commission undertaken by Fra Angelico and he was evidently unable to bring the project to completion before he was called back to Rome, where he died in February 1455.

The original appearance of this monumental cabinet is not known. Its purpose was to keep safe and to display the precious ex-votos that grateful worshipers donated to the miraculous shrine of the Santissima Annunziata. The program, which is entitled *Lex Amoris* (the Law of Love) on its last panel, seems to have required Fra Angelico to execute as many as forty small scenes. Thirty-two of these scenes by Fra Angelico and his assistants have come down to us on three large panels containing nine, twelve, and eleven scenes respectively. A fourth panel contains three episodes by Alessio Baldovinetti, who was evidently called upon to fill in a lacuna.

The title *Lex Amoris* refers to a doctrine of Saint Thomas Aquinas that is elaborated in these paintings by allegory and inscription: Christ did not come to destroy the old laws of the patriarchs, but to renew and complete them with a new law of love.[104] The series begins with the *Vision of Ezekiel* or the *Mystical Wheel*, in which the twelve Hebrew patriarchs and prophets are represented in the outer ring, which encloses the inner wheel with the eight authors of the New Testament: the Four Evangelists and Saints Paul, James, Jude, and Peter. The inscription from Genesis on the outer circle of the wheel describes the creation of the world, while, on the inner ring, the *Incipit* from the Gospel of John relates the new creation—the Incarnation of the Word of God. Each of the scenes from the life of Christ is framed on top by an Old Testament prophesy and below by a text from the New Testament in which the prophesy is fulfilled. The series concludes, as it begins, with an entirely literary panel. Scrolls with prophecies and texts are arranged, extraordinarily, in the shape of the seven-branched candelabra (menorah) of Jewish origin. The purpose of this superabundance of literary citations is clearly didactic: the Silver Treasury panels were destined to serve a large public as a kind of illustrated Bible, complete with all relevant texts. In 1450, on the eve of the invention of movable type, relatively few people possessed their own Bibles.

Although all of the surviving scenes were designed by Fra Angelico (apart from those by Baldovinetti), the artist's own hand is observable only in the first large panel of the series, illustrated here in color. The autograph scenes by Fra Angelico show no signs of waning powers or declining creativity. The *Nativity* is a superb redaction in the artist's last style of his earlier treatments of this favorite theme in paintings in Forlì and at San Marco (cell 5).[105] Joseph's golden robes are illuminated as if the radiant infant were a candle in the darkness; directly above them, a host of angels bask in the effulgence of the Incarnate Deity. The scene is framed above by a text from Isaiah (9:6), "For unto us a child is born, unto us a son is given," and below by Saint Luke (2:6-7), "The days were accomplished that she should be delivered, and she brought forth her firstborn son." During the fortnight between Christmas

SILVER TREASURY OF
SANTISSIMA ANNUNZIATA
Tempera and gold on panel,
each scene approximately
15⅛ × 14⅝ in. (38.5 × 37 cm)
Museo di San Marco, Florence
(see catalog 62A)

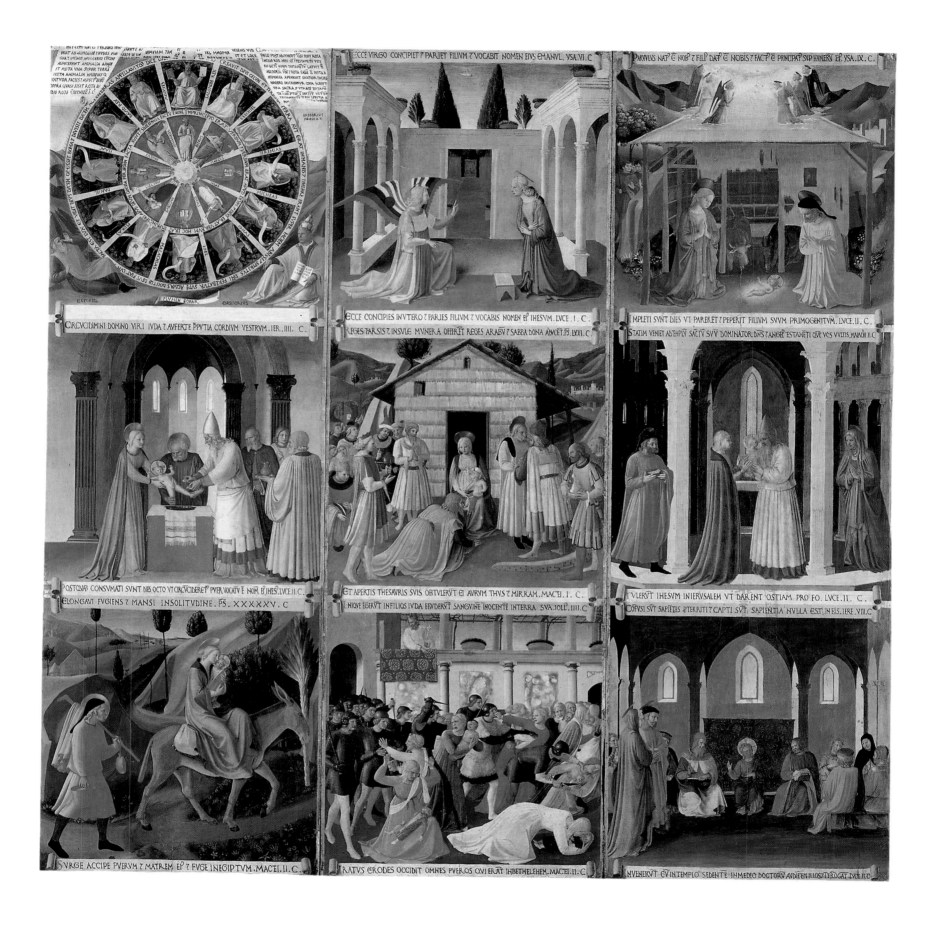

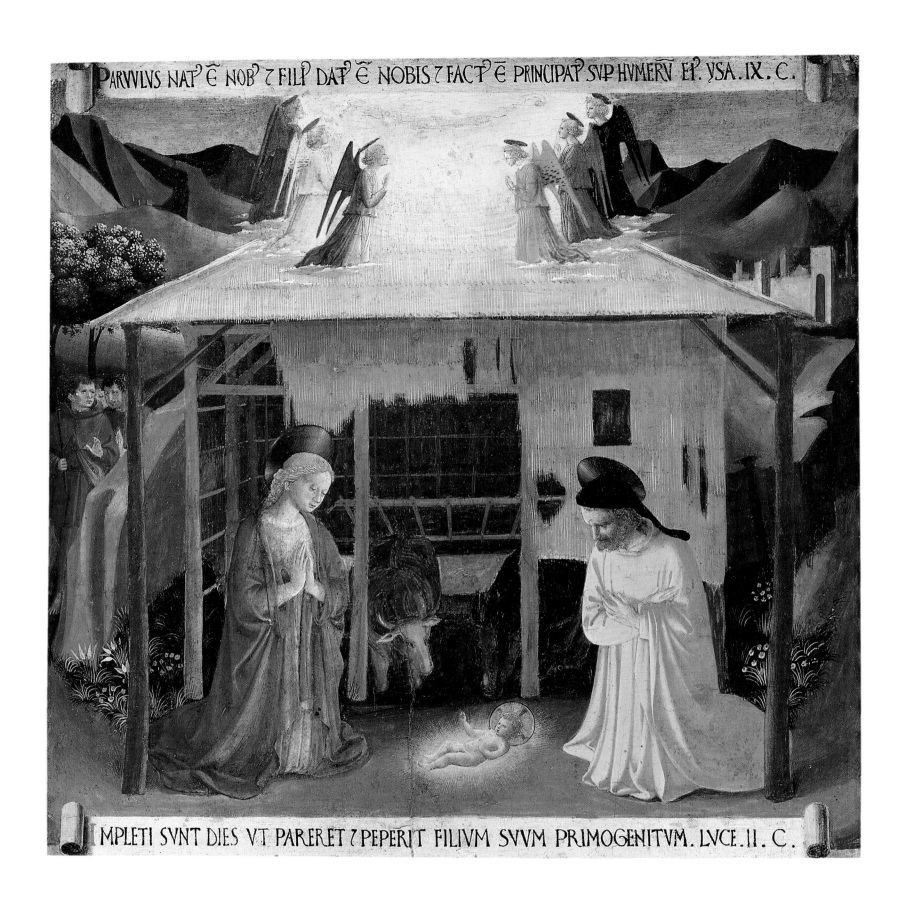

PARVVLVS NAT͞Ē NOB͞Z FILI DAT͞Ē NOBIS͞Z FACT͞Ē PRINCIPA͞T SVP HVMER͞V EͿ. YSA.IX.C.

MPLETI SVNT DIES VT PARERET͞Z PEPERIT FILIVM SVVM PRIMOGENITVM. LVCE.II.C.

Detail of the Nativity from the
SILVER TREASURY OF
SANTISSIMA ANNUNZIATA
Museo di San Marco, Florence
(see catalog 62A)

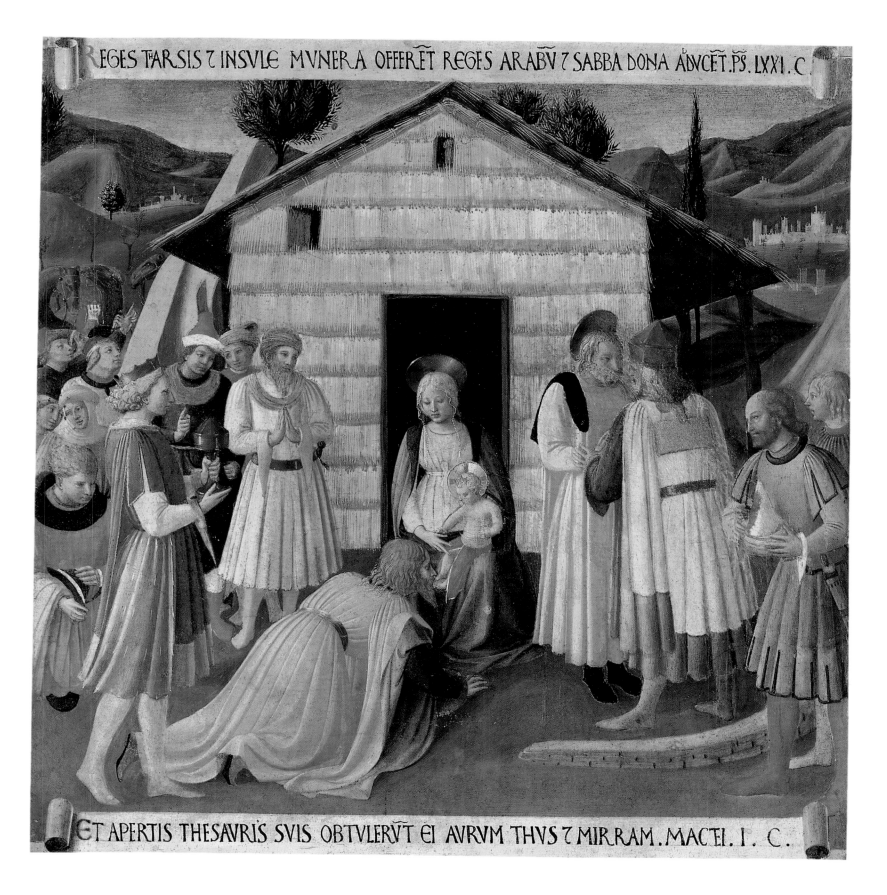

REGES TARSIS Z INSVLE MVNERA OFFERẼT REGES ARABV Z SABBA DONA ADVCẼT. PŚ. LXXI . C

ET APERTIS THESAVRIS SVIS OBTVLERV̄T EI AVRVM THVS Z MIRRAM . MACEI . I . C .

Detail of the Adoration of
the Magi from the SILVER
TREASURY OF SANTISSIMA
ANNUNZIATA
Museo di San Marco, Florence
(see catalog 62A)

and Epiphany, the dilapidated stables in Bethlehem seem to have received a much needed refurbishing, just in time for the arrival of the three wise men. Fra Angelico's own hand is evidenced in several fine heads of the participants in the *Adoration of the Magi*, a panel that has undoubtedly suffered considerable damage in the past. The kneeling king in the foreground recalls the corresponding Magus in the predella of the Linaiuoli Tabernacle of 1433, although this later composition is altogether more disciplined and coherent. The Old Testament prophesy, above, is taken from verse 10 of Psalm 71 in the Vulgate: "The kings of Tharsis and the islands shall offer presents: the kings of the Arabians and of Saba shall bring gifts." The historical fulfillment of this text is related by Saint Matthew (2:11), "And they opened their treasures and presented unto him gifts of gold, frankincense, and myrrh." The use of paired inscriptions is moreover an appropriate allusion to the Annunciate Virgin, whom Thomas Aquinas described as the point of convergence between the Old and the New Testaments.

CATALOG

THE CATALOG CONTAINS A CHECKLIST OF
all the paintings that I consider to be substantially auto-
graph. The works are listed in alphabetical order accord-
ing to their location. Certain altarpieces and frescoes of
known provenance are listed according to their original location; for example, all the frescoes executed by Fra Angelico for
his convent of San Domenico are listed under "Fiesole." The catalog entries provide the source references and the essen-
tial bibliographies for each individual painting. The authors cited in the bibliographies have accepted the attribution to
Fra Angelico, except where otherwise noted. The reader who desires more information on individual works has been
provided with cross-references to the relevant pages in Umberto Baldini and John Pope-Hennessy, although the defini-
tive *catalogue raisonné* of Fra Angelico's paintings remains
to be written. This is the first compilation ever made
of the innumerable citations of these works, and the
reader's patience is asked for inevitable omissions. A
separate section of other works ascribed to Fra Angelico
follows the main catalog. My views on the paintings
in this appendix are expressed in the respective entries.

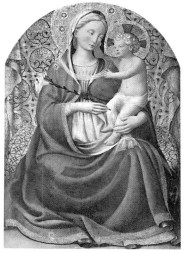

1

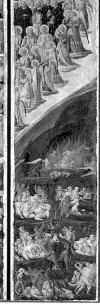

1A

1

MADONNA AND CHILD

Tempera and gold on panel,
29⅛ × 24 in. (74 × 61 cm)
Rijksmuseum, Amsterdam (a. 3011)

PROVENANCE

Quandt collection, Dresden, until 1869; Augusteum, Oldenburg, Germany, until 1923, when acquired by the Rembrandt Society for the Rijksmuseum.

1A

HEAD OF AN ANGEL

Tempera and gold on panel (fragment),
6⅞ × 5½ in. (17.5 × 13.9 cm)
Wadsworth Atheneum, Hartford,
Conn.; The Ella Gallup Sumner
Collection (1928.321)

PROVENANCE

Private collection, Russia; purchased by the museum from René Gimpel in New York in 1928.

Baldini, 1970, p. 103, cats. 62 and 62A (datable c. 1440)
Pope-Hennessy, 1974, p. 220 (not Angelico).

BIBLIOGRAPHY

W. Bode, 1923, no. 156; F. Schott-müller, 1924, p. 102 (late); L. Venturi, 1927, pp. 11-12 (1438); R. van Marle, 1928, x, p. 138 (late); A. E. Austin, Jr., 1929, pp. 2-3 (1425-40); M. Meiss, 1936, pp. 435-65; G. Bazin, 1949, p. 197 (c. 1440); J. Pope-Hennessy, 1952, p. 197 (workshop, 1440-45); *Mostra,* 1955, p. 44, cat. 24; L. Collobi-Ragghianti, 1955, p. 392 (late); C. Gomez-Moreno, 1957, pp. 183-93 (c. 1438-40); M. Salmi, 1958, pp. 106-7; B. Berenson, 1963, p. 11; R. Gimpel, *Journal d'un collectionneur-marchand de tableaux,* Paris, 1963, p. 287 n. 1; S. Orlandi, 1964, p. 59 (after 1445); B. Fredericksen and F. Zeri, 1972, p. 584; H. W. Van Os and M. Prakken, 1974, pp. 29-31, no. 2; P.J.J. van Thiel et al., 1976, p. 83; J. Cadogan, 1991, pp. 43-44; M. Boskovits, 1994, p. 321.

For Cadogan, a workshop collaboration of the late 1440s.

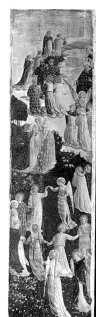

2

2

SAINT FRANCIS OF ASSISI

Tempera and gold on panel,
5 × 3¾ in. (12.5 × 9.5 cm)
Convent of San Francesco, Assisi

PROVENANCE

Acquired by legacy of Federico Mason Perkins.

BIBLIOGRAPHY

G. Palumbo, 1973, pp. 31, 74; M. Boskovits, "Appunti," 1976, p. 36 (early date); F. Zeri, 1988, p. 87 (c. 1430); C. B. Strehlke, 1994, p. 341.

Zeri correctly identified the saint and noted that this panel must have been part of a vertical frame, not a predella; Strehlke suggests an association with cats. 86 and 89 (below), which are fragments of an early altarpiece.

3

LAST JUDGMENT

Tempera and gold on panel, originally
single panel, 45¾ × 58¼ in. (116 ×
148 cm); left: 40½ × 11⅛ in. (103 ×
28.2 cm); center: 40½ × 25⅝ in.
(102.8 × 65.2 cm); right: 40⅜ × 11 in.
(102.7 × 28 cm)
Staatliche Museen, Berlin

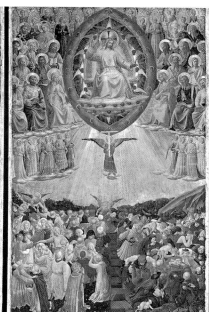

3

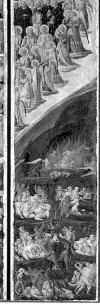

PROVENANCE

Private collection, Rome, 1811; Cardinal Fesch, Rome, 1816-45; Fesch sale, Rome, 1845; acquired by the Berlin Museum from the earl of Dudley in 1884.

Baldini, 1970, p. 109, cat. 111 (1447)
Pope-Hennessy, 1974, p. 221 (Zanobi Strozzi?)

BIBLIOGRAPHY

J. Crowe and G. B. Cavalcaselle, 1864, 1911 ed., IV, p. 92; B. Berenson, 1896, p. 98; R. L. Douglas, 1900, pp. 132, 191 (late); F. Schottmüller, 1911, pp. 140-48; *idem,* 1924, pp. 153-4 (1445-50); P. Muratoff, 1930, pp. 36, 82 (with assistant); *Beschreibendes Verzeichnis,* 1931, p. 18; J. Pope-Hennessy, 1952, p. 196 (Zanobi Strozzi); L. Collobi-Ragghianti, 1955, pp. 43-44 (Zanobi Strozzi); S. Orlandi, 1955, p. 47; M. Salmi, 1958, p. 50 (after 1446); B. Berenson, 1963, p. 11; *Katalog,* 1975, p. 27, cat. 60A.

The composition derives from Angelico's celebrated *Last Judgment* in Santa Maria degli Angeli (cat. 67). The attenuated figure style, and, specifically, the pose of

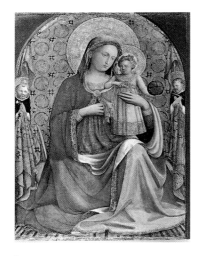

4

Christ, suggest an execution contemporary with Angelico's activity in Orvieto in 1447, as all writers have observed. The master's own hand can be detected in numerous passages of this excellent production of his workshop.

4
MADONNA AND CHILD WITH SAINTS DOMINIC AND PETER MARTYR
Tempera and gold on panel,
27⅝ × 20⅛ in. (70 × 51 cm)
Staatliche Museen, Berlin (60)

PROVENANCE
Edward Solly, London, first known owner; acquired by the Berlin museum with the Solly collection in 1821.

Baldini, 1970, p. 90, cat. 17 (1430-33)
Pope-Hennessy, 1974, p. 221
(workshop)

BIBLIOGRAPHY
J. Crowe and G. B. Cavalcaselle, 1869, 1911 ed., IV, p. 93 (autograph, but repainted); B. Berenson, 1896, p. 98; F. Schottmüller, 1911, p. 91; *idem*, 1924, p. 97 (1435-45); R. van Marle, 1928, X, p. 140 (Angelico?); P. Muratoff, 1930, pp. 36, 82; J. Pope-Hennessy, 1952, p. 197 (workshop); *Mostra*, 1955, cat. 54 (1433); M. Salmi, 1958, p. 102; B. Berenson, 1963, p. 11; *Katalog,*

1975, pp. 26-7, cat. 60 (1433); M. Boskovits, 1994, p. 322 n. 9 (cut at top).

Autograph, but repainted, generally dated c. 1433.

5
MADONNA AND CHILD ENTHRONED WITH SAINTS PETER, PAUL, AND GEORGE, FOUR ANGELS, AND A DONOR
Tempera and gold on panel, 11¾ ×
11½ in. (29.7 × 29.1 cm) (octagonal)
Museum of Fine Arts, Boston;
Gift of Mrs. W. Scott Fitz

PROVENANCE
Baron Triqueti, Paris (by 1869); Mme Lee-Childe, Paris; sale, Hotel Drouot, Paris, May 4, 1896, lot 1; Edward Aynard, Lyons; sale, Galerie Georges Petit, Paris, December 4, 1913, no. 35; with Kleinberger, New York.

Baldini, 1970, p. 95, cat. 42 (1435)
Pope-Hennessy, 1974, p. 222 (not Domenico di Michelino)

5 A

5

5 A
HEAD OF CHRIST
(Reverse)
Oil on panel, 11⅝ × 11½ in.
(29.5 × 29 cm) (octagonal)
Private collection

BIBLIOGRAPHY
J. Crowe and G. B. Cavalcaselle, 1864, 1911 ed., II, p. 93 (published as verso and recto); C. R. Post, "Madonna and Child with Angels, Saints, and a Donor," *Bulletin of the Museum of Fine Arts* 12, 1914, pp. 27-32; F. Schottmüller, 1924, cat. 22 (1430-40); R. van Marle, 1928, X, pp. 156, 164 (workshop); P. Muratoff, 1930, pp. 59, 91 (school); B. Berenson, 1932, p. 20; A. Venturi, 1933, pl. 180; U. Galetti and E. Camesasca, *Enciclopedia della pittura italiana*, 1950, p. 94; J. Pope-Hennessy, 1952, p. 197 (Domenico di Michelino); M. Salmi, 1958, p. 105, pl. 40A; Berenson, 1963, p. 11; L. Berti, 1963, p. 38 n. 108 (1435-36); S. Orlandi, 1964, pp. 63-64; B. Frederickson and F. Zeri, 1972, pp. 9, 564; M. Boskovits, 1983, pp. 11-13, fig. 5 (accepts both); P. Corsini, 1984, pp. 16-19; G. Fallani, 1984, pp. 51, 174; I. Venchi, 1984, p. 16; A. Tartuferi, 1990, pp. 45-48; L. Kanter, 1994, pp. 144-47.

Kanter accepts both panels as formerly joined at the back.

6

Baldini, 1970, p. 109, cat. 109 (1447)
Pope-Hennessy, 1974, p. 219 (late work)

BIBLIOGRAPHY

N. Valois, 1904, pp. 461-70 (identifies donor's portrait as Spanish Dominican Juan de Torquemada, b. 1388, made cardinal 1439, d. 1468); T. Borenius, 1921, pp. 209-10, pl. I-II (1449-53); R. van Marle, 1928, X, p. 92 (executed on investiture of Dominican Giovanni di Torquemada, which occurred in 1439); F. Schottmüller, 1924, pl. 170 (late work); P. Muratoff, 1930, pp. 65, 91; J. Pope-Hennessy, 1952, p. 196; M. Salmi, 1958, p. 44 (later); B. Berenson, 1963, p. 11; M. Boskovits, 1976, p. 44; E. P. Bowron, 1990, no. 560; C. Lloyd, 1992, pp. 126-27; W. Hood, 1993, p. 197.

6

CHRIST ON THE CROSS BETWEEN THE VIRGIN AND SAINT JOHN WITH CARDINAL JUAN DE TORQUEMADA AS DONOR

Tempera and gold on panel,
34¾ × 14¼ in. (88 × 36 cm)
Fogg Art Museum, Harvard University, Cambridge, Massachusetts;
The Hervey E. Wetzel Bequest Fund 1921.34

PROVENANCE

Private collection, Bologna, where acquired in 1860 by Louis Charles Timbal, Paris; Noel Valois, Paris, by 1904; Hervey E. Wetzel; acquired by the museum in 1921.

6A

SAINT SIXTUS

Tempera and gold on panel,
18⅛ × 6⅜ in. (46 × 16 cm)
Private collection

PROVENANCE

Artaud de Montor, Paris (*Peintres Primitifs: Collection de tableaux rapporté d'Italie*), 1808, no. 62; 1811, no. 85; 1843, no. 82 (as Giottino); Chalandon collection, Lyons and Paris; Mr. and Mrs. Deane Johnson, Bel Air, California; sold, Sotheby's London, December 6, 1972, lot 7.

Inscription on base: SC . . . TRV

This *Crucifixion* was originally the center panel of a portable triptych. Thanks to the researches of N. Valois, in 1904 the painting's owner, the kneeling donor figure has been identified as Juan de Torquemada, a Spanish Dominican, on whom the cardinalate of Saint Sixtus was bestowed by Pope Eugenius IV in 1439.

The panel representing Saint Sixtus was rediscovered in recent years by Pope-Hennessy (1974, p. 218; identified as Saint Peter), who suggested that it had originally served as a lateral wing of the late *Crucifixion* in the Fogg Art Museum, Cambridge. This reconstruction was accepted by Boskovits (1976, pp. 44-45), who identified the figure as Saint Sixtus (San Sisto) and detected in it a disguised portrait of Eugenius IV. A likely date for the commission of the triptych would therefore be 1445-47, or shortly after Angelico's first voyage to Rome in the papal service.

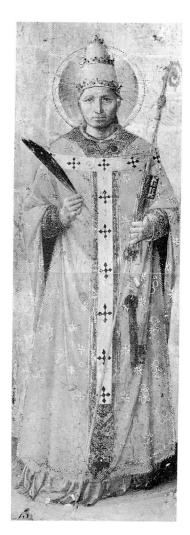

6A

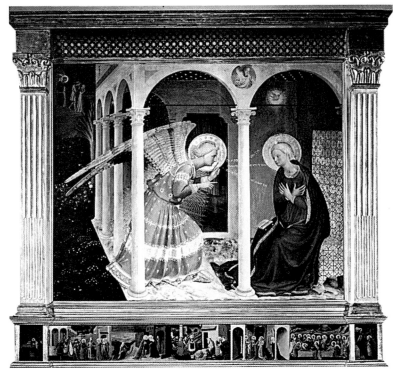

7

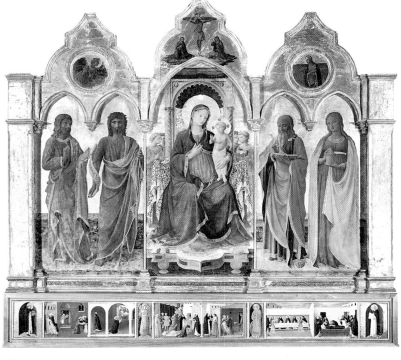

8

7
ANNUNCIATION
Tempera and gold on panel,
69 × 70⅞ in. (175 × 180 cm)
Museo Diocesano, Cortona

PROVENANCE

Formerly Church of San Domenico, Cortona.

Inscriptions: V. Alce, 1984, p. 380

Baldini, 1970, pp. 92-93, cat. 28
(1433-34)
Pope-Hennessy, 1974, p. 192

BIBLIOGRAPHY

P. V. Marchese, 1845, 2d ed., I, pp.
219, 248-49; J. Crowe and G. B.
Cavalcaselle, 1864, 1911 ed., IV,
pp. 73-74; R. L. Douglas, 1900,
pp. 44-53 (early, 1424); A. Wurm,
1907, pp. 4-5; F. Schottmüller, 1911,
cat. 72-74; *idem*, 1924, cat. 74-77
(1430-45); R. van Marle, 1928, X,
pp. 70-72 (late 1430s); P. Muratoff,
1930, pp. 37-38, 82 (1425-30, with
assistants in predella); R. Longhi,
1940, pp. 168, 187 (lost Masaccio is
source of this work); M. Salmi,
1947, pp. 82-83; G. Bazin, 1949, p. 26
(early 1430s); J. Pope-Hennessy,
1952, pp. 167-68 (1430-35); *Mostra*,
1955, pp. 50-51, cat. 28; S. Orlandi,
1955, pp. 55-56 (mid-1430s);
L. Collobi-Ragghianti, "Mostra,"
1955 (1425-35); U. Middeldorf, 1955,
pp. 179-94 (1433-44); B. Berenson,
1963, p. 11; M. Boskovits, "Adorazi-
one," 1976, p. 16 (similar to Monte-
carlo, earlier than Linaiuoli);
D. Cole, in *Mitteilungen . . .* , 1977,
pp. 95-100; D. Cole Ahl, 1981,
pp. 146-48; C. Lloyd, 1992, pp. 11,
44-49; W. Hood, 1993, pp. 100-102;
M. Boskovits, 1994, pp. 323-35.

Circa 1430. See page 92.

8
CORTONA ALTARPIECE
Tempera and gold on panel,
transferred to canvas in 1946-50,
85⅞ × 94½ in. (218 × 240 cm)
Museo Diocesano, Cortona

PROVENANCE

Formerly Church of San Domenico, Cortona.

Inscriptions: V. Alce, 1984, p. 383

Principal register, left to right:
 Saints Matthew and John the
 Baptist, 46⅛ × 27¼ in.
 (117 × 69 cm)
 Madonna and Child with Angels,
 54 × 26⅞ in. (137 × 68 cm)
 Saints Mark and Mary Magdalen,
 46⅛ × 27¼ in. (117 × 69 cm)
Cuspids, left to right:
 The Annunciate Angel, 8¼ in.
 (21 cm) diam.
 Crucifixion with the Virgin and
 Saint John Evangelist, 12¼ ×
 18½ in. (31 × 47 cm)
 The Virgin Annunciate, 8¼ in.
 (21 cm) diam.

Predella (total dimension 9⅛ × 90⅝ in.
[23 × 230 cm]), four figures frame
several scenes, left to right:
 Saint Peter Martyr
 Dream of Pope Innocent III, the
 Meeting of Saints Francis and
 Dominic, Saints Peter and Paul
 Appearing to Saint Dominic
 Saint Michael the Archangel
 Raising of Napoleon Orsini, Dispute
 of Saint Dominic and the Miracle
 of the Book
 Saint Vincent
 Saint Dominic and His Companions
 Fed by Angels, Death of Saint
 Dominic
 Saint Dominic

Baldini, 1970, pp. 96-97, cat. 49
(1435-36)
Pope-Hennessy, 1974, p. 197-98
(stylistically between Linaiuoli
[1433] and Perugia [1437])

BIBLIOGRAPHY

P. V. Marchese, 1845, 3d ed. 1869, II,
pp. 319; J. Crowe and G. B. Caval-
caselle, 1864, 1911 ed., IV, p. 74;
R. L. Douglas, 1900, pp. 66-67, 123,
191-92 (identifies with a painting
recorded as executed c. 1437 on

commission of Niccolò di Angelo
Cecchi—more probably painting is
one in same church by Sassetta);
A. Wurm, 1907, pp. 15-16 (accepts
only head of saint to right of
Virgin); F. Schottmüller, 1911,
pp. 75-77; *idem*, 1924, pp. 78-79
(1430-40, compares to Perugia
Altarpiece); R. van Marle, 1928,
x, p. 68 (1430-40); P. Muratoff,
1930, pp. 40-41, 82 (c. 1430, with
assistants in predella); L. Venturi,
1933, pp. 40-42 (early); *Florence*,
1946, pp. 28-29; U. Procacci, 1947,
pp. 330-31; J. Pope-Hennessy, 1952,
p. 170 (1435-36, predella by the
Master of Cell 2); U. Middeldorf,
1955, p. 189 n. 1); S. Orlandi, 1955,
pp. 57-58 (postdates papal bull of
1438); *Mostra*, 1955, pp. 45-48,
cat. 25-26; M. Salmi, 1958, p. 106;
B. Berenson, 1963, p. 11; L. Berti,
1967, pp. 18, 37; D. C. Cole, 1977,
pp. 95-100; D. Cole Ahl, 1981, pp.
148-49; C. Lloyd, 1992, pp. 72-73;
W. Hood, 1993, pp. 77-82.

Circa 1435. See pages 37-38.

9
MADONNA AND CHILD WITH SAINTS DOMINIC, PETER MARTYR, AND THE EVANGELISTS
Fresco, 56¾ × 93¾ in.
(144 × 238 cm) (lunette)
Church of San Domenico, Cortona
(lunette, west portal of the church)

Baldini, 1970, p. 97, cat. 50 (1435-36)
Pope-Hennessy, 1974, p. 197 (c. 1440)

BIBLIOGRAPHY
P. V. Marchese, 1845, 3d ed. 1869, 11,
pp. 318-19 (early work, cites papal
bull, 1438, by Eugenius IV, empow-
ering prior to "have sacred images
painted"); J. Crowe and G. B.
Cavalcaselle, 1864, 1911 ed., IV, p. 73
(early); R. L. Douglas, 1900, p. 191
(ruined); F. Schottmüller, 1911, p. 87
(1435-45); *idem*, 1924, p. 100 (2d ed.,
dates later, after Montecarlo);

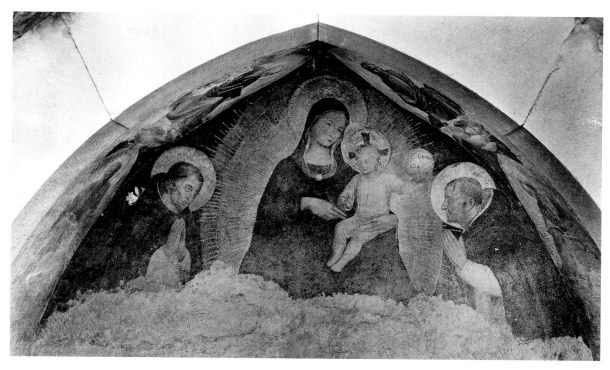

9

R. van Marle, 1928, x, p. 69 (1438);
J. Pope-Hennessy, 1952, p. 170
(1435-38); S. Orlandi, 1955, p. 59
(after 1445); M. Salmi, 1958, p. 29
(1438); B. Berenson, 1963, p. 11;
U. Baldini and L. Berti, 1966, fig. 12;
L. Berti, 1962, p. 208 (1435-40).

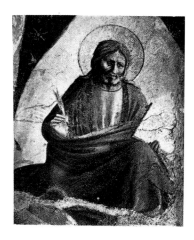
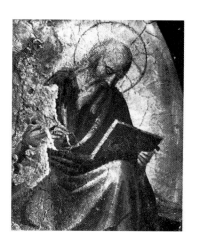

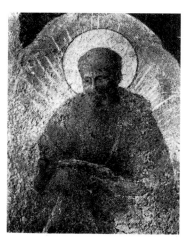
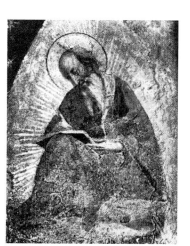

Frescoes in the intrados of the lunette (see 9, above)

10A
ANGEL ANNUNCIATE

10B
VIRGIN ANNUNCIATE

*Tempera and gold on panel, each
13 × 10⅝ in. (33 × 27 cm)
Detroit Institute of Arts; Bequest of
Eleanor Clay Ford (1977) (77.1.1, 77.1.2)*

PROVENANCE
Cardinal Desiderio Scaglia, 1621;
Baron Dominique Vivant-Denon
(sale Paris, May 1, 1836, lot 41);
duke of Hamilton, Glasgow (sale
June 24, 1882, no. 356); Winck-
worth, London (1882); J. E. Taylor
(sale, Christie's London, July 5,
1912, lot 11); Galerie Sedelmeyer,
Paris (until after 1913); Carl
Hamilton, New York; Edsel Ford,
Detroit (1925).

Baldini, 1970, pp. 93-94, cat. 331,J
(1434-35; included with Louvre
altarpiece)
Pope-Hennessy, 1974, p. 223 (other
works ascribed, cuspids for
Louvre?)

BIBLIOGRAPHY
J. Crowe and G. B. Cavalcaselle,
1864, 1911 ed., II, p. 73; R. van
Marle, 1928, x, p. 143; B. Berenson,
1932, p. 20; L. Venturi, 1933, nos.
176-77; J. Pope-Hennessy, 1952,
p. 197 (other works ascribed,
cuspids for Louvre?); S. Orlandi,
1955, p. 60 (rejects theory that
form part of Louvre altarpiece but
identifies with "two small images
painted by the Beato Giovanni
Angelico . . . representing the
Blessed Virgin and the Annunciate
Angel" presented by Convent of
San Domenico at Fiesole to Card.
Scaglia in 1622); M. Salmi, 1958,
p. 110; B. Berenson, 1963, p. 11;
P. Joannides, 1989, pp. 305-6;
C. B. Strehlke, 1994, pp. 345-48
(early 1430s).

Circa 1436-40, by comparison with
cat. 66. Strehlke publishes new
technical data.

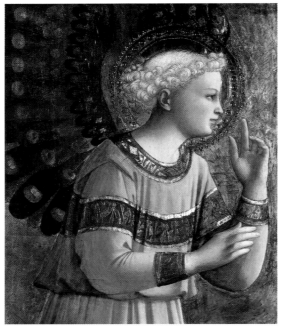

10A

10B

11–14
Frescoes for the Convent of San Domenico, Fiesole

11
CRUCIFIXION

*Fresco, 12 ft. 2 in. × 8 ft. 2½ in.
(3.65 × 2.50 m)
Convent of San Domenico, Fiesole
(in chapter room, covered with
whitewash until 1882)*

Baldini, 1970, p. 89, cat. 12 (1430)
Pope-Hennessy, 1974, p. 197 (fol-
lower of Angelico, c. 1450)

BIBLIOGRAPHY
R. L. Douglas, 1900, pp. 82-83, 96
(1430s); F. Schottmüller, 1911, p. 10;
idem, 1924, p. 171 (1420-30); R. van
Marle, 1928, x, p. 157 (school,
1420-30); P. Muratoff, 1930, p. 75
(1450); J. Pope-Hennessy, 1952,
p. 165 (1430); S. Orlandi, 1955,
pp. 41-42 (connects it with a state-
ment in the *Chronaca quadripartita*
that "the cabinets [*armadi*] in the
sacristy, the tables in the refectory,
and the seats in the chapter room
were made during the priorate of
Fra Pietro d'Antonio [1432] and
then of Fra Girolamo d'Antonio of

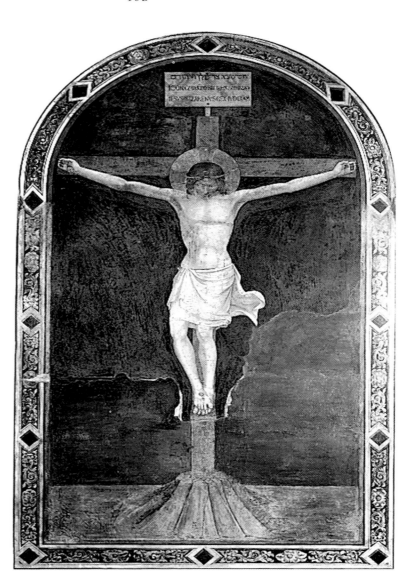

11

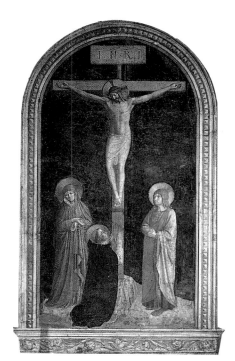

12

Perugia" [1432-34]); M. Salmi, 1958 (1434); B. Berenson, 1963, p. 13; L. Berti, 1964 (after Fiesole altarpiece, close to Masaccio); T. S. Centi, 1984, p. 64; M. Boskovits, 1994, p. 381 (1420s); C. B. Strehlke, 1994, p. 35.

Circa 1425.

12
CRUCIFIXION WITH THE VIRGIN, SAINT DOMINIC, AND SAINT JOHN
Fresco transferred to canvas,
14 ft. 3¼ in. × 8 ft. 6 in.
(4.35 × 2.60 m)
Musée du Louvre, Paris (no. 1294)

PROVENANCE

Refectory, Church of San Domenico; Bardini collection, Florence (1879); acquired by Louvre (1880).

Baldini, 1970, p. 108, cat. 104 (1440)
Pope-Hennessy, 1974, pp. 196-97
(before 1435)

SOURCES

Albertini, 1510, 1863 ed., p. 13: San Domenico, Fiesole, "there are many things by fra Giovanni"
Libro di Antonio Billi, 1506-30: Codice

Petrei, Magl. XIII, n. 89 (1991 ed., p. 78): "and in San Domenico, where he lived, he painted many panels."

Codice Strozziano, Magl. XXV, n. 636 (1991 ed., p. 128): "he painted in San Domenico in Fiesole, where he lived, many panels."
Chronica quadripartita del convento di S. Domenico di Fiesole, 1516 (S. Orlandi, 1954, p. 164): "He painted . . . several pictures in this Fiesole convent . . . in the old chapter room which is now the guest quarters."
L'Anonimo Magliabechiano, Magl. cl XVII, 17, 1536-46 (1968 ed., p. 103): "In the church of San Domenico in Fiesole there are several paintings of his which are well known to informed people as good examples of his style. He painted Our Lady outside the church above the entrance."
Chronaca Sancti Dominici de Fesulis (f.10) records that the painting was restored by Francesco Mariani in 1566.

BIBLIOGRAPHY

P. V. Marchese, 1845, 3d ed. 1869, II, p. 336 (in situ on wall opposite refectory, much repainted); G. Milanesi, 1878, p. 511 n. 1: ("In the same convent there are still two frescoes by Fra Giovanni: one in the room that was the refectory, representing Christ on the Cross, with Saint John and the Blessed Virgin on the sides"); J. Crowe and G. B. Cavalcaselle, 1864, 1911 ed., IV, p. 88; R. L. Douglas, 1900, p. 197 (ruined); F. Schottmüller, 1911, p. 212; *idem,* 1924, p. 228 (dubious); R. van Marle, 1928, X, pp. 53-58; P. Muratoff, 1930, p. 91 (school); J. Pope-Hennessy, 1952, p. 165; B. Berenson, 1963, p. 15; A. Brejon de Lavergnée and D. Thiébaut, 1981, p. 144; T. S. Centi, 1984, p. 64; W. Hood, 1993, pp. 155-56.

Damaged, but fully autograph, circa 1440

13
MADONNA AND CHILD WITH SAINTS DOMINIC AND THOMAS
Fresco transferred to canvas,
77¼ × 73⅝ in. (196 × 187 cm)
Hermitage Museum, Saint Petersburg

PROVENANCE

Church of San Domenico, Fiesole (chapter room, per Marchese, or dormitory at head of stair, per Orlandi); A. Mazzanti and C. Conti, Florence; Capponi collection, Florence (1879); Archduke Sergius of Russia (1882).

Baldini, 1970, p. 89, cat. 13 (1430)
Pope-Hennessy, 1974, p. 197
(1st half 1430s)

SOURCES

Albertini, 1510, 1863 ed., p. 13: San Domenico, Fiesole: "there are many things by fra Giovanni."
Libro di Antonio Billi, 1506-30: Codice *Petrei,* Magl. XIII, n. 89 (1991 ed., p. 78): "and in San Domenico, where he lived, he painted many panels."

Codice Strozziano, Magl. XXV, n. 636 (1991 ed., p. 128): "he painted

in San Domenico in Fiesole, where he lived, many panels."
Chronica quadripartita del convento di S. Domenico di Fiesole, 1516 (S. Orlandi, 1954, p. 164): "He painted . . . several pictures in this Fiesole convent . . . in the old chapter room which is now the guest quarters."
L'Anonimo Magliabechiano, Magl. cl XVII, 17, 1536-46 (1968 ed., p. 103): "In the church of San Domenico in Fiesole there are several paintings of his which are well known to informed people as good examples of his style. He painted Our Lady outside the church above the entrance."

BIBLIOGRAPHY

P. V. Marchese, 1845, 3d ed. 1869, II, pp. 337-38 (in situ in chapter room, one of Angelico's best works); G. Milanesi, 1878, II, p. 511, n. 1 ("In the same convent there are still two frescoes by Fra Giovanni: one in the room that was the refectory, representing Christ on the Cross, with Saint John and the Blessed Virgin on the sides; the other is in the old Chapter Room, with Our Lady with her Son in her arms,

13

between Saint Dominic and Saint Thomas Aquinas. This is very damaged by having been badly repainted"); J. Crowe and G. B. Cavalcaselle, 1869, 1911 ed., IV, p. 88; F. Schottmüller, 1911, p. 65; *idem*, 1924, p. 101 (1430-45, in 2d edition places later); J. Pope-Hennessy, 1952, p. 165 (1433); M. Salmi, 1958, p. 87 (pre-1433); B. Berenson, 1963, p. 14 (early); S. Orlandi, 1964, pp. 125-26; M. Boskovits, "Adorazione," 1976, p. 31 (1425-30); T. S. Centi, 1984, p. 64; M. Boskovits, 1994, p. 346.

1425-1430.

14
MADONNA AND CHILD
Fresco and sinopia transferred,
45¾ × 29⅝ in. (116 × 75 cm)
Church of San Domenico, Fiesole

In 1587, moved and placed with the wall on which it was painted over a doorway on the ground floor of the convent with the inscription: B. Joannes Angelicus huius cenobii filius pinxit.

Baldini, 1970, p. 96, cat. 46 (1435)
Pope-Hennessy, 1974, p. 196 (1430-35)

SOURCES
L'Anonimo Magliabechiano, Magl. cl XVII, 17, 1536-46 (1968 ed., p. 103): "In the church of San Domenico in Fiesole there are several paintings of his which are well known to informed people as good examples of his style. He painted Our Lady outside the church above the entrance."
Vasari, 1568, II, pp. 512-13: "Also the pictures that are in the arch over the door of San Domenico are by the same artist."

BIBLIOGRAPHY
S. Orlandi, 1955, p. 42 (relates to Madonna dei Linaiuoli); *Mostra*, 1955, p. 14; M. Salmi, 1958, p. 86; U. Procacci, 1960, p. 243, no. 51; T. Centi, 1961, pp. 3-9; B. Berenson, 1963, p. 13; T. S. Centi, 1984, p. 63.

The sinopia offers a beautiful example of Angelico's draftsmanship. The poor condition of the fresco precludes definitive dating.

15
SAN DOMENICO ALTARPIECE

Formerly over the high altar, the altarpiece was modified by Lorenzo di Credi in 1501 and dismantled in 1792. Only the central panel remains in San Domenico, Fiesole, in the first chapel on the left side.

14

14A

Principal register

15A
THE VIRGIN AND CHILD ENTHRONED WITH EIGHT ANGELS BETWEEN SAINTS THOMAS AQUINAS, BARNABAS, DOMINIC, AND PETER MARTYR
Tempera and gold on panel,
83½ × 93¼ in. (212 × 237 cm)
Church of San Domenico, Fiesole

Predella

RISEN CHRIST WITH ANGELS AND SAINTS
12⅝ × 96½ in. (32 × 245 cm) total;
five panels (left to right):

15B
DOMINICAN SAINTS
12⅝ × 8½ in. (32 × 21.5 cm)
15C
VIRGIN AND SAINTS
12⅝ × 25¼ in. (32 × 64 cm)
15D
CHRIST IN GLORY AMONG ANGELS AND SAINTS
12⅝ × 28¾ in. (32 × 73 cm)

15E
THE PRECURSORS OF CHRIST WITH SAINTS
12⅝ × 25 in. (32 × 63.5 cm)
15F
DOMINICAN SAINTS
12⅝ × 8¾ in. (32 × 22 cm)
National Gallery, London (no. 663)

PROVENANCE
Giovanni Metzger, Florence; collection V. Valentini, Prussian consul to Rome (1827); Gioacchino Valentini sold through A. MacBean, London, to the National Gallery in 1860.

Pilasters

15G
SAINT MARK
14¼ × 4⅜ in. (36 × 11 cm)
Inscribed on reverse: Questa figura rappresenta S. Marco apostolica evangelista, di mano di Gio; Beato / Angelico era una delle dieci che adorna / vano un altare del convento di S. Dome / nico di Fiesole

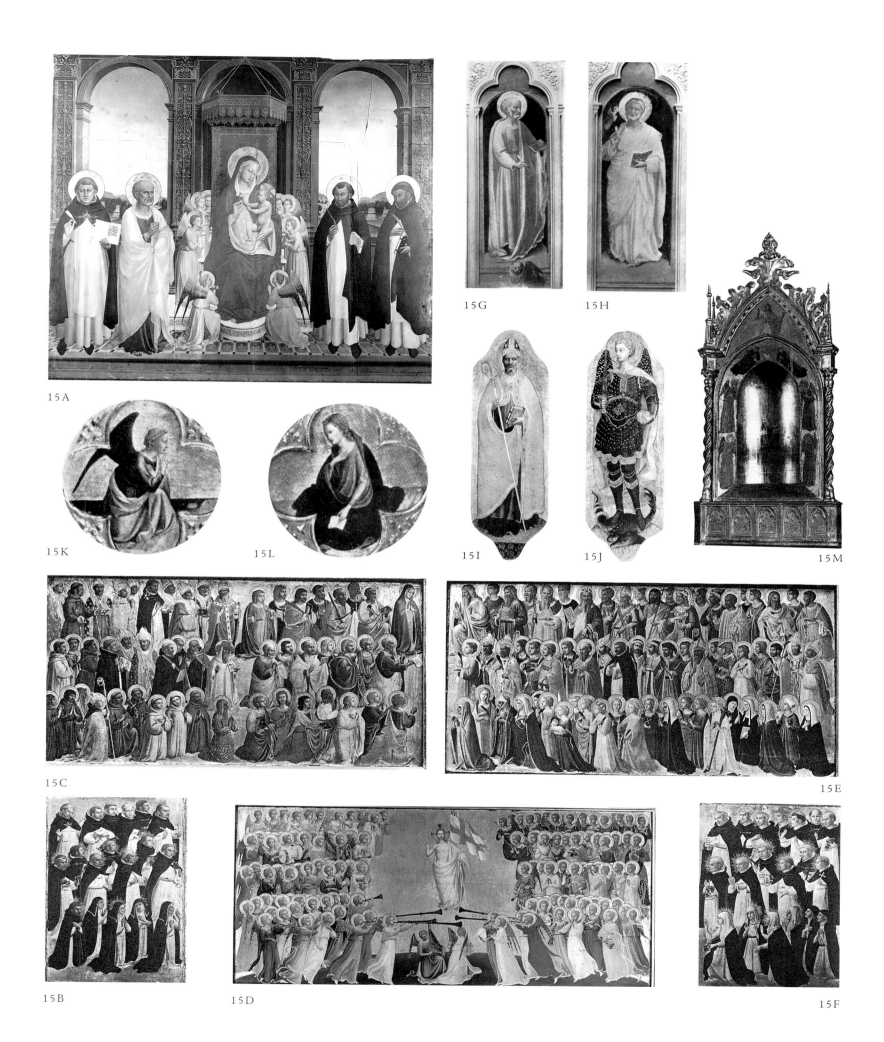

15A

15G 15H

15K 15L

15I 15J 15M

15C

15E

15B

15D

15F

15H
SAINT MATTHEW

12⅝ × 4⅜ in. (32 × 11 cm)

Inscribed on reverse: Questa figura rappresenta S. Matteo apostolica evangelista, di mano di Gio; Beato / Angelico era una delle dieci che adorna / vano un altare del convento di S. Dome / nico di Fiesole

Musée Condé, Chantilly

PROVENANCE

Collection Frédéric Reiset, Paris; acquired from him (p. 2, no. 4) by the Duc d'Aumale, Chantilly, in 1879.

15I
SAINT NICHOLAS

14¼ × 5½ in. (36 × 14 cm)

15J
SAINT MICHAEL ARCHANGEL

14¼ × 5½ in. (36 × 14 cm)

Deane Johnson Collection, Bel Air, California

PROVENANCE

Formerly Reverend Hawkins-Jones, Sheffield, England

Cuspids
—

15K
ANNUNCIATE ANGEL

15L
VIRGIN

Tucker collection, Vienna

PROVENANCE

Acquired in the nineteenth century

Ciborium
—

15M
GOD THE FATHER WITH SIX ANGELS

37 × 15¾ in. (94 × 40 cm)

Hermitage Museum, Saint Petersburg

PROVENANCE

Bardini collection, Rome, by 1911; collection of Count G. Stroganov, Rome; by his bequest to the Hermitage Museum

Baldini, 1970, pp. 87-89, 92; cat. 9, 25 (altarpiece c. 1430; ciborium, 1434)

Pope-Hennessy, 1974, pp. 189-90, 233 (1424-25, accepts Chantilly and Los Angeles pilasters; cuspids in other works ascribed, c. 1425 Angelico attribution plausible but questions whether from this altarpiece)

SOURCES

Chronica quadripartita del convento di S. Domenico Fiesole, fol. 3v (S. Orlandi, 1954, II, p. 112; October 1435 consecration of the church): "And the consecration of the church took place on the last Sunday in October in the aforesaid year. . . . The pictures on the high altar as well as on the minor altars were all painted by the hand of Fra Giovanni Pietro of the Mugello of this convent and were in place several years before the church was consecrated. The positions of the aforesaid altars was subsequently changed."

Albertini, 1510 (*Mostra*, 1955, p. 30): San Domenico, Fiesole: "there are many works by Fra Giovanni."

Libro di Antonio Billi, 1506-30: *Codice Petrei*, Magl. XIII, n. 89 (1991 ed., p. 78): "and in San Domenico in Fiesole, where he lived, he painted many pictures."

Codice Strozziano, Magl. XXV, n. 636 (1991 ed., p. 128): "He painted in San Domenico in Fiesole, where he lived, many pictures."

Chronica quadripartita del convento di S. Domenico di Fiesole, 1516 (S. Orlandi, 1954, p. 164): "He painted many altarpieces in various churches and chapels and confraternities, three of them are in this convent of Fiesole."

L'Anonimo Magliabechiano, Magl. cl XVII, 17, 1536-46 (1968 ed., p. 103): "In the church of San Domenico in Fiesole there are several paintings of his which are

well known to informed people as good examples of his style. He painted Our Lady outside the church above the entrance."

Vasari, 1568, II, pp. 509-10: "He also painted at San Domenico in Fiesole the painting over the high altar, which, perhaps because it seemed in poor condition, was retouched by other masters and made worse. But the predella and the ciborium are better preserved. An infinitude of little figures are seen in heavenly glory; they are so beautiful that they truly appear to be in paradise. And no one who goes up close can ever have his fill of looking at them."

Giglioli, *Catalogo delle cose d'arte e di antichita d'Italia*, Fiesole, 1933, 24-25: "Circa 1501, during the priorate of Fra Dominic of the Mugello, the tribune of the apse was renovated into two arches, and the high altar removed and placed next to the wall. . . . The painting above the high altar was renovated into rectangular form with additional painting and decorations executed by the distinguished painter Lorenzo de' Credi."

BIBLIOGRAPHY

D. Moreni, *Notizie istoriche dei contorni di Firenze*, III, 1742, p. 90 (gives pilasters to Lorenzo di Credi); P. V. Marchese, 1854, I, p. 229 (located in the choir; transcribes *Chronaca Sancti Dominici de Fesulis*); J. Crowe and G. B. Cavalcaselle, 1864, 1911 ed., IV, p. 88 n. 6 (identify ciborium formerly with Stefano Bardini, Florence, as part of altarpiece complex); B. Berenson, 1896, p. 100 (accepts London predella); F.-A. Gruyer, 1896, p. 15; idem, *Chantilly, Musée Condé, notices des peintures*, Paris, 1899, pp. 11-12; L. Douglas, 1900, p. 81 (1435-37, accepts the London predella); M. Wingenroth, 1905, p. 24 (accepts the London predella);

G. Macon, *Chantilly Musée Condé itineraire*, Paris, 1907, p. 45; N. Vrangel and A. Trubnikov, "Pictures from the Roman Collection of Count G. Stroganov," *The Old Years*, March 1909, p. 119; A. Venturi, 1911, p. 40; F. Schottmüller, 1911, pp. 3-9, ciborium pp. 12-13; idem, 1924, pp. 4-10, ciborium pp. 14-15 (altarpiece, 1420-25, ciborium 1420-30); R. van Marle, 1928, X, p. 42, pp. 184-85 (ascribes pilasters and predella to Zanobi Strozzi, ascribes cuspids to school); A. Venturi, 1927, p. 12; R. Longhi, 1928, p. 155; P. Muratoff, 1930, p. 31 (with Lorenzo di Credi, 1418-20, rejects the London predella); R. Longhi, 1940, p. 174; L. Collobi-Ragghianti, 1950, pp. 4, 6, 32, 54 (Zanobi Strozzi); J. Pope-Hennessy, 1952, pp. 166-67; *Mostra*, 1955, pp. 12-15 (1430-35), p. 16 (Bel Air pilasters studio); S. Orlandi, 1955, p. 25 (1428-34); M. Salmi, 1958, pp. 11, 85, 98 (before 1438, cuspids part of altarpiece, Chantilly pilasters are school); M. Davies, 1961, pp. 12-24; B. Berenson, 1963, pp. 11, 13, and 14 (autograph except for the pilasters in Chantilly executed by the studio, no listing for cuspids); S. Orlandi, 1964, p. 203; L. Berti, 1967, pp. 32-33 (dates ciborium c. 1434); M. Boskovits, "Appunti," 1976, pp. 32, 34, 42; M. Boskovits, "Adorazione," 1976, p. 8, *passim* (early, c. 1422-23); U. Baldini, 1977, pp. 236-46; D. Cole Ahl, 1980, pp. 364-65; E. de Boissard and V. Lavergne Durey, 1988, pp. 44-46; C. Lloyd, 1992, pp. 38-39; W. Hood, 1993, pp. 65-71; M. Boskovits, 1994, pp. 309-68.

See pages 84-85.

16–60
Frescoes for the
Convent of San Marco
Convent of San Marco, Florence

Entrusted to Dominicans of
Fiesole on January 21, 1436, by
Pope Eugenius IV, restructured by
Michelozzo beginning in 1437, at
request of Cosimo de Medici,
completed by 1452

Baldini, 1970, pp. 104-7, cats. 69-72,
95-101 (Work progressed from
the cells to the cloister; from the
chapter room [finished 1442] to
the church [consecrated 1443]).
Pope-Hennessy, 1974, pp. 202-6.

SOURCES
Fra Giuliano Lapaccini (d. 1458),
Cronaca di San Marco (R. Morcay,
1913, p. 14): "The third distinction
is seen in the paintings. The
panel for the high altar and the
figures in the chapter room, in
the very first cloister, and in all
the upper cells, and the Cruci-
fixion in the refectory were all
painted by a certain friar of the
Order of Preachers of the Fie-
solan convent, who was consid-
ered a great master of pictorial
art in Italy. He was called Fra
Giovanni Pietro of Mugello, a
man of extreme modesty and
religious ways."
Antonio Manetti, c. 1490
(S. Orlandi, 1964, pp. 195-96),
"Fra Giovanni . . . painted for
San Marco the picture on the
high altar, and also the chapter
room in the first cloister where
Christ is shown on the cross with
the thieves at his side and with
many saints; and many other
works in this church, especially in
the habitations of the friars."
Libro di Antonio Billi, 1506-30: *Codice
Petrei*, Magl. XIII, n. 89 (1991 ed.,
p. 77): "with great facility he
painted in Florence . . . also the
chapter room of San Marco in
Florence, and the picture of the

high altar with other paintings in
this church."
Codice Strozziano, Magl. XXV,
n. 636 (1991 ed., p. 128): "And
among other things, the chapter
room in San Marco, and the pic-
ture of the high altar, with more
paintings for this house."
Albertini, 1510, 1863 ed., p. 12: "In the
large convent and church of San
Marco, constructed in large part
by the Medici, there are numerous
good works. The main altarpiece
and the chapter room and the
figures in the first cloister are from
the hand of Fra Giovanni of the
Order of Preachers."
L'Anonimo Magliabechiano, Magl.
cl XVII, 17, 1536-46, 1968 ed., p. 102:
"In Florence, in the monastery of
the friars of San Marco he painted
the chapter room . . . and there are
more paintings by him in the
convent of these friars."

BIBLIOGRAPHY
P. Muratoff, 1930 (dates 1437-45);
F. Schottmüller, 1911, p. 95; *idem*,
1924, p. 272 (dates 1437-45); J. Pope-
Hennessy, 1952, pp. 179-87; *Mostra*,
1955, pp. 87-99, app. A; C. Gilbert,
1959, pp. 75-87; B. Berenson, 1963,
p. 13; L. Berti, 1965; M. Boskovits,
"Appunti," 1976, pp. 40-41;
P. Schaeffer, 1983, pp. 329-44;
M. Boskovits, 1983, pp. 11-24;
G. Bonsanti, 1990, pp. 115-72;
T. Verdon and J. Henderson,
1990, pp. 108-31; W. Hood, 1993;
M. Boskovits, 1994, pp. 369-95;
M. Scudieri, 1995, *passim*.

Cloister of Sant'Antonino

16
CRUCIFIED CHRIST
ADORED BY
SAINT DOMINIC
133⅞ × 81⅛ in. (340 × 206 cm)
Convent of San Marco, Florence
(on wall opposite entrance to cloister)

SOURCE
Vasari, 1568, II, 1863 ed., p. 508:
"Then he painted many beautiful
figures in fresco in lunettes in the
first cloister, and a much-praised
Crucified Christ with San Domen-
ico at his feet."

BIBLIOGRAPHY
J. Crowe and G. B. Cavalcaselle,
1864, 1911 ed., IV, pp. 81-83; R. L.
Douglas, 1900, p. 195; F. Schott-
müller, 1911, pp. 95-96; *idem*, 1924,
pp. 103-4; R. van Marle, 1928, X,
p. 98; P. Muratoff, 1930, p. 86;
W. and E. Paatz, 1952, III, p. 32;
Mostra, 1955, p. 98; M. Salmi, 1958,
p. 88 (after fresco in chapter room);
B. Berenson, 1963, p. 12; U. Baldini,
1970, p. 107, cat. 95 (autograph,
among last works); J. Pope-
Hennessy, 1974, p. 202 (designed
and executed by Angelico, after
1442); G. Bonsanti, in *San Marco*,
1990, pp. 161-62; W. Hood, 1993,
pp. 147-58; P. Morachiello, 1995,
p. 170; W. Hood, 1995, pp. 55-58.

17
SAINT DOMINIC
39⅜ × 57⅛ in. (100 × 145 cm)
Convent of San Marco, Florence
*(in lunette above entrance to chapter
room, north side of cloister)*

BIBLIOGRAPHY
J. Crowe and G. B. Cavalcaselle,
1864, 1911 ed., IV, p. 84; R. L. Doug-
las, 1900, p. 195; F. Schottmüller,
1911, p. 97; *idem*, 1924, p. 105; R. van
Marle, 1928, X, pp. 98-99; P. Mura-
toff, 1930, pp. 86-87 (omits); *Mostra*,
1955, p. 98; M. Salmi, 1958, p. 88
(1442); B. Berenson, 1963, p. 12

16

(restored); U. Baldini, 1970, p. 107,
cat. 96; J. Pope-Hennessy, 1974,
p. 202 (restored); G. Bonsanti, in
San Marco, 1990, p. 162 (destroyed);
W. Hood, 1993, p. 158.

18
SAINT PETER
MARTYR ENJOINING
SILENCE
42½ × 57⅛ in. (108 × 145 cm)
Convent of San Marco, Florence
*(in lunette above entrance to sacristy
on west wall of cloister)*

BIBLIOGRAPHY
J. Crowe and G. B. Cavalcaselle,
1864, 1911 ed., IV, p. 83; R. L.
Douglas, 1900, p. 195; F. Schott-
müller, 1911, p. 97; idem, 1924,
p. 105; R. van Marle, 1928, X,
pp. 98-99; P. Muratoff, 1930, p. 87;
Mostra, 1955, p. 98; M. Salmi, 1958,
p. 88; B. Berenson, 1963, p. 12;
U. Baldini, 1970, p. 107, cat. 97;
J. Pope-Hennessy, 1974, p. 202;
G. Bonsanti, in *San Marco*, 1990,
p. 162; W. Hood, 1993, p. 148.

17

18

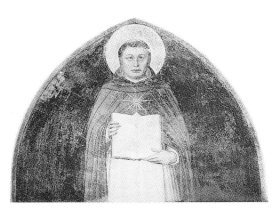

19

19
SAINT THOMAS AQUINAS

42½ × 57⅛ in. (108 × 145 cm)
Convent of San Marco, Florence (in lunette above west entrance to pilgrims' hospice on south wall of cloister)

BIBLIOGRAPHY

J. Crowe and G. B. Cavalcaselle, 1864, 1911 ed., IV, p. 84; R. L. Douglas, 1900, p. 195; F. Schottmüller, 1911, p. 98; *idem*, 1924, p. 106; R. van Marle, 1928, x, pp. 98-99; P. Muratoff, 1930, p. 87; M. Salmi, 1958, p. 88; B. Berenson, 1963, p. 12; U. Baldini, 1970, p. 107, cat. 98; J. Pope-Hennessy, 1974, p. 202; G. Bonsanti, in *San Marco*, 1990, p. 162; W. Hood, 1993, p. 160.

20
PIETÀ

47¼ × 50 in. (120 × 127 cm)
Convent of San Marco, Florence (in lunette above door to refectory)

BIBLIOGRAPHY

J. Crowe and G. B. Cavalcaselle, 1864, 1911 ed., IV, p. 84; R. L. Douglas, 1900, p. 195; F. Schottmüller, 1911, p. 98; *idem*, 1924, p. 106; R. van Marle, 1928, x, pp. 98-99; P. Muratoff, 1930, p. 87; *Mostra*, 1955, p. 98; M. Salmi, 1958, p. 88; B. Berenson,

1963, p. 12; U. Baldini, 1970, p. 107, cat. 99 (ruined); J. Pope-Hennessy, 1974, p. 205 (one of finest in cloister); G. Bonsanti, in *San Marco*, 1990, p. 162; W. Hood, 1993, p. 159; M. Boskovits, 1994, pp. 369-95.

21
CHRIST AS PILGRIM RECEIVED BY TWO DOMINICANS

42½ × 57⅛ in. (108 × 145 cm)
Convent of San Marco, Florence (in lunette above east entrance to hospice, south side of cloister)

BIBLIOGRAPHY

J. Crowe and G. B. Cavalcaselle, 1864, 1911 ed., IV, p. 84; R. L. Douglas, 1900, p. 195; S. Beissel, 1905, p. 22; F. Schottmüller, 1911, p. 99; *idem*, 1924, pp. 107-8; R. van Marle, 1928, x, pp. 98-99; P. Muratoff, 1930, p. 87; *Mostra*, 1955, p. 98; M. Salmi, 1958, p. 88; B. Berenson, 1963, p. 13; S. Orlandi, 1964, p. 77; U. Baldini, 1970, p. 107, cat. 100; J. Pope-Hennessy, 1974, p. 205; G. Bonsanti, in *San Marco*, 1990, p. 162; W. Hood, 1993, p. 160.

22
Chapter Room (sala capitolare)

CRUCIFIXION WITH ATTENDANT SAINTS

17 ft. 10½ in. × 30 ft. 10½ in.
(5.5 × 9.5 m)
Convent of San Marco, Florence (occupies entire north wall of chapter house)

At center: Crucifixion with the Virgin, the two Maries, Saint John

Saints shown at left of cross (left to right): Saints Cosmas and Damian, Lawrence, Mark, John the Baptist

Saints shown at right of cross (kneeling, left to right): Saints Dominic, Jerome, Francis, Bernard of Clairvaux, Giovanni Gualberto, Peter Martyr

Saints shown at right of cross (standing, left to right): Saints Ambrose, Augustine, Benedict, Romuald and Thomas Aquinas

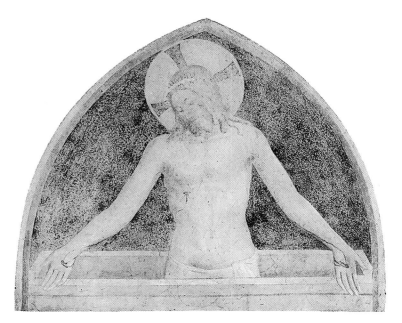

20

21

In border of fresco are eleven medallions, as follows. Center: pelican with inscription: SIMILIS FACTVS SVM PELLICANO SOLITVDINIS; remaining ten, left to right: unidentified figure with inscription: DEVS NATVRE PATITVR; Daniel with inscription: POST EDOMADES VII ET LXII OCCIDET(VR) CHR(ISTV)S; Zachariah with inscription: HIS PLAGATVS SVM; Jacob with inscription: AD PRAEDAM DESCENDISTI FILI MI DORMIENS ACCVBVISTI VT LEO; David with inscription: IN SITI MEA POTAVERVNT ME ACETO; Isaiah, with inscription: VERE LANGORES NOSTROS IPSE TVLIT ET DOLORES MEOS; Jeremiah, with inscription: O VOS OMNES QVI TRANSITE PER VIAM ATTENDITE ET VIDETE SI EST DOLOR SICVT DOLOR MEVS; Ezekial, with inscription: EXALTAVI LIGNVM H[VM]ILE; Job, with inscription: QVIS DET DE CARNIBVS EIVS VT SATVREMVR; and the Erythraean Sibyl, with the inscription: MORTE MORIETVR TRIBVS DIEBVS SOMNO SVBSCEPTO ET TVNC AB INFERIS REGRESSVS AD LVCEM VENIET PRIMVS.

SOURCES

Vasari, 1568, II, pp. 507-8: "The merits of this priest were especially admired by Cosimo de' Medici. After Cosimo had rebuilt the church and convent of San Marco he had him paint the Passion of Jesus Christ on a wall in the chapter room. On one side of Christ are seen all the saints who were heads and founders of orders, crying and lamenting; on the other side appears Saint Mark the Evangelist near to the Mother of the Son of God, who has fainted to see the Savior crucified. The grieving Maries are at her side, supporting her, and Saints Cosma and Damian appear also. It is said that Fra Giovanni portrayed from life his friend, the sculptor Nanni d'Antonio di Banco, in the figure of Saint Cosma. Below this work, he painted a frieze above the chairbacks representing a tree that has San Domenico standing upright and certain roundels in the branches contain all the popes, cardinals, bishops, saints and theologians that had belonged to the Preacher Friars until that time. In this work he made many portraits based on life with the assistance of the friars who sent for portraits from various places, including: San Domenico, center, who holds the branches of the tree; Pope Innocent V, a Frenchman; the blessed Ugo, first cardinal of the Order; the blessed Paul of Florence, patriarch; Sant'Antonino, archbishop of Florence [sic; he was prior of the convent at this time]; the blessed Giordano of Germany, second general of the Order; the blessed Niccolò; the blessed Remigio of Florence; Boninsegno, the Florentine martyr; all the preceding appear on the right side; on the left are shown Benedetto XI of Treviso; Cardinal Giandomenico of Florence; Pietro da Palude, patriarch of Jerusalem; Albertus Magnus of Germany; the blessed Raimondo of Catalonia, third general of the Order; the blessed Chiaro of Florence, head of the Roman province; Saint Vincenzio of Valencia; and the blessed Bernardo of Florence. All these heads are truly graceful and very beautiful."

BIBLIOGRAPHY

P. V. Marchese, 1845, 3d ed. 1869, II, p. 255; J. Crowe and G. B. Cavalcaselle, 1864, 1911 ed., IV, pp. 84-85; R. L. Douglas, 1900, pp. 99-100, 195 (most beautiful of all Italian paintings, regards red ground as evidence fresco incomplete, or blue overlay disappeared with time);

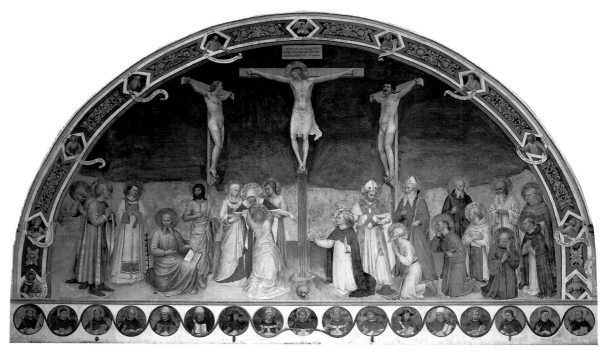

22

F. Schottmüller, 1911, pp. 100-105; *idem*, 1924, pp. 109-14; R. van Marle, 1928, x, pp. 99-106; P. Muratoff, 1930, pp. 54, 87 (with assistants, 1437-45); S. Orlandi, 1955, pp. 224, 268-70; *Mostra*, 1955, pp. 98-99; M. Salmi, 1958, p. 88; B. Berenson, 1963, p. 13; U. Baldini, 1970, p. 107, cat. 101 (chronology confirmed by docs. 1441-42); J. Pope-Hennessy, 1974, pp. 205-6 (months between August 22, 1441, and August 1442, studio intervention, figure of good thief perhaps Gozzoli); M. J. Marek, 1985, pp. 451-75; D. A. Covi, 1986, no. 91 (inscriptions); G. Bonsanti, in *San Marco*, 1990, pp. 162-64; W. Hood, 1993, pp. 184-93; M. Boskovits, 1994, pp. 369-95; Morachiello, 1995, pp. 193-96; W. Hood, 1995, pp. 61-69.

See pages 132-35.

Refectory

23
CRUCIFIXION WITH THE VIRGIN AND SAINT JOHN
Destroyed

SOURCES

Annali Sancti Marti, f.6.t assumed by P. V. Marchese (1845, 3d ed., 1869, I, pp. 257-58) to have been destroyed in 1534 in favor of Sogliani's fresco of *Saint Dominic and His Brethren Fed by Angels*

Upper Floor:
Frescoes in the Corridors

24
ANNUNCIATION
90½ × 117 in. (230 × 297 cm)
Convent of San Marco, Florence
(on inner wall of north corridor facing staircase)

Beneath fresco is inscription: Virginis intactae cvm veneris ante figvram preterevndo cave ne sileatvr ave.
Above this is an inscription of uncertain date from Adamo di San Vittore: Salve Mater pietatis et totivs trinitatis nobile triclinivm.

BIBLIOGRAPHY

P. V. Marchese, 1845, 3d ed. 1869, II, pp. 371-72; J. Crowe and G. B. Cavalcaselle, 1864, 1911 ed., IV, p. 85; R. L. Douglas, 1900, p. 106; A. Wurm, 1907 (reservations); F. Schottmüller, 1911, p. 106; *idem*, 1924, p. 115; R. van Marle, 1928, x, p. 76; P. Muratoff, 1930, p. 88 (with assistants); J. Pope-Hennessy, 1952, p. 201; *Mostra*, 1955, pp. 89-90 (among best); M. Salmi, 1958, p. 87; B. Berenson, 1963, p. 13; U. Baldini, 1970, p. 104, cat. 69 (among best of master; variously dated to early part of activity at San Marco: e.g., Francini-Ciaranfi, Salmi, Bellardonj, or toward Roman period, 1449); J. Pope-Hennessy, 1974, p. 206 (composition richest and most satisfying of Angelico's work and great part by master); V. Alce, 1984, p. 387; G. Bonsanti, in *San Marco*, 1990, p. 169; C. Lloyd, 1992, pp. 66-67; W. Hood, 1993, pp. 260-72; P. Morachiello, 1995, pp. 269-70; W. Hood, 1995, pp. 70-75.

See pages 136-41.

25
CRUCIFIED CHRIST ADORED BY SAINT DOMINIC
94⅛ × 66⅛ in. (239 × 168 cm)
Convent of San Marco, Florence (east end of north corridor)

At base is inscription: Salve mundi salvtare. salve salve iesv chare. Crvci tvae me aptare. Vellem verre tv scis qvare. Presta mihi copiam (Full text of hymn in Migne, Patr. Lat., CLXXXXIV, 1319)

BIBLIOGRAPHY

J. Crowe and G. B. Cavalcaselle, 1864, 1911 ed., IV, p. 85; R. L. Douglas, 1900, p. 195; F. Schottmüller, 1911, cat. 107; *idem*, 1924, p. 120 (with assistants); R. van Marle, 1928, x, p. 77. P. Muratoff, 1930, p. 88 (with assistants); *Mostra*, 1955, p. 90 (with assistants); B. Berenson, 1963, p. 13; Baldini, 1970, p. 104, cat. 70 (by tradition, not documented, saint is a self-portrait, major part autograph); J. Pope-Hennessy, 1974, p. 206 (weak variant of same subject in cloister); G. Bonsanti, in *San Marco*, 1990, p. 168; W. Hood, 1993, p. 195 (assistants); P. Morachiello, 1995, p. 288.

26
MADONNA AND CHILD ENTHRONED WITH EIGHT SAINTS (MADONNA DELLE OMBRE)
Fresco and tempera with gold, 6 ft. 4 in. × 8 ft. 10½ in. (1.95 × 2.73 m) (image); 10 ft. 5 in. × 8 ft. 10½ in. (3.20 × 2.73 m) (including marble base)
Convent of San Marco, Florence (inner wall, east corridor)

Saints shown from left to right: Saints Dominic, Cosmas, Damian, Mark, John the Evangelist, Thomas Aquinas, Lawrence, Peter Martyr

Inscribed on the open book held by Saint Mark the Evangelist: Secundum marcum. Initium evangelii Ihesu. (Filii) Dei. Sicut scriptum est in Isaya propheta. Ecce ego micto angelum meum ante faciem tuam qui praeparabit viam tuam ante te. Vox clamantis in deserto pa (Mark 1:1-3)

Inscribed on the open book held by the order's founder, Saint Dominic: Caritatem habete humilitatem servate paupertatem voluntariam possidete. Maledictionem dei

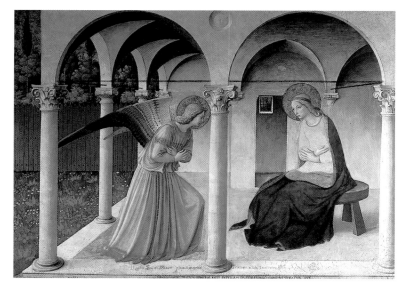

24

et meam imprecor possessiones
inducentibus in hoc ordine

SOURCE

Fra Giuliano Lapaccini, *Libri di
ricordi*, c. 1450

BIBLIOGRAPHY

R. L. Douglas, 1900, p. 195;
A. Wurm, 1907 (doubts); F. Schott-
müller, 1911, pp. 108-11; *idem*, 1924,
pp. 116-19 (in part); R. van Marle,
1928, x, pp. 94-95 (in part); P. Mura-
toff, 1930, p. 87 (with assistants);
M. Salmi, 1958, pp. 87-88 (1439);
B. Berenson, 1963, p. 13; L. Berti,
1964 (dates to 1439 on basis of
affinity to Michelozzo); U. Baldini,
1970, cat. 71 (autograph work of
highest quality: also Francini-
Ciaranfi dates to 1449, Baldini
judges after Angelico's visit to
Rome); J. Pope-Hennessy, 1974,
p. 206 (executed after Rome, extent
of studio intervention has been
exaggerated); D. Dini, G. Bonsanti,
1986, pp. 17-24; D. A. Covi, 1986,
nos. 61b and 199; G. Bonsanti, in
San Marco, 1990, pp. 169-71 (with
assistants, Gozzoli?); W. Hood,
1993, pp. 255-60; P. Morachiello,
1995, pp. 309-10; W. Hood, 1995,
pp. 77-83.

See pages 142-45.

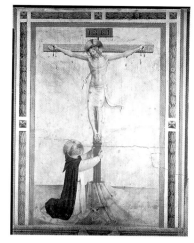

25

The Cells

Baldini, 1970, cat. 72-94.
Pope-Hennessy, 1974, pp. 206-10.

East Dormitory: Priests' Cells

27

▸ CELL 1:

NOLI ME TANGERE

65⅜ × 49¼ in. (166 × 125 cm)

BIBLIOGRAPHY

J. Crowe and G. B. Cavalcaselle,
1864, 1911 ed., IV, p. 87; B. Berenson,
1896, p. 98; R. L. Douglas, 1900,
p. 195; F. Schottmüller, 1911, p. 112;
idem, 1924, p. 121; R. van Marle,
1928, x, p. 77 (assistant); P. Mura-
toff, 1930, pp. 57, 82 (assistant);

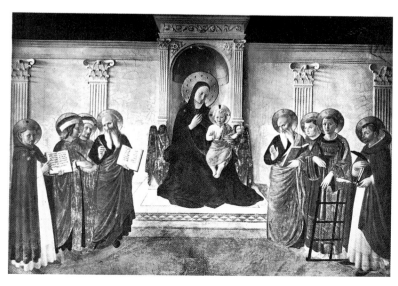

26

G. Bazin, 1949, p. 43 (Master of the
Annunciation assistant); J. Pope-
Hennessy, 1952, p. 183; M. Salmi,
1955 (modified); *Mostra*, 1955, p. 90;
B. Berenson, 1963, p. 13; M. Salmi,
1958, p. 86; U. Baldini, 1970, p. 104,
cat. 72 (clearly autograph); J. Pope-
Hennessy, 1974, p. 206 (no doubt
cartoon by Angelico and two fig-
ures wholly by his hand); C. Lloyd,
1992, pp. 88-89; G. Bonsanti, in *San
Marco*, 1990, p. 164; W. Hood, 1993,
pp. 241-42 (Gozzoli? rejects design
as by Angelico); Morachiello, 1995,
p. 44.

See pages 146-49.

28

▸ CELL 2:

LAMENTATION

72½ × 59⅞ in. (184 × 152 cm)

BIBLIOGRAPHY

R. L. Douglas, 1900, p. 195;
A. Wurm, 1907 (assistant);
F. Schottmüller, 1911, p. 114; *idem*,
1924, p. 122; R. van Marle, 1928, x,
p. 77 (assistant?); P. Muratoff, 1930,
pp. 57, 88 (assistant); J. Pope-
Hennessy, 1952, p. 183 (constructed
an unknown Master of Cell 2);
Mostra, 1955, pp. 90-91; M. Salmi,
1958, p. 44; B. Berenson, 1963, p. 13;
U. Baldini, 1970, p. 104, cat. 73;

J. Pope-Hennessy, 1974, p. 206
(neither cartoon nor fresco by
Angelico, denominates unknown
artist as Master of Cell 2); G. Bon-
santi, in *San Marco*, 1990, p. 164;
W. Hood, 1993, p. 221 (assistant);
P. Morachiello, 1995, p. 56.

See pages 146-49.

29

▸ CELL 3:

ANNUNCIATION

69¼ × 58¼ in. (176 × 148 cm)

BIBLIOGRAPHY

J. Crowe and G. B. Cavalcaselle,
1864, 1911 ed., IV, p. 87; R. L. Doug-
las, 1900, p. 195; F. Schottmüller,
1911, p. 113; *idem*, 1924, pp. 123-25;
R. van Marle, 1928, x, pp. 78-80;
P. Muratoff, 1930, p. 88; J. Pope-
Hennessy, 1952, p. 183 (wholly
Angelico except for Saint Peter
Martyr on left, which is by Master
of Cell 2); *Mostra*, 1955, pp. 90-91;
M. Salmi, 1958, p. 42 ("the noblest
fresco in the cells" among first exe-
cuted in convent); B. Berenson,
1963, p. 13; U. Baldini, 1970, p. 104,
cat. 74; J. Pope-Hennessy, 1974,
p. 206 (wholly by Angelico);
G. Bonsanti, in *San Marco*, p. 164;
C. Lloyd, 1992, pp. 86-87; W. Hood,
1993, pp. 208, 210, 216, 221, 237, 245,
272; P. Morachiello, 1995, p. 68;
W. Hood, 1995, pp. 106-7.

See pages 146-49.

30

▸ CELL 4:

CRUCIFIED CHRIST WITH SAINT JOHN THE EVANGELIST, THE VIRGIN, AND SAINTS DOMINIC AND JEROME

70⅛ × 59 in. (178 × 150 cm)

BIBLIOGRAPHY

R. L. Douglas, 1900, p. 195;
F. Schottmüller, 1911, p. 114; *idem*,
1924, p. 126 (assistant); R. van

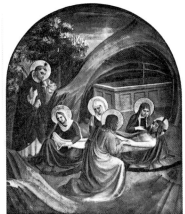

27

28

scheme designed and executed by Angelico); G. Bonsanti, in *San Marco*, 1990, p. 164; C. Lloyd, 1992, pp. 92-93; W. Hood, 1993, pp. 210-11, 221, 235, 254; P. Morachiello, 1995, p. 88; W. Hood, 1995, pp. 96-99.

See pages 150-53.

and head to his left are Angelico; the rest is Master of Cell 2); G. Bonsanti, in *San Marco*, 1990, pp. 164-65; C. Lloyd, 1992, pp. 90-91; W. Hood, 1993, pp. 211, 213, 216-17, 222, 244; P. Morachiello, 1995, p. 106; W. Hood, 1995, pp. 102-5.

See pages 154-57.

Marle, 1928, x, p. 80 (assistant); P. Muratoff, 1930, p. 88 (assistant); J. Pope-Hennessy, 1952, p. 183 (Master of Cell 2); *Mostra*, 1955, p. 91 (among first moment in convent); Salmi, 1958, p. 48 (assistant); B. Berenson, 1963, p. 13; U. Baldini, 1970, p. 104, cat. 75; J. Pope-Hennessy, 1974, p. 206 (design and execution by Master of Cell 2); G. Bonsanti, in *San Marco*, 1990, p. 164; P. Morachiello, 1995, p. 80.

See pages 150-53.

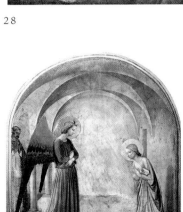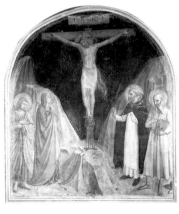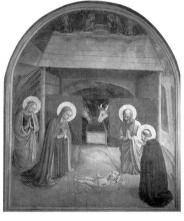

29

30

31

31

▶ CELL 5:

NATIVITY

69⅝ × 58¼ in. (177 × 148 cm)
with Saints Catherine of Alexandria and Peter Martyr

BIBLIOGRAPHY

J. Crowe and G. B. Cavalcaselle, 1864, 1911 ed., IV, p. 87; R. L. Douglas, 1900, p. 195; F. Schottmüller, 1911, p. 121; *idem*, 1924, p. 126 (assistant); R. van Marle, 1928, x, p. 80 (assistant); P. Muratoff, 1930, p. 88 (assistant); J. Pope-Hennessy, 1952, p. 183 (Master of Cell 2); *Mostra*, 1955, p. 91; M. Salmi, 1958, p. 44 (first group of frescoes by Angelico); B. Berenson, 1963, p. 13; U. Baldini, 1970, p. 104, cat. 76; J. Pope-Hennessy, 1974, p. 206 (executed by Master of Cell 2); G. Bonsanti, in *San Marco*, 1990, p. 164; W. Hood, 1993, pp. 221-22 (assistant); P. Morachiello, 1995, p. 84.

See pages 150-53.

32

▶ CELL 6:

TRANSFIGURATION

71¼ × 59⅞ in. (181 × 152 cm)

BIBLIOGRAPHY

P. V. Marchese, 1845, 3d ed. 1869, p. 39 (reports foreground figs. damaged); R. L. Douglas, 1900, p. 195; F. Schottmüller, 1911, p. 115; *idem*, 1924, p. 127; R. van Marle, 1928, x, p. 81; P. Muratoff, 1930, p. 88; J. Pope-Hennessy, 1952, p. 183; *Mostra*, 1955, p. 92; M. Salmi, 1958, p. 43 (among early frescoes); B. Berenson, 1963, p. 13; U. Baldini, 1970, pp. 104-5, cat. 77; J. Pope-Hennessy, 1974, p. 207 (splendid

33

▶ CELL 7:

THE MOCKING OF CHRIST WITH THE VIRGIN AND SAINT DOMINIC

73⅝ × 59½ in. (187 × 151 cm)

BIBLIOGRAPHY

R. L. Douglas, 1900, p. 195; F. Schottmüller, 1911, pp. 116-17; *idem*, 1924, pp. 128, 130-31; R. van Marle, 1928, x, p. 83 (assistant?); P. Muratoff, 1930, p. 89; J. Pope-Hennessy, 1952, p. 183 (design and figure of Christ and head to his left are Angelico; the rest is Master of Cell 2); *Mostra*, 1955, p. 92 (among first); M. Salmi, 1958, p. 43 (among early frescoes); B. Berenson, 1963, p. 13; U. Baldini, 1970, p. 105, cat. 78; J. Pope-Hennessy, 1974, p. 207 (design and figure of Christ

34

▶ CELL 8:

CHRIST RESURRECTED AND THE MARIES AT THE TOMB

71¼ × 59½ in. (181 × 151 cm)

BIBLIOGRAPHY

J. Crowe and G. B. Cavalcaselle, 1864, 1911 ed., IV, p. 87; R. L. Douglas, 1900, p. 195; F. Schottmüller, 1911, p. 118; *idem*, 1924, p. 129 (Angelico in greater part); R. van Marle, 1928, x, p. 84 (assistant); P. Muratoff, 1930, p. 89 (assistant); J. Pope-Hennessy, 1952, p. 185 (Master of Cell 2); *Mostra*, 1955, p. 92 (first moment); M. Salmi, 1958, p. 43 (Angelico assisted by Zanobi Strozzi?); B. Berenson, 1963, p. 13; U. Baldini, 1970, p. 105, cat. 79; J. Pope-Hennessy, 1974, p. 207 (composition and execution

by Master of Cell 2; Angelico may be responsible for execution of angel's head and drawings for angel and Virgin); G. Bonsanti, in *San Marco*, 1990, pp. 164-65, 171 (Mary's face by Assistant no. 1, young Gozzoli?); W. Hood, 1993, pp. 221, 223 (assistant); P. Morachiello, 1995, p. 122.

See pages 154-57.

1963, p. 13; U. Baldini, 1970, p. 105, cat. 80; J. Pope-Hennessy, 1974, p. 207 (composition and execution are by Angelico); G. Bonsanti, in *San Marco*, 1990, p. 161; C. Lloyd, 1992, pp. 68-69; W. Hood, 1993, pp. 214, 215, 221; P. Morachiello, 1995, p. 136; W. Hood, 1995, pp. 100-101.

See pages 154-57.

J. Pope-Hennessy, 1974, p. 207 (same as 1952); G. Bonsanti, in *San Marco*, 1990, pp. 164-65; C. Lloyd, 1992, pp. 7-8; W. Hood, 1993, pp. 207, 209, 212, 216, 218, 221, 226, 229; P. Morachiello, 1995, p. 152; W. Hood, 1995, pp. 92-95.

See pages 158-59.

(weak, two saints by Assistant no. 2, different hand than Assistant no. 1); W. Hood, 1993, pp. 209, 214, 216, 218, 224 (assistant); P. Morachiello, 1995, p. 162; W. Hood, 1995, pp. 88-92.

See pages 158-59.

South Dormitory: Cells of the Novitiates

38

▸ CELLS 15-21:

CRUCIFIED CHRIST ADORED BY SAINT DOMINIC

61⅛ × 31½ in. (155 × 80 cm)

BIBLIOGRAPHY

R. L. Douglas, 1900 (omits at p. 195); F. Schottmüller, 1911; *idem*, 1924 (omits); R. van Marle, 1928, x, p. 84 (rejects); P. Muratoff, 1930 (omits, except cell 21, Angelico with assistants); J. Pope-Hennessy, 1952, p. 185 (rejects); *Mostra*, 1955, p. 93 (school); M. Salmi, 1958, p. 45 (rejects); B. Berenson, 1963, p. 13 (some ruined); U. Baldini, 1970 (omits); A. Padoa Rizzo, 1972, p. 101 (ascribes to Gozzoli); J. Pope-Hennessy, 1974, p. 207 (most appear to be work of a single hand, but not even design is Angelico); G. Bonsanti, in *San Marco*, 1990, pp. 166, 168 (young Gozzoli); W. Hood, 1993, pp. 203, 205-6

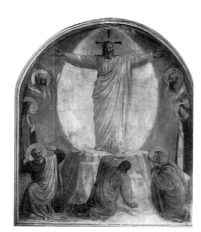

32

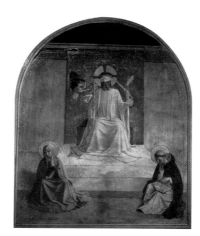

33

34

35

▸ CELL 9:

CORONATION OF THE VIRGIN

67⅜ × 59½ in. (171 × 151 cm)

Kneeling figures below show from left to right: Saints Thomas Aquinas, Benedict, Dominic, Francis of Assisi, Peter Martyr, Mark

BIBLIOGRAPHY

P. V. Marchese, 1845, 3d ed. 1869, I, pp. 382-83; J. Crowe and G. B. Cavalcaselle, 1864, 1911 ed., IV, pp. 85-87; R. L. Douglas, 1900, p. 195; F. Schottmüller, 1911, pp. 119-20; *idem*, 1924, pp. 132-33; R. van Marle, 1928, x, p. 84 (in part); P. Muratoff, 1930, p. 89 (assistants); J. Pope-Hennessy, 1952, p. 185; *Mostra*, 1955, pp. 92-93 (first moment); M. Salmi, 1958, p. 43 (among first frescoes done by Angelico); B. Berenson,

The Double Cell of the Prior, 10-11

36

▸ CELL 10:

PRESENTATION IN THE TEMPLE

67⅜ × 45⅝ in. (171 × 116 cm)

BIBLIOGRAPHY

P. V. Marchese, 1845, 3d ed. 1869, p. 36; R. L. Douglas, 1900, p. 195; F. Schottmüller, 1911, p. 122; *idem*, 1924, p. 134; R. van Marle, 1928, x, p. 84; P. Muratoff, 1930, p. 89 (assistant); J. Pope-Hennessy, 1952, p. 185 (central figures are by Angelico; subsidiary figures were repainted before the middle of the nineteenth century); *Mostra*, 1955, p. 93; M. Salmi, 1958, p. 44 (assistants); B. Berenson, 1963, p. 13; U. Baldini, 1970, p. 105, cat. 81;

37

▸ CELL 11:

MADONNA AND CHILD ENTHRONED WITH SAINTS AUGUSTINE AND THOMAS AQUINAS

70½ × 59 in. (179 × 150 cm)

BIBLIOGRAPHY

R. L. Douglas, 1900 (omits at p. 195); F. Schottmüller, 1911, p. 121; *idem*, 1924, p. 134 (assistant); R. van Marle, 1928, x, p. 84 (assistant); P. Muratoff, 1930, p. 89 (assistant); J. Pope-Hennessy, 1952, p. 185 (Master of Cell 2); *Mostra*, 1955, p. 93 (rejects); M. Salmi, 1958, p. 45 (assistant); B. Berenson, 1963, p. 13; U. Baldini, 1970, p. 105, cat. 82; J. Pope-Hennessy, 1974, p. 207 (Master of Cell 2); G. Bonsanti, in *San Marco*, 1990, pp. 165-68

35

(assistant); P. Morachiello, 1995, p. 294; W. Hood, 1995, pp. 84-87.

These frescoes were designed by Fra Angelico and painted with workshop assistance.

East Dormitory: Cells of the Clerics

39

▸ CELL 22:

CRUCIFIXION WITH THE VIRGIN

56¾ × 37⅞ in. (144 × 81 cm)

BIBLIOGRAPHY

R. L. Douglas, 1900 (omits at p. 195); F. Schottmüller, 1911; *idem*, 1924 (omits); R. van Marle, 1928, x (omits); P. Muratoff, 1930 (omits); J. Pope-Hennessy, 1952, p. 185 (rejects); *Mostra*, 1955, p. 93 (school); M. Salmi, 1958 (omits); B. Berenson, 1963, p. 13 (some ruined); U. Baldini, 1970 (omits); A. Padoa Rizzo, 1972, p. 101 (ascribes to Gozzoli); J. Pope-Hennessy, 1974, p. 207 (same hand as cells 15-21, not even design is Angelico); G. Bonsanti, in *San Marco*, 1990, pp. 166, 168 (Assistant no. 2); W. Hood, 1993, pp. 209-10, 214, 216, 224, 241; P. Morachiello, 1995, pp. 294-95; W. Hood, 1995, pp. 84-87.

40

▸ CELL 23:

CRUCIFIXION WITH THE VIRGIN AND SAINT DOMINIC AND TWO ANGELS

69¾ × 54 in. (177 × 137 cm)

BIBLIOGRAPHY

R. L. Douglas, 1900 (omits); F. Schottmüller, 1911; *idem*, 1924 (omits); R. van Marle, 1928, x (omits); P. Muratoff, 1930 (omits); J. Pope-Hennessy, 1952, p. 185 (Master of Cell 2); *Mostra*, 1955, p. 93 (rejects); M. Salmi, 1958 (rejects); B. Berenson, 1963, p. 13 (ruined); U. Baldini, 1970 (omits); J. Pope-Hennessy, 1974, p. 207 (designed and executed by Master of Cell 2); W. Hood, 1993, pp. 224-25; Morachiello, 1995, pp. 294-95.

41

▸ CELL 24:

BAPTISM OF CHRIST

70½ × 58¼ in. (179 × 148 cm)

BIBLIOGRAPHY

R. L. Douglas, 1900 (omits); F. Schottmüller, 1911, p. 123; *idem*, 1924, p. 135 (assistant); R. van Marle, 1928, x, p. 86 (assistant); P. Muratoff, 1930 (omits); J. Pope-Hennessy, 1952, p. 185 (later work by Master of Cell 2); *Mostra*, 1955, p. 93 (Angelico designed, executed with assistants); M. Salmi, 1958 (omits); B. Berenson, 1963, p. 13; U. Baldini, 1970, pp. 105-6, cat. 83; J. Pope-Hennessy, 1974, p. 207 (later work by Master of Cell 2); G. Bonsanti, in *San Marco*, 1990, pp. 166, 171 (Assistant no. 1, young Gozzoli); W. Hood, 1993, pp. 220 (assistant); P. Morachiello, 1995, pp. 294-95.

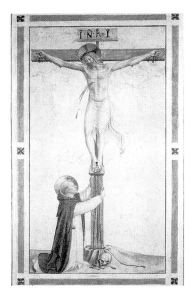

38B

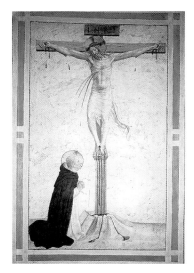

38C

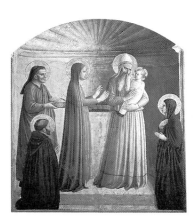

36

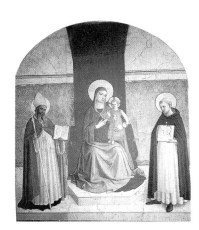

37

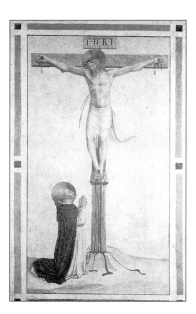

38A

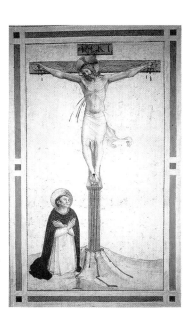

38D

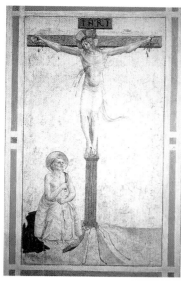

38E

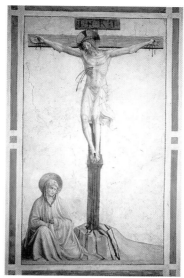

39

40

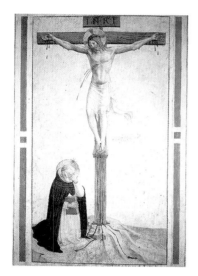

38F

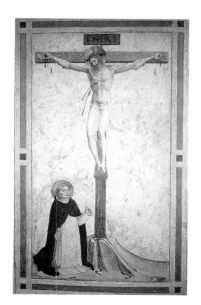

38G

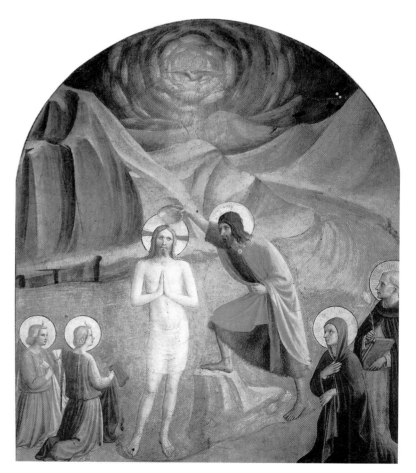

41

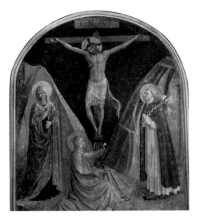

42

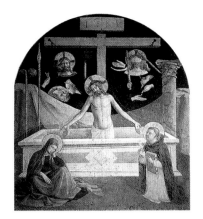

43

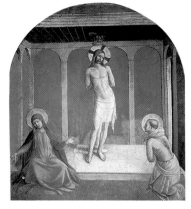

44

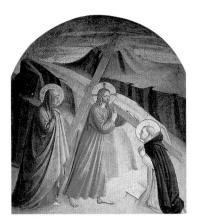

45

42

▸ CELL 25:

*CRUCIFIXION WITH
THE VIRGIN, SAINT
MARY MAGDALENE,
AND SAINT DOMINIC*

69⅜ × 53⅝ in. (176 × 136 cm)

BIBLIOGRAPHY

R. L. Douglas, 1900 (omits);
F. Schottmüller, 1911, p. 123; *idem*,
1924, p. 135 (assistant); R. van
Marle, 1928, x, p. 87 (with assis-
tant); P. Muratoff, 1930, p. 89
(assistant); J. Pope-Hennessy, 1952,
p. 185 (later work by Master of
Cell 2); *Mostra*, 1955, p. 94
(assistants); M. Salmi, 1958, p. 47
(planned in part by Angelico, with
assistants in moment after first
series of frescoes); B. Berenson,
1963, p. 13; U. Baldini, 1970, p. 106,
cat. 84; J. Pope-Hennessy, 1974,
p. 207 (late work by Master of
Cell 2); G. Bonsanti, in *San Marco*,
1990, pp. 166, 171 (Assistant no. 1,
young Gozzoli); W. Hood, 1993,
pp. 210 (assistant); P. Morachiello,
1995, pp. 294-95.

43

▸ CELL 26:

*CORPUS DOMINI
AND THE SYMBOLS
OF THE PASSION
CONTEMPLATED BY
THE VIRGIN AND
SAINT THOMAS
AQUINAS*

65 × 56 in. (165 × 142 cm)

BIBLIOGRAPHY

R. L. Douglas, 1900 (omits);
F. Schottmüller, 1911 (omits); *idem*,
1924, p. 136 (assistant); R. van
Marle, 1928, x, p. 88 (with assis-
tants); P. Muratoff, 1930, p. 89
(assistant); J. Pope-Hennessy, 1952,
p. 185 (later work by Master of
Cell 2); *Mostra*, 1955, p. 94
(assistants); M. Salmi, 1958, pp. 45,
48 (assistants); B. Berenson, 1963,
p. 13; U. Baldini, 1970, cat. 85;
J. Pope-Hennessy, 1974, p. 207
(late work by Master of Cell 2);
G. Bonsanti, in *San Marco*, 1990,
p. 166 (collaboration following
Angelico); W. Hood, 1993, p. 212
(assistant); P. Morachiello, 1995,
pp. 294-95.

44

▸ CELL 27:

*CHRIST AT THE
COLUMN WITH
THE VIRGIN AND
SAINT DOMINIC*

63⅞ × 56 in. (162 × 142 cm)

BIBLIOGRAPHY

R. L. Douglas, 1900 (omits);
F. Schottmüller, 1911 (omits); *idem*,
1924, p. 136 (assistant); R. van
Marle, 1928, x, p. 88 (assistant);
P. Muratoff, 1930, p. 89 (assistant);
J. Pope-Hennessy, 1952, p. 185 (later
work by Master of Cell 2); *Mostra*,
1955, p. 94 (assistant); M. Salmi,
1958, pp. 46-48 (rejects, Gozzoli?);
B. Berenson, 1963 (omits); U. Bal-
dini, 1970 (omits); J. Pope-Hennessy,
1974, p. 208 (later work by Master
of Cell 2); W. Hood, 1993, pp. 214,
216, 224, 244 (assistant); P. Mora-
chiello, 1995, pp. 294-95.

45

▸ CELL 28:

*CHRIST CARRYING
THE CROSS WITH
THE VIRGIN AND
SAINT DOMINIC*

58¼ × 51⅝ in. (148 × 131 cm)

BIBLIOGRAPHY

R. L. Douglas, 1900 (omits);
F. Schottmüller, 1911, p. 124; *idem*,
1924, p. 137 (assistant); R. van
Marle, 1928, x, p. 88; P. Muratoff,
1930, p. 89 (assistant); J. Pope-
Hennessy, 1952, p. 185 (later work by
Master of Cell 2); *Mostra*, 1955, p. 95
(assistant); M. Salmi, 1958, p. 46
(early work by Bonfigli); B. Beren-
son, 1963, p. 13; U. Baldini, 1970,
p. 106, cat. 86; J. Pope-Hennessy,
1974, p. 208 (later work by Master
of Cell 2); W. Hood, 1993, p. 221
(assistant); P. Morachiello, 1995,
pp. 294-95.

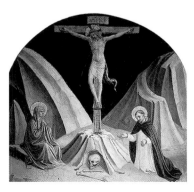

46

46

▸ CELL 29:

CRUCIFIXION WITH THE VIRGIN AND SAINT PETER MARTYR

78⅞ × 50⅜ in. (124 × 128 cm)

BIBLIOGRAPHY

J. Pope-Hennessy, 1952, and all earlier scholars omit; *Mostra*, 1955, p. 95 (school); B. Berenson, 1963 (omits); A. Padoa, "Benozzo ante 1450," *Commentari* xx, 1969, pp. 52-62 (by Benozzo Gozzoli); U. Baldini, 1970 (omits); J. Pope-Hennessy, 1974, p. 208 (follows Padoa as work of Benozzo Gozzoli c. 1442-44); Morachiello, 1995, pp. 294-95.

47

▸ CELL 30:

CRUCIFIXION WITH THE VIRGIN AND SAINT DOMINIC

61⅞ × 52 in. (157 × 132 cm)

BIBLIOGRAPHY

W. Hood, 1993, p. 210; P. Morachiello, 1995, p. 302.

Frescoes in cells 22 through 30 were designed by Fra Angelico and executed with workshop assistance.

48

North Dormitory: Cells with Episodes of the Life of Christ

48

▸ CELL 31:

CHRIST IN LIMBO

72⅛ × 65⅜ in. (183 × 166 cm)

BIBLIOGRAPHY

P. V. Marchese, 1845, 3d ed. 1869, I, 23 p. 381 (Cell of Sant'Antonino, Greek influence); R. L. Douglas, 1900, p. 195; P. D'Ancona, 1908, pp. 92-94; F. Schottmüller, 1911, p. 124; *idem*, 1924, p. 137 (Zanobi Strozzi?); R. van Marle, 1928, x, p. 88 (assistant); P. Muratoff, 1930, p. 89 (assistant); J. Pope-Hennessy, 1952, p. 185 (Master of Cell 31, neither Master of Cell 2 nor Zanobi Strozzi); *Mostra*, 1955, p. 95 (school); M. Salmi, 1958, p. 46 (Angelico with Zanobi Strozzi); B. Berenson, 1963, p. 13; U. Baldini, 1970, p. 106, cat. 87; J. Pope-Hennessy, 1974, p. 208 (Master of Cell 31, repeats 1952 comment); G. Bonsanti, in *San Marco*, 1990, pp. 166-67 (collaboration following Angelico); W. Hood, 1993, pp. 246, 260 (assistant); P. Morachiello, 1995, pp. 295-97.

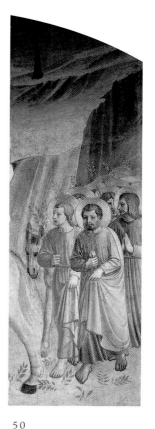

49

49

▸ CELL 32:

SERMON ON THE MOUNT

74⅞ × 78 in. (190 × 198 cm)

49A

▸ CELL 32A:

TEMPTATION OF CHRIST

68½ × 54 in. (174 × 137 cm)

BIBLIOGRAPHY

P. V. Marchese, 1845, 3d ed. 1869, I, pp. 376-77; R. L. Douglas, 1900, p. 195; F. Schottmüller, 1911, p. 125; *idem*, 1924, p. 138 (Zanobi Strozzi?); R. van Marle, 1928, x, p. 89 (Angelico in greater part); P. Muratoff, 1930, p. 90 (assistant); J. Pope-Hennessy, 1952, p. 195 (Master of Cell 31); *Mostra*, 1955, p. 95 (school); M. Salmi, 1958, p. 46 (Angelico with Zanobi Strozzi and Benozzo Gozzoli); B. Berenson, 1963, p. 13;

U. Baldini, 1970, p. 106, cat. 88; J. Pope-Hennessy, 1974, p. 208 (Master of Cell 31); G. Bonsanti, in *San Marco*, 1990, pp. 166-68 (Assistant no. 2); W. Hood, 1993, pp. 242, 246 (assistant); P. Morachiello, 1995, pp. 295-97; W. Hood, 1995, pp. 116-17.

50

▸ CELL 33A:

ENTRY INTO JERUSALEM

64¼ × 21¼ in. (163 × 54 cm)

50A

▸ CELL 33:

BETRAYAL OF JUDAS

71⅝ × 71¼ in. (182 × 181 cm)

BIBLIOGRAPHY

P. V. Marchese, 1945, 3d ed. 1869, I, pp. 378-79; R. L. Douglas, 1900, p. 195; F. Schottmüller, 1911, pp. 125-26; *idem*, 1924, pp. 138-39 (Zanobi Strozzi?); R. van Marle,

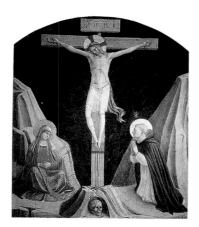

47

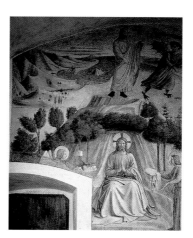

49A

50

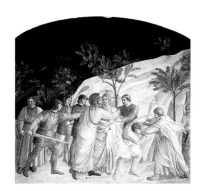

50A

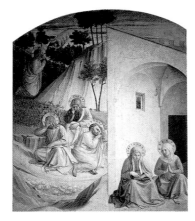

51

1928, x, p. 89 (assistant); P. Mura-
toff, 1930, p. 90 (assistant); J. Pope-
Hennessy, 1952, p. 185 (Master of
Cell 31); *Mostra*, 1955, p. 95 (school);
M. Salmi, 1958, p. 46 (rejects, except
the *Temptation*, which he assigns to
Angelico with assistant); B. Beren-
son, 1963, p. 13 (excludes the *Temp-
tation*); U. Baldini, 1970, p. 106,
cat. 88 (discusses in same entry as
cell 32, rejects); J. Pope-Hennessy,
1974, p. 208 (Master of Cell 31);
G. Bonsanti, in *San Marco*, 1990,
pp. 166-67 (with Benozzo Gozzoli);
W. Hood, 1993, pp. 230, 239, 242,
247 (assistant); P. Morachiello,
1995, pp. 295-97.

51

▸ CELL 34:

AGONY IN THE
GARDEN

69¾ × 57⅞ in. (177 × 147 cm)

BIBLIOGRAPHY

R. L. Douglas, 1900, p. 195; S. Beis-
sel, 1905, p. 36; F. Schottmüller, 1911,
p. 137; *idem*, 1924, p. 140 (Zanobi
Strozzi?); R. van Marle, 1928, x,
p. 89; P. Muratoff, 1930, p. 90
(assistant); M. Salmi, 1950, p. 154
(two women watching given to
Gozzoli); J. Pope-Hennessy, 1952,
p. 185 (Master of Cell 31); *Mostra*,
1955, p. 96 (school); M. Salmi,
1958, p. 47 (Angelico and Zanobi
Strozzi?); B. Berenson, 1963, p. 13;
U. Baldini, 1970, p. 107, cat. 89
(cites Salmi as execution by Zanobi
Strozzi); J. Pope-Hennessy, 1974,

p. 208 (Master of Cell 31); G. Bon-
santi, in *San Marco*, 1990, pp. 166-67
(with Benozzo Gozzoli); W. Hood,
1993, p. 245 (assistant); P. Morachi-
ello, 1995, pp. 295-97; W. Hood,
1995, pp. 114-15.

52

▸ CELL 35:

INSTITUTION OF
THE EUCHARIST

73¼ × 92⅛ in. (186 × 234 cm)

Accompanied by the words of
John 6:54: Qui mandvcat meam
carnem et bibit mevm sangvinem
habet vitam aeternam

BIBLIOGRAPHY

P. V. Marchese, 1845, 3d ed. 1869, 1,

p. 378; R. L. Douglas, 1900, p. 195;
S. Beissel, 1905, p. 36; F. Schott-
müller, 1911, p. 128; *idem*, 1924, p. 141
(Zanobi Strozzi?); R. van Marle,
1928, x, p. 89 (assistant); P. Mura-
toff, 1930, p. 90 (assistant); J. Pope-
Hennessy, 1952, p. 185 (Master of
Cell 31); *Mostra*, 1955, p. 96 (school);
M. Salmi, 1958, p. 47; B. Berenson,
1963, p. 13; U. Baldini, 1970, p. 107,
cat. 90 (with Zanobi Strozzi and
Gozzoli); J. Pope-Hennessy, 1974,
p. 208 (Master of Cell 31); G. Bon-
santi, in *San Marco*, 1990, pp. 166-68
(Assistant no. 2); W. Hood, 1993,
pp. 244-46 (assistant); P. Morachi-
ello, 1995, pp. 295-97; W. Hood,
1995, pp. 112-13.

53

▸ CELL 36:

CHRIST NAILED
TO THE CROSS

66⅝ × 52¾ in. (169 × 134 cm)

From mouth of Christ: Pr dimicte
illis qvia nes (civnt qvid facivnt)

BIBLIOGRAPHY

R. L. Douglas, 1900, p. 195; S. Beis-
sel, 1905, p. 40; A. Wurm, 1907
(Angelico only painted the head of
Christ); F. Schottmüller, 1911, p. 121;

idem, 1924, p. 140; P. Muratoff, 1930,
p. 90 (assistant); M. Salmi, 1950,
p. 154 (intervention of Gozzoli);
J. Pope-Hennessy, 1952, pp. 185-86
(Master of Cell 36); *Mostra*, 1955,
p. 96; M. Salmi, 1958, p. 47 (Angel-
ico, Zanobi Strozzi, and Gozzoli,
later work); B. Berenson, 1963, p. 13;
U. Baldini, 1970, p. 107, cat. 91;
J. Pope-Hennessy, 1974, p. 208
(Master of Cell 36); G. Bonsanti,
in *San Marco*, 1990, pp. 166-67
(collaboration following Angelico);
W. Hood, 1993, pp. 242, 245
(assistant); P. Morachiello, 1995,
pp. 295-97.

Frescoes in cells 31 through 36 were
designed by Fra Angelico and prob-
ably executed by Benozzo Gozzoli.

Room of the Lay Brothers

54

▸ CELL 37:

TRIPLE CRUCIFIXION
WITH SAINT JOHN
THE EVANGELIST,
THE VIRGIN, AND
SAINTS DOMINIC AND
THOMAS AQUINAS

83⅞ × 65 in. (213 × 165 cm)

BIBLIOGRAPHY

R. L. Douglas, 1900, p. 195;
F. Schottmüller, 1911, p. 129; *idem*,
1924, p. 142 (assistant); R. van

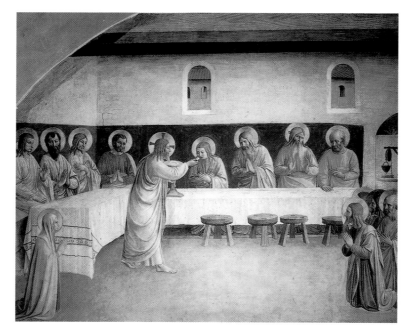

52

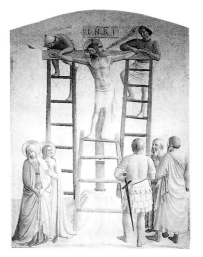

53

Marle, 1928, x, p. 89; P. Muratoff, 1930, p. 90 (assistant); J. Pope-Hennessy, 1952, p. 186 (Master of Cell 36); *Mostra*, 1955, p. 96 (assistant); B. Berenson, 1963, p. 13; U. Baldini, 1970, p. 107, cat. 92; J. Pope-Hennessy, 1974, p. 208 (Master of Cell 36); G. Bonsanti,

54

in *San Marco*, 1990, pp. 166-67 (collaboration following Angelico); W. Hood, 1993, pp. 241, 242, 248 (assistant); P. Morachiello, 1995, pp. 295-97; W. Hood, 1995, pp. 110-11.

By Fra Angelico and assistant.

The Double Cell of Cosimo de' Medici

55

▸ CELL 38:

CRUCIFIXION WITH THE VIRGIN AND SAINTS JOHN THE EVANGELIST, COSMAS, AND PETER MARTYR

59⅞ × 44⅛ in. (152 × 112 cm)

BIBLIOGRAPHY

A. Venturi, 1933, VII, pp. 70-72, 407 (Gozzoli); J. Pope-Hennessy, 1952, p. 186 (cites A. Venturi); M. Salmi, 1958, p. 89 (assistant); J. Pope-Hennessy, 1974, p. 209 (uncertain, cites Venturi, 1933 attribution to

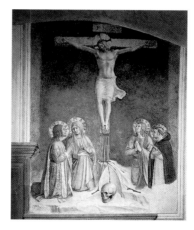

55

Gozzoli); G. Bonsanti, in *San Marco*, 1990, p. 168 (Gozzoli); W. Hood, 1993, pp. 246-53 (assistant); P. Morachiello, 1995, pp. 297-98; W. Hood, 1995, pp. 118-19.

Designed by Fra Angelico and executed by Benozzo Gozzoli.

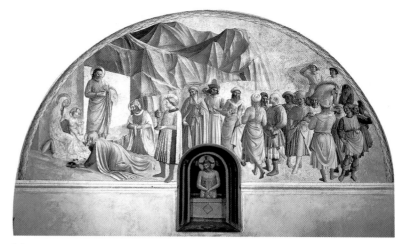

56

56

▸ CELL 39:

ADORATION OF THE MAGI

68⅞ × 140½ in. (175 × 357 cm)

PIETÀ (in tabernacle)

33⅞ × 23⅝ in. (86 × 60 cm)

BIBLIOGRAPHY

P. V. Marchese, 1845, 3d ed. 1869, I, pp. 373-76; J. Crowe and G. B. Cavalcaselle, 1864, 1911 ed., IV, p. 87; R. L. Douglas, 1900, p. 195; A. Wurm, 1907, p. 36 (partially autograph); F. Schottmüller, 1911, p. 130; *idem*, 1924, p. 143; R. van Marle, 1928, x, p. 90; P. Muratoff, 1930, p. 90 (assistant); G. Bazin, 1949, p. 43 (Master of the Annunciation assistant); W. and E. Paatz, 1952, p. 74; J. Pope-Hennessy, 1952, p. 186 (designed by Angelico, restorations make attribution impossible); M. Salmi, 1958, p. 46 (Angelico with assistant, *Pietà* by Gozzoli); B. Berenson, 1963, p. 13; U. Baldini, 1970, p. 107, cat. 93; J. Pope-Hennessy, 1974, p. 209 (designed by Angelico, restoration makes execution impossible to determine, possible intervention of Gozzoli; dates 1439-43); G. Bonsanti, in *San Marco*, 1990, p. 168 (Gozzoli); W. Hood, 1993, pp. 246-53; P. Morachiello, 1995, pp. 297-98; W. Hood, 1995, pp. 120-1.

Fra Angelico with assistance from Benozzo Gozzoli.

See pages 160-61.

North Dormitory: Cells of the Conversi

57

▸ CELL 40:

CRUCIFIXION WITH THE VIRGIN, SAINTS MARY MAGDALENE, JOHN THE EVANGELIST, AND DOMINIC WITH KNEELING ROMAN SOLDIERS

70⅛ × 71¼ in. (178 × 181 cm)

See Matthew 27:45,54.

BIBLIOGRAPHY

P. V. Marchese, 1845, 3d ed. 1869, I,

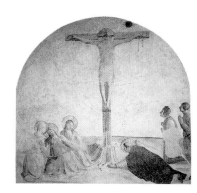

57

pp. 379-80 (reflects the fourteenth-century cult of the Magdalene)

58

▸ CELL 41:

CRUCIFIED CHRIST RECEIVING VINEGAR WITH THE VIRGIN, SAINTS DOMINIC, AND MARY MAGDALENE

71¼ × 63 in. (181 × 160 cm)

See Matthew 27:34,48 and John 19:29-30.

BIBLIOGRAPHY

P. V. Marchese, 1845, 3d ed. 1869, 1, p. 384 (fresco rediscovered in 1850, previously whitewashed)

59

▸ CELL 42:

CHRIST ON THE CROSS WITH THE VIRGIN AND SAINTS JOSEPH OF ARIMATHAEA(?), LONGINUS, DOMINIC, AND MARTHA

77⅛ × 78⅜ in. (196 × 199 cm)

See John 19:34.

BIBLIOGRAPHY

R. L. Douglas, 1900, p. 195; F. Schottmüller, 1911; *idem*, 1924 (omits); R. van Marle, 1928, x, p. 90 (Angelico in part); P. Muratoff, 1930 (omits); J. Pope-Hennessy, 1952, p. 186 (Master of Cell 36); *Mostra*,

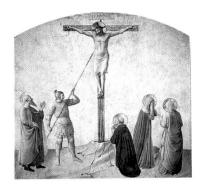

59

1955, p. 97 (design Angelico); M. Salmi, 1958, p. 44 (Angelico with assistant); B. Berenson, 1963, p. 13; U. Baldini, 1970, p. 107, cat. 94; J. Pope-Hennessy, 1974, p. 209 (Master of Cell 36); G. Bonsanti, in *San Marco*, 1990, p. 167 (Gozzoli); W. Hood, 1993, pp. 239-43; W. Hood, 1995, pp. 122-23.

By Fra Angelico with assistants. See pages 162-63.

60

▸ CELL 43:

CRUCIFIXION WITH THE VIRGIN AND SAINTS JOHN THE EVANGELIST, MARY MAGDALENE, AND DOMINIC

66⅝ × 54⅜ in. (169 × 138 cm)

See John 19:26-7.

All omit, until: J. Pope-Hennessy, 1952, p. 186 (Master of Cell 36); *Mostra*, 1955, p. 97 (Master of Cell 36); B. Berenson, 1963, p. 13; J. Pope-Hennessy, 1974, p. 209 (Master of Cell 36); G. Bonsanti, in *San Marco*, 1990, p. 167 (Gozzoli); W. Hood, 1993, p. 248 (assistant).

Frescoes in cells 40, 41, and 43 were designed by Fra Angelico and executed by an assistant. Only a small fragment, executed by an assistant, survives of the fresco in cell 44.

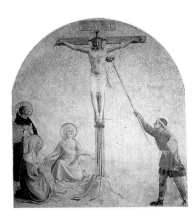

58

Plan of the Convent of San Marco

A = *Annunciation*

C = *Crucifixion*

M = *Madonna delle ombre*

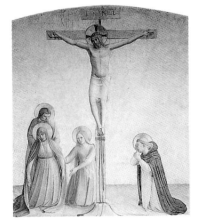

60

61

ANNALENA ALTARPIECE

Florence, Museo di San Marco

PROVENANCE

Formerly in the Dominican convent of San Vincenzo d'Annalena, Florence; removed to Paris after suppression of 1810; transferred to the Galleria dell'Accademia, 1846; and then to present location.

Main Register

61A

MADONNA AND CHILD AND SIX SAINTS

Tempera and gold on panel,
70⅞ × 79⅝ in. (180 × 202 cm)

Saints shown are from left to right:
Saints Peter Martyr, Cosmas, Damian, John the Evangelist, Lawrence, and Francis of Assisi

Predella

Six panels, each 7⅞ x 8⅝ in.
(20 × 22 cm)

61B

HEALING OF PALLADIA BY SAINTS COSMAS AND DAMIAN

61C

SAINTS COSMAS AND DAMIAN BEFORE LYSIAS

61D

SAINTS COSMAS AND DAMIAN SAVED FROM DROWNING

61E

SAINTS COSMAS AND DAMIAN VAINLY CONDEMNED TO DEATH BY FIRE

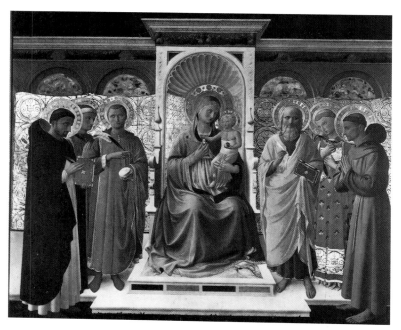

61A

61F

SAINTS COSMAS AND DAMIAN VAINLY CRUCIFIED AND STONED

61G

SAINTS COSMAS AND DAMIAN DECAPITATED

Florence, Museo di San Marco

Baldini, 1974, pp. 100-101, cat. 59 (1437-40)
Pope-Hennessy, 1974, pp. 211-12 (contrary to 1st ed. dates after San Marco Altarpiece, 1443-44; still unfinished when Angelico summoned to Rome in 1445)

BIBLIOGRAPHY

P. V. Marchese, 1845, 3d ed. 1869, p. 44; J. Crowe and G. B. Cavalcaselle, 1864, 1911 ed., IV, p. 90; B. Berenson, 1896, p. 98; F. Schottmüller, 1911, cats. 46-47; *idem*, 1924, cats. 56-57, 236-37 (1430-40); R. van Marle, 1928, X, pp. 62-63 (1430s); C. Phillips, 1919, p. 4 (questions the attribution of the Justinian panel to Angelico); P. Muratoff, 1930, pp. 45, 84-85 (1430-35, predella with assistant); R. Longhi, 1940, p. 175 (*Dream of Justinian* [*sic*] by Angelico in collaboration with Andrea di Giusto); L. Collobi-Ragghianti, 1950, pp. 463-64; G. Jahn-Rusconi, 1950, pl. 28 (1430s); J. Pope-Hennessy, 1952, p. 172 (dated later than Linaiuoli and Cortona, c. 1437-38); W. and E. Paatz, 1953, pp. 407-16 (permission to found convent given by Pope Nicholas V in 1450, building not begun until 1453, erection of oratory authorized 1455); S. Orlandi, p. 47; *Mostra*, 1955, pp. 36-39, nos. 20-21 (mid-1430s; quality of predella inferior to altarpiece); M. Salmi, 1958, pp. 104-5 (mid-1430s; predella: *Healing* by Battista di Biagio Sanguini; others by Zanobi Strozzi); A. Parronchi, 1961, pp. 31-37 (transposed with the altarpiece of Bosco ai Frati after transport to Paris); B. Berenson, 1963, p. 12; S. Orlandi, 1964, pp. 44-45 (disproves Parronchi's thesis); M. Boskovits, "Appunti," 1976, p. 42; L. Castelfranchi-Vegas, 1989, pp. 83-84 (c. 1435); A. De Marchi, in Bellosi, 1990, pp. 90-93; M. C. Impronta, in *San Marco*, pp. 106-7 (post-1434); C. Lloyd, 1992, pp. 94-95; W. Hood, 1993, pp. 102-7; M. Scudieri, 1995, p. 43.

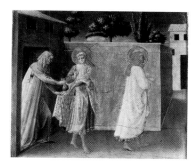

61B

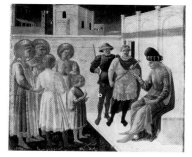

61C

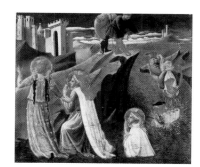

61D

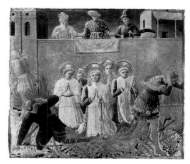

61E

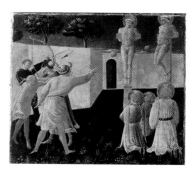

61F

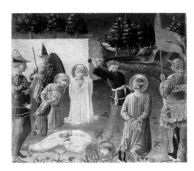

61G

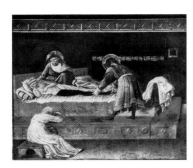

61H

61H
HEALING OF DEACON JUSTINIAN
Proposed as part of predella,
7¾ × 8¾ in. (19.5 × 22 cm)
Private collection, Italy

PROVENANCE
Duke of Lucca, sale, London, July 25, 1840, lot 1; Spencer Churchill collection, Northwich Park, England; sale Christie's London, May 28, 1965, lot 14; bought by Julius Weitzner, London

Baldini, 1970, p. 101, cat. 59H
Pope-Hennessy, 1974, p. 211 (Zanobi Strozzi; assumes predella included an eighth scene, *Burial of Saints Cosmas and Damian,* and a ninth scene, *Pietà*).

BIBLIOGRAPHY (predella)
J. Crowe and G. B. Cavalcaselle, 1864, 1911 ed., II, p. 302n (first ascribed to Angelico); S. Beissel, 1905, p. 51 (six scenes of Saints Cosmas and Damian formed part of predella); F. Schottmüller, 1911, p. 237 (school); R. van Marle, 1928, X, p. 182 (Zanobi Strozzi/school); P. Muratoff, 1930, p. 45; W. and E. Paatz, 1940, p. 132 (identifies incorrectly as part of San Marco Altarpiece); L. Collobi-Ragghianti, 1950, p. 27 (assigned Justinian panel to Zanobi Strozzi; part of Annalena predella); M. Salmi, 1950, p. 144 (assigns first panel to Battista di Biagio Sanguini and rest to Zanobi Strozzi); J. Pope-Hennessy, 1952, p. 172 (Zanobi Strozzi); *Mostra,* 1955, pp. 38-39 (quality inferior to altarpiece); M. Salmi, 1958, pp. 104-5 (Zanobi Strozzi; *Justinian* part of predella but execution by different hand); B. Berenson, 1963, p. 14 (as *Dream of the Deacon Justinian*).

Annalena Altarpiece, circa 1430; see pages 38-39.

62
SILVER TREASURY OF SANTISSIMA ANNUNZIATA
Museo di San Marco, Florence

PROVENANCE
Formerly in the church of the Santissima Annunziata, Florence, in a small oratory adjacent to the chapel built by Michelozzo to the left of the main entrance of the church; later moved to the Chiostro dell'Antiporto; in 1687 the cabinet was located in Feroni Chapel inside the church; in 1691 displayed in Galli Chapel; in 1785 in the library; the panels transferred thereafter to the Galleria dell'Accademia.

In the early 1450s Fra Angelico and his assistants painted scenes from the life of Christ, each 15⅛ × 14⅝ in. (38.5 × 37 cm), on large panels that were attached to the doors of a silver treasury commissioned by Piero de' Medici for a new oratory in the Church of Santissima Annunziata. This cycle of paintings is also known as the *Lex Amoris,* or Law of Love, which is the title inscribed on the last panel. Each scene is framed at top and bottom by inscriptions from the Old and New Testaments; the first and last scenes in the series contain many biblical inscriptions, which are transcribed by V. Alce, 1984, pp. 392-98, and discussed in detail by D. A. Covi, 1986, pp. 122-29. The original appearance of the Silver Treasury cabinet is not known; the most complete study on its subsequent modifications is still E. Casalini, 1963.

The paintings are today assembled in four groups, as follows:

62A
PANEL 1:
FIRST NINE SCENES
Tempera and gold on panel,
48½ × 48½ in. (123 × 123 cm)

The Mystical Wheel and the Vision of Ezekiel
Annunciation
Nativity
Circumcision
Adoration of the Magi
Presentation of Jesus in the Temple
Flight into Egypt
Massacre of the Innocents
Dispute with the Doctors

62B
PANEL 2:
THREE SCENES BY ALESSIO BALDOVINETTI
Tempera and gold on panel,
48½ × 17⅜ in. (123 × 44 cm)
(not illustrated; see M. Scudieri, 1995, p. 27)

Marriage in Cana
Baptism of Christ
The Transfiguration

62C
PANEL 3:
TWELVE SCENES
Tempera and gold on panel,
48½ × 63 in. (123 × 160 cm)

Resurrection of Lazarus
Entry of Christ into Jerusalem
Last Supper
The Payment of Judas
The Washing of the Feet
Institution of the Eucharist
The Prayer in Gethsemane
Betrayal of Judas
Capture of Christ
Christ before Caiaphas
Christ Mocked
Christ at the Column

62D
PANEL 4:
FINAL ELEVEN SCENES
Tempera and gold on panel,
48½ × 63 in. (123 × 160 cm)

The Way to Calvary
The Spoliation of Christ
Crucifixion
Deposition
Descent into Limbo
Three Maries at the Tomb
Ascension
Pentecost
Last Judgment
Coronation of the Virgin
Lex Amoris (The Law of Love)

Baldini, 1970, pp. 114-15, cat. 116 (1450)
Pope-Hennessy, 1974, pp. 216-18 (Angelico completed only upper panels, first nine scenes, leaving cabinet unfinished when he left Florence for Rome, 1451; others completed by his studio, 1455-61)

SOURCES
Fra Domenico di Giovanni da Corella, *Theotocon,* 1469 (*Mostra,* 1955, p. 25): "Where there are the silver reliquaries with various figures hidden behind the doors painted by the angelic painter named Giovanni, who was not inferior to Giotto and Cimabue whose fame was sung in the Tyrrhenian cities by Dante with sweet language. He flourished with his many virtues, temperate

62A

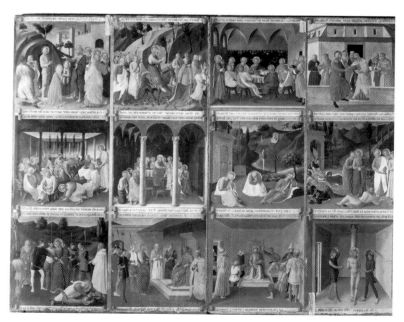

62C

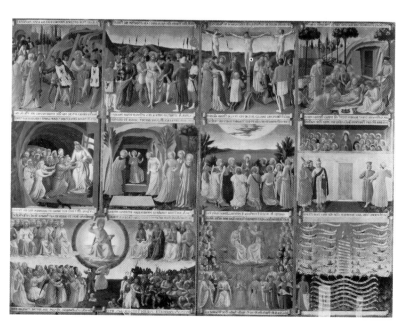

62D

nature and sincere faith. To him it was rightly conceded to surpass other painters in representing the grace of the Annunciate Virgin, so often depicted by the hand of Giovanni."

Antonio Manetti, c. 1490, p. 166 (S. Orlandi, 1964): "he painted . . . almost all of the tabernacle of the silver in the Annunziata of the Servites."

Albertini, 1510 (*Mostra*, 1955, pp. 29-30): "the ornamentations of the silver chest are from the hand of Fra Giovanni."

Libro di Antonio Billi, 1506-30:
Codice Petrei, Magl. XIII, n. 89 (1991 ed., p. 77): "In the cabinet where the silver is kept at the Annunziata church there are some small figures [by Fra Angelico]."

Codice Strozziano, Magl. XXV, n. 636 (1991 ed., p. 128): "In the cabinet where the silver is kept at the Annunziata church of the Servites there are small figures [by Fra Angelico]."

L'Anonimo Magliabechiano, Magl. cl XVII, 17, 1536-1546 (1968 ed., p. 102): "There are several small figures painted by his hand in the cabinet of the silver owned by the friars of the Annunziata church."

Vasari, 1568, II, pp. 511-12: "In the Annunciation chapel that Piero di Cosimo de' Medici had constructed in the Annunziata church in Florence he painted the shutters of the silver cabinet with small figures that are very carefully done."

Giovanni Cinelli, in F. Bocchi, 1677, p. 426: "In the niche that follows nothing is painted on the wall in this place where the fathers have prudently placed a panel by fra Giovanni Angelico of Fiesole, a man of holy and, according to some, beatific life. In addition to its diligence and design, this panel was made with colors so vivid that no one could ask for better, even though they were

painted more than 200 years ago. Paradise is represented here with all the choirs of Angels, whose faces are beautiful. This painting was the shutters of the cabinet which held the silver treasures of the altar of the Santissima Annunziata."

Baldinucci, *Notizie dei professori del disegno*, 1768, 1974 ed., I, p. 415: "He painted for the chapel of the Santissima Annunziata in Florence, which was made by Cosimo de' Medici, the doors of a large cabinet where the silver treasures were once kept, which used to be located on the wall on the right-hand side when one enters the chapel but was later removed and replaced by a sacred wooden Crucifix made around 1500 by Antonio San Gallo, the celebrated architect and sculptor. . . . The aforesaid doors, which were illustrated with little scenes of the life, death, and resurrection of the Saviour, were placed by the friars in the little cloister that is in front of the church, I believe in order to expose them to the greater veneration and enjoyment of the public. However, I do not know how long these pictures would have been preserved, since that place is much exposed to the elements. My lord, Grand Duke Cosimo III, having noticed this situation, ordered that they should be taken away and placed in a more venerable and hospitable place inside the church itself in the chapel of the Cinque Santi, on the wall nearest to the High Altar."

BIBLIOGRAPHY
P. V. Marchese, 1845, 3d ed. 1869, II, pp. 329-30 (early); J. Crowe and G. B. Cavalcaselle, 1864, 1911 ed., IV, pp. 78-79 (Fra Angelico, except for the *Marriage in Cana*, *Baptism*, and *Transfiguration*); R. L. Douglas, 1900, p. 192 (Angelico and pupils, except

for the *Marriage in Cana*, *Baptism*, and *Transfiguration* by Alessio Baldovinetti); A. D'Ancona, 1908, p. 81f. (Zanobi Strozzi); F. Schottmüller, 1911, pp. 164-83; *idem*, 1924, pp. 183-201; P. Muratoff, 1930, pp. 62-63, 90-91 (school of Angelico, c. 1448); W. and E. Paatz, I, 1940, p. 185; J. Pope-Hennessy, 1952, pp. 190-91; L. Collobi-Ragghianti, 1955 (*Ezekiel* by Zanobi Strozzi); *Mostra*, 1955, pp. 75-78, cats. 45-50; M. Salmi, 1958, p. 55 (*Nativity* by Gozzoli); B. Berenson, 1963, p. 12 (*Vision of Ezekiel* and *Lex Amoris* by Domenico Michelini); Casalini, 1963, pp. 104-24; A. Padoa Rizzo, 1972, p. 113 (*Nativity* by Gozzoli); M. Boskovits, "Adorazione," 1976, p. 9 (after 1450); V. Alce, 1984, pp. 392-98, D. A. Covi, 1986, pp. 122-29; M. C. Impronta, in *San Marco*, 1990, p. 109; C. Lloyd, 1992, pp. 19, 114-21; W. Hood, 1993, pp. 321-22; M. Scudieri, 1995, pp. 25-28.

Datable 1450-53. The first panel containing nine scenes, cat. 62A, was mostly painted by Fra Angelico himself. The two other large panels, cats. 62C and 62D, were executed under his supervision by a very capable assistant following his designs. The three scenes, cat. 62B, by Alessio Baldovinetti, were inserted a few years later and were not designed by Fra Angelico. See text and plate, pp. 186-89.

BOSCO AI FRATI ALTARPIECE

Tempera and gold on panel,
78¾ × 68½ in. (200 × 174 cm)
Museo di San Marco, Florence

Principal Register

Madonna and Child Enthroned with Two Angels and Six Saints,
68½ × 68½ in. (174 × 174 cm)
Saints (left to right): Saints Anthony of Padua, Louis of Toulouse, Francis of Assisi, Cosmas, Damian, and Peter Martyr

Predella

One panel, 10¼ × 68½ in. (26 × 174 cm), showing (left to right): Saints Dominic, Bernard, and Peter, Pietà, Saints Paul, Jerome, and Benedict

PROVENANCE
Formerly Bosco ai Frati, Mugello, in the Franciscan convent of San Buonaventura (completed by Michelozzo, 1438) on commission of Cosimo de' Medici near his villa at Cafaggiolo; transferred to Galerie florentine before 1810.

Baldini, 1970, pp. 113-14, cat. 115 (1450)
Pope-Hennessy, 1974, p. 215 (1450-52)

SOURCES
Fra Giovanni Ughi, *Chronaca del chiostro di San Francesco in Mugello*, 1563 (Florence, Archivio di Stato, Storie e Relazioni miscellanee, vol. 167 nuovo): "The beautiful panel on the High Altar which was painted by a friar of S. Domenico."

BIBLIOGRAPHY
J. Crowe and G. B. Cavalcaselle, 1864, 1911 ed., IV, pp. 89-90; B. Berenson, 1896, p. 118; *idem*, 1900, p. 100; *idem*, 1932, p. 104 (did not know predella); Fabriczy, 1904, pp. 70-71 (publishes Ughi archive);

F. Schottmüller, 1911, p. 158; *idem*, 1924, p. 172 (late; disassociated predella from this altarpiece); R. van Marle, 1928, x, p. 118 (did not know predella); P. Muratoff, 1930, p. 91 (with assistant, c. 1445); L. Collobi Ragghianti, 1950, pp. 17-27; J. Pope-Hennessy, 1952, pp. 176-78 (dated 1440-45, predella early Gozzoli?); *Mostra*, 1955, pp. 79-80, cat. 51 (predella rejoined to altarpiece); S. Orlandi, 1955; M. Salmi, 1958, p. 87 (dates 1450-52); B. Berenson, 1963, p. 12; C. Lloyd, 1992, pp. 106-7; M. C. Impronta, in *San Marco*, 1990, p. 109 (after 1450); W. Hood, 1993, pp. 104-5; M. Scudieri, 1995, pp. 38-39.

Datable to 1450-52.

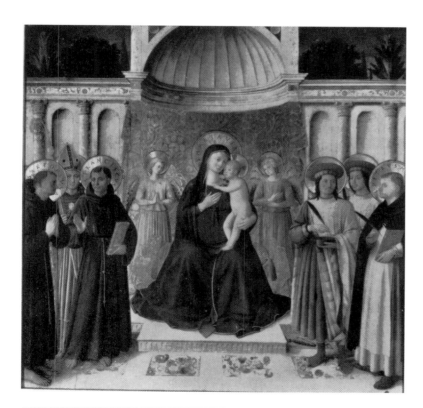

63

64
CRUCIFIXION
Tempera and gold on panel,
64⅝ × 39⅜ in. (164 × 100 cm)
Church of San Marco, Florence

PROVENANCE
Formerly Galerie florentine (1890) (no. 6084) as Lorenzo Monaco.

Baldini, 1970, cat. 8 (1428-30)
Pope-Hennessy, 1974, p. 225 (1425)

BIBLIOGRAPHY
U. Baldini, in *Decima mostra delle opere d'arte restaurate*, 1959 (1422-25); L. Berti, 1962, pp. 206-7 (1428-30); *idem*, 1963, p. 11; D. Cole Ahl, 1980, pp. 369-71; M. C. Impronta, in *San Marco*, 1990, p. 68 (second half of 1420s).

Uncertain attribution. Perhaps to be associated with the lost *Crucifix* painted for Santa Maria Nuova, Florence, in 1423.

65A
CRUCIFIXION WITH THE VIRGIN AND SAINT JOHN
65B
CORONATION OF THE VIRGIN
Tempera and gold on panel,
diam. 11⅛ in. (28 cm) each
Museo di San Marco, Florence

PROVENANCE
Church of Santa Maria della Croce al Tempio, Florence; transferred to Confraternity of Santa Lucia in the Santissima Annunziata (1786); Galleria dell'Accademia, Florence.

Baldini, 1970, p. 117, cat. 125, 126 (ascribed)
Pope-Hennessy, 1974, p. 225 (Master of Cell 2 at San Marco)

BIBLIOGRAPHY
F. Schottmüller, 1924, p. 234 (workshop); J. Pope-Hennessy, 1952, p. 225 (Master of Cell 2); M. Salmi, 1958, pp. 117-18; B. Berenson, 1963, p. 12; G. Bonsanti, 1985, pp. 30-31; M. C. Impronta, in *San Marco*, 1990, p. 106 (1437-40); M. Scudieri, 1995, p. 40.

Circa 1440 by Fra Angelico and assistant.

66
DEPOSITION FROM THE CROSS
Tempera and gold on panel,
72⅞ × 69⅜ in. (185 × 176 cm)
Museo di San Marco, Florence

PROVENANCE
Painted for the Compagnia di Santa Maria della Croce al Tempio, over altar on left side of church (commissioned by Fra Sebastiano di Jacopo di Rosso Benintendi on April 13, 1436, and completed by December 2, 1436); in 1786 passed to the Galleria dell'Accademia; transferred to Museo di San Marco in 1919.

Superimposed on background as if spoken by the Blessed Villana:

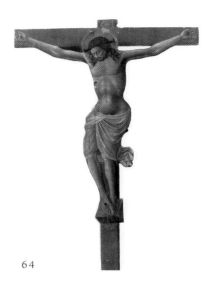

64

Xp[ist]o yh[es]v lamor mio crvcifisso (apparently an Italian version of a passage found in Saint Ignatius of Antioch, *Epistula ad Romanus*, chap. 7).

Baldini, 1970, cat. 53 (1436)
Pope-Hennessy, 1974, p. 199 (1436)

SOURCES
F. Albertini, 1510 (*Mostra*, 1955, p. 30): "and a panel at the Tempio della Giustizia is by the hand of Fra Giovanni."
Libro di Antonio Billi, 1506-30:
 Codice Petrei, Magl. XIII, n. 89 (1991 ed., p. 77): "[He painted] a panel in the Tempio where one sees the dead Jesus Christ with chorus of the Maries around him."
 Codice Strozziano, Magl. XXV, n. 636 (1991 ed., p. 128): "[He painted] a panel in the Tempio where one sees Jesus dead with a chorus of the Maries around him."
L'Anonimo Magliabechiano, Magl. cl XVII, 17, 1536-46 (1968 ed., p. 102): "And also in the Temple he painted a panel where Christ is dead with the Maries around him."
Vasari, 1568, II, p. 514: "For the compagnia of the Tempio in Florence he painted a panel with the dead Christ."

65

65A

BIBLIOGRAPHY

J. Crowe and G. B. Cavalcaselle, 1864, 1911 ed., IV, p. 90 n. 5; J. W. Brown, 1902, p. 122; R. Diaccini, 1922, pp. 32-33; F. Schottmüller, 1911, cat. 64; *idem,* 1924, cat. 92 (1433-45, places later in 2d edition); P. Muratoff, 1930, pp. 45, 68, 86 (assistant); G. Bazin, 1949, p. 185 (with assistant); W. and E. Paatz, 1952, III, p. 308; J. Pope-Hennessy, 1952, p. 176 (Angelico design; executed by Master of Cell 2); S. Orlandi, 1955, pp. 13-14, 31-32 (1435-36); *Mostra,* 1955, pp. 58-59, cat. 33; U. Middeldorf, p. 190n (notes date MIIIIXXXXI on edge of Virgin's veil; concurs with Orlandi that date refers to dedication of altar in 1440 by the Bishop of Feltre, Tommaso Tommasini Paruta); B. Berenson, 1963, p. 12; S. Orlandi, 1964, pp. 187-88; M. Boskovits, "Appunti," 1976, pp. 39, 44; S. Y. Edgerton, 1979, pp. 45-61; D. Cole Ahl, 1981, pp. 150, *passim;* D. A. Covi, 1986, no. 66; M. C. Impronta, in *San*

66

Marco, 1990, p. 74 (commissioned 1436, dates completion to 1440 citing Middeldorf); C. Lloyd, 1992, p. 9; W. Hood, 1993, p. 110; M. Boskovits, 1994, pp. 369-95.

See pages 46-47.

67
THE LAST JUDGMENT
Tempera and gold on panel,
41⅜ × 82⅝ in. (105 × 210 cm)
Museo di San Marco, Florence

PROVENANCE

Santa Maria degli Angeli, Florence, until c. 1482; by 1817 at Galleria dell'Accademia, Florence.

Baldini, 1970, p. 92, cat. 27 (1432-35)
Pope-Hennessy, 1974, p. 192 (c. 1431)

SOURCES

Antonio Manetti, 1494 (S. Orlandi, 1964, p. 196): "[he painted] one [panel] of the Judgement in the church of the Angeli."
Libro di Antonio Billi, 1506-30, *Codice Petrei,* Magl. XIII, n. 89 (1991 ed., pp. 77-78): "and in the monastero of the Angeli an Inferno and a Paradise."
 Codice Strozziano, Magl. XXV, n. 636 (1991 ed., p. 128): "And in the Angeli, that is, in the monastery, an Inferno and a Paradise."
F. Albertini, 1510, 1863 ed., p. 13: "a Judgement by Fra Giovanni."
Chronica quadripartita del convento di S. Domenico di Fiesole, 1516 (S. Orlandi, 1954, p. 164): "one in Santa Maria degli Angeli of the Camaldolite order."

L'Anonimo Magliabechiano, Magl. cl XVII, 17, 1536-46 (1968 ed., p. 102): "And in the church of the friars of the Angeli there is by his hand an Inferno and a Paradise."
Vasari, 1568, II, pp. 514-15: "and in the church of the monks of the Angeli, a Paradise and an Inferno with small figures; in this work he finely rendered the Blessed as beautiful, jubilant figures filled with celestial joy, while the Damned suffer the sorrowful pains of the Inferno, their sins and demerits impressed upon their faces. The Blessed pass through the gate of Paradise in a celestial dance, while the Damned are dragged by demons into the eternal punishments of Hell. This work is in this church on the right side as one faces the high altar, where the priest sits during the singing of the Mass."

BIBLIOGRAPHY

P. V. Marchese, 1845, 3d ed. 1869, I, pp. 397-404; J. Crowe and G. B. Cavalcaselle, 1864, 1911 ed., IV, pp. 91-92; R. L. Douglas, 1900, pp. 58-61 (early); A. Wurm, 1907, p. 60 (rejects); B. Berenson, 1909, p. 105 (authentic except right section); F. Schottmüller, 1911, pp. 25-29; *idem,* 1924, pp. 30-34 (1430-40); R. van Marle, 1928, X, p. 170 (cartoon by Angelico, executed by another hand, Zanobi Strozzi?); P. Muratoff, 1930, pp. 34-35, with assistant); G. Bazin, 1949, p. 184 (executed by another hand); W. and E. Paatz, 1952, III, pp. 121, 124; Pope-Hennessy, 1952, p. 175 (Zanobi Strozzi, 1435-40); *Mostra,* 1955, pp. 17-19, cat. 9; B. Berenson, 1963, p. 12; L. Bellosi, 1974, p. 19 n. 14; M. Boskovits, "Appunti," 1976, p. 33; D. Cole Ahl, 1981, pp. 139-40; A. Santagostino Barbone, 1989, pp. 255-78; M. C. Impronta, in *San Marco,* 1990, p. 72 (c. 1431); C. Lloyd, 1992, pp. 11, 42-43; W. Hood, 1993, p. 313 n. 38;

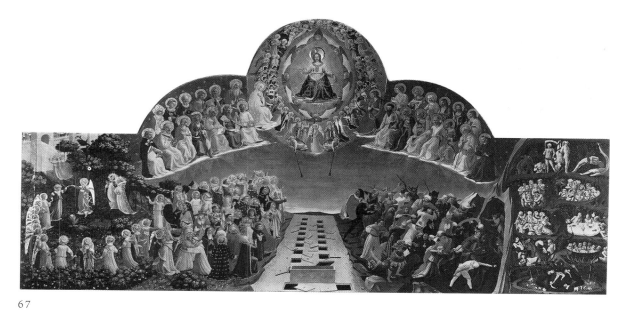

67

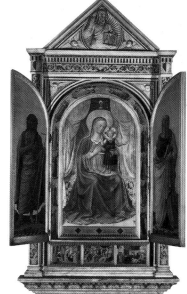

68

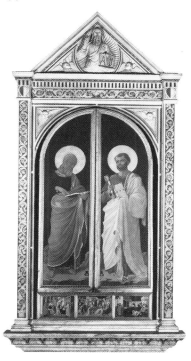

68A

M. Boskovits, 1994, pp. 309-68;
M. Scudieri, 1995, pp. 22-23.

See pages 98-105.

68
THE LINAIUOLI TABERNACLE
Tempera and gold on panel, in marble tabernacle designed by Ghiberti,
17 ft. 2 in. × 8 ft. 9 in. (5.28 × 2.69 m)
Museo di San Marco, Florence

PROVENANCE
Commissioned in 1433 for the guild hall of the Arte dei Linaiuoli; transferred to the Galleria degli Uffizi (1777), then to the Museo di San Marco (1924).

Centerpiece

MADONNA AND CHILD
115 × 69⅜ in. (292 × 176 cm)

TWELVE MUSICAL ANGELS
Each 7⅞ in. (20 cm) in height; form an interior semicircular frame about the Madonna and Child

Doors

Two double-sided panels, each 115 × 34⅝ in. (292 × 88 cm), from left to right:

68A
SAINT MARK;
SAINT PETER
(when closed)
68B
SAINT JOHN THE BAPTIST
68C
SAINT MARK
(when opened)

Predella

Three panels, each 15⅜ × 22⅛ in. (39 × 56 cm), from left to right:

68D
SAINT PETER PRAYING IN THE PRESENCE OF SAINT MARK
68E
THE ADORATION OF THE MAGI
68F
THE MARTYDOM OF SAINT MARK

Baldini, 1970, p. 91, cat. 24 (1433)
Pope-Hennessy, 1974, pp. 194-95

SOURCES
Vasari, 1568, II, p. 529: "and finally the large tabernacle that the Wool Merchants guild commissioned from him."

BIBLIOGRAPHY
P. V. Marchese, 1845, 3d ed. 1869, II, pp. 339-42; J. Crowe and G. B. Cavalcaselle, 1864, 1911 ed., IV, p. 78; A. Wurm, 1907, pp. 18-20 (only Saint Mark by Fra Angelico); R. van Marle, 1928, X, p. 60 (doubts lateral panels); F. Schottmüller, 1911, pp. 34-45; *idem*, 1924, pp. 36-47 (1433); P. Muratoff, 1930, pp. 43, 84 (1433, predella by assistant); J. Pope-Hennessy, 1952, p. 169; *Mostra*, 1955, pp. 29-31, cat. 16; S. Orlandi, 1955, pp. 43-44, 185-86; U. Middeldorf, 1955, pp. 179-94; R. Krautheimer, 1956, p. 385; B. Berenson, 1963, pp. 12-13; M. Boskovits, "Adorazione," 1976, p. 14 (commissioned July 1433, probably not completed before end of following year), p. 48 n. 13 (the noticeable difference of San Marco 1431-32 suggests that the Linaiuoli was not executed before 1434); *idem*, "Appunti," 1976, pp. 33, 38; M. Alexander, 1977, pp. 154-63; C. Gilbert, 1977, p. 16;

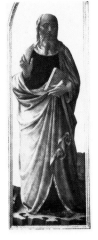

68B 68C

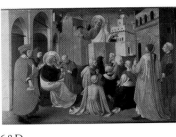

68D

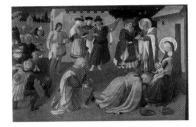

68E

68F

H. Glasser, 1977, pp. 57-58; L. Berti, 1980, p. 157, pl. 178; D. Cole Ahl, 1981, pp. 133, 143; C. Lloyd, 1992, pp. 50-54; M. C. Impronta, in *San Marco*, 1990, p. 73; W. Hood, 1993, pp. 81-84; M. Boskovits, 1994, pp. 326 n. 13, 331 n. 18 (dates 1433-36); M. Scudieri, 1995, pp. 34-35.

See pages 112-13.

69
SAN MARCO MISSAL
(no. 558)

Tempera and gold on parchment,
18¾ × 13¼ in. (47.5 × 33.7 cm)
Museo di San Marco, Florence
(no. 558)

PROVENANCE
Convent of San Domenico, Fiesole; Pietro Leopoldo Ricasoli, prior of the order of Santo Stefano (d. 1850), Florence; Leopold II, Grand Duke of Tuscany, and Maria Antonia, Grand Duchess of Tuscany.

Pope-Hennessy, 1974, p. 191 (1428-30)

SOURCES
Vasari, 1568, II, p. 506: "Similar to these are some other manuscripts, made with incredible care, that he left at San Domenico in Fiesole."

BIBLIOGRAPHY
M. Wingenroth, 1898, pp. 343-45; R. L. Douglas, 1900, pp. 180-81 (rejects); P. D'Ancona, 1908, pp. 81-95; *idem*, 1914, pp. 345-56 (Zanobi Strozzi); R. van Marle, 1928, x, p. 186; L. Collobi-Ragghianti, 1950, p. 467; *Mostra*, 1953, p. 301; *Mostra*, 1955, pp. 96-98, cat. 65; M. Levi-D'Ancona, 1959, pp. 1-38; L. Berti, 1962, pp. 277-308 (c. 1430); *idem*, 1963, pp. 1-38; R. Chiarelli, 1968, pp. 21-24; M. Boskovits, "Adorazione," 1976, pp. 30-37 (c. 1425); *idem*, "Appunti," 1976, pp. 30-54; C. Lloyd, 1979, pp. 34-37; A. Garzelli, 1985, pp. 11-13; L. Bellosi, pp. 98-101; L. Berti and A. Paolucci, p. 226;

M. Scudieri, in *San Marco*, 1990, pp. 16-17; *Pittura e Scultura*, 1990, pp. 39-40; C. B. Strehlke, 1993, pp. 19-20; M. Boskovits, 1994, pp. 346-47; C. B. Strehlke, 1994, pp. 332-39 (with inscriptions).

The San Marco Missal (no. 558) was first examined thoroughly by L. Berti (1962, 1963), who attributed to Fra Angelico the illuminations on the following pages:

9: *Calling of Saints Peter and Andrew*
11v: *Saint Stephen*
13v: *Saint John the Evangelist*
16: *The Holy Innocents*
21: *Conversion of Saint Paul*
24v: *Presentation in the Temple*
33v: *Annunciation*
41v: *Death of Saint Peter Martyr*
45: *Crucifixion*
48v: *Christ Crowned with Thorns*
55v: *Saint John the Baptist*
60v: *Saint Peter*
67v: *Saint Dominic in Glory*
68v: *Saint Dominic in Prayer*
73v: *The Assumption of the Virgin*
86v: *The Souls in Purgatory*
93: *Christ*
100: *Christ with an Angel*
109: *Christ with Three Other Figures*
156v: *The Virgin Protecting the Dominican Order*

69A

69B

69C

70
SANTA CROCE ALTARPIECE

This altarpiece has been convincingly reconstructed by Henderson and Joannides. In 1429 Fra Angelico received payment from the Compagnia di San Francesco for a painting in the Church of Santa Croce, Florence. The triptych was evidently dismantled at an early date; its panels are dispersed today among several different collections.

The upper register of the altarpiece consisted of three cuspids, a central Trinity flanked by the Annunciate Angel, on top of the left wing, and the Virgin, on top of the right wing.

Principal register, center panel

70A
MADONNA AND CHILD ENTHRONED
Tempera and gold on panel,
74½ × 31⅞ in. (189 × 81 cm)
Museo di San Marco, Florence

Inscribed on the scroll held in Christ's hand: Discite a me quia mitis sum z. umilis corde / z. invenientis requiem animabus vestris *(Matthew 11:29)*

PROVENANCE
In the Galleria dell'Accademia by 1884.

Principal register, left side panel

70B
SAINT JEROME (JOHN THE EVANGELIST?) AND SAINT JOHN THE BAPTIST WITH THE ANGEL ANNUNCIATE AT TOP

Principal register, right side panel

70C
SAINT FRANCIS AND SAINT ONOPHRIUS WITH THE VIRGIN ANNUNCIATE AT TOP
Tempera and gold on panel,
each 67 × 31⅛ in. (170 × 79 cm)
Florence, Museo di San Marco
(on loan from the Certosa di Galluzzo)

PROVENANCE
Side panels entered the Certosa del Galluzzo between 1817 and 1862.

BIBLIOGRAPHY
(Madonna col Bambino e Trinità)
S. Beissel, 1905, p. 54 (not by Angelico); B. Berenson, 1909, p. 105 (rejects *Trinity* at top); F. Schottmüller, 1911, p. 1; idem, 1924, p. 1 (1418-25, first work); R. van Marle, 1928, x, p. 188 (side panels by Andrea di Giusto); R. van Marle, 1928, x, p. 40 (earliest work); R. Longhi, 1928, p. 155 (after 1430); P. Muratoff, 1930, p. 27 (earliest work, c. 1420); B. Berenson, 1932, p. 100 (side panels by an artist between Masolino and Angelico); L. Collobi-Ragghianti, 1950, p. 269 (first attributes the side panels to Angelico, 1423-25); J. Pope-Hennessy, 1952, p. 197 (rejects *Trinity;* the *Virgin and Child* are "substantially autograph"; wings not by Angelico); L. Collobi-Ragghianti, 1955, p. 37; L. Berti in *Mostra,* 1955, cat. 2 (c. 1430); M. Salmi, 1958, pp. 8, 95 (earliest work, 1420); L. Berti, "foglio miniato," 1962, p. 214 n. 7 (first associates wings with central panel), pp. 207-15; B. Berenson, 1963, p. 12 (rejects *Trinità* and wings); L. Berti, 1963, pp. 1-38; U. Baldini, 1970, cat. 7 (1428-30); J. Pope-Hennessy, 1974, p. 224 (*Madonna and Child* by Angelico; rejects *Trinità;* rejects association with wings); M. Boskovits, "Appunti," 1976, pp. 36-37, 48-49 (rejects association with wings); idem, "Adorazione," 1976, pp. 31-34 (early 1430s); U. Baldini, 1977, p. 238 (1428-30, probably connected to Certosa wings); G. Bonsanti, 1982, p. 137; C. Chiarelli, 1982, p. 234; D. A.

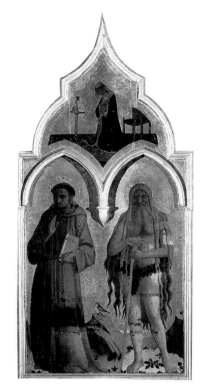

70C

Covi, 1986, no. 101; E. Fahy, 1987, pp. 178, 183; M. C. Impronta, in *San Marco,* 1990, p. 70 (1429); J. Henderson and P. Joannides, 1991, pp. 3-6 (1429); M. Boskovits, 1994, pp. 347-49; C. Strehlke, 1994, p. 31; M. Scudieri, 1995, p. 31.

Predella panels

70D
SAINT FRANCIS BEFORE THE SULTAN
Tempera and gold on panel,
11⅛ × 12¼ in. (28 × 31 cm)
Lindenau Museum, Altenburg, Germany

PROVENANCE
Acquired in Rome, 1845.

70E
MEETING OF SAINTS FRANCIS AND DOMINIC
Tempera and gold on panel,
11⅛ × 12¼ in. (28 × 31 cm)
Staatliche Museen, Berlin (no. 61)

PROVENANCE
Acquired 1823.

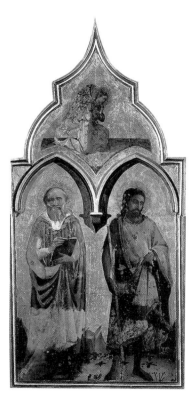

70A

70B

70F
DEATH OF SAINT FRANCIS
Tempera and gold on panel,
11½ × 27¾ in. (29 × 70.3 cm)
Staatliche Museen, Berlin (no. 61A)

PROVENANCE
Formerly in the Farrer and Fuller-
Maitland collections; presented to
museum in 1909 by W. von Bode.

70G
APPARITION OF
SAINT FRANCIS
AT ARLES
Tempera and gold on panel,
10¼ × 12¼ in. (26 × 31 cm)
Staatliche Museen, Berlin (no. 62)

PROVENANCE
Acquired 1823.

70H
STIGMATIZATION OF
SAINT FRANCIS
Tempera and gold on panel,
11⅛ × 13 in. (28 × 33 cm)
Pinacoteca Vaticana, Vatican City
(no. 258)

BIBLIOGRAPHY
Barbier de Montault, 1867 (anony-
mous late quattrocento); J. Crowe
and G. B. Cavalcaselle, 1864, 1911
ed., II, pp. 93 n. 5, 95; B. Berenson,
1896, p. 117 (Berlin 61 and 62);
A. Schmarsow, 1897, p. 179 (associ-
ates predella panels in Altenburg
and Berlin); F. Schottmüller, 1911,
pp. 159-62; idem, 1924, pp. 173-76
(workshop, possibly for the Bosco
ai Frati altarpiece, c. 1450-52);
P. Muratoff, 1930, pp. 59-60, 91
(assistant, c. 1445); L. Collobi-
Ragghianti, 1950, p. 467 (c. 1450);
Mostra, 1955, cat. 36 and 55;
M. Salmi, 1958, p. 35; B. Berenson,
1963, pp. 10-11, 15 (for Bosco ai
Frati); S. Orlandi, 1964, p. 204;
J. Pope-Hennessy, 1974, pp. 220-21,
233 (Angelico and assistants,
c. 1450); U. Baldini, 1970, cat. 63-67
(1440?); *Katalog*, 1975, pp. 27-28;

70D

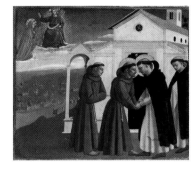

70E

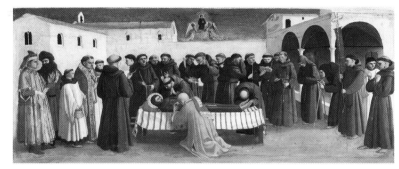

70F

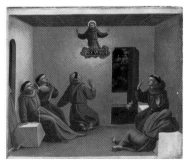

70G

70H

M. Boskovits, "Appunti," 1976, pp.
36-38 (associated predella panels
with side saints in Galuzzo);
J. Henderson and P. Joannides, 1991,
pp. 3-6 (associate the predella with
the Santa Croce Altarpiece, 1429);
M. Boskovits, 1994, pp. 347-50.

71
SAN MARCO
ALTARPIECE
Museo di San Marco, Florence

PROVENANCE
Painted for the high altar of San
Marco, 1438-40; removed to the
adjacent convent by 1677 (Conelli);
noted by Richa in a passage leading
to the church sacristy in 1745; the
predella panels were separated and
sold around 1817; the principal reg-
ister and two remaining predella
panels were transferred to the Gal-
leria dell'Accademia in 1884 and to
the Museo di San Marco in 1919.

Inscriptions: See V. Alce, 1984,
pp. 385-86.

Principal Register

71A
MADONNA AND
CHILD ENTHRONED
WITH ANGELS AND
SAINTS COSMAS,
DAMIAN, LAWRENCE,
JOHN THE EVANGELIST,
MARK, DOMINIC,
FRANCIS OF ASSISI,
AND PETER MARTYR
Tempera and gold on panel,
86⅝ × 89⅜ in. (220 × 227 cm)

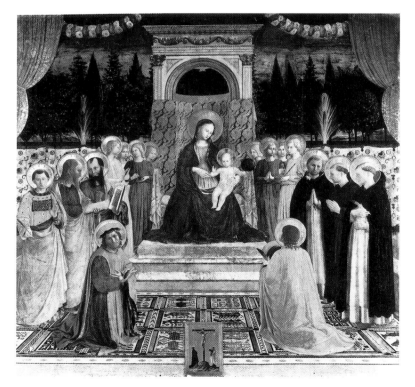

71A

71B
HEALING OF PALLADIA BY SAINTS COSMAS AND DAMIAN AND SAINT DAMIAN RECEIVING A GIFT FROM PALLADIA
14⅜ × 18⅜ in. (36.5 × 46.7 cm)
Washington, D.C., The National Gallery of Art; Kress Collection
(no. 790, K1387)

PROVENANCE
Collection Comte de Poutalès-Gourgier, Paris; sold Hotel Poutalès-Gourgier, Paris, March 27, 1865, no. 86, as Masaccio; collection Julius Bohler, Munich; Albert Keller, New York (by 1924); Duveen's, New York; Samuel H. Kress (1944)

71C
SAINTS COSMAS AND DAMIAN PRESENT THEIR BROTHERS TO THE PROCONSUL LYSIAS
14⅞ × 18⅜ in. (37.8 × 46.6 cm)

71D
LYSIAS POSSESSED BY DEVILS: SAINTS COSMAS AND DAMIAN THROWN INTO THE SEA
15 × 18⅛ in. (38 × 46 cm)

71E
THE CRUCIFIXION OF SAINTS COSMAS AND DAMIAN
15 × 18⅛ in. (38 × 46 cm)
Alte Pinakothek, Munich
(nos. WAF 36, WAF 37, WAF 38)

PROVENANCE
Purchased for the Bavarian Royal Collection from the art dealer K. Weiss, Berlin, in 1822.

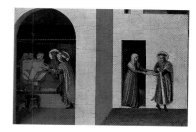

71B

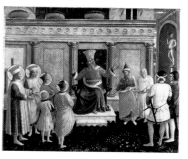

71C

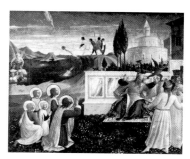

71D

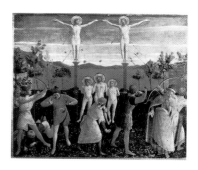

71E

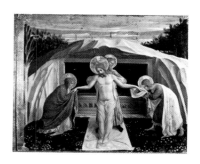

71F

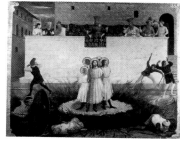

71G

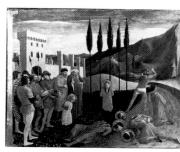

71H

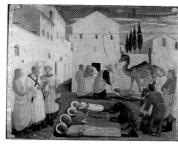

71I

71J

71F
PIETÀ (LAMENTATION OVER CHRIST)
15 × 18¼ in. (37.9 × 46.4 cm)
Alte Pinakothek, Munich
(no. WAF 38A)

PROVENANCE
Acquired by Crown Prince Ludwig, Munich, in 1818.

71G
ATTEMPTED MARTYRDOMS OF SAINTS COSMAS AND DAMIAN BY FIRE
14⅝ × 18⅛ in. (37 × 46 cm)
National Gallery of Ireland, Dublin

PROVENANCE
Lombardi-Baldi collection, purchased by the National Gallery of Ireland in 1886.

71H
DECAPITATION OF SAINTS COSMAS AND DAMIAN
14¾ × 18¼ in. (37.3 × 46.1 cm)
Musée du Louvre, Paris (no. 1293)

PROVENANCE
Nicolò Tachinardi; acquired in Florence by Valentini collection, Rome; Palazzo Imperiali, Rome, 1817; purchased in Rome in 1868 by Charles Timbal; sold by Mme Timbal to the Musée du Louvre in July 1882.

71I
BURIAL OF SAINTS COSMAS AND DAMIAN
14⅝ × 17¾ in. (37 × 45 cm)

Inscription from mouth of camel: Nolite eos sepa[rar]e a sepvltvra qvia no[n] sv[n]t separ[ati] a merito

71J
HEALING OF DEACON JUSTINIAN
14⅝ × 17¾ in. (37 × 45 cm)
Museo di San Marco, Florence

PROVENANCE

High altar, Church of San Marco, Florence, dedicated to Saints Cosimo and Damian, renovated by Michelozzo; removed from church in seventeenth century (Cinelli [1677] and Richa [1745]); principal register and last two predella panels in Florence transferred to Galleria dell'Accademia (1884) and Museo di San Marco (1919).

Baldini, 1970, pp. 101-2, cat. 60 (1438-40)

Pope-Hennessy, 1974, pp. 199-200 (commissioned 1438 and completed soon after 1440)

SOURCES

Antonio Manetti, c. 1490 (S. Orlandi, 1964, pp. 195-96): "Fra Giovanni . . . painted in San Marco the panel of the high altar."

F. Albertini, 1510, 1863 ed., p. 13: "In the large convent and church of San Marco, in great part constructed by the Medici, there are several good works. The major panel and the chapter room and the pictures in the first cloister are from the hand of Fra Giovanni of the order of Preachers."

Libro di Antonio Billi, 1506-30:

Codice Petrei, Magl. XIII, n. 89 (1991 ed., p. 77): "He painted in Florence, Rome and elsewhere, and the chapter room of San Marco in Florence and the panel of the high altar with many other figures in the church."

Codice Strozziano, Magl. XXV, n. 636 (1991 ed., p. 128): "and among the other works, the chapter room of San Marco, and the panel of high altar, and many other figures for this house."

Chronica quadripartita del convento di S. Domenico di Fiesole, 1516

(S. Orlandi, 1954, p. 164): "He painted a panel in San Marco in Florence."

L'Anonimo Magliabechiano, Magl. cl XVII, 17, 1536-46 (1968 ed., p. 102): "In Florence in the monastery of the friars of San Marco he painted the chapter room. The panel of the high altar in the church of these friars is by his hand. And many more paintings by him are in the convent of these friars."

Vasari, 1568, II, pp. 508-9: "But the panel of the high altar of that church is particularly beautiful and marvelous; the Madonna incites the devotion of all those who look at her on account of her simplicity and the saints all around her are similar. The predella with stories of the martyrdoms of Saints Cosimo and Damian and others is so well made that it is not possible to imagine anything made so carefully nor more delicate or better understood little figures than these."

F. Bocchi, 1591 (ed. G. Cinelli, 1677, p. 10): "Many paintings have been made there [San Marco] by Fra Giovanni of the same order, such as the high altar."

G. Cinelli, 1677, p. 26: "Many other paintings are in the convent such as . . . the panel of the high altar by Fra Giovanni."

BIBLIOGRAPHY

G. Richa, 1754, VII, p. 143 (located in the passageway to the sacristy); P. V. Marchese, 1845, 3d ed. 1869, II, p. 249 (discusses all three Munich predella panels as from San Marco, now in Germany by 1800s); J. Crowe and G. B. Cavalcaselle, 1864, 1911 ed., II, pp. 79-80, n. 2 (connected Munich predella to altarpiece); I. Lermolieff, 1891, p. 121; R. L. Douglas, 1900, pp. 192-93, 197; G. Weisbach, 1901, pp. 37-43 (some intervention by Pesellino); T. de Wyzewa, 1904, p. 339; A. Wurm, 1907, p. 21; F. Schottmüller, 1911, pp. 131-35; *idem*, 1924, pp. 144-48 (1438-40); A. Venturi, 1927, pp. 12, *passim*; R. van Marle, 1928, X, pp. 40, 90 (rejects Munich *Pietà* as part of predella); P. Muratoff, 1930, pp. 48, 85 (1438-40, predella with assistants); Bodkin, 1931, pp. 183-94 (on basis of columns accepts five); L. Venturi, 1933, cat. 161; G. Bazin, 1940, pp. 45, 183 (rejects Munich *Pietà* predella); L. Collobi-Ragghianti, 1950, pp. 468-73 (agrees five predella panels on basis of columns, but different five); M. Salmi, 1950, p. 154; G. Kaftal, 1952, col. 252; W. and E. Paatz, 1952, p. 44; J. Pope-Hennessy, 1952, pp. 174-75, 201, 203; E. Panofsky, 1953, pp. 273-74; S. Orlandi, 1955, p. 47; *Mostra*, 1955, pp. 65-73, cat. 39-43 (various proposals for reconstruction of altarpiece); M. Salmi, 1955, p. 147; U. Baldini, 1956, pp. 78-83; M. Salmi, 1958, pp. 36-41, 87, 112-13 (c. 1445, Munich predella, two figs. at right, Gozzoli, accepts Munich *Pietà* as part of predella); S. Orlandi, 1960, pp. 64, *passim*; B. Berenson, 1963, p. 12 (accepts all listed predella panels); S. Orlandi, 1964, pp. 70-72; E. H. Gombrich, 1966, pp. 38, *passim*; F. R. Shapley, 1966, pp. 94-95; M. Davies, 1972, p. 212; *Katalog*, 1975, pp. 11-12; C. Gilbert, 1977, pp. 25-26; R. Goffen, 1979, pp. 219-20; F. R. Shapley, 1979, pp. 8-10; H. Teubner, 1979, pp. 239-72; A. Brejon de Lavergnée and D. Thiébault, 1981, p. 144; D. Cole Ahl, 1981, pp. 133, 143, 153; C. Lloyd, 1982, pp. 15, 18, 78-85; D. A. Covi, 1986, *passim* (for the inscriptions); J. Miller, 1987, pp. 1-13; L. Bellosi, 1990, pp. 90-93 (with school); M. C. Impronta, in *San Marco*, 1990, p. 106 (c. 1436-40); W. Hood, 1993, pp. 97-104, 107-21; M. Scudieri, 1995, pp. 41-42.

See pages 124-29.

72
DISPUTED ALTARPIECE PILASTERS

The panels in this list have been alternately associated by scholars with the dismantled pilasters of the San Marco and Annalena altarpieces. They have been collected here with the hope of facilitating the rediscovery of their original locations and interrelationships.

72A
SAINT JEROME
72B
SAINT BERNARD
72C
SAINT ROCH
Tempera and gold on panel,
15⅜ × 5½ in. (39 × 14 cm) each
Lindenau Museum, Altenburg, Germany

PROVENANCE

Private collection, Rome, 1844; in catalogue of 1898 "nach der Mitteilung des Dr. Braun verburgt aus S. Marco in Florenz stammend"

Baldini, 1970, p. 101, cats. 59I, J, K

Pope-Hennessy, 1974, p. 201

BIBLIOGRAPHY

F. Schottmüller, 1911, p. 157; *idem*, 1924, p. 177; M. Salmi, 1958, pp. 22, 104; R. Oertel, 1961, pp. 145-46 (as part of Annalena Altarpiece); B. Berenson, 1963, p. 10 (part of San Marco Altarpiece).

72D
SAINT PETER MARTYR
Tempera and gold on panel,
10⅛ × 4⅞ in. (25.5 × 12.2 cm)
Her Majesty the Queen, Hampton Court (1209)

PROVENANCE

Giovanni Metzger, Florence (died 1844); acquired by Prince Albert in 1845.

Baldini, 1970, cat. 41 (1435)

Pope-Hennessy, 1974, p. 228 (perhaps by Angelico)

BIBLIOGRAPHY

P. V. Marchese, 1845, 3d ed. 1869, 1, p. 313; L. Cust, 1909, p. 202; R. van Marle, 1928, x, p. 144; B. Berenson, 1932, p. 22; R. Longhi, 1946, p. 73, no. 186 (early Gozzoli); J. Pope-Hennessy, 1952, p. 201 (perhaps by Angelico); L. Collobi-Ragghianti, 1955, p. 47; M. Salmi, 1958, p. 86 (possibly a pilaster from the Louvre *Coronation*); R. Longhi, 1960, p. 60; B. Berenson, 1963, p. 14; O. Millar, 1965, no. 6; J. Shearman, 1983, p. 13, cat. 8.

72E

SAINT THOMAS AQUINAS

Tempera and gold on panel,
15⅜ × 5½ in. (39 × 14 cm)
Cini collection, Venice

PROVENANCE

Private collection, Lake Bluff, Illinois; private collection, Italy.

Baldini, 1970, p. 95 n. 41: discusses at end of Hampton Court Saint Peter Martyr
Pope-Hennessy, 1974, p. 201

BIBLIOGRAPHY

J. Pope-Hennessy, 1952, pp. 175–76, fig. XI; W. Angelelli and A. De Marchi, 1991, p. 23.

72F

SAINT BENEDICT

Tempera and gold on panel,
15⅜ × 5⅛ in. (39 × 13 cm)
The Minneapolis Institute of Arts
(The Putnam Dana McMillan
Fund, 62.9)

Inscribed on reverse in eighteenth-century hand: "di Fra Giovanni da Fiesole/figuri che esistono S. Marco di Firenze"

PROVENANCE

First duke of Wellington; then by gift to his physician, Dr. Thomas Peregrine; sold E. F. Peregrine

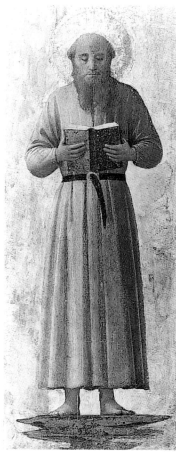

72A

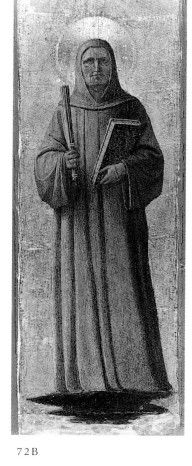

72B

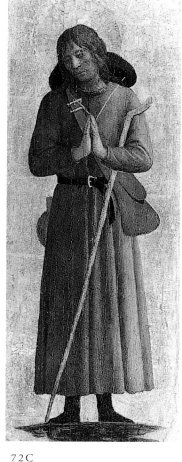

72C

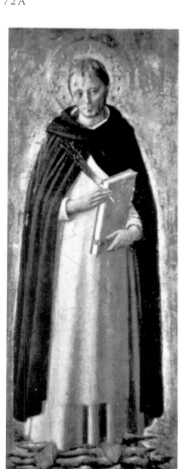

72D

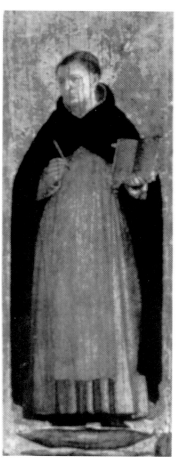

72E

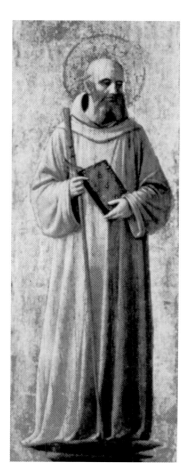

72F

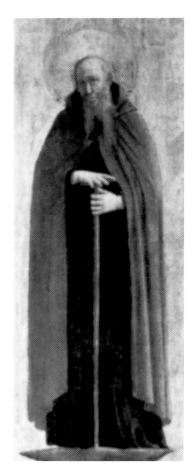

72G

Sotheby's, June 22, 1960, no. 10, to
Richard H. Zinzer, Forest Hills,
New York; by purchase to Minne-
apolis Institute of Arts, 1962.

Pope-Hennessy, 1974, p. 201

BIBLIOGRAPHY:
A. M. Clark, *Minneapolis Institute
of Arts Bulletin* LI (March 1962),
pp. 18-19; *Art Quarterly* XXV (sum-
mer 1962), pp. 166-67; *Apollo* LXXVI
(August 1962), pp. 493-94; *European
Paintings in the Minneapolis Institute of
Arts*, 1963, no. 203, p. 383.

72G
SAINT ANTHONY
ABBOT
Tempera and gold on panel,
dimensions unknown
Private collection

Pope-Hennessy, 1974, p. 201

73
SAN PIETRO
MARTIRE ALTARPIECE
Tempera and gold on panel,
54 × 66⅛ in. (137 × 168 cm)
Museo di San Marco, Florence

PROVENANCE
Executed for the high altar of San
Pietro Martire, Florence, the altar-
piece was transferred in 1557 to San
Felice, where it was described by
Vasari; exhibited at the Uffizi in
the early nineteenth century, then
transferred to the Pitti Palace
shortly before 1854 (Marchese);
assigned to the Museo di San
Marco after 1911.

Principal Register
(left to right)

Saints Dominic and John the Baptist
34¼ × 19⅜ in. (87 × 49 cm)
Madonna and Child
42⅛ × 22½ in. (107 × 57 cm)
*Saints Peter Martyr and Thomas
Aquinas*
34¼ × 19⅜ in. (87 × 49 cm)

Cuspids
(left to right)

Angel Annunciate
diameter: 6¾ in. (17 cm)
Saint Peter Martyr Preaching
in triangular space between left-
center cuspid
God the Father
diameter: 4⅜ in. (11 cm)
Death of Saint Peter Martyr
in triangular space between
center-right cuspid
The Virgin Annunciate
diameter: 6¾ in. (17 cm)

Baldini, 1970, pp. 85-86, cat. 1
(1425-28)
Pope-Hennessy, 1974, p. 190 (c. 1425)

SOURCES
Vasari, 1568, II, pp. 515-16: "He
made a panel with Our Lady, Saint
John the Baptist, San Dominic,

Saint Thomas, and Saint Peter
Martyr, in rather small figures, for
the nuns of San Pietro Martire,
who are located today in the for-
merly Camaldolite monastery of
San Felice in piazza."

BIBLIOGRAPHY
P. V. Marchese, 1845, 3d ed. 1869, I,
p. 445 (by Fra Benedetto or one
of Angelico's earliest and weakest
paintings); G. Milanesi in Vasari,
1568, II, p. 516 n. 1 (much retouched);
B. Berenson, 1896 (omits); L. Doug-
las, 1900 (omits); J. Crowe and
G. B. Cavalcaselle, 1864, 1911 ed., IV,
p. 91 n. 1 (either a copy or so totally
repainted that Angelico's hand can
no longer be recognized); F. Schott-
müller, 1911, p. 2 (overpainted, pos-
sibly with assistance of a pupil;
1420-25); *idem*, 1924, p. 11; R. van
Marle, 1928, X, p. 42; P. Muratoff,
1930, pp. 12 and 79 (by an anony-
mous contemporary); W. and E.
Paatz, 1952, IV, pp. 650-59; J. Pope-
Hennessy, 1952, pp. 197-99 (heavily
repainted, possibly Angelico
c. 1425); *Mostra*, 1955, pp. 24-25,

cat. 13 (painting cleaned for this
exhibition; Angelico c. 1428-29);
M. Salmi, 1958, p. 86; B. Berenson,
1963, p. 12 (workshop); D. A. Covi,
1968, no. 45G (inscription on halo
of Virgin: Ave Maria gratia plena
Dominvs); M. Boskovits, "Appunti,"
1976, p. 33; *idem*, "Adorazione," 1976,
pp. 17, *passim* (at p. 21 dates 1426-27);
D. Cole Ahl, 1980, pp. 379-81;
M. C. Impronta, in *San Marco*,
1990, p. 69 (c. 1429); W. Hood,
1993, pp. 72-77; M. Boskovits,
1994, pp. 309, *passim*; M. Scudieri,
1995, p. 18.

Circa 1426. See pages 86-91.

74
SANTA TRINITA
ALTARPIECE
Tempera and gold on panel,
69¼ × 72⅞ in. (176 × 185 cm)
Museo di San Marco, Florence

PROVENANCE
Church of Santa Trinita, Strozzi
Chapel, Florence (built 1418-23);
Galleria dell'Accademia, Florence.

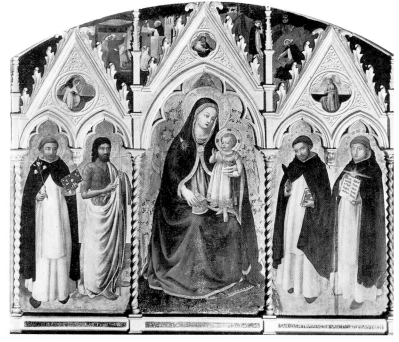

73

Central Panel

Deposition from the Cross

Below the three sections of the principal scene are the following inscriptions adopted from the Divine Order for Holy Saturday:

Plangent evm qvasi vnigenitvm
 qvia inocens (Zachariah 12:10)
Estimatvs svm cvm descenden-
 tibvs in lacvm (Psalms 87:5)
Ecce qvomodo moritvr ivstvs et
 nemo percipit corde (Isaiah 57:1)

Cuspids

Noli me Tangere
Resurrection
Holy Women at the Tomb

Predella

The altarpiece has no predella; three panels by Lorenzo Monaco with stories of Saints Onophrius and Nicholas (Accademia, nos. 8615, 8616, 8617) probably formed part of Lorenzo Monaco's original design for this altarpiece.

Cuspids and predella panels all executed before 1424-25 by Lorenzo Monaco, who received original commission.

Pilasters (see page 232)

Six figures and two medallions, each 5½ in. (14 cm) wide, on front and back

Left side (from top):
 back: *Saints Michael Archangel* (A), *Francis* (B), *Andrew* (C), *Giovanni Gualberto* (D); front: *Saints John the Baptist* (E), *Anthony Abbot* (F), *Lawrence* (G), *Benedict* (H)
Right side (from top):
 front: *Saints Peter* (I), *Peter Martyr* (J), *Paul* (K), *Dominic* (L); back: *Saint Stephen* (M), *unknown bearded saint* (N), *Saints Augustine* (O), and *Jerome* (P)

Baldini, 1970, pp. 99-100, cat. 58 (1437-40)
Pope-Hennessy, 1974, p. 210 (1443; Lorenzo Monaco left altarpiece unfinished at his death, 1425, finished by Angelico at a later date; left side weak; rejects predella)

SOURCES

Antonio Manetti, c. 1490 (S. Orlandi, 1964, p. 166): "and a panel in the sacristy of Santa Trinita representing the deposition of Christ from the cross."
Libro di Antonio Billi, 1506-30: Codice Petrei, Magl. XIII, n. 89 (1991 ed., p. 77): "and in the sacristy of Santa Trinita the panels where Christ is deposed from the cross."
L'Anonimo Magliabechiano, Magl. cl XVII, 17, 1536-46 (1968 ed., p. 102): "he made the panel in the sacristy of Santa Trinita where Christ is deposed from the cross."
Vasari, 1568, II, p. 513: "and in Santa Trinita, a panel in the sacristy, representing a Deposition from the Cross, in which he put so much care that it can be counted among the best things that he ever made"; "His portrait [Michelozzo] is by the hand of Fra Giovanni in the sacristy of Santa Trinita in the figure of an old Nicodemus with a hat on his head, who lowers Christ from the cross."

BIBLIOGRAPHY

P. V. Marchese, 1845, 3d ed. 1869, I, pp. 391-95; J. Crowe and G. B. Cavalcaselle, 1864, 1911 ed., II, p. 89; R. L. Douglas, 1900, pp. 91-93 (1441-46); G. Poggi, 1903; S. Beissel, 1905, pp. 54-57; A. Wurm, 1907, pp. 44-45 (limits Angelico's intervention to figure of Christ); F. Schottmüller, 1911, cats. 54-63; idem, 1924, cats. 58-67 (1430-40); R. van Marle, 1928, x, p. 53 (dates 1425); P. Muratoff, 1930, pp. 48-94, 87 (c. 1435, with some studio intervention); G. Pudelko, 1939, p. 78 (identified predella as part of Monaco's original altarpiece); F. M. Perkins, 1948, p. 4 (1440); G. Bazin, 1949, p. 182 (studio intervention, ascribes figure on left to Master of the Nativity in San Marco cells); J. Pope-Hennessy, 1952, p. 176 (c. 1440, denies left side as by

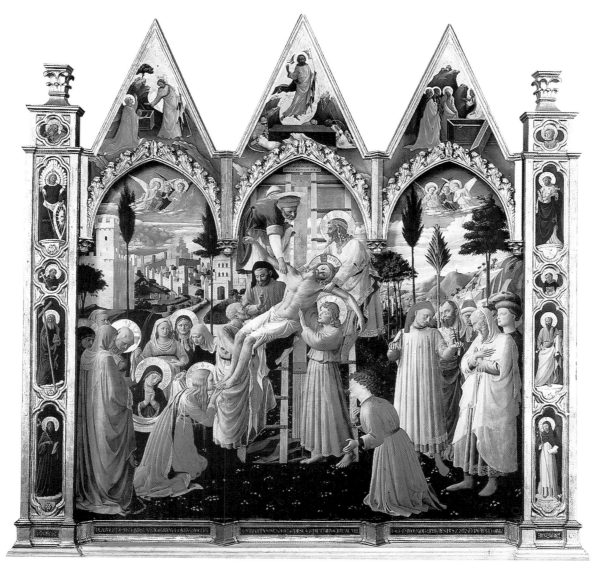

74

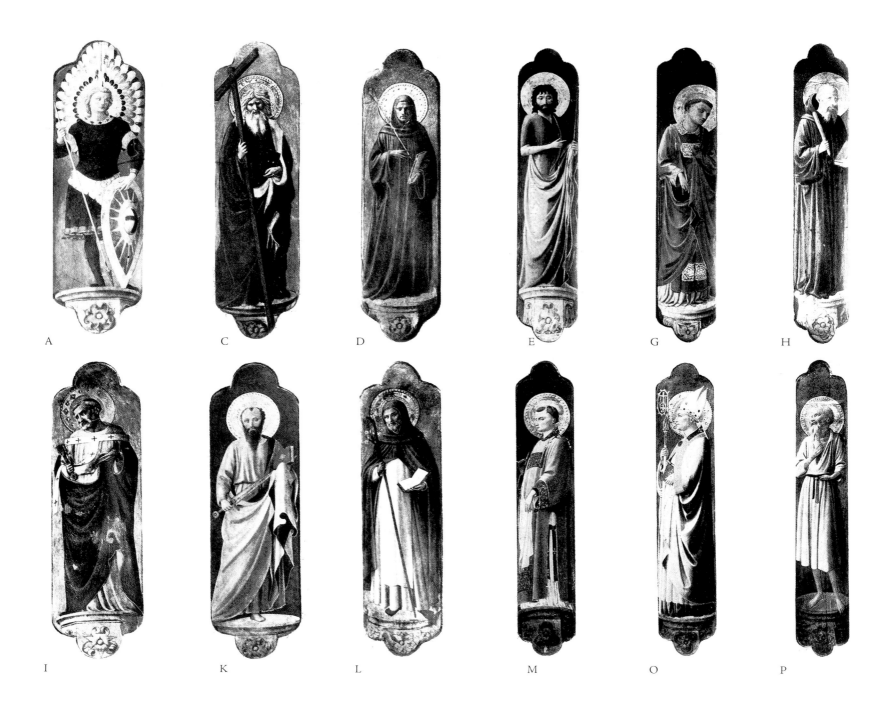

A C D E G H

I K L M O P

Pilaster figures and medallions (see 74, page 231)

B J N F

Angelico; Master of Cell 2?);
U. Middeldorf, 1955, pp. 182-83
(identifies kneeling figure in fore-
ground as Beato Alessio degli
Strozzi); *Mostra*, 1955, pp. 40-42,
cat. 22; L. Collobi-Ragghianti, 1955,
p. 42; S. Orlandi, 1955, p. 47;
M. Salmi, 1958, pp. 96-97 (c. 1436);
B. Berenson, 1963, p. 12; S. Orlandi,
1964, pp. 45-53 (work in progress
when financial transactions between
Palla Strozzi and Dominicans at
Fiesole were recorded, 1431-32,
altarpiece finished c. 1434-35);
M. Cammerer-George, 1966, pp.
187-88 (painting completed under
Palla Strozzi, destroyed after his
banishment in 1434, perhaps be-
cause included portraits of Strozzi
and his sons, later painted afresh,
1440, by Angelico); L. Berti, 1967,
p. 17 (1438-39); D. Davison, 1975,
pp. 315-47; M. Boskovits, "Appunti,"
1976, p. 42; A. Padoa-Rizzo, 1981,
pp. 5, 15-17; D. Cole Ahl, 1981,
pp. 140-43; R. Jones, 1984, pp. 38,
68 (begun by Lorenzo Monaco and
completed by Fra Angelico, placed
in the church in 1432); D. A. Covi,
1986, p. 72 (inscribed on halo of
Christ: [co]rona / glorie, possibly
based on Isaiah 18:5 or taken from
a tract such as Durandus, unique
use of this inscription); A. Padoa-
Rizzo, 1987, p. 125; L. Castelfranchi-
Vegas, 1989, p. 31 (1432, influenced
by humanism of Pala Strozzi);
M. Eisenberg, 1989, pp. 113-17 (the
altarpiece fully constructed but
only partially painted by Lorenzo
Monaco before his death; discusses
other hypotheses; refers views of
Creighton Gilbert on the inscrip-
tions); M. C. Impronta, in *San
Marco*, 1990, p. 71 (early 1430s);
C. Lloyd, 1992, pp. 54-65; W. Hood,
1993, pp. 87-90; M. Boskovits, 1994,
p. 331 n. 18; M. Scudieri, 1995, p. 15.

Datable to 1429-32. See pages 106-11.

75
FOUR RELIQUARY PANELS

Executed for Santa Maria Novella,
Florence, on commission from the
Dominican friar Giovanni Masi
(d. 1434); the panels were exposed
on the altar on appropriate feast
days. Three of the panels remained
in the reliquary cabinet in Santa
Maria Novella until 1868, when
they were transferred to San
Marco. The fourth panel, which
was last recorded in the church
in 1754, is almost certainly the
work now in Boston.

75A
MADONNA DELLA STELLA
Predella: Saints Peter Martyr,
Dominic, Thomas Aquinas
Tempera and gold on panel;
33⅛ × 20⅛ in. (84 × 51 cm)
Museo di San Marco, Florence

75B
THE ANNUNCIATION AND THE ADORATION OF THE MAGI
Predella:
*Saints Catherine of Siena, Apollonia,
Margaret, Lucy, Magdalene, Catherine
of Alexandria, Agnes, Cecilia, Dorothy,
Ursula in medallions in the base*
Tempera and gold on panel;
33⅛ × 19¾ in. (84 × 50 cm)
Museo di San Marco, Florence

75C
CORONATION OF THE VIRGIN
Predella: *The Adoration of the
Child by Angels*
Tempera and gold on panel;
27⅛ × 14⅝ in. (69 × 37 cm)
Museo di San Marco, Florence

75D
BURIAL AND ASSUMPTION OF THE VIRGIN
Tempera and gold on panel;
22⅞ × 14⅛ in. (58 × 36 cm)
*Isabella Stewart Gardner Museum,
Boston*

PROVENANCE
Item 75D acquired by Reverend
John Sanford in the early nine-
teenth century; bequeathed by him
in 1857 to Lord Methuen, second
baron of Corsham Court; by de-
scent to Paul Sanford Methuen,
third baron of Corsham Court;
sold by Colnaghi, London, to
Mrs. Gardner through the agency
of Bernard Berenson in 1899.

Baldini, 1970, p. 93, cats. 29-32 (1434)
Pope-Hennessy, 1974, pp. 224-25
(1430-34, workshop)

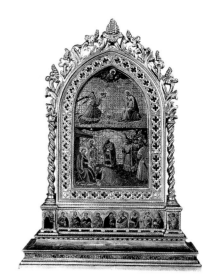

75B

SOURCES
Biliotti, *Cronica*, 1570-1600, XIX,
p. 24: "We have many other relics
of the saints, including those that
Fr Giovanni Masi of Florence, a
devout and quiet man, placed in
four panels which Fra Giovanni
of Fiesole, the painter called an-
gelic, adorned with paintings in
his beautiful manner. Fra Gio-
vanni Masi died in 1433 [*sic*: Masi
died in 1434]."
Vasari, 1568, II, p. 513: "and in Santa
Maria Novella, in addition to
those works already described, he

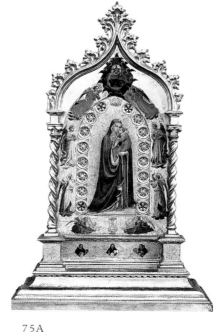

75A

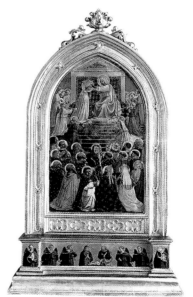

75C

painted little stories on the Easter candle and some reliquaries that are placed on the altar on the most solemn Feast days."

BIBLIOGRAPHY

G. Richa, 1754, III, p. 49 ("Finally we should note in the sacristy four panels, or wooden tabernacles, with Holy Relics in their frames and paintings by Fra Giovanni Angelico. These had been made by Fra Giovanni Masi. On them are represented in little scenes resembling miniatures the mysteries of the Virgin Mary"); F. Kugler, 1847, p. 358 (three reliquaries by Angelico in Santa Maria Novella, one missing); P. V. Marchese, 1845, 3d ed. 1869, I, p. 270; J. Crowe and G. B. Cavalcaselle, 1864, 1911 ed., IV, pp. 90-91 (three reliquaries in Santa Maria Novella), pp. 95-96 (*Death of the Virgin* in Methuen collection, Corsham, was formerly in a chapel near Livorno); R. L. Douglas, 1900, pp. 35-37 (*Burial and Assumption of the Virgin*, formerly Lord Methuen collection, now with Colnaghi and Co.; *Coronation* by an assistant); B. Berenson, 1909, pp. 104-5 (accepts four reliquaries, including ex-Methuen *Burial and Assumption of the Virgin* acquired by Mrs. Gard-

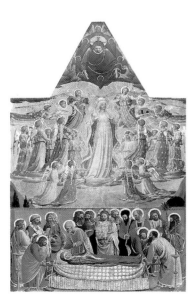

75D

ner, Boston); A. Wurm, 1907, p. 7 (rejects all four); F. Schottmüller, 1911, pp. 14-17, 23, 210; idem, 1924, pp. 12-13, 16-18 (1425-35; 2d ed. 1924: *Coronation* as dubious); E. Schneider, 1924, pp. 34-35; R. Papini, 1925, p. 15 (only the *Madonna della stella* and the *Annunciation* by Angelico); R. van Marle, 1928, X, pp. 44-46 (*Madonna della stella* and the *Annunciation* by Angelico; *Burial and Assumption of the Virgin* by Zanobi Strozzi); P. Muratoff, 1930, p. 80 (1420-25; *Coronation* and *Burial of the Virgin* by an assistant); P. Hendy, 1931, pp. 10-13; L. Venturi, 1933, II, cat. 174; W. and E. Paatz, 1952, pp. 834-35; G. Bazin, 1949, p. 181 (*Madonna della stella* and *Annunciation* by Angelico); J. Pope-Hennessy, 1952, pp. 199-200 (all four panels by Zanobi Strozzi); S. Orlandi, 1954, pp. 169-70; L. Collobi-Ragghianti, "Studi," 1955, pp. 22-47 (all four panels by Zanobi Strozzi); *Mostra*, 1955, pp. 7-10, 49-50, cats. 3, 4, 27 (1434); S. Orlandi, 1955, pp. 152-53; M. Salmi, 1958, pp. 97, 101 (1425, *Burial* with assistance); B. Berenson, 1963, p. 14; M. Meiss, 1963, p. 140 (*Burial* by studio); M. Boskovits, "Adorazione," 1976, pp. 17, 47 n. 11 (c. 1430); D. Cole Ahl, 1981, pp. 133, passim; M. C. Impronta, in *San Marco*, 1990, p. 70 (c. 1430, June 27, 1434, death of Fra Giovanni di Zanobi Masi is *terminus ante quem*); M. Boskovits, 1994, pp. 3 n. 11, 309-68; C. B. Strehlke, 1994, pp. 342-45; M. Scudieri, 1995, pp. 29-30.

Executed at various dates from the early 1420s to the early 1430s. See pages 92-97.

76
CRUCIFIXION WITH SAINTS NICHOLAS OF BARI AND FRANCIS
Tempera and gold on panel (cut out), 82¾ × 73¼ in. (210 × 186 cm) Sacristy of the Compagnia di San Niccolò da Bari (del Ceppo), Florence

76A
SAINT FRANCIS
(fragment)
Tempera and gold on panel, 27½ × 19¼ in. (69.8 × 48.9 cm) Philadelphia Museum of Art, John G. Johnson Collection; 14

PROVENANCE

Acquired by John G. Johnson in 1912 on the advice of Bernard Berenson.

Baldini, 1970, cat. 48 (1435)
Pope-Hennessy, 1974, pp. 226, 231 (1430, autograph except for the face of Saint Francis; *Saint Francis* in the Johnson collection is original except for the background and right hand, which is modern)

SOURCE

Cinelli, in F. Bocchi, 1677, p. 393 [without the name of the artist]: "In the sacristy there is the old panel of the high altar with a devout painting of the Crucified Christ with Saint Nicholas and Saint Francis."

BIBLIOGRAPHY

G. Poggi, 1909, p. 132 (Angelico); F. Schottmüller, 1911, p. 225; idem, 1924, p. 251 (dubious); B. Berenson, 1913, pp. 10-11, cat. 64 (1445-50); R. van Marle, 1928, X, pp. 116-17 (c. 1448); L. Collobi-Ragghianti, 1950, p. 467 (1447-53); *John G. Johnson Collection: Catalogue of Italian Paintings*, 1953, p. 3; W. and E. Paatz, 1952, IV, p. 394, 397-98 (in sacristy); J. Pope-Hennessy, 1952, p. 178; *Mostra*, 1955, pp. 45-46, cat. 25 (workshop 1433-34, *Saint Francis* in Philadelphia a fragment); M. Salmi, 1958, p. 101 (workshop 1433-34); B. Berenson, 1963, p. 15; B. Sweeny,

1966, p. 3, cat. 14; U. Baldini, in *Firenze restaura: Guida alla mostra*, 1972, p. 32; M. Boskovits, "Adorazione," 1976, p. 31 (second half 1425-30); U. Baldini, 1977, p. 240; L. Sebregoridi Fiorentini, 1985, pp. 47-49 (dismantled in 1611 by Giovanni di Zanobi and Vincenzo Sassi); M. C. Impronta, in *San Marco*, 1990, p. 71 (c. 1430); C. B. Strehlke, 1992, pp. 9-17 (1425-33); M. Boskovits, 1994, p. 346.

The chapel of San Niccolò del Ceppo was built in 1561-63; Pope-Hennessy suggested that this *Crucifixion* was transferred there from the previous church of Santi Filippo e Jacopo del Ceppo, built in 1414 by the Compagnia di San Niccolò and served by the Franciscans. By 1677, the painting had been removed to the sacristy. The head and bust of Saint Francis were replaced by a copy at the end of the nineteenth century. See C. B. Strehlke, 1992, for the most complete discussion of this work. The figure of Christ has a Giottesque monumentality that suggests a date toward the end of the 1420s.

77
CRUCIFIXION WITH THE VIRGIN AND SAINT JOHN THE EVANGELIST
Tempera and gold on parchment, 13⅜ × 8¾ in. (34 × 22 cm) Convent of Santa Trinita, Florence

Surrounded by decorative border with roundels of the four Evangelists and Saint Dominic, at bottom are two lines in capital characters:
Propter nos / homines
et propter nos / tram salvtem

Pope-Hennessy, 1974, p. 226 (autograph related to the San Marco Missal [no. 558])

BIBLIOGRAPHY

Mostra, 1961, p. 26, no. 190; L. Berti, 1962, pp. 207-15 (c. 1430); idem,

76

77

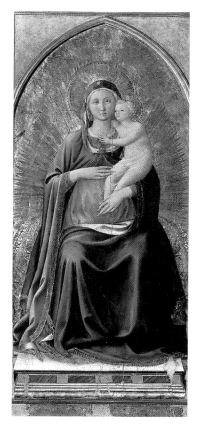

76A

1963, p. 34; S. Orlandi, 1964, p. 226; M. Boskovits, "Adorazione," 1976, p. 31; U. Baldini and S. Boni, 1982, pp. 127-29; A. Giudotti, in Padoa-Rizzo, 1987, pp. 385-86 n. 216; *Arte in Lombardia*, 1988, pp. 214-15.

Although it is generally accepted by scholars, it is difficult to place this miniature in the chronology of Fra Angelico's works.

78
MADONNA AND CHILD
Tempera and gold on panel,
52¾ × 23¼ in. (134 × 59 cm)
Galleria degli Uffizi, Florence
(depositi 143)

On base of frame, incomplete inscription: [ton]io di lvca e pier [o di ni] cholaio, e ser pier[o]

PROVENANCE
Prepositura di San Michele Archangelo, Pontasieve; Gallerie florentine (1924); Galleria degli Uffizi, Florence (1949).

Baldini, 1970, p. 96, cat. 44 (1435)
Pope-Hennessy, 1974, p. 226 (comparable to Bosco ai Frati Altarpiece)

BIBLIOGRAPHY
Exhibition of Italian Art, Royal Academy, London, 1930, no. 82; L. Collobi-Ragghianti, 1950, p. 467 (Zanobi Strozzi, 1447-53, relates to *Saint Francis* in Philadelphia); J. Pope-Hennessy, 1952, p. 178

(1440-45); *Mostra*, 1955, pp. 34-35, cat. 19; M. Salmi, 1958, p. 87 (c. 1439); B. Berenson, 1963, p. 11 (studio); L. Berti, 1980, p. 157, cat. P179; L. Castelfranchi-Vegas, 1989, p. 84 (c. 1435).

Pope-Hennessy rightly identified this panel as a late work, c. 1450.

79
SANT'EGIDIO ALTARPIECE

Executed for the nuns' choir in Sant'Egidio, the church of the hospital of Santa Maria Nuova, Florence. The painting seems to have been dismantled and removed shortly after it was seen by Vasari on the rood screen (*tramezzo*) of the church. By 1704, the main panel, the *Coronation of the Virgin*, had entered the Uffizi. Two panels presented to Cosimo II in 1629 are believed to have belonged to the predella of the altarpiece.

79A
CORONATION OF THE VIRGIN
Tempera and gold on panel,
44⅛ × 44⅞ in. (112 × 114 cm)
Galleria degli Uffizi, Florence (P174)
1612 (C.P.p. 180, n. 1290)

Nun's choir, Church of Santa Maria Nuova (Sant'Egidio), Florence; Galleria degli Uffizi, Florence (1704); Museo di San Marco, Florence (1825); Galleria degli Uffizi (1948).

Baldini, 1970, pp. 94-95, cat. 34 (1434-35)
Pope-Hennessy, 1974, p. 195 (1431-35)

79B
THE MARRIAGE OF THE VIRGIN
Tempera and gold on panel,
7½ × 19¾ in. (19 × 50 cm)
Museo di San Marco, Florence (P176)

78

79C
THE FUNERAL OF
THE VIRGIN

Tempera and gold on panel,
7½ × 20⅛ in. (19 × 51 cm)
Museo di San Marco, Florence (P177)

PROVENANCE

Presented by Marchese Botto to
Cosimo II de' Medici (1629?);
Galleria degli Uffizi, Florence
(1825); Museo di San Marco,
Florence (1924).

Baldini, 1970, p. 95, cats. 34, 37, 38
 (1434-35)
Pope-Hennessy, 1974, p. 195 (1431-35)

SOURCES

Antonio Manetti, c. 1490 (S. Or-
 landi, 1964, pp. 195-96): "he
 painted a panel in santo gilio
 [Sant'Egidio] in the convent of
 Santa Maria Nuova representing
 the coronation of Our Lady."
Chronica quadripartita del convento di
 S. Domenico di Fiesole, 1516 (S. Or-
 landi, 1954, p. 164): "One [work]
 in Sant'Egidio in the hospital of
 Santa Maria Nuova."
Libro di Antonio Billi, 1506-30:
 Codice Petrei, Magl. XIII, n. 89
 (1991 ed., p. 77): "a panel in San
 Celio [Sant'Egidio] in which
 Paradise is painted."
 Codice Strozziano, Magl. XXV,
 n. 636 (1991 ed., p. 128): "a panel in
 San Gallo [sic: Sant'Egidio] in
 which Paradise is painted."
L'Anonimo Magliabechiano, Magl.
 cl XVII, 17, 1536-46 (1968 ed.,
 p. 102): "and in San Gilio by his
 hand a panel in which Paradise
 is painted."
Vasari, 1568, II, p. 516: "One sees
 also in the tramezzo [rood
 screen] of Santa Maria Nuova a
 panel by his hand."

BIBLIOGRAPHY

P. V. Marchese, 1845, 3d ed. 1869, II,
pp. 343; J. Crowe and G. B. Caval-
caselle, 1864, 1911 ed., IV, p. 91 (three
predelle: *Marriage of the Virgin,*
Death of the Virgin, Birth [Naming]

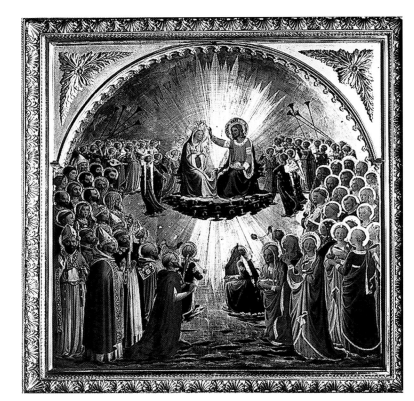

79A

of the Baptist); B. Berenson, 1896,
p. 98; R. L. Douglas, 1900, pp.
56-58 (early 1430s); A. Wurm, 1907
(school, rejects predella); R. van
Marle, 1928, X, pp. 48-52 (main fig-
ures by Zanobi Strozzi; F. Schott-
müller, 1911, pp. 20, 21, 30-33; *idem,*
1924, pp. 26-29 (1430-40, places
later in 2d edition, accepts pre-
della); P. Muratoff, 1930, pp. 32-33,
81 (c. 1425); W. and E. Paatz, 1940,
IV, p. 49 n; G. Bazin, 1949, p. 181
(workshop repetition of Louvre
Coronation of the Virgin); J. Pope-
Hennessy, 1952, p. 173 (Zanobi
Strozzi; c. 1440); M. Salmi, 1955,
p. 100 (1430-40, accepts predella);
Mostra, 1955, pp. 20-21, cat. 10, and
pp. 22-23, nos. 11-12 (accepts pre-
della); L. Collobi-Ragghianti, 1955
(1440); B. Berenson, 1963, pp. 11-12;
M. Meiss, 1963, p. 11; S. Orlandi,
1964, pp. 30-31 (rejects predella);
L. Berti, 1980, pp. 156-57, cat. P174,
P176-77; M. C. Impronta, in *San
Marco,* 1990, p. 73 (includes pre-
della, 1434-35).

Early 1430s. This dismantled altar-
piece appears to have been painted
in the interval between the *Naming
of the Baptist,* cat. 113b, and the *Depo-
sition* in the Strozzi Chapel, Santa
Trinita (cat. 74).

80A
THE NATIVITY
80B
AGONY IN THE
GARDEN

Tempera and gold on panel,
10¼ × 6⅜ in. (26 × 16 cm)
Pinacoteca, Forlì, Italy

Baldini, 1970, cats. 102, 103 (1440)
Pope-Hennessy, 1974, p. 226
 (c. 1433-34)

BIBLIOGRAPHY

R. Santarelli, 1897, p. 154; F. Schott-
müller, 1911, p. 224; *idem,* 1924,
p. 241 (workshop); R. van Marle,
1928, X, p. 159 (school); R. Longhi,
1940, p. 176 (early, pre-1430);
J. Pope-Hennessy, 1952, p. 200
(workshop); *Mostra,* 1955, cats. 34,
35 (1440); L. Collobi-Ragghianti,
1955, p. 47 (1446-48); M. Salmi,
1958, pp. 35, 110-11 (fully mature
work); S. Orlandi, 1964, p. 204;
G. Viroli, 1988, pp. 32-34.

Circa 1428. Giordano Viroli com-
ments that these figures are "the
most Masaccio-esque that can be
found outside of Masaccio."

79B

79C

81

THE VIRGIN AND CHILD ENTHRONED WITH TWELVE ANGELS

Tempera and gold on panel,
14⅝ × 11⅛ in. (37 × 28 cm)
Staedelsches Kunstinstitut, Frankfurt
(no. 838)

PROVENANCE
Acquired from F. Benucci in 1831.

Baldini, 1970, cat. 10 (1428-30)
Pope-Hennessy, 1974, pp. 191-92
(early)

BIBLIOGRAPHY
F. Schottmüller, 1911, p. 3; *idem*, 1924,
p. 11 (1420-25); R. van Marle, 1928,
x, pp. 46-48; J. Pope-Hennessy,
1952, p. 165 (1428); P. Muratoff,
1930, pp. 41-42 (not Angelico);
E. Schneider, 1933, p. 165 (not
Angelico); R. Longhi, 1940, p. 38
(Angelico); M. Salmi, 1958, p. 99;
B. Berenson, 1963, p. 14 (accepts in
part); S. Orlandi, 1964, pp. 36-37;
M. Boskovits, "Adorazione" 1976,
p. 31 (1425); C. Lloyd, 1992, pp. 16-17,
40-41; M. Boskovits, 1994, p. 344.

An important work for a private
patron, 1420-25.

82

CHRIST BLESSING

Tempera and gold on panel,
11⅛ × 8¾ in. (28 × 22 cm
[vertical split through center])
Her Majesty the Queen, Hampton
Court (1208)

PROVENANCE
William Blundell Spence, Florence;
sent by him to England, 1851;
acquired by Prince Albert and
Queen Victoria before March 1854.

Baldini, 1970, cat. 21 (1430-33)
Pope-Hennessy, 1974, p. 228
(c. 1430-31)

BIBLIOGRAPHY
L. Cust, 1909, p. 53; B. Berenson,
1932, p. 22; B. Nicolson, 1949, p. 137;
M. Salmi, 1958, p. 109; J. Pope-
Hennessy, 1952, p. 201 (Zanobi

80A

Strozzi); L. Collobi-Ragghianti,
1955, p. 43 (Zanobi Strozzi);
L. Berti, 1962, p. 304; B. Berenson,
1963, p. 14; S. Orlandi, 1964, p. 203;
J. Shearman, 1964, no. 4, pp. 7-8
(Gentile da Fabriano); O. Millar,
1965, no. 5; M. Boskovits, "Appunti,"
1976, p. 35; U. Baldini, 1977, p. 236
(from San Domenico Altarpiece,
1428-30); J. Fleming, 1979, pp. 499-
500; J. Shearman, 1983, pp. 13-15,
cat. 9 (workshop).

Circa 1420. Baldini, 1977, suggests
that this small panel was originally
part of the San Domenico Altar-
piece (cat. 15), modified by Lorenzo
di Credi in 1501.

83

CHRIST CROWNED WITH THORNS

Tempera and gold on panel,
21¾ × 15⅜ in. (55 × 39 cm)
Museo Civico Giovanni Fattori,
Livorno, Italy (on deposit from
Santa Maria del Soccorso)

PROVENANCE
Donated by Silvestro Silvestri in
1837 to the Cappella Addolorata
of Church of Santa Maria del
Soccorso, Livorno.

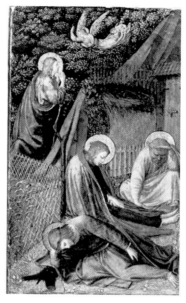

80B

Baldini, 1970, p. 96, cat. 45 (1435)
Pope-Hennessy, 1974, p. 227 (c. 1436)

BIBLIOGRAPHY
R. Longhi, 1928, pp. 153-59
(1430-35); M. Meiss, 1951, 1982 ed.,
pp. 42-46; J. Pope-Hennessy, 1952,
p. 200 (not by Angelico); *Mostra*,
1955, p. 32, no. 17; M. Salmi, 1958,
pp. 20-21, 103-4; G. Brunetti, 1977,
p. 230 (an unattributed painting
of this subject cited in a 1439
inventory of Santissima Annun-
ziata, Florence); M. Boskovits, 1983,
p. 20 (after 1440); L. Bellosi, 1990,
pp. 104-7, no. 15.

Circa 1450, as per L. Bellosi, 1990.

Inscription on the rim of robe:
 Rex regvm et D[omi]nanti[vm]
inscription in halo:
 Ih[esv]s Xp[istv]s san[ctv]s

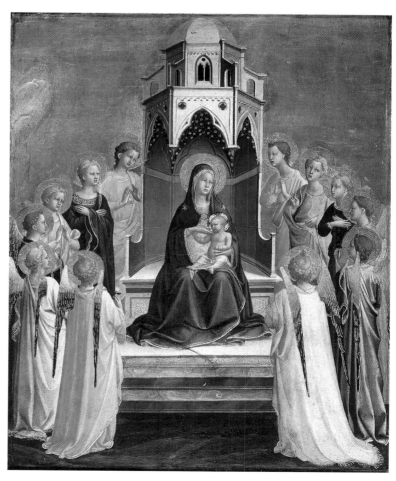

81

84
WINGS OF A TRIPTYCH:
THE BLESSED AND THE DAMNED
Tempera and gold on panels, each
18⅛ × 5⅜ in. (46 × 13.5 cm)
Private collection, London

PROVENANCE

Giovanni Metzger, before 1844;
Sir John Ramsden Bart, West
Riding, Yorkshire (before 1852);
by descent through his family;
Walpole Gallery, London.

BIBLIOGRAPHY

P. V. Marchese, 1845, 3d ed. 1869,
I, p. 447; E. Cartier, 1857, p. 445,
no. CXIX; Walpole Gallery, 1995,
pp. 12-15 (entry by Filippo Todini,
dates c. 1430).

These two wings evidently formed
part of a small folding triptych that
had already been dismantled by
1854 when they were first described
by Padre Marchese. The central
panel presumably represented the
Last Judgment. A dating to the early
1430s is most probable, as Todini
has pointed out by comparison
with the *Strozzi Deposition* formerly
in Santa Trinita.

85
SEVEN ROUNDELS ON GOLD GROUND,
from left:
A DOMINICAN NUN,
SAINT DOROTHY,
SAINT MARY
MAGDALENE, DEAD
CHRIST, SAINT JOHN
THE EVANGELIST,
SAINT CATHERINE OF
ALEXANDRIA AND
SAINT AGNES
Tempera and gold on panel,
8 × 61⅛ in. (20.3 × 155 cm)
Courtauld Institute, London
(Gambler Perry)

83

PROVENANCE

Christie's London, before 1900 (as
Starnina) with a provenance from
the Chiesa della Carmine, Cappella
di San Gerolamo, Florence.

Baldini, 1970, cat. 2 (predella to
 Saint Peter Martyr Altarpiece;
 1425-28)
Pope-Hennessy, 1974, pp. 9, 190.

BIBLIOGRAPHY

R. Longhi, 1940, p. 38 (early work,
comparable to Frankfurt *anconetta*);
B. Berenson, 1963, p. 14 (follower of
Angelico); D. Cole Ahl, 1980, p. 379;
idem, 1981, p. 134 (predella to Saint
Peter Martyr Altarpiece).

Early work, perhaps the predella to
the Saint Peter Martyr Altarpiece.
The Dominican nun is probably
Saint Catherine of Siena.

82

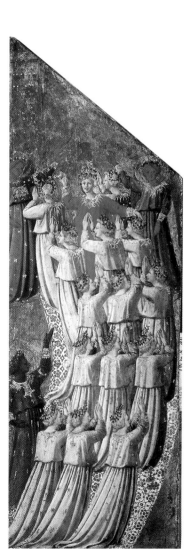

84

85A

85B

85C

86
A MARTYR BISHOP
OR ABBOT
Tempera and gold on panel,
6⅜ × 6⅛ in. (16 × 15.5 cm)
National Gallery, London (no. 2908)

PROVENANCE

Lady Lindsay (prior to 1893); by
bequest to National Gallery,
London, 1912.

Inscription (partial): mevs

Baldini, 1970, p. 98, cat. 54 (1436-37)
Pope-Hennessy, 1974, p. 227 (other
works attributed)

BIBLIOGRAPHY

R. van Marle, 1928, x, pp. 118, 577;
F. Schottmüller, 1924, p. 203;
J. Pope-Hennessy, 1952, p. 201
(workshop); M. Salmi, 1958, p. 87

(Zanobi Strozzi); M. Davies, 1961,
p. 31 (school); B. Berenson, 1963,
p. 14 (partly workshop); U. Baldini,
1977, p. 236 (for San Domenico);
C. B. Strehlke, 1994, p. 341.

Possibly from San Domenico,
Fiesole, as noted by Strehlke, who
associates this panel with cats. 2
and 89.

87
MADONNA AND CHILD
WITH TWO ANGELS
Tempera and gold on panel,
32¾ × 23¼ in. (83 × 59 cm)
Alba collection, Madrid

PROVENANCE

Acquired in 1857 in Florence by
D. Carlos Miguel, Duque de Alba.

Baldini, 1970, cat. 16 (1430-1435)
Pope-Hennessy, 1974, p. 190 (c. 1428)

BIBLIOGRAPHY

F. Schottmüller, 1924, p. 21 (1430-40);
Mostra, 1955, p. 83, cat. 53 (1430-35);
M. Salmi, 1958, p. 102 (c. 1430);
B. Berenson, 1963, p. 14 (restored);
M. Boskovits, "Adorazione," 1976,
p. 30 (early 1420s); M. Boskovits,
1994, pp. 346-47.

Circa 1430.

88
PRADO
ALTARPIECE
Tempera and gold on panel,
76⅜ × 76⅜ in. (194 × 194 cm)
The Prado, Madrid

PROVENANCE

Formerly San Domenico, Fiesole;
sold to Duke Mario Farnese on
February 28, 1611, for 1,500 ducati;
donated by the Duque de Lerma
to the Dominican church in Valla-
dolid, Spain; Monastero de las
Descalzas Reales, Madrid; trans-
ferred to Prado in 1861.

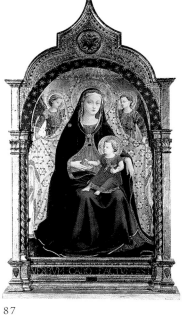

87

Central Panel

The Annunciation
60⅝ × 76⅜ in. (154 × 194 cm)

Predella

Five scenes on a single panel, each
scene 9⅛ × 13⅞ in. (23 × 35 cm),
from left to right:
Birth and Marriage of the Virgin
Visitation
Adoration of the Magi
Presentation of Jesus at the Temple
Funeral of the Virgin

Baldini, 1970, cat. 22 (1430-32)
Pope-Hennessy, 1974, p. 194 (work-
shop execution of Angelico design)

SOURCES

October 1435, consecration of the
Church. *Chronica quadripartita del
convento di San Domenico di Fiesole*,
1516, fol. 3v (S. Orlandi, 1954, II,
p. 112): "And the consecration of
the church took place on the last
Sunday in October in the afore-
said year. . . . The pictures on
the high altar as well as on the

86

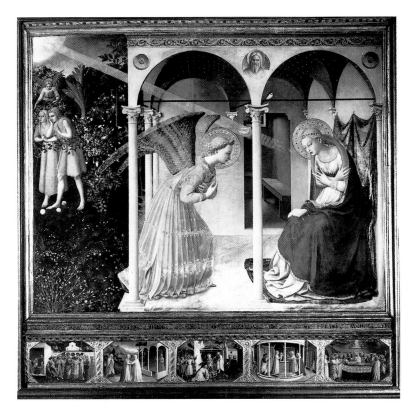

88

minor altars were all painted
by the hand of fra Giovanni
Pietro of the Mugello of this
convent and were in place several
years before the church was
consecrated. The positions of
the aforesaid altars were subse-
quently changed."
F. Albertini, 1510, 1863 ed., p. 13:
"There are many things by Fra
Giovanni."
Libro di Antonio Billi, 1506-30:
Codice Petrei, Magl. XIII, n. 89
(1991 ed., p. 78): "and at San
Domenico in Fiesole, where he
lived, he painted many panels."
Codice Strozziano, Magl. XXV,
n. 636 (1991 ed., p. 128): "he painted
at San Domenico in Fiesole,
where he lived, many panels."
*Chronica quadripartita del convento di
S. Domenico di Fiesole*, 1516 (S. Or-
landi, 1954, p. 164): "He painted
many altarpieces in different
churches, chapels and confrater-
nities; three of them are in this
convent in Fiesole."

L'Anonimo Magliabechiano, Magl.
cl XVII, 17, 1536-46 (1968 ed.,
p. 103): "In the church of San
Domenico in Fiesole there are
several panels by his hand, which
are very well known to those
who understand this field and
especially to those who know
his manner."
Vasari, 1568, II, p. 510: "In a chapel
in the same church there is a
panel by his hand, the annuncia-
tion to Our Lady by the Angel
Gabriel, the profile of whose face
is so devout, delicate, and fine
that it truly seems made not by
man but in paradise; and in the
field are Adam and Eve who were
the reason that the Redeemer
was incarnated by the Virgin. In
the predella there are also some
beautiful little scenes."

BIBLIOGRAPHY
P. V. Marchese, 1845, 3d ed. 1869, II,
p. 333 (document VI: sold to Mario
Farnese on February 28, 1611, for
1500 *ducati* and replaced by a copy,
which is also lost); J. Crowe and
G. B. Cavalcaselle, 1864, 1911 ed., IV,
p. 76; B. Berenson, 1896, p. 100;
R. L. Douglas, 1900, pp. 61-62, 197;
F. Schottmüller, 1911, cat. 66-71;
idem, 1924, cats. 68-73 (1430-45);
R. van Marle, 1928, X, pp. 178-81
(Zanobi Strozzi); P. Muratoff,
1930, p. 83 (school, c. 1430); S. de
Vries, 1933, p. 382; A. Sanchez-
Canton, 1949, pp. 12-13; L. Collobi-
Ragghianti, "Zanobi Strozzi," 1950,
p. 458; M. Salmi, 1950, p. 81 (after
1436); J. Pope-Hennessy, 1952,
p. 160 (later than Montecarlo);
B. Berenson, 1958, p. 138 (earlier
than Montecarlo); M. Salmi, 1958,
p. 110; B. Berenson, 1963, p. 14;
L. Berti, 1963, pp. 18-20 (1430-32);
M. Boskovits, "Adorazione," 1976,
passim, p. 17 (c. 1425, shortly after
the *Adoration*, cat. 9B), p. 28 (mid-
1420s because decorations on the
house of the Virgin are only in his
early works, eg., Fiesole and Frank-
furt; golden drapery on Virgin not
found after 1430); D. Cole Ahl,
1980, pp. 376-79; M. C. Impronta,
in *San Marco*, 1990, p. 69 (late
1420s); W. Hood, 1993, p. 265;
M. Boskovits, 1994, pp. 342-46.

Circa 1430-34.

89
A BISHOP SAINT
*Tempera and gold on panel,
6¼ × 6⅛ in. (15.9 × 15.6 cm)
Metropolitan Museum of Art,
New York; Bequest of Lucy G. Moses,
1990 (1991.27.2)*

PROVENANCE
Samuel Rogers, London (before
1856); Canon Sutton, London;
Langton Douglas, London (by
1928); Mr. and Mrs. Henry Moses,
New York (by 1932).

Baldini, 1970, p. 98, cat. 54 (1436-37)
Pope-Hennessy, 1974, p. 230

BIBLIOGRAPHY
M. Davies, 1961, pp. 31-32; B. Beren-
son, 1963, p. 14 (studio); P. J. Cardile,
1976, pp. 107, 248-49; U. Baldini,
1977, pp. 236, 244 n. 14; E. Boissard
and V. Lavergne-Durey, 1988, pp.
44-45; K. Christiansen, 1990, p. 39;
C. B. Strehlke, 1994, pp. 339-42.

Possibly from San Domenico,
Fiesole, as noted by Strehlke, 1994,
who associates this panel with cats.
2 and 86.

90
FRESCOES IN
THE CHAPEL OF
SAN BRIZIO
Chapel of San Brizio, Duomo, Orvieto

In 1447 Fra Angelico and Benozzo
Gozzoli, his assistant, completed
frescoes in two sections of the vault
of the Chapel of San Brizio, in the
right transept of the Duomo.

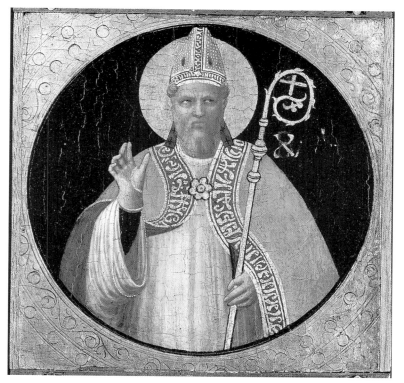

89

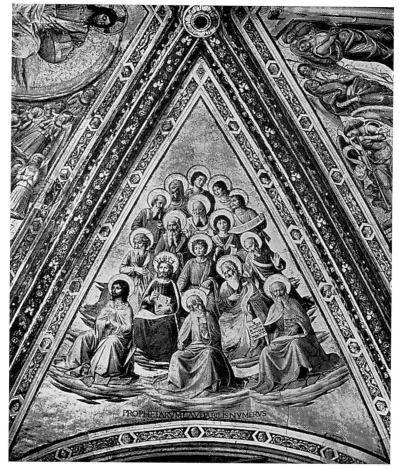

90A

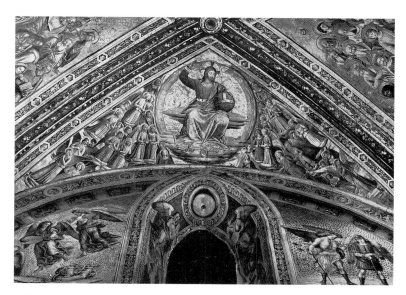

90B

90A
SIXTEEN PROPHETS
90B
CHRIST SEATED IN JUDGMENT WITH ANGELS

(Written below: prophetarvm lavdabilis nvmervs)

Baldini, 1970, p. 108, cat. 107 (1447)
Pope-Hennessy, 1974, pp. 214-15.

SOURCES
R. L. Douglas, 1900, pp. 184-87: reprints documents of the Duomo first published by L. Fumi, *Il Duomo di Orvieto*, 1891, pp. 393-95.

BIBLIOGRAPHY
P. V. Marchese, 1845, 3d ed. 1869, p. 44; J. Crowe and G. B. Cavalca-selle, 1864, 1911 ed., IV, p. 98; R. L. Douglas, 1900, pp. 140, 197; F. Pachi-oni, 1910, p. 426; F. Schottmüller, 1911, pp. 152-56; *idem*, 1924, pp. 165-69 (1447); R. van Marle, 1928, x, pp. 106-7; P. Muratoff, 1930, pp. 65, 91 (1447); M. Salmi, 1950, pp. 155-56; J. Pope-Hennessy, 1952, pp. 189-90;

Mostra, 1955, p. 100 (1447); B. Beren-son, 1963, p. 14 (assisted by Gozzoli, dates 1447), A. Padoa Rizzo, 1972, pp. 103-5; W. Hood, 1993, p. 239.

See pages 174-75.

91
ANGEL
Tempera and gold on panel,
$14\frac{5}{8} \times 9\frac{1}{8}$ *in. (37 × 23 cm)*
Musée du Louvre, Paris (no. 1294 B)

PROVENANCE
Acquired from the Gay collection by the Amis du Louvre in 1909.

Baldini, 1970, p. 95, cat. 40 (1435)
Pope-Hennessy, 1974, pp. 230-31 (workshop)

BIBLIOGRAPHY
F. Schottmüller, 1911, p. 208; Sey-mour de Ricci, 1913, p. 58 (part of tabernacle of San Domenico at Fiesole); F. Schottmüller, 1924, p. 35 (1430); R. van Marle, 1928, x, p. 58 (early); P. Muratoff, 1930, p. 84 (c. 1435, with assistant); B. Beren-son, 1932, p. 22; J. Pope-Hennessy, 1952, p. 203 (school); M. Salmi,

91

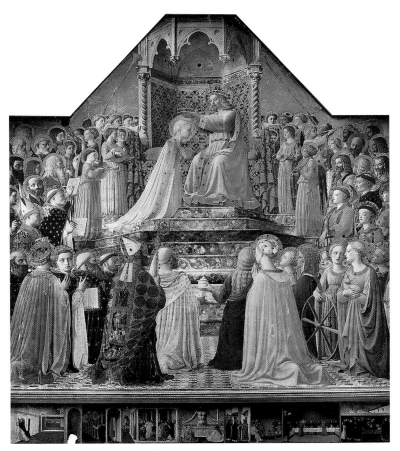

92

1958, p. 115; B. Berenson, 1963, p. 15; A. Brejon de Lavergnée and D. Thiébaut, 1981, p. 144 (school); F. Scalia, 1990, pp. 34ff.

According to Scalia, this angel and its companion (appeared at auction at Palais Gallièra, Paris, June 14, 1974) originally formed part of the ciborium of the San Domenico Altarpiece, Fiesole (cat. 15).

92

CORONATION OF THE VIRGIN ALTARPIECE FROM THE ALTAR OF SAN DOMENICO, FIESOLE

Tempera and gold on panel,
83⅞ × 83⅛ in. (213 × 211 cm)
Musée du Louvre, Paris
(inv. 314, no. 1290)

PROVENANCE

Formerly Church of San Domenico, Fiesole; transported to Paris by Napoleon in 1812.

Inscriptions, see: V. Alce, 1984, pp. 380-82; D. A. Covi, 1986, nos. 61a, 97, 410a.

Predella: one panel, 11⅝ x 82¾ in. (29.5 × 210 cm), depicting from left to right:

The Dream of Pope Innocent III, Saints Peter and Paul Appearing to Saint Dominic, The Healing of Napoleon Orsini, Pietà, The Dispute of Saint Dominic and the Miracle of the Book, Saint Dominic and His Companions Fed by Angels, Death of Saint Dominic

Baldini, 1970, p. 93-94, cat. 33 (1434-35)
Pope-Hennessy, 1974, pp. 215-16 (after 1450)

SOURCES

October 1435, consecration of the Church. *Chronica quadripartita del convento di San Domenico di Fiesole,* 1516, fol. 3v (S. Orlandi, 1954, II, p. 112): "And the consecration of the church took place on the last Sunday in October in the aforesaid year. . . . The pictures on the high altar as well as on the minor altars were all painted by the hand of Fra Giovanni Pietro of the Mugello of this convent and were in place several years before the church was consecrated. The positions of the aforesaid altars were subsequently changed."

F. Albertini, 1510, 1863 ed., p. 13: "San Domenico, Fiesole: There are many things by Fra Giovanni."

Libro di Antonio Billi, 1506-30:
Codice Petrei, Magl. XIII, n. 89 (1991 ed., p. 78): "and at San Domenico in Fiesole, where he lived, he painted many panels."

Codice Strozziano, Magl. XXV, n. 636 (1991 ed., p. 128): "he painted at San Domenico in Fiesole, where he lived, many panels."

Chronica quadripartita del convento di San Domenico di Fiesole, 1516 (S. Orlandi, 1954, p. 164): "He painted many altarpieces in different churches, chapels and confraternities; three of them are in this convent in Fiesole."

L'Anonimo Magliabechiano, Magl. cl xvii, 17, 1536-46 (1968 ed., p. 103): "In the church of San Domenico in Fiesole there are several panels by his hand, which are very well known to those who understand this field and especially to those who know his manner."

Vasari, 1568, II, pp. 510-11: "But of all the things that Fra Giovanni made, he surpassed himself and demonstrated his superlative skill and knowledge of art in a panel that is in the same church next to the door entering on the left-hand side; in this work Jesus Christ crowns Our Lady in the midst of a choir of angels and among an infinite multitude of saints, so many in number, so well made, and with such varied poses and expressions that one experiences an incredible pleasure in looking at them. Indeed it seems that those beatific spirits could not appear any different in heaven, or, to be precise, could not if they had bodies. Not only are all the saints alive with delicate and sweet expressions, but the overall coloring of the work seems worthy of the hand of a saint or of an angel, as indeed they are: for good reason this religious has always been called Fra Giovanni Angelico. In the predella, there are stories of Our Lady and of Saint Dominic, which are divine examples of this kind of painting; and I can personally confirm that I never see this work without it seeming new to me, nor do I ever leave it willingly."

BIBLIOGRAPHY

P. V. Marchese, 1845, 3d ed. 1869, II, p. 334 (removed by the French in 1812); J. Crowe and G. B. Cavalcaselle, 1864, 1911 ed., II, p. 89; R. L. Douglas, 1900, pp. 55, 197 (dates pre-1430); A. Wurm, 1907, p. 10 (entirely studio); F. Schottmüller, 1911, cats. 48-53; *idem,* 1924, cats. 48-54 (1430-1440); R. Papini, 1925,

p. 39 (some studio intervention); P. Muratoff, 1930, pp. 41–42, 83 (c. 1430, with assistant); C. Glaser, 1939, pp. 149ff; G. Bazin, 1949, p. 26 (post-1430); M. Salmi, 1950, p. 109 (pre-1430, elaborated slowly after 1435), pp. 148–49 (kneeling bishop in main panel ascribed to Battista di Biagio Sanguigni); J. Pope-Hennessy, 1951, pp. 216–23; idem, 1952, p. 173 (begun Angelico but completed by younger artist responsible for predella, Domenico Veneziano, 1438–39); J. White, 1957, pp. 170–71, 187n; M. Salmi, 1958, pp. 33, 86 (pre-1438); B. Berenson, 1963, p. 14; M. Meiss, 1963, p. 140; S. Orlandi, 1964, p. 25 (transcribes document that refers to dedication in October 1435 of high altar and nearby altars of Virgin Annunciate and Coronation of the Virgin "in which there is the painting of the Coronation of the Virgin with many Angels and Saints. The altarpieces of these altars were all painted by the hand of Fra Giovanni de' Piero of the Mugello, a son of this convent, several years before the church was consecrated"); L. Berti, 1964, pp. 18, 35; M. Boskovits, "Appunti," 1976, p. 44; H. Wohl, 1980, pp. 167–68; D. Cole Ahl, 1981, pp. 135–39; A. Brejon de Lavergnée and D. Thiébaut, 1981, p. 143; P. Joannides, 1989, pp. 305–6; M. C. Impronta, in San Marco, 1990, pp. 72–73 (c. 1431); C. Lloyd, 1992, pp. 13, 108–13; V. Alce, 1993, pp. 83–89; W. Hood, 1993, pp. 309–13.

Circa 1434. See pages 116–23.

93
MADONNA AND CHILD WITH SAINTS JOHN THE BAPTIST, DOMINIC, FRANCIS, AND PAUL
Tempera and gold on panel,
50⅜ × 26⅞ in. (128.8 × 68.2 cm)
Galleria Nazionale, Parma (no. 429)

PROVENANCE
Rosini collection, Pisa (as Gozzoli); Marchese Alfonso Tacoli Canacci, Florence, 1786; Giuseppe Campanini, Parma; acquired from the Campanini heirs in 1842 by the Accademia di Belle Arti, Parma; ceded in 1882 to the Regia Galleria, antecedent of the Galleria Nazionale.

Baldini, 1970, p. 90, cat. 18 (1430–33, with workshop)
Pope-Hennessy, 1974, p. 231 (foreground figures by another assistant, not Zanobi Strozzi)

BIBLIOGRAPHY
J. Crowe and G. B. Cavalcaselle, 1864, 1911 ed., IV, p. 93n (follower); B. Berenson, 1896, p. 100; R. L. Douglas, 1900, p. 197; F. Schottmüller, 1911, p. 19 (1425–35); idem, 1924, p. 2 (1420–30); R. van Marle, 1928, X, p. 58; P. Muratoff, 1930, p. 81 (with assistant); L. Collobi-Ragghianti, 1950, p. 468 (Toscani); J. Pope-Hennessy, 1952, p. 203 (foreground figures by Zanobi Strozzi, based on cartoon by Angelico); Mostra, 1955, p. 26, cat. 14; M. Salmi, 1958, p. 102 (designed by Angelico c. 1428–30, finished later by heavier brush, Gozzoli?); L. Berti, 1962, p. 149; B. Berenson, 1963, p. 15; M. Boskovits, "Adorazione," 1976, p. 31 (1425–30); L. Fornari Schianchi, 1983, p. 45 (Angelico with Zanobi Strozzi); D. A. Covi, 1986, no. 47A; M. Boskovits, 1994, p. 346.

Circa 1430–35, with minimal workshop assistance.

94
THE PERUGIA ALTARPIECE
Tempera and gold on panel
Galleria Nazionale dell'Umbria, Perugia

PROVENANCE
Formerly in the chapel of San Niccolò, Church of San Domenico, Perugia; transferred to the sacristy by 1706; removed to Paris during the Napoleonic invasion; on its return to Italy, two predella panels were acquired by the Vatican, when the polyptych was dismantled, and its original frame lost; chapel of Sant'Orsola, San Domenico; following the suppression of the convent in 1861, the paintings were taken to the Accademia delle Belle Arti, Perugia.

Baldini, 1970, cat. 57
Pope-Hennessy, 1974, p. 198

Principal register, central panel

94A
MADONNA AND CHILD WITH ANGELS
Tempera and gold on panel,
50⅜ × 34⅝ in. (128 × 88 cm)

Left wing: *Saints Dominic and Nicholas of Bari,* tempera and gold on panel, 40⅛ × 29½ in. (102 × 75 cm)
Right wing: *Saints John the Baptist and Catherine of Alexandria,* tempera and gold on panel, 40¼ × 30 in. (102 × 76 cm)

93

Upper register, two round cuspids on top of the lateral wings

Left
94B
ANGEL ANNUNCIATE
Tempera and gold on panel,
11½ in. (29 cm) diameter

Right
94C
VIRGIN ANNUNCIATE
Tempera and gold on panel,
11½ in. (29 cm) diameter

Left and right pilasters with twelve small panels of standing saints arranged in pairs, each approx. 11⅞ × 1⅝ in. (30 × 4 cm)
Left column, in pairs (descending order): *Saints Peter and Paul, Saints Louis and Mary of Egypt, Saints Benedict and Peter Martyr*
Right column, in pairs (descending order): *Saints John the Evangelist and Stephen, Saints Catherine of Siena and Jerome, Saints Thomas Aquinas and Lawrence*

Predella, three panels

94D
BIRTH OF SAINT NICHOLAS, HIS VOCATION, HIS CHARITY TO THREE POOR GIRLS
Tempera on panel,
13⅜ × 23⅝ in. (34 × 60 cm)
Pinacoteca Vaticana, Vatican City, Rome

94A

vits, "Appunti," 1976, p. 50 (S. Nic-
colò identified as portrait of
Eugenius IV, pope in 1437); D. Cole
Ahl, 1981, p. 152; M. Boskovits, 1983,
p. 24; L. Castelfranchi, 1985, p. 104;
A. De Marchi, 1985, pp. 53-57
(S. Niccolò identified as portrait of
Nicholas V, elected pope March 6,
1447); D. A. Covi, 1986, no. 389,
p. 107; A. De Marchi in L. Bellosi,
1990, pp. 94-97; M. C. Impronta, in
San Marco, 1990, p. 106 (1436-40);
C. Lloyd, 1992, pp. 12-16, 70-71,
74-77; W. Hood, 1993, pp. 90-95.

Datable to 1447-49. See pages
164-69.

94E
SAINT NICHOLAS ADDRESSING AN IMPERIAL MESSENGER AND SAVING A SHIP AT SEA
Tempera on panel,
13⅜ × 23⅝ in. (34 × 60 cm)
Pinacoteca Vaticana, Vatican City,
Rome

94B

94F
SAINT NICHOLAS FREEING THREE MEN CONDEMNED TO EXECUTION, THE DEATH OF SAINT NICHOLAS
Tempera on panel,
13⅜ × 23⅝ in. (34 × 60 cm)
Galleria Nazionale dell'Umbria,
Perugia

94C

SOURCES
Padre Timoteo Bottonio, *Annali*,
1578 (MS, Bibl. Com., Perugia,
n. 1150, vol B c. 42r, transcribed
by A. De Marchi, 1985, p. 56):
1437: "In this year, the panel of
the altar of Saint Nicholas in the
Guidalotti chapel was assigned to
be painted by Fra Giovanni of
Fiesole, holy and renowned

painter and priest of our Order.
By him is also the other panel
located in the old church above
the high altar."

BIBLIOGRAPHY
P. V. Marchese, 1845, 3d ed. 1869, II,
pp. 312-14 (cites 1437 date in *Annali*
of P. Bottonio, erroneous previous
attribution to Gentile da Fabriano,
identifies the cuspids of the dis-
mantled altarpiece); J. Crowe and
G. B. Cavalcaselle, 1864, 1911 ed.,
IV, pp. 76-77; B. Berenson, 1896,
p. 100; R. L. Douglas, 1900, pp.
68-72; W. Weisbach, 1901, pp. 41-43
(predella by Pesellino); F. Schott-
müller, 1911, pp. 78-86; W. Bombe,
1912, p. 77 (transcribes Annali with
1437 date); F. Schottmüller, 1924,
pp. 81-89 (1435-45; predella by
Pesellino); R. van Marle, 1928, X,
pp. 66-68 (predella by Pesellino);
P. Muratoff, 1930, pp. 41-43 and
66 (c. 1435, predella probably by
Pesellino); L. Venturi, 1933, p. 56;
G. Bazin, 1949, p. 182; J. Pope-
Hennessy, 1952, pp. 170-72;
C. Brandi, 1954, pp. 199-201;
U. Middeldorf, 1955, pp. 188-89
(post-1450); L. Collobi-Ragghianti,
1955 (only predella in Perugia by
Angelico); S. Orlandi, 1955, p. 61;
L. Berti in *Mostra*, 1955, pp. 52-57,
cats. 29-32 (soldiers at right in left
scene by Zanobi Strozzi); M. Salmi,
1958, pp. 30, 86; O. Gurrieri, 1960,
p. 28; B. Berenson, 1963, p. 15;
L. Berti, 1967, p. 9 (intervention in
predella by Maestro del Chiostro
degli Aranci, Giovanni di Consalvo);
U. Procacci, 1968, p. 150; Pope-
Hennessy, 1974, p. 198 (central pre-
della not by Angelico, possibly by
Giovanni di Consalvo); M. Bosko-

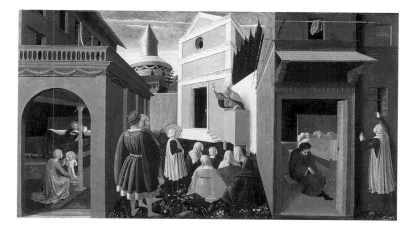

94D

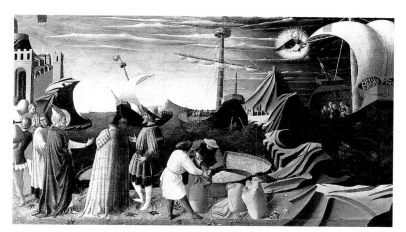

94E

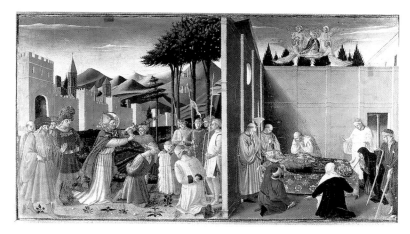

94F

95

CEDRI MADONNA (MADONNA OF HUMILITY)

Tempera and gold on panel,
40¼ × 22⅞ in. (102 × 58 cm)
Museo Nazionale, Pisa

PROVENANCE

Donated by the Alessandri family of Florence to the parish church of Cedri (Pisa) in 1791; transferred to the national museum in 1952.

BIBLIOGRAPHY

R. Longhi, 1952, p. 31 n. 3 (anonymous, c. 1433, influenced by Masolino and Angelico); G. Paccagnini, 1952, pp. 115-26 (Domenico Veneziano, c. 1430); C. Volpe, 1973, p. 19 (Angelico, c. 1425-26, influenced by Masaccio and Masolino); E. Carli, 1974, pp. 96-97 (Angelico?); M. Boskovits, "Appunti," 1976, pp. 34-35, 47 n. 7 (possibly associated with the

two wings, see our cat. 111, below); *idem*, "Adorazione," 1976, p. 25; D. Cole Ahl, 1980, pp. 365-67 (earliest painting by Angelico); M. Boskovits, 1994, p. 337; C. B. Strehlke, 1994, pp. 27-29 (c. 1418).

Circa 1420, influenced by Masolino.

95

96

CHRIST THE REDEEMER

Tempera on linen,
76 × 30¾ in. (193 × 78 cm)
(processional banner)
Museo Nazionale, Pisa

Baldini, 1970, p. 117, cat. 132
Pope-Hennessy, 1974, p. 231 (perhaps autograph later work)

BIBLIOGRAPHY

B. Berenson, 1896, p. 100; R. L. Douglas, 1900, p. 198; R. van Marle, 1928, x, p. 219; J. Pope-Hennessy, 1952, p. 203 (workshop); M. Salmi, 1958, p. 88 (from a design by Angelico); B. Berenson, 1963, p. 15; E. Carli, 1974, p. 97, cat. 116 (Angelico?).

Much damaged; appears to be an autograph work after 1436.

96

97

MADONNA AND CHILD (MADONNA WITH THE GRAPES)

Tempera and gold on panel,
40 × 23⅛ in. (101.6 × 58.6 cm)
The Barbara Piasecka Johnson Collection Foundation, since 1984.

PROVENANCE

Private collection, Florence (Oertel?) until 1950; acquired by the present owner in 1984.

Baldini, 1970, p. 89, cat. 14 (1430-1433)
Pope-Hennessy, 1974, p. 226 (Andrea Giusti?)

BIBLIOGRAPHY

L. Berti, 1963, p. 16, fig. 12 (Angelico with Zanobi Strozzi's assistance); L. Berti, 1967, p. 8 (1430); R. Longhi, 1968, p. 44, no. 5; R. Fremantle, 1970, pp. 39-49 (Masaccio); M. Boskovits, "Adorazione," 1976, pp. 25-28; P. J. Cardile, 1976, p. 307; U. Baldini, 1977, p. 240 (1428-30, possibly originally formed part of triptych with lateral wings formerly in Esterhazy collection); D. Cole Ahl, 1980, pp. 372-75; J. Stubblebine et al., 1980, p. 224; V. Alce, 1984, p. 354;

97

J. Grabski, 1990, pp. 56-61; M. C. Impronta, in *San Marco*, 1990, p. 69 (2d half 1420s); M. Boskovits, 1994, pp. 341, 343 (c. 1425).

Circa 1425-28, influenced by Masaccio.

98
ADORATION OF THE MAGI
Tempera and gold on panel,
24⅞ × 21¼ in. (63 × 54 cm)
Abegg-Stiftung, Riggisberg, Switzerland

PROVENANCE
Königliche Pinakothek, Munich, by 1838; returned to Wittelsbach family, Munich, 1924; Marczell von Nemes, Munich (sale, Munich, 16-19 June 1931, p. 18, no. 16, acquired by the following): Carl Abegg-Stockar, Zurich; by descent to Carl J. Abegg-Haegler.

Baldini, 1970, cat. 11 (1430)
Pope-Hennessy, 1974, pp. 231-32 (workshop, 1435)

BIBLIOGRAPHY
Verzeichnis der Gemälde in der Kgl. Pinakothek in München, Munich, 1838, p. 296, no. 550 (school of Giotto); L. Venturi, 1931, pp. 250-55 (Fra Angelico, 1430-40); L. Collobi-

Ragghianti, 1950, p. 468, cat. 11 (c. 1430); L. Collobi-Ragghianti, 1955, p. 47 (precedes predella of same subject in Linaiuoli Altarpiece); M. Salmi, 1958, pp. 87, 115 (with assistance, datable 1438/39-1446); L. Berti, 1963, p. 16; S. Orlandi, 1964, p. 84 (1440-45); M. Boskovits, "Adorazione," 1976, *passim* ("poco più tarda del 1423"); C. Syre, 1986, pp. 49-55, cat. 84; M. Boskovits, 1994, pp. 309-10.

Circa 1423-25, influenced by Gentile da Fabriano.

99
MADONNA AND CHILD WITH TWO ANGELS
Tempera and gold on panel,
31¾ × 18½ in. (80.5 × 47 cm)
Museum Boymans–Van Beuningen, Rotterdam, Netherlands (no. 2555)

PROVENANCE
Paul Cassirer, Berlin (as Masolino); acquired with the collection of D. G. van Beuningen, Vierhouten, by the Boymans museum in 1958.

Baldini, 1970, p. 86, cat. 5 (1425-30)
Pope-Hennessy, 1974, p. 232 (anonymous Florentine under influence of Arcangelo di Cola)

BIBLIOGRAPHY
A. Colasanti, 1920-22, pp. 539-40 (Arcangelo di Cola); R. Longhi, 1928, pp. 154-55 (1968 ed., p. 44,

98

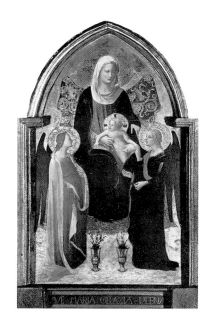

99

no. 5) (early work by Fra Angelico); B. Berenson, 1929, pp. 136, 140 (Arcangelo di Cola); R. van Marle, 1935, p. 304 (Arcangelo di Cola); R. Longhi, 1940, p. 174 (1975 ed., pp. 38, 56); M. Salmi, 1948, p. 225; *idem*, 1950, p. 78 (Angelico, mid-1420s); F. Zeri, 1950, p. 33 (Arcangelo di Cola); *Chefs d'oeuvre de la collection D. G. van Beuningen*, exh. cat., Paris, Petit Palais, 1952, no. 18; L. Collobi-Ragghianti, 1955, pp. 23, 46; M. Salmi, 1958, p. 9 (rejects); M. Chiarini, 1960, pp. 279-80; L. Berti, 1963, pp. 15, 36 (rejects); B. Berenson, 1968, p. 15; G. Vitalini Sacconi, 1968, p. 39 (Arcangelo di Cola); F. Zeri, 1969, pp. 13-14 (anonymous Florentine under influence of Arcangelo di Cola, c. 1425; also gives Contini-Bonacossi *Madonna* to this artist, c. 1420); P. Zampetti, 1971, p. 76 (Arcangelo di Cola); 1972, p. 126; H. W. Van Os and M. Prakken, 1974, pp. 44f (Florentine school, 1425); M. Boskovits, "Adorazione," 1976, p. 38 (early); A. De Marchi, 1992, pp. 140-42; M. Boskovits, 1994, pp. 355-56.

Circa 1423-25, influenced by Gentile da Fabriano.

100
MONTECARLO ALTARPIECE
Tempera and gold on panel,
93 × 62¼ in. (236 × 158 cm)
Museo della Basilica di Santa Maria delle Grazie, San Giovanni Valdarno (Arezzo)

Formerly over the second altar on the right in the church of the convent of San Francesco in Montecarlo, near San Giovanni Valdarno.

PROVENANCE
From the Convent of Montecarlo, near Florence.

Inscriptions: see V. Alce, 1984, p. 390; D. A. Covi, 1986.

Upper register

The Prophet Isaiah, tempera on circular panel.

Central panel

Annunciation, 58¾ × 62¼ in. (149 × 158 cm)

Predella

Five panels, each 6¾ × 10¼ in. (17 × 26 cm), from left to right:
Marriage of the Virgin
Visitation
Adoration of the Magi
Presentation of Jesus in the Temple
Funeral of the Virgin

Baldini, 1970, p. 108, cat. 106 (1440)
Pope-Hennessy, 1974, p. 193 (not picture described by Vasari, c. 1450)

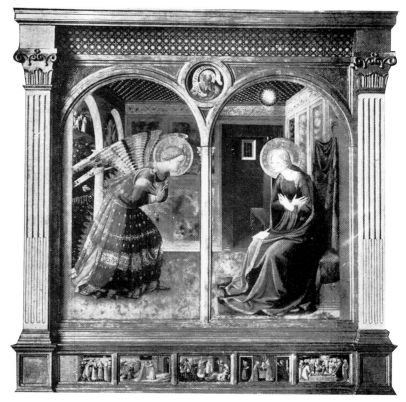

100

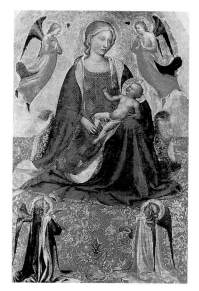

101

BIBLIOGRAPHY

E. Repetti, 1839, p. 334 (Sienese school); J. Crowe and G. B. Cavalcaselle, 1864, 1911 ed., IV, p. 76 (copy); Magherini-Graziani, 1904, pp. 92-94 (Masaccio); G. Poggi, 1909, pp. 72-74; F. Schottmüller, 1911, cats. 88-89; idem, 1924, cats. 90-91 (1435-40); R. van Marle, 1928, X; P. Muratoff, 1930, pp. 39, 82 (assistant; c. 1430); B. Berenson, 1932, p. 22 (studio); Procacci, 1947, pp. 39-40; G. Bazin, 1949, p. 181 (studio); M. Salmi, 1950, p. 96; J. Pope-Hennessy, 1952, p. 168; L. Collobi-Ragghianti, 1955, p. 38; Mostra, 1955, pp. 68-69, no. 42 (circle of Fra Angelico); M. Salmi, 1958, pp. 87, 111 (predella by Sanguigni); B. Berenson, 1963, p. 14 (predella by assistants); M. Boskovits, "Adorazione," 1976, p. 14 ("predella was certainly designed by Angelico even if executed by an assistant"), p. 16 (similar to Cortona and earlier than Linaiuoli in 1430s), p. 48 n. 12 (the curious absence of scenes on the two extremes of the predella seems evidence of a

different original destination: perhaps some scenes that were not appropriate to the Franciscans of Montecarlo were removed; the *Annunciation* is autograph, but the predella was entirely executed by an assistant, perhaps Zanobi Strozzi); A. M. Maetzke, 1979, pp. 44-47; D. A. Covi, 1986, nos. 1.b, 111, 121f; P. Joannides, 1989, pp. 303-5; M. Boskovits, 1994, p. 327 (predella by Zanobi Strozzi).

Scholars differ widely in their views as to the authorship and date of this *Annunciation*. It seems likely, following Joannides, that this altarpiece was commissioned by the Servite church of Sant'Alessandro in Brescia in 1432. For unknown reasons, the work was either rejected or never delivered. This theory does not conflict with Boskovits's view (1994) that the altarpiece was completed with a predella by Zanobi Strozzi and sent to Montecarlo after 1440.

101
MADONNA AND CHILD WITH FOUR ANGELS

Tempera and gold on panel,
31½ × 20⅛ in. (80 × 51 cm)
Hermitage Museum, Saint Petersburg
(v.4115)

PROVENANCE

Stroganov Collection; transferred from the Stroganov Palace, Saint Petersburg, 1922.

Baldini, 1970, p. 86, cat. 6 (1425-30).
Pope-Hennessy, 1974, p. 227 (rejects)

BIBLIOGRAPHY

A. Venturi, 1898, p. 495 (as Gentile da Fabriano); R. L. Douglas, 1900, p. 198 (ruined); A. Colasanti, 1921-22, pp. 544-45 (as Arcangelo di Cola); R. Longhi, 1928, p. 154 (Angelico); R. Longhi, 1940, p. 186; M. Salmi, 1950, p. 78; J. Pope-Hennessy, 1952, p. 206 (rejects); L. Collobi-Ragghianti, 1955, p. 46 n. 5; M. Salmi, 1958, pp. 8-9, 95 (?); *The Ermitage: Catalogue of the Collection*, 1958, p. 58 (executed for Convent of San Domenico in Fiesole); L. Berti, 1963, p. 18 (rejects); Levinson-Lessing, 1967, no. 5 (c. 1425); F. Zeri, 1969, p. 15 (tentatively Angelico); M. Boskovits, "Adorazione," 1976, pp. 35-38 (among earliest works, shows influence of Arcangelo di Cola, who arrived in Florence in June 1420); S. Vsevolozhskaya, *13th to 19th Century Italian Painting from the Ermitage Museum*, New York-Leningrad, 1981, p. 265; A. De Marchi, 1992, pp. 140-42 (c. 1421-22, comparable to Princeton *Saint Jerome* and Griggs *Crucifixion* in New York); M. Boskovits, 1994, p. 351.

Early work, c. 1420.

102
MADONNA AND CHILD

Tempera and gold on panel,
39⅜ × 26 in. (100 × 66 cm)
Pinacoteca Sabauda, Turin

PROVENANCE

Prince Michele Demetrio Boutourlin; Sig. A. Sandrini, Florence; Barone Garriod; Pinacoteca Sabauda by purchase (1852)

Baldini, 1970, pp. 102-3, cat. 61 (1440)
Pope-Hennessy, 1974, p. 233 (c. 1450)

BIBLIOGRAPHY

P. V. Marchese, 1845, 3d ed. 1869, I, p. 405; J. Crowe and G. B. Cavalcaselle, 1864, 1911 ed., II, p. 93n (not one of Angelico's best works); S. Beissel, 1905, p. 61; F. Schottmüller, 1911, p. 90; idem, 1924, p. 99 (1435-45); R. van Marle, 1928, X, p. 46; R. Longhi, 1928, p. 155; P. Muratoff, 1930, pp. 42, 88 (1430); F. Wittgens, 1940, p. 504; G. Fallani, 1945, p. 16; M. Salmi, 1950, p. 81 (c. 1434); J. Pope-Hennessy, 1952, p. 203 (rejects, then accepts, in corrigendum, after its cleaning; late autograph c. 1450); P. D'Ancona, 1953, p. 16; L. Berti, 1955, p. 282; L. Collobi-Ragghianti, 1955, pp. 391-92 (later); *Mostra*, 1955, p. 33, cat. 18; M. Salmi, 1958, pp. 28, 104 (panel reduced in height); N. Gabrielli, 1959, p. 15; B. Berenson, 1963, p. 15 (late); U. Baldini, 1964, p. 48; M. Boskovits, 1970, pp. 40-45; N. Gabrielli, 1971, pp. 53-54; K. Christiansen, 1990, p. 739

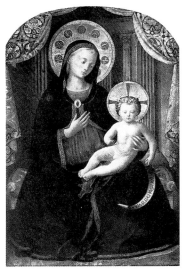

102

(before 1435); M. Boskovits, 1994, p. 322 n. 9.

Late work, probably painted in Rome, 1446-49. The pose of the child is borrowed from the antique.

103
TWO ANGELS
Tempera and gold on panel,
10½ × 6 in. (26.5 × 15 cm)
Pinacoteca Sabauda, Turin
(nos. 103, 104)

PROVENANCE
Giovanni Metzgar, Florence (d. 1844); Barone Garriod (1846); Pinacoteca Sabauda, by purchase.

Baldini, 1970, p. 92, cat. 26 (1434)
Pope Hennessy, 1974, p. 232 (other works ascribed–c. 1430; forms part of frame of type around Linaiuoli triptych)

BIBLIOGRAPHY
B. Berenson, 1896, p. 16; J. Crowe and G. B. Cavalcaselle, 1864, 1911 ed., IV, p. 93; R. L. Douglas, 1900, p. 199; F. Schottmüller, 1911, cat. 24; *idem*, 1924, cat. 55 (in 2d edition places after altarpiece in Louvre); R. van Marle, 1928, X, p. 46; P. Muratoff, 1930, p. 82 (1425-30, by assistant); J. Pope-Hennessy, 1952, p. 203 (school); M. Salmi, 1958, pp. 12, 99 (part of ciborium on high altar of Fiesole); N. Gabrielli, 1959, p. 15; Berenson, 1963, p. 15; N. Gabrielli, 1971, pp. 52-53; U. Baldini, 1977, p. 236 (examination of wood grain suggests they were part of central cuspid of triptych).

Uncertain attribution. Fragments of dismantled polyptych datable to the 1420s.

103

104–107
CHAPEL OF
NICHOLAS V
Frescoes, 21 ft. 7⅞ in. × 13 ft. 1½ in.
(6.6 × 4 m)
Vatican Palace, Vatican City

104
STORIES OF
SAINT STEPHEN

On the wall to the right
of the entrance

104A (above)
THE ORDINATION
OF SAINT STEPHEN,
SAINT STEPHEN
DISTRIBUTING ALMS
10 ft. 6⅞ in. × 15 ft. 5⅞ in.
(322 × 472 cm)

On the entrance wall

104B (above)
SAINT STEPHEN
PREACHING,
SAINT STEPHEN
ADDRESSING THE
COUNCIL
10 ft. 6⅞ in. × 13 ft. 6 in.
(322 × 412 cm)

On the wall to the left
of the entrance

104C (above)
THE EXPULSION OF
SAINT STEPHEN,
THE STONING OF
SAINT STEPHEN
10 ft. 6⅞ in. × 15 ft. 6¼ in.
(322 × 473 cm)

105
STORIES OF
SAINT LAWRENCE

On the wall to the right
of the entrance

105A (below)
THE ORDINATION OF
SAINT LAWRENCE
107 × 77⅝ in. (271 × 197 cm)

On the entrance wall

105B (below)
SAINT LAWRENCE
RECEIVING THE
TREASURES OF THE
CHURCH FROM
POPE SIXTUS II,
SAINT LAWRENCE
DISTRIBUTING ALMS
8 ft. 11 in. × 13 ft. 6½ in.
(271 × 410 cm)

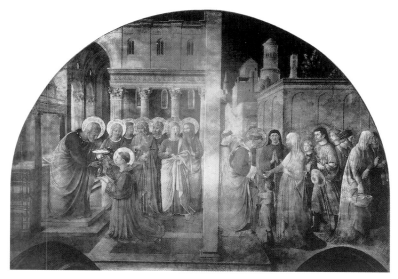

104A

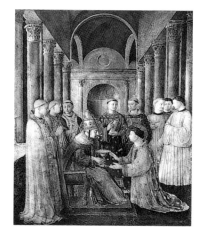

105A

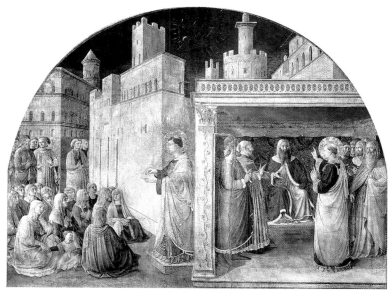

104B

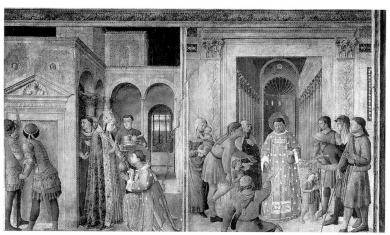

105B

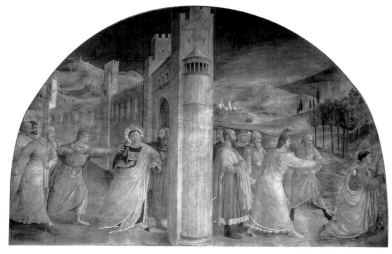

104C

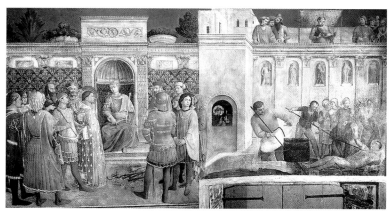

105C

106A

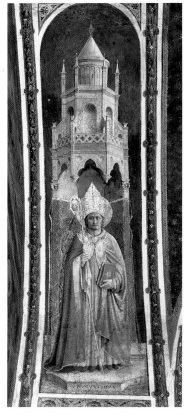

106B

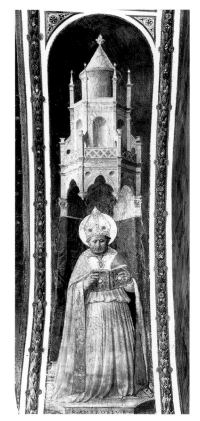

106C

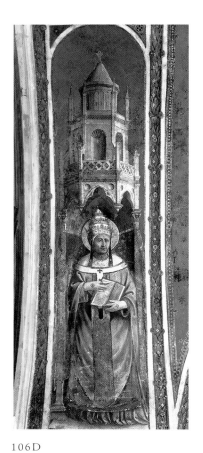

106D

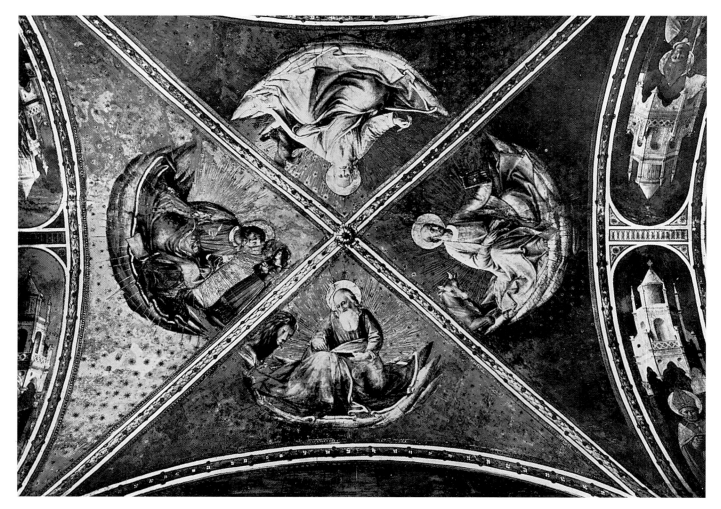

107

*On the wall to the left
of the entrance*

105C (below)
*SAINT LAWRENCE
BEFORE DECIUS,
THE MARTYRDOM OF
SAINT LAWRENCE*
8 ft. 11 in. × 15 ft. 6¼ in.
(271 × 473 cm)

*On lateral walls, eight full-
length saints, 130 × 37½ in.
(330 × 95 cm) each*

(below)
*SAINTS JEROME,
THOMAS AQUINAS
(106A), ATHANASIUS,
JOHN CHRYSOSTOM*

(above)
*SAINTS AUGUSTINE
(106B), AMBROSE
(106C), LEO (106D),
AND GREGORY
THE GREAT*

*On the ceiling vault,
the four Evangelists*

107
*SAINT LUKE,
SAINT MARK,
SAINT MATTHEW,
SAINT JOHN
THE EVANGELIST*

Baldini, 1970, pp. 110-12, cat. 113
(1447-50)
Pope-Hennessy, 1974, pp. 212-14

108
*MADONNA AND
CHILD ENTHRONED
WITH NINE ANGELS
AND SAINTS DOMINIC
AND CATHERINE OF
ALEXANDRIA*
*Tempera and gold on panel,
9⅛ × 7⅛ in. (23 × 18 cm)
Pinacoteca Vaticana, Vatican City
(no. 253)*

PROVENANCE

Bisenzio Collection, Rome; Earl of
Dudley, 1877; acquired by Pope
Pius IX (1877).

Baldini, 1970, p. 95 (1435)
Pope-Hennessy, 1974, p. 233 (Zanobi
Strozzi, c. 1449)

BIBLIOGRAPHY

E. Cartier, *Vie de Fra Angelico*,
Paris, 1857, p. 437; R. L. Douglas,
1900, p. 198; S. Beissel, 1905, p. 19;
F. Schottmüller, 1911, cat. 18; *idem*,
1924, cat. 20 (1425-35); R. van
Marle, 1928, x, p. 58; M. Wigenroth,
1926, p. 34; P. Muratoff, 1930, p. 80
(1420-25); G. Bazin, 1949, p. 23;
J. Pope-Hennessy, 1952, p. 204
(Zanobi Strozzi); *Mostra*, 1955, p. 11,
no. 5; M. Salmi, 1958, p. 99; G. Fal-
lani, 1984, p. 21; Walter Angelelli, in
Imago Mariae, Rome, 1988, cat. 57.

Circa 1440-45. Fully autograph
work with mystical overtones.

109
*ADORATION OF
THE MAGI*
*Tempera and gold on panel,
diameter: 54 in. (137.2 cm)
National Gallery of Art,
Washington, D.C.; Kress Collection
(no. 1085)*

PROVENANCE

Lorenzo de' Medici, Florence (inv.
1492); Palazzo Guicciardini, Flor-
ence (inv. 1807; as Botticelli); sold
July 1810; Dubois, Florence; William
Coningham, London; sold, Chris-
tie's London, July 9, 1849, no. 34,
as Filippo Lippi; Alexander Barker
(1854-74); sold Christie's London,
June 6, 1874, no. 42, as Filippino
Lippi; acquired for the Cook col-
lection, Richmond, Surrey (as
Filippo Lippi, c. 1430); Paul Drey,
New York; Samuel H. Kress (1947).

Baldini, 1970, cat. 133 (primarily by
Filippo Lippi)
Pope Hennessy, 1974, pp. 219-20
(begun by Angelico early 1450s
and finished by Lippi, 1455: 37
years after artist's death regarded
as "from the hand of Fra Giovanni"

SOURCE

1492 Lorenzo de' Medici Inventory,
published by Müntz, 1888, p. 60:
"A big *tondo* with a golden frame;
painted on it is Our Lady and
Our Lord and the Magi with their
offerings; painted by the hand of
fra Giovanni."

BIBLIOGRAPHY

G. F. Waagen, 1854, II, p. 125
(Benozzo Gozzoli); J. A. Crowe and
G. B. Cavalcaselle, 1864, 1911 ed., II,
p. 350 (Fra Filippo Lippi); A. Ven-
turi, 1911, p. 361 (Filippo Lippi);
T. Borenius, 1913, no. 16 (as Filippo
Lippi); R. van Marle, 1928, x, p. 402
(Filippo Lippi); B. Berenson, 1932-33,
pp. 1, 49ff. (Angelico, finished 1445
by Lippi); G. Pudelko, 1936, p. 68;
C. L. Ragghianti, 1936, p. 115;
Oertel, 1942, p. 70 (dates 1455-57);
M. Pittaluga, 1949, pp. 76, 211 (with

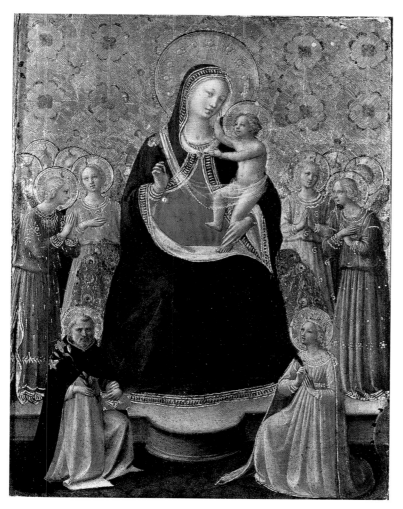

108

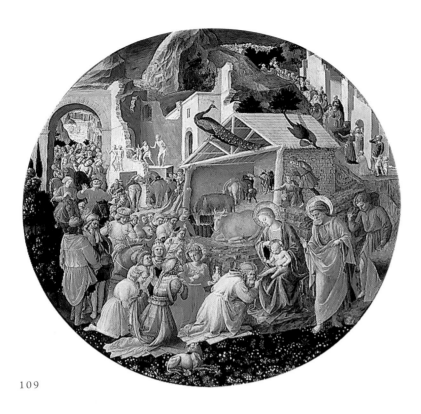

109

assistance of Pesellino); W. Suida, 1951, p. 42 (follows Berenson); J. Pope-Hennessy, 1952, p. 204 (substantially by Filippo Lippi); M. Salmi, 1958 (Lippi); R. Salvini, 1962, pp. 299-304; B. Berenson, 1963, p. 16 (finished by Filippo Lippi); Shapley, 1966, pp. 95-97 (as Angelico and Filippo Lippi); B. Berenson, "Postscript, 1949: The Cook Tondo Revisited," in 1969, pp. 235-42 (Lippi); M. Boskovits, "Appunti," 1976, p. 45 (begun by Angelico early 1440s, completed by Filippo Lippi; F. R. Shapley, 1979, pp. 10-11 (as Angelico and Filippo Lippi); C. Lloyd, 1992, pp. 23, 122-25; J. Ruda, 1993, pp. 210-15, 316-24, 437-41 (begun in the 1430s by Filippo Lippi, who worked on it intermittently with assistance from a follower of Fra Angelico; completed in the 1450s); M. Boskovits, 1995, pp. 32-67.

Late work. This famous painting was begun by Fra Angelico but left unfinished at his death. It was later completed by Filippo Lippi. Recently

Miklós Boskovits has convincingly distinguished the separated contributions of the two artists. Angelico's hand can most easily be seen in the Virgin and in the figures at upper right. In Boskovits's opinion, Angelico probably began work after his return from Rome in 1449/50; Lippi completed it in the later 1450s.

110
THE STIGMATIZATION OF SAINT FRANCIS AND THE DEATH OF SAINT PETER MARTYR
Tempera and gold on panel,
9⅝ × 17¼ in. (24.3 × 43.8 cm)
Strossmayer Gallery, Zagreb,
Croatia (34)

PROVENANCE
Acquired in Italy by Bishop Strossmayer, Djakovo, Hungary, in 1873; Strossmayer collection, Agram (Zagreb), after 1884.

Baldini, 1970, cat. 39 (1435)
Pope-Hennessy, 1974, p. 234 (not Angelico)

BIBLIOGRAPHY
J. Crowe and G. B. Cavalcaselle, 1864, 1911 ed., IV, p. 96; G. Frizzoni, 1904, pp. 426-27; F. Schottmüller, 1924, p. 202 (c. 1450); R. van Marle, 1928, X, pp. 116-17; M. Salmi, 1958, p. 25, 105 (before 1440); L. Berti, 1962, p. 301 (before 1440); B. Berenson, 1963, p. 16 (restored); D. A. Covi, 1986, p. 408 (inscription).

The ascription to Angelico has been accepted by all authorities except Pope-Hennessy. According to Crowe and Cavalcaselle, "The execution of this panel is exquisite; its preservation exceptionally good." Berenson, however, listed the panel as in restored condition.

111
TWO WINGS OF A TRIPTYCH
Tempera and gold on panel; left wing:
20¼ × 9 in. (51.4 × 22.9 cm); right
wing: 20⅜ × 8¼ in. (51.8 × 21 cm)
J. Paul Getty Museum, Malibu,
California; 92.PB.111.1, 92.PB.111.2

111A
Left wing
SAINT FRANCIS AND A BISHOP SAINT
111B
Right wing
SAINT JOHN THE BAPTIST AND SAINT DOMINIC

PROVENANCE
Private collection.

BIBLIOGRAPHY
M. Boskovits, 1983, p. 11, figs. 1-2.

The pair of panels was published by Boskovits following their appearance on the American art market. As the scholar has plausibly suggested, they must have originally constituted the side wings of a portable triptych executed earlier than 1431. The attribution to Angelico is supported by Everett Fahy.

112A
SAINTS CATHERINE OF ALEXANDRIA AND JOHN THE BAPTIST
Tempera and gold on panel,
22 × 12½ in. (55.9 × 31.8 cm)
Private collection

112B
SAINTS NICHOLAS AND AGNES
Tempera and gold on panel,
21⅝ × 12½ in. (54.9 × 31.8 cm)
Private collection

PROVENANCE
Esterhazy Collection, Hungary; on loan to Liechtenstein Collection, Vaduz, Switzerland

Pope-Hennessy, 1974, p. 190 (c. 1423)

BIBLIOGRAPHY
M. Boskovits, "Appunti," 1976, pp. 33f (accepts); *idem*, "Adorazione," 1976, pp. 25, 49 n. 22; U. Baldini, 1977, p. 240 (1428-30; possibly connected to the *Madonna and Child* now in the Johnson Collection,

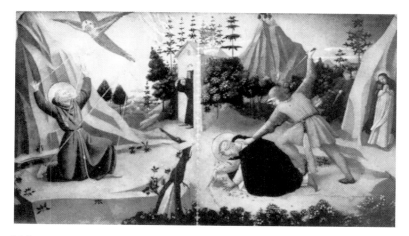

110

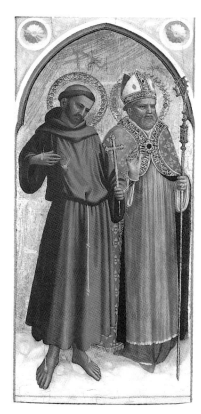

111A

111B

Princeton); D. Cole Ahl, 1980, pp. 374-76 (1425); M. C. Impronta, in *San Marco*, 1990, p. 69 (1425); M. Boskovits, 1994, p. 337.

Circa 1420-25.

113

ALTARPIECE WITH SAINTS ANTHONY ABBOT, BENEDICT, ROMUALD AND JULIAN

The existence of a lost altarpiece executed by Fra Angelico and his workshop has been deduced by Pope-Hennessy and Boskovits on the basis of four predella panels preserved in Antwerp; Chantilly; Cherbourg, France; and Houston. The principal register of the dismantled polyptych would have consisted of a central panel with the *Madonna and Child* and two lateral wings containing two pairs of saints. The identities of the saints would have corresponded to the stories depicted in the predella panels in the lower register of the altarpiece.

Principal register, of which only one of the lateral panels has been identified

113A
SAINT ANTHONY ABBOT

Tempera and gold on panel,
35⅛ × 13 in. (89 × 33 cm)
Private collection (not illustrated)

BIBLIOGRAPHY

M. Boskovits, "Appunti," 1976, p. 43, pl. 13; C. C. Wilson, 1995, pp. 737-40.

Lower register, for which four predella panels have been proposed

113B
THE APPARITION OF SAINT ROMUALD TO OTTO III

Tempera and gold on panel,
8¾ × 10⅝ in. (22 × 27 cm)
Musée Royal des Beaux-Arts, Antwerp, Belgium

BIBLIOGRAPHY

J. Crowe and G. B. Cavalcaselle, 1864, 1911 ed., II, p. 94n (their attribution not accepted by L. Douglas); P. Muratoff, 1930, p. 60 (school); M. Salmi, 1958 (in collaboration with Sanguigni); B. Berenson, 1963, p. II (studio, restored); U. Baldini, 1970, p. 116, cat. 117 (disputed attribution);

112A

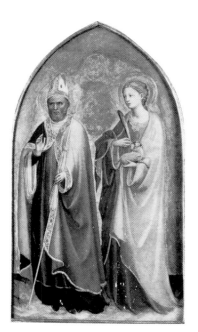

112B

J. Pope-Hennessy, 1974, p. 220
(not Angelico); M. Boskovits,
"Appunti," 1976, p. 42 (1430-35,
perhaps with assistance); C. C.
Wilson, 1995, p. 738 n. 738 (not
associated with Houston panel
by Angelico).

113C
SAINT BENEDICT
IN ECSTASY
Tempera and gold on panel,
7⅜ × 11⅛ in. (18.5 × 28.3 cm)
Musée Condé, Chantilly

PROVENANCE
Vente F. Reiset collection, Paris
1879, no. 3; acquired for the duc
d'Aumale.

BIBLIOGRAPHY
P. V. Marchese, 1854, 1, p. 44;
G. Lafenestre, *Maîtres anciens: Etudes
d'histoire et d'art,* 1882, p. 164 (imitator); F.-A. Gruyer, 1896, pp. 16-17
(follower); R. van Marle, 1928, x,
p. 184 (Zanobi Strozzi); F. Schott-
müller, 1924, cats. 249, 269 (school);
P. Muratoff, 1930, pp. 60, 91
(school); L. Collobi-Ragghianti,
1950, pp. 454-57 (as Zanobi
Strozzi); J. Pope-Hennessy, 1952,
p. 201; L. Collobi-Ragghianti, 1955,
p. 47 (Angelico?); M. Salmi, 1958,
pp. 89, 105 (Angelico and assistant,
part of predella for lost work at
the Certosa described in Vasari);
L. Berti, 1962, pp. 303–4, n. 19
(not Angelico); B. Berenson, 1963,
p. 11 (studio); S. Orlandi, 1964,
p. 205 (not Angelico); U. Baldini,
1970, cat. 120 (disputed attribu-
tion); idem, 1973, p. 116, n. 20 (not
Angelico); J. Pope-Hennessy, 1974,
p. 222 (not Angelico); D. Cole,
1977, pp. 499-501 (same artist as
Zagreb, Houston, Cherbourg, and
Antwerp panels); E. de Boissard
and V. Lavergne-Durey, 1988,
pp. 46-47 (Angelico?).

113D
VOCATION OF
SAINT AUGUSTINE
Tempera and gold on panel,
7⅞ × 12⅝ in. (20 × 32 cm)
Musée des Beaux Arts,
Cherbourg, France

PROVENANCE
Donated to the museum by Thomas
Henry in 1835.

BIBLIOGRAPHY
S. Reinach, "La Vision de Saint
Augustin," *Gazette des Beaux-Arts* 1,
1929, p. 257 (circle); R. Longhi,
1940, p. 175 (early); L. Collobi-
Ragghianti, 1950, p. 27 (as Zanobi
Strozzi); G. Kaftal, 1952, p. 104
(subject is Saint Augustine medi-
tating); Exhibited, *De Giotto à
Bellini,* Orangerie, Paris, pp. 30-31,
no. 44 (Angelico); M. Salmi,
1958, p. 92 (as Zanobi Strozzi);
B. Berenson, 1963, p. 142 (possibly
an early work by the Master of
Castello Nativity); U. Baldini,
1970, p. 98, cat. 52 (1436); J. Pope-
Hennessy, 1974, p. 222; M. Bosko-
vits, "Appunti," 1976, p. 43.

113E
TEMPTATION OF
SAINT ANTHONY
ABBOT
Tempera and gold on panel,
7¾ × 11⅛ in. (19.7 × 28 cm)
Museum of Fine Arts, Houston;
Edith A. and Percy S. Straus
Collection (44.550)

PROVENANCE
William IV of Prussia; Marczel
von Nemes, Munich; acquired
from K. W. Bachstitz in 1930 by
Percy S. Straus, New York.

BIBLIOGRAPHY
F. Schottmüller, 1924, p. 252 (fol-
lower); B. Berenson, 1932, p. 22;
L. Venturi, 1933, pl. 178 (1440);
R. Offner, 1945, pp. 22-23 (work-
shop); J. Pope-Hennessy, 1952, p. 176
(from photo, Angelico); *Mostra,*
1955, p. 43, cat. 23; B. Berenson,

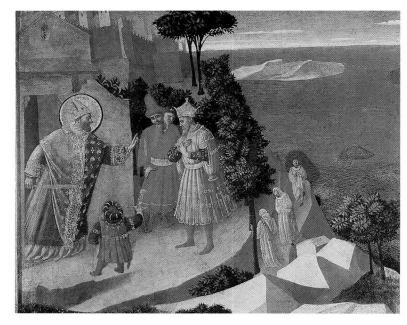
113B

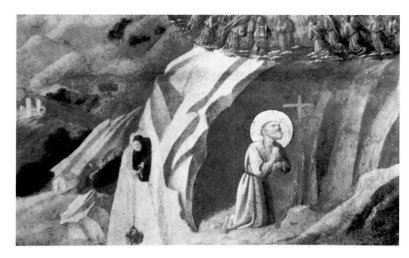
113C

113D

1963, p. 14; U. Baldini, 1970, p. 97, cat. 51 (generally accepted; 1436); J. Pope-Hennessy, 1974, p. 227 (imitator); M. Boskovits, "Appunti," 1976, p. 43; J. Pope-Hennessy, 1987, p. 105 (workshop); C. C. Wilson, 1995, pp. 737-40.

The four panels were separately discussed in the Fra Angelico literature until 1974, when Pope-Hennessy suggested that they had originally been united in the predella of a lost altarpiece executed by an unknown follower of the artist. This connection was accepted by Boskovits (1976), who insisted, rightly, on the autograph status of the *Temptation of Saint Anthony Abbot* in Houston. In addition, Boskovits published a photograph of a standing figure of Saint Anthony Abbot (private collection), which he proposed as possibly a lateral panel from the same dismantled altarpiece. This hypothesis has recently gained support from Wilson, who pointed out an engraving of c. 1460, which appears to be based upon these two panels of Saint Anthony Abbot. For Wilson, however, the Houston predella cannot be associated with the workshop pieces in Antwerp, Chantilly, and Cherbourg.

113E

114
ALTARPIECE WITH SAINTS JAMES, JOHN THE BAPTIST, FRANCIS, AND DOMINIC

The existence of a lost altarpiece by Fra Angelico was first deduced by Roberto Longhi on the basis of two predella panels in the Museo di San Marco and formerly in the collection of the Duc de Cars, Paris (today in Fort Worth). In recent years scholars have associated panels in Philadelphia and San Francisco with this same predella. The principal register of the dismantled polyptych would have consisted of a central panel with the Madonna and Child and two lateral wings containing two pairs of saints. The identities of the saints would have corresponded to the stories depicted in the predella panels in the lower register of the altarpiece.

Principal register, of which only one of the lateral panels has been tentatively identified

114A
SAINT JAMES
Tempera on panel,
31½ × 12⅝ in. (80 × 32 cm)
Private collection

PROVENANCE
Landor Collection, Florence; sale April 13–14, 1920, cat. 141, Florence; Minneapolis Museum of Art (1922–56).

BIBLIOGRAPHY
Minneapolis, 1926, p. 8 (follower of Filippo Lippi, c. 1450); R. van Marle, 1928, x, p. 177 (Zanobi Strozzi); L. Berti, 1963, p. 22; M. Boskovits, "Appunti," 1976, pp. 39–40, 51 n. 21; E. Fahy, 1987, p. 181.

Predella, of which four out of five panels have been identified (from left to right)

114B
NAMING OF SAINT JOHN THE BAPTIST
Tempera and gold on panel,
10¼ × 9½ in. (26 × 24 cm)
Museo di San Marco, Florence

PROVENANCE
Vincenzo Prati Collection; Galleria degli Uffizi, Florence (1778); Museo di San Marco (1924).

Baldini, 1970, pp. 94-95, cat. 35 (1434-35)
Pope-Hennessy, 1974, p. 196.

BIBLIOGRAPHY
L. Lanzi, 1795-96, ("più gaio e finito dell'Angelico"); J. Crowe and G. B. Cavalcaselle, 1864, 1911 ed., II, p. 91 (predella of the Sant'Egidio Altarpiece); R. L. Douglas, 1900, p. 195; R. van Marle, 1928, x, pp. 181-82 (Zanobi Strozzi); F. Schottmüller, 1911, p. 22; idem, 1924, p. 23 (1425-35; predella of Sant'Egidio Altarpiece); M. Salmi, 1936, p. 9 (1420-30, copied by Andrea Giusti in his Prato altarpiece, 1435); R. Longhi, 1940, p. 176 (associates with *Saint James* in Paris and with the two panels in Forli); J. Pope-Hennessy, 1952, p. 170 (1433-35; disassociates the Forli panels); *Mostra*, 1955, pp. 27-28, cat. 15; S. Orlandi, 1955, p. 204; M. Salmi, 1958, p. 103 (pre-1435); B. Berenson, 1968, p. 12; F. R. Shapley, 1966, p. 97 (as attributed to); M. Boskovits, "Appunti," 1976, p. 39; idem, "Adorazione," 1976, p. 31 (1425-30); L. Berti, 1980, p. 156, P175; U. Baldini, 1986, pp. 23–24, 27–28; E. Fahy, 1987, pp. 178-83; L. Berti and A. Paolucci, 1990, p. 228, cat. 84; M. C. Impronta, in *San Marco*, 1990, p. 73 (1435); C. B. Strehlke, 1993, pp. 5-26; M. Boskovits, 1994, pp. 346-47; C. B. Strehlke, 1994, pp. 327, 332.

114C
SAINT JAMES THE GREAT FREEING HERMOGENES
Tempera and gold on panel,
10⅝ × 9⅜ in. (26.8 × 23.8 cm)
Kimbell Art Museum, Fort Worth, Texas (AP 1986.03)

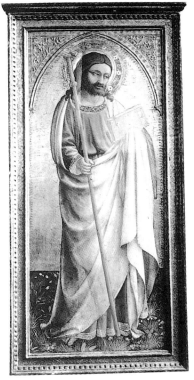

114A

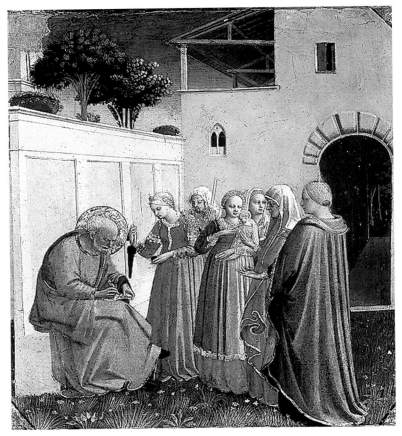

114B

1968, p. 12; F. R. Shapley, 1966,
p. 97 (as attributed to); M. Bosko-
vits, "Appunti," 1976, p. 39; *idem*,
"Adorazione," 1976, p. 31 (1425-30);
L. Berti, 1980, pp. 156, P175; U. Bal-
dini, 1986, pp. 23–24, 27–28;
E. Fahy, 1987, pp. 178-83; L. Berti
and A. Paolucci, 1990, p. 228, cat.
84; M. C. Impronta, in *San Marco*,
1990, p. 73 (1435); C. B. Strehlke,
1993, pp. 5-26; M. Boskovits, 1994,
pp. 346-47; C. B. Strehlke, 1994,
pp. 327, 332.

This panel had already been sepa-
rated from its companions by 1815,
when it was offered at the London
sale of the collection of Lucien
Bonaparte. Although its subject
was identified inexactly, the paint-
ing was correctly attributed to Fra
Angelico; the dimensions in the
catalogue indicate that the panel
had not yet been trimmed along its
left side.

114D
BURIAL OF THE
VIRGIN AND THE
RECEPTION OF HER
SOUL IN HEAVEN
Tempera and gold on panel,
10¼ × 20½ in. (26 × 52 cm)
The Philadelphia Museum of Art,
John G. Johnson Collection (15)

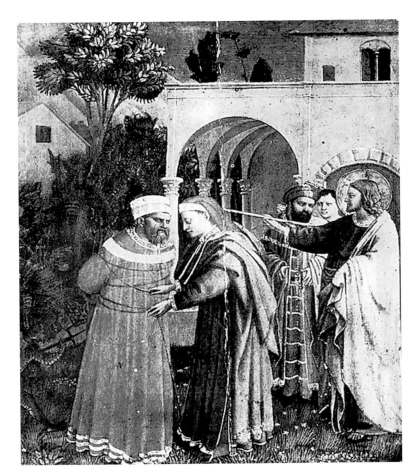

114C

PROVENANCE
Ignazio Hugford, Florence?; Lucien
Bonaparte, Prince of Canino, Rome
(by 1810); Bonaparte collection sale,
William Buchanan, London, 6 Feb-
ruary 1815, lot 61 (unsold); Bonaparte
collection sale, George Stanley, Lon-
don, 15 May 1816, lot 96 (*A Miracle*,
panel, 10½ × 9 in.; for description
see Getty Provenance Index, http://
www/gii.getty.edu); Comte Lafond,
Paris (c. 1865-79); Paris, François,
Duc des Cars, by descent (1932);
New York, Wildenstein.

Baldini, 1970, p. 95, cat. 36 (1434-35)
Pope-Hennessy, 1974, p. 196

BIBLIOGRAPHY
R. Longhi, 1940, p. 176 (associates
with the *Naming of the Baptist* in
Florence and with the two small
panels in Forlì); J. Pope-Hennessy,
1952, p. 170 (1433-35; disassociates
the Forlì panels); *Mostra*, 1955, p. 27;
S. Orlandi, 1955, p. 204; M. Salmi,
1958, p. 103 (pre-1435); B. Berenson,

PROVENANCE
Ignazio Hugford, Florence (d. 1778);
Lamberto Gori, Pisa (1789); Wil-
liam Young Ottley, London (d. 1836);
Warner Ottley (as Giotto), London;
sale Foster's, London, June 30, 1847,
lot 30 (as School of Angelico); Stan-
stead House, W. Maitland Fuller
(c. 1854); Agnew's, London; John G.
Johnson, Philadelphia (1900).

Baldini, 1970, p. 116, cat. 121 (other
works ascribed)

BIBLIOGRAPHY
G. Waagen, 1837-39, I, pp. 396-97;
J. Crowe and G. B. Cavalcaselle,
1864, 1911 ed., IV, p. 95 ("a noble
specimen of Angelico, which has

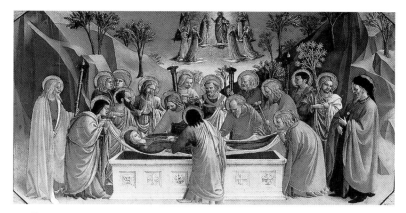

114D

115

for the main register by Boskovits reveal Fra Angelico in his most Masaccio-esque moment, 1426-29. The architecture in the *Naming of Saint John the Baptist*, cat. 113B, is skillfully derived from the background of the *Raising of the Son of Theophilus* by Masaccio in the Brancacci Chapel (prior to its modifications by Filippino Lippi; cf. J. T. Spike, 1995, pp. 195-96). This predella panel was copied by Andrea di Giusto in a polpytych in Prato dated 1435.

Two Drawings Attributed to Fra Angelico

115
KING DAVID PLAYING A PSALTERY

Pen and brown ink, purple wash on vellum, 7¾ × 7⅛ in. (19.7 × 17.9 cm)
British Museum, London

PROVENANCE
Malcolm Collection.

Pope-Hennessy, 1974, p. 235

BIBLIOGRAPHY
R. L. Douglas, 1900, p. 199;
A. E. Popham, 1950, p. 2; J. Pope-Hennessy, 1952, p. 205; M. Salmi, 1958, p. 85; B. Degenhart and A. Schmitt, 1968, no. 369; C. Lloyd, 1992, p. 32.

This is the only drawing that has generally been considered autograph by scholars. It should be taken as the basis for the reconstruction of the drawing style of Angelico.

often changed hands"); F. Schottmüller, 1911, pp. 213, 243 (workshop); B. Berenson, 1913, p. 11 (studio); F. Schottmüller, 1924, p. 233 (pupil of Angelico); R. van Marle, 1928, x, p. 182 (Zanobi Strozzi); "Notes," 1944, p. 89; M. Salmi, 1958, p. 86; B. Sweeny, 1966, p. 3, cat. 15 (studio); E. Fahy, 1987, pp. 178-83; C. B. Strehlke, 1993, pp. 5-26; *idem*, 1994, pp. 331-32.

114E
MEETING OF SAINTS FRANCIS AND DOMINIC

*Tempera and gold on panel,
10½ × 10⅛ in. (26.7 × 25.7 cm)*
*M. H. DeYoung Memorial Museum,
San Francisco (Kress Collection
no. K289)*

PROVENANCE
Ignazio Hugford, Florence?; Alexis Francois Artaud de Montor, Paris (1808-43); *Peintres Primitifs: Collection de Tableaux rapportée d'Italie*, sale, Hôtel des Ventes Mobilières, January 17-18, 1843, no. 129, as Baldovinetti; Georges Chalandon, Lyons and Paris; R. Langton Douglas, London (1924); Mrs. Walter Burns, London; Contini-Bonacossi, Florence; acquired by Samuel H. Kress, New York, in 1934; on loan to the National Gallery of Art, Washington, D.C., until 1950.

Baldini, 1970, p. 103, cat. 68 (1440)

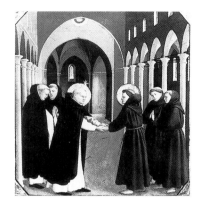

114E

Pope-Hennessy, 1974, p. 232 (other works ascribed)

BIBLIOGRAPHY
B. Berenson, 1909, p. 107 (late work); R. van Marle, 1928, x, p. 120; F. Schottmüller, 1924, p. 178 (c. 1450); *Mostra*, 1955, cat. 37; S. Orlandi, 1955, p. 204; San Francisco, p. 62, cat. 37; M. Salmi, 1958, p. 103 (pre-1435); B. Berenson, 1963, p. 15 (restored); F. R. Shapley, 1966, p. 97 (as attributed to); M. Boskovits, "Appunti," 1976, p. 39; *idem*, "Adorazione," 1976, p. 31 (1425-30); L. Berti, 1980, p. 156, P175; U. Baldini, 1986, pp. 23–24, 27-28; E. Fahy, 1987, pp. 178-83; C. B. Strehlke, 1993, pp. 5-26; M. Boskovits, 1994, pp. 346-47; C. B. Strehlke, 1994, pp. 327, 332.

See E. Fahy and C. B. Strehlke for the fullest discussion of this dismantled altarpiece. The predella panels and the *Saint James* proposed

116

116
JUSTICE (?)

Pen and brown ink, brush and brown wash, 7⅝ × 6¾ in. (19.3 × 17.0 cm)
*The Metropolitan Museum of Art,
New York (1975.1.264)*

PROVENANCE
V. Everit Macy, New York;
Robert H. Lehman collection.

BIBLIOGRAPHY
B. Berenson, 1961, no. 177a; B. Degenhard and A. Schmitt, 1968, p. 637; L. Collobi-Ragghianti, 1974, p. 64; G. Szabo, 1983, no. 7; A. Forlani-Tempesti, 1991, pp. 178-81, cat. 64.

Possibly autograph and related to one of Angelico's lost frescoes cycles in Rome, 1446-49.

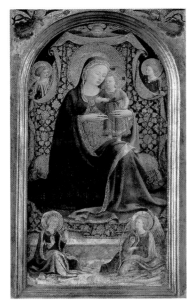

117

117
MADONNA AND CHILD WITH SAINT CATHERINE OF ALEXANDRIA AND FOUR ANGELS
Tempera and gold on canvas transferred from panel, 35⅞ × 18⅛ in. (91 × 46 cm)
Private collection, Basel

PROVENANCE
Barker collection; sale, Earl of Dudley, June 25, 1892, no. 39; acquired by Sedelmeyer, Paris, for 800 guineas; Dr. Ad Schaeffer, Frankfurt-am-Main (1911); Henckell collection, Weissbad, Switzerland (1924); Schniewind collection, Neviges, Germany (1963).

Baldini, 1970, p. 90, cat. 20 (1430-33)
Pope-Hennessy, 1974, p. 221 (workshop, c. 1435)

BIBLIOGRAPHY
G. Waagen, II, 1854, p. 231; J. Crowe and G. B. Cavalcaselle, 1864, 1911 ed., II, p. 93 n. 2; B. Berenson, 1909, p. 22; F. Schottmüller, 1911, p. 93; *idem*, 1924, p. 96 (1435-45); R. van Marle, 1928, x, pp. 138-40 (Gozzoli?); M. Salmi, 1958, pp. 17, 100-101; B. Berenson, 1963, p. 14.

During the nineteenth century, the painting belonged to several distinguished collections and was several times exhibited in England. The attribution to Fra Angelico was accepted by Crowe and Cavalcaselle, Berenson, and others, but questioned by Pope-Hennessy. From photographs, it appears that the painting has been subject to considerable repainting, rendering difficult any judgment of its authorship.

118
MADONNA AND CHILD WITH ANGELS (MADONNA OF HUMILITY)
Tempera and gold on panel, 13 × 11⅛ in. (33 × 28 cm)
Accademia Carrara, Bergamo

PROVENANCE
Bequest of Guglielmo Lochis, 1859.

Baldini, 1970, cat. 118 (attributed)
Pope-Hennessy, 1974, p. 229 (style of Fra Angelico)

BIBLIOGRAPHY
F. Schottmüller, 1911, p. 209 (repainted); *idem*, 1924, p. 239 (doubtful attribution); J. Pope-Hennessy, 1952, p. 201 (style of Fra Angelico); F. Rossi, *Accademia Carrara Bergamo: Catalogo dei dipinti*, 1979, no. 527, p. 34 (early work, c. 1420, with

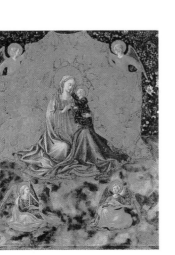

118

workshop intervention); G. Didi-Huberman, 1995, p. 82; M. Boskovits, 1995, p. 36 (Benozzo Gozzoli?).

Possibly autograph. The delicacy and preciousness of this small panel invite comparison with the reliquary panel at San Marco, cat. 75b, from the 1420s.

119
MADONNA AND CHILD
Tempera and gold on panel, 18⅜ × 13⅞ in. (46.5 × 35 cm)
Kunstmuseum, Bern (no. 875)

PROVENANCE
Formerly von Stürler collection.

Baldini, 1970, p. 116, cat. 119 (uncertain)
Pope-Hennessy, 1974, p. 221 (follower of Angelico)

BIBLIOGRAPHY
Exhibited in Stuttgart, *Frühe italienische Tafelmalerei*, 1950, cat. 3, as by Fra Angelico; B. Berenson, 1963, p. 11 (workshop).

From the photograph, the painting appears to be an autograph work, c. 1432.

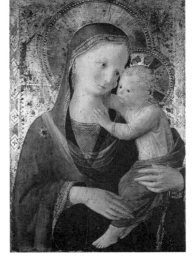

119

120
PREDELLA WITH SAINTS NICHOLAS, LAWRENCE, AND PETER MARTYR
Tempera and gold on panel, 4⅛ × 21⅝ in. (10.5 × 54.8 cm)
Kunstmuseum, Bern (no. 874)

BIBLIOGRAPHY
P. Toesca, "Trecenteschi toscani nel Museo di Berna," *L'Arte* 33, 1930, p. 4; *Berner Kunstmuseum; Führer durch die Sammlungsausstellung*, Bern, 1936, n. 18 (Masolino); L. Collobi-Ragghianti, 1950, pp. 463, 468 n. 13 (Zanobi Strozzi); H. Wagner, *Kunstmuseum Bern: Italienische Malerei, 13 bis 16. Jahrhundert*, Bern, 1974, p. 91 (Toscani); M. Boskovits, "Adorazione," 1976, pp. 38, 52 n. 40 (very early, similar to Rotterdam panel); M. Boskovits, 1994, p. 357, figs. 254-55.

Boskovits considers this the predella for an unidentified altarpiece, an early work by Angelico, comparable to the Rotterdam panel, cat. 99.

121
MADONNA AND CHILD
Tempera and gold on panel transferred to masonite, 15⅞ × 12⅛ in. (40.4 × 30.8 cm)
Fogg Art Museum, Cambridge, Massachusetts (1962-277); Art Museums Bequest of Lucy Wallace Porter

PROVENANCE
Elia Volpi (sale, American Art Association, New York, November 27, 1916, no. 991, as Masolino); A. Kingsley Porter; bequeathed to the museum by Lucy Wallace Porter.

Pope-Hennessy, 1974, p. 222 (attributed by Everett Fahy, c. 1423)

120

entry by E. de Fernandez-Gimenez),
pp. 39-40 (workshop); M. Bosko-
vits, "Adorazione," 1976, p. 38; idem,
1994, p. 357 (early work by
Fra Angelico).

Boskovits has eloquently defended
the attribution to Fra Angelico, but
the question remains open.

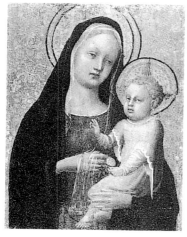

121

122

BIBLIOGRAPHY

L. Collobi-Ragghianti, *Studi*, 1955,
p. 43 (Zanobi Strozzi, c. 1436);
B. Berenson, 1963, p. 217 (Florentine
artist close to Masolino); M. Bos-
kovits, "Appunti," 1976, p. 33 (style
of Gentile da Fabriano); E. P.
Bowron, 1990, cat. 546 (Zanobi
Strozzi).

Uncertain attribution.

122
MADONNA AND
CHILD

*Tempera and gold on panel;
diameter: 7½ in. (19 cm)
Cincinnati Art Museum, Ohio;
Fanny Bryce Lehman Fund (1966.267)*

PROVENANCE

Palmieri Nuti collection, Siena,
until c. 1928; with Goudstikker,
Amsterdam, by 1928; purchased
by the museum from Piero Tozzi
in 1966.

Pope-Hennessy, 1974, p. 223 (near
Masolino)

BIBLIOGRAPHY

R. van Marle, 1928, x, pp. 43–44
(Angelico); P. R. Adams, "Fra Angel-
ico's Virgin and Child," *Art News*
LXV (December 1966), pp. 34-35,
76-77; B. Frederickson and F. Zeri,
1972, p. 9 (follower); J. T. Spike, 1993,
pp. 4-5 (follower).

The poor condition of the panel
precludes a definitive judgment.

123
CORONATION OF
THE VIRGIN

*Tempera and gold on panel,
10⅝ × 14¾ in. (27 × 37.2 cm)
Cleveland Museum of Art;
The Elizabeth Severance Prentiss
Collection (no. 44.79)*

PROVENANCE

Count Contini-Bonacossi, Florence;
Mrs. Francis F. Prentiss, Cleveland,
by 1924; bequeathed to the museum
by Elisabeth Severance Prentiss
in 1944.

Pope-Hennessy, 1974, p. 223 (close
to Arcangelo di Cola da Camerino)

BIBLIOGRAPHY

H. S. Francis, "Paintings in the
Prentiss Bequest," *Cleveland Museum
of Art Bulletin* XXXI, 1944, p. 87
(school of Fra Angelico); J. Pope-
Hennessy, 1952, p. 197; *Cleveland
Museum of Art: Catalogue of European
Paintings before 1500*, 1974 (catalog

124
THE VIRGIN AND
CHILD WITH
FOUR SAINTS

*Tempera and gold on panel,
6⅜ × 3⅞ in. (16.2 × 9.7 cm)
Detroit Institute of Arts; Founders
Society Purchase, Ralph Harman
Booth Bequest Fund (56.32)*

PROVENANCE

Baron Maurice de Rothschild,
Paris.

Baldini, 1970, p. 86, cat. 3 (early,
1425-28)
Pope-Hennessy, 1974, p. 223
(c. 1430-32)

BIBLIOGRAPHY

E. P. Richardson, *Bulletin of Detroit
Institute of Arts* XXXV, 1956, pp. 87-88
(1420s); E. P. Richardson, *Art Quar-
terly*, 1956, pp. 319-20 (c. 1420);
M. Salmi, 1958, p. 85; B. Berenson,
1963, p. 11; L. Berti, 1963, p. 38, n. 102;
M. Boskovits, "Adorazione," 1976,

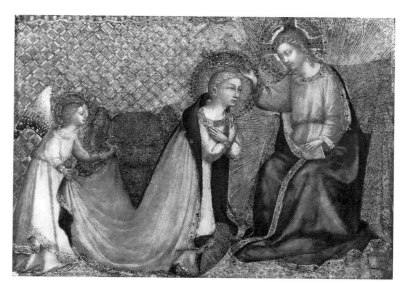

123

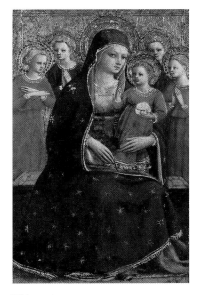

124

126

p. 31 (1425-30); *idem*, "Appunti," 1976, p. 35; *idem*, 1994, p. 346.

Probably autograph, c. 1428-32.

125
THE ANNUNCIATION
Tempera on panel,
10⅞ × 17⅜ in. (27.5 × 44 cm)
Staatliche Kunstsammlungen
Gemaldegalerie Alte Meister, Dresden

PROVENANCE
Acquired from the estate of Baron von Rumohr (1846).

BIBLIOGRAPHY
I. Lermolieff, 1880, p. 244 (young Gozzoli); K. Woermann, 1905, pp. 29f (school); F. Schottmüller, 1924, cat. 249; M. Boskovits, "Appunti," 1976, pp. 40, 51-52 n. 23 (restored in sixteenth century); *Gemaldegalerie*, 1979, p. 95, no. 7 (school).

Uncertain attribution. As noted by Boskovits, this *Annunciation* is composed of two cuspids that have been reshaped and joined together in a single panel, perhaps as early as the cinquecento. The two figures must have originally belonged to the upper register of a dismantled altarpiece.

126
SAINT BENEDICT ENJOINING SILENCE
Fresco
Cloister of the Monastery of the Badia, Florence

Baldini, 1970, cat. 122 (Master of the Chiostro degli Aranci)
Pope-Hennessy, 1974, p. 237 (Master of the Chiostro degli Aranci, Giovanni di Gonsalvo?)

SOURCE
Vasari, 1568, II, pp. 513–14: "In the Badia of the same city [Florence] he painted over a door in the cloister a Saint Benedict who makes a gesture of silence."

BIBLIOGRAPHY
L. Collobi-Ragghianti, 1950, n. 21 (early Angelico); J. Pope-Hennessy, 1952, p. 206 (nearly effaced); M. Chiarini, 1963, *passim*; M. Boskovits, "Appunti," 1976, p. 41 (Angelico, late 1430s).

The ruinous condition of the fresco precludes a definite judgment.

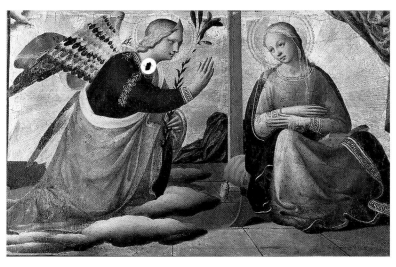

125

128

127
MINIATURES IN ANTIPHONARY
COR. [Choir Book] 43
Biblioteca Laurenziana, Florence
(not illustrated)

PROVENANCE
Reportedly from the Badia Fiorentina or San Domenico, Fiesole.

BIBLIOGRAPHY
P. D'Ancona, 1914, I, p. 57; *idem*, 1924, II, pp. 345-46 (Zanobi Strozzi); M. Boskovits, 1995, pp. 37-46, figs. 13-14, 16-18, 20, 21.

Uncertain attribution. Previously assigned to Zanobi Strozzi by all scholars, several of the small miniatures in this antiphonary have recently been assigned by Boskovits to Fra Angelico himself.

128
THE THEBAID
Tempera on panel,
29⅝ × 81⅞ in. (75 × 208 cm)
Galleria degli Uffizi, Florence

Baldini, 1970, p. 117, cat. 124 (Starnina)
Pope-Hennessy, 1974, p. 238 (probably Starnina)

Other Versions

THE THEBAID
Tempera and gold(?) on panel,
29 × 41⅜ in. (73.5 × 105 cm)
Szépmuvészeti Muzeum,
Budapest (no. 7)

THE THEBAID
Tempera and gold(?) on panel,
dimensions unknown
Collection Bartolini Salimbeni, Florence
(Provenance: Sale Palazzo Internazionale delle Arti, Florence, November 20, 1970, no. 113)

BIBLIOGRAPHY
R. Longhi, 1940, p. 173; M. Salmi, 1958, p. 93 (late work by Starnina; measurements do not coincide precisely with Medici inventory);

129

M. Boskovits, "Adorazione," 1976, p. 53 n. 46 (not by Angelico); M. Boskovits, 1978 nn. 4-5 (publishes Budapest version); A. De Marchi, 1992, pp. 148-49n; M. Boskovits, 1994, p. 365 n. 46 (all three versions are early works by Angelico); C. B. Strehlke, 1994, p. 26 (early Angelico).

Traditionally assigned to Starnina, this famous panel was assigned by Roberto Longhi to Fra Angelico, who cited in support the 1492 inventory of Lorenzo de' Medici, which cites "Una tavoletta di legname di bra. 4 in circha, di mano di fra Giovanni, dipintovi piu sotrie di santi padri, f. 25." The most recent scholarship has tended to regard this work as one of the earliest extant works by Angelico. In my opinion, however, the rediscovery of the works of Starnina makes it possible to recognize the *Thebaid* in the Uffizi as a fine and characteristic work by this older painter, who was probably the master of Guido di Pietro, called Fra Angelico. It is difficult, if not impossible, to reconcile the style of the *Thebaid* with the known juvenilia of Fra Angelico, for example, the San Domenico Altarpiece (cat. 15). The other known versions of the *Thebaid* seem to be workshop productions, such as are frequently encountered in Starnina's late period.

130

129
SAINT JOHN THE BAPTIST
Tempera and gold on panel,
4⅛ × 7⅛ in. (10.3 × 18 cm)
Museum der Bildende Kunste, Leipzig

Baldini, 1970, p. 117, cat. 127 (ruined)

BIBLIOGRAPHY
J. Crowe and G. B. Cavalcaselle, 1864, 1911 ed., II, p. 97; F. Schottmüller, 1924, p. 255; M. Salmi, 1958, p. 93 (ruined); B. Berenson, 1963, p. 11.

This small panel, probably a fragment, has been only infrequently discussed on account of its ruinous condition.

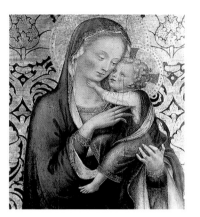

131

130
MADONNA AND CHILD WITH ANGELS
Tempera and gold on panel,
11⅞ × 8¾ in. (30 × 22 cm)
National Gallery, London (no. 5581)

PROVENANCE
Miss Rogers collection (as Giotto, prior to 1844); Samuel Rogers, sale May 2, 1856, lot 614 (as Giotto); Charles Sackville Bale, sale May 14, 1881, lot 290 (as Angelico); Cook collection, Richmond, Surrey, until purchased by National Gallery in 1945.

Baldini, 1970, p. 117, cat. 129 (other works ascribed)
Pope-Hennessy, 1974, p. 228 (not Angelico or Gozzoli)

BIBLIOGRAPHY
G. Waagen, 1854, p. 267; R. L. Douglas, 1903, p. 108 (Boccati); Borenius,

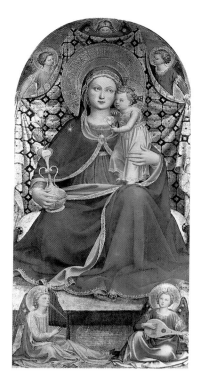

132

1913, cat. 15 (school); F. Schottmüller, 1924, p. 252 (dubious); B. Berenson, 1932, p. 172 (Domenico Veneziano?); R. Longhi, 1940, pp. 174-75 (Angelico); M. Salmi, 1947, p. 82 (early Piero della Francesca); J. Pope-Hennessy, 1952, p. 201 (not Angelico); M. Davies, 1961, pp. 36-37 (painter influenced by Angelico); B. Berenson, 1963, p. 95 (early Benozzo Gozzoli); M. Boskovits, 1995, p. 36 (Benozzo Gozzoli before 1450).

Benozzo Gozzoli.

131
MADONNA AND
CHILD
Tempera and gold on panel,
17¾ × 14¾ in. (45 × 37.5 cm)
The Norton Simon Foundation,
Los Angeles (F.1965.1001.P)

PROVENANCE

Stated to have come from the Oratorio dei Crociferi, Messina; Collection Lazzeri, Messina; Marchese Palermo; Mme Benjamin, Paris (1922); Duveen's, New York.

Baldini, 1970, cat. 47 (c. 1435)
Pope-Hennessy, 1974, p. 228 (not by Angelico nor his workshop)

BIBLIOGRAPHY

M. Salmi, 1958, pp. 63, 123 (late, comparable in style to the Bosco ai Frati Altarpiece).

Uncertain attribution.

132
MADONNA AND
CHILD WITH
FIVE ANGELS
Tempera and gold on panel,
39⅜ × 19⅜ in. (100 × 49 cm)
Thyssen-Bornemisza Collection, Madrid

PROVENANCE

Reportedly the painting cited by Vasari in Palazzo Gondi, Florence; King of the Belgians; Kleinberger,

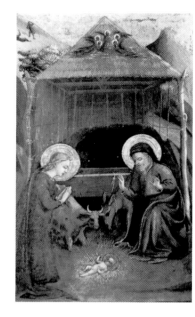

134

Paris (1909); New York, J. Pierpont Morgan, New York (1910).

Baldini, 1970, p. 90, cat. 19 (1430-33)
Pope-Hennessy, 1974, p. 229 (other works ascribed, c. 1450)

BIBLIOGRAPHY

A. Venturi, 1909, pp. 319-20 (before 1433); F. Schottmüller, 1911, p. 92; *idem*, 1924, p. 98 (1435-45); R. van Marle, 1928, x, pp. 139-40 (Gozzoli?); P. Muratoff, 1930, p. 84 (1430-33); B. Berenson, 1932, p. 22; L. Venturi, 1933, II, pl. 175 (pre-1433); L. Collobi-Ragghianti, 1950, p. 25; J. Pope-Hennessy, 1952, p. 201 (workshop); M. Salmi, 1958, p. 102; B. Berenson,

1963, p. 14; R. Heinemann, 1969, pp. 12-13; M. Boskovits, "Appunti," 1976, p. 42 (Angelico, c. 1435).

Probably a late work, 1445-49.

133
CRUCIFIXION
Tempera and gold on panel, cutout,
18½ × 14¼ in. (47 × 36 cm)
Saibene collection, Milan

PROVENANCE

Conte Carlo Gamba, Florence.

BIBLIOGRAPHY

O. Sirén, 1905, p. 90; R. van Marle, 1928, x, p. 168, n. 3 (Lorenzo Monaco); W. Suida, 1929, p. 392 (Lorenzo Monaco); A. Gonzalez-Palacios, 1970, p. 34 n. 241 (Lorenzo Monaco); M. Eisenberg, 1989, p. 198 (imitator of Monaco and of Angelico, active 1425-50); M. Boskovits, 1994, pp. 348-49 n. 32 (ill. p. 348; Angelico's contribution confined to retouches of a work by Lorenzo Monaco).

Uncertain attribution.

134
NATIVITY
Tempera and gold on panel,
11⅛ × 6⅞ in. (28.3 × 17.5 cm)
The Minneapolis Institute of Arts;
Bequest of Miss Tessie Jones in memory
of Herschel V. Jones (68.41.8)

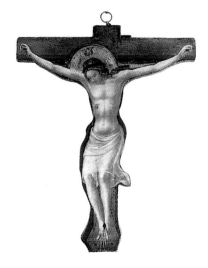

133

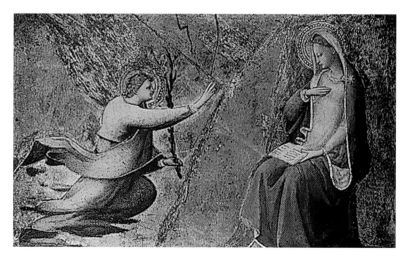

135

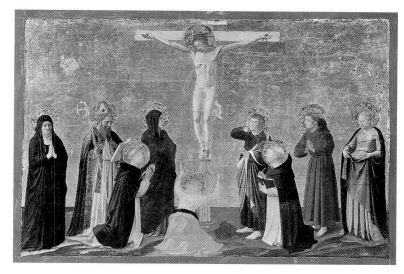

136

PROVENANCE

Possibly Borghese collection, Rome;
Marczell von Nemes collection,
Munich; Herschel V. Jones, Minne-
apolis (from 1930); Miss Tessie
Jones, Minneapolis, who bequeathed
it to the Institute of Arts in 1968.

Pope-Hennessy, 1974, p. 229 (not
by Angelico or his workshop)

BIBLIOGRAPHY

F. Schottmüller, 1924, p. 242 (pupil
of Angelico); L. Collobi-Ragghianti,
"Zanobi Strozzi," 1950, p. 463;
A. Clark, 1968, p. 63; *idem*, 1969,
p. 69 (workshop); *European Paintings*,
1971, p. 385, no. 204; M. Boskovits,
"Adorazione," 1976, p. 38 (among
earliest), p. 41 (possibly originally
formed part of a portable triptych
with New Haven panels); M. Bos-
kovits, 1994, pp. 357, 361.

Uncertain attribution.

135
ANNUNCIATE ANGEL
THE VIRGIN
ANNUNCIATE

*Tempera and gold on fragmentary
panels, 7¼ × 11¼ in. (18.4 × 28.6 cm)
Yale University Art Gallery, New
Haven, Connecticut; Gift of Hannah D.
and Louis M. Rabinowitz (1959.15.6)*

PROVENANCE

Albertini collection, Pistoia; Rabin-
owitz collection, New York.

BIBLIOGRAPHY

L. Venturi, 1945, p. 15 (Fra Filippo
Lippi); C. L. Ragghianti, 1949, p. 80
(as Zanobi Strozzi); C. Seymour,
1961, p. 18 (near Maestro della Croci-
fissione Griggs, Giovanni Toscani);
M. Boskovits, "Adorazione," 1976,

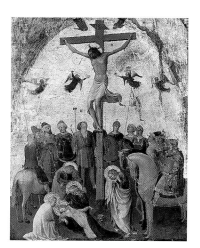

137

pp. 38, 41 (Angelico, possibly part of
portable triptych); M. Boskovits,
1994, pp. 357, 361.

Uncertain attribution. Boskovits
compares to cat. 134, above.

136
CRUCIFIXION WITH
THE VIRGIN AND
SAINTS MONICA,
AUGUSTINE, DOMINIC,
MARY MAGDALENE,
JOHN THE EVANGELIST,
THOMAS AQUINAS,
FRANCIS, AND
ELIZABETH OF
HUNGARY

*Tempera and gold on panel,
15¾ × 19¾ in. (40 × 50 cm)
The Metropolitan Museum of Art,
New York; Bequest of Benjamin
Altman, 1913 (no. 14.40.628)*

PROVENANCE

Gouvello de Kériaval, Paris; Benja-
min Altman, New York.

Baldini, 1970, p. 108, cat. 105 (1440)
Pope-Hennessy, 1974, p. 229 ("it is
not impossible that it was painted
about 1440-45 by Fra Angelico")

BIBLIOGRAPHY

J. Crowe and G. B. Cavalcaselle,
1864, 1911 ed., p. 22; F. Schottmüller,
1924, p. 243 (dubious, pictures be-
fore cleaning with two palm trees
in background); R. van Marle, 1928,
x, p. 160 (workshop); J. Pope-
Hennessy, 1952, p. 201 (workshop,
recalls Master of Cell 36); M. Salmi,
1958, p. 89, identifies it with a de-
scription of a Fra Angelico that
hung in the *anticamera* of Piero di
Lorenzo in the Palazzo Medici,
described in 1492: "a small square
picture painted with a Christ on
the Cross with 9 figures around
him" (quoted by E. Müntz, 1888,
p. 86); B. Berenson, 1963, p. 14
(restored); F. Zeri and E. Gardner,
1971, pp. 78-79.

A severely damaged, but autograph,
work, c. 1445.

137
THE GRIGGS
CRUCIFIXION

*Tempera and gold on panel,
25¼ × 19⅜ in. (64 × 49 cm)
The Metropolitan Museum of Art,
New York; Bequest of Maitland
Fuller Griggs, 1943 (43.98.5)*

PROVENANCE

Charles A. Loeser, Florence; Count
Gregory Stroganoff, Rome (until
1911); Princess Serbàtov, Rome (until
c. 1914); Rome, private collection
(until c. 1925); Edward Hutton,
London (?); Maitland Fuller Griggs,
New York (1925); by bequest to
the Metropolitan Museum of Art
in 1943.

BIBLIOGRAPHY

R. Offner, 1933, p. 166 (Master of
the Griggs Crucifixion); L. Venturi,
1933, II, cat. 185 (as Masolino);
R. Longhi, 1940, p. 43 (Master of
the Griggs Crucifixion); L. Bellosi,
1966, pp. 44-58; F. Zeri and E.
Gardner, 1971, pp. 75-77; M. Eisen-
berg, 1976, pp. 275-83 (Giovanni
Toscani); H. Wohl, 1980, p. 84
(Giovanni Toscani); L. Bellosi in
Arte in Lombardia, 1988, p. 196
(early Angelico); A. De Marchi
in L. Bellosi, 1990, p. 85; C. B.
Strehlke, 1994, pp. 324-6 (early
Angelico); M. Boskovits, 1994,
pp. 365 (early Angelico).

Not by Fra Angelico. This famous
problem piece cannot be associated
with the Uffizi *Thebaid*, cat. 128,
or the *Saint Jerome* in Princeton,
cat. 139.

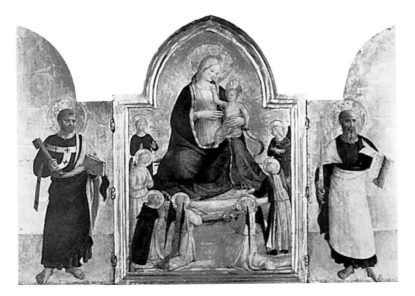

138

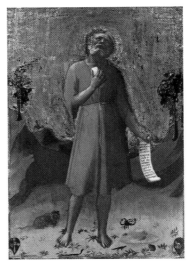

139

n. 30 (dates to beginning of the 1420s, citing Bellosi); C. B. Strehlke, 1994, p. 31 (1424-25).

The attribution remains undecided between Masolino and Fra Angelico. Kollewijn has fixed the date of its inscription to 1424-25.

140
TRIPTYCH: ASCENSION, LAST JUDGMENT, PENTACOST

Tempera and gold on panel,
21¾ × 15 in. (55 × 38 cm) (center)
22⅛ × 7⅛ in. (56 × 18 cm) (wings)
Galleria Nazionale, Rome
(Barberini; no. 723)

Baldini, 1970, p. 109, cat. 110 (1447)
Pope-Hennessy, 1974, p. 218 (3 panels designed by Angelico and central panel at least autograph)

BIBLIOGRAPHY
P. V. Marchese, 1845, 3d ed. 1869, I, p. 446; J. Crowe and G. B. Cavalcaselle, 1864, 1911 ed., IV, p. 92 (altered in shape); B. Berenson, 1896, p. 120; *idem*, 1900, pp. 101-2; R. L. Douglas, 1900, p. 198; S. Beissel, 1905, p. 120 (executed for Santa Maria Sopra Minerva); F. Schottmüller, 1911, pp. 149-51; *idem*, 1924, pp. 163-64

138
TRIPTYCH: THE VIRGIN AND CHILD WITH SAINT DOMINIC AND SIX ANGELS BETWEEN SAINTS PETER AND PAUL

Tempera and gold on panel (laid down on later panel): 15⅛ × 7⅞ in. (38.3 × 20 cm) (center), 15⅛ × 4⅜ in. (38.3 × 10.9 cm) (right), 15⅛ × 4½ in. (38.3 × 11.4 cm) (left)
Ashmolean Museum, Oxford (no. 42)

PROVENANCE
Fox-Strangeways Gift (probably 1834).

Baldini, 1970, p. 107 (sub cat. 91, ascribed to the Master of Cell 36)
Pope-Hennessy, 1974, p. 230 ("pastiche of Angelico's work painted about 1450 by a provincial artist for some local Dominican community")

BIBLIOGRAPHY
T. Borenius, 1916, no. 47 (late imitator of Florentine fifteenth-century painting); R. van Marle, 1928, x, p. 161 (rejects); L. Collobi-Ragghianti, 1955, p. 47 (Master of Cell 36); B. Berenson, 1963, p. 14 (wings, studio); J. Byam-Shaw, 1967, pp. 39-40, cat. 20 (studio); D. A. Covi, 1986, no. 101.b (the inscription is a short-ened version of the inscription on the Louvre Coronation of the Virgin); M. Boskovits, 1976 (*idem*, 1994 ed., p. 354n, workshop execution, 1430).

Uncertain attribution. The high quality of this triptych has been persuasively defended by both Byam Shaw and Boskovits. The attenuated proportions of the lateral saints (which Berenson ascribed to the master's workshop) suggest a date later than 1440.

139
SAINT JEROME

Tempera and gold on panel,
19¾ × 13⅞ in. (50 × 35 cm)
Princeton University Art Museum,
New Jersey (no. 63.1)

PROVENANCE
Formerly Mather collection, Washington Crossing.

Baldini, 1970, p. 86 (1424-25)
Pope-Hennessy, 1974, p. 231 (Master of the Griggs Crucifixion)

BIBLIOGRAPHY
R. Offner, 1920, pp. 68-76 (Masolino); A. Venturi, 1924, pp. 132-34 (Masolino); R. Offner, 1930, pp. 68-70 (painting carries arms of Ridolfi and Gaddi families and likely to commemorate a marriage of 1424); B. Berenson, 1932, p. 513 (as Sassetta); J. Pope-Hennessy, 1939, pp. 183-84 (Masolino); R. Longhi, 1940, p. 174 (Angelico); L. Collobi-Ragghianti, 1955, pp. 23ff. (Angelico, 1423-24); M. Salmi, 1958, p. 97 (possibly by Angelico, 1424-26); L. Berti, 1963, p. 38; M. Meiss, 1974, p. 139 n. 12 (circle of Masaccio); M. Eisenberg, 1976, pp. 275-83 (Giovanni Toscani); M. Boskovits, "Adorazione," 1976, p. 31 (Angelico, 1425-30); U. Baldini, 1977, p. 240; H. Wohl, 1980, p. 84 n. 30; L. Bellosi in *Arte in Lombardia*, 1988, p. 196 (beginning 1420s); R. Kollewijn, 1990, pp. 413-20 (1424-25 indicated by iconography); M. Boskovits, 1994, pp. 346-47

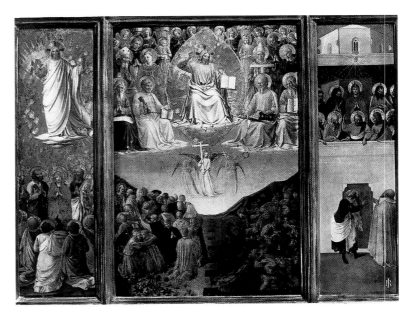

140

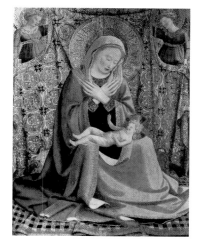

141

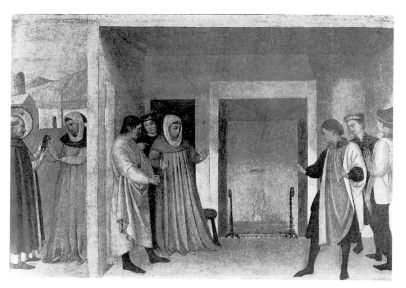

143

Knoedler's New York; Andrew W. Mellon (1937).

Baldini, 1970, p. 89, cat. 15 (1430-33)
Pope-Hennessy, 1974, p. 233
 (Zanobi Strozzi, 1440-45)

BIBLIOGRAPHY

National Gallery, 1945, pp. 5-6 (1430-40); J. Pope-Hennessy, 1952, p. 204 (Zanobi Strozzi); C. Gómez-Moreno, 1957, p. 192 n. 35; M. Salmi, 1958, pp. 17, 102; B. Berenson, 1963, p. 15; B. Fredericksen and F. Zeri, 1972, p. 645; F. Shapley, 1979, p. 13, cat. 5 (as attributed to, studio 1430/35); M. C. Impronta, in San Marco, 1990, p. 68 n. 9 (1413).

Uncertain attribution.

(denies wings as part of central panel, not as good as Berlin); R. van Marle, 1928, x, pp. 133–34; P. Muratoff, 1930, p. 84 (assistant, 1425-30); B. Berenson, 1932, p. 107; G. Bazin, 1949, p. 46 (rejects); J. Pope-Hennessy, 1952, p. 191 (rejects wings); B. Berenson, 1963, p. 15; L. Castelfranchi-Vegas, 1989, pp. 157-58 (first Roman period).

Roman workshop piece inferior to cat. 3.

141
MADONNA AND CHILD WITH TWO ANGELS (MADONNA OF HUMILITY)
Tempera and gold on panel,
24 × 18 in. (61 × 45.5 cm)
National Gallery of Art,
Washington, D.C.; Andrew W.
Mellon Collection (1937.1.5.5)

Inscribed on Virgin's halo: ave Maria gratia plena Do[minus tecum] (Luke 1:28)

PROVENANCE

Edward Steinkopff, London and Lyndhurst (acquired in Italy during nineteenth century); Lady Seaforth (Mary Margaret Stewart-MacKenzie), Brahan Castle, Canon Bridge, Scotland (d. 1933);

142
CRUCIFIXION WITH THE VIRGIN AND SAINT JOHN
Tempera and gold on parchment,
page from a missal, 5 × 6¾ in.
(12.5 × 17 cm)
Private collection (not illustrated)

PROVENANCE

Stefano Taverna, Bishop of Milan; sale, Hoepli collection (1932), Milan, as Niccolò da Bologna.

BIBLIOGRAPHY

M. Boskovits, "Appunti," 1976, pp. 35, 48 n. 10, fig. 9 (in Kunst-historisches Institut, Florence, as Lorenzo Monaco).

Uncertain attribution.

143
DISPUTATION OF SAINT DOMINIC AND THE MIRACLE OF THE BOOK
Tempera and gold on panel,
9½ × 13⅝ in. (24 × 33.5 cm)
Location unknown

PROVENANCE

Collection Sir Thomas Barlow, London; R. C. Witt; Hon. Robert Bruce; Lord Rothmere (exh. Burlington Fine Arts Club, London, 1919, as Masolino).

Baldini, 1970, cat. 56 (1436-37)
Pope-Hennessy, 1974, p. 228
 (ruinous condition, doubtful)

BIBLIOGRAPHY

B. Berenson, "Quadri senza," 1932, p. 524 (ruined work, c. 1440); B. Berenson, 1963, p. 14 (restored).

144
HEAD OF CHRIST
Detached fresco, 14⅝ × 11⅞ in.
(37 × 30 cm)
Museo di Palazzo Venezia, Rome
(not illustrated)

PROVENANCE

Found in the Monastery of Santa Chiara in Piperno in 1921.

BIBLIOGRAPHY

R. Papini, 1921, pp. 37-38 (Gozzoli); A. Padoa-Rizzo, 1992, cat. 25 (Gozzoli); M. Boskovits, 1995, p. 38 (Fra Angelico).

Boskovits's attribution to Fra Angelico is convincing. This fragmentary fresco was probably saved from one of the artist's destroyed fresco cycles in Rome, 1446-49.

COMPARATIVE ILLUSTRATIONS

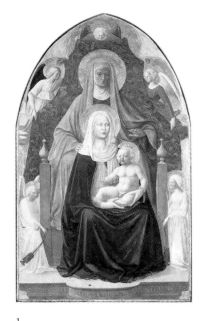

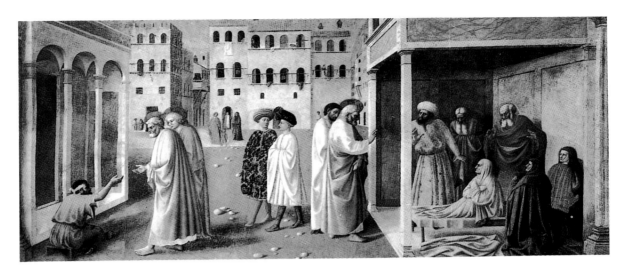

1

2

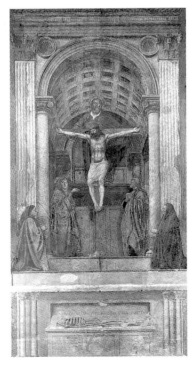

3

1. Masolino and Masaccio, *Sant'Anna Metterza Altarpiece*. Galleria degli Uffizi, Florence.
2. Masolino, *Saint Peter Healing the Lame* and *The Raising of Tabitha*. Cappella Brancacci, Santa Maria del Carmine, Florence.
3. Masaccio, *Tribute Money*. Cappella Brancacci, Santa Maria del Carmine, Florence.
4. Masaccio, *Trinity*. Santa Maria Novella, Florence.
5. Gentile da Fabriano, *Adoration of the Magi*. Galleria degli Uffizi, Florence.

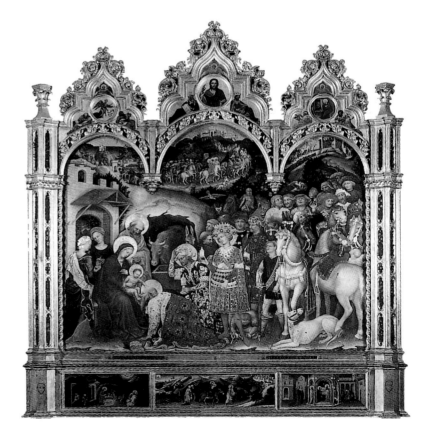

4

5

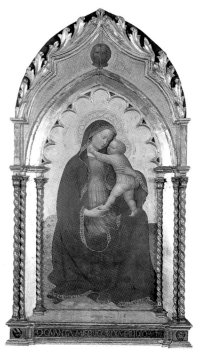

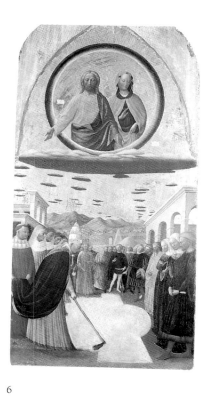

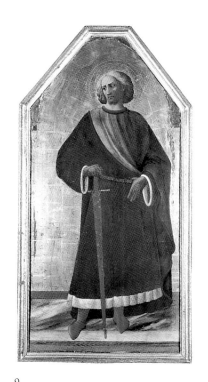

6 7 8 9

6. Masolino, *The Foundation of Santa Maria Maggiore*. Museo Nazionale di Capodimonte, Naples.
7. Masolino, *Madonna dell'Umiltà*. Kunsthalle, Bremen.
8. Gherardo Starnina, *Saint Benedict*. Convento del Carmine, Florence.

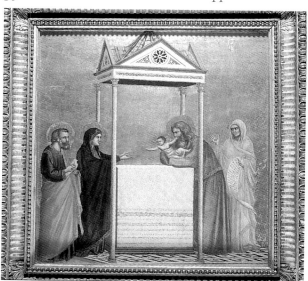

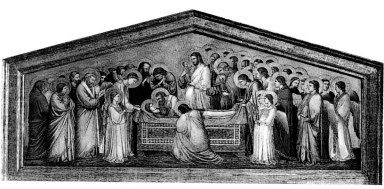

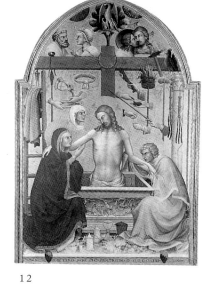

10 11 12

9. Masolino, *Saint Julian*. Santo Stefano a Ponte, Florence.
10. Giotto, *Madonna in Majesty*. Galleria degli Uffizi, Florence.
11. Giotto, *Dormition of the Virgin*. Staatliche Museen, Berlin.
12. Lorenzo Monaco, *Man of Sorrows*. Accademia, Florence.
13. Giotto, *Presentation in the Temple*. Isabella Stewart Gardner Museum, Boston.
14. Attributed to Gherardo Starnina, *Last Judgment*. Alte Pinakothek, Munich.

13 14

NOTES

LIFE AND WORKS

1. He was traditionally known as Beato Angelico in Italy long before his formal beatification by Pope John Paul II on October 3, 1982. For the papal text, *Qui res Christi gerit*, see T. S. Centi, 1984, pp. 144-49.

2. See T. S. Centi, 1984, pp. 5-53, for a defense of the traditional view, based on Vasari and a notation of 1407 in the 16th-century *Chronaca Quadripartita* of San Domenico, Fiesole, now generally rejected by scholars, which placed the artist's birth around 1386 and postulated his exile, with other Dominican Observantists in Cortona and Foligno from 1409 to 1417.

3. The information that he was born near Vicchio dates back to the 16th-century *Chronaca* of the convent of San Domenico in Fiesole. See *Mostra*, 1955, document 44. C. Gilbert, 1984, p. 283, calculated that 1400 would be the latest possible date for Angelico's birth.

4. W. Cohn, 1955, pp. 210-11.

5. W. Cohn, 1955, document 3-5.

6. S. Orlandi, 1964, p. 7.

7. W. Cohn, 1955, document 3-4.

8. W. Cohn, 1956, pp. 218-20. Ambrogio di Baldese executed paintings in this chapel 1415-17. Cf. S. Orlandi, 1964, p. 8.

9. E. Marino, 1984, p. 42 n. 101, lists some of the proposed identifications of Angelico's master.

10. G. C. Argan, 1955, pp. 10-11, has commented on Vasari's self-imposed censorship, noting that Vasari put Fra Angelico first in the list of students of Masaccio's Brancacci Chapel but omitted any such influence in Fra Angelico's biography since (in Argan's paraphrase) "if his painting is divinely inspired, there is no point in assigning it to historical sources."

11. G. Milanesi in Vasari, 1568, II, p. 527.

12. A notable exception is G. C. Argan, 1955, p. 11: "not until Filippo Baldinucci in the 17th century, and Luigi Lanzi in the 18th, made the first systematic attempt to sort out the Italian schools of painting, did Fra Angelico take his rightful place in the rise of Florentine painting."

13. F. Baldinucci, 1681 (Florence, 1974 ed.), I, pp. 414-15.

14. S. Orlandi, 1954 (1), pp. 163-67; cf. T. S. Centi, 1984, p. 22, for a different reading of this document.

15. O. Sirén, 1904, pp. 349-52.

16. J. van Waadenoijen, 1982, p. 39.

17. M. Boskovits, 1991, cat 9. *Madonna in trono col Bambino tra i Santi Antonio Abate, Francesco, Maria Maddalena e Lucia*, tempera, 42¾ × 21⅞ in (108.5 × 55.5 cm).

18. See cat. 127, below.

19. R. Longhi, 1940 (1975 ed.), pp. 38, 50 n. 16.

20. R. Longhi, 1940 (1975 ed.), p. 50 n. 17: "una tavoletta di legname di bra. 4 in circha, di mano di fra Giovanni, dipintovi più storie dei santi padri."

21. J. Crowe and G. B. Cavalcaselle, 1864, 1911 ed., II, p. 19.

22. W. Cohn, 1955, pp. 210-11.

23. W. Cohn, 1956, pp. 218-20.

24. C. Gilbert, 1984, pp. 282-83.

25. C. Gilbert, 1984, p. 283.

26. D. Cole, 1977, pp. 95-96.

27. Benedetto also professed at San Domenico, Fiesole, and Checca's son was Angelico's assistant in Rome and Orvieto.

28. If Angelico was in fact a member of Starnina's workshop, his master's unexpected death in 1413 would have left him orphaned again in the sense of losing the guardian of his career.

29. C. Gilbert, 1984, p. 283; W. Hood, 1993, pp. 9-10.

30. A. De Marchi, 1992, p. 138; Vasari, 1568, II, 513.

31. E. Marino, 1984, pp. 44-45.

32. A. De Marchi, 1992, pp. 135-38, is my source for this discussion of a possible connection between Dati's activities and Angelico's early career.

33. M. Meiss, *Painting in Florence and Siena after the Black Death*, first published in 1951, remains the classic study of this period.

34. See W. Hood, 1993, *passim*, for historical information on the Dominican Observance and for a detailed interpretation of Fra Angelico's art from this particular perspective.

35. N. Rubinstein, 1990, p. 74.

36. Cosimo's patronage of Observantist reform has recently been studied by Nicolai Rubinstein, 1990, pp. 63-82, and Crispin Robinson, 1992, pp. 181-94. In response, perhaps, to these studies, W. Hood, 1995, pp. 14-16, allows Cosimo de' Medici more importance in the transfer of the Dominican Observantists to San Marco than in his previous monograph (1993); Hood continues to deny Cosimo any role in the iconographical program of San Marco apart from the representation of the Medici name saints. See J. T. Spike, 1993, p. 52.

37. For recent scholarship on Zanobi Strozzi, see M. Levi D'Ancona, 1994, pp. 69-74.

38. S. Orlandi, "Beato Angelico," 1954, p. 170.

39. M. Boskovits, "Adorazione," 1976, p. 21.

40. J. Henderson and P. Joannides, 1991, pp. 3-6.

41. For the author's views on Masaccio, see J. T. Spike, 1995. The standard *catalogue raisonné* is P. Joannides, 1993.

42. M. Boskovits, 1966, pp. 52, 63.

43. B. Berenson, 1952, p. 49.

44. L. Berti, "Miniature," 1962, p. 278.

45. See my reconstruction of this fresco, in J. T. Spike, 1995, cat. 5F. By the same token, it is possible that the Angelico school illuminations of Saint Peter (c.60v) and Saint Paul (c.61v), with their characterizations *all'antica*, conserve a memory of the famous pair of lost frescoes of these saints in the Carmine Church by Masolino and Masaccio, respectively.

46. A. De Marchi, 1992, p. 136.

47. T. S. Centi, 1984, p. 54.

48. A. De Marchi, 1992, p. 135. The influence of Starnina on Ghiberti's early pictorial designs, for example, the *Vetrata con S. Lorenzo* in the Duomo (1412-15), should be underscored.

49. A. Ladis, 1981, pp. 378-79.

50. C. de Benedictis, 1991, p. 20, "The behavior and cultural climate of the city's *elite* were deeply influenced by the humanists, who thus determined the quality, features, and aspirations of art collecting in the fifteenth century."

51. E. Müntz, 1888, pp. 60, 64, 85, 86; cf. J. Pope-Hennessy, 1974, p. 238.

52. The proposal by S. Orlandi, 1964, pp. 29-30, to associate the *Last Judgment* with the decision on August 31, 1431, to construct the Oratorio degli Scolari was mainly accepted by subsequent scholars; however, the hypothesis was firmly rejected in the monographic study by A. Santagostino Barbone, 1989, pp. 261-62.

53. C. Somigli, 1988, p. 196. Cf. A. Santagostino Barbone, 1989, p. 272.

54. P. Castelli, 1982, p. 44, describes Traversari as almost a "coordinator and prompter of artistic activity in the second quarter of the fifteenth century."

55. R. Krautheimer, 1956, pp. 178-87.

56. Years after the fact, in his *Commentari*, Ghiberti asserted his creative independence in his designs for the bronze doors, but his reference (1947, p. 3) to the necessity for an artist to listen diligently to philosophy should also be weighed in this context.

57. A. Santagostino Barbone, 1989, p. 270, n. 63, identifies all of these saints. The unidentified Old Testament personage seated next to Abraham might represent Melchizedek.

58. Quoted by J. Miziolek, 1990, p. 53.

59. J. Miziolek, 1990, p. 53.

60. A. Santagostino Barbone, 1989, p. 272, whose research underscores the necessity to reconstruct the unique iconographical program of this painting.

61. J. Henderson and P. Joannides, 1991, pp. 3-6.

62. See the contradictory discussions in D. D. Davisson, 1975, pp. 315-47, and R. Jones, 1984, pp. 9-106; cf. S. Orlandi, 1964, document IX, for gifts made by Palla Strozzi to San Domenico, Fiesole, in 1431-32.

63. See the discussion in M. Eisenberg, 1989, p. 97.

64. Henry James, "The Autumn in Florence," 1873, in *Italian Hours*, 1987, p. 274.

65. D. D. Davisson, 1975, p. 323.

66. Unfortunately, the loss of Masolino's landscapes in the lunettes of the Brancacci Chapel makes it impossible to know whether they also might have influenced Fra Angelico. See J. T. Spike, 1995, p. 46.

67. A. Ronen, 1992, p. 611. The significance of this inscription was first pointed out by A. Parronchi, 1966, pp. 41-42. According to some sources, Ambrogio Traversari also had knowledge of Hebrew.

68. Masaccio had died in 1428, and Masolino is believed to have departed for Rome shortly after March 10, 1429.

69. G. C. Argan, 1955, p. 72.

70. J. Ruskin, 1873, III, p. 105.

71. P. Joannides, 1993, cat. 28, 29, and P. L. Roberts, 1993, cat. XI, XII, differ as to the dates of these two paintings.

72. Vasari, 1568, II, p. 297.

73. The increased attention in Florentine paintings to the interior of the Virgin's room has been justifiably mooted as a possible reflection of contemporary Netherlandish treatments of this theme; Masolino's and Fra Angelico's *Annunciations* differ notably from northern models, however, for their use of one-point perspective and for their lack of interest in surrounding the Virgin with a panoply of symbolic objects.

74. An exception would be the lost *Annunciation* that Vasari (1568, II, p. 507) noted on the wings of an organ in Santa Maria Novella.

75. P. Joannides, 1989, pp. 303-4.

76. W. Hood, 1993, p. 102.

77. Saint Francis was the patron saint of Pier Francesco, Cosimo's nephew, the son of Lorenzo. Recently, F. Ames-Lewis, 1993, p. 212, has suggested a connection between this figure and Lorenzo's other son, also named Francesco.

78. C. Elam, in F. Ames-Lewis, 1992, p. 169, states that Giovanni di Bicci completed this chapel before his death in 1429, a fact that might also bear upon the date of this altarpiece.

79. Cf. I. Ciseri, in *San Lorenzo*, 1993, p. 75.

80. Perhaps its frame resembled that of the coeval Cortona *Annunciation*, which is equally groundbreaking in its classicism and rectilinearity.

81. *Letter to the Philippians* (3:20): "our conversation is in heaven." See R. Goffen, 1979, p. 199.

82. J. Ruda, 1978, pp. 358-61.

83. L. Castelfranchi-Vegas, 1989, pp. 83-84.

84. M. Alexander, 1977, p. 154.

85. S. Orlandi, 1964, p. 44.

86. By curious coincidence, Fra Angelico was called upon in 1434 to evaluate a 1433 altarpiece by Bicci di Lorenzo, which was merely a rehash of Gentile's Quaratesi altarpiece of 1425. See S. Orlandi, 1964, p. 53.

87. U. Middeldorf, 1955, p. 186.

88. M. Alexander, 1977, pp. 154-63.

89. See cat. 13.

90. S. Orlandi, 1964, p. 47.

91. No record of Fra Angelico's ordination is preserved.

92. *Mostra*, 1955, document III.

93. F. Carbonai–M. Salmi, in *San Marco*, 1989, p. 262. For a conflicting view, namely, that Giovanni Dominici's requests were firmly rejected in 1418, see M. Ferrara and F. Quinterio, 1984, p. 185. Cf. also T. S. Centi, 1984, p. 81.

94. G. Brucker, 1974, pp. 135-36.

95. K. D. Ewart, 1899, p. 42.

96. K. D. Ewart, 1899, p. 46.

97. Vespasiano da Bisticci, 1963, pp. 218-19.

98. The Silvestrines duly transferred to San Giorgio, but vociferously protested their fate at the Council of Basel, where their efforts were thwarted by Roberto de' Martelli, a Medici agent, and by Cardinal Torquemada, a friend of Fra Antonino Pierozzi. "The comportment of the Domenicans degenerated even to the shamelessness of intercepting the letters that the Silvestrines tried to send to the pope in support of their proprietorial interests." M. Ferrara and F. Quinterio, 1984, p. 186. The ensuing scandal served to increase the Domenicans' gratitude for Cosimo's support.

99. In N. Rubinstein, 1990, p. 66, whose source is R. Morçay, 1913, p. 8.

100. E. Garin, in *San Marco*, 1989, p. 80.

101. Cf. S. Orlandi, *La Beata Villana*, 1955, pp. 38-39. Beata Villana died January 29, 1361, which became her feast day. She was buried in the habit of a Domenican Tertiary, in accordance with her desire, in Santa Maria Novella. Fra Sebastiano is sometimes incorrectly called her nephew (e.g., J. Pope-Hennessy, 1974, p. 199); he was her direct descendent, however; his father, Jacopo, was the son of Villana.

102. S. Orlandi, *La Beata Villana*, 1955, p. 42.

103. Transcription as per D. A. Covi, 1986, p. 66, who identifies the source as the *Epistula ad Romanus*, chap. 7, by Saint Ignatius of Antioch. It has not previously been noted that this phrase, correctly attributed to Ignatius, also appears in the famous *Divine Names*, by Pseudo-Dionysius the Areopagite, 1987, 709B (in Italian in Turolla, 1956, p. 236). In either event, its use in this painting is testimony to the permeation of humanism in Florence by this date; there is no evidence that Beata Villana was a student of patristic texts.

104. G. C. Argan, 1955, p. 78.

105. S. Orlandi, 1964, document XVII, p. 188.

106. U. Middeldorf, 1955, p. 190n.

107. D. Cole, 1977, pp. 95-96.

108. See H. Wohl, 1980, pp. 339-40, for transcription and full discussion.

109. Cited by E. Garin, in C. Vasoli, 1980, p. 92.

110. C. Gutkind, 1940, p. 292.

111. Vespasiano da Bisticci, 1963, p. 34.

112. L. Bruni, quoted in E. Garin, 1941, p. 73.

113. E. Garin, in *San Marco*, 1989, p. 89.

114. L. Castelfranchi Vegas, 1989, p. 40.

115. E. Garin, in *San Marco*, 1989, p. 81.

116. E. Garin, in *San Marco*, 1989, p. 88.

117. L. Marchetti, 1993, p. 12, emphasizes the importance of the library of San Marco for Cosimo's policies of urban development. It is but a brief distance from this observation to the hypothesis that Cosimo's interest in taking on San Marco might have been stimulated from the outset by the fact that Niccoli's library was soon to be donated to a convent.

118. There was no tradition for significant libraries in Dominican Observantist convents. W. Hood, 1993, p. 36, suggests that the formal separation of the Fiesole and San

Marco convents in 1445 was possibly inspired by resentment felt by some of the friars against the library. If so, the library's influence on the friars' lives must have been considerable.

119. Vespasiano da Bisticci, 1963, p. 223.

120. C. Elam, in F. Ames-Lewis, ed., 1992, p. 159.

121. M. Ferrara and F. Quinterio, 1984, p. 187. Fra Lapaccini in the *Cronaca di San Marco* (followed by Vasari, 1568, II, p. 441) reported that Cosimo had spent 36,000 *ducati*; Vespasiano da Bisticci, 1963, p. 219, recorded the sum as 40,000 *fiorini*.

122. Cited by M. Ferrara and F. Quinterio, 1984, p. 187.

123. Quoted in T. S. Centi, 1984, p. 95.

124. Vasari, 1568, II, p. 441.

125. R. Morçay, 1914, pp. 76-77.

126. The date of 1442 might also, therefore, be applicable to the frescoes in the so-called prior's cell (10-11) at the end of the novitiates' corridor. Unfortunately, there is very little information available regarding the chronological relationship between Michelozzo's renovations and Fra Angelico's frescoes. I am grateful to Creighton Gilbert for sharing with me his unique knowledge of these problems.

127. See L. Castelfranchi Vegas, 1989, p. 103. The sole surviving inventory of the San Marco library dates from later in the quattrocento, but the additions to Niccoli's nucleus are easily spotted (translations by Marsilio Ficino, for example), and do not affect its character. The inventory is most accessible in E. Garin, in *San Marco*, 1989, pp. 115-48. For the "canon" compiled by Parentucelli see A. Manfredi, 1988, p. 183, with additional bibliography.

128. *Mostra*, 1955, document 15.

129. C. Gilbert, 1975, p. 261, concludes that fresco painting was usually abandoned during the winter months. E. Camesasca, 1966, pp. 291-98, found evidence of practices varying from painter to painter, region to region; there are records of Vasari painting frescoes in both summer and winter, for example.

130. J. Pope-Hennessy, 1974, p. 25.

131. According to Susan McKillop (cited in W. Hood, 1993, p. 116), the zodiacal symbolism in the carpet possibly refers to the inauguration and the conclusion of the Council of Florence.

132. J. I. Miller, 1987, p. 2.

133. J. I. Miller, 1987, p. 3.

134. U. Baldini, 1970, p. 101.

135. H. Wohl, 1980, pp. 37-41 and fig. 17.

136. A. Ladis, 1993, pp. 42-45.

137. L. B. Alberti, 1956, book 3, p. 90.

138. H. Wohl, 1980, pp. 40-1.

139. W. Hood, 1993, p. 184. One could add that the splendor of this fresco—which was far more striking before its precious blue background was scraped off—was also out of character for the poor Observantists.

140. San Giovanni Gualberto is the single exception.

141. The omission of Saint Catherine of Siena from this company is a question that deserves investigation.

142. M. J. Marek, 1985, pp. 451-75.

143. G. Schiller, 1968, II, pp. 148-49. A reference to the sufferings of the pelican can be found in Psalm 102. The *Physiologus* drew numerous parallels between Christ's Passion and the pelican's supposed acts of self-sacrifice on behalf of its offspring, including piercing its own breast to nourish them with blood, and its resurrection after three days.

144. D. A. Covi, 1968, p. 115.

145. V. Alce, "Catalogo degli iscrizioni," in *Beato Angelico Miscelleanea di Studi*, 1984, p. 389; W. Hood, 1993, p. 188; P. Morachiello, 1995, p. 196.

146. E. Turolla, in his introduction to *Dionigi Areopagita*, 1956, pp. 39-44, argues convincingly that the Nicaean Council of 325 constitutes a certain *terminus ante quem* for this church father.

147. Alan Perreiah suggests an alternative translation, "the God of nature suffers."

148. The authority of sybilline prophecies was also upheld by Lactantius.

149. A. Ronen, 1992, p. 611

150. G. Brucker, 1975, p. 218.

151. C. Trinkaus, 1983, p. 255.

152. C. Trinkaus, 1983, p. 255. His excellent library of Latin, Greek, and Hebrew philosophical and religious works today forms the nucleus of the Vatican *fondo ebraico* and a large part of its *fondo palatino graeco e latino*.

153. A. Ronen, 1992, p. 604.

154. These are the terms used by Nicholas of Cusa. Cf. E. Garin, "La cultura filosofica fiorentina nell'età medicea," in V. Vasoli, ed., 1980, p. 83.

155. E. Garin, 1941, pp. 141-42. U. Proch, 1988, pp. 155-56, discusses the close relationship between the address and the formal Decree of Union, *Laetentur coeli* (July 6, 1439). It has not previously been noted that Traversari took his text from Saint Paul's Letter to the Ephesians, 2:13-20. These verses are the principal biblical basis for the redemptive program of the frescoes in the cells in San Marco.

156. G. Holmes, in F. Ames-Lewis, ed., 1992, pp. 24-25.

157. E. Marino, 1991, p. 243. Six sessions were held in Florence between January 16, 1439, and February 24, 1443; the council was then reconvened as the Concilio Lateranense in Rome by Eugenius IV on October 14, 1443. In the same article (pp. 243-44) Father Marino writes in support of the identification by E.M.L. Wakayama, 1982, pp. 93-106, of the *Story of Noah* fresco by Paolo Uccello at Santa Maria Novella as an allegory of the Council of Florence, including even the portrait of Eugenius IV.

158. The pope's extraordinary gesture of staying overnight in Cosimo's cell in San Marco certainly expresses his approval, and, no less, his sense of shared responsibility for the renovation and decoration of the convent.

159. L. Castelfranchi Vegas, 1989, p. 40.

160. P. O. Kristeller, 1980, p. 3.

161. C. Trinkaus, 1983, p. 15.

162. C. Trinkaus, 1983, p. 16.

163. C. Trinkaus, 1983, p. 18.

164. Vespasiano da Bisticci, 1963, p. 213.

165. D. Hay, 1988, p. 11.

166. C. Trinkaus, 1983, p. 253.

167. E. Marino, 1984, p. 45.

168. P. O. Kristeller, 1990, p. 40. Ambrogio Traversari actively promoted the study of the more Platonic fathers such as Basil, Gregory of Nyssa, Origen, and Dionysius the Areopagite: cf. V. Vasoli, 1988, pp. 75-88; J. Hankins, 1990, p. 64.

169. 1 Corinthians 1:22-24. Cf. Augustine, *Confessions*, vii, ix, 14.

170. *De Trinitate*, xv, 5, 8.

171. *De Trinitate*, xv, 5, 9. It is noteworthy how many times Augustine quotes in these chapters from Paul's First Epistle to the Corinthians. Cf. V. J. Bourke, 1992, pp. 121-22.

172. H. Baron, 1955, I, p. 263.

173. M. Boskovits, 1983, p. 13; W. Hood, 1993, *passim*, repeatedly notes the "anomaly" of these splendid decorations in an Observantist Dominican convent.

174. S. Jayne, 1985, p. 17. See G. Didi-Huberman, 1995, p. 179, who discusses the similarities between the "hybrid reasoning" of Plato and Dominican exegesis. P. Brown, 1967, p. 97, describes Plotinus's rejection of the "long pedestrian processes of discursive reasoning."

175. *Summa contra Gentiles*, 1.57. Cf. S. Jayne, 1985, pp. 17-18.

176. J. Pelikan, "Introduction," *Pseudo-Dionysius: The Complete Works*, 1987, p. 21, estimates that Saint Thomas cites Pseudo-Dionysius about 1,700 times.

177. A. Manfredi, "Per la biblioteca di Tommaso Parentucelli," in P. Viti, ed., 1994, p. 670.

178. *Ecclesiastical Hierarchy* 5, 501b and 10, 273c.

179. *Ecclesiastical Hierarchy* 3, 432c.

180. Axters and Hood have pointed out parallels between the different postures adopted by Saint Dominic in these frescoes and the Dominican prayer manuals then in use, especially the thirteenth-century *De modo orandi*.

181. *Ecclesiastical Hierarchy* 5, 504c.

182. W. Hood, 1993, p. 208.

183. W. Hood, 1993, pp. 218-20.

184. *Celestial Hierarchy* 7, 205c.

185. W. Hood, 1993, pp. 209-10, who does not distinguish, however, between the frescoes in cells 1-9 and 22-29: "On both sides of the clerics' dormitory Crucifixes are intermingled with compositions clearly based on historiated subjects, and the subjects are arranged in no apparent sequence." C. Gilbert, 1978, pp. 710-13, distinguished these rows of cells.

186. Moreover, the Areopagite (*Ecclesiastical Hierarchy* 2, 404b) urges triple immersion baptism in order to remind the initiate of the death and emersion of Jesus after three days in the tomb. P. Brown, 1967, p. 107, notes that Saint Ambrose preached that baptism was a spiritual "death."

187. *Ecclesiastical Hierarchy* 5, 504b.

188. *Ecclesiastical Hierarchy* 5, 504b.

189. For example in the rendering of 1985 by the architects A. Benfante and P. Perretti (*San Marco*, 1989, pl. III), Cosimo's cell is assigned the first place, and these cells are numbered 18 through 26.

190. *Ecclesiastical Hierarchy* 2, 392a.

191. P. Morachiello, 1995, p. 43.

192. G. Didi-Huberman, 1995, p. 163.

193. I suspect that the internal sequence of the triads was influenced by Pythagorean numerical symbolism. For example, 6 is particularly fitting for the cell of the Transfiguration, since 6 was considered a perfect number, comprising both human and divine elements. A rectangle with the ratio 3:2 (thus composed of the factors of 6) can be inscribed in the open center of this fresco. See M.J.B. Allen, 1994, p. 134 (and pp. 64-72 for the significance of the other numbers).

194. Albertus Magnus, *Mariale* 150, quoted by G. Didi-Huberman, 1995, p. 125.

195. *Ecclesiastical Hierarchy* 2, 404b.

196. C. Pepler, 1953, p. 16.

197. 1 Corinthians 15:45, "And so it is written, the first man Adam was made a living soul; the last Adam was made a quickening spirit."

198. G. Didi-Huberman, 1995, pp. 77-78, 193.

199. A. Plogsterth, 1975, p. 433.

200. A. Plogsterth, 1975, p. 433.

201. One can assume that there is also symbolism in the letters that correspond to these shapes, O and T for the first two triads, for example. Cf. G. Didi-Huberman, 1995, pp. 189-90.

202. Gaston, "Liturgy and Patronage in San Lorenzo, Florence, 1350-1650," 1987, pp. 114-15.

203. E. Garin, 1992, p. 100.

204. M. Boskovits, 1983, p. 13.

205. W. Hood, 1993, p. 240.

206. Andrew Blume has kindly shown me his transcription of a page of accounts for San Marco (BMLF, San Marco 902 [Ricordanze 1445-]), which records Cosimo's payment for virtually all of the convent's expenses, from the friars' grain, wine, and shoes, to all of the books for the choir and for the library. The same document notes laconically that Cosimo did not leave any legacy to San Marco and that under Lorenzo the Magnificent, the Medici gifts had decreased to 12 *lire* every week.

207. N. Rubinstein, 1990, p. 67.

208. M. Boskovits, 1983, p. 13.

209. G. Bonsanti, 1990, p. 121; W. Hood, 1993, p. 26.

210. W. Hood, 1993, p. 216, who asks, "But did the Constitutional requirement have to be followed literally?" That no other Dominican convent violated these rules seems the answer to this question.

211. N. Rubinstein, 1990, p. 67-68.

212. G. Bonsanti, 1983, p. 33, who noted that that the frescoes in the cells were painted in relatively few *giornate*.

213. To judge from the *Transfiguration* in cell 6, he employed plane geometry for symbolic purposes, but made relatively little use of spatial perspective.

214. M. Baxandall, 1986, p. 139.

215. Cf. J. Crowe and G. B. Cavalcaselle, 1864, 1911 ed., IV, p. 78.

216. For this comparison, and others regarding Giusto di Padova, see R. Longhi, 1968, IV, p. 20.

217. C. 1330, now in the Accademia, Florence. Gaddi is one of the few painters singled out for praise by Cristoforo Landino in the preface to his commentary on the *Divina Commedia*, 1481.

218. J. Crowe and G.B. Cavalcaselle, 1911 ed., IV, p. 78.

219. Cf. C. Trinkaus, 1983, p. 253: "Salutati, . . . Petrarch and the humanist movement in general sought to achieve in its religious concerns something that might well be called *theologia rhetorica*. Though I have not found a contemporary use of the term, it does seem appropriate for the humanists' concern of putting all the language arts and sciences—the secular study of the world—at the service of the propagation of the Divine Word."

220. It should be noted that M. Boskovits, 1995, p. 34, does not see Gozzoli's hand at San Marco so extensively as I do.

221. S. Orlandi, 1954, document x, p. 192.

222. Cf. W. Hood, 1993, p. 38, for a theory that some of the Fiesole friars were dissatisfied with the anomalous influence exerted by Cosimo de' Medici on the San Marco convent.

223. S. Orlandi, 1964, p. 115.

224. This tradition, which seems to have some historical basis, is discussed by S. Orlandi, 1964, pp. 86-88, and C. Gilbert, 1975, pp. 248-49.

225. S. Orlandi, 1964, p. 115 n. 2.

226. R. Klibansky, 1941-43, p. 295.

227. C. Gilbert, 1975, pp. 245-65; this article resolved uncertainties that dated back to Vasari.

228. Vasari, 1568, II, p. 517.

229. M. Boskovits, 1995, p. 9, who notes that Vasari (II, p. 517) refers to frescoed portraits that were detached from the Cappella del Sacramento prior to its destruction by Paolo III. For the old attribution to Gozzoli, cf. A. Padoa Rizzo, 1992, cat. 25.

230. C. Gilbert, 1975, p. 260.

231. Vasari, 1568, II, p. 517.

232. C. Gilbert, 1975, pp. 259 and 264.

233. L. Douglas, 1911, p. 185.

234. S. Orlandi, 1964, p. 109. In addition, see the discussion of the Orvieto documentation in C. Gilbert, 1975, pp. 259-60.

235. C. Gilbert, 1975, p. 259 n. 63.

236. Signorelli was required to complete the vault "according to the drawings already delivered by the venerable man Fra Giovanni who had begun the painting of the vault." See S. Orlandi, 1964, pp. 112-13.

237. L. Castelfranchi Vegas, 1989, p. 112.

238. Vespasiano da Bisticci, 1963 ed., p. 46.

239. R. Klibanski, 1941-43, p. 296.

240. Vespasiano da Bisticci, 1963, p. 49.

241. A. De Marchi, 1985, pp. 53-57. It has been suggested that the Saint Jerome in the Polittico dei Gesuati (Pinacoteca, Siena), dated 1444, by Sano di Pietro reflects the Saint Nicholas in this altarpiece; its prototype is instead the Saint Mark on the outside shutter of the Linaiuoli Tabernacle.

242. C. Gilbert, 1975, p. 250.

243. L. Castelfranchi Vegas, p. 147.

244. For this and the other documents, C. Gilberti, 1975, pp. 250-53.

245. C. Gilbert, 1975, p. 251 n. 26.

246. S. Orlandi, 1964, p. 117.

247. S. Orlandi, 1964, pp. 114-17.

248. S. Orlandi, 1964, p. 118 n. 1.

249. S. Orlandi, 1964, pp. 194-95.

250. M. Warnke, 1993, p. 48, goes so far as to discuss Cosimo's "personal painter Fra Angelico" in terms of a Medicean policy of exporting their culture abroad.

251. C. Robinson, in F. Ames-Lewis, 1992, *passim*.

252. C. Robinson, in F. Ames-Lewis, 1992, p. 188.

253. S. Orlandi, 1964, p. 124, points out that the niche behind the Madonna is based upon the apse of the Pantheon in Rome.

254. S. Orlandi, 1954, p. 197, document XI D.

255. See the discussion of this cycle in M. Boskovits, 1987, pp. 41-47.

256. See I. Biffi, *I Misteri di Cristo in Tommaso D'Aquino*, Milan, 1994, I, p. 105.

257. S. Orlandi, 1954, p. 178; *Mostra*, 1955, document 25.

258. S. Orlandi, 1964, p. 118.

259. M. Boskovits, 1995, *passim*.

260. S. Orlandi, 1964, p. 128.

261. S. Orlandi, 1964, p. 144.

262. S. Orlandi, 1964, p. 147.

263. S. Orlandi, 1964, p. 148.

264. *Mostra*, 1955, p. 25.

265. Cf. P. V. Marchese, 1869, I, p. 257, "The name was applied to the first [Saint Thomas] for having better described than anyone else the angelic and the divine; the same name can be assigned appropriately to the artist for having made visible the same qualities with his line and color."

266. W. Kerrigan and G. Braden, 1991, p. 106.

267. Transcribed in *Mostra*, 1955, p. 26. I am grateful to Feliciano Paoli for examining the first edition of Landino's *Proemio*, 1481, for me.

268. Landino's comments were paraphrased in a contemporary chronicle by the Franciscan Fra Mariano, who uses *angelico* as an adjective, not as part of the artist's name. Cf. S. Orlandi, 1964, p. 33 n. 4.

PLATES

1. G. Ferguson, 1954, pp. 47-48. The motif would also evoke for Florentines the dedication of the Duomo to Santa Maria del Fiore.

2. D. Covi, 1986, p. 598.

3. S. Orlandi, 1964, p. 17.

4. The angels in this picture conform to a Masolinesque typology that can also be traced in paintings by Francesco d'Antonio, a less gifted painter whose works are interesting because some are securely dated earlier than 1420. The most advanced painting in Florence in the second decade must have been the graceful and moderately natural style that Masolino derived from Starnina.

5. U. Baldini, 1970, p. 86, first associated this predella with this altarpiece.

6. Vasari, 1568, II, pp. 515-16.

7. J. T. Spike, 1995, pp. 90-92.

8. J. Ruskin, 1873, II, p. 426.

9. Psalms 104:2, "Who coverest thyself with light as with a garment."

10. G. Didi-Huberman, 1995, p. 197.

11. L. Douglas, 1900, pp. 44-45.

12. See M. Boskovits, 1995, pp. 322-23, for a valuable stylistic analysis of this painting.

13. Or, in the Eastern church, a mosaic in an apse. Cf. the standing Virgin isolated against a golden background in the apse of the Cathedral of Torcello, reproduced in P. Amato, 1988, p. 13.

14. D. Shorr, 1954, p. 39.

15. The presence of adoring angels may also be intended to evoke her title, *Regina Angelorum*.

16. The three hierarchies of the angelic host were defined by Pseudo-Dionysius the Areopagite in the *Celestial Hierarchy*, 1987, pp. 160-73; his system is conveniently summarized by C. E. Clement, 1897, pp. 12-13. Cf. P. L. Roberts, 1985, pp. 295-96.

17. A. Grabar, 1968, p. 133.

18. A. Grabar, 1968, pp. 132-34.

19. One star can also refer to Mary's title as *Stella Maris*, "star of the sea," which Saint Ambrose and other church fathers understood to be the meaning of her name in Hebrew. According to A. Plogsterth, 1975, p. 436, a single star alludes to her perpetual virginity. For E. Marino, 1984, p. 48, the star should be seen in context with the "vision" of the star in the key of the vault of the left bay in the transept of Santa Maria Novella.

20. Presumably the gold lining of the Virgin's cloak, as well as the brilliant gold background of this panel, refer to this apocalyptic vision of the Virgin clothed in the sun. Benozzo Gozzoli drew upon this text in his *Madonna degli Angeli*, 1457-58, in Sermoneta; cf. P. Raponi in P. Amato, 1988, cat. 62.

21. G. Ferguson, 1954, p. 204.

22. G. Ferguson, 1954, p. 262.

23. T. S. Centi, 1984, p. 32.

24. Their number probably refers to the four and twenty elders described in Revelations 4:4, although the distinction between the Second Coming and the Apocalypse is a theological fine point that was much discussed. Cf. J. Miziolek, 1990, p. 54 n. 78.

25. To be precise, this region resembles Dante's Purgatory, where souls are cleansed of the seven deadly sins; Angelico has even represented torments emblematic of anger, avarice, gluttony, and so on.

26. A. Santagostino Barbone, 1989, p. 270, suggests that these souls are ascending to the "mountain of the Lord, to the house of the God of Jacob" prophesied by Isaiah 2:2-3.

27. A. Santagostino Barbone, 1989, p. 261, convincingly refutes both the 1431 dating proposed by S. Orlandi, 1964, pp. 29-30, and P. V. Marchese's misreading of Vasari, which induced subsequent writers to assume that this painting was made as the back (*spalliera*) of the celebrant's seat near to the altar.

28. J. Ruskin, 1873, III, p. 106.

29. Plato, *The Republic*, part XI, 614B–617; 1987 ed., pp. 447-55.

30. The principal symbolic meanings of the circle are all appropriate in this context: unity, perfection, eternity.

31. J. James, 1993, p. 17.

32. Quoted by J. James, 1993, pp. 69-70.

33. In his *Scipio's Dream (Somnium Scipionis)* at the conclusion of his own *De republica*; quoted by J. James, 1993, p. 63.

34. Vasari, 1568, II, p. 513, who seems to have confused the figures of Joseph of Arimathaea and the patrician Nicodemus, believed that the figure of "Nicodemo vecchio con un cappuccio in capo" was a portrait of Fra Angelico's friend, Michelozzo.

35. H. James, "The Autumn in Florence," 1873, in *Italian Hours*, 1987, p. 274.

36. G. C. Argan, 1955, p. 73.

37. G. C. Argan, 1955, p. 73.

38. Cf. D. Covi, 1986, p. 114.

39. Psalm 88:4.

40. M. Alexander, 1977, pp. 154-61.

41. T. Centi, 1984, p. 74.

42. L. Castelfranchi Vegas, 1989, p. 34.

43. See G. Didi-Huberman, 1995, pp. 29-34 for a valuable discussion of the possible meanings of fictive marbles and stones. Pseudo-Dionysius the Areopagite provides the point of departure for these interpretations.

44. "I am the mother of fair love, and fear, and knowledge, and holy hope." Ecclesiastes 24:24. V. Alce, 1993, p. 85.

45. G. Ferguson, 1955, p. 123.

46. It directly inspired the analogous series on the predella to the Cortona Altarpiece.

47. G. Kaftal, 1948, p. 13. See Kaftal for a complete description of this cycle.

48. J. Pope-Hennessy, 1974, p. 216, proposed to date the *Coronation* to after 1450 because he assumed that its linear perspective was based upon Domenico Veneziano's Santa Lucia altarpiece of the 1440s.

49. Ecclesiasticus 24:17-19. S. Orlandi, 1964, p. 73. Cf. J. I. Miller, 1987, pp. 3-4.

50. Henry James, "Florentine Notes," 1874, in *Italian Hours*, 1987, pp. 292-93.

51. "But now in Christ Jesus ye who sometimes were far off are made near by the blood of Christ. For he is our peace, who had made both one, and hath broken down the middle wall of partition between us; Having abolished in his flesh the enmity. . . . And that he might reconcile both unto God in one body by the cross, having slain the enmity thereby; And came and preached peace to you which were afar off, and to them that were near. For through him we both have access by one Spirit unto the Father."

52. G. Didi-Huberman, 1995, pp. 193-94.

53. G. Didi-Huberman, 1995, p. 18.

54. Albertus Magnus quoted in G. Didi-Huberman, 1995, pp. 188-89.

55. This connection was first recognized by Padre Venturino Alce, 1993, pp. 200-201.

56. P. Muratoff, 1930, pp. 50-51.

57. L. Douglas, 1900, p. 114.

58. D. Dini, 1996, p. 40.

59. See G. Didi-Huberman, 1995, pp. 196-97, for a learned discussion of shadows, although not in connection with this painting.

60. Indeed, the Platonic character of *Hebrews* has placed in doubt its traditional attribution to Paul; a certain Apollos of Alexandria is often mentioned as the possible author. See R. Goffen, 1980, p. 504, for this point and for a discussion of *Hebrews* as the probable text for Masaccio's *Trinity* fresco in Santa Maria Novella, Florence.

61. Plato, *The Republic*, part X, 597-99 (1987, pp. 425-26).

62. Cardinal Bessarion was struck by the fact that Dionysius Areopagita, "the father of Christian theology," was "anxious to use not only Plato's doctrines but also his words." Quoted by R. Klibansky, 1941-43, p. 310.

63. G. Didi-Huberman, 1995, pp. 50-53, who explores other fascinating connotations of these stones.

64. V. Alce, 1993, p. 201.

65. Pseudo-Dionysius the Areopagite, *Ecclesiastical Hierarchy* I, 373B; trans. C. Luibheid, 1987.

66. P. Rorem, in *Pseudo-Dionysius*, 1987, p. 21.

67. See the table on p. 67; the deliberated variations from the temporal sequence are justified by numerous passages in the *Divine Names* by Pseudo-Dionysius: "In their own way and their own order, souls rise through immaterial and indivisible conceptions to a unity beyond all conceptions." (II 949D); "The categories of eternity and of time do not apply to him [God], since he transcends both and transcends whatever lies within them." (5 825B).

68. Pseudo-Dionysius, *Ecclesiastical Hierarchy* 2, 392A.

69. Thomas Aquinas, *Summa Theologica* 3A.51.2, quoted by G. Didi-Huberman, pp. 85-86.

70. This identification is tentative, because the saint lacks her customary attribute of the wheel. This fresco displays the essential elements of the vision of the Nativity experienced by Saint Bridget of Sweden while on a pilgrimage to the Holy Land. G. Kaftal, 1978, fig. 217, illustrates an anonymous painting, c. 1400, of Saint Bridget's vision, which includes the same juxtaposition of cave and crib-tomb that we find in Fra Angelico.

71. G. Didi-Huberman, 1995, p. 39.

72. J. Miziolek, 1990, p. 57.

73. Pseudo-Dionysius the Areopagite, *The Divine Names* I, 592C.

74. J. Miziolek, 1990, p. 60. These personages are placed around Christ so as to circumscribe a rectangle of a 3×2 proportion.

75. This observation was suggested to me by Mino Gabriele. See C. Gilbert, 1994, p. 59, for discussion of the imagery of the world-egg.

76. Pseudo-Dionysius the Areopagite, *Celestial Hierarchy* 3, 165A.

77. M. Eisenberg, 1989, pp. 99-100, fig. 18.

78. This painting by Monaco is certainly the source for Fra Angelico's fresco in cell 26.

79. P. Morachiello, 1995, p. 37, demonstrates that the one-point perspective in this fresco recedes to a central vanishing point on the chest of Christ. See *idem*, pp. 32-39, for other diagrams of interest, although they do not always strictly reflect the geometry of the forms within the paintings themselves.

80. The subject of cell 7 seems to have been chosen to allude to the thrones, the angels that constitute the seventh tier in the *Celestial Hierarchy* of Pseudo-Dionysius. Dante, *Paradiso* XXVIII, 104-5, notes that these angels are appropriately named, because they comprise the bottom of the highest triad and are thus the "thrones" for the sovereign angels above them.

81. R. Longhi, 1968, p. 20, fig. 33A. It is not known by what intermediary this fresco in the baptistry of Padua would have been known to Fra Angelico.

82. Pseudo-Dionysius the Areopagite, *Celestial Hierarchy* I, 121A. Saint Augustine confirmed this Platonic distinction between corporeal and spiritual sight (C. *Acad.* III, 17, 37).

83. W. Hood, 1993, p. 218.

84. For an opposing view, see M. Boskovits, 1994, pp. 379-95.

85. J. Pope-Hennessy, 1987, cat. 26.

86. W. Hood, 1993, p. 252, who writes that Susan McKillop independently reached the same conclusion.

87. R. Hatfield, 1970, pp. 107-61.

88. T. S. Centi, 1984, pp. 104-5.

89. In my opinion, the collaboration of assistants, including Benozzo Gozzoli, is only significant in the crowd of figures on the right.

90. The name of the Chaldeans is used in the Book of Daniel as a synonym for "astrologer."

91. Quoted by J. James, 1993, p. 26.

92. C. Peppler, 1953, p. 17.

93. A.-M. Gerard, 1994, p. 1363.

94. G. Ferguson, 1955, pp. 46-47, who also cites it as a Christian symbol of hope in resurrection and of immortality.

95. The dowries given by Saint Nicholas were actually three gold balls; this variation in the iconography is probably a reference to Nicholas V's personal association with Saint Lawrence, whom Fra Angelico depicted receiving bags of gold and silver money, his attribute, in the Cappella Niccolina.

96. A. De Marchi, 1985, pp. 53-57. Nearly all authorities accept the traditional date of c. 1437 based on the chronicle compiled, c. 1570, by Fra Timoteo Bottonio. Only U. Middeldorf, 1955, p. 188, had previously proposed a late dating for this work.

97. The saints represented on the pilasters include not only the expected Dominicans, but also saints appropriate to Nicholas V: Peter, Paul, Lawrence, and Stephen.

98. J. Ruskin, 1873, II, p. 481.

99. R. L. Douglas, 1900, p. 141.

100. A. Greco, 1980, p. 21.

101. V. Alce, 1993, p. 305.

102. R. L. Douglas, 1900, p. 146.

103. *Cronaca di Firenze di Benedetto Dei*, in Bibl. Nazionale di Firenze, Magl. XXV, n. 165, fol. 96.

104. S. Orlandi, 1964, p. 120.

105. As was observed by V. Alce, 1993, p. 313.

106. J. Ruskin, 1873, II, p. 426.

CHRONOLOGY

1395–1400
Guido di Piero di Gino, known today as Beato or Fra Angelico, is born near Vicchio in the Mugello region to the north of Florence.[1] G. Vasari places his date of birth somewhat earlier, 1387–88.[2]

1417
OCTOBER 31: Guido di Piero, who resides in the neighborhood of San Michele Visdomini, enrolls in the Compagnia di San Niccolò in the church of the Carmine in Florence.[3]

1418
JANUARY 28, FEBRUARY 15: Guido di Piero receives two payments from the Capitani of Orsanmichele for a (lost) painting [tabule altaris] for the altar of the chapel of Giovanni de' Gherardini in San Stefano a Ponte.[4]

1423
JUNE: "Fra Giovanni of the Friars of San Domenico of Fiesole" is paid by the Ospedale di Santa Maria Nuova for the painting of a cross. This is the earliest record of the name taken by Guido di Piero after his entrance into the Observantist Dominicans.[5]

1425
Fra Angelico's presence in Fiesole is indicated in the testament of A. Rondinelli, who entrusts the execution of a painting in his family's chapel to the "frate del convento di S. Domenico che è a Camerata."[6]

1429
MARCH 4: Fra Giovanni signs a notarial act, his earliest extant signature.[7]
MARCH 30: The convent of Fiesole is owed ten florins by the church of San Pietro Martire, Florence, for an altarpiece executed by Fra Giovanni.[8]
SEPTEMBER 24: Fra Benedetto di Piero del Mugello, the brother of Fra Giovanni, is ordained a priest.[9]
OCTOBER 22: Fra Giovanni participates in a chapter meeting at San Domenico di Fiesole.[10]

1431
JANUARY 28: Fra Giovanni participates in a chapter meeting at San Domenico di Fiesole.[11]

1432
The 1432 Chronaca of Sant'Alessandro in Brescia records a payment for a painting: "Fatta in Fiorenza la quale depinse fra Giovanni."[12]
DECEMBER 12: Fra Giovanni is cited as vicario in a list of the friars at Fiesole.[13]

1433
JANUARY 24: Fra Giovanni, vicario, signs a notarial act.[14]
JULY 11: Fra Giovanni receives the commission from the Arte dei Linaiuoli to execute the paintings for a tabernacle designed by Lorenzo Ghiberti.[15]

1434
JANUARY 14: Fra Giovanni da Fiesole values a tabernacle painted by Bicci di Lorenzo and Stefano d'Antonio for the convent of San Niccolò in Florence at 145 fiorini d'oro.[16]

1435
JANUARY 20: Fra Giovanni is present at a chapter meeting of the brothers of San Domenico in Fiesole.[17]
MAY 13: Fra Giovanni is cited in the will of the sister of Sant'Antonino.[18]
LAST SUNDAY OF OCTOBER: Consecration of the church of San Domenico, Fiesole.[19]

1435–36
Fra Angelico is vicario of San Domenico, Fiesole, in these years while the prior is occupied with the transfer to Florence; he signs various financial documents.[20]

1436
FEBRUARY: Some friars from the convent of San Domenico transfer to San Marco in Florence, but Fra Giovanni remains in Fiesole.[21]
APRIL 13: Fra Giovanni receives the commission for the Deposition from the Cross for the altar of the Compagnia di Santa Maria della Croce al Tempio.[22]
DECEMBER 2: He receives a payment for the Deposition from the Cross for the Compagnia di Santa Maria della Croce al Tempio.[23]

1437–43
Restoration of the church and the convent of San Marco, Florence.[24]

1438
MARCH 26: Fra Giovanni ("fratre Johanne Pieri Gini de Mugello, comitatus Florentie, magistro picture") is listed as a witness to the testament of a merchant, Giovanni di Tommaso ser Cecco, in Cortona.[25]

1440
The renovations in the choir of the church of San Marco are reportedly completed.[26]

1441
AUGUST 22: Fra Giovanni signs a notarial act related to the testament of the mother of Fra Alessio degli Albizi in the sacristy of San Marco; the chapter room of the convent is not yet completed.[27]
MAY 7: Fra Giovanni's sister, Donna Checca, receives a bequest of ten gold florins in this testament.[28]

1442
MARCH 19: Fra Giovanni, painter, is cited in a document as sindicho of the convent of San Marco.[29]
AUGUST 25: Fra Giovanni is present at a meeting held in the chapter room of the convent of San Marco, an indication that its construction is completed by this date.[30]

1443
JANUARY 6: Pope Eugenius IV attends the rededication of the high altar of the Church of San Marco and stays the night in Cosimo's cell in the convent.[31] Fra Angelico's frescoes are presumably completed by this date.

1445
JULY: Fra Giovanni signs the document of formal separation between the Dominican friaries of San Marco, Florence, and San Domenico, Fiesole.[32]

1446
JANUARY 25: Fra Giovanni is absent from a meeting at his convent in Fiesole.[33]

1446
MAY 10: Fra Giovanni is in Rome in the service of Pope Eugenius IV.[34] He is approached concerning the commission for frescoes in the Duomo, Orvieto.

1447
FEBRUARY 23: Pope Eugenius IV dies and is laid in the Vatican in the small Chapel of the Sacrament, which is "newly painted."
MARCH 13: Fra Giovanni and assistants are at work in Saint Peter's, Rome.[35]
MAY 11: Fra Giovanni is recorded as having painted a chapel and to be working on another in the palace of the Pope Nicholas V.[36]
MAY 23, JUNE 1: Two payments are recorded to Fra Giovanni for work on the "chappella di Santo Pietro."[37]
JUNE 8: Fra Giovanni is in Orvieto for the Feast of Corpus Domini with his assistants, Benozzo Gozzoli, Giovanni di Antonio della Checca, his nephew, and Jacopo d'Antonio da Poli.[38]
JUNE 14: Fra Giovanni signs a contract to decorate the Cappella di San Brizio in the Duomo of Orvieto.[39]
JULY 11: An assistant, Pietro da Niccola da Orvieto, is added to work with Fra Giovanni in Orvieto.[40]
SEPTEMBER 28: Fra Giovanni and his three collaborators are paid 103 fiorini d'oro for their work at Orvieto.[41]

1448
Fra Giovanni reportedly receives the commission from Piero de' Medici to paint the Silver Treasury for the church of Santissima Annunziata in Florence.[42]

1449
Fra Giovanni with his collaborators decorates the studio of Pope Nicholas V in the Vatican palace. He receives a payment of 182 ducati 62 bol. and 8 den. The studio was later destroyed by Pope Julius II.[43]

1450
MARCH: Fra Benedetto, brother of Fra Giovanni, dies after an illness in convent of San Domenico, Fiesole.[44]

1450
SPRING 1450–JUNE 1452: Fra Giovanni is prior of the convent of San Domenico, Fiesole, succeeding his brother.[45]

1451
OCTOBER 23: Fra Giovanni, priore, pays Vespasiano da Bisticci two fiorini d'oro for paper.[46]

1452
MARCH 21: The leading citizens of Prato write to Sant'Antonino asking him to encourage Fra Giovanni to paint the main chapel of the Duomo.
MARCH 30: Fra Giovanni goes to Prato with Bernardo di Bandinello and four deputies of the Duomo, but returns to Fiesole the next day without having reached agreement.[47]

1454
NOVEMBER 30: A contract between the Palazzo del Comune di Perugia and the painter Benedetto Bonfigli names Fra Giovanni, together with Fra Filippo Lippi and Domenico Veneziano, as experts who may be called to evaluate the paintings. This is the last documentary reference to Fra Giovanni in life.[48]

1455
FEBRUARY 18: Fra Giovanni of Fiesole dies in the convent of Santa Maria sopra Minerva in Rome.

NOTES

1. Cf. C. Gilbert, 1984, p. 283.
2. Vasari, 1550, 1878 ed., II, p. 522.
3. W. Cohn, 1955, pp. 210–11.
4. W. Cohn, 1956, pp. 218–20; S. Orlandi, 1964, doc. VII.
5. W. Cohn, 1956, pp. 218–20; U. Baldini, 1970, p. 83.
6. A. T. Ladis, 1981, pp. 378–79.
7. S. Orlandi, 1954, p. 47.
8. Mostra, 1955, doc. I.
9. S. Orlandi, 1964, doc. XI.
10. S. Orlandi, 1954, doc. IIA, p. 180.
11. S. Orlandi, 1954, doc. IIB, p. 180.
12. Mostra, 1955, doc. 4.
13. S. Orlandi, 1954, doc. IIIA, p. 182; Mostra, 1955, doc. 3.
14. S. Orlandi, 1954, doc. IIIB, p. 182; Mostra, 1955, doc. 3.
15. Mostra, 1955, doc. 5; S. Orlandi, 1964, doc. XIV.
16. U. Baldini, 1970, p. 83.
17. S. Orlandi, 1954, doc. IIIC, p. 183.
18. S. Orlandi, 1954, doc. IIID, p. 183.
19. U. Baldini, 1970, p. 83.
20. S. Orlandi, 1964, doc. XV.
21. S. Orlandi, 1964, pp. 40–41.
22. S. Orlandi, 1954, doc. IX, pp. 190–91; S. Orlandi, 1964, pp. 53, 187–88, 200.
23. S. Orlandi, 1954, doc. IX, pp. 190–91.
24. U. Baldini, 1970, p. 83.
25. V. Alce, 1982, pp. 422–30.
26. S. Orlandi, 1964, pp. 68–69.
27. S. Orlandi, 1954, doc. VI, p. 187; Mostra, 1955, doc. 15.
28. S. Orlandi, 1954, doc. V, p. 186; Mostra, 1955, doc. 14.
29. Mostra, 1955, doc. 19.
30. S. Orlandi, 1954, doc. VIII, p. 189; Mostra, 1955, doc. 16.
31. S. Orlandi, 1954, pp. 173–74.
32. S. Orlandi, 1954, doc. X, p. 192.
33. C. Gilbert, 1984, p. 283.
34. Mostra, 1955, doc. 22; S. Orlandi, 1964, doc. XVIII.
35. Mostra, 1955, doc. 20.
36. Mostra, 1955, doc. 22.
37. Mostra, 1955, doc. 20; S. Orlandi, 1964, pp. 188–89.
38. S. Orlandi, 1964, pp. 109, 188–89.
39. S. Orlandi, 1964, p. 110.
40. Mostra, 1955, doc. 22.
41. Mostra, 1955, doc. 23; S. Orlandi, 1964, p. 111.
42. S. Orlandi, 1964, pp. 119, 203.
43. Mostra, 1955, doc. 21; S. Orlandi, 1964, doc. XVIII.
44. S. Orlandi, 1964, pp. 114–15.
45. S. Orlandi, 1954, doc. XIC; Mostra, 1955, docs. 19, 25.
46. Mostra, 1955, doc. 19; S. Orlandi, 1964, doc. XID, p. 197.
47. S. Orlandi, 1954, p. 178; Mostra, 1955, doc. 25.
48. Mostra, 1955, doc. 26.

BIBLIOGRAPHY

circa 1280: J. da Varagine, *Legenda aurea. Legendatio della Vite de' Santi*, Venice

2nd half 15th century: A. Manetti, *Vite di xiv uomini singhulary in Firenze dal mcccc innanzi* (ed. G. Milanesi, Florence, 1887)

1436: L. B. Alberti, *Della pittura* (ed. Malle, Florence, 1950)

circa 1437: Cennino Cennini, *Il Libro dell'Arte*

1481: C. Landino, *Commento a Dante*, Florence

1510: F. Albertini, *Memoriale di molte statue e pitture . . . di Florentia*, Florence (ed. 1863)

circa 1516–30: *Il Libro di Antonio Billi* (ed. F. Benedetucci, Rome, 1991)

circa 1536–46: *L'Anonimo Magliabechiano* (ed. A. Ficarra, Naples, 1968)

1550: G. B. Belli, *Venti vite d'artisti*, G. Mancini, ed., Archivio Storico Italiano (ed. 1896)

1550, 1568: G. Vasari, *Le vite de' più eccellenti architettori, pittori e scultori*, Florence (ed. G. Milanesi, Florence, 1878)

1584: R. Borghini, *Il Riposo*, Florence

1677: F. Bocchi, *Le Bellezze della città di Firenze* (1591), G. Cinelli, ed., Florence

1681: F. Baldinucci, *Notizie dei professori del disegno da Cimabue in qua*, Florence (ed. Florence, 1845; reprinted with notes and index by P. Barocchi and A. Boschetto, 6 vols., Florence, 1974)

1754–62: G. Richa, *Notizie istoriche delle chiese fiorentine*, Florence, 10 vols.

1769–91: J. Reynolds, *Discourses on Art* (ed. E. G. Johnson, Chicago, 1891)

1795–96: L. Lanzi, *Storia pittorica dell'Italia*, Bassano

1827: C. F. Rumohr, *Italienische Forschungen*, Berlin-Stettin, vol. 2, pp. 243-51 (ed. Schlosser, Frankfurt, 1920, pp. 376-81)

1839: E. Repetti, *Dizionario geografico fisico storico della Toscana*, 6 vols., Florence

1840: A. Gaye, *Carteggio inedito d'artisti*, Florence

1843: M. Gualandi, *Memorie originali italiane riguardanti le belle arti*, vol. 4, pp. 109-11

1845: P. V. Marchese, *Memorie dei più insigni pittori, scultori e architetti domenicani*, Florence

1847: F. T. Kugler, *Handbuch der Geschichte der Malerei*, vol. 1, Berlin

1854: G. Waagen, *Treasures of Art in Great Britain*, vol. 2, London

1857: E. Cartier, *Vie de Fra Angelico de Fiesole*, Paris

1858–60: J. Ruskin, *The Stones of Venice*, London

1864: J. Crowe and G. B. Cavalcaselle, *A New History of Painting in Italy*, London

1867: Barbier de Montault, *Catalogo della Biblioteca Vaticana*, Vatican City

1868: Mrs. Jameson, *Memoirs of Early Italian Painters*, London

1869: P. V. Marchese, *Memorie dei più insigni pittori, scultori e architetti domenicani*, 3d ed., Genoa

1873: J. Ruskin, *Modern Painters*, New York

1878: G. Milanesi, in G. Vasari, *Le vite*, Florence, vol. 2, pp. 287-326

1879: J. Crowe, ed., *The Cicerone for Italy: Painting*, London

1880: I. Lermolieff, *Die Werke italienischen Meister in der Galerien von München, Dresden, und Leipzig*, Leipzig

1883: J. Crowe and G. B. Cavalcaselle, *Storia della pittura in Italia*, vol. 2, Florence

1888: E. Müntz, *Les Collections des Mèdicis au xve. Siècle*, Paris

1891: I. Lermolieff, *Kunsthistorische Studien*

1896: B. Berenson, *The Florentine Painters of the Renaissance*, New York–London
F.-A. Gruyer, *La Peinture au Château de Chantilly*, Paris

1897: E. Santarelli, *Le Gallerie Nazionali Italiane*, vol. 3, Rome
A. Schmarsow, *Festschrift zu Ehren des Kunsthistorischen Instituts in Florenz*
M. Wingenroth, *Die Jugendwerke des Benozzo Gozzoli*

1898: A. Schmarsow, "Maîtres Italiens à la Galerie d'Altenburg et dans la collection A. de Montor," *Gazette des Beaux-Arts*, pp. 494-510
A. Venturi, "Quadri di Gentile da Fabriano a Milano e Pietroburgo," *L'Arte 1*
M. Wingenroth, "Beitrage zur Angelico-Forschung," *Repertorium für Kunstwissenschaft 21*, pp. 343-45

1899: K. Dorothea Ewart, *Cosimo de' Medici*, London

1900: R. Langton Douglas, *Fra Angelico*, London

1901: A. Venturi, *Storia dell'Arte italiana*, 11 vols. (1901-37), Milan
G. Weisbach, *Pesellino und die Romantik der Rennaissance*, Berlin

1902: J. W. Brown, *The Dominican Church of Santa Maria Novella in Florence*, Florence
A. Della Torre, *Storia dell'Accademia Platonica*, Florence

1903: G. Poggi, *La Cappella e la tomba di Onofrio Strozzi nella chiesa di Santa Trinita*, Florence

1904: C. Fabriczy, "Michelozzo di Bartolomeo," *Jahrbuch der Preussischen Kunstsammlungen 25*, pp. 70-71
G. Frizzoni, "La Pinacoteca Strossmayer nell'Accademia di Scienze ed Arte di Agram," *L'Arte*, pp. 426-27

G. Magherini-Graziani, "Memorie del pittore in San Giovanni Valdarno e nei dintorni," *Masaccio*, Florence
O. Sirén, "Di alcuni pittori fiorentini che subirono l'influenza di Lorenzo Monaco," *L'Arte 7*, pp. 349-52
N. Valois, "Fra Angelico et le Cardinale Jean de Torquemada," *Société Nationale des Antiquaires de France, Centenaire 1804-1904: Recueil de Mèmoires*, pp. 461-70
T. de Wyzewa, "Fra Angelico au Louvre et la légende dorée," *Revue de l'art ancien et moderne 26*, pp. 329-40

1905: S. Beissel, *Fra Giovanni Angelico da Fiesole, sein Leben und seine Werke*, 2d ed., Freiburg
L. Douglas, *L'Arte* (ed. Cook Madonna), London, p. 108
O. Sirén, *Don Lorenzo Monaco*, Strasbourg
Woermann, *Katalog der kgl. Gemaldegalerie zu Dresden*, 6th ed., Dresden

1907: E. Cochin, *Il Beato Fra Giovanni Angelico da Fiesole*, Rome

1908: J. Crowe and G. B. Cavalcaselle, *A History of Painting in Italy*, 2d ed., London
P. D'Ancona, "Un ignoto collaboratore dell'Angelico: Zanobi Strozzi," *L'Arte 11*, pp. 81-95

1909: B. Berenson, *The Florentine Painters of the Renaissance with an Index to Their Works*, 3d ed., New York–London
L. Cust, *Catalogue of Paintings and Drawings in Buckingham Palace*, London
G. Pacchioni, "Gli ultimi anni del Beato Angelico," *L'Arte 12*, pp. 2-3
G. Poggi, "L'Annunciazione del Beato Angelico a S. Francesco di Montecarlo," *Rivista d'Arte*, pp. 138-40
A. Venturi, "La Madonna della Collezione Kleinberger," *L'Arte 12*, pp. 319-20

1910: G. Pacchioni, "Gli inizi artistici di Benozzo Gozzoli," *L'Arte 13*, pp. 423-42
R. Papini, "Dei disegni di Benozzo Gozzoli," *L'Arte 13*, p. 290
R. Papini, "Riguardo al soggiorno dell'Angelico in Roma," *L'Arte 13*, pp. 138-39

1911: J. Crowe and G. B. Cavalcaselle, *A New History of Painting in Italy*, L. Douglas, ed., London
F. Schottmüller, *Fra Angelico da Fiesole: Des Meisters Gemalde. Klassiker der Kunst in Gesamtausgaben*, 1st ed., Stuttgart

1912: W. Bombe, *Geschichte der Peruginer Malerei bis zu Perugino und Pinturicchio*, Berlin

1913: B. Berenson, *Catalogue of a Collection of Painting and of Some Art Objects (The Johnson Collection): Italian Paintings*, Philadelphia
T. Borenius, *A Catalogue of the Paintings at Doughty House, Richmond, and Elsewhere in the Collection of Sir Frederick Cook*, vol. 1, London
R. Morçay, ed., "La Cronaca del Convento fiorentino di San Marco: la parte più antica, dettata da Giuliano Lapaccini," *Archivio Storico Italiano 71*, pp. 1-29
Seymour de Ricci, *Description des Peintures du Louvre*, vol. 1

1914: P. D'Ancona, *La Miniatura Italiana*, vol. 2, pp. 345-56
J. Mesnil, "Masaccio et la théorie de la perspective," *Revue de l'art ancien et moderne*, pp. 145-46

R. Morçay, *Saint Antonin. Fondateur du couvent de Saint-Marc, Archevêque de Florence, 1389-1459*, Paris

1916: T. Borenius, *Pictures by the Old Masters in the Library of Christ Church*, Oxford

1919: C. Phillips, "Scenes from the Legend of SS. Cosma and Damian," *The Burlington Magazine 34*, p. 4

1920: R. Offner, "Saint Jerome by Masolino," *Art in America 7*, pp. 68-76

1921: T. Borenius, "A Fra Angelico for Harvard," *The Burlington Magazine 39*, pp. 209-10
A. Colasanti, "Nuovi dipinti di Arcangelo di Cola da Camerino," *Bollettino d'Arte 2*, n.s. 1 (1921-22), pp. 539-40
R. Papini, "Due Opere di Benozzo Gozzoli," *Bollettino d'Arte 1*, n.s., pp. 37-38

1922: Fr. R. Diaccini, *La Basilica di Santa Maria Novella*, Florence

1923: W. Bode, *Catalogue van den Jubileum Tentoonstelling in der Rijksmuseum te Amsterdam*, Amsterdam

1923–26: R. Van Marle, *The Development of the Italian Schools of Painting*, 19 vols., The Hague

1924: E. Panofsky, *Idea: A Concept in Art Theory* (ed. 1968, New York, trans. by J. S. Speake)
E. Schneider, *Fra Angelico da Fiesole*, Paris
F. Schottmüller, *Fra Angelico da Fiesole: Des Meisters Gemalde. Klassiker der Kunst in Gesamtausgaben*, 2d ed., Stuttgart
A. Venturi, *L'Arte e San Girolamo*, Milan, pp. 132-34

1925: R. Papini, *Fra Giovanni Angelico*, Bologna

1926: J. Mesnil, "Masaccio and the Antique," *The Burlington Magazine 48*, pp. 91-98

1927: L. Venturi, *Studi dal Vero*, Milan, pp. 11-12

1928: R. Longhi, "Un dipinto dell'Angelico a Livorno," *La Pinacoteca 3*, pp. 153-59 (in R. Longhi, *Opere complete*, 1968, VI, pp. 37-45)

1929: A. E. Austin, Jr., "A Small Tempera Panel by Fra Angelico," *Wadsworth Atheneum Bulletin*, Jan., pp. 2-3
G. Bacchi, "La Cappella Brancacci," *Rivista Storica Carmelitana 1*, vol. 2, pp. 55-68
G. Bacchi, "Gli affreschi della Sagra di Masaccio," in *Rivista Storica Carmelitana 1*, pp. 107-12
B. Berenson, "Quadri senza casa," *Dedalo 10*, pp. 136-40
W. Suida, "Lorenzo Monaco," *Thieme-Becker Allgemeiner Lexikon der bildenden Kunstler*, Leipzig, p. 23

1930: H. Brockhaus, "De Brancacci-Kapelle in Florenz," *Mitteilungen des Kunsthistorisches Institutes in Florenz 3*, pp. 160-82
P. Muratoff, *Fra Angelico*, London–New York
R. van Marle, "La pittura all'esposizione d'arte antica italiana di Amsterdam," *Bollettino d'Arte*, p. 304

1931: Bodkin, "A Fra Angelico Predella," *The Burlington Magazine* 58, pp. 183-194

Hendy, *The Isabella Stewart Gardner Museum: Catalogue of the Exhibited Paintings and Drawings*

L. Venturi, "Nella collezione Nemes," *L'Arte*, pp. 250-55

Beschreibendes Verzeichnis der Gemälde im Kaiser Friedrich Museum und Deutschen Museum, Berlin

1932: B. Berenson, *Italian Pictures of the Renaissance*, Oxford

B. Berenson, "Quadri senza casa," *Dedalo* 10, pp. 512-41

B. Berenson, "Fra Angelico, Fra Filippo Lippi e la cronologia," *Bollettino d'Arte*, pp. 1, 49ff.

Cecchini, *La Galleria Nazionale dell'Umbria in Perugia*

A. Ciaranfi, "Lorenzo Monaco miniatore," *L'Arte*, pp. 302-17

1933: Biagetti, "Una nuova ipotesi intorno allo studio e alla cappella di Niccolò v nel Palazzo Vaticano," *Atti della Pontificia Accademia Romana di Archeologia* 4, pp. 205-14

R. Offner, "The Mostra del tesoro di Firenze sacra, II," *The Burlington Magazine* 63, pp. 166ff.

S. de Vries, "Jacopo Chimenti da Empoli," *Rivista d'Arte* 15, p. 382

L. Venturi, *Italian Paintings in America*, 3 vols.

1934: F. J. Mather, "Two Unpublished Fra Angelicos," *Art in America* 22, pp. 92-93

R. Oertel, "Masaccio und die Geschichte der Freskotechnik," in *Jahrbuch der Preussischen Kunstsammlungen* 55, pp. 229-40

1935: F. Ehrle and H. Egger, *Der Vatikanische Palast in seiner Entwicklung bis zur Mitte des XV Jahrhunderts*, Vatican City

R. van Marle, "La pittura all'esposizione d'arte antica italiana di Amsterdam," *Bollettino d'Arte* 28, 1935, p. 304

1936: B. Berenson, *I pittori italiani del Rinascimento: Catalogo dei principali artisti e delle loro opere con un indice dei luoghi*, Milan

B. Berenson, *Italian Pictures of the Renaissance: A List of the Principal Artists and Their Works, with an Index of Places: Florentine School*, 2 vols., London

M. Meiss, "The Madonna of Humility," *The Art Bulletin* 18, pp. 435-65

G. Pudelko, "Per una datazione delle opere di Fra Filippo Lippi," *Rivista d'Arte* 18, p. 68

M. Salmi, "La giovanezza di Fra Filippo Lippi," *Rivista d'Arte*, 18, p. 9

1938: M. Wackernagel, *Il mondo degli artisti nel Rinascimento fiorentino*, Leipzig (Italian translation by A. Sbrilli, scientific revisions by G. de Juliis, Rome, 1994)

1939: C. Glaser, "The Louvre Coronation and the Early Phase of Fra Angelico's Art," *Gazette des Beaux Arts*, 21, pp. 149ff.

J. Pope-Hennessy, *Sassetta*, London

G. Pudelko, "The Stylistic Development of Lorenzo Monaco, II," *The Burlington Magazine* 74, pp. 76-81

1940: C. Gutkind, *Cosimo de' Medici, Il Vecchio*, Florence

R. Longhi, "Fatti di Masolino e di Masaccio," *Critica d'Arte*, pp. 145-91 (reprinted in Longhi 1975, pp. 3-65)

R. Oertel, "Wandmalerei und Zeichnung in Italien," *Mitteilungen des Kunsthistorisches Instituts in Florenz*, pp. 217-314

F. Wittgens, *Mentore*, Milan

1941: E. Garin, *Il Rinascimento italiano, documenti di storia e di pensiero politico*, Milan

1942: R. Oertel, *Fra Filippo Lippi*, Vienna

1943: R. Klibansky, "Plato's Parmenides in the Middle Ages and the Renaissance," *Medieval and Renaissance Studies* 1, pp. 281-330

1944: F. J. Mather, "The Problem of the Brancacci Chapel Historically Considered," *Art Bulletin* XXVI, 1944, p. 186

"Notes: Seven Joys of Our Lady: A Christmas Exhibition at the Cloisters," *Metropolitan Museum of Art Bulletin*, n.s., no. 4 (December), p. 89

1945: G. Fallani, *Il Beato Angelico*, Rome

F. J. Mather, *Excavating Buried Treasure*, Princeton, N.J.

The National Gallery of Art: Preliminary Catalogue of Paintings and Sculpture, Washington, D.C.

R. Offner, "The Straus Collection Goes to Texas," *Art News*, May 15-31, pp. 22-23

L. Venturi, *The Rabinowitz Collection*, New York

1946: R. Grinnel, "Iconography and Philosophy in the Crucifixion Window at Poitiers," *The Art Bulletin* 28, pp. 171-96

R. Longhi, *Catalogue of the Exhibition of the King's Pictures*, Royal Academy, London

Mostra di opere d'arte restaurate, Florence

1947: L. Ghiberti, *I Commentarii, Commentarii*, O. Morisani, ed., Naples

U. Procacci, "Recent Restoration in Florence, II," *The Burlington Magazine* 89, pp. 330-31

M. Salmi, "Un ipotesi su Piero della Francesca," *Arte figurativa* 3, pp. 82-83

1948: F. Antal, *Florentine Painting and Its Social Background*, London (ed. Cambridge, Mass., 1986)

E. H. Gombrich, "Icones Symbolicae: The Visual Image in Neo-Platonic Thought," *Journal of the Warburg and Courtauld Institutes* 11, pp. 163-92

G. Kaftal, *St. Dominic in Early Tuscan Painting*, Oxford

F. M. Perkins, *La Deposizione: Beato Angelico*, Milan

M. Salmi, *Masaccio*, 2d ed., Milan

1949: G. Kaftal, *St. Catherine in Tuscan Painting*, Oxford

B. Nicolson, "Two Little Known Pictures at Hampton Court," *The Burlington Magazine* 91, p. 137

M. Pittaluga, *Filippo Lippi*, Florence

A. E. Popham, *The Italian Drawings of the XV and XVI Centuries in the Collection of His Majesty the King at Windsor Castle*, London

C. L. Ragghianti, "Collezioni americane. La Collezione Rabinowitz," *Critica d'Arte* 27, p. 80

A. Sanchez-Canton, *Museo del Prado, Catalogo de los Cuadros*, Madrid

Chefs d'oeuvre de la Collection D.G. Van Beuningen, Petit Palais, Paris

1950: K. Bauch, "Christus am Kreuz und der heilige Franziskus," *Eine Gabe der Freunde für Carl Georg Heise zum 28. VI. 1950*, Berlin, pp. 103-12

L. Collobi-Ragghianti, "Domenico Michelino," *Critica d'Arte* 3, year 8, no. 5, fasc. 31 (January), pp. 363-78

L. Collobi-Ragghianti, "Zanobi Strozzi pittore," *Critica d'Arte* 3, year 8, no. 6, fasc. 32 (March), pp. 454-73; year 9, no. 1, fasc. 33 (May), pp. 17-27

W. A. Eden, "St. Thomas Aquinas and Vitruvius," *Medieval and Renaissance Studies*, pp. 183-85

A. E. Popham, *Italian Drawings in the Department of Prints and Drawings in the British Museum: the Fourteenth and Fifteenth Centuries*, vol. 1, London

D. Redig de Campos, *Atti della Pontificia Accademia Romana di Archeologia* 23-24, 385-88

M. Salmi, "Problemi di Angelico," *Commentari* 1

F. Zeri, "Arcangelo di Cola: due tempere," *Paragone* 1, p. 33

1951: R. Longhi, "Un ritrovamento eccezionale," *Paragone* 25, p. 64 (reprinted in Longhi 1975, p. 75)

J. Pope-Hennessy, "The Early Style of Domenico Veneziano," *The Burlington Magazine* 93, pp. 216-23

W. Suida, *Paintings and Drawings from the Kress Collection*, San Francisco

1952: A. H. Armstrong, "The Greek Philosophical Background of the Psychology of St. Thomas," *The Aquinas Society of London, Aquinas Paper* 19, London

B. Berenson, *The Italian Painters of the Renaissance*, London

G. Kaftal, *Saints in Italian Art*, vol. 1 (*Iconography of the Saints in Tuscan Painting*), Florence

R. Longhi, "Il Maestro di Pratovecchio," *Paragone* 35

W. Paatz and E. Paatz, *Die Kirche von Florenz*, Frankfurt

G. Paccagnini, "Una Proposta per Domenico Veneziano," *Bollettino d'Arte* 37, pp. 115-26

J. Pope-Hennessy, *Fra Angelico*, London

1953: J. Anderson, *An Introduction to the Metaphysics of St. Thomas Aquinas* (1989 ed.), Washington, D.C.

P. Bargellini, "Il Beato Dominico, Sant'Antonino e il Beato Angelico," *Atti e memorie della R. Accademia di S. Luca* 6 (1953-56), pp. 47-51

C. Brandi, *Mostra di dipinti restaurati*, Florence

P. D'Ancona, *Beato Angelico*, Milan

V. Mariani, "Spazio reale e spazio ideale in Beato Angelico," *Atti e memorie della R. Accademia di S. Luca* 6 (1953-56), pp. 40-44

E. Panofsky, *Early Netherlandish Painting*, Cambridge, Mass.

C. Pepler, "The Basis of St. Thomas's Mysticism," *The Aquinas Society of London, Aquinas Paper* 21, London

U. Procacci, "Sulla cronologia delle opere di Masaccio e di Masolino tra il 1425 e il 1428," *Rivista d'Arte* 27, pp. 3-55

Mostra storica nazionale del miniature, Rome

1954: G. Ferguson, *Signs & Symbols in Christian Art*, New York

S. Orlandi, "Il Beato Angelico," *Rivista d'Arte* 29, pp. 161-97

S. Orlandi, *Sant'Antonino*, Florence

S. Orlandi, "Su una tavola dipinta da Fra Filippo Lippi per Antonio Branca," *Rivista d'Arte*, pp. 199-201

F. Zeri, "Alvaro Pirez, 'Tre Tavole'" *Paragone* 2, pp. 44-47

1955: G. C. Argan, *Fra Angelico*, Geneva

V. Alce, "Il Beato Angelico alla luce degli ultimi studi," *Arte Cristiana* 43, pp. 183-202

V. Alce, "L'arte del Beato Angelico," *Memorie domenicane* 72, vol. 1, pp. 38-92

H. Baron, *The Crisis of the Early Italian Renaissance*, Princeton, N.J.

L. Berti, "Mostra del Beato Angelico," *Bollettino d'Arte* 40

W. Cohn, "Il Beato Angelico e Battista di Biagio Sanguigni," *Rivista d'Arte* 30, pp. 207-21

L. Collobi-Ragghianti, "Una Mostra di Angelico," *Critica d'arte nuova* 10, n.s., pp. 389-94

L. Collobi-Ragghianti, "Studi angelichiani," *Critica d'arte nuova*, n.s. no. 7 (January), pp. 22-47

U. Middeldorf, "L'Angelico e la scultura" *Rinascimento* 6, pp. 179-94 (reprinted in *Collected Writings, 1939-1973*, Florence, 1980, vol. 2, pp. 183-99)

S. Orlandi, "Beato Angelico: note cronologiche," *Memorie domenicane* 72, vol. 1, pp. 3-37

S. Orlandi, *La Beata Villana terziaria domenicana fiorentina del sec. XIV*, Florence

S. Orlandi, *Necrologio di S. Maria Novella: Testo integrale dall'inizio (MCCXXXV) al MDIV; corredato di note biografiche tratte da documenti coevi*, Florence

A. Paganucci, "L'iconografia del Beato Angelico," *Memorie domenicane* 72, vol. 1, pp. 93-100

A. Rohlfs-von Wittich, "Das Innenraumbild als Kriterium für die Bildwelt," *Zeitschrift für Kunstgeschichte* 18, pp. 109-35

E. Panofsky, *Meaning in the Visual Arts*, New York

E. P. Richardson, "A Fra Angelico Madonna," *The Detroit Institute of Arts Bulletin* 35, vol. 4, pp. 87-88

I. Taurisano, *Beato Angelico*, Rome

Mostra dei documenti sulla vita e le opere dell'Angelico e delle fonti storiche fino al Vasari, exhibit. catalog (May-September 1955), Florence

Mostra delle Opere di Fra Angelico, exhibit. catalog (April-May), Vatican City

1956: L. B. Alberti, *On Painting*, J. R. Spencer, ed. and trans., London

U. Baldini, *Commentari* 7, pp. 78-83

W. Cohn, "Nuovi documenti per il Beato Angelico," *Memorie domenicane* 73, vol. 4, pp. 218-20

I. M. Colosio, "Il Dottore Angelico e il Pittore Angelico," *Rivista di Ascetica e Mistica* 2, pp. 3-20

Dionysius the Areopagite, *Le Opere*, E. Turolla, ed., Padua

R. Krautheimer, *Lorenzo Ghiberti*, Princeton, N.J.

S. Orlandi, "I maestri del Beato Angelico," *Memorie domenicane* 73, vol. 1, pp. 3-16

S. Orlandi, "Quando è nato il Beato Angelico," *Memorie domenicane* 73, vol. 1, pp. 52-54

1957: C. Gomez-Moreno, "A Reconstructed Panel by Fra Angelico," *The Art Bulletin*, pp. 183-93

E. Holt, *A Documentary History of Art*, vol. 1, New York

J. White, *The Birth and Rebirth of Pictorial Space*, London

1958: B. Degenhart and A. Schmitt, *Corpus der italienischen Zeichnungen 1300-1450*, Berlin, I-II, no. 369

The Hermitage: Catalogue of the Collection, Leningrad

M. Levi D'Ancona, "Some New Attributions to Lorenzo Monaco," *The Art Bulletin* 40, pp. 180-89

O. Magnusson, *Roman Quattrocento Architecture*, Stockholm

M. Meiss, "Four Panels by Lorenzo Monaco," *The Burlington Magazine* 100, pp. 191-96

M. Salmi, *Il Beato Angelico*, Spoleto

G. Urbani, "Angelico," *Enciclopedia Universale dell'Arte*, Venice-Rome, vol. 1, p. 407

V. Zoubov, "Leon Battista Alberti et les auteurs du Moyen Age," *Mediaeval and Renaissance Studies*, pp. 245-66

1959: *Catalogo della X Mostra d'opere d'arte restaurate*, Florence

N. Gabrielli, *La Galleria Sabauda a Torino*, Turin

C. Gilbert, "The Archbishop of Florence on the Painters of Florence, 1450," *The Art Bulletin*, pp. 75-87

John Herron Art Museum: Paintings from the Collection of G.H.A. Clowes, exhibit. catalog, Indianapolis
M. Levi D'Ancona, "Zanobi Strozzi Reconsidered," *La Bibliofilia* 61, pp. 1–38
P. Murray, *An Index of Attributions before Vasari*, Florence

1960: E. Borsook, *The Mural Painters of Tuscany*, London (2d ed., Oxford, 1980)
M. Chiarini, "Nota sull'Angelico," *Arte Antica e Moderna* 2, pp. 279–80
B. Degenhart, "Gentile da Fabriano in Rom und die Anfänge des Antikenstudiums: Ein Musterblattkomplex Gentiles und seiner Schüler," *Münchner Jahrbuch der bildenden Kunst* 11, pp. 59–60
O. Gurrieri, *La Chiesa di San Domenico di Perugia*, Perugia
E. Panofsky, *Renaissance and Renascences in Western Art*, New York (2d ed., 1969)
U. Procacci, *Sinopie e affreschi*, Florence

1961: *Mostra d'Arte Sacra Antica*, Florence
B. Berenson, *I disegni dei pittori fiorentini* (ed. 1961, originally published 1938, Milan)
A. M. Brown, "The Humanist Portrait of Cosimo de' Medici," *Journal of the Warburg and Courtauld Institutes*, pp. 186–215
T. S. Centi, "Disegno originale del Beato Angelico scoperto nel suo convento," *Memorie domenicane* 78, pp. 3–9
M. Davies, *The Earlier Italian School (National Gallery Catalogues)*, 2d ed., London
A. Grabar, *Christian Iconography: A Study of Its Origins*, Princeton, N.J.
G. B. Ladner, "Vegetation Symbolism and the Concept of the Renaissance," *Essays in Honor of Erwin Panofsky*, Millard Meiss, ed., New York, pp. 303–22
P. Meller, "La Cappella Brancacci: Problemi, ritrattistici e iconografici," *Acropoli* 3, pp. 186–227, and 4, pp. 273–312
R. Oertel, *Frühe Italienische Malerei in Altenburg*, Berlin
A. Parronchi, "Postilla sul neo-Gaddismo degli anni 1423–25," *Paragone* 12, pp. 19–26
C. Seymour, Jr., *The Rabinowitz Collection of European Paintings*, New Haven

1962: L. Berti, "Un foglio miniato dell'Angelico," *Bollettino d'Arte* 47, pp. 207–15
L. Berti, "Masaccio a S. Giovenale di Cascia," in *Acropoli* 2, pp. 149–65
L. Berti, "Miniature dell'Angelico (e altro)," *Acropoli* 2, vol. 4, pp. 277–308, and 3 (1963), vol. 1, pp. 1–38
R. Salvini, in *Scritti di storia dell'arte in onore di Mario Salmi*, pp. 299–304

1963: B. Berenson, *The Italian Pictures of the Renaissance: The Florentine School*, London
E. Casalini, "L'Angelico e la cateratta per l'armadio degli argenti alla SS. Annunziata di Firenze," *Commentari* 14, pp. 104–24
M. Chiarini, "Il Maestro del Chiostro degli aranci: Giovanni di Consalvo portoghese," *Proporzione* 4
M. Meiss, "Masaccio and the Early Renaissance: The Circular Plan," *Studies in Western Art: Acts of the 20th International Congress of History of Art*, Princeton, N.J., pp. 123–45
R. Oertel, "Perspective and Imagination," *Studies in Western Art: Acts of the 20th International Congress of History of Art*, Princeton, N.J., pp. 146–59
V. da Bisticci, *The Lives of Illustrious Men of the xvth Century*, in M. P. Gilmore, *Renaissance Princes, Popes, and Prelates*, New York–London

1963–64: T. M. Centi, "Sulla nuova cronologia dell'Angelico," *Bollettino dell'Istituto storico artistico orvietano* 19–20, pp. 91–100

1964: U. Baldini, *Beato Angelico*, Spoleto
L. Berti, *Masaccio*, Milan
G. Fiocco, "La Biblioteca di Palla Strozzi," *Studi di bibliografia e di storia in onore di Tammaro de Marinis*, Verona, vol. 2, pp. 306–10
S. Orlandi, *Beato Angelico: Monografia storica della vita e delle opere, con un'appendice di nuovi documenti inediti*, Florence
J. Pope-Hennessy and R. Lightbown, *Italian Sculpture in the Victoria and Albert Museum*, London
J. Shearman, *Italian Art in the Royal Collection, The Queen's Gallery*, London

1965: L. Berti, "L'Angelico a San Marco," *Forma e Colore* 13
A. Cartotti Oddasso, "Iconografia del Beato Angelico," in *Memorie domenicane* 82, pp. 113–19
O. Millar, *Italian Drawings and Paintings in the Queen's Collection*, London
S. Orlandi, "Per la cronologia del Beato Angelico," *Memorie domenicane* 82, pp. 43–51
C. Shell, "Francesco d'Antonio and Masaccio" *The Art Bulletin* 47, pp. 465–69

1966: U. Baldini and L. Berti, eds., *Mostra degli affreschi staccati*, Florence
L. Bellosi, "Il Maestro della Crocifissione Griggs: Giovanni Toscani," *Paragone* 193, pp. 44–58
M. Boskovits, "Giotto Born Again," *Zeitschrift für Kunstgeschichte* 29, pp. 51–66
E. Camesasca, *Artisti in bottega*, Milan
M. Cämmerer-George, *Die Rahmung der Toskanischen Altarbilder im Trecento*, Strasbourg, pp. 187–88
E. H. Gombrich, "The Early Medici as Patrons of Art," in *Norm and Form*, London, pp. 38ff.
A. Parronchi, "Titulus Crucis," *Antichità viva*, pp. 41–42
U. Procacci, "L'uso dei documenti negli studi di storia dell'Arte e le vicende politche ed economiche in Firenze durante il primo Quattrocento nel loro rapporto con gli artisti," *Donatello e il suo tempo, Atti dell'VIII Convegno internazionale di Studi sul Rinascimento*, Florence
M. Salmi, "Il Sassetta di San Martino," *Commentari* 17, pp. 73–82
F. R. Shapley, *Paintings from the Samuel H. Kress Collection*, vol. 1, London
J. Shearman, "Masaccio's Pisa Altarpiece: An Alternative Reconstruction," *The Burlington Magazine* 108, pp. 449–55
B. Sweeney, *Catalogue of Italian Paintings, John G. Johnson Collection*, Philadelphia

1967: J. Byam-Shaw, *Paintings by Old Masters in the Library of Christ Church*, Oxford
Levinson-Lessing, *The Ermitage, Leningrad: Medieval and Renaissance Masters*
D. Redig de Campos, *I Palazzi Vaticani*, Bologna
J. Shearman, "Le rovine dell'arte fiorentina: ciò che l'alluvione è costata alla civiltà," *Paragone* 18, no. 203, pp. 13–33

1968: L. Berti, *L'opera completa di Masaccio*, Milan
R. Chiarelli, *I codici miniati del Museo di San Marco a Firenze*, Florence, pp. 21–24
B. Degenhard and A. Schmitt, *Corpus der italienischen Zeichnungen, 1300–1400*, vol. 1, Berlin
A. Grabar, *Christian Iconography: A Study of Its Origins*, Princeton, N.J.
R. Longhi, "Me pinxit e quesiti caravaggeschi," *Edizione dell'opera completa di R. Longhi*, Florence, vol. 4, 44, no. 5
P. Partner, "Firenze and the Papacy in the Early Fifteenth Century," *Florentine Studies*, N. Rubenstein, ed., London, pp. 381–402
U. Procacci, *The Great Age of the Fresco*

V. Sacconi, *Pittura marchigiana: la scuola camerinese*, Trieste
G. Schiller, *Ikonographie der Christlichen Kunst*, vol. 3, Hamburg
R. Sellheim, "Die Madonna mit der Schahada," *Festschrift Werner Caskel*, Leiden, pp. 308–15

1969: B. Berenson, *Homeless Paintings of the Renaissance*, Bloomington, Ind.
M. Boskovits, "Mariotto di Cristofano: Un contributo all'ambiente culturale di Masaccio giovane," *Arte Illustrata* 2, pp. 4–13
P. Brown, *Augustine of Hippo*, Berkeley–Los Angeles
N. F. Cantor and P. L. Klein, *Medieval Thought: Augustine & Thomas Aquinas*, Waltham, Mass.
R. Heinemann, *The Thyssen-Bornemisza Collection*, Lugano
G. Holmes, *The Florentine Enlightenment: 1400–1450*, New York
A. Padoa, "Una precisazione sulla collaborazione di Benozzo Gozzoli agli affreschi del Convento di San Marco," *Antichità viva* 8, vol. 2, pp. 9–13
R. Weiss, *The Renaissance Discovery of Classical Antiquity*, New York (2d ed., 1988)
F. Zeri, "Opere maggiore di Arcangelo di Cola," *Antichità viva* 8, pp. 13–14

1970: U. Baldini, *L'opera completa dell'Angelico*, Milan
M. Boskovits, "Due secoli di pittura murale a Prato—Aggiunti e precisioni," *Arte illustrata* 25–26, pp. 40–45
R. Fremantle, "Masaccio e l'Angelico," *Antichità viva* 9, vol. 6, pp. 39–49
A. Gonzalez-Palacios, "Indagini su Lorenzo Monaco," *Paragone* 21, p. 34
L. Grassi, *Teorici e Storia della Critica d'Arte*, Rome
A. Prandi, "Cultura e gusto nell'arte del Beato Angelico," *Miscellanea Gilles Gérard Meersseman*, Padua, pp. 548–76
C. Seymour, *Early Italian Paintings in the Yale University Art Gallery*, London

1971: *European Paintings in the Minneapolis Institute of Arts*, Minneapolis
N. Gabrielli, *Galleria Sabauda, Maestri Italiani*, Turin
J. Polzer, "Masaccio and the Late Antique," *The Art Bulletin* 53, pp. 36–40
P. Zampetti, *Paintings from the Marches*, Rome
F. Zeri, *Italian Paintings, The Metropolitan Museum of Art, Florentine School*, New York

1972: M. Baxandall, *Painting and Experience in Fifteenth Century Italy*, Oxford (2d ed., 1974)
B. Frederickson and F. Zeri, *Census of Pre-Nineteenth Century Italian Paintings in North American Public Collections*, Cambridge, Mass.
P. O. Kristeller, *Renaissance Thought and the Arts*, Princeton, N.J.
Old Paintings, 1400–1900: Catalogue of the Collection, Rotterdam
A. Padoa Rizzo, *Benozzo Gozzoli Pittore Fiorentino*, Florence

1973: M. Davies, *Rogier van der Weyden*, London
C. Volpe, "Alcune restituzioni al Maestro dei Santi Quirico e Giulitta," *Quaderni di Emblema* 2, Bergamo, pp. 19ff.
M. Meiss, *Painting in Florence and Siena after the Black Death*, Princeton, N.J. (2d ed., 1978)
G. Palumbo, *Collezione Federico Mason Perkins*, Assisi

1974: M. Baxandall, "Alberti and Cristoforo Landino: The Practical Criticism of Painting," *Convegno Internazionale indetto nel v centenario di Leon Battista Alberti (1972)*, Rome
L. Bellosi, *Buffalmacco e il Trionfo della Morte*, Turin
E. Carli, *Il Museo di Pisa*, Pisa
Cleveland Museum of Art, *European Painting before 1500 in the Cleveland Museum of Art*, Cleveland, pp. 89–91
L. Collobi-Ragghianti, *Il Libro de' disegni del Vasari*, 2 vols., Florence
A. I. Fraser, *A Catalogue of the Clowes Collection*, Indianapolis
E. H. Gombrich, "The Sky Is the Limit: The Vault of Heaven and Pictorial Vision," *Essays in Honor of James J. Gibbon*, Cornell, N.Y.
R. Longhi, *Giudizio sul Duecento e Ricerche sul Trecento nell'Italia Centrale*, Florence
M. Meiss, "Scholarship and Penitence in the Early Renaissance," *Pantheon* 32
J. Pope-Hennessy, *Fra Angelico*, London
H. W. Van Os and M. Prakken, *The Florentine Paintings in Holland 1300–1500*, Maarssen, The Netherlands
J. van Waadenoijen, "A Proposal for Starnina: Exit the Master of the Bambino Vispo," *The Burlington Magazine* 116, pp. 82–91
N. C. Wixom, "Master of 1419, Madonna and Child Enthroned," in *European Painting before 1500 in the Cleveland Museum of Art*, Cleveland, pp. 89–91

1975: M. Boskovits, "Il Maestro del Bambino Vispo: Gherardo Starnina o Miguel Alcaniz," *Paragone* 81, pp. 3–15
M. Boskovits, *Pittura fiorentina alla vigilia del Rinascimento*, Florence
G. Brucker, *Renaissance Florence*, New York
D. D. Davisson, "The Iconology of the Santa Trinita Sacristy, 1418–35: A Study of the Private and Public Functions of Religious Art in the Early Quattrocento," *The Art Bulletin* 57, pp. 315–47
R. Fremantle, *Florentine Gothic Painters*, London
C. Gilbert, "Fra Angelico's Fresco Cycles in Rome: Their Number and Date," *Zeitschrift für Kunstgeschichte* 38, pp. 245–65
Katalog der ausgestellten Gemälde des 13.-18. Jahrhunderts. Gemäldegalerie Staatliche Museen Preussischer Kulturbesitz Berlin, Berlin
R. Longhi, "Fatti di Masolino e di Masaccio e Altri Studi sul Quattrocento," *Opere complete di Roberto Longhi*, vol. 8, Florence
A. Padoa Rizzo, "Aggiunte a Paolo Schiavo," *Antichità viva* 14, pp. 3–8
A. Plogsterth, "A Reconsideration of the Religious Iconography in Hartt's 'History of Italian Renaissance Art,'" *The Art Bulletin* 57, pp. 433–37
J. Ruda, "The National Gallery Tondo of the Adoration of the Magi and the Early Style of Filippo Lippi," *Studies in the History of Art* 7, pp. 7–39

1976: M. Boskovits, "Appunti sull'Angelico," *Paragone* 27, no. 313, pp. 30–54
M. Boskovits, *Un'adorazione dei magi e gli inizi dell'Angelico*, Berne
P. J. Cardile, "Fra Angelico and His Workshop at San Domenico (1420-1435): The Development of His Style and the Formation of His Workshop," Ph.D. dissertation, Yale University
M. Eisenberg, "The Penitent St. Jerome by Giovanni Toscani," *The Burlington Magazine* 118 (May), pp. 275–83
E. H. Gombrich, *The Heritage of Apelles*, London
M. Kemp, "Ogni dipintore dipinge sè: a Neoplatonic Echo in Leonardo's Art Theory," *Essays in Honor of Paul Oskar Kristeller*, C. H. Clough, ed., Manchester

E. Micheletti, *Gentile da Fabriano*, Milan

F. Sricchia Santoro, "Sul soggiorno spagnolo di Gherardo Starnina e sull'identità del 'Maestro del Bambino Vispo,'" *Prospettiva* 6, pp. 11-29

P.J.J. van Thiel et al., *All the Paintings of the Rijksmuseum in Amsterdam*, Amsterdam

1977: M. Alexander, "The Sculptural Sources of Fra Angelico's Linaiuoli Tabernacle," *Zeitschrift für Kunstgeschichte* 38, pp. 154-63

U. Baldini, "Contributi all'Angelico: Il trittico di San Domenico di Fiesole e qualche altra aggiunta," *Scritti di storia dell'arte in onore di Ugo Procacci*, Milan, pp. 236-46

G. Brunetti, "Una vacchetta segnata A," *Scritti di storia dell'arte in onore di Ugo Procacci*, Milan, pp. 228-35

C. Gilbert, "Peintres et menuisiers au début de la Renaissance en Italie," *Revue de l'Art* 37, & 16

B. Cole, *Agnolo Gaddi*, Oxford

D. Cole, "Fra Angelico: His Role in Quattrocento Painting and Problems of Chronology" (Ph.D. dissertation, University of Virginia), Charlottesville, Va.

D. C. Cole, "Fra Angelico: A New Document," *Mitteilungen des Kunsthistorischen Institutes in Florenz* 21, pp. 95-100

S. Y. Edgerton, "'Mensurare temporalia facit Geometria spiritualis,' Some Fifteenth-Century Italian Notions About When and Where the Annunciation Happened," *Studies in Medieval and Renaissance Painting in Honor of Millard Meiss*, New York, pp. 115-30

H. Glasser, *Artists' Contracts of the Early Renaissance*, New York–London

R. Krautheimer, "Fra Angelico and—perhaps—Alberti," *Studies in Medieval and Renaissance Painting in Honor of Millard Meiss*, New York, pp. 290-96

G. Vigorelli, *L'opera completa di Giotto*, Milan

1978: M. Boskovits, *Toskanische Fruhrenaissance—Tafelbilder*, vol. 4, Budapest

B. J. Delaney, "Antonio Vivarini and the Florentine Tradition," *Commentari* 29, pp. 81-95

C. Gilbert, *Fra Angelico, Theologische Realenzyklopädie*, vol. 2, no. 5, Berlin and New York, pp. 710-13

G. Kaftal, *Iconography of the Saints in the Painting of North East Italy*, Florence

Lorenzo Ghiberti, "materia e ragionamenti," exhibit. catalog, Florence

J. Ruda, "A 1434 Building Programme for San Lorenzo in Florence," *The Burlington Magazine* 120, pp. 358-61

E.M.L. Wakayama, "Lettura iconografica degli affreschi della Cappella Brancacci: analisi dei gesti e della composizione," *Commentari* 1-4, pp. 72-80

1979: S. Y. Edgerton, "A Little Known Purpose of Art in the Italian Renaissance," *Art History* 1, pp. 45-61

J. Eissengarthen, "Die formale und künstlerische Entwicklung des liturgischen Gewandes seit den Anfängen," *Das Münster* 32, pp. 117-25

J. Fleming, "Art Dealing in the Risorgimento, II," *The Burlington Magazine* 121, pp. 492-508

Gemaldegalerie Alte Meister Dresden, Katalog der ausgestellten Werke, Dresden

R. Goffen, "Nostra Conversatio in Caelis Est: Observations on the Sacra Conversatio in the Trecento," *The Art Bulletin* 61, pp. 219-20

A. M. Maetzke, *Arte nell'aretino: seconda mostra di restauri*, Florence

G. Marchini, *Filippo Lippi*, Milan

J. Pope-Hennessy, "The Ford Italian Paintings," *The Detroit Institute of Arts Bulletin* 57, vol. 1, pp. 15-23

F. Shapley, *Catalogue of the Italian Paintings,* *National Gallery of Art*, 2 vols., Washington, D.C.

D. Sutton, "Robert Langton Douglas, III: Fra Angelico Revalued," *Apollo* 109, pp. 262-70

H. Teubner, "San Marco in Florenz: Umbauten vor 1500. Ein Beitrag zum Werk des Michelozzo," *Mitteilungen des Kunsthistorisches Instituts im Florenz* 23, pp. 239-72

1980: D. Cole Ahl, "Fra Angelico: A New Chronology for the 1420s," *Zeitschrift für Kunstgeschichte* 43, pp. 360-81

A. Braham, "The Emperor Sigismund and the Santa Maria Maggiore Altarpiece," *The Burlington Magazine* 122, pp. 106-12

L. Berti, ed., *Gli Uffizi: Catalogo Generale*, 2d ed., Florence

E. Borsook, *The Mural Painters of Tuscany*, 2d ed., Oxford

B. Cole, *Masaccio and the Art of Early Renaissance Florence*, Bloomington, Ind.

A. Conti, "Arte all'aretino, Arezzo, San Francesco, 30 novembre 1979-20 febbraio 1980 [exhibit.]," *Prospettiva* 21, pp. 102-4

M. D. Emiliani, ed., with contributions by R. Angeli, D. Arasse, E.M.L. Wakayama, and R. Ziti, *La Prospettiva Rinascimentale: Codificazione e Trasgressioni* (conference records, Milan, 1977), Florence

A. Godoli and A. Natali, *Luoghi della Toscana medicea*, Florence

P. O. Kristeller, *Renaissance Thought and the Arts, Collected Essays*, Princeton, N.J.

E. Liberti, "S. Pietro Martire nell'arte del Beato Angelico," *Arte Cristiana* 68, pp. 39-44

J. Pope-Hennessy, *The Study and Criticism of Italian Sculpture*, New York

J. Stubblebine, M. Gibbons, F. Cossa, S. Sitt, G. Chapman, "Early Masaccio: A Hypothetical Lost Madonna and a Disattribution," *The Art Bulletin*, p. 224

C. Vasoli, ed., *Idee, istituzioni, scienza ed arti nella Firenze dei Medici*, Florence

H. Wohl, *The Paintings of Domenico Veneziano, c. 1410-1461*, New York

1981: D. Cole Ahl, "Fra Angelico: A New Chronology for the 1430s," *Zeitschrift für Kunstgeschichte* 44, pp. 133-58

A. Brejon de Lavergnée and D. Thiébaut, *Catalogue sommaire illustré des peintures du musée du Louvre: Italie, Espagne, Allemagne, Grande-Bretagne et divers*, Paris

R. Goffen, "Masaccio's Trinity and the Letter to the Hebrews," *Memorie domenicane* 2

F. Haskell and N. Penny, *Taste and the Antique*, New Haven and London (2d ed., 1982)

The Museum of Fine Arts, Houston, Guide to the Collection, Houston

A. T. Ladis, "Fra Angelico: Newly Discovered Documents from the 1420s," *Mitteilungen des Kunsthistorischen Institutes im Florenz* 25, pp. 378-79

A. Padoa Rizzo, "Nota breve su Colantonio, van der Weyden e l'Angelico," *Antichità viva* 20, vol. 5, pp. 15-17

S. Vsevolozhskaya, *13th to 19th Century Italian Painting from the Ermitage Museum*, New York–Leningrad

1982: V. Alce, "Il Beato Angelico a Cortona nel 1438," *Memorie domenicane*, n.s. 13, pp. 422-30

U. Baldini and S. Boni, "Beato Angelico, Crocifissione," *Metodo e Scienza: Operatività e ricerca nel restauro*, Florence, pp. 127-29

G. Bonsanti, *La città degli Uffizi*, Florence

P. Castelli, "Lux Italiae: Ambrogio Traversari monaco camaldolese. Idee e immagini nel Quattrocento fiorentino," *Atti e memorie dell'Accademia toscana di scienze e lettere La Colombaria* 47, n.s. 33, pp. 41-90

C. Chiarelli and G. Leoncini, *La Certosa del Galluzzo a Firenze*, Florence

K. Christiansen, *Gentile da Fabriano*, London

C. Del Bravo, *Etica o Poesia, e Mecenatismo: Cosimo il Vecchio, Lorenzo e Alcuni Dipinti*, Florence

T. T. Matthews, "Cracks in Lehmann's 'Dome of Heaven,'" *Source* 1, pp. 12-16

E.M.L. Wakayama, "Per la datazione delle storie di Noè di Paolo Uccello: un'ipotesi di lettura," *Arte Lombarda*, n.s. 61, pp. 93-106

1983: G. Bonsanti, "Preliminari per l'Angelico restaurato," *Arte Cristiana* 71, pp. 25-34

M. Boskovits, "La fase tarda del Beato Angelico: una proposta di interpretazione," *Arte Cristiana* 71, pp. 11-24

P. J. Cardile, *Fra Angelico and His Workshop at San Domenico (1420-1435): The Development of His Style and the Formation of His Workshop* (Ph.D. dissertation, Yale University), Ann Arbor, Mich., University Microfilms

B. Cole, *The Renaissance Artist at Work: From Pisano to Titian*, New York

L. Fornari Schianchi, *La Galleria Nazionale di Parma*, Parma

B. Santi, "Giovanni da Ponte," *Mostra di opere d'arte restaurate nelle province di Siena e Grosseto*, exhibit. catalog, pp. 81-83

P. Sheaffer, "White Light and Meditation at San Marco," *Memorie domenicane*, n.s. 14, pp. 329-34

J. Shearman, *The Early Italian Pictures in the Collection of Her Majesty the Queen*, Cambridge

G. Szabo, *Masterpieces of Italian Drawing in the Robert Lehman Collection, The Metropolitan Museum of Art*, New York

C. Trinkaus, *The Scope of Renaissance Humanism*, Ann Arbor, Mich.

J. van Waadenoijen, *Starnina e il gotico internazionale a Firenze*, Florence

1984: D. Cole Ahl, "Il 'Dio Padre' del Beato Angelico al Louvre: Analisi di un'opera giovanile," *Antichità viva* 23, vol. 3, pp. 19-20

V. Alce, *Il Beato Giovanni: Pittore Angelico*, Siena

V. Alce, "Cataloghi ed indici delle opere del Beato Angelico," *Beato Angelico: miscellanea di studi*, edited by the general postulation of the Dominicans, papal commission on holy art in Italy, Rome, pp. 351-405

V. Alce, "Saggio bibliografico sul Beato Angelico" and "Catalogo degli iscrizioni," *Beato Angelico: miscellanea di studi*, edited by the general postulation of the Dominicans, papal commission on holy art in Italy, Rome, pp. 407-62

Beato Angelico: miscellanea di studi, edited by the general postulation of the Dominicans, papal commission on holy art in Italy, Rome

L. Bellosi, "Il Museo di San Marco," *Prospettiva* 37, pp. 87-88

K. Bering, *Fra Angelico: mittelalterlicher Mystiker oder Maler der Renaissance*, Essen

A. Cavallaro, "Aspetti e protagonisti della pittura del Quattrocento romano in coincidenza dei Giubilei," *Roma, 1300-1875, L'arte degli Anni Santi*, exhibit. catalog, Rome, pp. 334-38

A. Chastel, "Signum harpocraticum," *Studi in onore di Giulio Carlo Argan*, Rome, vol. 1, pp. 147-59

P. Corsini, ed., *Italian Old Master Paintings*, exhibit. catalog, New York

G. Fallani, *Vita e opera di Fra Giovanni Angelico*, Florence

M. Ferrara and F. Quinterio, *Michelozzo di Bartolomeo*, Florence

C. Gilbert, "The Conversion of Fra Angelico," *Scritti di storia dell'arte in onore di Roberto Salvini*, Florence, pp. 281-87

R. Jones, "Palla Strozzi e la sagrestia di Santa Trinita," *Rivista d'Arte* 37, pp. 9-106

E. Marino, "Beato Angelico: umanesimo e teologia," *Beato Angelico: miscellanea di studi,* edited by the general postulation of the Dominicans, papal commission on holy art in Italy, Rome, pp. 465-533

E. Micheletti and A. M. Maetzke, eds., *Masaccio e l'Angelico: due capolavori della diocesi di Fiesole*, exhibit. catalog, Fiesole

B. Sabatine, *Pope Nicola v's Chapel of Saints Stephen and Lawrence by Fra Angelico: An Historical Interpretation* (Ph.D. dissertation, University of Oregon, 1982), Ann Arbor, Mich., University Microfilms

F. Scalia and C. de Benedictis, *Museo Bardini a Firenze*, Florence

I. Venchi, "Cronologia del Beato Angelico," *Beato Angelico: miscellanea di studi*, edited by the general postulation of the Dominicans, papal commission on holy art in Italy, Rome, pp. 3-28

I. Venchi, "La veridicità di Giorgio Vasari nella biografia del Beato Angelico," *Beato Angelico: miscellanea di studi*, edited by the general postulation of the Dominicans, papal commission on holy art in Italy, Rome, pp. 91-124

M. Wynne, "Masaccio and Beato Angelico at Fiesole," *Apollo* 120, no. 270, p. 13

1985: G. Bonsanti, *Il museo di San Marco*, Florence

M. Boskovits, *The Martello Collection*, Florence

L. Castelfranchi, "L'Angelico e il 'De Pictura' dell'Alberti," *Paragone* 36, nos. 419-23, pp. 97-106

A. Conti, "Attenzione ai restauri," *Prospettiva* 40, pp. 3-9

A. De Marchi, "Per la cronologia dell'Angelico: il Trittico di Perugia," *Prospettiva* 41, pp. 53-57

M. Ficino, *Commentary on Plato's Symposium on Love*, S. Jayne, trans., Dallas, Tex.

A. Garzelli, *Miniatura fiorentine del Rinascimento: 1440-1525: Un primo censimento*, Scandicci

D. Herlihy and C. Klapisch-Zuber, *Tuscans and Their Families: A Study of the Florentine Catasto of 1427*, New Haven

M. J. Marek, "Ordenspolitik und Andacht: Fra Angelicos Kreuzigungfresko im Kapitelsaal von San Marco zu Florenz," *Zeitschrift für Kunstgeschichte* 48, pp. 451-75

A. Paolucci, *Il Museo della Collegiata di S. Andrea in Empoli*, Florence

J. Pope-Hennessy, *Italian Renaissance Sculpture*, New York

P. L. Roberts, "Saint Gregory the Great and the Santa Maria Maggiore Altarpiece," *The Burlington Magazine* 127, pp. 295-96

L. Sebregondi Fiorentini, *La confraternita di San Niccolò del Ceppo*, Florence

L. Schneider, "Shadow Metaphors and Piero della Francesca's Arezzo Annunciation," *Source* 5, 1985, pp. 18-22

1986: M. Baxandall, *Giotto and the Orators*, Oxford

L. Berti, "L'ambiente artistico fiorentino," *Art Dossier, Donatello* 3, pp. 8-17

D. A. Covi, *The Inscription in Fifteenth Century Florentine Painting*, New York

J. Godwin, *Music, Mysticism, and Magic: A Sourcebook*, London

W. Hood, "Saint Domenic's Manners of Praying: Gestures in Fra Angelico's Frescoes at San Marco," *The Art Bulletin* 68, pp. 195-206

C. Syre, *Ihm, Welcher der Andacht Tempel baut*, Munich

1987: P. Bober and R. Rubinstein, *Renaissance Artists & Antique Sculpture* (2d ed.), New York

A. Chastel, "L'art du geste à la Renaissance," *Revue de l'Art* 75, pp. 9-16

E. Fahy, "The Kimbell Fra Angelico," *Apollo* 125, no. 301, pp. 178-83

C. Frosinini, "Alcune precisazioni su Mariotto di Cristofano," *Rivista d'Arte*, pp. 443ff.

R. Gaston, "Liturgy and Patronage in San Lorenzo, Florence, 1350-1650," *Patronage, Art, and Society in Renaissance Italy*, K. Simons, P. Simons, and J. C. Eade, eds., Humanities Research Centre, Canberra, Clarendon Press, Oxford, pp. 110-33

R. van Hadley, ed., *The Letters of Bernard Berenson and Isabella Stewart Gardner, 1887-1924*, Boston

P. Hills, *The Light of Early Italian Painting*, London

H. James, *Italian Hours*, New York

J. I. Miller, "Medici Patronage and the Iconography of Fra Angelico's San Marco Altarpiece," *Studies in Iconography* 11, pp. 1-13

A. Padoa Rizzo, *La Chiesa di Santa Trinita a Firenze*, Florence

F. Petrucci, "La pittura a Firenze nel Quattrocento," *La pittura in Italia: il Quattrocento*, vol. 1, 2d ed., Milan, pp. 272-304

A. Pinelli, "La pittura a Roma e nel Lazio nel Quattrocento," *La pittura in Italia: il Quattrocento*, vol. 2, 2d ed., Milan, pp. 415-21

E. Pillsbury and W. Jordan, "Recent Painting Acquisitions, III: The Kimbell Art Museum," *The Burlington Magazine* 129, pp. 767-76

Plato, *The Republic*, Desmond Lee, trans. and ed., 2d ed., London

Pseudo-Dionysius the Areopagite, *The Complete Works* (C. Luibheid, trans.), New York

E. Samuels, *Bernard Berenson: The Making of a Legend*, Cambridge, Mass.

Supplementum Festivum Studies in Honor of Paul Oskar Kristeller, Binghamton, N.Y.

W. F. Volbach, *Il Trecento: Firenze e Siena*, Vatican City

E.M.L. Wakayama, "Masolino o non Masolino: problemi di attribuzione," *Arte Cristiana* 75, pp. 125-36

F. Zeri, ed., *La Pittura in Italia: Il Quattrocento*, 2 vols., Milan 1986 (ed. 1987)

1988: P. Amato, ed., *Imago Mariae: Tesori d'arte della civiltà cristiana*, exhibit. catalog, Rome

Arte in Lombardia tra Gotico e Rinascimento, exhibit. catalog, Milan

L. Berti, *Masaccio*, Firenze

J. Bialostocki, "The Door of Death, the Survival of a Classical Motif in Sepulchral Art," reprinted in *The Message of Images: Studies in the History of Art*, Vienna

E. de Boissard and V. Lavergne-Durey, *Chantilly, Musée Condé, Peintures de l'Ecole italienne*, Paris

A. Field, *The Origins of the Platonic Academy of Florence*, Princeton, N.J.

G. C. Garfarnini, ed., *Ambrogio Traversari nel VI Centenario della Nascita*, international conference (Camaldoli-Florence, 1986), with essays by C. Vasoli, "La cultura fiorentina al tempo del Traversari," pp. 69-94; U. Proch, "Ambrogio Traversari e il decreto di unione di Firenze: Una rilettura della 'Laetentur caeli' (6 luglio 1439)," pp. 147-64; A. Manfredi, "Traversari, Parentucelli e Pomposa: Ricerche di codici al servizio del Concilio di Firenze," pp. 165-88; C. Somigli, "Ambrogio Traversari autobiografico," pp. 194-200; P. Castelli, "Marmi policromi e bianchi screziati: In margine alle valutazioni estetiche del Traversari," pp. 210-24; M. Gigante, "Ambrogio Traversari interprete di Diogene Laerzio," pp. 247-60; P. Viti, "Per un'indagine filologica sul Traversari: la traduzione dell'Adversus Gentiles di sant'Atanasio," pp. 483-509

M. L. Gatti Perer, "Novità sulla decorazione della Biblioteca di S. Maria Incoronata a Milano," *Arte Lombarda*, pp. 195-234

C. Gilbert, *L'Arte del Quattrocento nelle Testimonianze Coeve*, Florence-Vienna

D. Hay, *Renaissance Essays*, London

P. Joannides, "The Colonna Triptych by Masaccio and Masolino: Chronology and Collaboration" *Arte Cristiana* 76, pp. 339-46

A. Ronen, "Gozzoli's St. Sebastian Altarpiece in San Gimignano," *Mitteilungen des Kunsthistorischen Instituts in Florenz* 32, pp. 77-126

G. Viroli, *La Pinacoteca Civica di Forlì*, Bologna

F. D. Zervas, "'Quos volent et eo modo quo volent': Piero de' Medici and the *Operai* of SS. Annunziata, 1445-55," *Firenze and Italy, Renaissance Studies in Honour of Nicolai Rubinstein*, P. Denley and C. Elam, eds., London, pp. 465-79

F. Zeri, *La collezione Federico Mason Perkins*

1988–89: A. R. Calderoni Masetti, "Lo smalto traslucido: problemi di tecnica e altro," *Prospettiva* 53-56, pp. 222-26

1989: L. Berti and R. Foggi, *Masaccio, Catalogo Completo dei dipinti*, Florence

L. Castelfranchi Vegas, *L'Angelico e l'Umanesimo*, Milan

M. Eisenberg, *Lorenzo Monaco*, Princeton, N.J.

P. Joannides, "Fra Angelico: Two Annunciations," *Arte Cristiana* 77, pp. 303-8

La Chiesa e il Convento di San Marco a Firenze, vol. 1, Florence

A. Santagostino Barbone, "Il Giudizio Universale del Beato Angelico per la chiesa del monastero camaldolese di S. Maria degli Angeli a Firenze," *Memorie domenicane*, n.s. 2, pp. 255-78

1990: U. Baldini, *Masaccio*, Florence

L. Bellosi, *Pittura di Luce: Giovanni di Francesco e l'arte fiorentina di metà Quattrocento*, exhibit. catalog, Florence

L. Berti and A. Paolucci, *L'età di Masaccio: il primo Quattrocento a Firenze*, exhibit. catalog, Florence

Biblioteca de "Lo Studiolo," Museo della casa fiorentina

E. P. Bowron, *European Paintings before 1900 in the Fogg Art Museum*, Cambridge, Mass.

K. Christiansen, "Masaccio and the 'pittura di luce,'" exhibit. review, *The Burlington Magazine* 132, pp. 736-79

L. Gérard-Marchant, "Les Indications chromatiques dans le 'De Pictura' et le 'Della Pittura' d'Alberti," *Histoire de l'art* 11, pp. 23-36

J. Grabski, *Opus Sacrum*, Warsaw

J. Hankins, *Plato in the Italian Renaissance*, vol. 1

J. Hankins, "Cosimo de' Medici and the Platonic Academy," *Journal of the Warburg Institute* 53, pp. 144-62

R. Kollewijn, "Alcune Osservazioni di Ordine Iconografico a Proposito del 'Girolamo Penitente' di Princeton," *Mitteilungen des Kunsthistorischen Instituts in Florenz*, pp. 413-20

J. Miziolek, "Transfiguratio Domini in the Apse at Mount Sinai and the Symbolism of Light," *Journal of the Warburg and Courtauld Institutes*, pp. 42-60

N. Rubinstein, "Lay Patronage and Observant Reform in Fifteenth-Century Florence," *Christianity and the Renaissance*, Syracuse, N.Y., pp. 63-82

La Chiesa e il Convento di San Marco a Firenze, vol. 2, Florence

F. Scalia, "Contributo all'Angelico: Nuovi documenti per il Ciborio di San Domenico a Fiesole," *Critica d'Arte* 55, nos. 2-3, pp. 34-40

A. Tartuferi, *Italian Paintings and Miniatures from the XIV to the XVII Centuries*, Galerie Adriano Ribolzi, Monte Carlo, pp. 45-48

T. Verdon and J. Henderson, "Fra Angelico at San Marco," *Christianity and the Renaissance*, Syracuse, N.Y., pp. 108-31

Da Biduiino ad Algardi: Pittura e Scultura a confronto, Turin

1991: W. Angelelli and A. De Marchi, *Pittura dal Duecento al primo Cinquecento nelle fotografie di Girolamo Bombelli*, Milan

C. Avery, *Donatello*, Florence

M. Boskovits, *Dipinti e sculture in una raccolta toscana*, Florence

J. Cadogan, ed., *Wadsworth Atheneum Paintings, II: Italy and Spain Fourteenth through Nineteenth Centuries*, Hartford, Conn.

K. Christiansen, "A Bishop Saint," *Recent Acquisitions: A Selection, 1990-1991*, Metropolitan Museum of Art Bulletin 49, no. 2 (Fall), p. 39

C. De Benedictis, *Per la storia del collezionismo italiano*, Florence

A. Forlani-Tempesti, *Italian Fifteenth to Seventeenth Century Drawings in the Robert Lehman Collection*, Princeton, N.J.

A. Gambuti, "L'uso della policromia nella architettura raffigurata," *Il bianco e il verde: Architettura policroma fra storia e restauro* (conference records, Florence, 1989), Florence, pp. 45-51

J. Henderson and P. Joannides, "A Franciscan Triptych by Fra Angelico," *Arte Cristiana* 79, pp. 3-6

W. Kerrigan and G. Braden, *The Idea of the Renaissance*, London

E. Marino, "Il 'Diluvio' di Paolo Uccello a Santa Maria Novella ed il Concilio di Firenze, 1439-1443," *Memorie domenicane*, pp. 241-344

D. Wigny, *Firenze*, Milan

G. Wolf, "'Velaverunt faciem eius.' Überlegungen zum Christusbild des Quattrocento," *Kritische berichte* 19, no. 3, pp. 5-18

1992: F. Ames-Lewis, ed., *Cosimo il Vecchio de' Medici, 1389-1464: Essays in Commemoration of the 600th Anniversary of Cosimo de' Medici's Birth*, Oxford, with essays by G. Holmes, "Cosimo and the Popes," pp. 21-31; J. Hankins, "Cosimo de' Medici as a Patron of Humanistic Literature," pp. 69-93; A. C. De La Mare, "Cosimo and his Books," pp. 115-56; C. Elam, "Cosimo de' Medici and San Lorenzo," pp. 157-79; C. Robinson, "Cosimo de' Medici and the Franciscan Observants at Bosco ai Frati," pp. 181-92; J. Paoletti, "Fraternal Piety and Family Power: Artistic Patronage of Cosimo and Lorenzo de' Medici," pp. 193-219

V. J. Bourke, *Augustine's Love of Wisdom: An Introspective Philosophy*, Bloomington, Ind.

A. De Marchi, "Una fonte senese per Ghiberti e per il giovane Angelico," *Artista: Critica dell'arte in Toscana*, pp. 130-51

C. Lloyd, *Fra Angelico*, London

A. Rizzo, *Benozzo Gozzoli: Catalogo completo*, Florence

A. Ronen, "Iscrizioni ebraiche nell'arte italiana del Quattrocento," *Studi di storia dell'arte sul medioevo e il rinascimento: Nel centenario della nascita di Mario Salmi* (records of international conference, Arezzo-Florence, 1989), Florence, pp. 601-24

1993: V. Alce, *Angelicus Pictor*, Bologna

F. Ames-Lewis, "Art in the Service of the Family," *Piero de' Medici, il Gottoso*, A. Beyer and B. Boucher, eds., Berlin, pp. 207-20

E. Conti et al., *La Civiltà Fiorentina del Quattrocento*, Florence

J. Gagliardi, *La Conquête de la Peinture*, Paris

W. Hood, *Fra Angelico at San Marco*, New Haven

J. James, *The Music of the Spheres*, New York

P. Joannides, *Masaccio and Masolino: A Complete Catalogue*, London

A. Kenny, *Aquinas on Mind*, London–New York

A. Ladis, *The Brancacci Chapel*, Florence–New York

P. L. Roberts, *Masolino da Panicale*, Oxford

J. Ruda, *Fra Filippo Lippi: Life and Work with a Complete Catalogue*, London

San Lorenzo: i documenti e i tesori nascosti (exhibit. catalog), Florence

J. T. Spike, "Fra Angelico a San Marco," *Il Giornale dell'Arte* 110 (April), p. 52

J. T. Spike, *Italian Paintings in the Cincinnati Art Museum*, Cincinnati, Ohio

C. B. Strehlke, "Fra Angelico and Early Florentine Renaissance Paintings in the John G. Johnson Collection at the Philadelphia Museum of Art," *Philadelphia Museum of Art Bulletin* 88, no. 376 (Spring), pp. 5-26

1994: M.J.B. Allen, *Nuptial Arithmetic: Marsilio Ficino's Commentary on the Fatal Number in Book VIII of Plato's Republic*, Berkeley, Calif.

M. Boskovits, *Immagini da meditare*, Milan

G. Di Cagno, *The Cathedral the Baptistry and the Campanile*, Florence

E. Garin, "Il problema dell'anima e dell'immortalità nella cultura del quattrocento in Toscana" (1951), reprinted in *La Cultura filosofica del rinascimento italiano, ricerche e documenti*, Milan

C. Gilbert, *Piero della Francesca et Giorgione*, Paris

L. Kanter, *Italian Paintings in the Museum of Fine Arts, Boston*, vol. 1, Boston

L. Kanter, *Painting and Illumination in Early Renaissance Florence, 1300-1450* (exhibit. catalog), The Metropolitan Museum of Art, New York

M. Levi D'Ancona, *The Illuminators and Illuminations of the Choir Books from Santa Maria Nuova in Florence*, Florence

A. Norden-Gerard, *Dizionario della Bibbia*, Milan

C. B. Strehlke, "Fra Angelico," *Painting and Illumination in Early Renaissance Florence, 1300-1450* (exhibit. catalog), The Metropolitan Museum of Art, New York

P. Viti et al., *Firenze e il Concilio del 1439*, conference records, Florence

1995: M. Boskovits, "Attorno al Tondo Cook: precisazioni sul Beato Angelico su Filippo Lippi e altri," *Mitteilungen des Kunsthistorischen Institutes in Florenz* 39, pp. 32-67

G. Didi-Huberman, *Fra Angelico: Dissemblance and Figuration*, Paris

W. Hood, *Fra Angelico: San Marco, Florence*, New York

P. Morachiello, *Beato Angelico: Gli affreschi di San Marco*, Milan

J. T. Spike, *Masaccio*, Milan, New York, and Paris

Walpole Gallery, *Treasures of Italian Art*, London

C. C. Wilson, "Fra Angelico: New Light on a Lost Work," *The Burlington Magazine*, November, pp. 737-40

INDEX OF WORKS

(**Bold type** indicates illustrations.)

INDEX OF NAMES

PHOTOGRAPHY CREDITS

The photographers and the sources of the photographic material other than those indicated in the captions are as follows:

Bardazzi Fotografia Osmannoro: pages 2, 6, 10, 14, 18, 24-25, 31, 33, 35, 40-41, 45, 49, 87, 90-91, 94-95, 99, 102-103, 109-111, 133, 137, 141.

Bayerische Staatsgemäldesammlungen, Munich: page 267 (ill. 14).

© Bildarchiv Preussischer Kulturbesitz, Berlin 1996 (Photo: Jörg P. Anders): page 267 (11); catalog 3, 4, 70E-G.

Blauel/Gnamm–Artothek, Peissenberg, Germany: pages 8-9, 126-27, 129; catalog 71C, 71E, 81.

Cincinnati Art Museum: catalog 122.

© The Cleveland Museum of Art, 1996: catalog 123.

Piero Corsini Inc. (Photo: Eric Pollitzer), New York: catalog 5A.

© 1985 and 1989 Detroit Institute of Arts Founders Society: catalog 10A-B, 124.

Rodolfo Fiorenza, Rome: pages 75, 171-75.

The J. Paul Getty Museum, Malibu, Calif.: catalog 111A-B.

G.F.S.G., Florence: catalog 24, 29, 35, 36, 42-43, 51-52.

Fogg Art Museum, Harvard University Art Museums, © President and Fellows, Harvard College, Cambridge, Mass.: catalog 6, 121.

Kimbell Art Museum (Photo: Michael Bodycomb 12/91), Fort Worth: page 59; catalog 114C.

Kunstmuseum Bern: catalog 119, 120.

Lindenau-Museum, Altenburg, Germany (Sächsische Landesbibliothek, Abteilung Deutsche Fotothek/Grossmann, Dresden): catalog 70D, 72A-C.

The Metropolitan Museum of Art (All rights reserved), New York: catalog 89, 116, 136-37.

The Minneapolis Institute of Arts: catalog 72F, 134.

Monumenti, Musei e Gallerie Pontificie, Vatican City: catalog 70H.

Museum of Fine Arts, Boston: catalog 5.

The Museum of Fine Arts, Houston: catalog 113E.

The National Gallery (reproduced by courtesy of the Trustees), London: page 13; catalog 15B-F, 86, 130.

© 1996 Board of Trustees, National Gallery of Art, Washington, D.C.: page 37; catalog 71B, 109, 142.

Reali, Photographic Archives, National Gallery of Art, Washington, D.C.: catalog 114A.

The Norton Simon Museum, Pasadena, Calif.: catalog 131.

Philadelphia Museum of Art: catalog 76A, 114D.

The Art Museum, © 1996 Trustees of Princeton University (Photo: Clem Fiori), Princeton: catalog 139.

The Barbara Piasecka Johnson Collection, catalog 97.

Private collection, Milan: catalog 133.

RCS Libri & Grandi Opere, Milan: pages 19, 113; catalog 22, 25, 31-32, 34, 37, 38A-G, 39-40, 49A, 50A, 60.

© Photo Réunion des Musées Nationaux, Paris: pages 117, 119, 122-23; catalog 12, 92.

© Photo Réunion des Musées Nationaux—H. Lewandowski, Paris: pages 120-21.

Private collection, London: pages 28-29; catalog 84.

Scala, Florence: pages 21, 56-57, 63, 67, 69, 73, 77, 79, 88-89, 93, 97, 104-5, 106-7, 114-15, 125, 131, 134-35, 138-39, 144-45, 147-49, 151-53, 155-57, 159-61, 163, 177-79, 181-85, 187-89; catalog 7, 8, 15A, 26, 56, 61A, 62A, 67, 68, 68A, 73-74, 114B.

Soprintendenza per i Beni Artistici, Architettonici e Ambientali dell'Umbria, Perugia: pages 165-66, 168-69; catalog 94A-F.

Soprintendenza per i Beni Artistici, Architettonici e Ambientali di Arezzo: catalog 9.

Staatliche Kunstsammlungen Dresden (Aufnahme: Pfauder), Dresden, Germany: catalog 125.

© Isabella Stewart Gardner Museum, Boston: page 267 (13); catalog 75D.

Wadsworth Atheneum, Hartford, Conn.: catalog 1A.

Yale University Art Gallery, New Haven, Conn.: catalog 135.